HERBERT J. SPINDEN

A STUDY OF MAYA ART

ITS SUBJECT MATTER AND HISTORICAL DEVELOPMENT

With a New Introduction and Bibliography by
J. ERIC S. THOMPSON
Formerly on the Staff of the Carnegie Institution of Washington

DOVER PUBLICATIONS, INC., NEW YORK

Published in Canada by General Publishing Com-
pany, Ltd., 30 Lesmill Road, Don Mills, Toronto,
Ontario.
Published in the United Kingdom by Constable
and Company, Ltd., 10 Orange Street, London WC 2.

This Dover edition, first published in 1975, is an
unabridged republication of the work originally
published by the Peabody Museum, Cambridge,
Mass., in 1913, as Volume VI of the Memoirs of the
Peabody Museum of American Archaeology and
Ethnology, Harvard University.
A new introduction and bibliography have been
prepared specially for the present edition by J. Eric
S. Thompson.

International Standard Book Number: 0-486-21235-1
Library of Congress Catalog Card Number: 74-20300

Manufactured in the United States of America
Dover Publications, Inc.
180 Varick Street
New York, N.Y. 10014

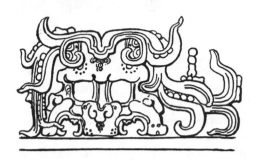

INTRODUCTION
TO THE DOVER EDITION

H. J. SPINDEN (1879–1967)

THE CAREER

Herbert Joseph Spinden—Joe, as he was invariably called—was born in Huron, South Dakota, on August 16, 1879. His paternal grandfather, Samuel Spinden, had come from Switzerland to settle in Iowa before 1850. In his late teens, young Spinden worked with railroad survey parties in Montana, Idaho and Washington, and in 1900 he joined the gold rush to Nome, Alaska, an action which to those of us who knew him later in his life seems very much out of character.

Entering Harvard as a student of anthropology two years later, he came under the influence of Roland Dixon, Frederick Putnam and Alfred Tozzer, great anthropologists in their generation. In the summer of 1905, he, George Will (later to become an authority on the archaeology of the Dakotas) and two other undergraduates excavated mounds in the territory of the Mandans, then nearing extinction, around Bismarck, North Dakota. This work resulted in a paper in which Will and Spinden collaborated, *The Mandans: A Study of Their Culture, Archaeology, and Language*, published by Peabody Museum, Harvard University, the following year. Will, senior author, presumably wrote the archaeological section; Spinden, one supposes, searched the literature to recover descriptions of Mandan culture.

Spinden received his A.B. in 1906, and, while serving as a teaching fellow, his A.M. in 1908, followed by his Ph.D. the following year. The thesis he submitted for the last was an earlier form of *A Study of Maya Art*. The present fuller version was published by Peabody Museum, Harvard University, in 1913.

From 1909 to the end of 1920 Spinden served as assistant curator of anthropology at the American Museum of Natural History, New York. Soon after joining the

museum he published his *Table Showing the Chronological Sequence of the Principal Monuments of Copan, Honduras,* which, greatly expanded, formed much of the third part of *A Study of Maya Art.* With that work published, he widened his interests, devoting much time to the study of agriculture in the New World before Columbus, its origins and scope. In several papers on the subject he listed the very many plants brought under cultivation by the American Indian and made a very cogent point: "If we remember that in the four hundred years that the white man has dominated the New World he has not reduced to cultivation from wild stock a single important staple, the wonder of the American Indian agriculture becomes still greater." He stressed his view that a near New-World-wide "archaic" culture was the vehicle of that very extensive distribution of agricultural plants and systems of cultivation. Two or three decades ago that view had little support, but in recent years it has regained some favor in a modified form.

In 1917 the American Museum of Natural History published Spinden's handbook *Ancient Civilizations of Mexico and Central America* with subsequent revised editions in 1922, 1928 and 1946. For its time this well-illustrated book was a splendid introduction to the subject, but, naturally, the tremendous advances in archaeology during the past fifty years have made many parts obsolete.

Following the United States entry into the First World War Spinden, together with other Middle American archaeologists, notably Sylvanus Griswold Morley, served in that area as agents of U.S. naval intelligence. I have sometimes wondered why U.S. Intelligence in both world wars chose such men. Their knowledge of those countries was largely confined to archaeology and their command of Spanish poor. Morley and Spinden were notorious for their bad Spanish; Central-American-born Americans spoke the language from their infancy and had contacts in every corner of those lands. Spinden operated largely in the Republic of Honduras and El Salvador.

Meanwhile, Spinden was developing a new interest which was to absorb much of his time for the next thirty-five years, the problem of the correlation of the Maya calendar with our own. Once that was satisfactorily settled there would be an historical framework for the high cultures of all Middle America. Working with historical sources covering events of the early Spanish colonial period, some recorded in Maya documents, others in Spanish accounts, Spinden presented a paper in December 1919 to the National Academy of Sciences which offered a day-for-day correlation of the Maya and Gregorian calendars (he projected the latter backward—it came into use in the Spanish dominions in A.D. 1582).

At the end of 1920 Spinden took up an appointment as curator of Mexican archaeology and ethnology at Peabody Museum, Harvard University. This position at his alma mater was created largely to give him freedom to pursue the correlation question, and was financed by his old teacher Alfred Tozzer and various friends of the museum. Thus released from museum duties, he busied himself in writing *The Reduction of Maya Dates,* published by the museum in 1924. In this he gave the evidence, as he saw it, supporting his correlation, together with the exact equivalents in our calendar for almost all Maya dates then known.

For some time this correlation received wide acceptance, but today no working archaeologist supports it or any correlation within a couple of centuries. Astronomers found it unacceptable from their viewpoint. Spinden had committed himself too soon. Between 1925 and 1930 John E. Teeple, a chemical engineer who had taken up Maya astronomical inscriptions as a hobby, worked out the Maya systems of recording lunar reckonings and the synodical revolutions of the planet Venus. These proved that dates which by Maya calculation were those of new moon fell about ten days after new moon in the Spinden correlation. Similarly, dates which the Maya recorded as at or within a few days of heliacal rising of Venus after inferior conjunction fell about 290 days after those dates in the Spinden correlation. It was a knockout blow for that correlation.

It was more than that; it was a tragedy for Spinden. For the rest of his active life

he devoted a great part of his time and energy to defending his correlation. It became an obsession. In its support he interpreted historical or pseudo-historical events, notably the reported journey of Quetzalcoatl to Yucatan, in temporal settings which with the growth of knowledge concerning ancient Mexican history became less and less tenable. Had he never embarked on his correlation studies, one may be confident that the latter half of his career would have equalled in brilliance that of his early years. In defence of his position he published two lengthy papers, *Maya Inscriptions Dealing with Venus and the Moon* (1928) and *Maya Dates and What They Reveal* (1930), as well as several short papers which dealt directly or indirectly with the subject.

In 1926 Spinden took a post at the Buffalo Museum of Science, which he left in 1929 to become curator of ethnology (later curator of American Indian art and primitive cultures) at the Brooklyn Museum, a post he held until his retirement in 1951, in his seventy-second year. During his years at Brooklyn he was responsible for the Brooklyn Museum School Service, an experiment supported by the Carnegie Corporation which has been widely adopted by other museums.

Spinden was an art historian rather than an archaeologist, having studied the art of various early or primitive cultures long before public interest in that field was aroused. Except perhaps during his 1905 trip to Mandan country, he never put trowel or whisk brush to earth. He made various trips to Maya country. His first, to Yucatan, was in 1910; his second, a most vigorous one, was with Morley in 1914, across the Peten and down the upper Usumacinta river. In 1921 a search for unreported Maya ruins led him south of Xkanha in the heart of the Yucatan peninsula. In 1926 he explored the eastern coast of the peninsula, as described below. Unfortunately, he did not publish anything on those field trips.

One of the few Maya archaeologists in fiction was Russell Aldridge, Ph.D., a character in Frances Parkinson Keyes' once best-seller *Dinner at Antoine's*, who "prowled the jungles of Yucatan." He was "a fast man with a hieroglyph, a drink, a samba, and a back-to-back pair of jacks in the order named," and he had very high hopes of finding Maya hieroglyphic books in caves on the Bay Islands, a strange optimism since the Maya did not live on those islands. If Maya archaeologists remotely resemble Dr. Aldridge, it is perhaps just as well Joe Spinden was not one.

Spinden had the honor of being elected president (1936–37) of the American Anthropological Association. He taught in the summer school of the University of Mexico, and from its foundation he was Honorary Counsellor of the Seminario de Cultura Maya of the University of Mexico.

THE MAN

Joe Spinden was a burly man, at least six feet tall, with blue eyes, round face with a look of innocence, and, at least since 1926 when I first knew him, a shock of white hair.

In 1926 the journalist Gregory Mason, with the backing of the New York *Times*, organized an exploratory trip up the then little-known east coast of Yucatan. In the party were Spinden, an ornithologist, and a commander in the U.S. Navy Reserve. Renting a schooner with auxiliary engine in Belize, British Honduras, they proceeded north in search of Maya sites, rare birds and hydrographic data (the U.S. Navy was then using a chart of Cozumel Island based on a Royal Navy survey of 1831). Later that year Mason published *Silver Cities of Yucatan* (Putnam's Sons), an account of that successful exploratory trip.

In this he has a number of illuminating portraits of members of the expedition. "Spinden . . . , who talks even more than I (as I see it) and has twice as much to say, is the leader in the free-for-all, Donnybrook of badinage, personal animadversion and 'ragging' which has kept up with no intermission except for sleep since we assembled at New Orleans." Again, writing of the cramped quarters on the schooner, Mason describes Spinden's dunnage as "a great mixed mass of papers, books, cigar boxes, photographic material, hunting knives, candy jars, boots, medi-

cine bottles, ink bottles, blankets and dis-ordered clothing" which buried his unused bunk and that of a second member of the expedition. When able to forget his sea-sickness, he "puts off the manner of a pathetic child lost in the dark for a sudden smile of winsome friendliness."

In those passages Mason puts his finger on three characteristics of Spinden, his in-ability to stop talking, his untidiness and his air of needing to be mothered.

At the conclusion of that east coast trip of 1926 Spinden visited Chichen Itza at a time when a group of us young archaeolo-gists was preparing to visit various ruins in western Yucatan during Easter week, work at Chichen then shutting down. We invited Spinden to join us, hoping to learn much from that great authority. Now-adays, luxurious buses take tourists along tarred roads to Uxmal, Kabah and such sites; 1926 there were just tracks which only a Model T Ford might, with luck, negotiate. We had constantly to get out to push and often lift our two Fords over rock ledges. We got lost more than once, the trail petering out in some Maya corn-field. Spinden talked incessantly, trying to needle each of us in turn. Then for the best part of an hour he sang his version of "La Cucaracha," which he called *cuca-racho*, with tum-tum-tum replacing most of the words. It is strange how a man so sensitive to beauty in art could have been so insensitive to atmosphere. Lost, tired, sweaty and dirty, each and every one of us was ready to murder him. He was trying to keep us cheerful!

His untidiness was not confined to his physical surroundings; he had a tendency to be untidy intellectually. After publica-tion of *The Reduction of Maya Dates*, Toz-zer asked him to prepare a report on the collection of artifacts, particularly the jades, recovered from the sacred well (*cenote*) of Chichen Itza. Two years later, when Spinden moved to Buffalo, the report was far from finished. The trouble was that some Maya design would remind him of one on Persian carpets or on vessels from the Ucayali tributary of the Amazon, and he would spend weeks or even months exploring the art styles of those areas. He accumulated an amazing store of informa-tion which stood him in good stead for the remainder of his life, but had little to do with the job on hand.

His feeling for all forms of primitive art was extraordinarily perceptive; he made, for instance, a study in depth of the treatment of the bat motif throughout the New World. In such work he was aided by his skill with pen and pencil; all the line drawings—there are well over six hundred —in *A Study of Maya Art* were made by him from originals, photographs or pub-lished line drawings.

He had one defect, unfortunately fatal in the field of Maya archaeology, in which intensive excavation, research and new techniques call for constant revision of ideas: he never discarded an idea he had once advanced. For instance, brushing aside incontrovertible evidence that a se-quence of pottery types found in burials in temples at the site of Holmul, Peten, cov-ered the period A.D. 1 to A.D. 600 in his cor-relation, evidence confirmed by all subse-quent field work in that area, Spinden pro-nounced them not only not of the Maya Classic period but, instead, of the twelfth century. He claimed that the vessels had been deposited in the graves of a certain Huetzin (a Toltec ruler who, he believed, had died in A.D. 1147 and had been buried at Holmul) and his followers, and that all the pottery was of that date. Unhappily, that inability to adjust to new knowledge tarnished the brilliance of his early years.

In 1928 he married Ellen Collier of Co-hasset, Mass., who in 1933 published a penetrating study of "Totonac" culture, *The Place of Tajin in Totonac Archaeol-ogy*, a work which must have owed much to her husband. His second marriage was to Ailes Gilmour in 1948. There was a son of that marriage, Joseph Gilmour Spinden.

THE BOOK

A Study of Maya Art, as noted, was published in 1913, four years after the original version had been submitted in partial fulfillment of requirements for his Ph.D. degree. Revision of the first two parts appears to have been minimal; the third part seems to have been considerably expanded.

It was a pioneer and highly successful study of a very complex subject. W. H. Holmes' classic *Archaeological Studies among the Ancient Cities of Mexico* (1895–97) had been a splendid introduction to Maya architecture, but the treatment had been architectonic; G. B. Gordon in *The Serpent Motive in the Ancient Art of Central America and Mexico* (1905) had explored that subject, but not with the deep insight Spinden was to bring to bear. Apart from those two writings Spinden was exploring an unknown field.

A. P. Maudslay and T. A. Joyce, both outstanding Mayanists, reviewing *A Study of Maya Art* in *The American Anthropologist,* made this judgment: "As a level-headed and consistent discussion of a complicated subject, it will remain a book that no future student can neglect." That appraisal still holds good, certainly for the bulk of the memoir, despite the enormous increase of knowledge of the Maya in the past sixty years.

Part I, "General Consideration of Maya Art," brilliantly covers the subject matter —the human figure, gods, reptiles and birds. Strangely, the Maya largely ignored vegetation, except for maize motifs, in their art, probably because it had few direct associations with their gods. Whereas analysis of subject matter would be a relatively straightforward matter in the study of many cultures, it is far from so in treating of the Maya, whose art is overwhelmingly religious and dwells so much on deities who blend features, symbols and attributes of a bewildering complexity.

The art of mediaeval Europe is also overwhelmingly religious, but with our Christian heritage we can match known symbols to figures—grill, lion, bull, eyes on plate, wheel and so on; no similar key to Maya symbolism exists. Again, European religious art often has secular settings—landscapes, notably in Flemish art, interiors and architectural backgrounds. Religious incidents—the Annunciation, Nativity, Last Supper and so on—called for grouping of individuals and scenery. There was then almost nothing comparable in Maya art, partly because that art has survived mainly in sculpture, but largely because in Spinden's day few life scenes on pottery had been found and

Maya murals were very rare, for those of Uaxactun and Tulum and the magnificent scenes at Bonampak were yet undiscovered. Also, the masses of pottery figurine whistles, many with scenes of everyday life, were yet to be brought to light. With such handicaps Spinden faced a formidable task.

He was particularly successful in diagnosing the component elements of serpents and the strange dragon-like lizards with which they so often blend. He isolated and identified orbital plates over the creatures' eyes, the strange "beards" beneath their lower jaws, their elongated and swept-back upper jaws, nostril plugs, feathers, plant elements, death symbols and other attributes with a success only attainable by long study of the gamut of Middle American art aided by the trained eye of the artist.

This section, the most important in the book, is almost as pertinent now as when it was written.

Part II, "Consideration of the Material Arts," is devoted to a review of Maya architecture, sculptured monuments (as entities; their elements are discussed in Part I), pottery, jewelry, textiles, etc. In the long section on architecture Spinden was influenced by Holmes' treatment of building techniques, but much new material from important sites discovered since Holmes' day gave him full scope to expand in that field. His discussion of decoration of facades and roof-combs and investigation of the component elements of mask panels were exploratory studies in a new field.

The section on pottery was written before anything had been learned of ceramic sequences, such an important tool of the modern archaeologist, and so it is no more than a description of outstanding pieces then known from all over the area.

In the description of jewelry there is not a word on the jades and gold objects from the sacred *cenote* of Chichen Itza, which were stored a few yards from where Spinden studied and wrote. Presumably he was obeying orders from above, for that material had been smuggled out of Mexico and a sense of guilt pervaded Peabody Museum's halls comparable to that in any

Massachusetts meeting house 250 years earlier.

In a brief survey of the surviving Maya hieroglyphic books Spinden was, I believe, the first to suggest that several scribes wrote the Dresden codex, a point proved over fifty years later by the German scholar Günter Zimmermann.

In Part III, "Chronological Sequence," Spinden arranges in a sequence of increasing artistic achievement dated monuments of the Classic period, site by site, and sets the results against the dates in the Maya calendar which they carry. Presumably influenced by the turn-of-the-century idea that the course of civilization is always upward, he assumes perhaps too readily that the sequence was always from early awkward delineation to a late culmination of masterpieces, for he makes no allowance for the effects of individual skill or lack of it. Nevertheless, in broad terms he makes his point in the case of Copan monuments, but is less successful with those of other sites.

In keeping with the outlook of the time, the Maya in the highlands of Guatemala are almost completely ignored. That was not really Spinden's fault, for at that time nobody knew or cared anything about that area. It was not until Alfred Vincent Kidder began to excavate in the highlands in the early thirties that the important role of that area in Maya history was acknowledged.

In the concluding pages Spinden examines Maya art in relation to the styles of other peoples of Central America and Mexico. Like his contemporaries, he subscribed, with reservations, to the doctrine then prevalent of the Maya as a mother civilization which had given birth to all the other cultures of Middle America. That sort of matrolatry has a peculiar fascination for archaeologists. No sooner had the Maya mother-concept been demolished after much effort than another generation of archaeologists set up the Olmec cultural ancestress in her place and danced around

her as though she were another golden calf. Luckily, there is more than one Moses ready to burn her in the fire.

Finally, Spinden extends his survey of Indian art to the Mississippi drainage, Georgia and the great plains, noting resemblances to Middle American art which had already attracted attention, but viewing them with caution.

The twenty-nine plates complement the line drawings.

OTHER PRINCIPAL WRITINGS OF SPINDEN

An Ancient Sepulchre at Placeres del Oro, State of Guerrero, Mexico. *American Anthropologist*, 13 : 29–55. 1911.

The Origin and Distribution of Agriculture in America. *Proceedings 19th International Congress of Americanists*, Washington, D.C., 1915, pp. 269–76. Washington, 1917.

Ancient Civilizations of Mexico and Central America. *American Museum of Natural History Handbook 3*. New York, 1917.

The Reduction of Maya Dates. *Peabody Museum, Harvard University, Papers*, vol. 6, no. 4. Cambridge, Mass., 1924.

Maya Inscriptions Dealing with Venus and the Moon. *Buffalo Society of Natural Sciences Bulletin*, vol. 14, no. 1. Buffalo, 1928.

Maya Dates and What They Reveal. *Brooklyn Institute of Arts and Sciences, Museum, Science Bulletin*, vol. 4, no. 1. Brooklyn, 1930.

Origin of Civilizations in Central America and Mexico. *Fifth Pacific Science Congress: The American Aborigines*, pp. 219–46. Vancouver, 1933.

Indian Manuscripts of Southern Mexico. *Smithsonian Institution Annual Report*, 1933, pp. 429–51. Washington, D.C., 1935.

Sun Worship. *Smithsonian Institution Annual Report*, 1939, pp. 447–69. Washington, D.C., 1940.

J. ERIC S. THOMPSON

EDITORIAL NOTE

THIS Memoir is the result of researches by Dr. Spinden in the Peabody Museum while a graduate student in the Division of Anthropology of Harvard University during the years 1906–1909. He presented the substance of the Memoir as a thesis for the degree of Doctor of Philosophy on May 1, 1909. During these researches he discovered and worked out the chronological sequence of the ancient monuments in Honduras and Guatemala, and in Yucatan and other portions of Mexico. Later in making a comparison with the Maya dates included in the hieroglyphic inscriptions on the monuments he found a remarkable correspondence between the dates and the several periods as determined by the character of the art itself. This important discovery was pointed out by Dr. Spinden to other workers in the Museum and to students in the Division. Thus this correlation between Maya art and Maya dates became generally known long before Dr. Spinden, at the suggestion of his friends in the Museum, presented a paper "On the Historical Development of Art at Copan," before the International Congress of Americanists, held in the City of Mexico in September, 1910.

After his graduation, and on leaving Cambridge to take the position as Assistant Curator in Anthropology in the American Museum of Natural History, Dr. Spinden continued his studies of the ancient art of Central America and Mexico, and made trips to Mexico, Honduras and Guatemala for the purpose of confirming, from the original monuments, some points which were not perfectly clear in the casts and photographs that he had studied. The results of his later studies are incorporated in this Memoir.

With two or three exceptions the illustrations in the text are from drawings by the author, either from the original sculptures or from photographs and illustrations.

Dr. Spinden is the first Maya scholar who has devoted himself to a thorough study of the ancient art of Central America as shown by the architecture, the sculptured monuments and other objects found in the ruined cities of the ancient Maya people.

The Museum is indebted to the Committee on Central American Research for the publication of this Memoir.

F. W. PUTNAM.

PEABODY MUSEUM OF HARVARD UNIVERSITY,
Cambridge, November 28, 1912.

AUTHOR'S PREFACE

THE study of Maya art, here presented, is based upon a thesis for the degree of Doctor of Philosophy submitted May 1, 1909, in Harvard University. While the matter has expanded greatly under further study, still the thesis presented contained an exposition of the chronological sequence of the monuments, which the writer considers the most noteworthy contribution, as well as chapters on the analysis of the designs and the principles of the architecture. It was thought wise to present the portion relating to the historical development of art at Copan before the Congress of Americanists at Mexico City in September, 1910, otherwise the subject matter has not been given to the public. The attempt has been made to be precise and exoteric in the discussion of this most involved subject.

It is with gratitude that the writer acknowledges his indebtedness to the many persons who have aided and encouraged him in this work. The inception of this research took place in Anthropology 9, a course on Mexican and Central American archaeology offered in Harvard University by Dr. A. M. Tozzer. Its continuance has been largely due to the support and coöperation of the small band of students of Maya culture headed by Mr. C. P. Bowditch. Thanks are also due to Mrs. Zelia Nuttall of Mexico City, to Mr. E. H. Thompson of Chichen Itza, Yucatan, and to Mrs. W. M. James of Merida, Yucatan, as well as to many other persons in Mexico, Guatemala and Honduras.

In the revision of the manuscript the writer received valued assistance from Dr. Tozzer. For the revision of the proof he is indebted to Professor Putnam and to Miss Mead and to the latter also for the preparation of the index. Mr. C. C. Willoughby has given his kind attention to the preparation of the plates and to the making of the blocks for the illustrations in the text. The map of the region covered by the Maya civilization was drawn by Mr. L. M. Hendrick, Jr., according to data compiled from several sources.

Since his connection with the American Museum of Natural History the writer has been greatly indebted to his superiors in the Museum, who have done everything in their power to further his labors in this field.

H. J. S.

AMERICAN MUSEUM OF NATURAL HISTORY,
New York, November 28, 1912.

CONTENTS

LIST OF FIGURES IN THE TEXT

[1] References to author and year are according to the Bibliography given at the end of the volume. All references to Maudslay are to the archæological portion of the Biologia Centrali-Americana, 1889–1902. Where the name of the site or monument is stated but no reference to a publication is given the reader may ordinarily gain additional information by consulting the Table of Nomenclature beginning on page 249. Here the sites are arranged alphabetically and the principal contributions to our knowledge of each site is noted and correlated.

LIST OF PLATES

PLATE I. QUIRIGUA.

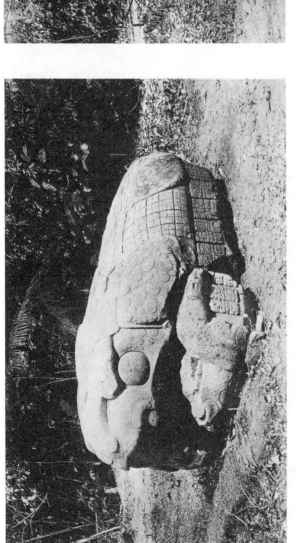

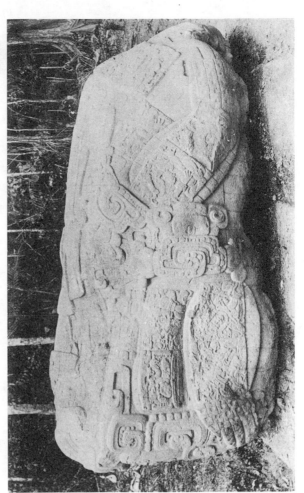

1, ALTAR G, VIEWED FROM THE NORTHWEST.

2, ALTAR G, WEST SIDE.

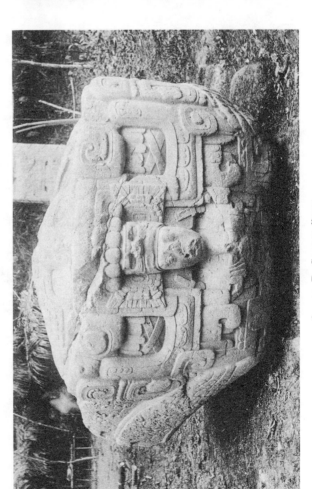

3, ALTAR B, SOUTH SIDE.

4, ALTAR B, EAST SIDE.

PLATE 2.

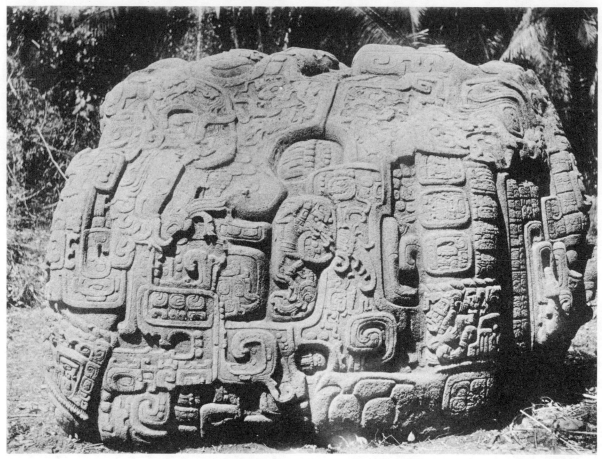

1, QUIRIGUA: ALTAR P, WEST SIDE.

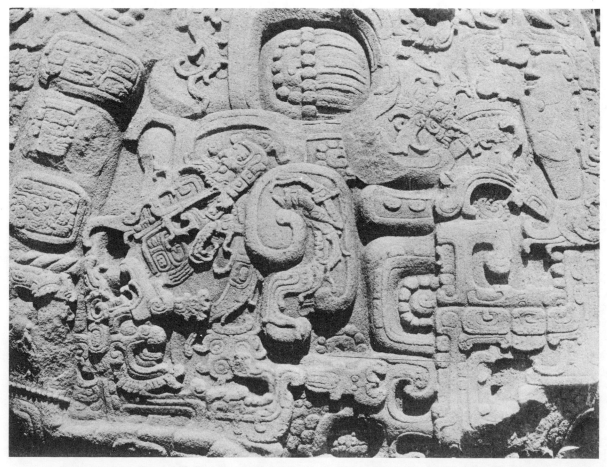

2, QUIRIGUA: ALTAR P, DETAIL OF EAST SIDE, SHOWING OVERLAID GROTESQUE ORNAMENT.

PLATE 3.

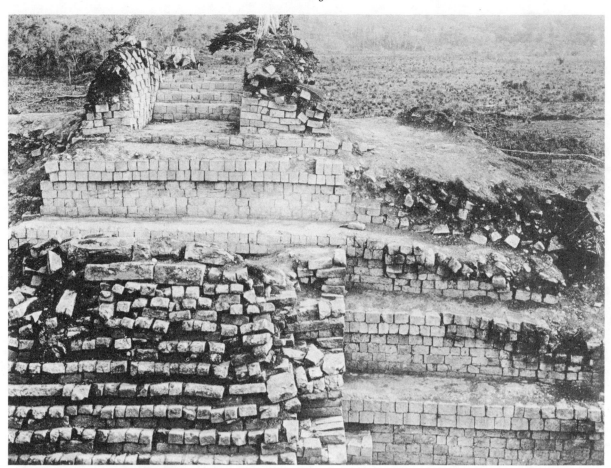

1, COPAN: MOUND 21, SHOWING TERRACED PYRAMID WITH STAIRWAY, AND CHAMBER WITH INTERIOR STEPS.

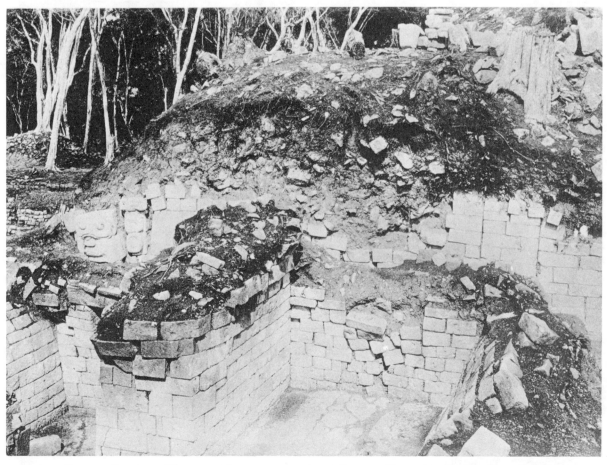

2, COPAN: INTERIOR WALLS OF STRUCTURE 21A, AND CORNER MASK ON SIDE OF STRUCTURE 22.

PLATE 4.

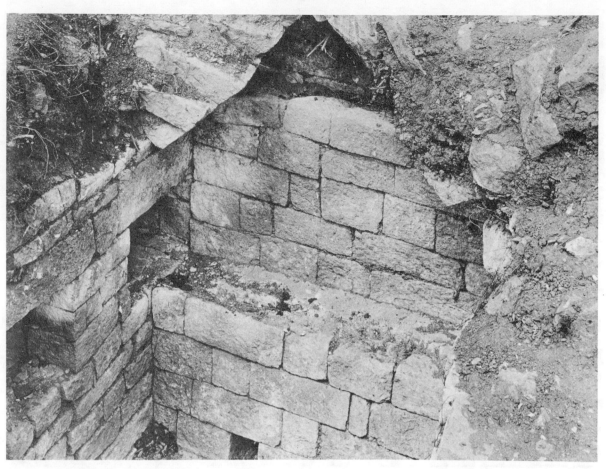

1, COPAN: SMALL VAULTED CHAMBER, SHOWING NICHES, SHELVES, AND ROOFING STONES.

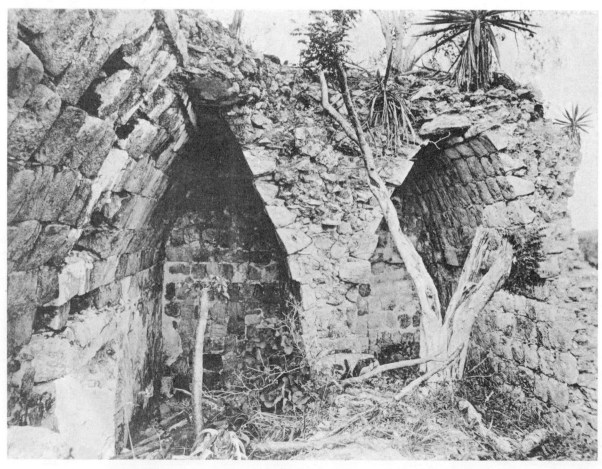

2, LABNA: CROSS-SECTION SHOWING TWO CHAMBERS OF THE TEMPLE.

PLATE 5.

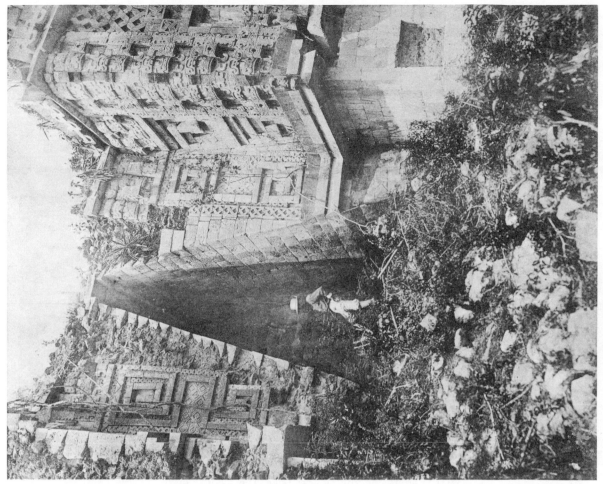

2. UXMAL: SEALED PORTAL VAULT IN THE HOUSE OF THE GOVERNOR. THE
VENEER CHARACTER OF THE CUT STONE IS EVIDENT.

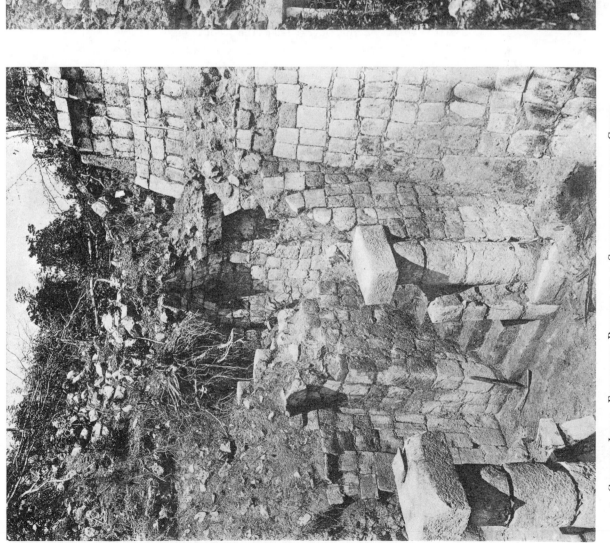

1, CHICHEN ITZA: EXCAVATED PORTION OF A STRUCTURE NEAR THE GROUP
OF THE COLUMNS.

PLATE 6.

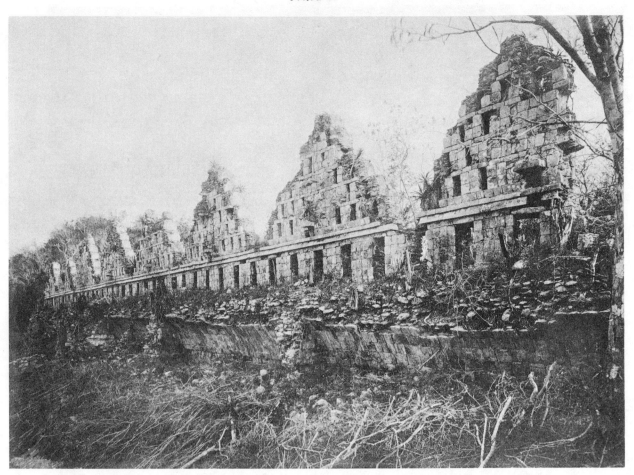

1, UXMAL: HOUSE OF THE DOVES; SERRATED ROOF-COMB.

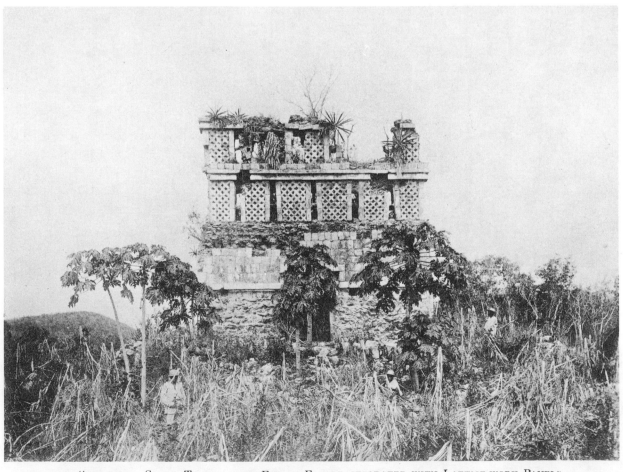

2, SABACCHE: SMALL TEMPLE WITH FLYING FAÇADE DECORATED WITH LATTICE-WORK PANELS.

PLATE 7.

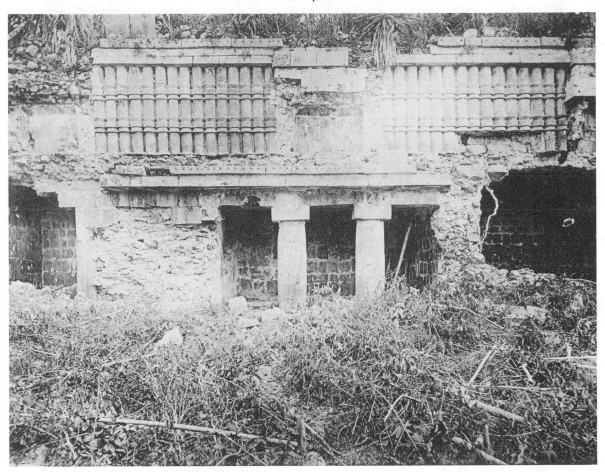

1, CHACMULTUN: EDIFICE 1, SHOWING USE OF COLUMNS FOR SUPPORT AND DECORATION, ALSO ROOF NICHES OVER DOORWAYS.

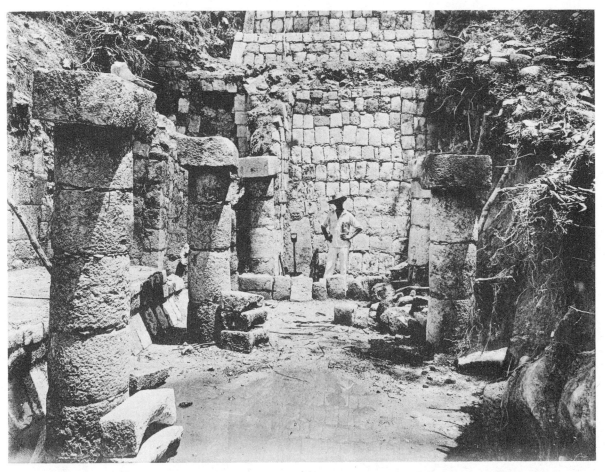

. CHICHEN ITZA: EXCAVATED PORTION OF A STRUCTURE NEAR THE GROUP OF THE COLUMNS, SHOWING COLUMNS WITH ABACI.

PLATE 8.

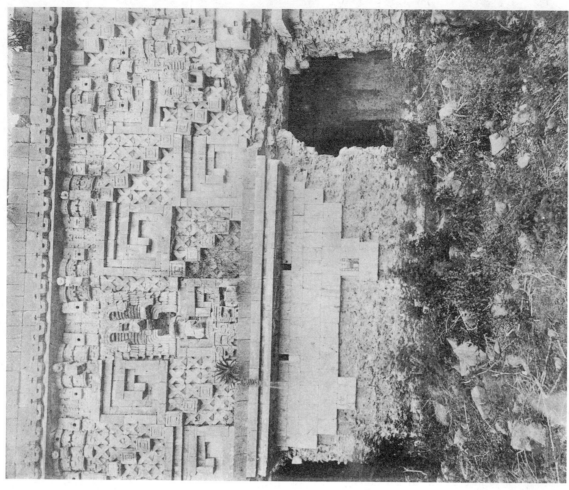

2, UXMAL: HOUSE OF THE GOVERNOR; MIXTURE OF GEOMETRIC, HIGHLY CONVENTIONALIZED, AND FAIRLY REALISTIC MOTIVES.

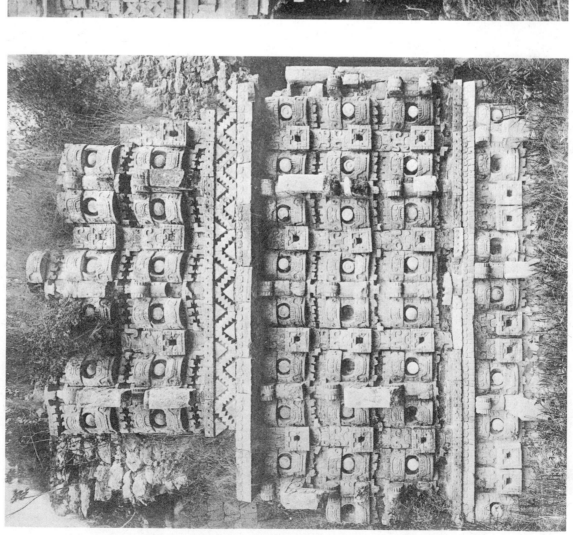

1, KABAH: PORTION OF THE FAÇADE OF STRUCTURE 1, SHOWING SOMEWHAT SIMPLIFIED MASKS IN THE UPPER AND LOWER ZONES.

PLATE 9.

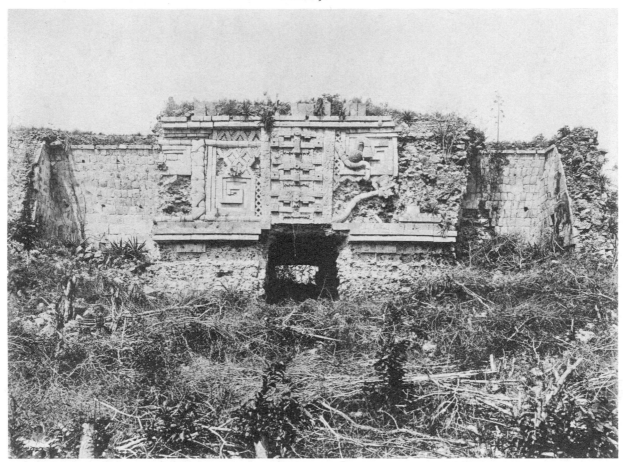

1, UXMAL: WESTERN RANGE OF NUNNERY QUADRANGLE; MASK PANELS, GEOMETRIC DECORATION,
AND FREE USE OF WINDING SERPENT MOTIVE.

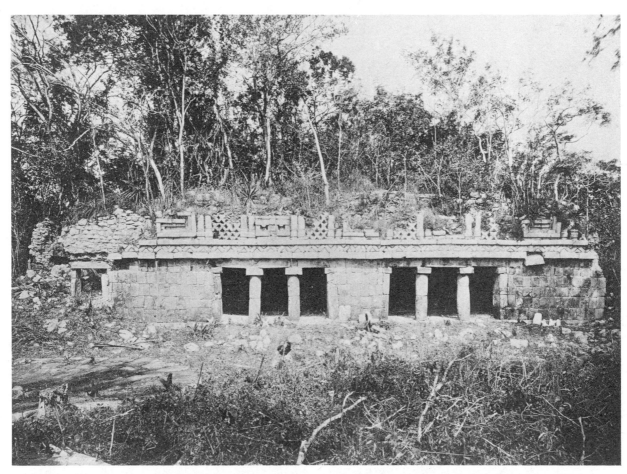

2, LABNA: PALACE, EAST WING OF UPPER RANGE; SIMPLIFIED MASK PANELS OVER WIDE DOORWAYS,
FLANKED BY LATTICEWORK AND FRET PANELS.

PLATE 10.

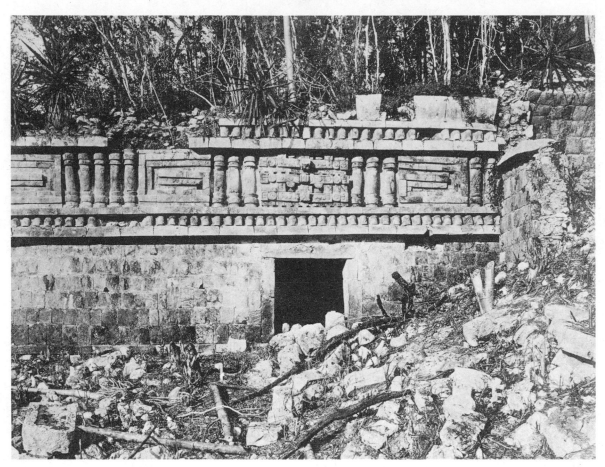

1, LABNA: PALACE, WEST WING, LOWER RANGE; SIMPLIFIED MASK PANELS.

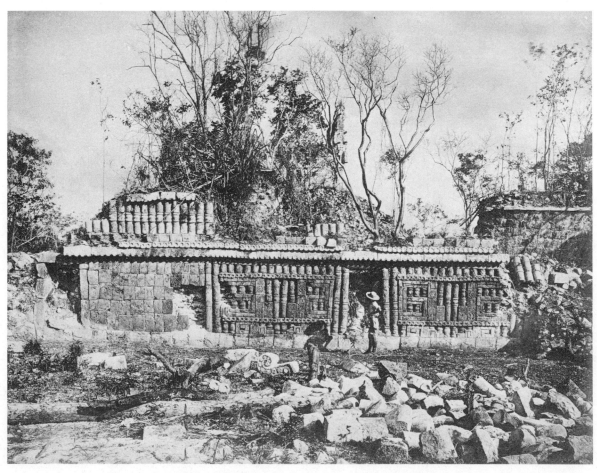

2, LABNA: BUILDING NORTH OF PORTAL; MASK PANELS IN LOWER ZONE, SHOWING SUBSTITUTION
OF GEOMETRIC MOTIVES FOR THE ORIGINAL PARTS.

PLATE 11.

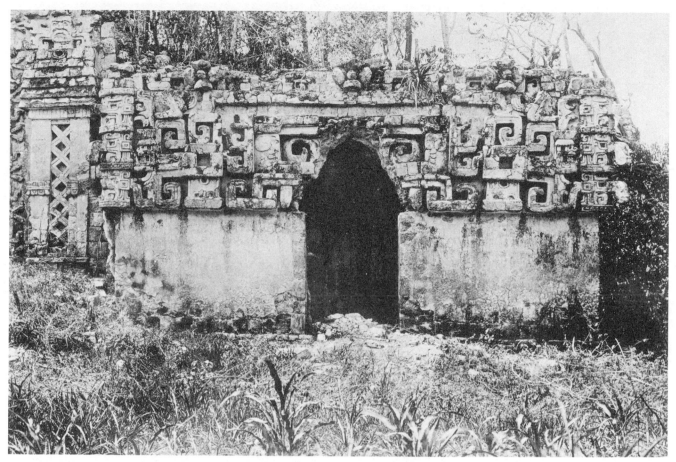

1, HOCHOB: LEFT WING OF PRINCIPAL STRUCTURE: MASK PANEL OVER DOORWAY.

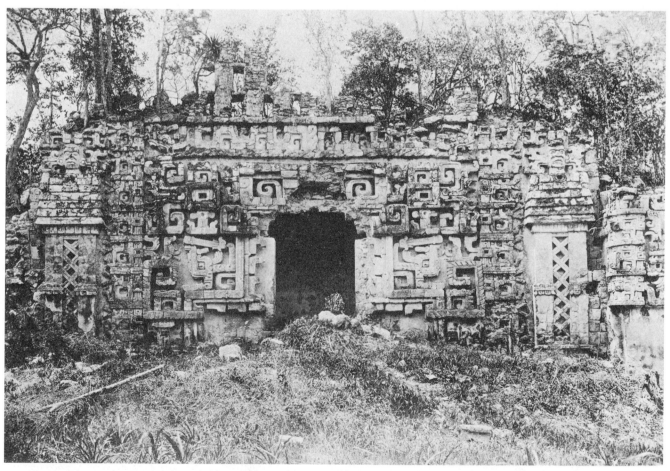

2, HOCHOB: MIDDLE PORTION OF PRINCIPAL STRUCTURE; MASK PANEL OVER DOORWAY AND PROFILE SERPENT HEAD
AT EACH SIDE OF DOORWAY IN MIDDLE ZONE.

PLATE 12.

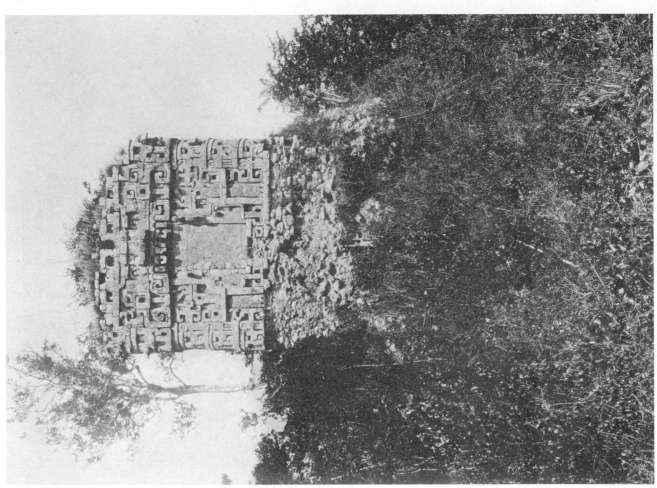

2, DSIBILNOCAC (ITUBIDE): TEMPLE WITH SEALED DOORWAY; MASK PANEL AND
LATERAL PROFILE MASKS.

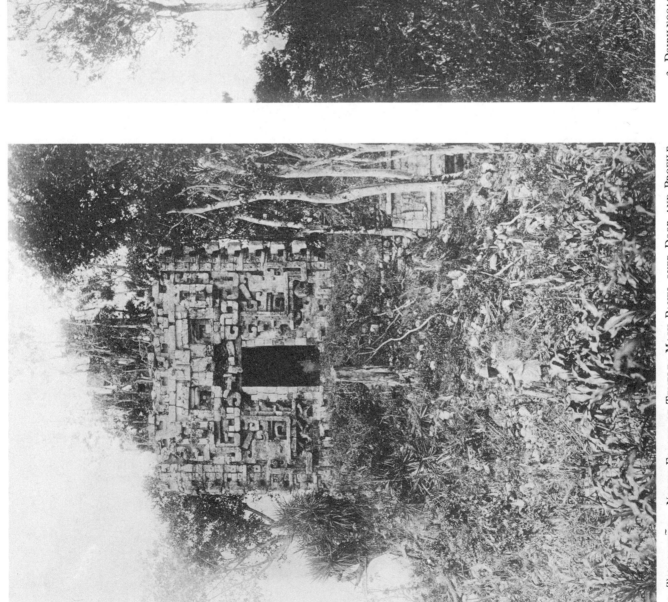

1, TABASQUEÑO: NORTH FAÇADE OF TEMPLE; MASK PANEL OVER DOOR AND PROFILE
PANEL AT EACH SIDE OF DOOR.

PLATE 13.

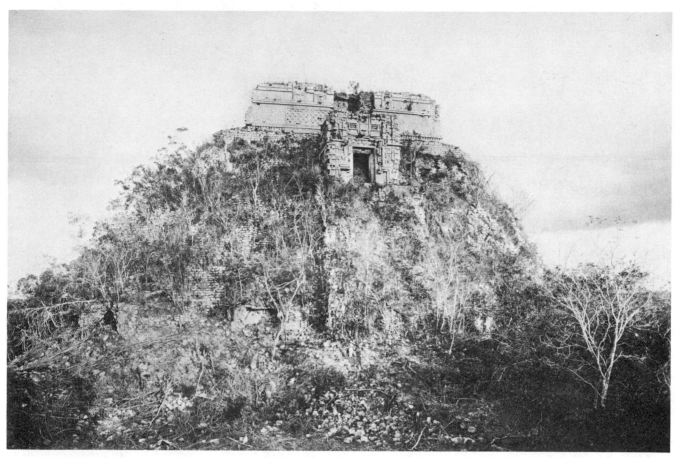

1, UXMAL: HOUSE OF THE MAGICIAN.

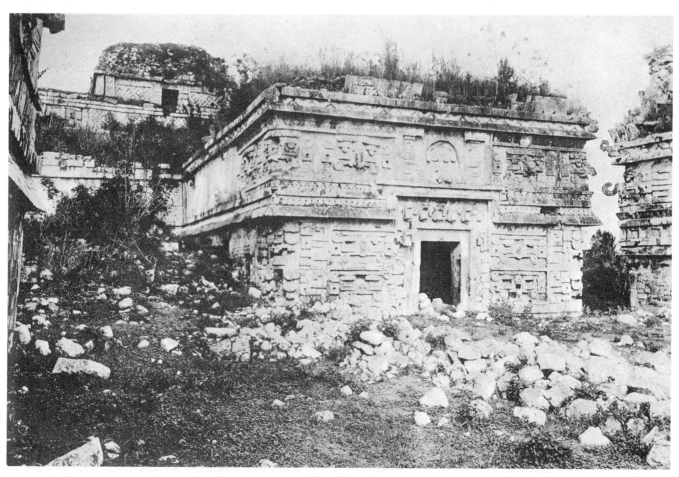

2, CHICHEN ITZA: CASA DE MONJAS; EASTERN FAÇADE OF THE EAST WING.

PLATE 14.

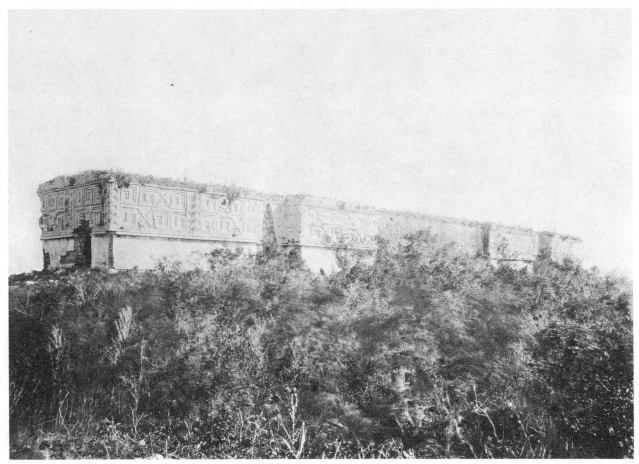

, UXMAL: HOUSE OF THE GOVERNOR; GEOMETRIC DECORATION ALTERNATING WITH MASK PANELS IN TIERS.

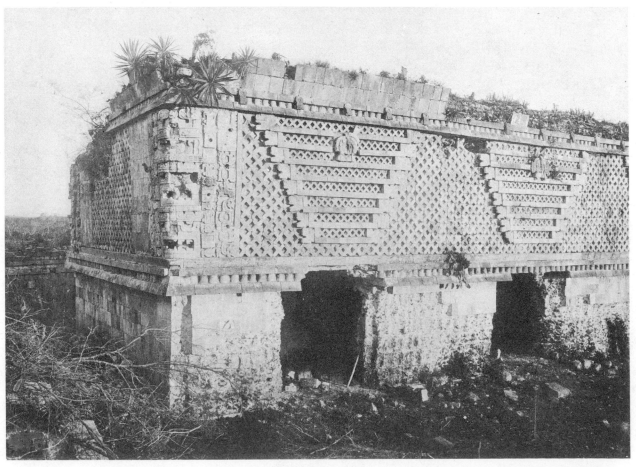

2, UXMAL: EASTERN RANGE OF NUNNERY QUADRANGLE; LATTICE-WORK DECORATION OVERLAID WITH OTHER MOTIVES; ELABORATED CORNER MASKS.

PLATE 15.

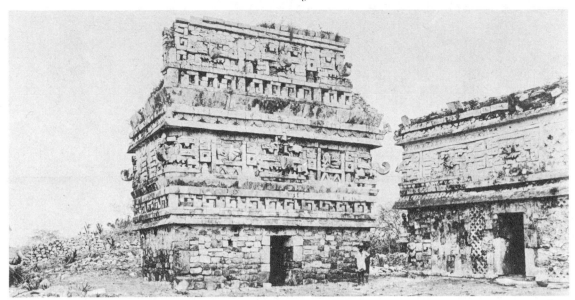

1, CHICHEN ITZA: THE IGLESIA, SHOWING FLYING FAÇADE. THE MASKS OF THE FLYING FAÇADE ARE MADE OF REFUSE MATERIAL.

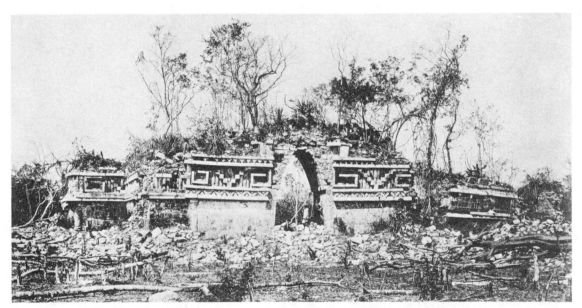

2, LABNA: THE PORTAL ARCH FROM THE SOUTHEAST; GEOMETRIC DECORATION.

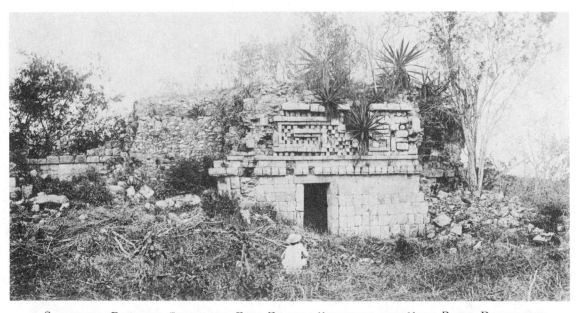

3, SABACCHE: PRINCIPAL STRUCTURE, EAST FAÇADE; GEOMETRIC AND MASK PANEL DECORATION COMBINED.

PLATE 16.

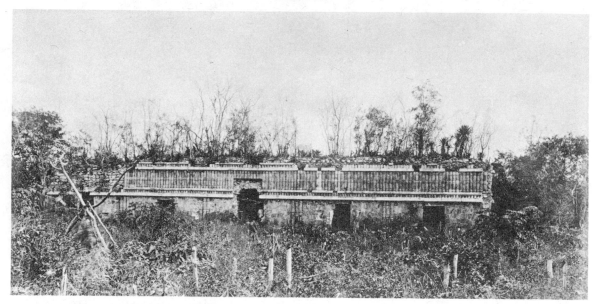

1, KABAH: CASA 3, SHOWING SEVERE USE OF BANDED COLUMNS IN FAÇADE DECORATION.

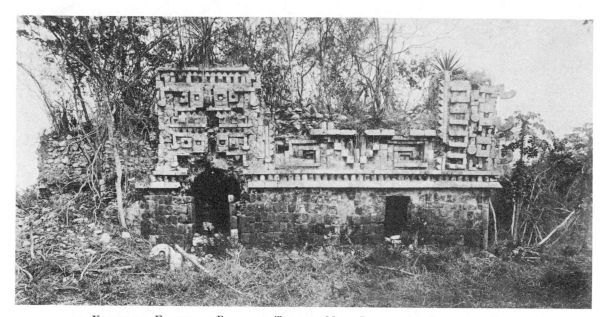

2, XLABPAK: FAÇADE OF PRINCIPAL TEMPLE; MASK PANELS AND GEOMETRIC PANELS.

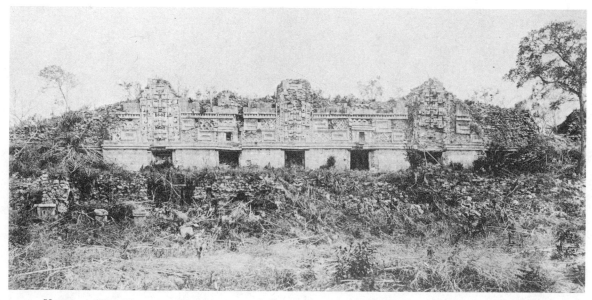

3, UXMAL: THE NUNNERY, NORTH RANGE; MASK PANELS ALTERNATING WITH ROOFED NICHES OVER DOORWAYS.

PLATE 17.

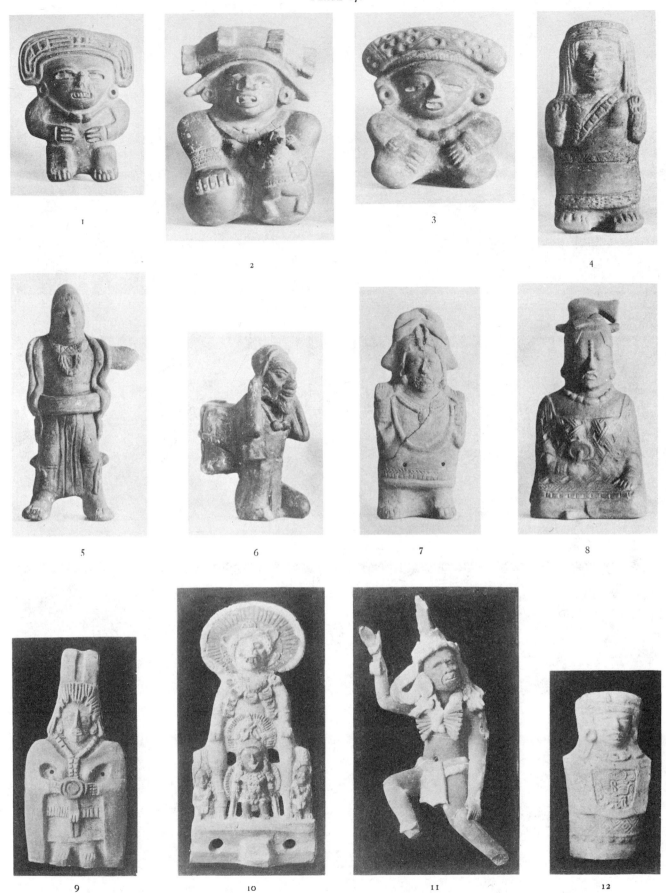

1-3, TERRA-COTTA WHISTLES FROM THE ULOA VALLEY, HONDURAS; 4, 7, TERRA-COTTA WHISTLE AND FIGURINE FROM JONUTA, TABASCO, MEXICO; 5, 6, TERRA-COTTA FIGURINES FROM MOUNDS AT KAMELA, RIO SALINAS (CHIXOY), GUATEMALA; 8, MODERN CAST FROM TERRA-COTTA MOULD, RIO SALINAS, GUATEMALA; 9-12, TERRA-COTTA FIGURINES FROM THE ISLAND OF JAINA, CAMPECHE.

PLATE 18. COPAN: SERIES OF ARCHAIC STELAE.

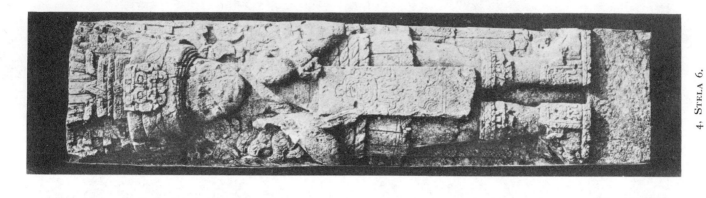

4, STELA 6.

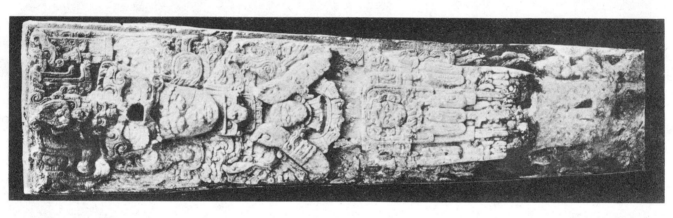

3, STELA P.

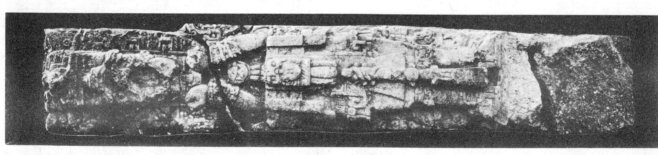

2, STELA E.

1, STELA 7.

PLATE 19.

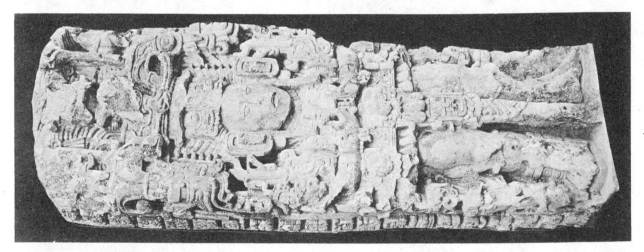

5

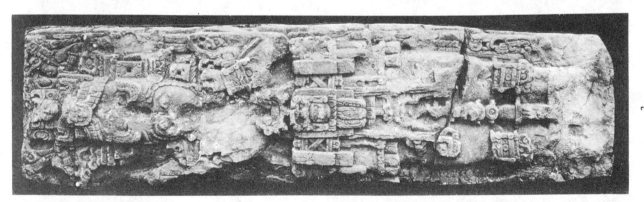

4

3

2

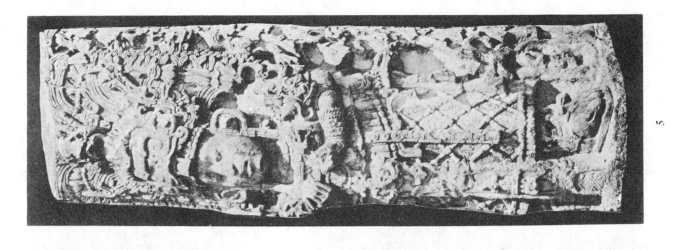

1

1, 2, Fragments of Stela 5, showing Sculpture on Opposite Sides; 3, Stela 3; 4, Stela N; 5, Stela H.

Copan: Series showing Development of Sculpture.

PLATE 20.

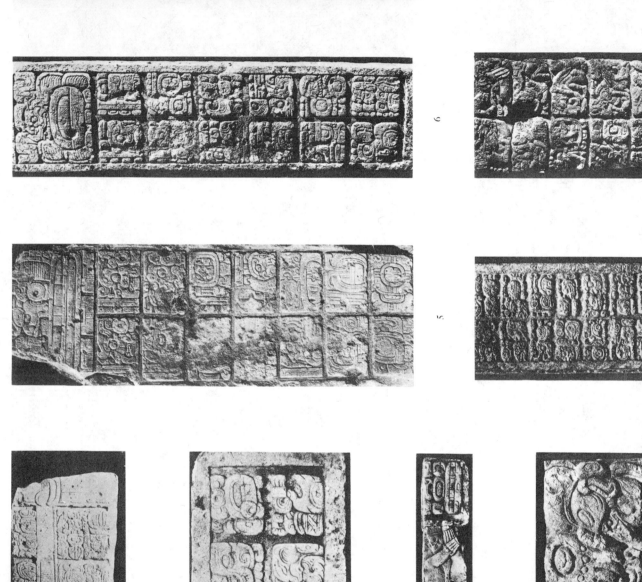

COPAN: 1, FRAGMENT OF AN OLD ALTAR FOUND IN THE HIEROGLYPHIC STAIRWAY; 2, HIEROGLYPHS FROM THE HIEROGLYPHIC STAIRWAY; 3, 4, HIEROGLYPHS FROM HIEROGLYPHIC STAIRWAY; 5, HIEROGLYPHS FROM STELA 9: 6, HIEROGLYPHS FROM STELA 6: 7. HIEROGLYPHS FROM STELA A; 8. HIEROGLYPHS FROM STELA D. QUIRIGUA: 9, HIEROGLYPHS FROM STELA D; 10, HIEROGLYPHS FROM STELA F.

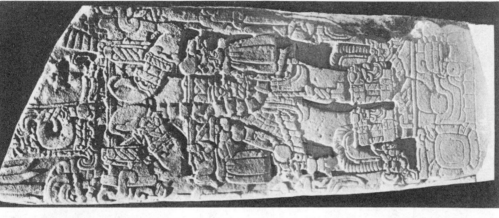

4, STELA 16.

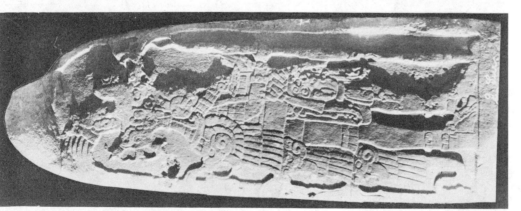

3, STELA 1.

PLATE 21.

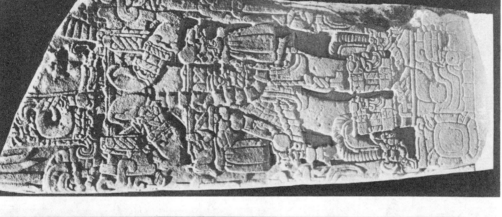

2, STELA 9.

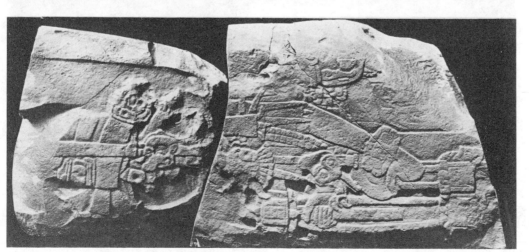

1, STELA 7.

TIKAL: SERIES SHOWING DEVELOPMENT OF SCULPTURE.

PLATE 22. TIKAL.

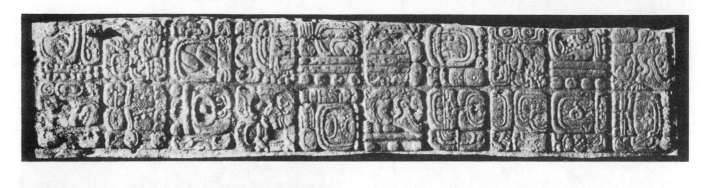

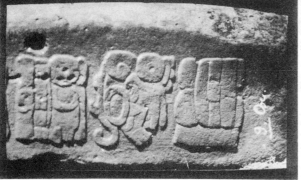

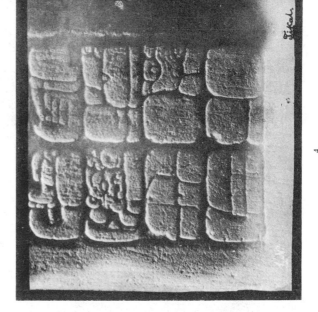

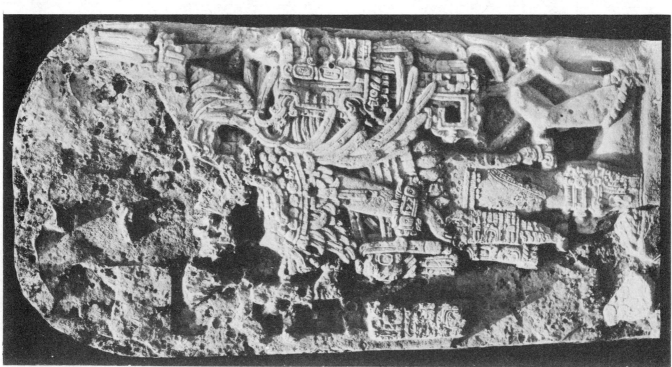

1, STELA 5. 2, THREE HIEROGLYPHS FROM STELA 13. 3, THREE HIEROGLYPHS FROM STELA 9.
4, EIGHT HIEROGLYPHS FROM STELA 1. 5, PART OF HIEROGLYPHS FROM WEST SIDE OF STELA 5.

PLATE 23.

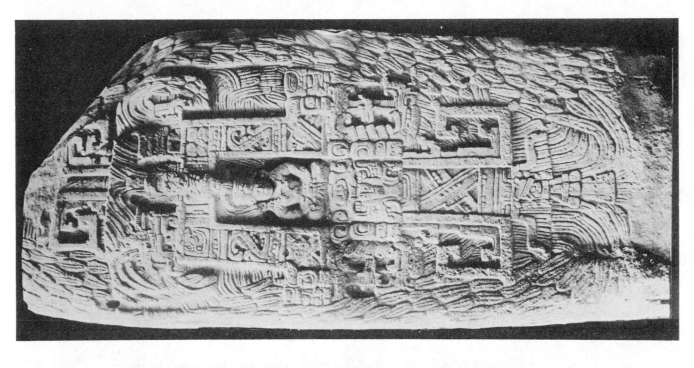

3, QUIRIGUA: STELA 1, BACK.

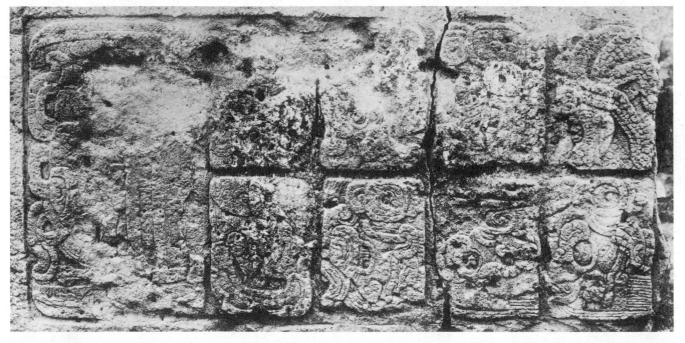

2, COPAN: STELA 15.

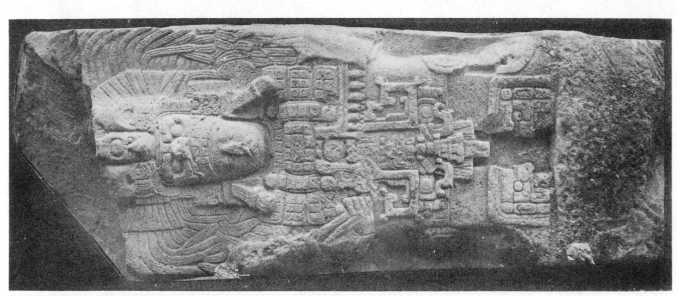

1, QUIRIGUA: STELA 1, FRONT.

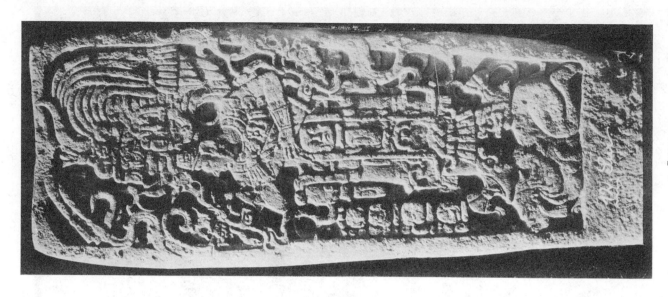

3, STELA 12.

PLATE 24. NARANJO: SERIES SHOWING DEVELOPMENT OF SCULPTURE.

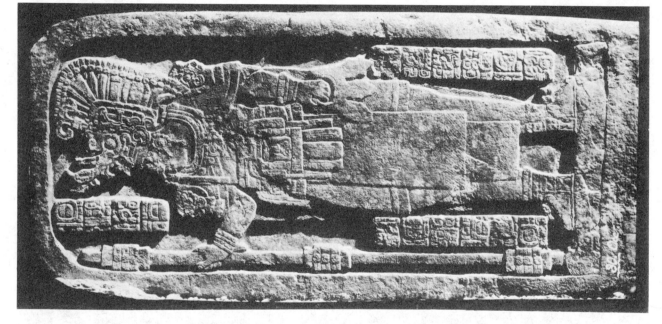

2, STELA 30.

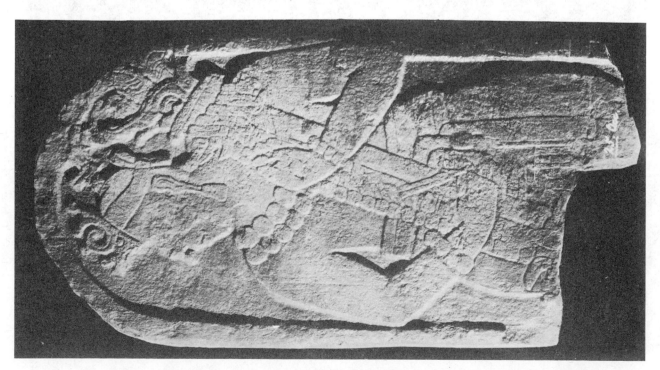

1, STELA 25.

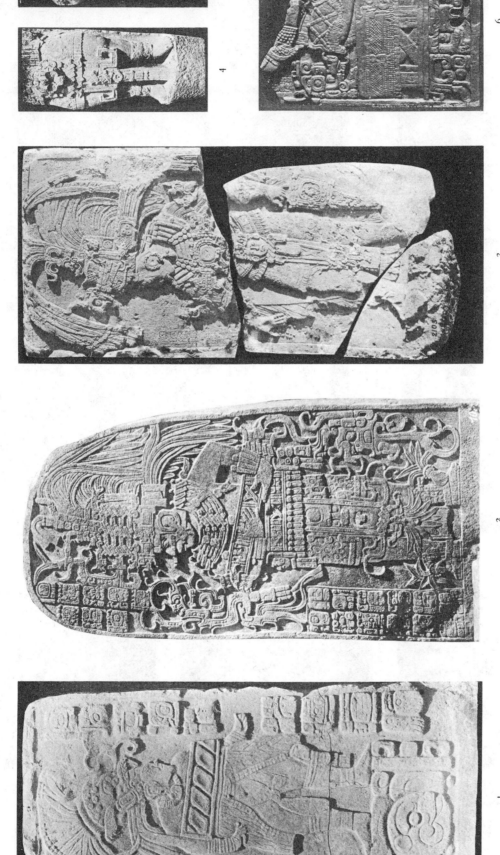

PLATE 25.

SEIBAL: 1, STELA 7; 2, STELA 10. PIEDRAS NEGRAS: 3, STELA 13. OCOSINGO: 4, LOWER PORTION OF STELA 1; 5, PORTION OF STELA 2.
CANKUEN: 6, LOWER PORTION OF STELA 1.

PLATE 26.

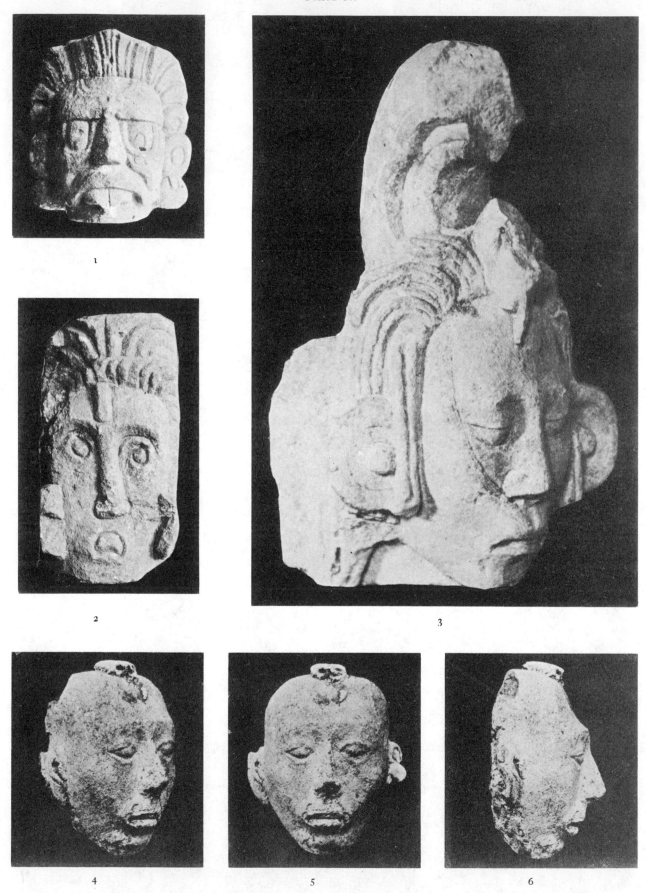

PLATE 27.

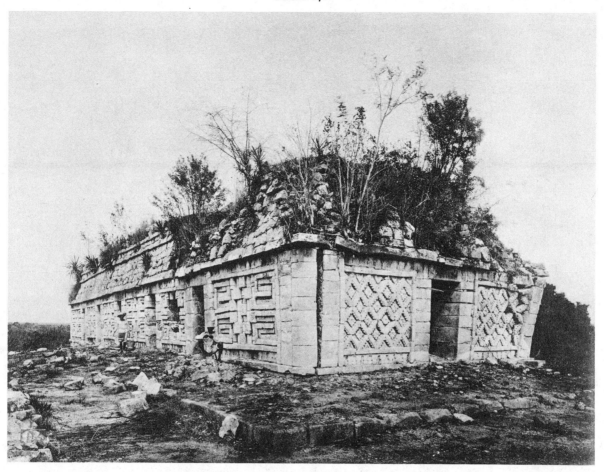

1, CHICHEN ITZA: CASA DE MONJAS; SECOND RANGE.

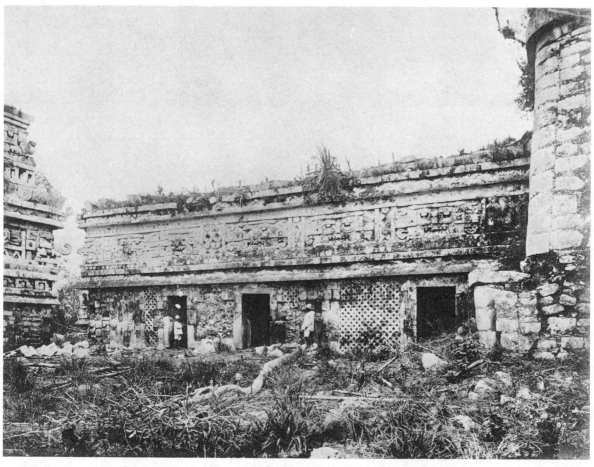

2, CHICHEN ITZA: CASA DE MONJAS; EAST WING, FROM THE NORTH.

PLATE 28. CHICHEN ITZA: CASA DE MONJAS.

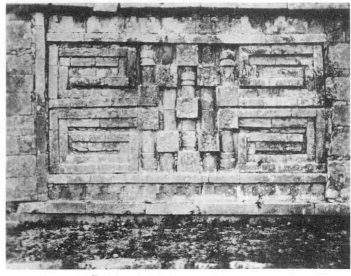

1, REUSED STONES, UPPER CHAMBER.

2, GEOMETRIC PANEL, SECOND RANGE.

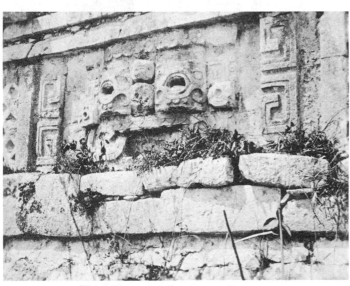

3, MASK PANEL IN FRIEZE OF FOUNDATION.

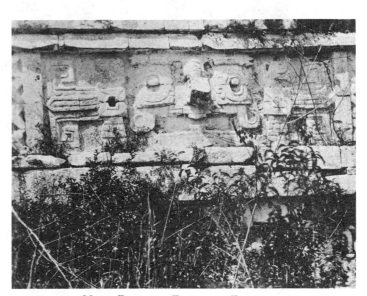

4, MASK PANEL IN FRIEZE OF FOUNDATION.

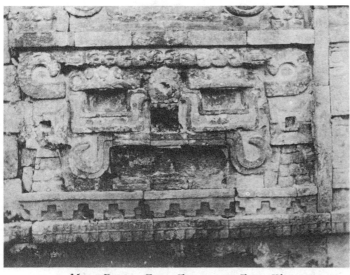

5, MASK PANEL, EAST FAÇADE OF EAST WING.

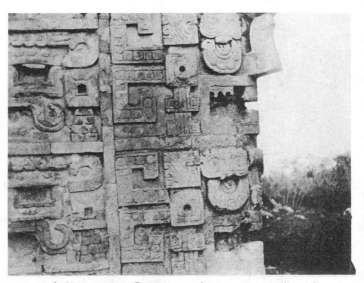

6, NORTHEAST CORNER OF FAÇADE, EAST WING.

PLATE 29.

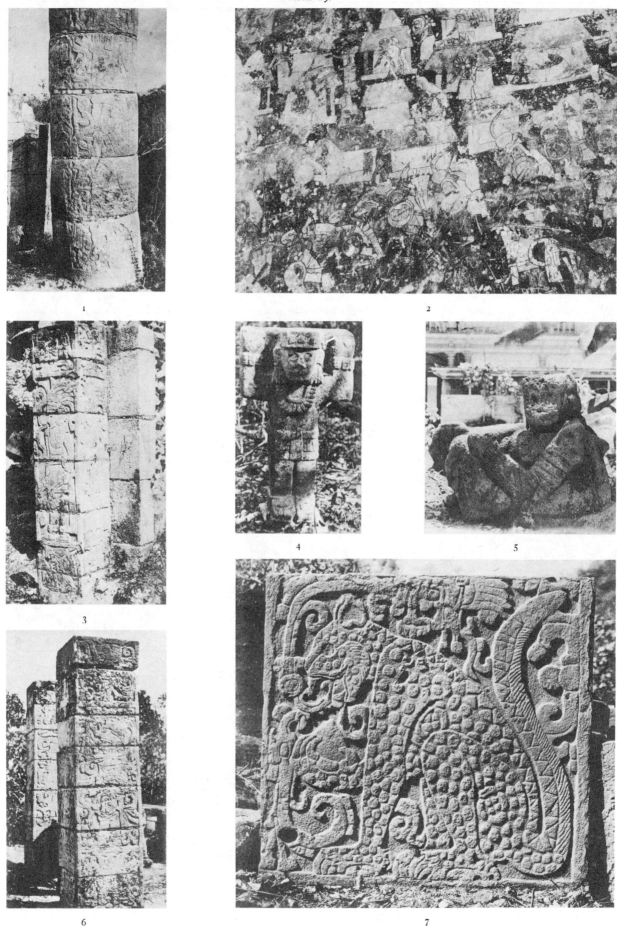

1, SCULPTURED COLUMN, NORTH TEMPLE OF BALL COURT. 2, FRESCO PAINTING, TEMPLE OF THE JAGUARS.

3, PILASTER, TEMPLE OF THE TABLES. 4, ATLANTEAN FIGURE. 5, CHACMOOL FIGURE AT SAN SALVADOR.

6, SCULPTURED COLUMNS, TEMPLE OF THE TABLES. 7, JAGUAR RELIEF, MAUSOLEUM, MOUND 13.

ALL EXCEPT NUMBER 5 ARE AT CHICHEN ITZA.

MAP OF THE
PRINCIPAL ARCHAEOLOGICAL SITES OF
THE MAYA AREA
COMPILED FROM VARIOUS SOURCES

• = CITIES OF MAJOR IMPORTANCE
○ = CITIES OF MINOR IMPORTANCE

Lloyd M. Hendrick Jr. Del.

MAYA ART

INTRODUCTION

Area. The region in which remains of the pre-Columbian Maya civilization are found corresponds closely with that still inhabited by Indians speaking dialects of the Maya linguistic stock. Roughly it lies between 87° and 94° west longitude and 14° and 22° north latitude. More exactly it comprises, in Mexico, the states of Tabasco and Chiapas and the peninsula of Yucatan (with the states of Campeche and Yucatan and the territory of Quintana Roo), in addition to the whole of British Honduras, the two-thirds of Guatemala lying north of the Motagua River, and a considerable portion of Honduras including the head-waters of the Copan River, the lower course of the Uloa, and, in all probability, the rich central valley of Comayagua.

Relation to Surrounding Cultures. Upon the west the Maya area adjoins those of the Zapotecan and Nahua cultures. Although there is hardly a doubt concerning the common origin of these three most important civilizations of Mexico and Central America, yet environmental, chronological and linguistic differences have made them at least superficially distinct. In all three there were apparently two or more periods of widespread high culture, each followed by a period of disintegration and lower culture.

It has been argued that all were branches of an early civilization located on the plateau of Mexico and referable to the legendary Toltecs. A detailed discussion of this question will be taken up further on, after evidence has been presented. In this place it is only necessary to point out that, owing to the imperfections of Nahua reckoning, all dates before 1325, the year generally accepted for the founding of Tenochtitlan, the Aztec capital, must be regarded as largely fictitious. It will be shown that the Toltec or pre-Aztec remains were for the most part contemporary with the brilliant period of the cities of northern Yucatan, but much later than the first florescence of southern Maya art. The Zapotecan and Nahua cities, found in a flourishing condition by the Spaniards, apparently rose after the Maya culture had declined.

It seems unnecessary to consider at length the various wild speculations concerning Old World origins of New World civilizations. Lord Kingsborough's attempt to identify the nations of America with the lost tribes of Israel was in keeping with the speculative age in which he wrote. The far-fetched theories of Dr. Le Plongeon must be laid to an over vivid imagination, although there is no gainsaying the painstaking enthusiasm of this unfortunate student. But no reasonable excuse can now be found for writers who, on the strength of this or that similarity, cheerfully leap the bounds of space, time and reason to derive the religious and artistic conceptions of the Maya from Egypt, India or China. The evidence these writers present is always insufficient and usually wrong.

Where real similarities exist they probably can be explained by pure chance or by psychic unity.

In determining origins, however, account may well be taken of the single outlying group of the Maya-speaking peoples, the Huasteca, who inhabit the low coast region north of Vera Cruz, and in whose territory many remains of cities as yet undescribed are known to occur. It is possible but not likely that a careful study of this disconnected group will indicate a northern origin for Maya arts. An origin to the south of the stated limits is hardly conceivable, owing to the great and sudden falling off in handicraft and ideas once the southern frontier has been crossed. Such similarities as do exist may easily be accredited to the Nahua colonies which, in the last centuries before the coming of Europeans, were planted even farther south than Lake Nicaragua. No matter, however, to what other region fuller investigation may refer the humble beginnings of Maya art, the indisputable fact remains that in all essential and characteristic features it was developed upon its own ground.

Natural Divisions. The Maya area, as above defined, contains three principal natural divisions. In each of these the differences in climate, in natural resources, and in topography are marked enough to have had a decided effect upon the material culture of the inhabitants. The first of these divisions comprises the peninsula of Yucatan; the second, the great central valley; the third, the cordilleran plateau on the south and west. Since the entire region lies south of 22°, it is distinctly tropical except where the altitude counteracts, and is subject to the doldrum rains under the high sun. The duration of this summer rainy season is less in Yucatan than in the two other regions of greater land relief.

The peninsula of Yucatan is a limestone plain of recent geological formation, with its highest ridges but a few hundred feet above the sea.[1] It has no river valleys because, owing to the porous and soluble nature of the limestone, the drainage[2] is subterranean. There are many caverns and sink-holes. The caverns seldom show signs of former habitation and then only as retreats.[3] The sink-holes are often very large and form natural wells or cenotes. These cenotes determined the location of most ancient and modern towns. Often, however, artificial reservoirs and cisterns, called chultunes,[4] were constructed. In the southeast several large lakes occur, Lake Peten being the most important. The soil of Yucatan is shallow, and although trees grow rapidly and in dense masses they seldom attain great height. The universal building stone is limestone, which also is burned for lime.

The wide valley plain of the meandering Usumacinta and its maze of tributary streams is a region little known and poorly mapped. It supports at present a small, roving population of wood-cutters and a few hundred squalid Lacandone Indians, though it must formerly have been the seat of wealth and power, to judge from its ruined cities, such as Yaxchilan, Piedras Negras, and Seibal. Like Yucatan, the rocks are young and calcareous. Maler is probably in error when he refers to sandstone at Piedras Negras. In the great alluvial valley stone may be had at but a few points where the hills come close to the river. Consequently many sites show now only the earthen foundation mounds from which the wooden superstructures have long since vanished. Timber is plentiful, the

[1] For a discussion of the geology see Sapper, 1896. [3] Thompson, 1897, a; Mercer, 1896.
[2] Casares, 1905; Mercer, 1896, p. 21, footnote. [4] Thompson, 1897, b; Stephens, 1843, II, p. 227.

whole region being covered with a dense tropical forest of mahogany and other large trees. The rivers form the highways of travel. The surface of the land is marked by extensive swamps and a number of lakes; hills of moderate elevation vary the topography, and on the southern and western margin the land rises suddenly to the continental plateau.

This plateau attains an average height above the sea of about 8000 feet, but is deeply dissected by the Chiapas, Usumacinta and Motagua river systems. The crest of the continental range lies so close to the Pacific that no large streams flow into that ocean. The plateau swings to the east round the head of the Usumacinta basin and reaches the shores of Lake Izabel in long narrow spurs, while outlying ridges extend well into British Honduras. The flora of the plateau region is characterized by the oak and the pine, but much of the country is fairly open and well adapted to agriculture. These uplands formed the highway for migrations north and south, and supported a large heterogeneous population, but were apparently never the seat of such high culture as obtained in the lowlands. Copan and Quirigua are both situated on valley floors. Ledges of old blue limestone and of a soft volcanic tuff furnished an abundant supply of excellent building material at the former, while at the latter city a much harder stone of similar volcanic origin was encountered.

Early Notices. The number of early historical references to the Maya Indians is small, partly due to the fact that the principal theatre of action for the Spaniards lay in the valley of Mexico. Few of the soldiers of those strenuous days found time to lay aside the sword. As for the Spanish priests, most were as deeply imbued with fanaticism as were the natives whose culture they sought to destroy. They were incapable of comprehending the real character of the native religion, which they summed up as devil worship. They were true iconoclasts, and went about throwing down idols, burning ancient chronicles and destroying everything that would keep alive the remembrance of old times. Most of the first-hand information on the culture of the Maya must be gleaned from the writings of Cogolludo, Landa, Lizana and the "Relations of Yucatan" which consist of reports sent in by the heads of various towns and provinces. Excellent second-hand information is found in the works of the great historians, Herrera, Oviedo and Villagutierre.

The first expeditions from Cuba to the mainland made a number of landings along the coast of Yucatan,[1] where the Spaniards met bands of natives and visited their towns. Bernal Dias del Castillo, who sailed and fought with Francisco Hernandez de Cordoba in 1517, with Juan de Grijalva in 1518 and with the redoubtable captain Hernando Cortes in 1519 and for many years afterwards, describes Maya temples and sculptures. Dias [2] writes as follows:

"They led us to some large houses very well built of masonry, which were the Temples of their Idols, and on the walls were figured the bodies of many great serpents and snakes and other pictures of evil looking Idols. These walls surrounded a sort of altar covered with clotted blood. On the other side of the Idols were symbols like crosses, and all were coloured. At all this we stood wondering, as they were things never seen or heard of before."

At first reading this might be considered an adequate description, from the blunt pen of a sixteenth-century soldier, of the run of Maya architecture and

[1] For an early map see Valentini, 1902. [2] Dias del Castillo, 1908, I p. 1

art. But on examining the ruins [1] of the buildings referred to in this and similar notices (on Cozumel Island, near Cape Catoche, etc.), it is evident that they must have been decidedly inferior to the great temple structures of interior Yucatan. Though the same principles of construction were applied in both localities, yet the workmanship of the temples on the seacoast was much cruder, and the ornamentation of the façades much less permanent. Beyond doubt, the same people erected all these buildings but during different stages of culture.

It is possible that Tuloom, on the east shore of Yucatan, was visited or observed from the sea by the expedition of Juan de Grijalva. His chaplain, Juan Dias, speaks [2] enthusiastically of a city facing the sea and having great walls and towers. He compares this city to Seville, and mentions that it was inhabited by a large population. Unfortunately Tuloom has since been visited only by Stephens, who found it in ruins, and by Dr. Howe in 1911, who was forced to limit his stay to two days. Stephens [3] comments on the fresh appearance of the walls, and expresses his belief that Tuloom was inhabited until after the Conquest. This may be the case, because in several architectural features Tuloom varies from cities known to be early.

In regard to the inland cities of Yucatan there are early notices of Chichen Itza and Uxmal that are worthy of consideration. These passages indicate that both cities were fallen from their ancient glory, although still the centers for certain religious rites. There is no evidence that the stone buildings of either city were actually inhabited at the time of the Spanish conquest.

Bishop Diego de Landa,[4] writing about 1566, says of Chichen Itza:

"The elders among the Indians say that they remember to have heard from their ancestors that in that place there once reigned three Lords who were brothers, and who came to that land from the west. And they brought together in these cities a great number of towns and people, and ruled them for some years with justice and in peace . . . that soon they split into factions, so wanton and licentious in their ways, that the people came so greatly to loathe them that they killed them, laid the town waste and themselves dispersed, abandoning the buildings and this beautiful site . . ."

Landa [5] also gives a fairly accurate description and a crude plan of the famous Castillo, and mentions survivals of the ancient religious practices in connection with the sacred cenote.

Stephens [6] quotes at length from the title paper to the land upon which the ruin of Uxmal is situated. It appears that the Regidor received by royal grant certain meadows and places, uncultivated and useless except for pasturage, whereby a great service would be done to God because "it would prevent the Indians in those places from worshiping the devil in the ancient buildings which are there, having in them idols, to which they burn copal, and performing other detestable sacrifices, as they are doing every day notoriously and publicly." This grant having been contested by an Indian claimant, the matter was settled by payment. A later document runs as follows: "In the place called the edifices

[1] Le Plongeon, quoted in Salisbury, 1878, pp. 76–84; Stephens, 1843, II, pp. 365–378, 415–417; Holmes, 1895–1897, pp. 57–78.
[2] Dias, Juan, 1838, pp. 11–12.
[3] 1843, II, p. 406.

[4] Landa, 1864, p. 340. Passage translated by Maudslay, 1889–1902, III, pp. 6–7.
[5] 1864, pp. 342–344.
[6] 1843, I, pp. 322–325.

of Uxmal and its lands, the third day of the month of January, 1688, . . . he walked with me all over Uxmal and its buildings, opened and shut some doors, etc." The last statement, in regard to the opening and shutting of doors, seems a mere legal formula to indicate acts of possession. Maya temples, in all probability, never had doors that opened and shut. While these passages prove conclusively that the buildings were still held sacred by the natives, they cast little light upon the question when Uxmal ceased to be a real city.

Of more value in deciding this vexatious question is an account of Uxmal dated a full century earlier (1586). This account,[1] written by one of the companions of Alonzo Ponce, a Franciscan delegate, is so accurate and detailed that it deserves to be given in full. Not all the buildings of the city were examined and described by this early traveler, yet one can recognize with ease each structure taken up, for the descriptions of the outward appearances apply to-day with hardly the change of a word. The curious reader may compare this passage with the excellent modern description of the same buildings by Mr. Holmes.[2]

The earlier description is as follows:

"On the north of the ranchos where the father delegate was lodged, as has been seen, which is about twenty leagues from Merida, to the south of that city, stands a *ku* or *mul* [artificial pyramid], very tall and made by hand. It is very difficult to ascend this by its 150 stone steps, which are very steep and which, from their being very old, are very dilapidated. On the top of this *mul* a large building [House of the Magician] has been built, consisting of two[3] vaulted rooms, made of stone and lime, the stones being carved with great care on the outside. In old times they took the Indians who were to be sacrificed to these rooms, and there they killed them and offered them to the idols. The father delegate went up this *mul* as soon as he arrived there, and this surprised the others greatly, since many others did not dare to go up and could not have done so if they had tried. Close to this *mul* and behind it on the west, there are lower down many other buildings built in the same way with stone and lime and with arches. The stones are carved with wonderful delicacy, some of them having fallen and others badly injured and ruined, while others can still be seen, and there is much in them worth examining. Among these there are four very large and handsome buildings [Nunnery Quadrangle] set in a square form, and in the middle is a square plaza, in which grew a thicket of large and small trees, and even on top of the building there were very large and dense trees growing. The building [South Range of the Nunnery Quadrangle] which faces the south, has on the outside four[4] rooms, and on the inside eight others, all arched with cut stone, and as carefully joined and put together as if very skillful workers of the present had built them. These arches, and all the other old arches which have been found in this province, are not rounded over in the form of a cupola nor like those which are made in Spain, but are tapered as the funnels of chimneys are made when built in the middle of a room, before the flue begins, since

[1] Relacion Breve, 1872, LVIII, pp. 455–461.

[2] 1895–1897, pp. 86–96, and panoramic drawing. Comparison may also be made with Stephens, 1843, I, pp. 166–180; 299–308; 312–318.

[3] It should be noted that the padre ascended this pyramid by the main stairway on the eastern side. He thus could gain access only to the two end rooms of the main temple. The center room of this building has its only doorway on the west, looking out upon the roof of the two-chambered annex. For the names given to these buildings the reader is referred

to the table of nomenclature at the end of this volume, p. 252.

[4] Here again the numbering of the rooms is slightly at fault. This building has eight rooms on the outside as well as the inside. There are also two rooms at either end. Such minor inaccuracies need not be wondered at when one considers the luxuriant tropical vegetation which covered everything. The padre properly noted that this building faced outward as well as inward. It served, in fact, as the façade of the entire group of four correlated structures.

both sides draw together little by little and the space between becomes more narrow, till on the top one wall is separated from the other by about two feet and there they place a layer, which extends inwards four or five inches on each side, and over this they place flags or thin flat stones in a level position, and with these the arch is closed, so that there is no key to the arch, but with the great weight of stone and mortar, which is placed on top and which strengthens the sides, the arch is closed and remains fixed and strong. The ends of this arched building are continuous and straight from top to bottom. At the door of each of the rooms of this building on the inside, there are four rings of stone, two on one side and two on the other, — two of them being high up and two lower down and all coming out of the same wall. The Indians say that from these rings those who lived in these buildings hung curtains and portières, and it was to be noticed that no one of these rooms, nor of all the others, which we found there, had any window, small or large. The rooms were therefore rather dark, especially when they were made double, one behind the other, so that even in this, this idolatrous race gave evidence of the darkness and obscurity of the error in which it was enshrouded. The high lintels of all these doors were made of the wood of the chico zapote, which is very strong and slow to decay, as could well be seen, since most of them were whole and sound, although they had been in position from time immemorial, according to the statements of the old Indians. The door jambs were of stone carved with great delicacy.[1] On the façades of the building, both on those which face the plaza or courtyard, as well as on those which face outward, there are many figures of serpents, idols and shields, many screens or latticework, and many other carvings which are very beautiful and fine, especially if one look at them from a distance like a painting of Flanders, and they are all carved from the same kind of stone. In the middle of this building a great arch is made, so that it takes in all the depth of the building, and therefore it is the entrance to the courtyard or the above-mentioned plaza. It would appear that this entrance had been plastered and that on the plaster paintings had been made in blue, red and yellow color, since even now some of them remain and can be seen. Nearly all the rest of the stones had been plastered but not painted.

"The building [Eastern Range of the Nunnery Quadrangle] which stands at the west, behind the previously mentioned mound of sacrifices, was in the best condition and uninjured. It had four doors which opened on to the courtyard or plaza with as many rooms, arched in the same way as the others, and beyond each room was another, so that there were eight in all. Between these four doors, two on one side and two on the other, there was still another door which opened on the patio, and within this was a very large hall, long and broad, with two small rooms on the sides; and beyond this hall there was another — a little smaller, with two other small rooms — one on each side, so that inside of this one door there were six rooms, four small and two large, making, with the other eight, fourteen rooms which this building contained. On the inside façades and ends of this building, there were carved many serpents in stone, and heads of savages and other figures in the manner of shields, and at the four corners (since each building stood by itself and not joined or connected with the other) there were many other carvings cut in the round like a half curve, with tips, which looked like serpent heads, and which stood at half a vara from the rest of the carvings.

"The building on the north [North Range of the Nunnery Quadrangle] is the tallest, and has more carvings and figures of idols, serpents and shields and other very beautiful things about it, but it is very much injured and the most

[1] Stephens states, 1843, I, p. 308, that the doorways of the central group of chambers in the Eastern Range are ornamented with sculptures, the only instances of interior decoration at Uxmal. No reproductions of these sculptures are known.

of it has fallen. It has ten [1] doors which open on the plaza and another which opens on the eastern end, and inside each one there are two rooms, and so among them all there are twenty-two rooms in that building made of stone and lime, and arched like the others, but the most of them, especially those inside, have fallen. Before the ten doors above mentioned there has been made a terrace, *paseo*, or walking-place, somewhat broad and open on all sides, to which one ascends from the plaza by steps which are now half in ruins. All this terrace has below it other arched rooms with doors opening on the same plaza, and these are covered and stopped up with stones and earth and with large trees which have grown there.

"The building on the west [Western Range of the Nunnery Quadrangle] is very elegant and beautiful on the outside façade, which looks on the plaza, since serpents made of stone extend over the whole of it so as to enclose it from end to end, making many turns and knots, and they finally end with the head of one of them, on one end of the building, joined with the tail of the other, and the same thing happens on the other end of the building. There are also many figures of men and idols, other figures of monkeys, and of skulls and different kinds of shields — all carved in stone. There are also over the doors of the rooms some statues of stone with maces or sticks in their hands, as if they were mace-bearers, and there are bodies of naked Indians with their *masteles* (which are the old-fashioned loin-clothes of all New Spain, like breeches), by which it is shown that these buildings were built by Indians. In this building are seven doors,[2] of which six open on the patio and the seventh on the end which faces the north, and inside of each door are two rooms, so that there are fourteen rooms in all, arched like the others.

"Besides these four buildings there is on the south of them distant from them about an arquebus shot, another very large building [House of the Governor] built on a *mul* or hill made by hand, with abundance of buttresses on the corners, made of massive carved stones. The ascent of this *mul* is made with difficulty, since the staircase by which the ascent is made is now almost destroyed. The building, which is raised on this *mul*, is of extraordinary sumptuousness and grandeur, and, like the others, very fine and beautiful. It has on its front, which faces the east, many figures and bodies of men and of shields and of forms like the eagles which are found on the arms of the Mexicans, as well as of certain characters and letters which the Maya Indians used in old times — all carved with so great dexterity as surely to excite admiration. The other façade, which faces the west, showed the same carving, although more than half the carved part had fallen. The ends stood firm and whole with their four corners much carved in the round, like those of the other building below. There are in this building fifteen doors, of which eleven face the east, two the west [3] and one each face the north and south, and within these doors there are twenty-four rooms arched like the others. Two of these rooms are in the northern end, and two others in the southern end, while two are in the west front, and all the rest in the eastern front — all made with special accuracy and skill.

"The Indians do not know surely who built these buildings nor when they were built, though some of them did their best in trying to explain the matter, but in doing so showed foolish fancies and dreams, and nothing fitted into the facts or was satisfactory. The truth is that to-day the place is called Uxmal, and an intelligent old Indian declared to the father delegate that, according to what the ancients had said, it was known that it was more than nine hundred

[1] According to the plans of Mr. Holmes this building has twelve doors which open on the plaza and one door at each end, making fourteen in all. All the rooms are double.

[2] According to Holmes all seven doors open on the court.

[3] The small chambers under the great arches of this building must have been counted on both the eastern and western face. The central chamber of the eastern front has three doors; apparently only one of these was counted.

years since the buildings were built. Very beautiful and strong they must have
been in their time, and it is well known from this that many people worked to
build them, as it is clear that the buildings were occupied, and that all about
them was a great population, since this is now evident from the ruins and remains
of many other buildings, which are seen from afar; but the father delegate
did not go to these ruins, since the thicket was very close and dense, and there
was no opportunity to open and clear out a path so as to reach them. And now
they all serve only as dwellings and nests for bats and swallows and other birds,
whose droppings fill the rooms with an odor more disgusting than delightful.
There is no well there, and the farmers of the vicinity carry their drinking water
from some little pools of rain-water which there are in that region. It may be
easily suspected that these buildings were depopulated for want of water, al-
though others say that this is not so, but that the inhabitants departed for an-
other country, leaving the wells which were there choked up."

Similar notices of the evident antiquity of Tiho[1] (Merida), Izamal,[2] and
other cities might be quoted. The complete silence in regard to other important
centers of northern Yucatan, such as Labna and Kabah, tells the same story of
desertion and desolation.[3]

Cortes, during his wonderful march from Vera Cruz to Honduras, seems to
have found none of the stone-built cities of the Usumacinta region inhabited.
The identifying of the village of Teutiercar with Palenque is surely incomplete.
"This village," says Cortes,[4] "is very pretty, and is called Teutiercar by the
natives. There are in it very handsome mosques or idol-houses, where we took
up our abode, casting out their gods, at which the natives showed no great dis-
content . . ." There is no reason to suppose that the idol-houses were built
of stone. Indeed, in speaking of a near-by village of equal importance, he writes:[5]
"Cagoatespan was entirely burnt down, even to the mosques and idol-houses."
Many passages indicate that the idols of this region were carved of wood and
not of stone. When more permanent structures are suggested, there are no
modern remains to test conclusions. Bernal Dias[6] thus describes a town on
Lake Peten: "We proceeded towards a place named Tayasal, situated on an
island, the white temples, turrets and houses of which glistened from a distance."
Although this town was a capital of a province, no noteworthy remains are
found on its site.[7] At the end of the journey, had Quirigua still been the center
of such wealth and power as its monuments bear witness to, Cortes would prob-
ably have found food there and would not have been forced to ascend to the
highlands. As Maudslay[8] points out, the praise that Cortes bestows on the
town of Chacujal, where the present remains are of the most meager sort, is a
pretty sure indication that he visited none of the really great cities. Yet, had
these great cities still been maintained, he could hardly have missed them all.

Copan was visited in 1576 by Diego Garcia de Palacio,[9] who saw there "ruins
and vestiges of a great population and of superb edifices, of such skill and splen-
dor that it appears that they could never have been built by the natives of that
province." The natives informed him "that in ancient times there came from

[1] Bienvenida, 1877, p. 71.
[2] Lizana, pp. 3 et seq., and Landa, 1864, p. 32.
[3] Charnay, 1885, p. 329, is evidently in error in thinking Landa refers to these cities as recently abandoned.
[4] 1868, p. 36. See also, Seler, 1895, c, p. 22.
[5] Cortes, 1868, p. 25.
[6] Dias del Castillo, 1803, pp. 117 et seq.
[7] Maler, 1910, p. 169. For an account of the destruction of Tayasal in 1697 see Villagutierre, 1701, pp. 481–483.
[8] 1889–1902, II, p. 29.
[9] Gordon, 1896, pp. 47–48.

Yucatan a great Lord, who built these edifices, but at the end of some years returned to his native country, leaving them entirely deserted."

Maler[1] is doubtless right in identifying Yaxchilan with the ruined city discovered by Alzayaga during the Lacandone wars. It is described[2] thus: "They arrived at a place, where it was plain that there must have been once a very ancient city, owing to the great number of stone foundation-walls, and enormous ancient ruins of edifices which they found; which city must have measured more than a league in circumference." The fact that the wild and untaught Lacandone Indians to this day bring offerings of copal to the old ruined temples of Yaxchilan is worthy of note in weighing the evidence above quoted in regard to Uxmal.

Regarding Comalcalco, perhaps the westernmost Maya city of importance, the ruins of which lie on the right bank of the Rio Seco about forty miles west of Frontera, there is also credible evidence of desolation. Charnay[3] attempts to identify this city with the historical Cintla, where Cortes fought his first great battle, but all his arguments are signally refuted by the independent researches of Rovirosa[4] and Brinton.[5] At the coming of the Spaniards the inhabitants of this portion of Tabasco spoke a Maya dialect and probably belonged to the Tzendal tribe. But they had evidently fallen away from the high culture of their ancestors.

Upon the highlands of Guatemala and southern Mexico certain large towns are known to have been occupied at the time of the conquest. Alvarado,[6] in a dispatch to Cortes, describes Utatlan. In this description the Spanish captain pays special attention to fortifications and leaves the bare impression that the town consisted of inflammable buildings crowded together. The ruins found on the site of this old town show small mounds, one of which in Stephens'[7] time still retained part of its stone facing and traces of frescos. There is nothing here, however, fit to be compared with the monumental remains in the lowlands. Indeed, it appears that at no period, historic or prehistoric, did architecture on the plateau reach a high stage of development. But the ceramic and other remains[8] of minor arts prove undoubtable connection at some time with the lowland civilization. Since, however, this open plateau lies upon the frontier of the Maya area and upon the main road for migration north and south, it is but natural that it should be the first to feel the effects of an ascendant neighboring culture. It will be shown that influence from the Nahua cities to the north was marked.

The above and similar notices from the accounts of the first European observers, referring to the various parts of the Maya area, make it pretty evident that when white men set foot on the shores of Mexico the golden age of Maya civilization had long since passed. Not a single great city was maintained in its ancient splendor. It is equally evident that certain phases of the ancient culture, such as referred to religious ideas, were still kept up and that the art of writing and recording time were still understood at least by a portion of the people. The decadent culture was surely a survival of the higher and earlier

[1] 1903, pp. 106–108.
[2] Villagutierre, 1701, p. 362.
[3] 1885, pp. 163–177.
[4] 1897, pp. 16 *et seq.*
[5] 1896, pp. 262–264.
[6] 1838, p. 112.
[7] 1841, II, p. 184; Maudslay, 1889–1902, II, pp. 30–38.
[8] Bulletin 28, pp. 77–121 and 639–670.

one in the same area, and the Maya of historical times were the descendants of the builders of the monuments.

Native Accounts. The conclusions stated in the preceding paragraph are borne out by certain native literary material. This native material is of two kinds, pre-Columbian and post-Columbian; the one written in hieroglyphs and the other in European script but with Maya words.

As is well known, the Indians of Mexico and Central America possessed a compound system of ideographic and phonetic writing and were on the very threshold of the alphabet. The Nahua hieroglyphs of personal and place names are readily solved; first, because the glyphs are so strongly pictographic that the component parts may be recognized; secondly, because the method of writing was maintained after the conquest and in part mastered and described by the Spanish priests. The Mexican place name glyphs or cartouches show an elaboration of the rebus method in which advantage was taken of the position, color and all the possibilities of punning pictures. The system of writing in vogue among the Maya was probably the same, but with a greater degree of conventionalization.

Only three pre-Columbian Maya books or illuminated manuscripts are known to exist. They are known by the names of, 1st, the Dresden Codex;[1] 2d, the Tro-Cortesianus;[2] 3d, the Peresianus.[3] These treat subjects much more complex than many of the Nahua codices and afford no easy beginnings for their elucidation. Thus far it has only been possible to work out their meanings in a general way, except where numbers are concerned. They treat of the calendar and of associated religious ceremonies.[4]

Among the books destroyed by the zealous Spanish priests there are said to have been some on civil and religious history and some on rites, magic and medicine. They seem to have been held in great veneration, and in all probability had either been handed down from former times or else carefully copied from earlier originals. The manuscripts were capable of withstanding wear and tear, being written on both sides of strips of prepared deerskin or stout paper of maguey fiber sized with fine lime.[5] These strips were folded screenwise between boards.

Although most of these invaluable records had been lost, yet educated natives attempted to save something from the wreck of ancient culture by writing down in European script certain digests of chronicles. These make up the so-called Books of Chilan Balam.[6] The different redactions from different towns vary in details, but all agree in carrying back Maya history many hundred years.

Two Maya tribes from the highlands of Guatemala have preserved somewhat similar ancient accounts. Both in the Annals of the Cakchiquels[7] and in

[1] Förstemann, 1880 and 1892.

[2] Codex Troano published by Brasseur de Bourbourg, 1869–70, and the Codex Cortesianus by Rady y Delgado in 1892. For convenience the two parts are usually put together and the numbering of the pages made consecutive as is shown in the Table of Nomenclature at the end of this volume.

[3] Codex Peresianus reproduced by Léon de Rosny, 1887 and 1888. The pagination was probably as shown in the Nomenclature but references are made to the plates as numbered by de Rosny.

[4] By far the most important single contribution to the study of the codices is Förstemann's Commentary on the Dresden Codex.

[5] Important early references to codices are Peter Martyr in Brasseur de Bourbourg, 1869–70, I, pp. 2–3; Aguilar, 1639, p. 88; Alonzo Ponce, Relacion breve, LVIII, p. 392; Landa, 1864, p. 44; Villagutierre, 1701, pp. 393–394.

[6] Brinton, 1882, b and d.

[7] Brinton, 1885, a.

the Popol Vuh [1] of the Quiché there is a mythological preamble identical in regard to certain place names (Zuiva, Nonoual, etc.) with that which introduces the definite historical sequence in the Books of Chilan Balam. Without doubt a careful study of these three accounts — considerable portions of which are still unpublished — will make possible a valuable outline of the ancient history of the Maya.

Political and Religious Ideas. The Spaniards found the Maya-speaking people divided into many small tribes, each independent of the others and under the direction of its hereditary chief. About twenty such tribes are recorded for the peninsula of Yucatan alone.[2] There was an organized priesthood and a well-marked nobility with strict regard for descent. Probably the priesthood and the nobility were more or less closely joined. Nepotism was apparently the prevailing system under which the chiefs assigned secondary political offices such as that of headman of a village. Practically nothing is known regarding the qualifications of the priests or their divisions into classes. It is clear, however, that the priesthood and the nobility held a monopoly of learning.

It seems necessary to postulate for the period of national greatness a much more centralized form of government than existed at the time of the conquest in order to account for the magnitude and splendor of the temples and public buildings. These could have been built only at great expense of wealth and labor and under a highly organized system of superintendence. Tradition, however, refers to confederacies and not to a united empire. It seems possible that the Maya, like the Greeks, were religiously and artistically a nation while politically a number of sovereign states. Under the powerful stimulus of a religious and artistic awakening of national scope, city after city may have arisen, in influence and wealth. Conquest, colonization, abandonment of old sites and migration to new ones may be inferred from striking similarities in the remains of certain cities. But, whatever the political conditions under which the Maya flourished, there were doubtless intervals of decadent culture due to civil strife. Finally, perhaps a scant century before the coming of Europeans, the entire political fabric fell apart.

Little is known concerning the details of Maya religious ideas. A list of divinities is given by Cogolludo [3] and other information added by Lizana [4] and Landa.[5] There seems to have been belief in a supreme deity without form or substance. Outwardly religion was greatly concerned with the plumed serpent, especially in the personification known as Kukulcan. There were, however, many lesser divinities.[6] Some of these were closely connected with the plumed serpent, and seem to have been merely individual or functional expressions of this more generalised godhead. An idea of the symbolical complications which probably prevailed throughout Maya religion may be gained from the Popol Vuh, the cosmogonic myth of the Quiché.

The ceremonials seem to have been characterized by pageants and processions, by incense burning, and to some extent by human sacrifice. It is clear that human sacrifice never reached among the Maya the horrible extreme that it held among the Nahua in Mexico City. For incense, both rubber and copal

[1] Brasseur de Bourbourg, 1861.
[2] Brinton, 1882, b, pp. 25–26.
[3] 1680, pp. 196–198.
[4] 1893, pp. 4–5.
[5] 1864, pp. 144–168; 206–232, etc.
[6] Schellhas, 1904, and Brinton, 1894, b, pp. 37–68.

gum, the latter burning with a cloud of white smoke and a pleasant perfume, were used. This feature of incense burning, coupled with the prescribed making of the pottery burners, was purely ritualistic. Consequently it was practiced by the mass of the people and has survived to this day, while the complex theology died with the priests and nobles. Thus Dr. Tozzer[1] has been able to connect the chief ceremonies of the pagan Lacandone Indians of the present day with the yearly renewal of the incense burners, as described by Landa in the sixteenth century.

The insufficient direct knowledge of gods and ceremonies has been pieced out by the study of the ancient codices, and of the sculptured representations on stelae and on temple walls. Apparently astronomy, the understanding of which made possible the calendar, was of first importance. Planets and stars, as well as the sun and moon, were represented by divinities. The forces of nature, such as the rain, the wind, and fertility in its various forms, were conceived as individual or as variant gods. That warfare had its strong religious aspects is seen in the prevalence of bound captives in the sculptured groups and in the use of spears and shields in the ceremonial regalia. Many particulars regarding sacrifice are also to be gathered from these sources. These particulars support the conclusion that human sacrifice played but a minor rôle in the religious practice of the Maya.

Present Population. The present population of the Maya area is largely made up of Indians of the original stock, showing no great amount of race mixture. In many regions tribal distinctions are still clear. The range of culture is remarkable. In northern Yucatan the Maya have long been civilized and under the sway of the Catholic church. Even here, however, they still use their native language in almost entire purity, while a careful observer can detect in the modern religious rites many remnants of ancient custom and superstition. There is no chance that an understanding of the ancient hieroglyphs now exists among any of the Indians here or elsewhere in the area. Along the southern coast of Yucatan, in the territory of Quintana Roo, some of the tribes are at present independent of the Mexican rule. The ruins of Tuloom and others in this region are practically closed to investigation. These wild Indians and the tribes of British Honduras and the Peten department of Guatemala show only a moderate degree of culture.[2] The status of the Lacandone Indians[3] of the Usumacinta Valley is lower yet. Scattered thinly in family groups, these people have indeed reverted to the wild. Although their religion is now of the primitive spiritual guardian type, the ritual still preserves features that point upward to the past, as also does the making of pottery and cloth. On the highlands the Quiché and other tribes live in agricultural communities and possess an interesting decorative art, making excellent textiles. This art seems to be quite distinct from the ancient Maya art.

The estimates of numbers by the Spanish historians were doubtless excessive, but the country is capable of supporting a large population. The Maya-speaking tribes number to-day several hundred thousand. Large tracts of territory that show abundant remains of habitation are now entirely deserted.

Materials Available for Study. Remains of Maya art are for some branches of the subject quite extensive, while for others they are wofully lacking. Tak-

[1] 1907, pp. 106 *et seq.* [2] Sapper, 1895, *b.* [3] Tozzer, 1907.

ing all in all, however, there is no reason to complain, because the mass of material preserved for study is probably greater than that which has survived from the great art of Greece. The remains may be considered under two heads: first, architecture; second, minor arts.

The entire Maya area is dotted with groups of structures, great and small, some admirably preserved, others ruined beyond repair. Some of these structures were temples, while others may have been for secular use. Probably more domestic architecture has all passed away. Some of the complicated structures may have been chiefs' palaces, but it is more probable that they resembled monasteries. The church and state were one. These structures still show much of the original embellishment in stone carving, wood carving, frescos and stucco work.

The minor arts include ceramics, textiles — most of the data on which must be taken second hand from the sculptures — ornaments carved in semi-precious stones, a little metal work, and, most noteworthy of all, the ancient illuminated manuscripts.

Previous Studies. Recent study in the field of Maya culture has been directed mostly towards the elucidation of the codices and the decipherment of the hieroglyphic inscriptions. As a result of the labors of Bowditch, Goodman and Thomas, the calendar system has been worked out in many of its finer details, while Förstemann, Seler and Schellhas have collected much data upon the nature of the gods and the ceremonies. The facts brought out by these investigators are of great value to the student of art, because they furnish a basis for the chronological sequence of forms and for the interpretation of designs and sculptures.

Descriptions of the buildings and other monuments may be gleaned from early and modern writings. The scanty notices of the Spanish conquerors have already been considered. The first travelers to draw the attention of the world to the wonderful structures of Central America were Stephens and Catherwood. The detailed accounts of the former and the accurate drawings of the latter are still of the greatest service to the student. The drawings of Waldeck are beautiful but inaccurate. The voluminous writings of Brasseur de Bourbourg contain many valuable references, but most of the theories and conclusions are untenable. The same may be said of the works of Le Plongeon. The era of enthusiastic travelers was followed by that of trained observers. Holmes,[1] in particular, has explained the process of Maya construction, and prepared admirable panoramic views of Chichen Itza, Uxmal and Palenque. For overshadowing importance, however, first place must be given to Maudslay's[2] elaborate publication. In the four volumes of plates are figured, both by photographic reproduction and by clear drawings, the most important sculptures and buildings of Copan, Quirigua, Tikal, Yaxchilan, Palenque and Chichen Itza. The text, however, gives little more than brief descriptions of the monuments, with hardly any stylistic comparison, the author apparently being content to let his splendid illustrations speak for themselves. With these deserve to be mentioned the accounts of explorations at Copan and along the Uloa River by Gordon, and explorations in Yucatan and in the Valley of the Usumacinta by Maler, as well as the more popular narratives of Charnay. All of the latter works deal only ob-

[1] 1895–1897.　　　　　　　　　　　[2] 1889–1902.

jectively with Maya art, and are in reality hardly more than storehouses of selected material. Unselected material of equal value may be found in the collections of photographs and maps which constitute the field reports of various expeditions of the Peabody Museum. Such reports include much unpublished material, as, for instance, Thompson's explorations of Labna, Kabah and other sites in northern Yucatan. Miss Breton's reproduction[1] of the frescos of Chichen Itza in color is of the greatest value, because it preserves a splendid example of a kind of perishable art that has survived in few places, and that is peculiar in giving intimate glimpses of the ordinary life of the people. It is to be hoped that this excellent work may soon be published to the world.

Among institutions who have supported field work in the Maya area, first place must be accorded to the Peabody Museum which has sent out many expeditions both to explore and to excavate. The results are seen in the splendid collections in this museum and in the many publications by Thompson, Gordon, Maler and Tozzer, mostly appearing in the Memoirs. Dr. Seler[2] conducted the only systematic field work that has taken place on the highlands of Guatemala. Excavations were also made by Maudslay, Dieseldorff and others.

Special notice must be given Dr. Gordon's paper on the Serpent Motive in the Ancient Art of Central America and Mexico,[3] because this is the only attempt at a general consideration that has been made.

The modern ethnology of Maya-speaking tribes has been covered by Stoll,[4] Starr,[5] Tozzer,[6] and Sapper.[7] In general, however, the survivals of the ancient art are apparently slight, and little has been done in collecting myths. Maya art is on a much higher scale than any art in America except possibly the textile art of Peru. It deserves earnest study for the contributions which it is able to make to comparative religion and to comparative art.

[1] A complete reproduction of these paintings is on exhibition in the Peabody Museum.
[2] 1901, c. [3] 1905. [4] 1889. [5] 1900–1904. [6] 1907. [7] 1905.

I. GENERAL CONSIDERATION OF MAYA ART

THE influence of a national religion upon a national art was never more unmistakable than in the case of the Maya. But, indeed, it is universally important. Religion is able to furnish the deepest and truest inspiration which the human mind is capable of receiving. Being ideal in itself, it develops the imagination so that this in turn finds secret meanings in common things. Moreover religion, as a communal element in the life of the nation, turns the attention of all artists to a common purpose. Through this focusing of the attention religion leads inevitably to an intensive rather than a diffuse development of art. But once this intensive development has exhausted the possibilities of the established ideas, then religion throws its powerful influence against further disorganizing change. Thus religion enriches art and makes it permanent.

In the case of the Maya the art might almost be termed the concrete expression of the religion, since all the great monuments were apparently connected with religious practices and no minor object was too humble to receive decorations with religious significance. Clearly this wonderful art rose under the communal inspiration of a great religious awakening and was conserved by the persistence of ritual. Doubtless the art reacted strongly upon the religion which gave it birth, filling that religion with symbolism and imagery. The two worked hand in hand. The spreading of the religion meant a spreading of the art, and the graphic representations of the art rendered the religion intelligible. It was probably through the objective ritual on the one hand and the objective art on the other, that the religion of the Maya was enabled to leap the bounds of language and impress itself so strongly upon the Nahua and Zapotecan peoples.

The student finds in the ancient masterpieces of Yucatan and Central America a fine technique and an admirable artistic sense largely given over to the expression of barbarous religious concepts. Upon the scale of development the art is many points higher than the religion, in spite of the close connection between them. At first glance too exotic and unique to be compared with the art of the Old World, nevertheless Maya art furnishes upon examination many analogies to the early products of the classic Mediterranean lands. Indeed upon technological grounds — such as the knowledge displayed of foreshortening, composition and design — Maya art may be placed in advance of the art of Assyria and Egypt and only below that of Greece in the list of great national achievements.

The representation of the body of man himself was not all-important to the Maya as to the Greeks, for a good and sufficient reason, although it received a very considerable share of attention. The Greeks conceived and represented their divinites and mythical heroes in human form. Hence they idealized this form till it embodied the finest possible conception of strength and grace. Now the gods and culture heroes of the Maya had fundamentally the physical char-

acteristics of reptiles, birds and lower mammals, or were, at best, grotesque figures of composite origin. However, these brute gods, as we shall see, were often more or less humanized, resembling in a general way the half-animal, half-human gods of Egypt and Assyria. Human beings appear only in the mundane guise of priests, worshipers, rulers, warriors, and captives. The strange subject matter of Maya art should not militate against its real artistic merits, for the finest products of an inspired imagination are always worthy of respectful study.

The principal methods employed by the Maya in the graphic and plastic arts differed little from those of classic lands. Delineation and painting upon a variety of substances including paper and plaster, carving in wood and stone and modeling in clay and stucco were widely practiced. Terra cotta figurines made from moulds are very common. Metal working was highly developed as far as the technical processes are concerned, but the scarcity of materials was such that only ornaments were commonly made. The stones used in the temples and monuments were cut and carved with stone implements. The Maya might have accomplished greater wonders if they had had fine-grained marble instead of coarse and uneven limestone, and iron or bronze chisels instead of stone knives.

In Maya plastic art the three usual divisions may be made; namely, low relief, high relief and full round. Much of the high relief, however, shows no more modeling than does the low relief, the figures being simply blocked out in high relief, but still retaining a comparatively flat outer surface. Sometimes high relief shows flat sculpture upon two or more planes. Fine examples of blocked-out high relief of these two sorts are found at Copan and Yaxchilan. But high relief with excellent modeling also occurs, particularly in the stucco work of Palenque. Sculpture in the full round reaches its highest development at Copan, probably because the stone found there was very easy to work. There may have been another reason. The habit of representing faces and bodies in front view seems to lead directly to the full round treatment, especially of the face. Profile figures, on the other hand, appear best in low relief. At Copan the majority of figures are presented in front view, and there is a steady progression from low relief, through high relief, to the exact reproduction of the human body. At Quirigua and Piedras Negras, where other front-view figures occur, the greater part of the body is shown in low relief, but the face is generally carved in high relief or in the natural roundness. The full round method of representation is also accorded to figures seated in a niche that occur at the two cities just referred to. But low relief is by far the most common mode of sculpture in wood, stone and stucco, and may be studied to advantage in all the principal Maya cities.

Homogeneity of Maya Art. The homogeneity of Maya art, in spite of the many necessary differences due to time and place, will prove itself as the description proceeds. In the following pages the aim will be to give a general explanation of the most widespread phenomena. Illustrations on particular points will be taken from all parts of the area, and from both major and minor arts. For instance, the pottery decoration of the uplands will show features similar to the architectural decoration of the lowlands, or the drawings of gods in the codices will agree with stone and stucco figures on monoliths and temple walls.

Simply by way of illustration two or three series of particular similarities

that cover nearly the entire Maya area may be given in detail. Fig. 1 presents a number of faces of diverse forms. Most are strikingly grotesque, and all possess the curious feature of a cruller-like ornament over the nose. This ornament is adventitious and unnatural, and, although apparently insignificant, yet it furnishes the strongest kind of proof of cultural unity, because it is in the nature

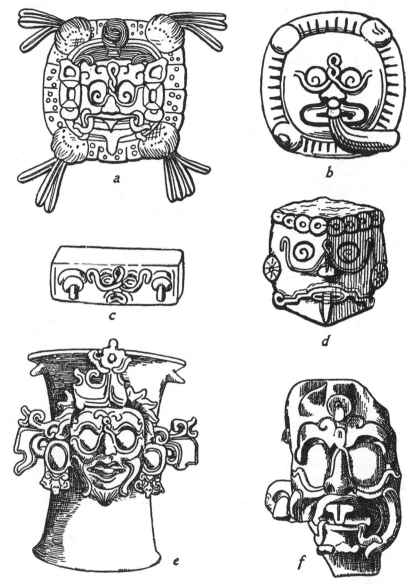

FIG. 1. — Heads with curled nose ornament: *a*, Palenque; *b*, Copan; *c*, Quen Santo; *d*, Labna; *e*, Coban; *f*, Panzamala.

of an unconscious admission. The first specimen, *a*, is a representation of the so-called sun shield on the tablet of the Temple of the Sun at Palenque; *b*, is a somewhat similar design from Copan. It is carved upon a block of stone with a tenon at the back so that it could be set into a temple wall. Shields having decorative faces of the same general type as these are represented as worn on the left arms of many of the warlike figures on the monuments. Noteworthy examples occur at Tikal, lintel of Temple II,[1] Naranjo, Stela 21,[2] and Yaxchilan, Stela 11.[3] The same device appears on faces in other situations, that may or

[1] Maudslay, 1889–1902, III, pl. 73. [2] Maler, 1908, *b*, pl. 35. [3] Maler, 1903, pl. 74.

may not represent the same thing. In *c* we have a simple face crudely carved upon a rectangular block of stone. This object was found by Dr. Seler at Quen Santo on the highlands of western Guatemala.[1] Object *d* comes from the opposite side of the Maya area: it is a corner-stone from the ruins of Labna in northern Yucatan. A clay figurine (Plate 17, fig. 12) from the Island of Jaina near Campeche likewise has a face with the twisted nose ornament incised or stamped upon it. Reverting again to the distant highlands, we see in *e* a remarkable

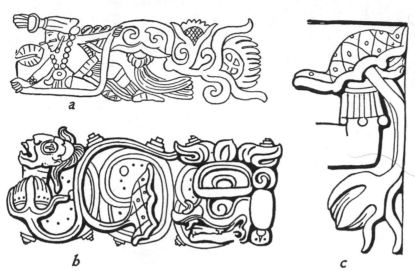

Fig. 2. — Plant motive showing flowers and leaves: *a*, Chichen Itza; *b*, Palenque; *c*, Madrid Stela.

vase in the collection of Mr. E. P. Dieseldorff of Coban,[2] with applied ornament in the form of an excellently modeled face. This vase was excavated from ruins near Coban. The last specimen, *f*, comes from Panzamala,[3] some distance east of Coban. Other examples of this peculiar feature might be given.[4] Most, if not all the faces which have been described probably represent some form of the Sun God. This point will be discussed later.

Other examples of widespread similarities may be given to include certain important cities where the face with the twisted nose ornament is not known to occur. The representation of plants is rarely seen in Maya art, except in a very peculiar motive that Maudslay[5] has worked out rather fully and which he calls the water-plant motive. This water plant as used in decorative bands is shown in Fig. 2, *a* and *b*, while *c* offers a more realistic presentation from the so-called Madrid Stela.[6] The design frequently occurs on pottery. The flower has somewhat the appearance of the water lily, and in many instances a fish is shown seemingly in the act of feeding upon the petals. Examples of the fish and water-plant design present much stronger proof of culture affinity among the cities where they occur than do the simple water-plant forms, for designs analogous to the latter are universal, whereas the association of fish and flower is very unusual. In Fig. 3 are given examples, taken from different parts of the Maya area, that illustrate this peculiar motive. It occurs in full vigor at Copan, Palenque and Chichen Itza, as well as at many other sites, both on the highlands and lowlands. Its exact meaning is somewhat difficult to determine, but it apparently carries the idea of water. It is attached as an ornamental detail to the bodies of animals and to the heads of divinities that are probablyas so-

[1] Seler, 1901, *c*, p. 112.
[2] Seler, p. 1901, *c*, p. 178.
[3] Seler, 1901, *c*, p. 179.
[4] For instance, the feature seems to occur on a head from Bellote on the coast of Tabasco, Char-

nay, 1885, p. 162, and on a vase from San Salvador, Seler, 1901, *c*, pp. 180–181.
[5] 1889–1902, IV, pp. 37–38 and pl. 93.
[6] Léon de Rosny, 1882, pl. 2.

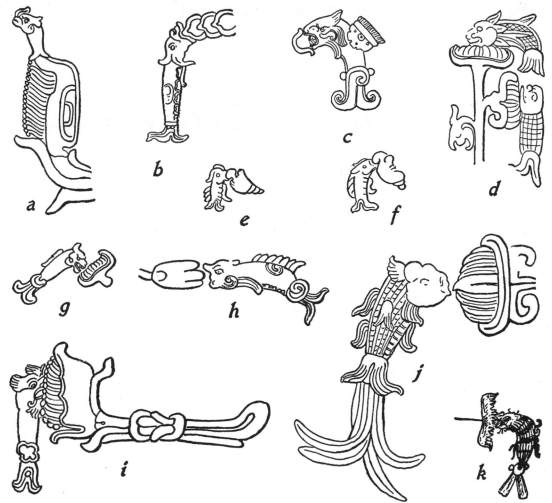

FIG. 3. — Plant and fish motive: *a* and *i*, Copan; *b*, *e*, *f* and *h*, Palenque; *c*, Chajcar; *d* and *j*, Chichen Itza; *g*, Ixkun; *k*, Nebaj.

ciated with water. Fig. 4, from the Dresden Codex, represents one of the Maya gods — known as God B or the Long-nosed God — wading into the water and

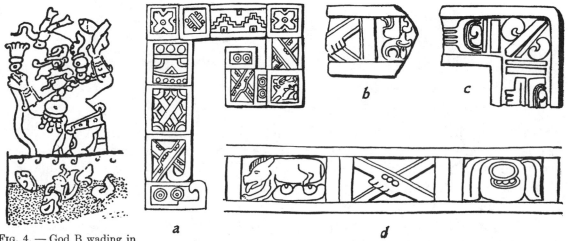

FIG. 4. — God B wading in water and pulling a flower: Dresden Codex.

FIG. 5. — Astronomical signs in bands: *a*, Uxmal; *b* and *c*, near Coban; *d*, Chichen Itza.

pulling up a water plant. Fish and shells are shown in the water, the lower depths of which are colored green.

The planets and other astronomical bodies are generally represented by simple oblong hieroglyphs arranged in strips or bands. These signs occur as details of ornamentation on the dress of human figures, particularly on the belts, as

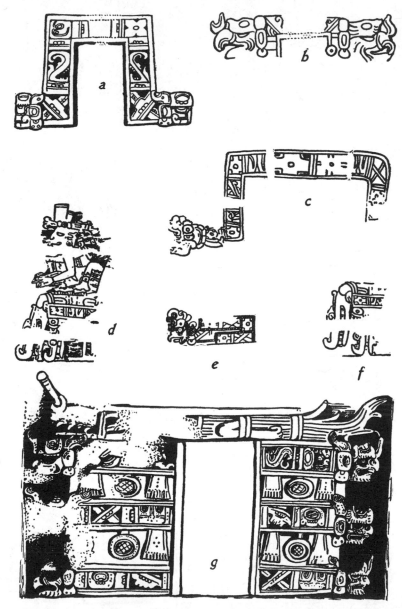

FIG. 6. — Astronomical signs combined with bird and animal heads: *a*, Quirigua; *b*, Copan; *c*, *d*, and *f*, Codex Peresianus; *e*, Dresden Codex; *g*, Naranjo.

markings upon various ceremonial objects and upon the elongated bodies of monstrous creatures, as general motives of architectural enrichment, as well as in connection with many gods and with intricate astronomical calculations. The forms written in the codices are similar to those carved upon the monuments, but show a more cursive delineation.

The general similarity between the bands of astronomical signs in various parts of the Maya area is brought out by the examples given in Figs. 5 and 6. Of these Fig. 5, *a*, is from the front of the annex to the House of the Magician

at Uxmal, *b* and *c* are pottery fragments from the neighborhood of Coban on the highlands of Guatemala, and *c* is from the eastern façade of the Monjas at Chichen Itza.

Fig. 6 presents a second series showing the astronomical signs combined with birds' heads and upon seats or thrones across which are bound grotesque animals. A very close parallel is evidenced in *a* and *c*, the first from the back of a monolith at Quirigua, the second from the Peresianus Codex. In neither of these specimens is the head very distinct. Often bands of astronomical signs are terminated by birds' heads, as may be seen from *b* on the back of Stela H at Copan, *e* in the Dresden Codex and *g*, the base of the splendidly carved Stela 32 at Naranjo. The latter sculpture really represents an elaborate throne, but the human figure seated upon it is so badly mutilated that it was not reproduced in the drawing. Across the top of this throne is a grotesque animal trussed and bound. The same sort of thing is represented by drawings in the Peresianus Codex (*d* and *f*), likewise connected with astronomical signs. This grotesque animal will be discussed more fully in a later section, where many other objects combined with star symbols will come up for consideration. The interpretation of the particular signs will also be postponed.

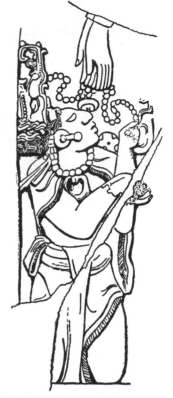

FIG. 7. — Detail showing kneeling worshiper: Yaxchilan.

As stated, the only reason for giving the preceding examples at this time is simply to remove all possible doubt concerning the homogeneity of the ancient art within the limits ascribed to the Maya culture. This is seen in important things as well as in the relatively unimportant ones just given. The latter, however, have the unusual quality of covering not only all the geographical range but most of the chronological range as well.

THE HUMAN FORM

An easy understanding of Maya art may be had by starting with subjects least opposed to the familiar ones of the Old World and proceeding thence into the labyrinth of fantastic conceptions peculiar to the New World.

Subjects Represented. The representation of the human figure seldom served as an end in itself. The men and women shown in the sculptures are seemingly engaged in religious ceremonies and acts of adoration. The divinities which they worshiped are more or less clearly indicated. As a rule, the human figures are those of priests or warriors. But even in the case of the latter the religious motive is rarely absent and human beings free from the artistic domination of gods of lower nature. There are, however, a number of sculptures which apparently memorialize success in war, and in these none of the usual religious paraphernalia appears.

An example of adoration is seen in Fig. 7 that reproduces part of the beautifully carved but badly broken Stela 7 at Yaxchilan. This kneeling worshiper

wears a loose cloak over the shoulders, a light garment that covers the thighs and a rather elaborate headdress in the form of a somewhat grotesque animal head. His face is turned upward and his hands are lifted to receive whatever

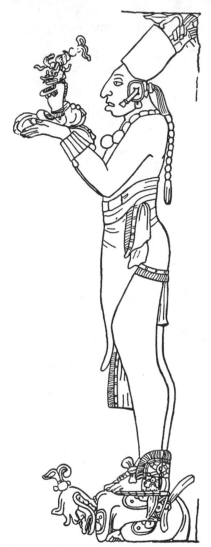

the being above may care to bestow. From a pair of hands above him, that belong to a standing figure so badly shattered that it cannot be reproduced, descend certain objects that may indicate an answering of his prayer. Immediately above the face of the kneeling figure is a sign resembling that for corn or maize, lower down is the symbol of the sun, while the scroll-work of small circles may represent rain or, perhaps, fruitfulness. This tableau, then, might be considered to represent a prayer for the corn crop and the sun and rain most necessary for its welfare. Such an interpretation would be in keeping with the principles of sympathetic magic according to which the thing desired is usually represented either pictographically or dramatically.

Very often a human figure holds in his arms or hands one or more ceremonial objects. In the next drawing (Fig. 8) a man in simple attire stands upon the back of a grotesque being and supports upon his uplifted palms a manikin. He is one of two priest-like figures sculptured on the justly famous tablet of the Temple of the Sun at Palenque.[1] Many other examples of human beings engaged in religious services will be given in other places.

FIG. 8. — A presiding priest: Palenque.

Many sculptures show human beings seated upon thrones before which are standing or kneeling worshipers. These seated persons may represent rulers or high priests who were worshiped as the embodiments of gods. The divinities themselves were of a low animal order. But the government as well as the religion of the Maya was probably of totemic origin, and so might be expected to emphasize close relationships between the temporal and spiritual rulers and the animal gods. These seated figures frequently hold the same ceremonial objects as the standing ones, while in other

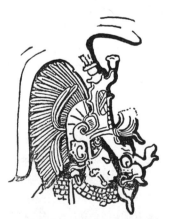

FIG. 9. — Man wearing mask: Yaxchilan.

cases the ceremonial objects are held aloft by attendants. The human overlord as the agent of the god is clearly shown on Stela 11 at Yaxchilan.[2] On this monument is a standing human figure wearing the mask of a grotesque god (see Fig. 9 for the mask) who threatens with his baton several bound captives kneeling before him.

[1] Maudslay, 1889–1902, IV, pl. 88. [2] Maler, 1903, pl. 74.

A sculpture that seems to refer only to war and conquest is reproduced in Fig. 10. This is Lintel 12 at Yaxchilan. In the center is a chief with spear and shield and in full regalia. The head of a slain enemy hangs hair down from his breast, and cross bones decorate his dress. At the left is one of his assistants, likewise armed. Kneeling on the ground are four captives bound with rope. Upon the bodies of these captives are glyphs which may record their names and the date of their capture. At the upper part of the stone are two bands of glyphs, left blank in the drawing, which possibly contain the narrative of the

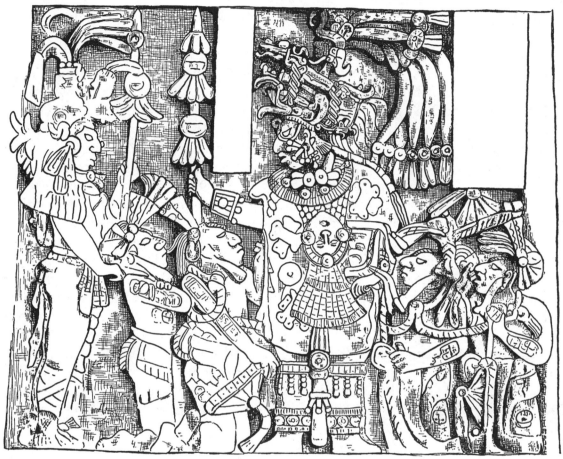

FIG. 10. — Memorial of conquest: Lintel 12, Yaxchilan.

victory or other information of historical interest. Several analogous sculptures might be described if space warranted.

It is exceedingly doubtful whether any sculptures were seriously intended as portraits of individual chiefs or priests. To be sure, there are a number of face types depending upon variation in form of features and in expression. Usually one type prevails in each city. On the stelae of Quirigua several types are to be seen, but the degree of individualism is slight. Possibly, as was the case in Egypt, the faces of portrait statues varied slightly, while individualism was expressed in dress, ornament or inscription.

The general physiognomy represented on Maya sculptures differs widely from the accepted European types of beauty. It seems pretty clear that artificial flattening of the head was practiced and that straightened foreheads and retreating chins were held to be marks of beauty. The nose is usually prominent

and of a somewhat Hebraic cast. The lower lip is protruding and pendulous and the mouth kept slightly open. This type is not characteristic of the modern Maya Indians, who, however, do not retain the ancient practice of deformation. Hamy [1] compares the faces carved at Palenque with those of two Mexican microcephalic freaks on exhibition in Europe about 1850. The striking resemblance he notes seems to be purely the result of chance. Besides cranial deformation other modifications of the natural form were in vogue. Filed teeth and teeth inlaid with jade and other minerals have been found in a number of burial sites, as well as cumbersome nose and ear plugs.

In regard to evidence of style which may be associated with particular sculptors, it is by no means lacking. There is a widely advocated theory that primitive art is purely communal. To be sure, the first artists did not ordinarily sign their works, but strict regard for ownership of designs or of songs is no rare thing among primitive people. What reason is there to hold that artistic genius among the Maya was not essentially the same as in our own land, simply because the social organization of the nation and the subject matter furnished by the religion are different? Real contributions to human culture are always referable to individuals, and the fact that the records are lost matters not. But the individual lives and works within the mode of his nation and his epoch. He adds something of his own to art, theology or what not, and that something is more noticeable in present view than in retrospect. Upon analysis that something frequently resolves itself into a new imaginative reconciliation of previously known elements. Rarely, indeed, the individual may strike back to real origins and make a radical departure from traditional habits of thought and expression. The works of the most flagrant individualist of to-day will to-morrow fall into an inevitable scheme of evolution. It is reasonable to suppose that each of the various groups into which the stelae of Copan may be divided was the work of a single sculptor, or of a school under the direction of a single artist. Each group shows, as we shall see, a conscious and typical arrangement of common elements. But through all the groups runs a thread of change and development of which the artists themselves may well have been entirely unconscious, except in its more obvious features.

Poses and Groupings. The poses as exemplified on the monolithic monuments, commonly called stelae, most of which present a single human figure, or a single figure on the front and another on the back, will be taken up first. Then the more unusual poses and the complex groupings on the monuments and elsewhere will be briefly considered.

In the case of the Copan stelae the pose is practically uniform throughout the long series. The priest, chief, or whoever it is that is represented, stands in an erect attitude, with his heels together, and holds an object called the Ceremonial Bar against his breast. The body shows perfect bilateral symmetry. Certain changes in the pose, which, in a later section, will be co-ordinated with changes in manner of carving to establish in part the chronological sequence of the monuments, may here be mentioned. In the earliest stelae the upper arms lie close to the side and the forearms rise almost vertically. In the later stelae the forearms are almost horizontal. Again, on the greater number of the monuments, the feet are represented as turned directly outward, forming a straight

[1] 1875.

angle. But at the end of what we will call the Archaic Period, the sculptors began to take advantage of the increased relief, furnished by the heavy apron, to turn the feet inwards, till in the latest examples the pose became almost natural. Some of these stelae are reproduced in Plates 18 and 19.

On a few of the stelae at Quirigua the feet are likewise set at less than a straight angle. It may be noted that in general the stelae of Quirigua are later than those of Copan, but that they show a reversion to less laborious construction. The poses are much the same, though on some of the monuments a manikin figure on a staff, commonly called the Manikin Scepter, replaces the Ceremonial Bar. This substitution breaks up the bilateral symmetry, since the staff is held diagonally across the body and not horizontally.

As before stated, low relief practically necessitates the profile view of the face. Many stelae at Tikal, Naranjo, etc. (Plate 21, figs. 1–4; Plate 24, figs. 1–3 and Plate 25, figs. 1–2) show the same pose as those of Copan except that the face is turned in profile. With the feet turned straight out this pose is an awkward one. Often, however, the body appears in profile as well as the face (Plate 22, fig. 1). In such cases the Ceremonial Bar is replaced by other ceremonial objects. Frequently a staff or scepter is held before the face with one hand, while the other holds a decorated pouch at the side. Sometimes spear and shield replace the ceremonial objects. The feet are either one behind the other, as though the person were taking a short step, or else the outer foot covers and conceals the inner one. The bodies are represented as erect and motionless.

In a few instances two standing figures are brought face to face with each other, as on Stela 11 at Yaxchilan.[1] More often a warlike figure stands above or beside a bound captive. In other cases where two persons are shown one is seated while the other stands.

Seated figures are rather common on stelae in the Peten and Usumacinta cities. The most important type of monument, especially at Piedras Negras, shows a figure in high relief seated cross-legged in a niche with the hands upon the knees. There seems little doubt but that the niche really represents a canopied throne. Such a throne in profile with a seated personage is seen on Stela 5[2] at this city. As a rule, however, the royal thrones, while richly upholstered, do not have canopies. It is worthy of note that on most of the stelae presenting a tableau of several persons, the interest centers in a seated figure. A good example of this is the remarkable Stela 12[3] at Piedras Negras on which a number of individuals, including priests or warriors, and bound captives are arrayed before a seated being that may represent either a chief or a divinity, but more probably the former.

As to the disposition of the legs in seated poses, there is considerable variety. Usually they are crossed Turkish fashion and represented either in front or side views. Sometimes only one leg is drawn up, while the other extends downward, the result being a free, graceful pose. Seated figures are also shown with both feet on the ground in the usual attitude. But when this method of sitting is represented in front view the knees are bent outward and the heels raised, as on Stela 2 at Cankuen.[4]

[1] Maler, 1903, pl. 74, fig. 2.

[2] Maler, 1901, pl. 15, fig. 2.

[3] Maler, 1901, pl. 21.

[4] Maler, 1908, a, pl. 12, fig. 2.

Poses which show motion are rather rare on the stelae. Of course the mere act of offering is common enough. One monument at San Juan de Motul [1] apparently shows two heavily dressed beings in the act of dancing. The knees are turned outward and the heels are raised so that the figures seem to stand on tiptoe in a somewhat squatting attitude. But it is probable that this peculiar pose is intended to represent sitting rather than dancing, as indicated by the

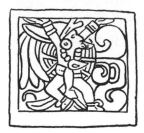

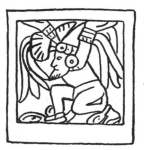

FIG. 11. — Atlantean figures on pilasters: Chichen Itza.

Cankuen stela referred to above and by the principal figure on the lintel of Temple IV at Tikal.[2] The sprinkling of maize or other small grains upon the ground is represented on Stela 13 at Piedras Negras (Plate 25, fig. 3). Various gesticulations are clearly shown on Stela 2 [3] of La Mar. Here the poses exhibit unusual freedom.

The poses and groupings on sculptured lintels, panels, steps, etc., show so much variety that it seems almost impossible to treat them in a general way. At Copan there are a number of sculptures which show small seated figures arranged in rows. The best examples are Altar Q [4] and the interior step of Temple 11.[5] The pose is slightly different in each case, the variety being more marked upon the last-mentioned monument.

Most of the lintels of Yaxchilan show two figures facing each other, one with the body in front view and the face in profile and the other with both body and face in profile. As a rule, one figure is somewhat subordinated to the other. A number of lintels show more than two figures each, as, for instance, Lintel 12, which has already been presented (Fig. 9) as an example of a memorial of conquest. The panels and tablets of Palenque exhibit a great variety of grouping, but no remarkable departures from the poses of other cities. The processional arrangement of human figures so highly developed at Chichen Itza [6] is un-Maya and belongs, as we shall see, to the very latest period of Maya art, when influence from the highlands of Mexico had set in strongly. In these representations there is crude delineation, but often an admirable sense of action. Muscular effort also appears in the strained poses of the small atlantean figures carved on columns and door jambs at this city (Fig. 11).

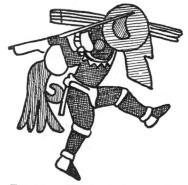

FIG. 12. — Warrior in fresco paintings: Chichen Itza.

In the codices and frescos action is usually indicated, and the body is represented in many positions. Warriors depicted on the walls of the inner chamber of the Temple of the Jaguars at Chichen Itza are especially active, as may be seen from the one reproduced in Fig. 12. A portion of this fresco represents a spirited battle with much lifelike detail. Part of page 60 of the Dresden Codex

[1] Maler, 1910, pl. 45.

[2] Maudslay, 1889–1902, III, pl. 78. For notation see Table of Nomenclature, p. 256.

[3] Maler, 1903, pl. 36.

[4] Maudslay, 1889–1902, I, pl. 92.

[5] Maudslay, 1889–1902, I, pl. 8.

[6] Maudslay, 1889–1902, III, pls. 44 et seq.

is reproduced in Fig. 13, from which an idea of the more complicated poses and groupings in this wonderful manuscript may be obtained. Other illustrations of the points so far covered will appear as the discussion proceeds.

Foreshortening and Perspective. As may be gathered from the foregoing description of poses and group-ings, the Maya had a considerable but by no means complete mas-tery of the technical difficulties of representing objects with three dimensions upon a surface with only two. High and low relief form something of a transition for this process. In foreshort-ening they greatly excelled the Egyptians and Assyrians, since they became sufficiently skilled to draw the entire body in pure profile, besides representing the legs and feet with ease and pre-cision in a variety of sitting and reclining positions.

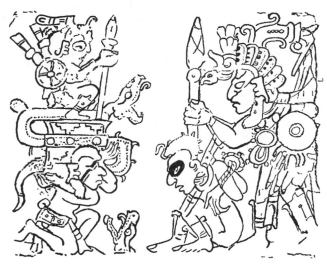

FIG. 13. — Example of complicated grouping: Dresden Codex.

The real difficulty in the development of perspective is that the artist's previous knowledge of the object interferes with his visual impres-sions. He cannot let the hand draw the picture as the eye sees it. He knows

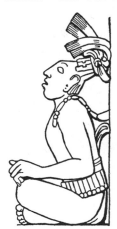

FIG. 14. — Seated fig-ure in pure profile: Palenque.

that a man possesses two arms and so feels constrained always to draw two arms in plain view. The Maya artists established a sort of compromise between appearance and reality. When they could not find a way to correct the drawing, they at least succeeded by graceful and pleasing treatment in distracting attention from the errors in delineation. The historical develop-ment of skill in foreshortening will be demonstrated in another section. Only the more perfect phases will be treated here.

The mastery of the pure profile may be studied to advant-age at Palenque. A good example from this city is given in Fig. 14, which represents a seated individual with very little clothing to conceal the body. It will be noted that the upper part of the breast is drawn in profile, as well as the head and legs, and that the more distant arm does not appear in the picture.

When, however, the body was covered with heavy drapery or elaborate ornaments, the difficulties of foreshortening all the details were sometimes be-yond the skill of the artists, especially when the profile pose was adopted. This ineffectiveness is best seen in the braided breast ornaments which seem to pro-ject outwards when they should lie flat on the breast. Examples may be seen in the right-hand priestly figure of the tablet of the Foliated Cross at Palenque [1] and in the drawing which Maler [2] gives of part of the incised tablet at Xupa. In all fairness to the Maya sculptors it must be stated that the difficulty with this detail seems to have been overcome on other monuments at Palenque.

[1] Maudslay, 1889–1902, IV, pl. 81.　　　　　[2] 1903, p. 21.

A change in pose of an exact 90 degrees, that is, from front view to profile or *vice versa*, was for the most part readily accomplished. Among the complicating details of the more elaborate dresses worn by human beings were small heads, probably of stone, with appendages of one sort or another. These heads were placed on the breast and on the middle and sides of the girdle. When the body was in front view, the head on the breast and the one on the front of the

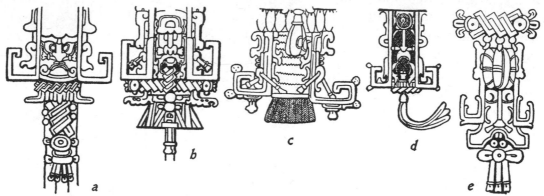

FIG. 15. — Elaborated aprons on the monuments: *a*, Copan; *b*, Quirigua; *c*, Ixkun; *d*, Tikal; *e*, Palenque.

girdle were likewise drawn in the full face, while those at the sides of the girdle were presented in profile view. When the pose was shifted to the profile, the small heads on the breast and on the front of the girdle were likewise shifted into the profile. One of the heads at the side of the girdle was thrown into the front view, and the other disappeared behind the body. Other objects, such as disk-shaped and bar-shaped breast ornaments, aprons, shields, etc., that appeared

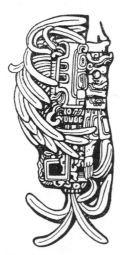

FIG. 16. — Foreshortening of feathers: Tikal.

entire in front view were ordinarily divided vertically in halves, and only the nearer half drawn when the pose was turned in another direction. The circle seems never to have been foreshortened into an ellipse, but instead was divided vertically as above. The modifications in circular breast ornaments when viewed from the side are easily seen on some of the lintels of Yaxchilan which show both profile and front-view figures with the same style of dress.[1] Shields in half view are worn by the sculptured warriors of the Temple of the Jaguars at Chichen Itza.[2]

Fig. 15 presents a series of elaborate aprons of a widespread type. There is a grotesque face in the middle and a fret at each side. The latter, as we shall see, is really a highly modified serpent head. At the top are usually shell pendants, in groups of three, which project out over the rest of the apron. At the bottom are plumes, braided strips and tassels. Aprons of this sort are occasionally represented on human beings in side view, and in these cases the face in the center becomes converted into a profile face. The adjacent fret is retained without change, and the more distant one disappears from view. Fig. 16 represents an object in side view, the lower part being very similar to the aprons we have just examined. This

[1] See, for instance, Lintels 2 and 3 (Maler, 1903, pls. 47 and 48).

[2] Maudslay, 1889–1902, III, pls. 38, 49 and 50.

object is attached to the headdress and hangs down at the back of a human figure (Plate 22, fig. 1). The fret is readily seen, and the face in profile in front of it can be made out after a little study. Higher up appears the group of three shell pendants. But the feathers that issue from the side of this object are splendidly foreshortened by the use of sweeping curves. The front view of feather projections on similar objects attached to headdresses may be examined

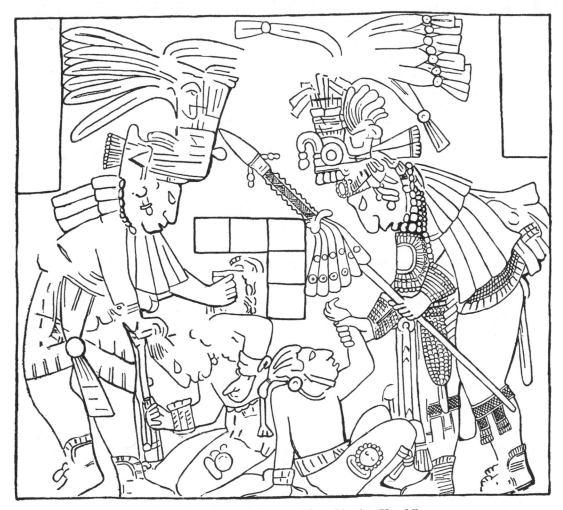

FIG. 17. — Low relief composition: Lintel 8, Yaxchilan.

for comparison on Lintels 1, 2, 3, 5, 33, etc.,[1] at Yaxchilan and Lintel 2[2] at Piedras Negras.

The human body is seldom represented in what might be called quarter-view, but there are a few interesting departures from the prevailing front and profile studies that deserve note. One of these is seen in the left-hand person on Lintel 8 at Yaxchilan (Fig. 17). This sculpture pictures two warriors bending over and grasping two partially fallen captives. The attitudes are all exceptionally free, but the figure to which special attention has been called has few parallels in this respect. The face is in profile, but the rest of the body is twisted almost but not quite into front view. One foot is partially raised from the ground. Altogether the drawing shows with considerable success a

[1] Maler, 1903, pls. 46–48 and 63. [2] Maler, 1901, pl. 31.

pose having many difficulties. The carving on this lintel is, however, in such low relief that it appears to be hardly more than an incised sketch.

On Stela 13 at Piedras Negras (Plate 25, fig. 3) is carved a superb figure apparently in the act of scattering grains of some sort. The shoulders in this instance are likewise twisted around, but not to so great an extent as in the drawing we have just examined. Other representations of the human body in more or less twisted attitudes are seen on the stucco panels of House D of the Palace at Palenque.[1]

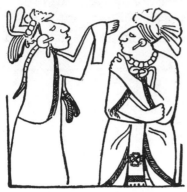

FIG. 18. — Kneeling figures: Stela 1, La Mar.

The manipulation of drapery does not appear to any great extent in Maya art. As a rule, the dresses of both male and female subjects are covered with stiff and inflexible ornament. Some of the crouching women at Yaxchilan [2] have the lower borders of their dresses extended over the ground in a rather picturesque manner. Two simply draped persons are presented in Fig. 18. The folds of the garments are represented by incised lines. Better examples yet may be seen on Stela 1 at Cankuen (Plate 25, fig. 6) and on Stela 7 at Yaxchilan (Fig. 7). But the highest development of drapery in the Maya area occurs at Palenque. One of the most interesting examples is given in Fig. 19. The apron and cloak fall in free and graceful folds, and a sort of twisted scarf hangs down behind the back.

Perspective in its application to many objects, such as a crowd or a landscape, the Maya seem scarcely to have considered at all. Figures in different planes of perspective may have been intended when they are shown in tiers one above the other. When two or more human beings are placed together, there is usually no unnatural difference in size, to express kingly qualities as is so common in Egyptian scenes. On some of the stelae the captives and kneeling figures are clearly supplementary and are crowded into the available space. The small figures of men and animals interwoven so gracefully into the scroll ornaments of many of the Copan stelae seem to be primarily decorative.

The frescos of Chichen Itza are about the only known attempt to handle a crowd or to portray everyday life. On the best one of these, against a green field, are shown many warriors of equal size engaged in combat. At the top of the picture, and apparently in the middle distance, are houses

FIG. 19. — Representation of drapery: Palenque.

[1] Maudslay, 1889–1902, IV, pls. 32–37. [2] Maudslay, 1889–1902, II, pl. 87.

near which are women preparing for flight. The scene is very natural, as if viewed from a considerable height, and the absence of perspective does not make itself felt. A group of trees in a corner of the scene is drawn with much decorative effect.[1] When, however, the artist puts his hand to drawing a mountain or hill with men clambering over it, he goes quite beyond his power. One or two such attempts are very crude.

Expression. Except in the more or less grotesque figures, there is very little in the way of expression. The drooping eye in profile faces gives a certain air of sadness, and the finest faces in the full round have perfect serenity (Plate 26, fig. 3). Sometimes, however, there is a sullen expression upon the faces of the captives that is probably intentional, as may be seen from the four kneeling persons in Fig. 10. In grotesque conceptions, however, grimaces and scowls are admirably portrayed.

Perhaps the best example of characterization is the old man smoking a tubular pipe, who adorns one side of the doorway to the shrine of the Temple of the Cross at Palenque.[2] The thin lips, stooped back and weak knees of old age are extremely well presented.

Composition. Composition in simple and in subtle kind finds high expression in Maya art. Not only the direct opposition of practically equal figures, as on Stela 1 of Ixkun,[3] but also balance secured by difficult modes and measures, distinguishes the work of the Central American people. Long feathers drooping in graceful curves as well as strips and blocks of glyphs are commonly employed to fill out corners and carry the lines of interest.

The tablets of Palenque might serve as models of composition in which the most intricate methods are used. In the three tablets of the Sun, the Cross, and the Foliated Cross[4] the balance is across the vertical, medial axis. The attendant priests in each instance are of different heights, and blocks of glyphs and other devices are employed to give equal weight to the two sides of the picture. The pyramidal type of composition is illustrated in the stucco panels of House A of the Palace.[5] Here there is in each case a central standing figure who holds before himself a ceremonial staff. The staff balances the headdress of this principal subject. In each of the lower corners is a seated figure who looks upward. This arrangement gives weight and stability to the design as a whole. Many other examples of pyramidal grouping might be mentioned. The two lintels of Yaxchilan reproduced in Figs. 10 and 17 show agreeable composition. In both designs the bottom is made much heavier than the top, although the pyramid is not very obvious. Composition on the diagonal is not so common among the Maya as some other forms. This may be explained by the abhorrence of blank spaces. Still in some sculptures a diagonal line of interest is maintained. Attention might be called in this regard to one of the most remarkable works of art that the Maya produced in the matter of composition and execution. The splendid lintel taken by Maudslay[6] from Yaxchilan and deposited in the British Museum represents a divine serpent which towers above a crouching female worshiper who holds up a basket of offerings. In the mouth

[1] Maudslay has reproduced this but without entire success, 1889–1902, III, pl. 40.
[2] Maudslay, 1889–1902, IV, pl. 72.
[3] Maudslay, 1889–1902, II, pl. 69.
[4] Maudslay, 1889–1902, IV, pls. 76, 81 and 88.
[5] Maudslay, 1889–1902, IV, pls. 8–11.
[6] Maudslay, 1889–1902, II, pl. 87.

of the serpent appears the upper part of a being in human form — probably an anthropomorphic god — who threatens the woman below with a spear. The top of this picture possesses a heavier interest than the bottom, and the diagonal line of division is well marked.

It has been frequently pointed out that the Maya did not subordinate sufficiently for our tastes and that they did not understand the contrast value of blank space. Of course it is probable that most of the more complicated designs were painted in different colors. Under this treatment much of the complexity would disappear.[1] After all, the principal reason the drawings seem involved to European eyes is because they are utterly unintelligible. But it might here be noted that there was a tendency to simplify and to limit the field of vision toward the end of the first Great Period. This tendency is mostly in evidence at Piedras Negras and Palenque. The principal figures or groups are often carefully framed in by strips of astronomical signs, etc., and considerable blank space preserved as a background.

The sense of careful and accurate composition was probably developed along with the carving of hieroglyphs. Each glyph is indeed a careful bit of composition and design limited to a definite and uniform space. The matter represented in a single glyph ranges from whole figures of men and animals to cryptic abbreviations. Examination shows that the spaces were nicely divided and mapped out before the finer details were added.

A number of monuments have unfinished figures and inscriptions that show the preliminary blocking out in the rough. Altar L at Copan and Stela 1 at Tikal (Plate 22, fig. 4) may be given as examples. Rough free-hand drawings found on walls at Tikal[2] and elsewhere give some idea of the artists' preliminary studies.

THE SERPENT

The Origin of the Serpent in Art. The unique character of Maya art comes from the treatment of the serpent. Indeed, the trail of the serpent is over all the civilizations of Central America and southern Mexico. Any attempt to explain the origin of the serpent in Maya art must take note of the following facts concerning the religion and social organization of the Maya:

1st. The belief in many animal gods, some being more powerful than others.

2nd. The association of these powerful gods with natural phenomena.

3rd. The marked progression of these animal gods towards anthropomorphism.

4th. A strong political structure almost amounting to theocracy.

5th. A ruling class with careful regard for inheritance.

6th. The number and magnitude of public works of a religious nature.

All of these conditions may be explained as direct indigenous outgrowths of generalized totemism. This is widespread among the American Indians as well as among primitive peoples in almost all parts of the world.

Totemism, which as a religious and social institution varies widely in many details, may be said to have as its basis a primitive philosophical conception of

[1] A fine instance of this is seen in Miss Breton's restoration of the painted sculptures of the Lower Chamber of the Temple of the Jaguar at Chichen Itza now installed in the Museum of the University of Pennsylvania.

[2] Maler, 1911, pp. 56–63.

the world. According to this conception all, or at least a part, of the objects of man's physical environment, such as animals, plants, heavenly bodies, and various sorts of natural phenomena, are his equals or even his superiors in the possession of skill and intelligence and a will to help or hinder. The individual chooses from these his best friend in the society of nature. The methods by which the choice is made are legion, but fasting, revery and self-hypnotism are common features. The religious side of totemism concerns the worship of the acquired guardian spirit of the individual or the inherited guardian spirits of the clan. Of course this worship does not constitute the whole of the religion of any people unless the powers of the totems are extended to cover the more general activities and phenomena of nature. The governmental side of totemism is of even greater importance than the religious, from which, however, it is derived. Principally through its relation to ideas of inheritance totemism tends to emphasize the importance of the family or clan and gives rise to a strong and stable society with well-defined leadership.

In a progressive community the different clan protectors do not long maintain an equal status. An unusual or striking ritual, a popular myth or a change in the condition of life may elevate one clan totem over the totem of other clans of the same tribe. Or the political fortunes of a family may redound to the credit of the being worshiped by that family. When a god, as when a man, rises from the ruck of the commonplace, he attracts to himself the strong qualities of his inferiors, for even among gods nothing succeeds like success. Such a process of survival and absorption may partially account for the importance of the serpent and other animal forms in Maya religion and art.

But there is good reason to suspect that the serpent was more potent in art than in religion and that its importance in the latter was partly reflected from the former. The peculiar form of the serpent's body was able to furnish a richer theme and one with more obvious possibilities of artistic development than could that of any other animal in the early list of totemic divinities. Most of the more or less anthropomorphic gods of the historic Maya pantheon are distinct enough in powers and attributes and seem to have successfully cast off some earlier animal nature only to be endowed afresh with ophidian characters. On the other hand, there is no single god that can safely be called the serpent god to the exclusion of all others. As a result of its artistic extension the serpent seems to have lost its earlier religious intention and to have become merely a sign or an attribute of divinity in general.

Zoölogical Observations. In any analytical study of this most complicated subject it is necessary to distinguish three aspects. The first aspect concerns the physical or zoölogical basis or explanation for any representation. The second aspect concerns methods of idealization or evidences of the reaction of religious ideas and inspiration upon the given natural form. The third aspect concerns conventionalization, so called, or the modifications brought about by a sense of pure design. More briefly these three aspects are, 1st, physical, 2nd, religious, 3rd, decorative.

The serpent is seldom represented realistically, but we may safely infer that the rattlesnake was the prevailing model. The common rattlesnake of Central America and southward is the *Crotalus durissus*, which has been thus described [1]

[1] Ditmars, 1910, pp. 353–354.

as to its coloration: ". . . the ground color is rich yellow or pale olive; a chain of large brown rhombs, bordered with light yellow, extends along the back."

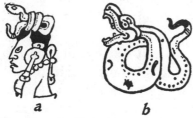

Rarely, indeed, did the Maya draw snakes with the markings given above. Rattles are sometimes shown, but in many cases these too are omitted. Usually the picture conveys merely a general suggestion of the snake with every feature more or less modified. Still the lack of realism was not owing to the inability of the artist, as may be seen from a number of excellent drawings in the codices (Fig. 20).

Fig. 20. — Realistic serpents: Dresden Codex.

Parts of other creatures are frequently added to the body of the snake, but it is usually difficult to make a zoölogical identification of these additions. The most important are the plumes of the quetzal bird and ornaments and features taken from the human form. The jaguar is also a close associate of the snake in Maya art. Clawed forefeet are often seen on some of the more complicated representations. Other animals make occasional contributions to the more or less grotesque conceptions, while some features appear that apparently have no zoölogical explanation. It will be shown that in the composite figures now one component and now

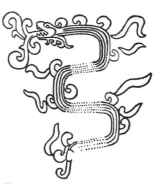

Fig. 21. — Idealized serpent: Fresco painting: Chichen Itza.

another comes to the front, but that all are artistically controlled by the suggestion of the snake. The unnatural combinations are doubtless attempts to figure characters that appear in the mythology and religion.

Idealization. But while the religion provided the gross composites just noted, as subjects for artistic expression, it also inspired a fine, spiritual idealization of them. This idealization was achieved by two methods which, although fundamentally distinct, nevertheless worked hand in hand.

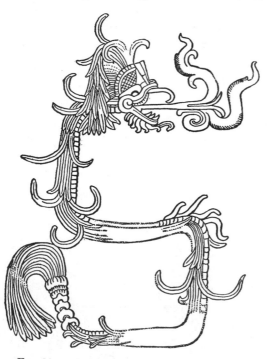

Fig. 22. — Feathered serpent: Chichen Itza.

According to the first method of idealization the body and head of the serpent were elaborated by the additions of scrolls, spirals, undulating lines and other elements essentially serpentine. Sinuosity received its ultimate expression. Thus the serpent of religion was distinguished from the serpent of nature by being made more ideally serpentine. Fig. 21 presents an example of such elaboration from the frescos of Chichen Itza.

The second method followed in the idealization of the serpent was progressively anthropomorphic. The serpent was endowed with certain human aspects

by the addition, in the first stage, of ornaments worn by human beings. Nose and ear plugs appear on comparatively unelaborated representations. Fig. 22 shows a plumed serpent whose head is decorated by nose plugs and by a feather headdress. The plumes on the body curve outward in much the same manner as the scrolls just considered. As a final stage in the evolution of the divine serpent, a human or grotesquely human head was placed in the wide-open jaws. This device is well illustrated in Fig. 23. This latter addition is perhaps the most striking and original feature of Maya art and has, as we shall see, a most significant development.

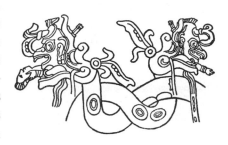

FIG. 23. — Serpents with grotesque heads in their mouths: Copan.

Fig. 24 shows a beautiful representation of the divine serpent from Yaxchilan in which both the above-described methods of idealization receive lucid expression. In this example the body markings of the serpent are also brought into play.

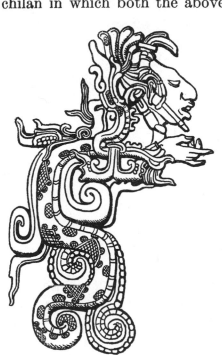

FIG. 24. — Divine serpent with human head and hand in mouth: Yaxchilan.

The explanation of this progressive anthropomorphism is simple and dependent upon universal principles. It is but the graphic record of a process that takes place in all religions, from totemism upwards, in which the supernatural relations between men and animals are intensified.

In gods, as in men, there is always the union of a body and a mind. The body of the god may be any natural form, vegetable, animal or human, but the mind is always like that of man himself. It is impossible for man, savage or civilized, to conceive of a divinity with an intellect essentially different from his own although the powers may be magnified or extended. When the body of the god is imagined as that of an animal, there comes, with increase of culture, a growing sense of incongruity or inadequacy in the association of a superior mind with an animal body. As a first stage, the animal-like body of the god becomes larger or more mysterious than that of the every-day wild animal of the same species. Such a stage may be seen, for instance, in the totem gods and clan ancestors of the tribes of the northwest coast of America. Gradually the divinities assume human form and manners. The half-animal, half-human gods of Egypt, Assyria, India and Peru, as well as the deities of the Maya, show the middle stage. Complete anthropomorphism is seen in the gods of Greece. Even here, however, there are many scholars who maintain that an earlier animal nature of these gods is disclosed by the peculiar epithets, by sacred animals, plants, etc., and by sacrifices. Be this as it may, it is clear that after they had achieved human form the gods had to struggle to keep up with the ethical progress of their worshipers.

It was, as before remarked, the special quality of human form in the Greek gods which directed Greek artists toward the human form as a principal subject for artistic treatment.

Aside from human associations, the human body possesses little, if any, more absolute beauty than does the most humble object shaped by the refining hand of nature, be it bird, flower or stone. In any really great national art the choice of subjects from such a wide field is usually directed by the specialized enthusiasm of religious fervor.

The Serpent in Design. It is necessary to consider the serpent in regard to modifications which result from its constant repetition as a decorative and symbolical motive. In this aspect of art the serpent combines with diverse objects, natural and artificial, and presents many phases of so-called conventionalization.

The character of the delineation of any figure in decorative art is determined by a sort of survival of the fittest. These surviving forms show certain qualities of order — especially harmony of measures and dominant directions, or parallelism of lines — that constitute the basis for any successful appeal to the esthetic sense. The suggestion has already been made that the artistic success of the reptilian motive in design probably had much to do with making the same motive strong in religion. Many divinities of diverse animal natures seem to have been overcast by the serpent, and the actual intrusion of ophidian features into distinct representations can often be demonstrated.

Any national or regional design is, of course, finite. Its scope is limited by one or more modes wherein it is intensively developed. Now, in the case of the Maya the physical nature of the serpent reacted strongly upon the national sense of beauty. Not that they saw beauty where there was none, but that they accepted the special beauty of the serpent and neglected the other kinds. The serpent appeared to them the ultimate expression of grace.

It must be admitted that the snake's body has a very simple but exceedingly graceful outline. Good artistic values can be obtained with little difficulty with this as a motive. The body swells and tapers. Within a little distance the body can bend upon itself, and the curves produced by such bending are almost capable of being plotted by formulas, so simple are the factors which govern them. But the snake's body does not ordinarily fall into the simple and uniform wave forms with which it is commonly associated. Instead, it makes a succession of quick curves which merge into tangents or into long, slow curves.

The characteristic lines of the snake's body in repose or motion seem, upon careful study, to be as nearly angular as the physical limitations allow. A snake will stretch out along a wall and fold itself as closely as it can into a corner.

In Maya design the serpentine alternation of quick and slow curves strikes the dominant note. Fig. 25 presents a collection of parts of designs chosen from many different situations. In all of these examples the angular shaping of the curves is manifest. The angular drawing of the serpent itself appears in *a* to *d*, while the remaining figures show the use of comparable lines in a variety of other instances. The striking development of vertical or horizontal lines of interest should also be noted. This is not due to the suggestion of the serpent, but rather to the universal principle of harmony of directions. The skill with

which tapering masses are handled must elicit admiration. Here is a relation of lines directly opposed to parallelism, yet the sense of the parallel is preserved, while the grace and variety of converging lines only lend a subtle interest.

The prevalence of tapering, flamelike masses is characteristic of Maya art (Fig. 24, *e, f, h, l*, etc.). These forms were doubtless suggested by the representations of the snake's body. Two other prominent characters may have

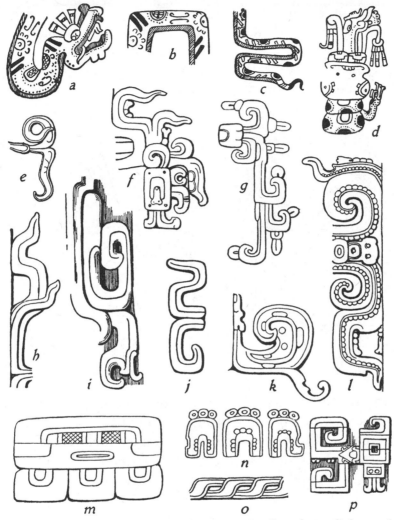

FIG. 25. — Details showing influence of serpentine forms: *a–d*, Tro-Cortesianus Codex; *e, f,* and *h,* Palenque; *g,* Chichen Itza; *i, k, m,* and *n,* Quirigua; *j,* Copan; *l* and *o,* Tikal; *p,* Labna.

had a similar origin. One of these is the use of the double outline and other applications of parallel lines. Parallelism of lines introduces into any design an emphasis of contours and a harmony of measures. The origin of the double outline may be traced to the common method of drawing the belly of the snake so as to distinguish the area of large ventral scale plates from the rest of the body. This demarcation may be seen in the first four examples given in Fig. 25. In *m* is given one of the important factors of the great glyph that introduces the so-called Initial Series dates. The three loops at the bottom and the single loop at the top may represent in a vague and symbolical manner a portion of a serpent's body. But if the device of the double outline comes from this natural source its application was greatly extended, as may be seen from its occurrence

in the remaining examples in the collection above noted. The suggestion may also have come from drawing the midribs of feathers, but this seems less likely.

The common use of rows or series of small circles is another pleasing feature of many drawings. These circles are probably derived by suggestion from the small scales on the body of the snake. Altar O at Copan (Fig. 26) shows these body scales, but it must be admitted that they seldom appear on important works of art. A fine application of this decorative element is seen in Fig. 25, *l*, a detail from one of the wooden lintels of Tikal. Groups of circles frequently decorate the eyes of serpents and of gods. They are also used as symbols of water and fruitfulness.

In the imaginative modification of any given natural figure, for purposes of decorative art, there are a number of rather definite processes. Each of these

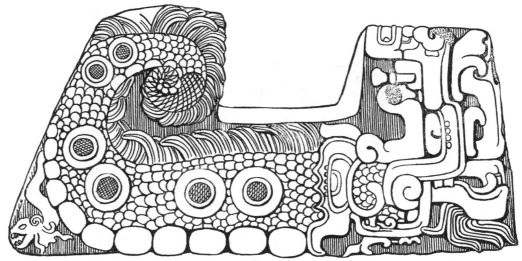

Fig. 26. — Plumed serpent with elaborated head: Altar O, Copan.

is amenable to the fundamental principles of design, such as balance, rhythm and harmony, as these terms have been elucidated by Dr. Ross.[1] Each process may show, moreover, the phases of conscious and unconscious manipulation of the subject matter. Lastly, these processes of intensive development of a design motive, like the already described methods of the idealization of the serpent, work both singly and in combination. It is possible to detect much of the counterplay.

The processes are:

1. Simplification. 2. Elaboration. 3. Elimination. 4. Substitution.

Careful analysis of one group of designs after another, during which special attention is paid to the changes in homologous parts, makes pretty clear the manner in which the imagination works. In the first place, imagination does not create, it merely reshapes and recombines, taking suggestions and material from any thing lying within the field of experience. It may be likened to a kaleidoscope. Instead of bits of vari-colored glass are shaken up elements disassociated from originally composite ideas. Through some agent of order these are rearranged symmetrically, so that the result satisfies the logical sense. In any developed decorative art the student may find a graphic record of the progress of imagination.

The term "conventionalized art" comprises a number of diverse mani-

[1] 1907; see also Batchelder, 1910.

festations. To be exact, all art is conventionalized of necessity. In any representation there is always a compromise with truth and a mental allowance for inadequacy. But when any idea other than that of giving the most realistic representation possible is uppermost in the mind of the artist, the result may without any quibble be termed conventionalized. As a rule the decorative idea is more important than the realistic, and is achieved by limiting the field of the design and by modifying the lines of the model in a purely formal manner.

Simplification. In an early paper that has not received the attention it merits, Dr. Harrison Allen[1] discusses the relations between natural forms and art forms. He finds that the tendencies of conventional art are:

FIG. 27. — Reptilian radicles after Dr. Harrison Allen.

 1st, to repeat the normal lines of the model;
 2nd, to diminish the normal lines of the model;
 3rd, to modify according to a symbol;
 4th, to modify according to mythic or religious ideas.

FIG. 28. — Drawing of rattlesnake's head, showing the parts.

The primitive designs given in paintings, etc., he calls "primals"; the final forms which result from a series of variants he calls "ultimates"; and the more or less ideographic figures that preserve the essential lines of a natural series of variants he calls "radicals." In the art of Mexico and Central America he finds a very common radical which he terms the "crotalian curve," because it preserves the supposedly essential lines of the profile of the rattlesnake. Examples of this crotalian curve are given in Fig. 27. It may be pointed out that this radical is more characteristic of Nahua than of Maya art. Maya art was vital, original and constructive, while Nahua art was largely devoted to imitations and to derived forms. The phrase, "normal lines of the model," must be allowed a very liberal interpretation. In almost all kinds of realistic art among people of low culture the normal lines of any natural form are at best roughly approached.

In Fig. 28 is given a sketch of a rattlesnake head. When the mouth is wide open, the forked tongue does not naturally protrude as it does in this drawing. Note particularly the dentition. At the top are two backward curving fangs, while at the bottom are a number of small raking teeth.

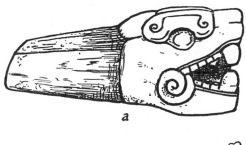

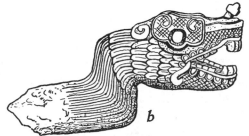

FIG. 29. — Serpent heads with tenons: Chichen Itza.

Note also that immediately above the eye is a scale plate somewhat more prominent than the other scales that cover the face.

The nearest approach to this natural head in sculptural, decorative art occurs at Chichen Itza in carvings in the full round (Fig. 29, a and b). These ex-

[1] 1881, pp. 289 et seq.

amples show dentition quite different from the natural form. At the front of the mouth are several teeth resembling incisors, and behind these are a number of molar teeth. The tongue hangs out at the back of the mouth. In *b* the prominent scales around the mouth are clearly indicated, but the scales on the rear part of the head resemble feathers and in fact upon the neck are unmistakably so represented. The supraorbital scale plate is greatly enlarged, and a nose plug is added.

In Fig. 30 is shown a typical serpent head in profile as developed by the Maya for decorative purposes, with the parts lettered and named. The nose and ear ornaments have been taken over from the human figure and perhaps the beard as well. The two kinds of teeth shown are more fanciful in shape than those just examined. One kind is pretty clearly molar, and the other kind may be called incisor for convenience. The spiral-shaped object at the back of the mouth (*n*) may have originally represented the articulation of the jaw, although it is commonly referred to as a curled fang and is identified by Gordon [1] with the sheath of the tongue. The tongue itself is shown in front of this object. Of the added features one of the most important is the small object (*e*), extending along the top of the nose, that is labeled the "nose scroll" for want of a better name. Through it is thrust the nose plug, which usually represents a bone. To the circular ear plug (*l*) is attached a flowing ornament divided into three parts. This head exhibits all the parts that characteristically belong to the developed serpent head in Maya decorative art. As can be seen, it is very different from the head of a natural snake. All the scales on the head are omitted in the conventional form except the large scale above the eyes (*k*), and this is greatly enlarged. The nose is elongated and the upper jaw made considerably longer than the lower one. To sum up, the head lacks prominent natural features, the remaining natural features are greatly modified and a number of unnatural features are added.

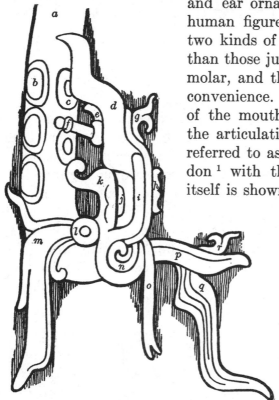

FIG. 30. — Typical conventionalized serpent head: *a*, body; *b*, belly markings; *c*, back markings; *d*, nose; *e*, nose scroll; *f*, nose plug; *g*, incisor tooth; *h*, molar tooth; *i*, jaw; *j*, eye; *k*, supraorbital plate; *l*, ear plug; *m*, ear ornaments; *n*, curled fang; *o*, tongue; *p*, lower jaw; *q*, beard; *r*, incisor tooth.

The delineation of this head shows, however, artistic skill of no mean merit. The lines of interest are either vertical or horizontal, although the masses themselves are of varied contours. The subtle and skillful use of sinuous shapes is deserving of note.

This head is an excellent example of simplification. All the details are represented economically in few lines, and there is a splendid harmony of parts that defies analysis. Of course the simplification could be carried further by

[1] 1905, p. 138.

omitting the extraneous features. Indeed, a sort of factoring out could be carried on till the irreducible characteristic was reached. According to Dr. Allen's nomenclature, such an irreducible characteristic would be a "radical."

Elaboration. Of less real worth in the development of art but of more common occurrence is the process of elaboration. This process amplifies rather than reduces and by means of adventitious ornament renders the original form more complex. The unnatural features that appear on the typical serpent head just described are evidences of elaboration of a sort. But the most interesting elaboration does not add new features so much as it makes the old ones more complex. In Fig. 26 is reproduced a plumed serpent from Copan. The head

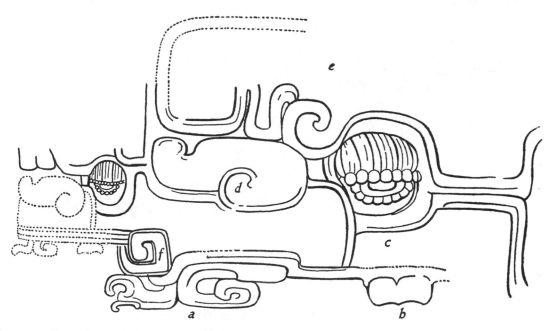

FIG. 31. — Part of underlying design, Altar P, Quirigua: *a*, incisor teeth; *b*, molar tooth; *c*, eye; *d*, nose scroll; *e*, supraorbital plate; *f*, fang of supplementary head.

shows most of the features already noted. The three divisions of the ear ornament hang down over the neck, but the ear plug itself is not visible. The nose turns up and then back. The nose plug is seen directly over the supraorbital plate. The short lower jaw with the beard and the long upper jaw with the large teeth are easily made out. The flame-like object that issues from the mouth may represent breath. So far little evidence of elaboration has been mentioned. This, however, appears in the treatment of the upturned nose and the tongue. The end of the nose, that turns back horizontally, is modified into a grotesque face, best seen by turning the picture on end with the head down. The tongue, which hangs out at the back of the mouth just behind the two molar teeth, is itself the upper jaw of a serpent possessing nose plug, supraorbital plate, and teeth of two kinds.

Extreme types of the elaboration of the serpent head are found on Altar P of Quirigua (Plate 2). This altar, as will be shown later, represents a curious and grotesque conception known as the Two-headed Dragon. The ornamentation that overlies the body of this monster is several layers deep. In particular, on each side of the body, are two pendent serpent heads lacking the

lower jaws. Each serpent head is elaborated to the last degree, but the manner of enrichment is different in each case.

Fig. 31 offers in a simplified and partial drawing the first of these heads. In *a* and *b* we see the incisor and molar teeth, respectively, in *c* the eye decorated with feather-like markings, in *d* the nose scroll, and in *e* the remains of the supraorbital plate which projects farther forward than usual. The upturned nose of this serpent head, part of which appears at the left of the drawing, really lies along the ground on the great sculptured boulder. The details are so modified by the irregularities of the stone and so concealed by other overlying figures that they can be made out only with the greatest difficulty. This nose itself consists of two small superimposed faces of which the eyes are

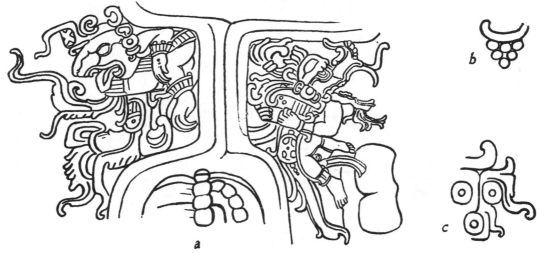

FIG. 32. — Overlying ornament, Altar P, Quirigua: *a*, ornament above the eye; *b* and *c*, water symbols.

the only obvious features. The lower one is partly reconstructed in the drawing. The detail marked *f* is the curled fang at the back of the mouth of this subordinate face.

But the elaboration of the great serpent head does not stop with this. The larger spaces are overlaid with grotesques, as may be seen from Fig. 32, *a*, which gives the two designs decorating the back part of the eye. Another grotesque occupies the nose scroll and the space above the incisor teeth. The smaller spaces are filled up with motives that seem to be modifications, for the most part, of a very common water symbol (Fig. 32, *b* and *c*). This incrustation of ornament would seem to have no relationship with the serpent heads beneath, or with the Two-headed Dragon which the serpent heads themselves overlie, except to embellish.

A second serpent head from Altar P occupies a similar and adjacent position to the one just examined, which, in fact, it partly conceals. It is given in Fig. 33, *a*. The original parts of the serpent are here much more difficult to distinguish, for the ornamental details are more closely incorporated. A human face, bearing a peculiar forehead ornament and a prominent nose plug, is readily seen in front of the serpent's upper jaw. This human face and the serpent jaws that partially enclose it are upside down on the monument, but are set right side up in the drawing. Curling locks of hair are seen at the side of the face. Perhaps the forehead ornament is intended for a tuft of knotted hair.

The eye of the serpent is indicated by the sunken space in the center of the design just back of the human forehead. The teeth project from the angles of the jaw in the form of double scrolls. The upturned nose ends in a grotesque and highly modified face, redrawn in *b*. As a whole, the face is comparable to the one already noted on Altar O at Copan (Fig. 26). It possesses a forehead ornament analogous to that of the human face beneath (Fig. 33, *a*). The back or top of what was originally the supraorbital plate consists of a face greatly modified, the

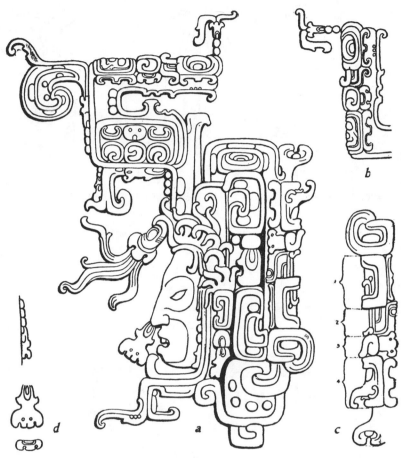

FIG. 33. — Elaborated serpent head, Altar P, Quirigua: *a*, entire head; *b*, grotesque face terminating the nose; *c*, grotesque bead at the back; *d*, details representing bones.

parts of which are indicated in *c*. The mouth of this face incloses a second one. Note also on various parts of the representation the use of the motive given in *d*, frequently in partial form and in connection with circles. This motive apparently represents the end of a bone. As we shall see in another section, the rather grewsome use of bones is highly developed in the art of the Maya.

In connection with these two elaborated heads on the side of Altar P it must be emphasized that they themselves merely serve to elaborate the body of the so-called Two-headed Dragon.

Elimination. Elimination of one feature after another of a natural motive till only one or two survive is a common phenomena the world over in decorative art. In Maya art the process is frequently observed in the case of the serpent. Very often the entire lower jaw is omitted, as in the examples of elaborated heads we have just examined. In fact, the upper part of the serpent head

adapts itself to many situations, usually with little change in the relative positions of the different features but with much change in their configuration. More complete elimination, leading to the survival of but one or two details, is rather rare in the best period. It is more frequent in ceramic decoration and in the sculptures of Chichen Itza and other late cities in northern Yucatan. Examples of incomplete and highly modified heads running the gamut of change will now be given. In Fig. 34 are shown serpent heads that lack the lower jaw

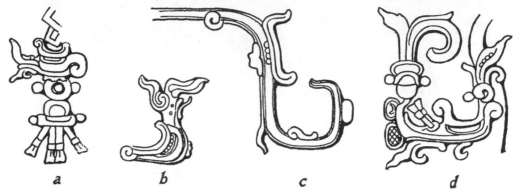

a b c d

FIG. 34. — Modified serpent heads: *a* and *d*, Copan; *b* and *c*, Palenque.

and occasionally other features such as the ear plug with its attachments. In some instances there is a compensation for the loss by the application of foreign bodies. These heads are parts of elaborate figures, but are here given as individual examples.

Very often the elongated nose of the incomplete serpent head is bent backward to form a fret. Examples are furnished in Fig. 35. The significance of

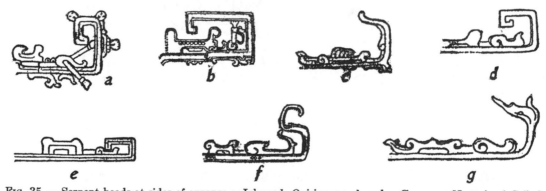

FIG. 35. — Serpent heads at sides of aprons: *a*, Ixkun; *b*, Quirigua; *c*, *d*, and *g*, Copan; *e*, Naranjo; *f*, Seibal.

this and other geometric modifications will be discussed at length in another place. Heads of this type occur particularly as enrichment of a widespread form of apron that is seen on many of the heroic sculptures. This apron (Fig. 15) has characteristically a front-view face in the middle and a profile serpent head at each side. In Fig. 35, *a* and *b*, the serpent heads retain the eye with its supraorbital plate, the nose scroll pierced by a single or double nose plug, and both the molar and incisor types of teeth. In *c* of the same series the nose plug is eliminated and in *d* to *g* both the teeth and the nose plug are wanting. Formal heads of this character also occur in other situations. Sometimes ear and nose plugs of human beings are modified into serpent heads with the nose

turned back in a fret.[1] The detail also is found in some of the elaborate head-dresses represented on stelae and lintels.[2]

In marked contrast to the angular development just described there are many incomplete serpent heads cast into flamboyant lines. Examples of these

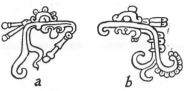

Fig. 36. — Serpent heads conventionalized in flamboyant manner: Chichen Itza.

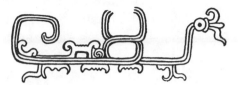

Fig. 37. — Nose plug representing a conventionalized serpent head: Piedras Negras.

are given in Fig. 36. In *a* the eye is seen at the top, and in front of this is the double nose plug. The nose turns downward in a flamelike scroll. The inner division of the nose represents the incisor tooth, while the molar tooth is shown below and to the right of the eye. The ear plug survives in the object at the extreme right. A somewhat similar head looking in the opposite direction is given in *b*.

The reptilian motive is very intrusive and is much used for the enrichment of all manner of objects. In fact, most of the examples of incomplete serpent heads given above are themselves details that serve to complicate other conceptions. Fig. 37 illustrates the fanciful development of the nose plug of an elaborate bird, while Fig. 34, *c*, is one side of a comparable nose plug upon a similar bird head. Fig. 38 probably represents some sort of plant growth. Each branch, however, is modified by the addition of an incomplete serpent head and by other foreign details. The so-called crosses on the tablets of Palenque probably repre-

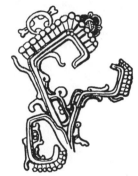

Fig. 38. — Vegetal form modified by serpent features: Palenque.

sent trees. The branches are greatly modified by reptilian details. Fig. 39 reproduces a section of a vinelike decoration at Chichen Itza that is limited to a narrow band. Flowers, fruits and fish are clearly represented. Serpent fea-

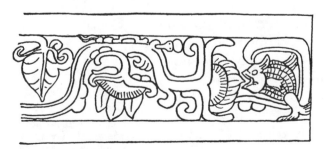

Fig. 39. — Vegetal form with the stem modified by serpent features: Chichen Itza.

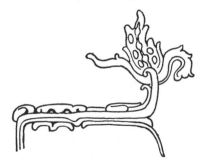

Fig. 40. — Plant form with stem modified into a serpent head: Quirigua.

tures are attached to the stems in some places. In this example the eye, the nose plug and the teeth are readily seen on the upper bend of the vine. Another example of the same sort of modification in a floral motive by adding certain serpentine features is seen in Fig. 40, taken from the Altar P at Quirigua.

[1] For example, Maler, 1903, pl. 72, fig. 3.　　　　[2] Maler, 1903, pls. 46 and 47.

The stelae of Copan and Quirigua are notable examples of reptilian enrich-
ment. Fig. 41 reproduces an ear plug with which are connected no less than
four more or less complete serpent heads. The one which shows the greatest
elimination is that which issues from the side of the ear plug. Only the tip of
the nose survives in this instance. Examples might be multi-
plied, but enough have been given to make clear the various
processes and stages of change.

Substitution. The process of substitution likewise plays a
great part in all highly developed art, whether barbaric or
civilized. The substitution of new and striking details for old
and commonplace ones — even at the cost
of the first meaning of the design — is one
of the simplest and most natural ways by
which the imagination can reconstruct and
revivify worn-out subjects. The creative
effort is much less in making a parody than
an original production. For the parody
preserves, in greater or lesser degree, the
fundamental composition upon which much
of the esthetic interest of the original de-

FIG. 41. — Detail of
an ear plug with
attached serpent
heads: Copan.

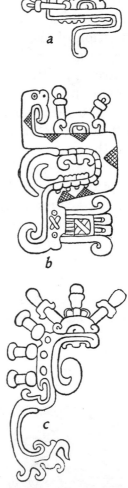

FIG. 42. — Serpent heads
modified largely by
multiplication of nose
plugs: Chichen Itza.

pends. Especially in decorative art, details of a composi-
tion realistic or geometric may be progressively replaced by
other quite different details until in the end only a trace
of the original setting remains. The true history of the
design is made clear only through a study of the homol-
ogous parts of a series of stages.

Occasionally, as in the series of three heads given in
Fig. 42, there is a sort of degenerate modification due to
the redoubling or displacing of some feature. In *a* we see
a rather simple serpent head with the nose plug projecting
forward from the front of the eye. In *b* this object is
doubled and projects from the top of the eye, while in *c* it
is repeated many times upon the eye and in front of it.

Elaboration and substitution are closely akin, but, in-
deed, all the processes that have been described work hand
in hand. Each has its special field where it may be studied
to best advantage. Substitution may be studied best in
the development of the Mask Panel, which will be taken
up under Architecture. Since, in principle, this process is
simpler than any of the others, the illustration of it will be
postponed till the consideration of the latter subject.

Lest a false idea concerning the relation of the realistic
motive to the geometric should follow from the examples of development and
modifications that have just been given, it seems best to take up at this time
a brief discussion of geometric art in its relation to the serpent and other life
forms.

The Serpent and Geometric Art. It has for some years been the vogue
among students of primitive art to derive all geometrical elements in decorative

art from realistic forms through increasing conventionalization. Even in so elaborate an art as that of the Maya there have been attempts to derive the fret, the spiral, the guilloche, etc., from the serpent.[1] The usual method adopted to show such derivation is to arrange the designs in a "series" with a recognizable life form at one end and a pure geometric form at the other, and between these extremes to place a number of highly modified figures which show increasing similarity with one or other of the extremes. Such a method of study is highly useful and suggestive. But there are three possible lines of explanation. The change might be considered to move from the realistic to the geometric, from the geometric to the realistic, or from both the extremes inward. In order to prove either of the first two processes it is necessary to establish two things: first, chronological sequence, for the derived form must come after its original in point of time; second, a reasonable explanation why the

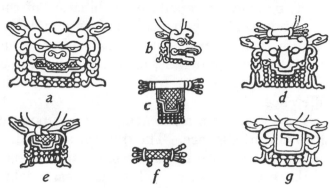

FIG. 43. — Breast ornaments: Copan.

change occurred. As regards the first point, it is often upon the same object that all the stages of change are represented, as, for instance, in the case in the carved paddles of the Hervey Islands, the study of which by Stolpe really led to the derivative method of explanation. Such a series in Maya art might be taken from the breastplates of the small human figures on the step of Temple 11 at Copan (Fig. 43), to prove beyond doubt that the tau sign is derived

FIG. 44. — Serpent head modified by a fret turning down: Copan, back stairway of Temple 11.

from the mouth of the jaguar. The successive elimination of one feature after another till only the opening of the mouth remains is so obvious that it needs no comment. All the stages of change here given are shown on this one monument, with the exception of c and f that illustrate another departure and are taken from Altar Q, showing the same style of sculpture. Few students would insist that any historical significance could be attached to the phenomenon under such circumstances. But chronological sequence from lost sculptures might be assumed and the possibility of survivals invoked. At least it is reasonable to ask why the change took place. What natural quality is present in a jaguar's face that would lead to the survival of the mouth in the form of a tau sign? And why should the cross hatching within this mouth (a) survive on a bar-shaped breast ornament (f) and not on the tau sign (g)? We have seen that the nose of the serpent in Maya design is frequently elongated and turned back to form a fret. What is there about a serpent's nose that would ever suggest a fret? And if a reason is forthcoming would it also explain how the process might proceed in the opposite direction, as shown in Fig. 44, or in no particular direction at all, as in the majority of cases? Why were two serpent bodies placed head to tail in the first place and so twisted that they could conveniently develop into the

[1] In particular, Gordon, 1905.

guilloche? There remains for consideration the third explanation, namely, that of the working inward from the two extremes. This process might be termed involution.

It is almost self-evident that all kinds of art are of a twofold nature and depend for their effect upon two sorts of appeal. The first of these is physiological and the second psychological — the one absolute, the other varying from man to man or nation to nation. Pleasure is produced by an invariable physical reaction such as may come from two wires tuned, we will say, an octave apart, or from more subtle combination of sounds which awaken the imagination and recall experience. Colors and lines and masses may please simply because their relationship to each other is such that they react harmoniously upon the sensory organs, or in a larger way because they epitomize experiences more or less common to all persons, but still with an element of individual difference.

Pure geometric art reacts directly upon our senses and does not appeal at all to our intelligence. The fret, the spiral, the guilloche, and many other simple forms, really make up an absolute art that is universal in its successful appeal to the esthetic sense. This universal quality apparently depends upon the mathematical relationships which exist between the parts of each figure. The fret, like the diatonic scale, contains a definite series of measures.

Now natural objects, animals, plants, crystals, human beings or landscapes, present in their forms a resultant of many complex forces each operating infallibly and invariably. While the erosive refinement is in many cases incomplete or imperfect, yet it is true that nature approximates true and orderly types. The utilitarian and the esthetic processes go back to the very origins of life and perhaps even before that to the economics of chemical combination. According to the stern law of nature only the fittest forms survive, but the test of fitness is at once mechanical and social. Ultimate utility is expressed in good lines and in forms that appeal to the sense of the beautiful. It will be granted that the natural lines of all objects of natural origin contain many elements of beauty. But these natural lines are so subtle that the rude hand of man is not at first able to imitate them, even when his eye perceives them clearly. Man can, however, express the fundamental harmony of parts in a simpler system. He can do this by throwing his crude drawings of natural forms into a geometric mould. By doing this he gives his realistic art, already quick with life as he perceives it, a certain absolute power to react upon other men who may not know the thing he saw. This fusion of the realistic and geometric is called conventionalized art. It may occur at any stage of cultural development. But the higher the stage the more successfully is the artist able to keep his harmonic qualities and at the same time approach the ultimate natural form. For illustration let us say the ultimate form is a circle. Rather than make an imperfect circle the artist draws a square, which he is able to make faultless. Then, by a process of lopping off corners in a perfectly orderly way, he is finally able to approximate the unattainable circle. In the highest form of realistic art, that subtle relation of parts which leads to the sense of balance, or rest, and which we call composition, is indeed due to the primary training of man in the school of geometric expression.

At a much lower stage of culture than that which obtained among the Maya,

textile and ceramic decoration lead to the working out of simple geometric forms through the necessary limitations of method and material. Among the Maya the guilloche, occurring on pottery decoration of the Uloa Valley, antedates by centuries the same motive of decoration on buildings in northern Yucatan. Similarly the fret appears as a textile design on the dress of figures carved upon stelae and lintels of Piedras Negras and Yaxchilan long before it was developed as a pattern for façade embellishment at Uxmal and Chichen Itza. The same early use of the geometric figures in minor art that were later transferred to architecture has been noted in Egypt and in Greece. But while it may be possible to demonstrate a later development of the same motives in architecture than in minor art, yet it must be noted that these forms existed throughout the entire period and constituted a national treasury of ideas from which anyone could take what he chose and apply it where he desired. These and other geometric forms were to the Maya artist merely modes of order into which he could throw his serpent forms. By this fusion the geometric forms were rendered more interesting and the serpent forms more orderly. The general theory of involution given above accounts for realistic, geometric and conventionalized art existing side by side; the different degrees of modification according to this method of change do not require a time sequence.

Of course time brings many and important changes. There is often a marked tendency for rich conventionalisms to degenerate into meager geometric moulds. But this is simply an evidence of dissolution when the unstable compound of conventional art breaks down into its original components. The determination of the real sequence of Maya art will be attempted in another part of this work. It will then be shown that there were two or more periods of decadence when the fabric of Maya art stood in a fair way to be destroyed.

Typical geometric patterns will be given under the sections on architecture, textiles and ceramics.

The Serpent in some of its Religious Aspects. There are many classes of objects and figures of religious import that are intimately connected with the serpent. Several plainly defined series will be considered in order. Then intermediate forms will be presented to show how all these classes, which are at first sight distinct, really merge and blend into one another in a most surprising manner. The objects and figures of the monuments will be correlated with those of the codices when such a correlation is possible. Finally the representations of the principal gods will be taken up in some detail.

The Ceremonial Bar. The Ceremonial Bar is the name given to a peculiar object of unknown use that is commonly held in the arms of the priest-like figures represented in the sculptures. It occurs at a number of cities in the southern part of the Maya area, usually upon stelae, but in two or three known instances upon minor works of art. It is particularly important at Copan, where its development can be most clearly traced. This object does not occur in recognizable form in any of the manuscripts.

In its first phase the Ceremonial Bar is composed of a double-headed serpent with a flexible, drooping body. In the wide-open jaws of each serpent head may be seen a human or grotesque face. The most primitive example is found on the Leiden Plate. A portion of the incised drawing on this jadeite slab

is reproduced in Fig. 45, showing the double-headed serpent with the grotesque heads and the arms that support it. Other examples are found on the following stelae at Copan: E, I, P, 1, 2, 3, 5, 6 and 7, all of which, as will be demonstrated in another section, belong to the earlier period of that city. The Ceremonial Bar of Stela P which is reproduced in Fig. 46, *a*, shows the type in its greatest richness of detail. The Ceremonial Bar of Stela I is interesting because it represents a dead snake. The pendent body consists only of vertebrae and on the jaws are the characteristic markings that indicate death.

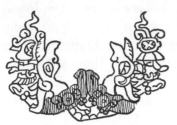

FIG. 45. — The Ceremonial Bar: Leiden Plate.

In the second phase (Fig. 46, *b*) the central portion of the Ceremonial Bar is no longer pendent, but is transformed into a straight panel usually decorated with astronomical signs. The serpent jaws are often much enlarged. Ceremonial Bars of this general type have a notable distribution. They occur upon all the later stelae of Copan as well as upon stelae at Naranjo, Tikal, Yaxha, Quirigua, Yaxchilan, Ocosingo and uncertain sites on the highlands of Guatemala. They apparently do not occur at Piedras Negras and Palenque, or at any of the cities of northern Yucatan.

At Copan the Ceremonial Bar is always held in a horizontal position against the breast of a standing figure in front view. In other cities it is sometimes held diagonally, and the resulting asymmetry may have been a powerful factor in causing it to be greatly modified. Composite and variant forms of this object will be taken up presently and treated in some detail.

The Manikin Scepter. A second important ceremonial object, of strikingly different character, will next be considered. After its commonest phase this object has been called the Manikin Scepter, but this catch phrase does not apply equally well to all appearances. The Manikin

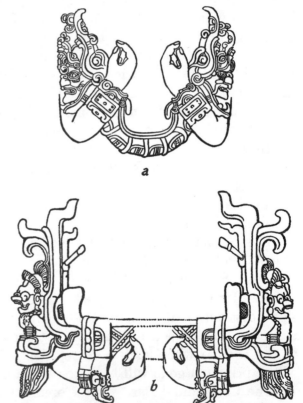

FIG. 46. — The Ceremonial Bar: Copan, *a*, Stela P; *b*, Stela N.

Scepter is a small grotesque figure that is usually, as the name implies, held out in one hand of the priest or ruler. A flexible appendage in the form of a serpent serves as a handle. Fig. 47 shows two examples of the Manikin Scepter, *a* from Yaxchilan and *b* from Quirigua. Representations of this general type have a wide distribution among the cities of the southern Maya area and even occur at Sayil [1] and Santa Rosa Xlabpak [2] in northern Yucatan.

[1] Maler, 1895, p. 278. [2] Maler, 1902, p. 223.

The face of the manikin varies considerably, but is characterized by a long turned-up nose and a wide-open mouth which has in its upper jaw a prominent flame-shaped tooth. The lower jaw is usually much shorter than the upper one. These grotesque features are decidedly reptilian according to the Maya standard for such things. Indeed, the upper part of the face will bear comparison part for part with the typical serpent head. Often a long celt-shaped object projects from the forehead. The body of the small figure has, as a rule, no covering except a belt with apron attached and such minor ornaments as arm bands and necklaces. There are usually oval markings on the legs, back and arms that may be intended to represent the scales of snakes or other reptiles. The provenance of the appendage is an interesting problem and several explanations may be given. Its purpose was doubtless to indicate still more clearly the ser-

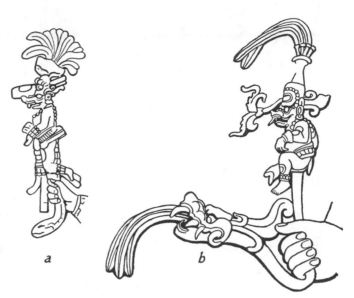

FIG. 47. — The Manikin Scepter: a, Yaxchilan; b, Quirigua.

pentine nature of the figure, but there is great uncertainty whether it is a modified leg or phallus or even the umbilical cord. Only one leg is shown on the examples that are clear enough for detailed study, and it seems probable that the pendent serpent takes the place of the more distant leg. The general lack of sex significance in Maya art is an argument against phallic origin. It may, of course, represent the umbilical cord, but it does not begin at the right point.

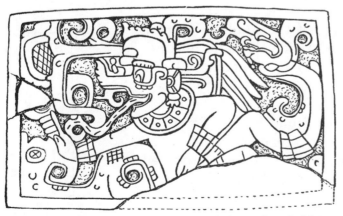

FIG. 48. — Manikin Scepter on potsherd, Santa Cruz Quiché.

In Fig. 48 is reproduced a potsherd from the highlands of Guatemala, that has an incised representation of the Manikin Scepter so modified as to fill an oblong space. The serpent appendage is seen at the right. Unfortunately the design is not complete, but the decorative band on the base of the appendage resembles a leg or arm band and may indicate that the serpent appendage is really a modified leg.

The same manikin type of figure appears in the guise of a newly born child at Palenque. In the Temple of the Inscriptions are four panels with stucco relief which show a human being holding a child in one arm, while the other arm is stretched out to support the ophidian appendage (see Fig. 49, a). The

faces on all these representations are unfortunately destroyed. Maudslay's drawings give both feet of the child, but a study of the photographs shows

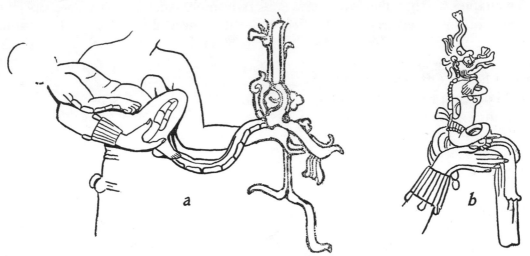

FIG. 49. — Manikin Scepter as child: Palenque.

that the restoration of the more distant foot is doubtful, although the knee is clear enough.

In two or three sculptures at Yaxchilan[1] the manikin figure with the flexible appendage is seated upon an inverted basket-like object on the top of a pole.

Manikin figures without the flexible appendage are sculptured upon the tablets of the Temple of the Cross, the Foliated Cross and the Sun at Palenque.[2] They are represented either in a sitting or reclining attitude upon a folded cloth supported by the outstretched hands of a priest. The best preserved example is given in Fig. 49, b.

The final stage of the Manikin Scepter is marked by the survival of the characteristic head upon some sort of staff. Proof of the actual connection of this type with the more complete ones just described appears upon a stela found by Dr. Tozzer at a ruin on the upper Tzendales River. The object carved upon this stela is reproduced in Fig. 50. The head is clearly of the same character as heretofore. It is set upon a short staff which is held out opposite the face of the principal personage in the manner already noted. The body, however, is entirely eliminated. The staff itself is rigid for the greater part of its length, but the lower end bends outward and terminates in a serpent head. This staff, then, is clearly a survival of the ventral appendage. Examples of the head upon

FIG. 50.—The Manikin Scepter with body reduced to a staff: Tzendales.

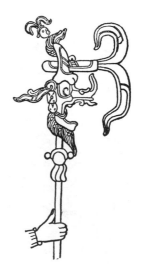

FIG. 51. — The Manikin head on a staff: Palenque.

[1] Maler, 1903, pls. 50 and 67. [2] Maudslay, 1889–1902, IV, pls. 76, 81, and 88.

a simple staff occur at Tikal,[1] Piedras Negras[2] and Palenque. Fig. 51 shows one from the last-named city.

Two-headed Dragon. The monstrous creature to which Maudslay has given the name "Two-headed Dragon" will next be considered. This grotesque ani-

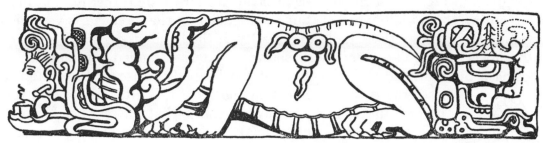

FIG. 52. — Two-headed Dragon: Copan.

mal is seen in its simplest form on the side of a small rectangular altar at Copan (Fig. 52). The principal characters are as follows. There are two heads, one of which distinctly belongs to the front and the other to the rear, as may be seen from the direction in which the feet are pointed. The markings on the legs and belly are reptilian, and there is a prominent water symbol on the side. The feet in this example are clawlike, but in many other cases they resemble the cloven hoofs of deer or peccary. The front head is hard to characterize, but as a rule the face or snout is long and shaped somewhat like that of a crocodile. Often the eye is feathered and decorated with a diagonal cross. In the specimen before us a human head is seen in the open jaws, but this feature is out of

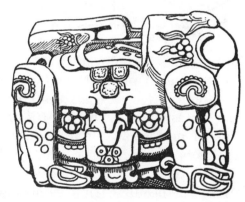

FIG. 53. — Middle part of Altar M: Copan.

FIG. 54. — Trifoil scroll on joints of Two-headed Dragon.

type. The rear head is much more definitely marked. It is a rather grotesque face with an upturned nose. The head-dress is a triple symbol with a leaflike object in the center, a shell in top view or profile on one side and on the other an oval object marked with a diagonal cross. Upon the forehead is usually the kin or sun sign that resembles the common ring and cross symbol. The lower jaw is represented as a bleached bone, and sometimes the nose has a cavity that likewise indicates death.

A more elaborate treatment of this motive is seen in a number of altars at Copan and Quirigua. The central portion of the Altar of Stela M is presented in Fig. 53. In this instance the body of the monster is carved on one huge block of stone, but the front and rear heads are each carved on a smaller block. The feet are all pointed the same way and are of the cloven type. The joints of the legs, on this example and many others, are marked with a peculiar scroll which generally assumes the trifoil form given in Fig. 54. A grotesque face bearing water symbols occupies each side between the front and hind legs, and another similar

[1] Maudslay, 1889–1902, III, pl. 73. [2] Maler, 1901, pl. 15, fig. 2.

face adorns the top. Thus we have on this specimen five faces, three of which
may be accounted for by the process of elaboration that has already been ex-
plained. The separate blocks upon which the front and back faces of the mon-
ster are carved have unfortunately suffered mutilation. A sketch of the rear
face is given in Fig. 55. The three signs of the headdress are rather hard to make
out excepting the middle member, but the kin sign on the forehead is very clear
as well as the characteristic grotesque face with the bone grooves and crescents
on the lower jaw. The front block shows a widely extended reptilian mouth
enclosing a human head. In the effort of the Peabody Museum Expedition to

set the two supplementary blocks of this altar in position they
were unfortunately turned around so that the rear head appears
at the front of the animal in the photographic reproduction
and *vice versa.*[1]

Fig. 55. — Rear head
of Altar M: Copan.

The Altar of Stela N [2] is somewhat similar, but lacks the
upper face and is carved from a single block. Upon the top
of this altar is the trifoil scroll that characteristically occurs
on the joints. The Altar of Stela D is interesting on account
of the syncopation that it shows. This monument is a more
or less cubical block bearing two faces on diagonally opposite
corners. One of these faces represents the front head of the
Two-headed Dragon and the other the rear one. On each intermediate corner
is a vertical bone with two clawed feet attached. These two leg bones with
their double feet are all that remain of the body of the monster. The face
that corresponds to the front is ornamented with water symbols. The rear face
is given in Fig. 56. This clearly represents a
death's head, as may be seen by the nose and
by the circles, crescents and wavy lines on the
jaws. The peculiar triple symbol is absent, but
the eyes are modified into the shape of the kin
sign.

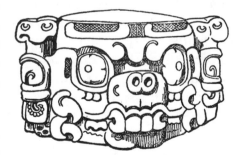

Altar B of Quirigua (Plate 1, figs. 3 and 4)
presents far greater elaboration than any speci-
men so far considered. A more or less irregular
boulder is completely covered with carvings in

Fig. 56. — Rear head of Altar D: Copan.

low relief and of very great detail. The front head has feathered eyes marked
with the diagonal cross. In the open jaws is a human head with an animal
headdress. The legs are doubled upon themselves frog fashion and have the
trifoil scroll at the joints. The feet are reptilian in appearance. The rear head
is crowded into an irregular space and is represented in profile in a horizontal
position looking downward. The sun symbol is carved upon the forehead, and
the middle element of the triple headdress is given in an elaborated style. The
entire top of the altar is covered with a complicated scroll-work face. The legs
conceal so much of the sides that there is no room for additional faces in these
positions. These legs, however, are themselves overlaid with large hieroglyphs
of the most elaborate type.

Altars O and P at Quirigua belong to the same series as the preceding sculp-
tures. The first of these is not in a very good state of preservation and the de-

[1] Gordon, 1902, *a*, pl. 17. [2] Maudslay, 1889–1902, I, pl. 83.

tails are difficult to make out. Altar P (Plate 2), sometimes called the "Great Turtle Altar," is perhaps the most complicated as well as the best preserved piece of sculpture in the entire Maya area. It is a natural boulder of great size and of hard stone, with carvings in fairly high but delicately modeled relief. Maudslay [1] regards this sculpture as a representation of a turtle, but a comparison of details shows that it belongs to the Two-headed Dragon group, although much modified by the several layers of ornament that conceal the animal form beneath. The front face shows a richly attired human figure in front view seated cross-legged upon the lower jaw of a great, open mouth. This human figure resembles very closely those carved on the stelae. In the right hand he holds the Manikin Scepter and in the left a shield. Concerning the great head that

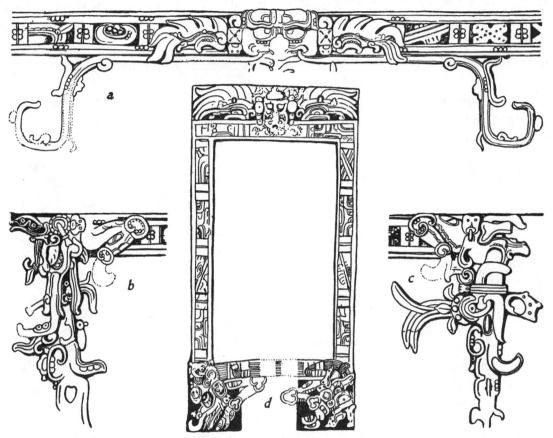

FIG. 57. — Two-headed Dragon with elongated body: *a–c*, Palenque; *d*, Piedras Negras.

contains this figure little can be said. The pointed teeth in both the lower and upper jaw are easily discernible. The eye is decorated with feathers and with the diagonal cross. The rear head bears evidences of death and is of a grotesque type, but the sun sign and the triple headdress are absent. The head on the top of the monument resembles that on Stela M at Copan, and is marked with many water symbols. The sides of this great altar are ornamented by conventionalized serpent heads that hang down from the sides of the face above and partly overlie each other. These heads have already been explained in some detail as examples of artistic elaboration (Figs. 31 to 33).

A return to less labored presentation of the Two-headed Dragon is now in order. At Copan this motive is used in the adornment of the inner doorway

[1] 1889–1902, II, p. 17.

of Temple 22. The partly destroyed design has been restored by Maudslay.[1] The pendent heads of the monster rest upon the hands of two seated human figures and the body stretches across the doorway. In the significant details of heads and legs this representation agrees with the type specimen that was described first. The feet are of the cloven type. The parts of the body adjacent to the heads show ventral scale plates, but the rest of it consists of a number of S-shaped devices in which are entangled small human figures with grotesque faces.

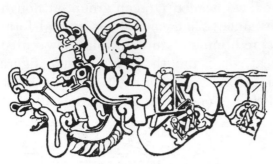

FIG. 58. — Manikin Scepter and portion of Ceremonial Bar: Tikal.

Fig. 57, *a–c*, gives an example of the Two-headed Dragon with the body still further modified. This design stretches over the doorway and along each side of a room at Palenque, and is executed in stucco. The heads are fairly true to type and the legs as well, but the body is conventionalized into a long band of astronomical symbols. Upon the center of this band and directly over the doorway is perched a bird with wings extended, the head very much out of proportion to the rest of the body. The rear head of the monster is turned upside down, perhaps to emphasize its inferior position. The phase of the Two-headed Dragon shown in this figure is well established. Several fine examples occur on the stelae of Piedras Negras, one of which is given in Fig. 57, *d*. Here the astronomical band forms a framework for a human being seated in a niche, and the two heads are brought close together at the bottom just in front of a sort of throne. Note the legs with cloven feet and with trifoil scrolls at the knees. Other forms related to the Two-headed Dragon will be given presently.

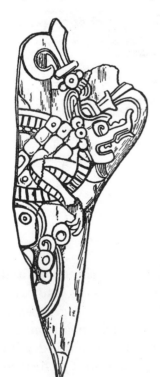

FIG. 60. — Fragment of carved bone: Copan.

FIG. 59.—Rear end of Ceremonial Bar: Siebal.

Composite Types and Miscellaneous Variations. The three objects or conceptions whose principal developments have just been described certainly appear distinct enough at first glance. But as a matter of fact each is more or less connected with the other, and all break down into variant types and gradually lose their individual characters. The intermediate stages will be presented first, in order, and then the decadent stages will be treated.

The connecting link between the Ceremonial Bar and the Manikin Scepter appears at Tikal upon Stelae 1 and 2. The human beings represented on these

monuments hold against their breasts unmistakable Ceremonial Bars of the second or straight-bodied phase. But sitting on the lower jaws of the serpent heads that terminate the bars is the complete Manikin Scepter, ventral appendage and all (Fig. 58). This little figure has quite evidently replaced the head or bust that usually appears in the serpent's mouth on other representations of the Ceremonial Bar. Many of these heads or busts are found upon examination to resemble the physiognomy of the manikin, but others

are of a very different type. The Manikin Scepter is a common substitute for the Ceremonial Bar. It probably is not derived from this object but from the more generalized bottom of the serpent. At Seibal the Ceremonial Bar seems to have been under the influence of an elongated Two-headed Dragon as may be seen on Stela

Fig. 61. — Ceremonial Bar held in tilted position, Yaxchilan.

9, and Stela 10 (Plate 2b, fig. 2). This object is held in the hands of the human being in a tilted position. The upper or forward end is developed into a dragon head with the kin sign. The head that usually appears in the jaws of the serpent has in this case been moved upward and attached to the serpent's body. This same feature appears on the Ceremonial Bar of Stela 10 at Seibal. The lower or back end of the Seibal specimen reproduced in Fig. 59, is modified into a likeness of the inverted rear head of the Two-headed Dragon. The details are expressed in a flamboyant style, but the triple headdress with the shell, the leaf-like object and the saltire are discernible as well as the typical grotesque face with the kin sign on the forehead and the bleached bone for a lower jaw.

The connection between the Manikin Scepter and the Two-headed Dragon is more difficult to demonstrate. Altar P at Quirigua represents, as we have seen, a very much elaborated Two-headed Dragon that has in the mouth of

Fig. 62. — Man holding two-headed serpent ceremonial bar, Yaxchilan.

the front head a human figure carrying a Manikin Scepter. But this circumstance may have no significance whatsoever concerning the connection between these two concepts inasmuch as there was no real attachment of the rear head of the monster to the head of the manikin. Aside from the symbols indicating special powers that are marked upon the rear head the physiognomy of the two figures is almost identical. It will be shown presently that these heads may be classed as different manifestations of a generalized god. In the meantime a more defi-

[1] Maler, 1908, *a*, pl. 10, fig. 2. [2] Maler, 1908, *b*, pl. 22, fig. 1.

nite idea of the affinity may be gathered from Fig. 60. This reproduces a carved fragment of bone, formerly painted red, that was picked up on the river front at Copan and is now in the Peabody Museum. The design shows a part of a reptilian monster with scaly legs and a head that is very similar to the manikin

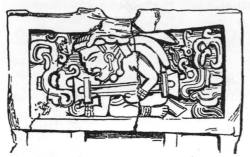

FIG. 63. — Ceremonial Bar on pottery box from Coban.

head. Although this head is most easily explained as the rear head of the Two-headed Dragon, still all the noted symbols are absent.

The Ceremonial Bar is seen in a number of variant and decadent forms. When held in a tilted rather than horizontal position, its symmetry begins to break down. Such a tilted bar is given in Fig. 61 from one of the Yaxchilan stelae. Note the dislocation of the lower head. A reversion of type to the original flexible serpent may be seen in Fig. 62, which likewise is found at Yaxchilan. The body of the bar is a flexible snake body that folds over the arm of the seated human figure. In the open jaws are likenesses to the head of the Manikin Scepter. Fig. 63 reproduces a piece of finely modeled pottery from the uplands of Guatemala upon which the Ceremonial Bar is represented in a simple manner with a knife blade instead of a head in the serpent jaws. The same feature appears on Stela 25 [1] at Naranjo. On the small stelae at Ocosingo (Plate 25, fig. 5) the Ceremonial Bar appears to end in serpent heads without any object in the mouth. On Stelae A and C at Quirigua [2]

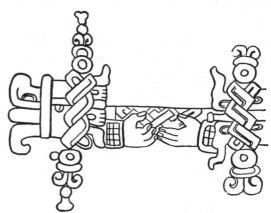

FIG. 64. — Degenerate form of the Ceremonial Bar: Copan.

the Ceremonial Bar ends in small incomplete heads. The lower jaws are lacking and a long pendent object seems to be attached in their stead. A very decadent form of the bar is seen on Stela 11 at Copan (Fig. 64).

Some objects appear as possible substitutes for the Ceremonial Bar, being held in much the same way. On Stelae 11 and 16 at Tikal appears the object shown in Fig. 65. In the center of an

FIG. 65. — Substitute for Ceremonial Bar: Tikal.

openwork staff is set a grotesque head of familiar type. On the south face of Stela F at Quirigua the human figure is represented with his hands held against his breast in the attitude taken when holding the Ceremonial Bar. However, no such object is in evidence. Below each hand is a serpent head that is suspended from a chain attached well up on the headdress. These two serpent heads may be survivals of the old order. It is interesting to note that an almost identical arrangement is seen at Palenque, as is made clear by the two

[1] Maler, 1908, b, pl. 40, fig. 1. [2] Maudslay, 1889–1902, II, pls. 4 and 16.

drawings given in Fig. 66, *a* and *b*. The decadent forms and the possible survivals above noted are of great value in determining chronological sequence.

There are a number of curious sculptures that are perhaps related to the Two-headed Dragon group. The most important are Altars G 1, G 2, G 3[1] and O[2] at Copan. These are vertical slabs of stone that are carved into reptilian forms. They make a series midway between the Two-headed Dragon and the ordinary representations of the Feathered Serpent.

The Feathered Serpent on one side of Altar O has already been figured and described (Fig. 26). The design on the opposite side shows two serpents with greatly enlarged heads and small intertwined bodies, ending in "Ahau" symbols. The heads are similar in detail to the head on the opposite side of the altar,

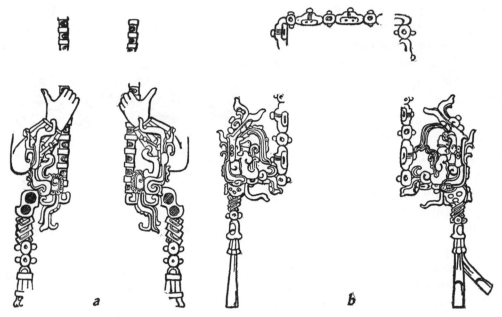

FIG. 66. — Serpent heads attached to chain-like objects: *a*, Quirigua; *b*, Palenque.

and the upturned noses end in the same grotesque face. But under each head is a leg with a clawed foot. In the space enclosed by the intertwined bodies is a bunch of feathers.

Altars G 2 and G 3 represent a double-headed serpent (the two heads being uniform in all particulars) with an arched body decorated by triangular and circular markings and by a mane of feathers. There are no legs on either of these reptilian forms. Altar G 1 is more elaborate. It also has two heads, one being smaller than the other, and a short body concealed beneath feather fringes and a double column of glyphs. The smaller head is similar to the heads of Altars G 2 and G 3 except that it has a Venus symbol marked on the eye and a grotesque bust in the mouth. Under this head is a leg, the character of which does not appear very clearly. The larger head also has a grotesque figure in the mouth. The lower jaw of this mouth consists of a bleached bone. The leg under the head also has bones marked by circles and wavy lines.

From this description it is apparent that the last head comes pretty close to the type of the Two-headed Dragon, and that the series as a whole simply

[1] Maudslay, 1889–1902, I, pls. 116–117. [2] Maudslay, 1889–1902, I, pls. 84–85.

emphasizes the lack of definite demarcation between the various conceptions in Maya art. Minor details on headdresses, etc., show two-headed reptile forms of a nondescript type, an example appearing in Fig. 67. Other phases of two-headed animals, now approaching the type of the Ceremonial Bar and now the Two-headed Dragon, will receive still further consideration in connection with material in the codices and the representations of certain gods.

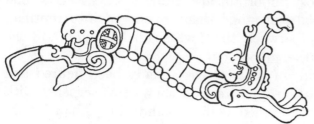

FIG. 67. — Two-headed figure: Yaxchilan.

The Serpent Bird. This name is applied to a bird motive with certain reptilian features that occurs in many of the southern Maya cities. According to Maudslay,[1] "the most essential character of the design seems to be the presence of a conventional snake's head (without a lower jaw) in place of or overlying the bony structure of the bird's wing." He adds that the Serpent Bird may simply be another way of expressing the idea intended to be conveyed by the Feathered Serpent. Maudslay[2] gives an entire plate to the explication of this complex figure, picking out the various essential parts in different colors.

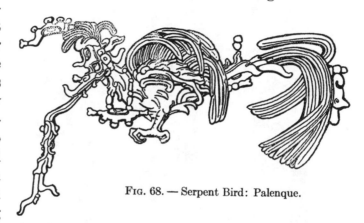

FIG. 68. — Serpent Bird: Palenque.

It is a question whether the single feature of the wings is sufficient to show that the Serpent Bird represents a fixed idea. The head of the Serpent Bird assumes a number of distinct forms, and the head is usually the part that expresses the real individuality.

This bird is seen in profile at Palenque and Piedras Negras. In the former city it is represented in two cases on the tops of the ceremonial trees, which so closely resemble crosses that they have caused much foolish speculation. The heads of these two birds are similar to the long-nosed grotesque heads of the manikin figures which are represented elsewhere on the same tablets. One of these birds is reproduced in Fig. 68. The conventionalized serpent head may be easily seen on the under side of the wing in an inverted position.

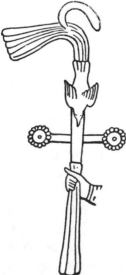

FIG. 69.—Staff representing a bird on a tree: Yaxchilan.

The general idea of a bird upon a cross-shaped tree occurs rather widely, but in other instances the serpent head on the wing does not make its appearance. For instance, the idea is embodied in a sort of ceremonial wand that is seen a number of times at Yaxchilan (Fig. 69). Likewise in the illuminated manuscripts from the neighboring Zapotecan area, the bird

[1] 1889–1902, I, p. 63. [2] 1899–1902, I, pl. 99.

on the cross-shaped tree plays an important part, but the bird is without reptilian features.[1]

The Serpent Bird of Piedras Negras is perched upon the top of a grotesque head that forms a sort of canopy over a seated personage on Stela 5.[2] The face of this bird is not of the long-nosed variety, but is much more nearly human.

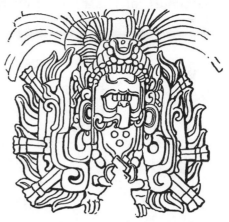

Fig. 70. — Serpent Bird. Stela H: Copan.

The plumage, however, is much the same as that of the Palenque examples and doubtless imitates that of the quetzal.

The front view representation of the Serpent Bird is much more common than the profile view. Fine examples may be seen on the back of Stela H at Copan (Fig. 70)[3] and at the top of the lintel of Temple IV at Tikal.[4] The serpent heads are arranged vertically on the inner sides of the wings in the Copan specimen and horizontally on the under sides of the wings at Tikal. In both cases long bones in pairs project outward from these serpent heads and extend across the fringe of feathers. In the last example the bird is really perched upon the arched body of the Two-headed Dragon. This same association is seen in Fig. 57, a and d, already described. In these cases the wings are fully spread, with the serpent heads in an inverted horizontal position. A stucco ornament over a door at Ocosingo represented a Serpent Bird of this type. An incomplete drawing of this by Catherwood[5] has been repeatedly miscalled a Winged Globe in various labored attempts to connect the civilization of the Maya with Egypt.

Objects similar to the wings of the Serpent Bird are widely found on stelae

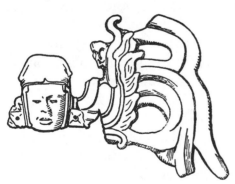

FIG. 71. — Small clay head with wing attached to ear plug: Copan.

and other sculptures as lateral ear ornaments of the richly dressed human figures. This device might be called the Wing Panel. A rather realistic instance of it is given in Fig. 71, and more conventionalized forms in Fig. 72. Of the examples given here a and b show a single serpent head at the side of the wing, while c and d show one head at the top and another at the bottom.

It is quite possible that the Wing Panel was invented and developed as an independent ornament and was later used in the artistic elaboration of any sort of bird figure. We have seen throughout this study that the serpent was a very active element in art and was able to force itself into all sorts of designs. Birds in their more natural aspects will be taken up separately, when further evidence concerning the serpent head on the wing will be offered.

The Long-nosed God. Having examined in some detail certain of the more important religious objects shown in the sculptures, we are now in a position to

[1] Seler, 1902–1903, pp. 77–81; Nuttall, 1901, pp. 187–190.
[2] Maler, 1901, pl. 15, fig. 2.
[3] Maudslay, 1889–1902, I, pl. 61.
[4] Maudslay, 1889–1902, III, pl. 78.
[5] Stephens, 1841, II, p. 259.

attempt a correlation of the material on the monuments with that in the codices. The objective method gives safer results than the subjective and will be employed in most cases. We will first consider the multifold character and phases of a figure that must represent one of the principal Maya gods. From a persistently characteristic feature this deity is termed the Long-nosed God.

Because of the natural exuberance of Maya art identification even of gods is far from easy. Fewkes [1] declares that in any attempt to classify the Maya

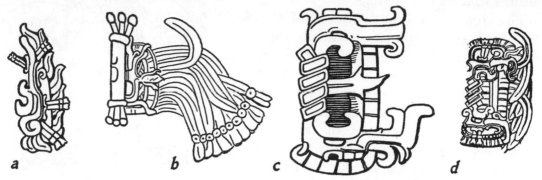

FIG. 72. — The Wing Panel: *a*, Copan; *b*, Yaxchilan; *c* and *d*, Quirigua.

deities the character of the head must be taken as the basis. This statement is true within certain limits, simply because characterization is more easily expressed in the head than elsewhere, especially when the figures are largely anthropomorphic. But in many cases the character and decoration of the body are also significant and should be examined. It was remarked in the preliminary explanation that the more or less human head or bust in the mouth of the divine serpent was intended to express the fundamentally human intelligence of an animal divinity. More detailed study has shown that the serpent itself is merely a badge and cloak of godship. The personality and special powers of the individual gods who have more or less of the serpent character are expressed largely by symbols and by grotesque modifications of the face and body.

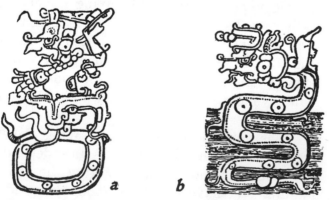

FIG. 73. — God B, issuing from serpent and with serpent body: Dresden Codex.

Schellhas, in his well-known paper on the "Representation of Deities of the Maya Manuscripts," calls the most common figure in the codices God B. He declares [2] that this god is "a universal deity to whom the most varied elements, natural phenomena and activities are subject." Many authorities consider God B to represent Kukulcan, the Feathered Serpent, whose Aztec equivalent is Quetzalcoatl. Others identify him with Itzamna, the Serpent God of the East, or with Chac, the Rain God of the four quarters and the equivalent of Tlaloc of the Mexicans.

Typical examples of this god are shown in Figs. 73 and 74. The nose is, after

[1] 1894, pp. 260–262. [2] 1904, p. 16.

all, the most characteristic feature. This is long and usually rather pendulous, with a curled object attached to the top. The mouth shows a flame-shaped tooth at the front and frequently a somewhat similar object at the back. The representations of this god in the Tro-Cortesianus Codex are similar to those in the Dresden Codex as far as features are concerned, but the style of delineation is much coarser in the former manuscript. The general similarity of the face of this god to the face of the serpent is apparent: the former is simply the latter shortened and humanized to a slight extent. The curled object above the nose is clearly the homologue of the nose scroll of the serpent (Fig. 30), through which the nose plugs are thrust. On some of the faces of God B in the Dresden Codex the nose plugs are still attached to this object.

Fig. 74. — God B holding serpent in his hand: Dresden Codex.

A personage so important in the manuscripts as is God B could hardly escape representation in the sculptures. Indeed, with slight chance of error, he may be identified with a number of figures, characterized by a long nose, that occur in many situations. In fact, some of the phases of a Long-nosed God of the sculptures have already been discussed under the title of the Manikin Scepter. We have seen the head of this grotesque deity thrust forth from the gaping jaws of the serpent, and we have seen the entire body — with its peculiar serpentine appendage that declares over and again the ophidian nature of the god — seated upon the under jaw of the serpent head on the Ceremonial Bar, or held up as a sacred thing before worshipers. In representations in the Dresden Codex God B likewise issues from the jaws of the serpent (Fig. 73, a). In other representations he sits cross-legged upon the open mouth. He even appears in some drawings with the body of a serpent (Fig. 73, b). But in the majority of cases he has the body and the dress of a man.

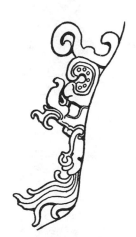

Fig. 75.— Head of Long-nosed God as secondary ornamentation: Quirigua.

Reverting again to the long-nosed manikin god of the sculptures, it has been noted that the ventral appendage disappears in the more advanced stages and that the face expresses the exact nature of the divinity by its striking reptilian features. God B likewise has reptilian features, as has already been shown. A comparison of the two discloses a remarkable similarity of parts. The following features of the face are practically identical: 1st, long, sinuous nose with the nose scroll at the top; 2d, long, single or double tooth at front of mouth; 3d, curled fang at back of mouth; 4th, lower jaw much shorter than upper jaw. Besides these similarities in the face there are often comparable oval markings on the limbs and torso. In Fig. 74 we see God B holding up a snake in the exact manner that the Manikin Scepter is held in the sculptures.

On the monuments many long-nosed grotesque faces occur as details of artistic enrichment (Fig. 75) on human figures and other objects as well as in the mouths of serpents on the Ceremonial Bar and in other connections. The range of form is remarkable and the transitions smooth and without a

break. In some cases the long-nosed faces receive a decidedly elaborate treatment (Fig. 76).

In the codices there is a second kind of long-nosed figure with an extremely elaborate face who is called God K (Fig. 77, b). According to Schellhas,[1] God K is closely related to God B and yet distinct from him. He suggests that this god has some astronomical significance. Brinton[2] and Fewkes[3] consider

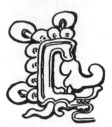

FIG. 76. — Head with elaborated nose: Quirigua.

him simply a special manifestation of God B, and Förstemann[4] holds that he is a storm god. The close relation between God B and God K is indicated in many ways. For instance, the former sometimes wears the latter's head on the top of his own (Fig. 77, c).

The face of God K seems to be derived from the face of the elaborated serpent that is often associated with God B. In the Tro-Cortesianus codex we find the body of God B attached to the middle portion of a snake bearing the head of God K (Fig. 77, a). In the Dresden Codex the serpent, from the mouth of which God B issues and upon the jaws of which he sits, has a remarkable likeness to the same god (Fig. 73, a). We have already seen that the face of God B itself resembles the serpent face, but the resemblance is not so striking as in the case of God K. Anthropomorphism is more complete in the case of the more important deity.

It might be well before proceeding on another line of inquiry to consider briefly the functions of the Long-nosed God in the phases so far presented (including Gods B and K of the codices and the Manikin Scepter God and certain similar forms on the monuments). This generalized deity is prominently associated with water and vegetation. Leaflike objects, water plants, fish and shells are frequently represented in connection with him. In the codices in the guise of God B, he is seen in the

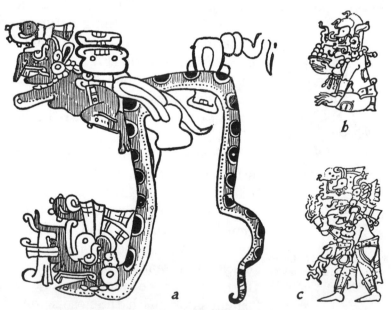

FIG. 77. — God K in his relation to the serpent and to God B: a, Tro-Cortesianus Codex; b and c, Dresden Codex.

pouring rain (Fig. 78, a) or near bodies of water (Fig. 4). Sometimes he appears in the form of the water serpent (Fig. 73, b). Fig. 78, b, shows him associated with the kan or maize sign, and c represents him with leaves attached to his body and the growing maize plant in his hand. In the form of God K he appears in connection with a sacrifice the apparent object of which

[1] 1904, p. 32.
[2] 1894, b, p. 54.
[3] 1895, b, pp. 216–217.
[4] 1906, p. 60.

is to obtain good crops.[1] Drawings from other sources than the codices connecting the Long-nosed God with leaves, flowers and water are very common. A cylindrical terra cotta vase in the American Museum of Natural History bears an interesting design which is represented rolled out in Fig. 79. The principal subject is a head of the Long-nosed God, lacking the lower jaw. Bulblike

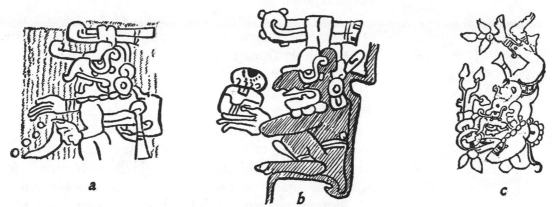

Fig. 78. — The Long-nosed God in relation to rain and corn growing: *a* and *b*, Tro-Cortesianus Codex;
c, Dresden Codex.

objects and flowers that resemble water lilies are attached to the forehead and to the ear plug. Nearby is a curious bird which probably is intended for a pelican. The association of water seems to be pretty clear in this instance.

The Manikin Scepter and the Ceremonial Bar are evidences of worship, but offer little information concerning the powers of the object worshiped. On Stela 11[2] at Yaxchilan a human figure wearing a mask with an elaborated nose

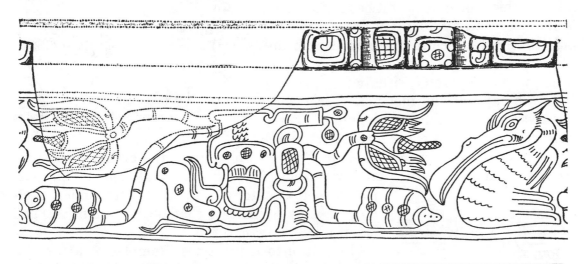

Fig. 79. — The Long-nosed God combined with flowers and other objects.

(Fig. 9) holds in one hand the Manikin Scepter and in the other a club with which he appears to threaten three bound captives who kneel before him. It seems possible that this universal deity may have also been concerned with war. The astronomical significance of the Long-nosed God is not clear. In the codices neither God B nor God K seems to be connected with the sun, but such a

[1] Förstemann, 1906, pp. 59–60. [2] Maler, 1903, pl. 74, fig. 1.

connection is indicated in Fig. 80 by the kin sign on the forehead of the Long-nosed God in the serpent mouth. The grotesque being here represented holds in his hand a leaflike object. In the phases so far considered it is most significant that the Long-nosed God seems to be entirely beneficent, since death signs do not occur in connection with him.

There is another large group of representations that shows a Long-nosed God with features indistinguishable from those of the god just considered, but who seems to be connected unchangeably with death. It seems possible that these figures may symbolize the destructive extremes to which the generally beneficent sky god may sometimes go in causing flood or drought. Or they may indicate a dualism, pure and simple, in which each power for good is directly opposed by a second one for evil.

FIG. 80. — The Long-nosed God with the sun sign on his forehead: Copan.

Sometimes when the head of the Long-nosed God of the first type appears in the mouth of the serpent, the death's head of the second type is attached to the serpent tail (Fig. 81, a and b). Examples of such an opposition of good and bad are fairly common.

A somewhat similar appearance of this Long-nosed God with the attributes of death has already been considered in connection with the Two-headed Dragon. The rear head of this monster, it will be remembered, is characterized by a long nose and by symbols that have been interpreted as referring to the sun, to water and to death. This head occurs in many situations detached from the body of the monster. Frequently it serves as a headdress for human figures on stelae, lintels and other monuments.[1] Its

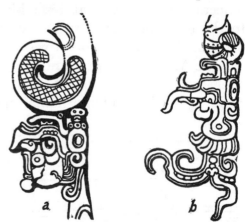

FIG. 81. — Long-nosed death heads attached to serpent tails: a, Copan; b, Yaxchilan.

hieroglyph is perhaps to be seen in Fig. 82, which gives the details of its own peculiar headdress. In Fig. 83 the head of this god with all its attributes is placed in the center of a band of astronomical symbols, possibly to indicate that the powers of this god are of a heavenly nature.

Fig. 84, a to c, furnishes examples of a peculiar object that in the first instance comes out of the end of a Ceremonial Bar where the bust of the manikin god with shield and spear is also featured, and in the next two instances is attached to the head of the other similar Long-nosed God, just considered, with the three signs as a headdress. This second god has in c the kin sign upon his forehead, but in b he has

FIG. 82. — Hieroglyphs of the rear head of the Two-headed Dragon: Palenque.

[1] For instance, Copan, Stelae H and I, Maudslay, 1889–1902, I, pls. 61 and 63; Palenque, Palace, House A, Maudslay, 1889–1902, IV, pl. 10, and Yax-chilan, Lintel 14, Maler, 1903, pl. 55, and Piedras Negras, Stela 3, Maler, 1901, pl. 13.

the sign which Seler [1] considers the general sign for all heavenly bodies. The pendent object with the symbols attached may indicate water descending in a flood. In Fig. 85 we have a somewhat similar object descending from the hands of a priest or deity. The kan or perhaps the imix symbol is seen as well as

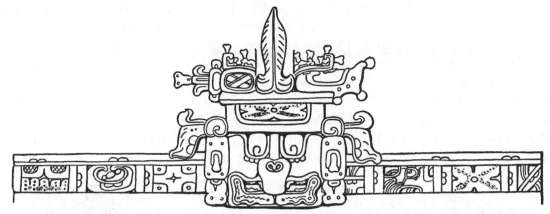

FIG. 83. — The rear head of the Two-headed Dragon attached to a band of astronomical symbols: Palenque.

the sun sign. These representations deserve comparison with the last page of the Dresden Codex, where is depicted, according to Förstemann, the destruction of the world. In this picture a great flood of water gushes forth from the mouth

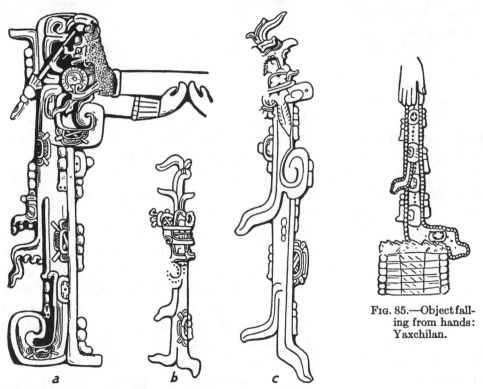

FIG. 85.—Object falling from hands: Yaxchilan.

FIG. 84. — Objects that may represent falling water: a, Quiriqua, b and c, Palenque.

of the composite monster that terminates the band of astronomical signs. Water also descends from the signs of the sun and moon that are attached to the lower side of the astronomical band. An old woman with a serpent upon her head, with crossbones on her skirt, and with jaguar feet inverts a bowl of water.

[1] 1901–1902, pp. 169–170.

Upon the water that pours out of the bowl is the sign of the unlucky day, Eb, and the sign for zero, or completion.[1] At the bottom of the picture is a black god with the ominous moan bird perched upon his head. The old woman with the serpent upon her head will be reconsidered presently.

There are many representations of the Long-nosed God that possess the bleached bone for a lower jaw and sometimes the kin sign on the forehead, but lack the characteristic shell, leaf and saltire symbols. Often heads of this type appear as hieroglyphs with numerals in connection (Fig. 86). Still other examples fulfill some unknown function of symbolism or suggestion in the enrichment of stelae. Fig. 87 shows a small inverted head, attached to a vinelike object. The lower jaw, as before, is fleshless. When the head of the Long-nosed God appears as a headdress the lower jaw is often lacking, but when such is the case it is often possible to find other symbols of death upon the face.

FIG. 86. — The head of the Long-nosed Death God as a period glyph: Copan.

FIG. 87. — The inverted Long-nosed Death God attached to a vinelike object: Copan.

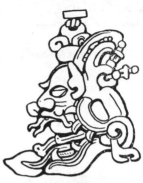

FIG. 88. — Head in serpent mouth: Tikal.

Let us examine one more example. Fig. 88 shows a more or less human head enclosed in the jaws of a snake. The nose is not elongated, but the flamelike teeth seem to place this representation among those of the deity we have been considering. Upon the head itself are no death symbols, but immediately below the head we see two bonelike objects as well as another object that almost surely represents a leaf. In this case, then, attributes of life and death seem to be both indicated in connection with one individual.

A mass of evidence has been presented in regard to the general conception of a Long-nosed God with constant affinity to the serpent. It has been shown that there are two groups of special manifestations, one of which is good and the other bad. Each one of these groups presents several distinct phases which, however, are found upon fuller investigation to merge into one another. A number of explanations for this state of affairs might be advanced: 1st, that each phase represents a distinct divinity; 2d, that each group represents a divinity of diverse interests who is directly opposed to the divinity of the other group of interests; 3d, that all the phases and the groups are merely attempts to differentiate the powers of one general and universal god.

It is too early to make a choice of these explanations or of others that might be advanced in their stead. The study of primitive religions shows that in general the line of change is from many gods towards fewer gods and finally to one god. Assimilation is a much more common phenomenon than differentiation. Very often one god or a group of gods rises above the others and gradually absorbs

[1] This picture is not on the last page in revised numbering. See the Nomenclature, p. 261.

or assimilates the less fortunate rivals. Such may have happened in the case of the Maya. The phases and the groups of phases that have just been described may represent many gods merged into one.

The Roman-nosed God. One of the most important gods in the codices is God D, whose face seems likewise to be recognizable in the sculptures. In the codices he takes the form of an old man with a Roman nose and an eye ornamented with a scroll, beneath which are small circles. The corners of his mouth are drawn back and surrounded by deep wrinkles. Sometimes a single tooth projects forward from the front part of the upper jaw, and when this is absent a stub tooth may appear in the lower jaw. But as often as not both jaws are toothless. Frequently he wears a flowing beard.

According to Schellhas,[1] God D is a Moon and Night God; Fewkes,[2] as well as Thomas, Seler and Förstemann, consider this figure to represent Itzamna,

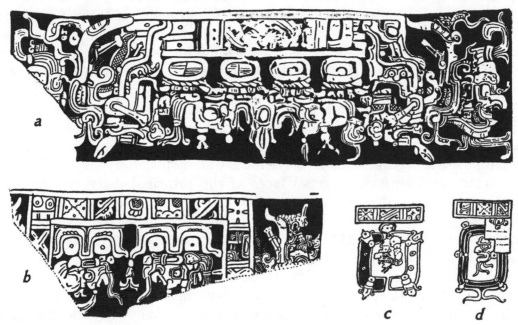

FIG. 89. — The Roman-nosed God as Sky God: *a* and *b*, Yaxchilan; *c* and *d*, Dresden Codex.

while Brinton[3] thinks he is Kukulcan. It can be pretty definitely demonstrated that God D is a universal sky divinity with powers extending over the day as well as the night. He is not so obviously connected with the serpent as is God B. The weight of evidence seems to incline towards the interpretation of this divinity as Itzamna rather than Kukulcan. Both God B and God D have the strongly deformed teeth which Cogolludo gives as the characteristic of Itzamna. Until the indentification is complete, however, it seems best to employ titles that are without prejudice.

Some connection between God D and the sun is indicated by the kin sign that occasionally appears on the forehead of this god. The general connection with all the heavenly bodies is made clear by several passages in the Dresden Codex. In Fig. 89, *c*, we see the head of God D inclosed in a figure half white and half black that may symbolize alternating night and day. Over the head of the god is the usual sun sign, while above this is a strip of astronomical signs.

[1] 1904, pp. 22–28. [2] 1895, *b*, pp. 208–216. [3] 1894, *b*, p. 56.

A variant of the above appears in *d*, where the sun sign is placed on the forehead of the god.

Let us now turn for a moment to the monuments. Fig. 89, *a* and *b*, presents two examples of a very complicated design, occurring several times at Yaxchilan, that resembles the familiar Two-headed Dragon. The legs of the more complete specimen (*a*) have trifoil scrolls at the joints and cloven feet exactly like those of the Two-headed Dragon figures of the elongated phase shown on page 55. Also the body consists of a band of astronomical symbols. The two heads, however, are similar to each other rather than strongly differentiated, and other heads of more or less human forms are seen in the mouths and elsewhere in connection with the body.

On the original monument from which *a* is taken (Stela 1) [1] there is a bust of a human being or of a god directly over the center of the planet strip that forms the body of the two-headed monster, and its resemblance to God D of the codices is evident at the first glance. The Roman nose, the open mouth with the lips drawn back, the wrinkles on the cheek, the peculiar tooth projecting outward, the ornamented eye and the flowing hair and beard are all features that occur in the codices in connection with God D. The air of old age is admirably characterized.

At either side of this central bust are representations of small human beings. Each of these figures is seated in a device which in one case is circular and possibly represents the sun and in the other is crescent-shaped and may represent the moon. Each figure holds in his arms a Ceremonial Bar. At both ends of the Ceremonial Bars appear small faces of the principal deity in the mouths of the serpent heads (Fig. 61).

Reverting to Fig. 89, *a* and *b*, it hardly needs pointing out that the face which so closely resembles God D likewise appears in the jaws of these two-headed monsters. As if this were not enough repetition, it occurs twice more on the under side of each one of the bodies. The latter examples are worthy of examination. The faces look directly downward, but one is the obverse of the other, so that the lower parts of the heads are in conjunction. In *a* the two heads amalgamate into one, but in *b* they are separate and easily seen.

The two heads of God D of the codices (*c* and *d*) that are attached to the planet signs and sun symbols acquire a new significance in the light of these sculptured pictures.

It is impossible to state what connection exists between the Two-headed Dragon and the grotesque creature just discussed that is so completely loaded down with the faces that resemble God D. There is some reason, however, for believing that the Roman-nosed God is associated with the front head of this curious monster in somewhat the same way that the Long-nosed God is associated with the rear head.

On pages 4 and 5 of the Dresden Codex is represented a scaly green monster with a head at each end (Fig. 90). In the open mouth of the front head is the face of God D.[2] Above this monster are the glyphs of a number of the principal gods, but no glyph that belongs exclusively to the monster itself. This monster may represent the same conception as the Two-headed Dragon that takes so many forms in the sculptures.

[1] Maler, 1903, pl. 69. [2] Förstemann, 1906, p. 68.

God D, according to Schellhas,[1] appears as a benevolent deity in the codices, but it seems certain that, like God B, he either has dual aspects or else is directly opposed by another divinity of similar form. In his benevolent appearance he assumes a close connection with maize, but his other powers and relationships are not clear. God E, who is the Maize God, seems to be rather lacking in real power and dependent upon the aid of other gods. He receives this aid from God B as benevolent rain god and God D as benevolent sun god.

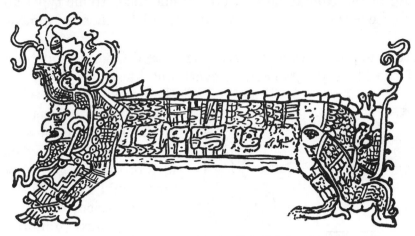

Fig. 90. — Two-headed monster with face of God D: Dresden Codex.

The malevolent aspect of God D — or the evil-minded deity that assumes his form — is seen in the female figure that Schellhas[2] has named by the letter I and which he further describes as a destructive Water Goddess. It may be remarked at this time that sex seems to be a shifting and uncertain attribute among the Maya gods. Although generally masculine, nevertheless the principal deities sometimes assume female form.

The Goddess I has already been brought before the reader in connection with the destructive flood symbols discussed on page 67. It seems clear that this deity has some affinity to the composite monster with the astronomical symbols on its narrow body that appears at the top of page 74 of the Dresden Codex. The floods that issue from the body of this monster are augmented by the water from an inverted bowl that the goddess holds in her hands. Goddess I appears several times more in conjunction with gushing streams of water, both in the Dresden Codex and in the Tro-Cortesianus, and shows an indefinite relationship to God D. Her hieroglyph is uncertain, but the hieroglyph of God D is used in one instance where her picture occurs. The physiognomy of this goddess resembles strikingly that of God D. A constant and peculiar feature is a headdress consisting of a knotted serpent.

Perhaps the natural opposition intended to be conveyed by God D and Goddess I is that which exists in nature between the clear sky in which appear the sun and stars, and the black storm clouds which blot out these orbs and deluge the earth with destructive floods. Fewkes, who offers much evidence of the close connection existing between Gods B, D and G, seems to be inclined to accept[3] the relationship implied in the Dresden Codex between God D and Goddess I.

To return to the sculptures, the face of the Roman-nosed God — which is

[1] 1904, pp. 22–23. [2] 1904, pp. 31–32. [3] 1895, *b*, p. 210.

perhaps a safer title than God D for the general appearance of this divinity — appears frequently in the serpent mouths that terminate the Ceremonial Bar. Reference has already been made to one example of this at Yaxchilan. At Copan good examples are seen on Stelae P, 2 and I, and at Naranjo on Stelae 6, 7, 20 and 32, while numerous other citations from different cities might easily be given. In fact, it may be stated with some assurance that the heads on the Ceremonial Bar are nearly equally divided between representations of the Long-nosed God and of the Roman-nosed God. While the extreme types are clear and well fixed, the two types of heads blend into each other by almost insensible gradations.

Still another manifestation of the Roman-nosed God is probably seen in the face form of the kin glyph, which, as every one knows, is the period glyph of the lowest order in the calendarical inscriptions, representing one day. If this god is, as we surmise, a god of both night and day but with the idea of the sun god uppermost, his face would serve nicely as a sign for the period, one day. The kin glyph is fairly uniform, examples from diverse monuments and cities being given in Fig. 91, a to d. Sometimes the kin sign appears on the face, usually the nose is of the Roman type, a peculiar terraced tooth that is commonly described as filed projects from the front of the upper jaw, and a flowing beard is often present. The eye likewise shows similarities to the eye of the god we have been studying. The so-called normal form of the glyph simply abbreviates the above-described face to the kin sign and the flowing beard (Fig. 91, g). This glyph occurs in other situations than the initial series inscriptions. It is one of the common glyphs in the so-called supplementary series that follows the initial series.

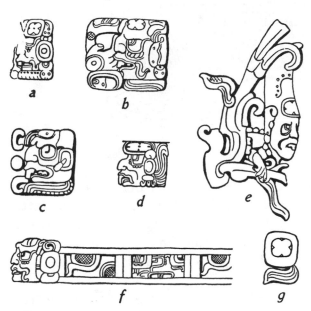

FIG. 91.—The kin glyph and the Roman-nosed God as Sun God: a, b, e and g, Copan; c, Yaxchilan; d, Chichen Itza; f, Palenque.

The face numeral for four, which occurs only in the inscriptions, is likewise probably a variant form of the Roman-nosed God. The kin sign is usually placed on the cheek in front of the ear ornament. The face numeral for fourteen is similar except for some indication of death such as a bone for the lower jaw. The glyph of the month Yaxkin, in at least one instance [1] in the inscriptions, also offers evidence of the use of the face in question.

One of the common astronomical signs shows the face of the Roman-nosed God curiously conventionalized. This has been interpreted by Seler [2] as a symbol of the sun. Fig. 91, f, gives a portion of the strip of planet signs at the base of the Tablet of the Sun at Palenque. This strip ends in the god's face in the phase most common as the day period glyph. Back of this face is a rectan-

[1] Bowditch, 1910, pl. IX, 9. [2] 1901–1902, p. 165.

gular panel containing a sign that resembles Caban and has been interpreted as referring to the moon. Next to this sign, and alternating with it during the entire course of this strip of symbols, is the conventionalized face of the Roman-nosed God looking upward. This type of face occurs many times at Yaxchilan, Piedras Negras and Palenque. A beautiful example greatly enlarged to frame in the entire side of a niche for a seated figure at Piedras Negras is given in Fig. 92.

While discussing the homogeneity of Maya art (pages 20–21) there was presented a series of strips of astronomical symbols, some of which are combined with bird heads. These bird heads are in profile at the ends of the strips (Fig. 6, g). Later, while elucidating the development of the Two-headed Dragon, the occasional presence of the Serpent Bird upon the central part of the elongated body was noted (page 61). It seems possible that some connection may be established between these bird heads and the multiform Roman-nosed God, but the results are ambiguous. The face of God D certainly appears on birds in the Peresianus Codex.[1] The so-called Serpent Bird on Stela 5[2] at Piedras Negras

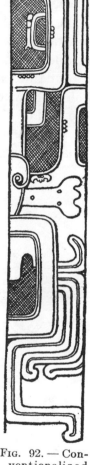

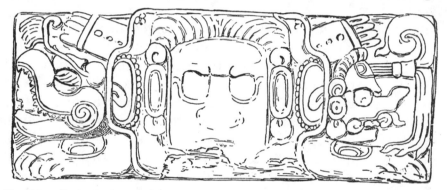

FIG. 93. — Sculptured block, showing Two-headed Dragon and Roman-nosed God: Copan.

presents a face of the same type. The front view example of the Serpent Bird from Palenque (Fig. 57, a) likewise shows similar features. An interesting sculpture from the northeastern group of mounds at Copan is sketched in Fig. 93. This sculpture is an abbreviated form of the Two-headed Dragon. The front head is true to type, while the rear head has the features of the Long-nosed God, but lacks the usual symbol of the shell, etc., on the forehead. In place of the monster's body is a somewhat damaged face in front view that probably represents the Roman-nosed God. An analogous design is found as the headdress of the principal figure on the north side of Stela N[3] of the same city.

FIG. 92. — Conventionalized head of Roman-nosed God: Piedras Negras.

But these examples, after all, may not indicate the survival of the Serpent Bird that in other cases is perched upon the body of the Two-headed Dragon. Nearly all the animal altars of Copan of the Two-headed Dragon type are elaborated by the intrusion of grotesque heads between the legs and upon the back. The real explanation of these anomalous conditions may be artistic exuberance rather than complication of religious ideas.

The representations of the Roman-nosed God that are executed in the full

[1] Léon de Rosny, 1888, pls. 4 and 8. [2] Maler, 1901, pl. 15, fig. 2. [3] Maudslay, 1889–1902, I, pls. 77 and 79.

round show the same features as the more common profile studies and at the same time make possible the identification of the front view representations in low relief. Small heads on the belts of Stelae I and H at Copan likewise show the transition between profile and front-view faces. A large block of stone on the northeast corner of Mound 16 at Copan [1] is carved into an excellent portrait of the divinity. Upon the forehead is the usual kin sign. A tassel-like nose ornament hangs down over the mouth, and at either side of the latter is a deep crease or wrinkle. Another similar head adorns the Jaguar Stairway.[2] In the Peabody Museum are a number of excellent original carvings from Copan that represent the Roman-nosed God with the terrace-shaped tooth (Plate 26, fig. 1).

In the same collection there are several heads with the twisted or cruller-shaped ornament over the nose. Examples of faces of this type have already been presented in Fig. 1, and the wide distribution has received due notice. A re-examination of these faces will bring out many points of resemblance to one or another of the phases of this important god. It seems possible that this definite manifestation may refer directly to the sun disk, the Tonatiuh of the Nahua. Seler,[3] however, considers the face with the twisted nose ornament to represent the god of the Evening Star.

The face glyphs for seven and seventeen show this god in profile with the twisted ornament in view. On one of the wooden lintels at Tikal [4] is carved a human figure with this nose ornament and with the number seven on his cheek. Examples of the face glyphs for seven and seventeen agree with the face on this tablet in the matter of the twisted ornament over the nose. The sign for seventeen has in addition the fleshless jaw bone, as is usual for numbers above ten. The twisted element appears also on heads in the Ceremonial Bar, an instance being Stela 2 at Copan.

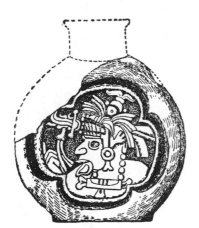

FIG. 94. — Pottery flask with face of Roman-nosed God: Uloa Valley.

Many other representations, in the light of the variations and developments that have been noted, seem to represent the generalized Roman-nosed God. Among others may be mentioned the atlantean figures that support the altar as well as those on whose backs stand the officiating priests on the tablet of the Sun Temple at Palenque.[5] The old man smoking a tubular pipe from the same city is another case in point.[6] The same face stamped upon a pottery flask in the Peabody Museum is shown in Fig. 94.

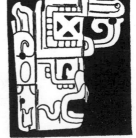

FIG. 95. — Jadeite slab representing a Sun God: Ocosingo.

Let us now consider briefly some of the indeterminate representations that lie between the Long-nosed God and the Roman-nosed God. Fig. 95 is a drawing of a thin jadeite plate from Ocosingo which is alike on the two sides and has some features indicated by stencil-like perforations and others by low relief carving. The diagonal cross on the fore-

[1] Maudslay, 1889–1902, I, pl. 10, b.
[2] Maudslay, 1889–1902, I, pl. 18, a, and Stephens, 1841, I, p. 143.
[3] 1902–1903, I, p. 317.
[4] Maudslay, 1889–1902, III, pl. 73.
[5] Maudslay, 1889–1902, IV, pl. 88.
[6] Maudslay, 1888–1902, IV, pl. 72.

head probably represents the sun symbol. The nose is slightly broken, but it is evident that it never projected much farther than now. It is impossible to say with assurance whether this face represents the Long-nosed God or the Roman-nosed God. In Fig. 96 we see eight heads. Some of these, such as *a* and *e*, are good examples of the Long-nosed God; others, such as *d* and *h*, represent the opposite conception. The remaining heads are much more ambiguous, although it seems likely that *b* and *f* fall in the Long-nosed group and *c* and *g* in the Roman-nosed group. The heads which terminate the upturned noses of elaborated serpents (see Fig. 26 and Fig. 33, *b* and *c*) almost all belong to an ambiguous middle series. In fact, Fig. 96, *b* and *g*, already discussed, are found in such positions.

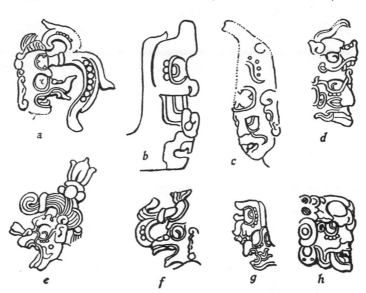

Fig. 96.—Intermediate series. Long-nosed God and Roman-nosed God: *a–d, f* and *h*, Copan; *e*, Palenque; *g*, Tikal.

Aside from these intermediate types there is abundant evidence of a close connection between the two generalized forms. Fig. 97 shows two drawings from the Dresden Codex in which the two deities are combined. In *a* we find God B, the principal phase of the Long-nosed God, seated upon the head of God D, the principal phase of the Roman-nosed God. This latter head is marked with bunches of circles which have been interpreted as water symbols. In *b*, on the other hand, we see God D, with a sun symbol in his hand, wearing the head of God B as a headdress.

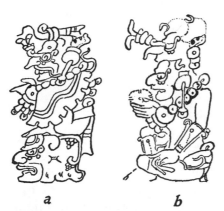

Fig. 97.—Close association of God B and God D: Dresden Codex.

We have observed that both the Long-nosed God and the Roman-nosed God occasionally bear the sun symbol. Now the Sun God, *par excellence,* of the Dresden Codex is God G according to the classification of Schellhas. This god takes the form of an old man with a Roman nose and a body marked with sun symbols (Fig. 98). The feature that distinguishes him from God D is an ornamental hook that is attached to his nose. It is possible to see in this characterization a sort of compromise between the natural nose of God D and the fantastic serpentine nose of God B. Schellhas[1] finds that God G is closely connected with God B. Fewkes[2] goes farther and groups Gods B, D and G together. God N may also belong here.

Fig. 98.—God G, the Sun God: Dresden Codex.

[1] 1904, p. 28. [2] 1895, *b*, pp. 216–218.

In closing this discussion it seems best to reiterate the most significant point of all. Both the Long-nosed God and the Roman-nosed God are distinct enough in their general appearances and yet each blends into the other. Moreover each divinity is presented in a number of phases, which at first glance seem to be distinct and characteristic, but which upon further examination are all found to break down into a most chaotic state. The best explanation that can be offered is that the two most important gods in the pantheon became more and more important, and absorbed and assimilated their less powerful rivals. Then, too, the artistic importance of the serpent undoubtedly led to convergent evolution of many forms. Other gods less closely allied to the serpent will soon be presented.

OTHER SUBJECTS

The Jaguar. This animal received a great deal of attention from Maya artists and possessed a religious importance secondary only to the serpent. Many of the headdresses and breastplates represent the face of the jaguar. A fine

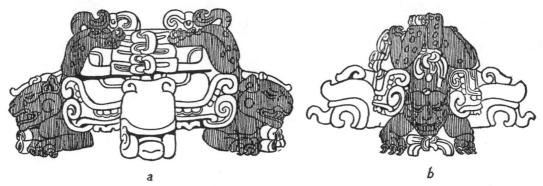

<center>a b</center>

FIG. 99. — Altar of Stela F: Copan.

series of such breastplates are shown on Altars Q, L and T, and on the sculptured interior step of Temple 11 at Copan. The Temple of the Jaguars at Chichen Itza gets its name from a frieze representing jaguars in a procession. The Jaguar Stairway at Copan is another notable occurrence of this animal in architectural design. The jaguar seems to have served in a general way as a model for some of the animal altars of Copan and Quirigua. Altar G at Quirigua (Plate 1, figs. 1 and 2) presents a particularly fine jaguar head. Altar F at Copan consists of several carved stones fitted together that represent two jaguars bound to the side of two grotesque heads. Two views of this altar are reproduced in Fig. 99, a and b. A possible combination of the jaguar and the serpent in monstrous and grotesque creations may be seen in some of the altars of the Two-headed Dragon type. In particular the clawed feet seemed to be derived in some instances from this animal.

Double-headed jaguar seats are represented at a number of sites, particularly Palenque [1] and Uxmal [2] and Chichen Itza.[3] Perhaps the finest example was the throne modeled in stucco upon the Tablet of the Beau Relief at the former city. This famous panel is now destroyed, but its original features are preserved more

[1] Maudslay, 1889–1902, IV, pl. 44. [2] Stephens, 1843, I, p. 183.

[3] Maudslay, 1889–1902, III, pl. 35, b, and pl. 50.

or less exactly in the drawing of Waldeck.[1] Jaguar seats occur at Chichen Itza on the carved lintels.

The Chacs or Rain Gods of the Four Quarters were conceived in the form of jaguars, and the Balam or Jaguar Priests were an important religious institution among the Maya. Jaguar priests which may or may not correspond to the Balam priests are represented upon Stela A[2] at Quirigua, Stela 10[3] at Piedras Negras and Stela 8[4] at Siebal. They are in human form and dress with the exception of the hands and feet, which have the claws and markings of the jaguar.

Many references to the jaguar occur in the codices, but their meanings are uncertain. Fig. 100 reproduces a drawing in the Dresden Codex where the animal is realistically represented. The only unnatural feature is a flower resembling a waterlily that is attached to the forehead. A jaguar design engraved upon a vase from Peto in northern Yucatan is figured in a later section of this paper (Fig. 185). This remarkable specimen shows a jaguar sitting in a floral circlet and wearing a cloak and breech cloth, not to mention arm and leg bands, nose plugs, etc. His headdress consists of the head of the Long-Nosed God and a small flower similar to that shown in the Dresden Codex specimen. A painted potsherd from Copan (Fig. 101) presents an analogous drawing of an elaborately dressed jaguar, with a so-called

Fig. 100. — Realistic drawing of a jaguar: Dresden Codex.

speech scroll issuing from his mouth, who wears over his forehead a leaflike ornament. The same leaflike design occurs again on one of the lintels of Tikal.[5]

Fig. 101. — Jaguar on a potsherd: Copan.

It seems possible that some connection may be established between the water plant and fish motive (page 18) that has already been described and this powerful beast of the jungle.

The jaguar skin is frequently represented as a garment. Skirts showing the typical jaguar markings prevail on the figures at Copan and are common elsewhere. Sometimes the entire skin[6] with head and tail attached is represented as thrown over the shoulder or about the waist.

Birds and Feathers. The ceremonial and artistic importance of birds and feathers in Maya art can hardly be overestimated. Representations of the former occur in the glyphs and codices and upon the sculptured monuments in connection with some of the more recondite and peculiar features of religion and design. Feathers form a common motive for decoration on stelae and the façades of buildings and are, as well, an integral part of the gala and everyday dress of the people as represented by sculptures and frescos.

The Feathered Serpent and its reciprocal concept the Serpent Bird have

[1] Waldeck, 1866, pl. 42.
[2] Maudslay, 1889–1902, II, pl. 8.
[3] Maler, 1901, pl. 19.
[4] Maler, 1908, a, pl. 7.
[5] Maudslay, 1889–1902, III, pl. 71.
[6] For a good example see Maudslay, 1889–1902, IV, pl. 72.

already been discussed at some length. It was indicated that both simply form a general basis for a large part of the peculiarly involved art of this people and that further definite characterization was accomplished by adding specific details of one kind or another. It was pointed out that several species of birds (judging by the head) might have the unnatural feature of a conventionalized serpent jaw lying along the wing, and that this unnatural feature was the only fixed characteristic of the so-called Serpent Bird. It was shown that this peculiar wing might even occur separately in the device known as the Wing Panel, and that, as such, it frequently served as lateral ear ornaments for the more complicated figures on the monuments.

The natural characters of birds are sometimes clearly given, but more often the representation is vague and grotesque. Many bird faces approach now the serpent and now the human type. Most of the more elaborate specimens have ear plugs, nose plugs and teeth. The teeth are of the same two kinds as seen on the serpent jaws,

FIG. 102. — Various representations of birds: *a–c*, Copan; *d*, Codex Borgia; *e* and *k*, Palenque; *f* and *j*, Codex Peresianus; *g*, Dresden Codex; *h*, Quirigua; *i*, Codex Tro-Cortesianus.

namely, a rather realistic molar and a curious flame-shaped incisor usually divided into two parts. Very often the curled object at the back of the mouth likewise appears.

Among the birds represented in the Maya codices Drs. Tozzer and Allen [1] have identified the following: herons, probably of several species, frigate bird, ocellated turkey, king vulture, black vulture, harpy eagle, Yucatan horned owl and screech owl, coppery-tailed trogan or quetzal, blue macaw and perhaps a few others. The bird reproduced in Fig. 79 doubtless represents the pelican, as

[1] 1910, pp. 324–346. See also Seler, 1909–1910, pp. 427–457, 784–846.

may be seen from the character of the greatly enlarged bill which shows the knot that appears during the mating season.

The length to which the Maya artist would go in representing a single species is shown in Fig. 102, *a–c*. Of these, *a* is a glyph carved on the back of Stela B at Copan, the first part of which gives the head of the blue macaw, while *b* is a sculpture in the full round representing the same bird and coming from the same city. Note the nostril at the top of the bill, the eyes surrounded by a circlet of small knobs as well as the hook-shaped appendage to the base of the eye, likewise composed of knobs. In *c* the short lower bill and the tongue are omitted and a more or less human ear with characteristic decoration is introduced at the side of the face. The upper bill is lengthened and enlarged. This last figure occurs twice on the front of Stela B at Copan and has often been explained as an elephant trunk. The true explanation has been worked out independently by a number of students.[1] Drawing *d* reproduces a bird with a similar head from one of the Mexican codices.

Birds, either entire or in part, are frequently found on the more elaborate headdresses of the priests and warriors on the monuments. An interesting example from Palenque is given as Fig. 102, *e*, which represents a heron with a fish in its mouth. The same idea with only the upper part of the bird in view appears at Seibal on Stela 10 (Plate 25, fig. 2) and a second variant (*g*) may be seen in the Dresden Codex.

Flying birds of various sorts flutter before priests who perform certain ceremonies in the Peresianus Codex from which *f* is taken. Other carefully drawn birds are perched upon the backs of seated women in the Dresden Codex.[2] A black vulture attacking a snake is very realistically represented on page 36 of the same manuscript. Other vultures are shown devouring sacrificial victims, etc. Birds, among which the ocellated turkey is prominent, are themselves decapitated and given as offerings to one god or another.

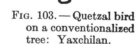

Particularly fine examples of this may be found on pages 25–28 of the Dresden Codex. A quetzal bird on a conventionalized tree is shown in Fig. 103. A variant form has already been presented and discussed (Fig. 69 and page 60).

FIG. 103. — Quetzal bird on a conventionalized tree: Yaxchilan.

FIG. 104.—The moan bird; Dresden Codex.

Anthropomorphic birds which may represent minor deities are found in the manuscripts. An officiating priest in the guise of an ocellated turkey with human body is the principal figure on page 8 of the Peresianus Codex. The Yucatan screech owl, known as the Moan bird and popularly associated with death by the Maya, is characteristically represented in the drawing reproduced in Fig. 104. In this case the sprouting maize plant appears as a headdress, the association probably indicating a failure of the crops. The glyph of this bird occurs very frequently in the codices, usually with evil intent. The vulture and the harpy eagle are also represented with features

[1] Parry, 1893, p. 166. Gordon, 1909, pp. 193–195. Tozzer and Allen, 1910, p. 343.
[2] For example, pp. 16–18.

drawn from the figure and ornamentation of man. The possible connection be-
tween the Roman-nosed God and a bird of some sort has already been mentioned.

Bird heads are prominent in the hieroglyphs, but the features are usually
modified towards the serpent or the human type. In particular the higher
period glyphs, including the cycle, katun and tun, commonly show birdlike
hooked noses. As is well known, these glyphs are of two types, the face type
and the so-called normal type. With the latter we have at present no concern.
The face type is the more usual, but it is very difficult to determine the signifi-

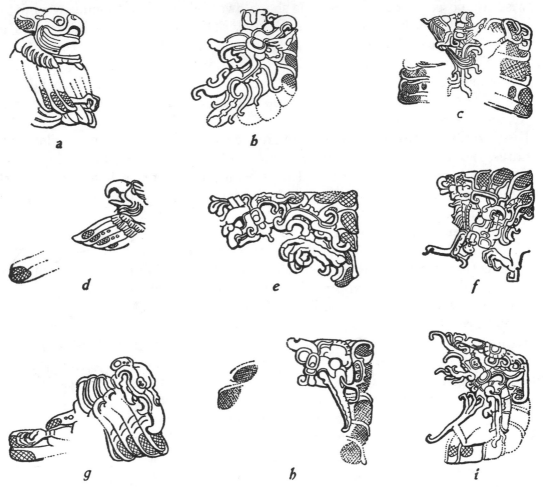

FIG. 105. — Highly modified birds as period glyphs: a, d and g, Stela D, Copan;
b, e and h, Stela D, Quirigua; c, f and i, Altar B, Quirigua.

cant feature from which the meaning of the face is drawn. Fortunately there are
four examples of initial series which show bodies as well as heads. The earliest and
clearest of these is on Stela D at Copan. On this monument each number is repre-
sented as a human being who carries the period upon his back. Two other in-
stances of full-form glyphs occur on Stela D at Quirigua and the fourth upon Altar
B at the same city. These latter examples of picture writing show a contest be-
tween the being who represents the number and the one who represents the period.
The complexities and involutions of these sculptures are almost beyond solu-
tion. In the series given here for comparison only the period forms are shown.

The cycle according to the Copan example is represented by a parrotlike
bird (Fig. 105, a), but in two Quirigua drawings (b and c) this resemblance is
lost. In all three the lower jaw consists of an open hand with thumb pointing

forward, but in the first example this feature is somewhat disguised. In the Quirigua specimens the serpent head on the wing greatly complicates the design. It will be seen at once that this is the adventitious feature that has already been discussed under the caption, the Serpent Bird. Unfortunately nothing appears in these drawings to fix the species of bird unless we accept the suggestion of the parrot offered by the Copan example. In the simple face forms of the cycle

glyph, as may be seen in the series given by Mr. Bowditch,[1] the hand that replaces the lower jaw is a fairly constant feature. Most of the faces have beaked noses, but, aside from this and the hand just mentioned, they are exceedingly divergent.

Fig. 105, *d*, *e* and *f* give the bird figures that appear in the katun glyphs, and *g*, *h* and *i* those of the tun glyphs. Both these series are unintelligible as far as definite interpretation is concerned. The subject of the former may indeed be an eagle, as suggested by Mr. Bowditch. The subject of the latter is in all cases an extremely grotesque bird. The bird beak is pretty clearly shown in many of the abbreviated glyphs, and in these the frequent presence of a

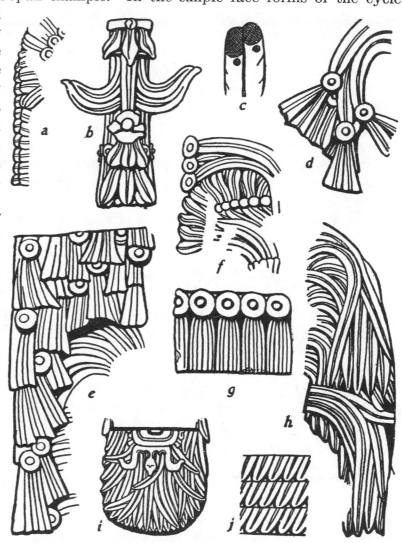

Fig. 106. — Examples of sculptured feathers: *a*, *b*, *d*, *e*, *f*, *g*, Copan; *c* and *i*, Piedras Negras; *h*, Seibal; *j*, Uxmal.

peculiar ornament in front of the forehead and back of the ear suggests the Yucatan screech owl or Moan bird. This bird is closely connected with the idea of death. In harmony with the interpretation is the bone that appears on the lower jaw of many of the heads where the bird element is wanting.

Perhaps the clearest and most consistent use of a bird head is in the hieroglyph for the month Kayab.[2] This glyph has been explained as the head of a turtle, but a careful comparison of all the forms shows that it really represents a macaw. The short under bill and the tongue are clearly marked, as well as the nostrils at the base of the bill. Often the feathers at the back of the head can be easily distinguished.

[1] 1910, pl. 12.　　　　[2] Bowditch, 1910, pls. 8 and 10.

Fig. 106 shows typical examples of the use of feathers in decoration. In *a* is given the first appearance of independent feather-work decoration on a Copan stela. Previous stelae in this city do not show feather drapery, although it subsequently was magnificently developed, as may be seen from details given in *d* and *e*. The handling is very free, and frequent use is made of a sort of rosette that loops or binds the feathers together. Long plumes with these circular ornaments occur widely on headdresses (Copan, Tikal, Ikxun, Yaxchilan, Kabah, Chichen Itza, etc.) and in simplified form are used as motives for mouldings on the façades of buildings from Copan to the cities of northern Yucatan. Feather drapery without such binding is likewise common. The flowing headdresses of the Seibal stelae furnish good examples, as may be seen from *h*. This free feather-work is represented in architecture by the example figured in *j* that occurs, according to Stephens,[1] on the House of the Birds at Uxmal. Occasionally attempts were made to give the finer details of feathers, as appears in *c*, which may represent a turkey plume. Notched margins are likewise seen on some representations of long feathers occurring on the monuments. Feather cloaks and aprons are commonly worn by the elaborately attired figures on the stelae. Specially beautiful examples of these are found at Piedras Negras and Naranjo.[2] The apron of Stela D at Copan is reproduced in *b*, while in *i* is given the more elaborate one of Stela 7 at Piedras Negras.

FIG. 107. — Head showing manipulations of feathers to fill out corners: Yaxchilan.

One of the most noteworthy features of feather-work is the service it pays to composition. The Maya artists frequently balanced their designs by sweeping plumes. Fig. 107 illustrates the use of feathers in filling up corners. The feather-work of the Maya never becomes stiff and heavy. The curves are those natural to drooping feathers and quite in contrast to the rather tortuous curves derived from the serpent.

Miscellaneous Animals. Besides the classes of figures that have already been considered, examples may be given of many other animals, of bats, of fish and shells and of plants. Some of these play very minor rôles and are presented without elaboration. Others were apparently of some religious significance and show modifications towards anthropomorphism. It is possible that some of the latter were of ancient totemic importance.

According to Förstemann,[3] the snail denoted the winter solstice and the tortoise the corresponding period of the summer. Both are represented in the codices and the sculptures, but under somewhat different conditions. The hieroglyph for the month Kayab, in which the summer solstice falls, is explained by Förstemann as the head of the tortoise, but it seems almost certain that this head represents the blue macaw, as may be seen by the spiral hook under the eye, the dotted circle around the eye and the nasal opening at the upper part of the bill (compare the typical glyphs[4] with Fig. 102, *a* and *b*). The tortoise

[1] 1843, I, p. 311.
[2] Maler, 1901, pl. 21, seated figure, and Maler, 1908, *b*, pls. 30, fig. 2, and 35, fig. 2.
[3] 1902, p. 27, and 1906, p. 161, etc.
[4] Bowditch, 1910, pls. 8 and 10.

clearly occurs in connection with astronomical signs in the codices,[1] but its exact significance is open to some doubt. The snail does not seem to have any clearly defined meaning of an astronomical nature.

The Altar of Stela C at Copan is carved in the form of a tortoise or turtle,[2] but the so-called Great Turtle Altar at Quirigua is not properly a turtle but an extremely elaborate example of the composite animal aready described as the Two-headed Dragon. Small turtle carvings form a sort of frieze on the House of the Turtles at Uxmal. The most striking use of this reptile in art is seen at Chichen Itza, where it reaches the anthropomorphic stage. Here the carapace of the turtle incloses the middle part of the human body. This figure may be studied on the façade of the Iglesia, where it is represented in high relief, and on columns and jambs of the Castillo, the Temple of the Tables and other buildings, where it occurs as an atlantean or caryatid motive in low relief. The turtle is drawn realistically on the piers of the Lower Chamber of the Temple of the Jaguars.

The snail, so called, is represented in combination with human form

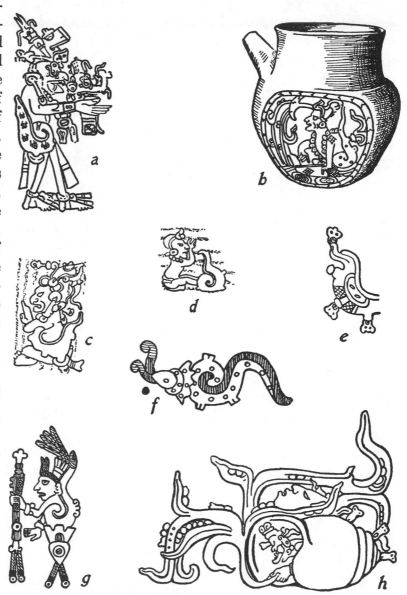

FIG. 108.—Shells and figures associated with them: *a*, Codex Peresianus; *b*, Chama; *c* and *d*, Dresden Codex; *e*, Tikal; *f*, Codex Nuttall; *g*, Codex Borgia; *h*, Palenque.

much more often than the tortoise, and occurs not only on the buildings at Chichen Itza just referred to, but also in the codices and on objects of minor art such as pottery. The word "snail" is commonly used, but there are no means of telling whether the shell represented belongs to the snail or to some other mollusk. According to Tozzer and Allen[3] the shell is probably that of the *Fasciolaria gigantia*, which is the largest known American shell and is found along the coast of Yucatan.

In Fig. 108 are given a number of representations of the human form com-

[1] For instance, Tro-Cortesianus, p. 37; Peresianus, pl. 24. [2] Gordon, 1896, p. 40. [3] 1910, p. 296.

bined with a shell. The first example is from the Peresianus Codex, and shows the personage which Schellhas[1] calls God N, the God of the End of the Year. Seler,[2] however, names him the Old Bald-headed God, and suggests that he governed the moon. He is probably related to God D, the principal Roman-nosed

FIG. 109. — God N: Dresden Codex.

God. Usually, but not always, this God N wears a large shell from which the upper part of his body seems to emerge. A drawing of this god from the Dresden Codex without the shell appendage is given in Fig. 109. It is worthy of note that the tun glyph or year symbol often appears on the headdress. Mr. Dieseldorff excavated near Coban on the highlands of Guatemala several pieces of pottery that have painted or incised representations of the Shell God: one of these is presented in Fig. 108, b. Sculptured figures on buildings at Chichen Itza often have a shell attached to the body (Fig. 110). Differing somewhat from these is the small childlike figure sitting under water with his feet in a shell (Fig. 108, d). Among the Nahua the snail was commonly associated with birth and death, as in the drawing from a Mexican codex that is reproduced in Fig. 108, g. In the lower, right-hand corner of the Tablet of the

Foliated Cross at Palenque is a shell (h) in which is partially concealed the Long-nosed God. From the hands of this god issues a plant amid the leaves of which is a face resembling that of the Maize God. The shell in this connection probably appears as an indication of water. The shell that is shown in top or profile view on the headdress of the rear head of the Two-headed Dragon needs no further comment. It probably is a sign indicating water, and apparently has no connection with the so-called Snail God. So much for this conflicting evidence concerning shells combined with the human body.

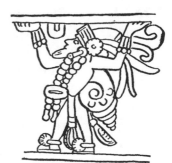

FIG. 110. — Man with shell attached: Chichen Itza.

Representations of shells occur as details of dress on many of the stelae. A common girdle ornament is given in Fig. 111, the principal part being a central group of three pendants probably cut from large shells. Smaller shells, resembling the olive shell, sometimes form a fringe at either side, as in b and c.

The head of the leaf-nosed bat makes the hieroglyph for the month Zotz,[3] which means bat in the Maya language. Upon the back of Stela D at

FIG. 111. — Shell girdle ornaments: a, Palenque; b, Ikxun; c and d, Copan.

Copan this month glyph (Fig. 112, a) is given its full form and the membranous wings clearly represented. The Bat God was probably a deity of considerable importance[4] both among the Maya and the surrounding nations. Elsewhere at Copan he is represented with a human body but with the same upturned nose (Fig. 112, b and c). The more or less humanized figure of the bat with wings outstretched occurs as a painted decoration upon pottery from the Uloa

[1] 1904, pp. 37–38.
[2] 1902–1908, III, pp. 593–595.
[3] Bowditch, 1910, pls. 7 and 9.
[4] Seler, 1902–1903, pp. 112–115.

Valley [1] and from the highlands of Guatemala.[2] A fine example is also found on the remarkable stucco reliefs of Acanceh in northern Yucatan.

Animals such as the deer, the dog, the peccary, etc., are usually represented with little variation from the natural form. The first-mentioned occurs rather

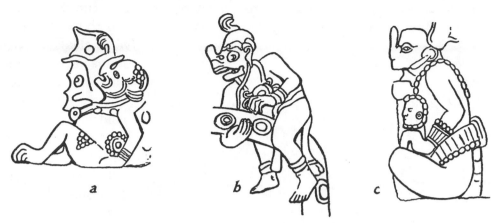

Fig. 112. — Anthropomorphic figures of the bat: Copan.

frequently in both the sculptures and the manuscripts (Fig. 113). The dog is given a ceremonial importance in the codices. From the body markings it has been determined that a domesticated species is represented. Other animals are not of enough interest to be presented in a detailed study at this time.

Fig. 113. — Realistic drawing of a deer: Dresden Codex.

The principal occurrence of vegetable life has already been noticed under the discussion of the fish and water-plant motive.

Bones and Death. The frequent representation of death and its attributes is responsible for the more gruesome aspects of Maya art. Symbols of death are found everywhere in the codices and sculptures. Bones and death's heads even occur as motives for architectural embellishment. Maya religion seems to have been strongly dualistic and to have been concerned with the unceasing conflict between good and evil, life and death. If we may

Fig. 114. — Representation of human sacrifice: Piedras Negras.

credit the evidence of the art, repeated many times over, the Death God rode supreme over all the other deities. Perhaps the explanation is that death and destruction were within the sphere of every god if he cared to extend his powers beyond a given point. The dual natures of the general divinities called the Long-nosed God and the Roman-nosed God have been explained by examples. The power of the Death God over good crops and over women in childbirth is strikingly represented in the codices. Propitiation against death was accomplished at the cost of life. Although human sacrifice was not so excessive as among the Mexicans, still it existed and is clearly represented on page 3 of the Dresden Codex as well as in Fig. 114 from Piedras Negras and in a number of cases at Chichen Itza.

The usual representations of skulls, skeletons and separate bones show some curious and characteristic features. A typical collection is given in

[1] Gordon, 1898, *a*, pls. 1, fig. 11, and 3, *b*. [2] Dieseldorff, 1894, *b*.

Fig. 115. In *a*, *b*, *d* and *h* are shown long bones. As a rule, they have knobbed ends, the knobs being two or three in number. On the enlargement at each end of the bone are usually two circles or crescents, while a wavy line runs along the middle of the shaft. Most ear and nose plugs as they occur on the monuments of the southern Maya cities appear to represent bones. In *g* the ear plug of an old man (the Roman-nosed God?) upon a tablet at Palenque shows three bones

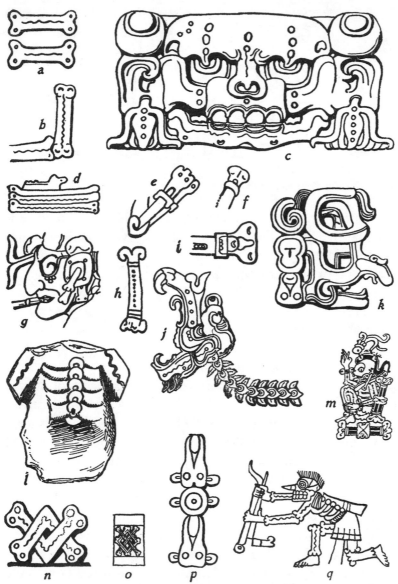

very clearly. Usually bones are somewhat conventionalized as follows. An encircling band is first placed below the enlargement at the end of the bone (*h* and *e*), then the head of the bone, already possessing the small circles or crescents, is modified into a simple face. Such little faces are given in *f* from the headdress of Stela H and in *i* from the nose plug of the large conventionalized face on the back of Stela B, both at Copan, while *k* and *p* represent similar devices from Palenque. Long bones as motives for architectural decoration are given in *n* and *o*, the first from Tikal and the second from the environs of Uxmal.

The characteristic death head is usually grotesque rather than strictly realistic, as may be seen from *c* taken from Altar R at Copan. Here death is indicated

FIG. 115. — Various representations of bones and death: *a*, Chichen Itza; *b*, *c*, *f*, *i* and *j*, Copan; *d*, *e* and *n*, Tikal; *g*, *k* and *p*, Palenque; *l* and *o*, Uxmal; *m*, Dresden Codex; *q*, Mexican codex.

principally by the presence of circles, ovals and crescents on the forehead, the jaws, etc. The eyes show little modification, while the nasal cavity of the skull is inadequately represented. The setting of the teeth in bone rather than in the gums is indicated by the use of double and triple outlines. Although the face seems intended to represent a bleached skull, yet the ears are drawn in full flesh. Similarly in many other delineations the hands and feet are represented entire, while the legs, arms and other parts are bare bone. The torso of a skeletal figure from Uxmal that is now in the American Museum of Natural History is

reproduced in *l*. Often bodies are represented practically entire yet with certain symbols which indicate death. A device resembling a percentage sign and often called the maggot symbol surely indicates death. Dotted lines connecting small circles as well as black spots and closed eyes appear to do the same.

The Death God has been called God A by Schellhas,[1] who gives full information concerning his attributes and associations. An elaborate representation of the Death God seated on a throne made of bones is given in *m* of Fig. 115. Note the use of lines or circles and dots along the limbs and the full-fleshed hands and feet. A frequent characteristic of the Death God is a spiny back, made so by projecting vertebrae (Fig. 116). The hieroglyphs of the Death God have been definitely determined. They are found in many places where the figure is absent and seem to indicate misfortune and failure. The attributes of the Death God appear in connection with many conceptions represented on the monuments. In particular the rear head of the Two-headed Dragon has, as we have seen, a bone for the lower jaw. Many other figures of the Long-nosed God are also characterized by this gruesome feature. On Stela I at Copan the double-headed serpent that forms the Ceremonial Bar is a thing of dry bones, as may be seen from Fig. 115, *j*, which reproduces part of it. The heads in the mouths of this object represent the Roman-nosed God.

FIG. 116.—Death God: Dresden Codex.

The importance of the death element in the hieroglyphs is easily illustrated. The day Cimi and the number ten are represented in the four ways shown in Fig. 117: *a* is the face of a dead person characterized by the closed eye, *b* is the so-called maggot sign, *c* is a face bearing this sign and *d* is a skull. The face glyphs for numbers from 11 to 19 are often merely the faces from 1 to 9 with added death symbols such as a bone for the lower jaw. The same feature usually occurs in the face forms of the tun glyph.

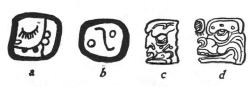

FIG. 117.—Glyphs indicating death: *a* and *b*, Dresden Codex; *c*, Quirigua; *d*, Copan.

Grotesque Figures. Figures which according to European standards would be termed grotesque occur frequently in Maya representative art. In some cases the grotesque character seems to have been taken seriously as a means of expressing a supernatural quality. Most of the representations of gods in the codices are grotesque in many of their features. The manikin figure derived from the serpent is certainly grotesque, and by this grotesqueness the reptilian nature of this god in human form is made evident to anyone. The methods used by Maya artists to produce grotesque figures and effects are much the same as prevail elsewhere. Some are true composites, while others show purely fanciful exaggeration.

The elaborate bird forms in some of the initial series inscriptions have already been commented upon. Very similar forms appear on various parts of the so-called Great Turtle Altar at Quirigua (Plate 2). At first it seemed possible that some cryptic inscription was contained in these figures, but the possibility of this is slight. Examples of these grotesques have been given in Fig. 32.

[1] 1904, pp. 10–15.

Conscious manipulation on the part of the artist is shown in faces which might be described as reversible. Fig. 118, *b*, presents such a face from the Great Turtle Altar. As it stands, this represents a grotesque human face with a knob nose, a protruding tongue and a fringe of beard. When this face is inverted, it becomes an elaborate but typical bird head. A small figurine of a fish attached

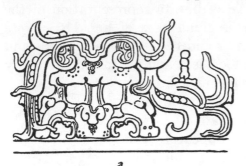
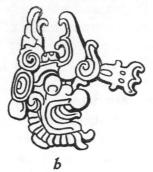

a b

Fig. 118. — Grotesques: *a*, head with three faces, Palenque; *b*, inverted bird's head, Quirigua.

Fig. 119. — Fish with a face on its back, attached to shell: Chajcar.

to a shell is shown in Fig. 119. A very good likeness of the Long-nosed God may be seen along the back, facing in the opposite direction, the posterior dorsal fin of the fish forming the nose of the god. The breast ornament of Stela N of Copan is also a reversible face. Maudslay[1] has commented on the straps that hang from the girdles of stelae at Copan. In a number of cases the wrapping at the top of the straps forms part of an inverted head (Fig. 120).

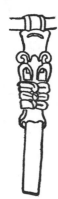

Facial expression is more highly developed in grotesque than in realistic sculpture. The elaborated initial series glyphs, already referred to, have many figures showing grimaces and other violent distortions of the face.

Maize God. The Maize God which Schellhas[2] has termed God E usually bears upon his head the kan sign, which represents a grain of maize. To the latter is ordinarily attached a growth of some sort that may either represent an ear of maize surrounded by leaves or a young sprout. The simple kan sign is basis of the glyph for the day, Kan (Fig. 121), and likewise occurs in many other situations. Offerings of maize cakes are indicated in the codices by bowls containing kan signs. The sign is also placed in juxtaposition with some of the gods to indicate powers favorable or unfavorable to good crops. The kan sign in connection with the ear of maize or the sprout, whichever it may be, is shown

Fig. 120. — Girdle strap wrappings modified into an inverted face.

in Fig. 122, *d*. This latter object is sometimes represented as a curiously conventionalized serpent head of which the eye at the top is the most conspicuous feature. According to Schellhas the head of

Fig. 121. — Glyphs of the day Kan.

the Maize God was itself evolved out of this object. In this statement, however, he probably goes too far. Sometimes, as in Fig. 122, *b*, the face and the headdress are very closely combined or even fused together. Sometimes the face is divided into a forward and a backward part and the two divisions differentiated in color. But as often as not the face and form of the Maize God is

[1] 1889–1902, I, p. 37. [2] 1904, pp. 24–25.

youthful, beautiful and of a purely human type (Fig. 122, *a* and *b*). The Maize

God, apparently represented as newly born, and with the umbilical cord still attached, may be seen on Plate 19 of the Peresianus Codex (Fig. 122, *c*).

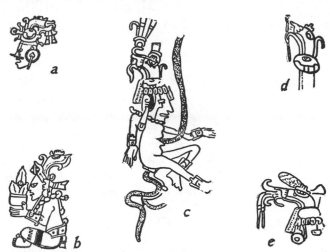

FIG. 122. — Various representations of the Maize God: *a* and *b*, Dresden Codex; *c–e*, Codex Peresianus.

On the monuments the representation of this god may be discerned in the youthful figure with a leafy headdress, examples of which are given in Fig. 123. It occupies a secondary position on the monuments, but the characters are constant and are, moreover, consistent with those appearing on the figures in the codices. On Stela H at Copan several small human beings of this type, Fig. 123, *e*, may be seen climbing round and over the interwoven bodies of serpents. At Quirigua the occurrence is similar (*f*), while at Tikal the head shown in *b* thrusts itself out of the eye of a richly embellished serpent head, the upturned nose of which is shaped into the face of the Roman-nosed God (Fig. 96, *g*). In all these drawings the determining feature is the bunches of circles enclosed in leaflike objects that may represent the ear of maize or bursting seed pods. In an interesting stucco decoration in the Palace at Palenque (Fig. 123, *a*) are shown comparable circular details as well as maize ears rather realistically drawn, while the god himself appears at the top of the design. De-

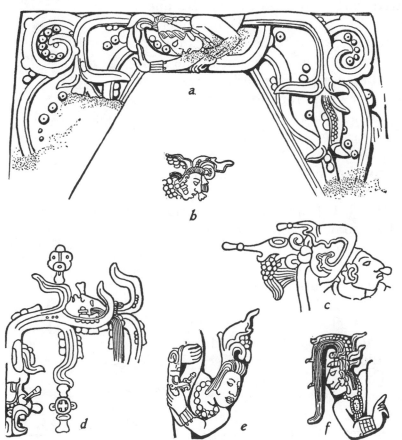

FIG. 123. — The Maize God in the sculptures: *a* and *d*, Palenque; *b*, Tikal; *c* and *e*, Copan; *f*, Quirigua.

tails which seem to represent ears of maize or bursting pods are recorded in a drawing by Waldeck [1] of one of the now lost tablets of Palenque. The maize

[1] Maudslay, 1889–1902, IV, pl. 86.

ears in this instance seem to depend from the inverted head of the Long-nosed God. The form of the Maize God in all these instances is distinctly human and in marked contrast to the other deities so far considered. The beautiful sculpture[1] from the façade of Temple 22 at Copan which Maudslay calls a "singing girl" may represent the youthful Maize God. Other comparable figures from the same building are in the Peabody Museum (Plate 26, fig. 3). The headdress resembles that of this deity as given in the codices. There is clear enough evidence that the faces and figures of the Long-nosed God, the Roman-nosed God and the Death God were used to decorate the façades of temples in this city, and the usage may have included other deities as well. Two sculptured stones from the terrace east of the Great Plaza at Copan doubtless bear representations of the Maize God.[2] The figures are human. The headdress has the usual sign of the growing plant surmounted by a small face of the Long-nosed God.

FIG. 124.—God C and his hieroglyph: Dresden Codex.

The Maize God seems to have been a divinity with little absolute power. He is frequently shown in the codices under the protection of the benevolent gods, B and D, or under the malign control of the Death God whom Schellhas calls God A.

The Maize God seems to bear some relation to the numbers eight and eighteen,[3] because his face occurs in some instances as the glyph for these numbers. The higher number shows, of course, the usual death signs in addition to the natural features.

FIG. 125.—God C with a mottled green body: Codex Peresianus.

Other Divinities. The following gods according to the system of Schellhas have already been considered in more or less detail: A, B, D, E, G, I, K and N. In addition to these many other forms that do not fall into this category have been taken up. There remain a number of fairly well-defined gods who deserve brief comment.

a

c

d

b

e

FIG. 127.—Hieroglyphs containing face of God C: a, Palenque; b, Copan; c–e, Tro-Cortesianus Codex.

FIG. 126.—God C: Tro-Cortesianus Codex.

God C, the god of the North Star or the northern sky, has very characteristic features. Figs. 124, 125 and 126 present drawings of God C from each of the three Maya codices. The face of this god was found a number of times as a hieroglyph during the exploration of the Hieroglyphic Stairway at Copan, one of the original stones now being in the Peabody Museum. It also occurs in various other inscriptions (Fig. 127) and in astronomical bands on several of the monuments. No extensive use of this god's figure has come to light in the larger sculptures.

Gods F and H have not been clearly identified in the sculptures. The first

[1] Maudslay, 1889–1902, I, pl. 17, a and b. [2] Gordon, 1896, p. 2. [3] Bowditch, 1910, pls. 16 and 17.

is a god of war who has human form. It is possible, of course, this portrait appears in some of the sculptures that deal with warfare and conquest. The second god is called the Chicchan God because he has certain markings on his face that resemble the markings on the serpent body and on the glyph for the day Chicchan. He also seems to be a warlike divinity. Seler calls this god the Young God. He may perhaps be identified with the head having purely human features that rarely appears in the serpent mouth (Fig. 24). As a rule, the head in the serpent mouth belongs to the Long-nosed God group or to the allied group of the Roman-nosed God.

Gods L and M are represented in the manuscripts with black bodies. The latter according to Schellhas may be identified with Ekchuah, the black god of the traveling merchants. Goddess O represents an old woman; few representations of her occur. God P has been called the Frog God. The frog is represented with some frequency on the monuments and seems to be the original of the uinal glyph that represents the month. This connection appears to be purely phonetic, however, since "uo" means frog and "u" month.[1]

Astronomical Signs. Bands of astronomical symbols have already been many times referred to and compared in a general way. There is considerable uncertainty concerning the exact significance of many of the individual symbols. It is probable that the sun and moon, the important planets, and the larger constellations were represented specifically and that there were other signs that were general and inclusive in their meaning.

It has already been demonstrated that one of the so-called astronomical symbols is the conventionalized face of the Roman-nosed God (Fig. 128, a). The sign probably signifies either the sun

Fig. 128. — Sun symbols: a, Palenque; b, Yaxchilan; c and d, Dresden Codex.

specifically or the more general idea of day or light. Its importance is indicated by the fact that in one case it occupies the entire space at the side of a monument (Fig. 92) and in another alternates with the unusual Caban sign (Fig. 91, f) that may represent its opposite, which might be the moon, or perhaps darkness.

The usual form for the sun is the normal kin sign (Fig. 128, b), which consists of an oval or oblong with one or more marks extending inward from the middle of each side. Sometimes a circle occurs in the center.

Dr. Seler [2] includes in this group of sun symbols the forms with dotted diagonals (Fig. 128, c and d), which Förstemann considers to be symbols for the planet Mercury. Mr. Bowditch,[3] however, shows that the calculations in the Dresden Codex upon which the supposition is based do not agree very closely with the periods of revolution of this planet. The sign is of very frequent occurrence, both in the sculptures and in the manuscripts.

Another form which may represent the sun is less commonly encountered. It is more or less circular, with a normal kin sign in the center and a serpent head projecting outward at four points. As an astronomical symbol it may be seen on Stela 10 at Piedras Negras[4] and perhaps in the upper division of Stela 1

[1] Bowditch, 1910, pp. 257–258. [2] 1901–1902, pp. 165–166. [3] 1910, p. 228. [4] Maler, 1901, pl. 19.

and in the upper left-hand corner of Stela 4 at Yaxchilan.[1] As a medallion decoration on piers it occurs at Palenque,[2] where it incloses a head. It likewise is found in the Peresianus Codex.[3] In the frescos of Chichen Itza a sun disk is represented with a serpent head projecting on the four diagonals (Fig. 129). This sun disk is itself a Nahua and not a Maya concept, but the four serpent heads in connection with it may hark back to a genuinely native origin.

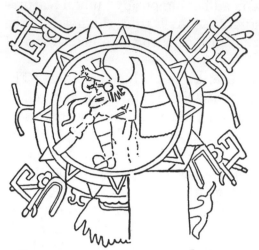

FIG. 129. — Sun disk represented in fresco: Chichen Itza.

A symbol which Förstemann considers a moon symbol (Fig. 130, a) occurs very frequently in the codices on terms of equality with the kin sign in the heraldic shields which are attached to the under sides of astronomical bands. It represents in a cursive and a demotic manner an ornamented eye or a partial face. This symbol is very similar to the sign for twenty in the codices as well as to the hieroglyph for God D, the principal phase of the Roman-nosed God in the manuscripts. Dr. Seler[4] considers these signs to represent the bloody sockets of gouged-out eyes, the hieroglyphs of Itzamna, whom he considers Lord of Life and of the Milky Way. He is probably right in the general conclusion that the face represents a god who takes the form and features of an old man. But the points upon which the interpretation is made appear highly fanciful and hardly to be supported by objective study. Ornamented eyes are of very general occurrence, and in most cases where circles are drawn beneath them there is no other evidence of "gouged sockets." It seems probable that this cursive face should be correlated with

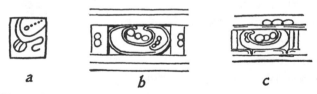

a b c

FIG. 130. — Symbols that may represent the moon: a, Dresden Codex; b and c, Palenque.

the rectangular presentation of the Roman-nosed God that has just been considered (Fig. 128, a). This symbol that occupies so prominent a place in the monuments does not appear in the manuscripts unless under the present guise.

As for the crescent-shaped symbols (Fig. 130, b and c) which Dr. Seler in the same passage associates with the symbol of the ornamented eye, just considered, a comparison of other forms does not seem to support his conclusions. The form occurring on Stela 10 at Piedras Negras[5] clearly shows a head inclosed in the deep crescent. The most interesting example of this figure is seen in the upper right-hand figure of Stela 4 at Yaxchilan, where it is in a position of opposition to the circular sign with the four serpent heads. It is of course quite possible that these crescent symbols should represent the moon. They also resemble one of the glyphs of the so-called Supplementary Series.[6] The symbols of the planet Venus are pretty well ascertained. There are two principal forms, as

[1] Maler, 1903, pls. 69 and 70. [3] De Rosny, 1887, pl. 21. [5] Maler, 1901, pl. 19.
[2] Maudslay, 1889–1902, IV, pl. 6. [4] 1901–1902, pp. 166–167. [6] Bowditch, 1910, p. 244.

shown in Fig. 131, *a* and *b*. Also there are many irregular or unusual forms that include one of these simple signs combined with an animal or some other object. Venus symbols are of very common occurrence not only in astronomical bands but also as details on various sculptured figures and in the hieroglyphic inscriptions. In fact, some of the most extensive inscriptions may refer largely to the correlation of the solar and Venus years. An extended passage in the Dresden Codex is given over to this

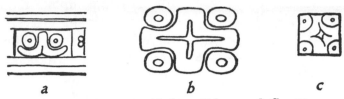

subject.[1] Some of the variant signs of the Venus symbol doubtless refer to different appearances and conjunctions of this planet. Gordon[2] derives the Venus symbol of the first type from the con-

FIG. 131. — Venus symbols: *a*, Palenque; *b*, Copan; *c*, Dresden Codex.

ventionalized jaws of the serpent. But the stages of this development are not very clear if you omit the doubtful forms that occur in Nahua art. The second type seems, however, to have developed from the first by a simple folding over or reduplication.

Another sign which is pretty well settled as to its significance represents the face of God C, the divinity who rules the North Star or the entire northern sky. This sign occurs more frequently in the codices than on the monuments.

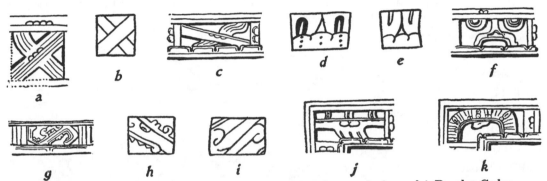

FIG. 132. — Planet symbols: *a*, Copan; *c*, *f*, *g*, *j* and *k*, Palenque; *b*, *d*, *e* and *i*, Dresden Codex.

A symbol in the form of a cross (Fig. 132, *a-c*) is exceedingly common. It probably has some very general meaning such as the sky as a whole. This sign frequently occurs as a hieroglyph and upon headdresses. The symbol which resembles Akbal may mean night or it may have some more specific meaning. Comparable forms in the manuscripts and monuments are given in the text (Fig. 132, *d-f*). This symbol has been referred to the planet Jupiter on rather doubtful grounds.[3] The symbol which shows a serpent head arranged diagonally in the oblong panel (Fig. 132, *g-i*) has been similarly ascribed to Saturn. Other symbols of less frequent use are shown in Fig. 132, *j* and *k*, as well as in Figs. 5, 6, 83 and 89.

Hieroglyphs. The Maya hieroglyphs have been so many times referred to in the text that it seems hardly necessary to accord them here more than a general treatment. Although at the present time few of the hieroglyphs have been deciphered, the task does not seem to be an insurmountable one. A large part of

[1] Bowditch, 1909. [2] 1905, pl. 6. [3] Bowditch, 1910, pp. 229–231.

the inscriptions have to do with astronomical calculations which introduce certain absolute factors. In fact, the glyphs connected with numbers and the calendar are now pretty well ascertained, including the so-called period glyphs and the numerals from one to twenty, and the signs for each of the twenty days and for each of the eighteen months. The hieroglyph for the extra period of five days used to complete the annual calendar is also known as well as the signs

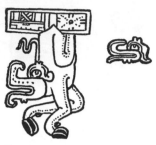

Fig. 133. — Composite monster and its glyph: Dresden Codex.

for zero or completion. Some of the hieroglyphs which refer to certain heavenly bodies and to certain gods have been isolated. The symbols for the four directions have been determined with considerable certainty as well as a few other signs of lesser importance. It may be remarked, *en passant*, that the results of Le Plongeon[1] and Brasseur de Bourbourg[2] are of very little value so far as the decipherings of inscriptions are concerned. Nor has the so-called alphabet of Landa[3] proved of much service, although it was evidently taken down in good faith.

Most of the Maya hieroglyphics are probably ideographic and consist of abbreviated pictures of the thing intended or of some object connected with it. In Fig. 133 we see a representation of some mythological conception and the glyph which refers to it. The glyph that probably stands for the rear head of the Two-headed Dragon contains, as we have seen (Fig. 82), the three peculiar signs of the headdress and the sun sign on the forehead.

It seems pretty clear that certain symbols have a phonetic value, probably of the syllabic rather than of the alphabetic type. This phonetic character is particularly demonstrable in words containing the syllable *kin*, which may be represented by the sun symbol. But it is extremely doubtful if there was a complete syllabary adapted to narrative texts. The general status of writing was probably much like that of the Valley of Mexico, which has been explained by Brinton, Peñafiel and others, although it is possible that the range of subjects was somewhat greater. The

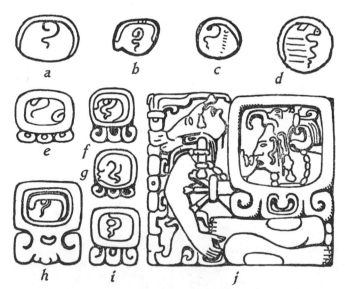

Fig. 134. — Series showing modifications of glyphs: *a* and *b*, Cib; *c–j*, Caban; *a*, Peresianus Codex; *b*, Dresden Codex; *c*, Tro-Cortesianus Codex; *d*, Landa; *e*, Copan; *f–j*, Quirigua.

Nahua seem to have learned this valuable art from their southern neighbors. Many points of divergence in the two areas must be ascribed to the differences in organic structure in the two languages as well as to the different standards of art.

In addition to what is now known we may expect to find in the Maya inscrip-

[1] 1886 and 1896. [2] 1869–1870. [3] 1864, pp. 316 *et seq.*; Valentini, 1880; Brinton, 1894, *b*.

tions some hieroglyphs that give the names of individuals, cities and political divisions and others that represent feasts, sacrifices, tributes and common objects of trade as well as signs referring to birth, death, establishment, conquest, destruction and other such fundamentals of individual and social existence. Juxtaposition of these hieroglyphs together with directive signs and dates would make possible records of considerable accuracy. On many of the monuments the small number of hieroglyphs left, once all the dates have been eliminated, suggests that such an abbreviated system of writing was in vogue.

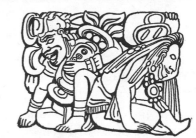

FIG. 135. — Hieroglyph with entire figures: Stela D, Copan.

As to names of individuals or cities, it is worthy of note that several of the sculptures show hieroglyphs over the heads or upon the bodies of human beings. These might very well be names (Figs. 10 and 17). The hieroglyphs over the heads of the warriors in the processions shown on the walls of the Lower Temple of the Jaguars at Chichen Itza may represent cities rather than individuals. They are of Nahua rather than Maya type, however.

The degree of variation in the Maya hieroglyphs that have been ascertained is very great, as may be seen from the series collected by Mr. Bowditch.[1] Fig. 134 presents a series of glyphs of the day Caban which are unusually consistent. The characteristic feature is the corkscrew curl. But even this feature reappears in other glyphs, particularly in the forms for the day, Cib, from the codices. An example of elaboration is given in Fig. 135 from Stela D at Copan. The essential features of the hieroglyph seem to be those that are carried in the arms of the two human figures. Other examples of complicated hieroglyphs have received comment. It is apparent from these examples that the study of the art is very necessary if one is to arrive at an understanding of the subject matter expressed in these abbreviated or elaborated pictures.

[1] 1910.

II. CONSIDERATION OF THE MATERIAL ARTS

ARCHITECTURE

Assemblage. The mapping of the principal Maya ruins has disclosed several styles of assemblage of the city as a whole, each of which seems to have a fairly definite geographical distribution and at the same time a topographical explanation. The clear types will here be briefly described as well as some of the apparent transitions.

Most of the Maya cities were built upon level ground, either extensive plains or valley floors. Where such was the case the assemblage was unhampered and followed the fashion of the region or perhaps of the period. But in some instances — particularly in the western part of the Maya area — the cities were hemmed in by hills and streams. Here the assemblage had to adapt itself to surroundings, but doubtless the builders attempted to preserve as much of the usual order as they could.

Perhaps the most careful and elaborate grouping of the city as a whole is seen at Copan.[1] In this place there is a massive platform mound, a sort of artificial acropolis, with terraces and sunken courts at various levels. Rising from the flat of this principal mound are small pyramids of the usual type crowned with temples. The great mound overlooks an extensive plaza in which are set up stelae. The plaza is surrounded by a stepped wall as if it were a sort of theater. The so-called sunken courts are also inclosed by stepped walls and are drained by tunnels that pass under the walls. Most of the small mounds which mark the domiciliary structures lie on the opposite side of the great mound from the plaza.

This elaborate mode of grouping may have been intended to obtain a broad architectural effect. While there is apparently no definite orientation, there is an orderly alignment of the buildings and terraces. At Quirigua[2] a very similar assemblage is found, both as regards the form of the artificial acropolis and the use of the plazas in which were set up stelae.

The use of the great platform mound to serve as a base for a number of smaller substructures also characterizes the great ruins of the Peten region. But in these cities the artificial acropolis is perhaps not so conspicuous as in the cities just named. A plan of Ixkun by Maudslay[3] shows an artificial acropolis on which are several pyramids arranged around courts. At Naranjo,[4] near the western end of the city, is a large rectangular mound with a lower adjoining terrace. Upon this large mound are remains of six structures very much destroyed. At the eastern end of the city there is, in all probability, a low but extensive mound which serves as a foundation for the three principal courts with their inclosing structures.

[1] Maudslay, 1889–1902, I, pl. 1; Gordon, 1896, pl. 1.
[2] Maudslay, 1889–1902, II, pl. 2.
[3] 1889–1902, II, pl. 67.
[4] Maler, 1908, *b*, p. 83.

At Tikal there are, according to the recent explorations of Dr. Tozzer [1] and Mr. Merwin, no less than three great foundation mounds that mark out the civic and religious centers of this most important city. These mounds are of considerable height, but do not compare with the great mound of Copan. Upon these mounds are many closely connected courts surrounded by temple and palace structures. The artificial acropolis also occurs at Nakum, La Hondradez and other sites in the Peten region. [2]

The orientation of courts and buildings with strict regard for the four directions prevails among the cities of southern Yucatan that have just been mentioned as well as at Siebal [3] and doubtless other places. It does not occur at Copan and Quirigua, although at these sites there is an orderly alignment of walls and mounds. At Copan an east and west line passing directly across the city seems to have been surveyed with tolerable accuracy and marked by two stelae placed on hills on opposite sides of the valley. [4] Perhaps the most interesting point concerning the use of closely connected and carefully oriented courts is that each court with its associated buildings naturally served as a unit of city growth and that the sequence is more or less exactly indicated by position.

The ruins of northern Yucatan, [5] although situated in a level country, show neither the artificial acropolis nor the careful orientation that distinguishes the cities of the south. Occasionally advantage was taken of slight natural elevations, as at Labna. The irregular platform mounds that serve as foundations for the larger structures may perhaps be considered decadent examples of the early artificial acropolis. The assemblage may be termed haphazard. There are, as a rule, several independent groups of correlated buildings. These independent groups may represent different periods of city growth. In the correlations of buildings within these groups the principle of arrangement is very often that of the rectangular court with one or more buildings on each side.

Yaxchilan, [6] Piedras Negras [7] and Palenque [8] are examples of cities situated in narrow valleys where the topography modified the assemblage. In the first two sites natural hills or ridges were leveled off and terraced. But the buildings erected upon these hills have little exact and premeditated grouping. The same may be said of Palenque. No natural or artificial acropolis occurs at this site, unless the mound that supports the Palace is considered one, but instead a narrow valley, the sides of which were terraced to a considerable height. There is good reason to believe that the artificial acropolis would have prevailed at these cities if the topography had permitted. At Comalcalco, which is even farther west than Palenque, there is, according to Charnay, [9] a massive mound upon which are the ruins of several buildings. The same occurs at Ocosingo or Tonina. [10]

Certain minor features of assemblage will now be presented principally in

[1] Tozzer, 1911, pls. 29 and 30.

[2] Sapper, 1897, p. 360 (Ixtinta) and p. 362 (S. Clemente).

[3] Maler, 1908, a, p. 13.

[4] Gordon, 1898, b, p. 4, gives a map of the environs of Copan, as does Maudslay, 1886.

[5] For plans of Chichen Itza see Maudslay, 1889–1902, III, pl. 2, and Holmes, 1895–1897, pls. 17 and 18. For Uxmal see Holmes, 1895–1907, pls. 8 and 9, and Stephens, 1843, I, p. 165. For Labna see Stephens, 1843, II, frontispiece showing panorama, and an unpublished map made by the Peabody Museum under Mr. Thompson. For Kabah see Stephens, 1843, I, p. 385. For Ake see Charnay, 1885, p. 249. For Tuloom see Stephens, 1843, II, p. 396.

[6] Maudslay, 1889–1902, II, pl. 76; Maler, 1903, pl. 39.

[7] Maler, 1901, pl. 33.

[8] Holmes, 1895–1897, pls. 24 and 25; Maudslay, 1889–1902, IV, pl. 1.

[9] 1885, p. 167.

[10] Sapper, 1897, p. 361.

connection with frontier ruins. Along the Uloa River [1] the influence of Copan and Quirigua may be seen in the arrangement of mounds and courts. At one of the ancient ruins a crude stela appears in front of the principal mound. The use of sunken courts and of plazas with stelae extends up the Motagua River and over the highlands of Guatemala as far as the Chiapas Valley. Many of the plans of ancient settlements given by Sapper [2] and Seler [3] show similarities to the lowland sites. Careful orientation was not observed. These outlying towns were doubtless provincial in character, and most of them seem to have flourished at a later period than the great cities of the Peten region. The elaborate artificial acropolis is not seen, while the parallel walls of the so-called ball courts present a new and probably un-Maya feature.

Many of the frontier settlements offer definite evidence of fortification that is lacking elsewhere. Tenampua [4] in central Honduras is described as occupying an impregnable position upon a lofty hill and as being further strengthened by surrounding walls. A number of towns in the highlands of Guatemala [5] were placed between barrancas and in other easily defended positions. Of course the artificial acropolis in the great cities may have been partly intended for defense. There is no doubt that warfare was highly and scientifically developed. Stephens [6] describes a wall at Tuloom that seems to have surrounded the city. Upon the frescos of Chichen Itza are represented earthworks behind which warriors are fighting, as well as what may be taken for scaling ladders.

Function of Buildings. Little is known concerning the function of Maya buildings other than that they were largely of a religious nature.

It is possible to distinguish between buildings for strictly ceremonial uses, such as the small temples on lofty pyramids, and other buildings, usually larger and situated on lower terraces, which may have served as dwellings for the priests and the nobility. This latter group includes the great rambling collections of rooms, usually arranged around courts and commonly called palaces. Evidence concerning the differentiation and development of the temple and the palace will appear under various headings.

Towers of several stories were sometimes built, but their use is unknown. The square tower at Palenque, four stories in height, has often been described.[7] A similar structure, not so high, is found at Comalcalco.[8] Maler [9] figures a tower-like structure, with a great stucco face on one side, that occurs at Nocuchich, as well as another tower of more slender dimensions. Round towers occur at Mayapan [10] and at Chichen Itza, the example from the latter city being the famous Carocol.[11] It seems pretty clear that these towers were not intended for observation. None of the towers have pyramidal substructures, and in each city where examples are found there are other buildings that exceed the tower in elevation. The round towers are said to have been associated with the worship of Kukulcan.

[1] Gordon, 1898, a, p. 11.

[2] 1895, a. Map No. 5 (Hacienda Grande); No. 6 (Las Quebradas); No. 8 (Cakiha); No. 9 (Chacujal); No. 11 (Sacramento); No. 12 (Bolonchac); No. 13 (Saculeu); No. 17 (Kalamté); No. 18 (Comitancillo); No. 20 (Sajcabaja).

[3] 1901, c, pp. 100 and 131 (Quen Santo).

[4] Squier, 1858, pp. 133–138, and Bancroft, 1875–1876, IV, pp. 72–77.

[5] Maudslay, 1889–1902, II, pls. 70 (Rabinal), 72 (Utatlan) and 73 (Iximché).

[6] 1843, II, pp. 395–396.

[7] Maudslay, 1889–1902, IV, pl. 39; Holmes, 1895–1897, pp. 179–186.

[8] Charnay, 1885, p. 170.

[9] 1895, pp. 281 et seq.

[10] Stephens, 1843, I, p. 136.

[11] Maudslay, 1889–1902, III, pl. 20.

The ball court or gymnasium seems to have a foreign origin and will be discussed in that connection, together with certain other imported ideas, architectural, decorative and religious. This structure is found in none of the early Maya cities.

The dwellings of the common people in ancient times were probably not essentially different from the huts still made and used by the natives of Yucatan.[1]

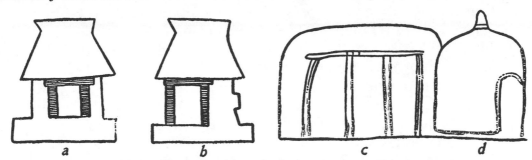

FIG. 136. — Representations of Indian huts in fresco: Chichen Itza.

These huts are generally oval in plan, containing a single room. The framework is of light poles skillfully bound together by withes. The walls are of wattle and mud, while the roofs are heavily thatched with the leaves of the Sabal and other palms. Mural paintings in the Temple of the Jaguars at Chichen Itza represent the ancient dwellings of the lower classes. Examples of these are reproduced in Fig. 136. Near most of the remains of stone temples and palaces there are, according to Mr. Thompson,[2] many evidences of these poorer dwellings. The outlines of the huts may be traced out by the uneven surface of the ground and the three-stone fireplaces uncovered by slight excavation.

Ground-Plans. Some idea of the uses to which buildings were put may be obtained from a study of the ground-plans. The simple room, with the door in

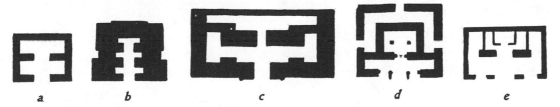

FIG. 137. — Series showing development of the sanctuary: a, Two-roomed Temple; b, Temple I, Tikal; c, Temple 22, Copan; d, Castillo, Chichen Itza; e, Temple of the Sun, Palenque.

the center of one of its long sides, seems to have been the common starting-point for both the temple and the palace type of structures. In the case of the temple this simple room was modified by interior partitions until there was a clear development of the sanctuary or inner sacred chamber, while in the growth of the palace structures there was an agglutinative process by which one room, with or without interior divisions, was simply set up against another. Rarely indeed is there a series of interior doorways connecting the different room units of a large building.

The development of the sanctuary in the temple is indicated in the series of temple ground-plans shown in Fig. 137. The simple two-chambered temple, a step in advance of the single room that served as a starting-point, is shown in *a*. Here

[1] Thompson, 1892, *a*, p. 262. [2] 1892, *a*, pp. 263 *et seq*.

the inner room, getting only the diffused light from the outer door, might fittingly have been considered the holy of holies and the mysterious abode of divinity. Often the floor of this interior room is raised a foot or more above that of the outer room and the doorway and inner walls adorned with sculptures. The temples of Tikal have very massive walls and small cell-like rooms, sometimes three in number one behind the other (Fig. 137, *b*). The wooden lintels over the doorways are in some cases splendidly carved. The ground-plan of Temple 22, at Copan, is given in *c* of this series. The ceremonial importance of the inner chamber of this temple is emphasized by elaborate carvings, representing the Two-headed Dragon supported by kneeling atlantean figures. This design enclosed the doorway. The entrance to the inner chamber of Temple 11, at Copan, is also elaborately ornamented by carvings. The highest form of the sanctuary is seen at Palenque (*e*), in the Temples of the Sun, the Cross and the Foliated Cross. The sanctuaries here are little temples in themselves, roofs and all, and are adorned with the most wonderful native bas-relief carvings of the New World. Some of the temples of Chichen Itza also have well-defined sanctuaries, as may be seen from *d*, the ground-plan of the Castillo. In many temples there is a built-up bench in the sanctuary which may have served as an altar. In some cases table altars have been found in position in the outer room directly in front of the door to the sanctuary.

FIG. 138. — Structures showing the extreme development of the portico: Group of the Columns, Chichen Itza.

Closely paralleling the development of the inner division of the simple temple into a true sanctuary, the outer division becomes a portico. At Copan, Quirigua and Tikal, where the walls are exceedingly massive, the temple façades are broken by but one doorway. As one proceeds toward the north, the walls become much lighter, although at best cumbersome, and two or more doorways, symmetrically placed, give entrance to the outer chamber of the temple. At Yaxchilan nearly all the temples have several doorways. At Palenque the doorways are placed so closely together that the portions of the wall remaining between them are hardly more than piers. At Labna, Chichen Itza and other cities of northern Yucatan these pierlike portions of the wall are often actually replaced by square or round columns. With the extended use of such supports the front room of the temple becomes more and more open. Fig. 138 gives two ground-plans that illustrate this ultimate development of the outer chamber into a light and airy portico. In *a* the sanctuary is a small cell behind a wide open chamber and in *b* the portico has a double row of columns. The buildings showing double rows of columns are found only in northern Yucatan and are of late date. It will be shown in a later treatment that the development of the sanctuary and the portico, that has just been sketched out, is really historical and covers practically the entire chronological range of Maya art.

Some structures, not properly of the one-room origin just described, but consisting of two or more independent rooms, were probably used as temples and not for civil or domiciliary purpose. The House of the Magician at Uxmal is an example. The main temple has three rooms in a row without connecting doorways. The middle chamber of this temple opens in the direction opposite

to the doorways of the end chambers and is, in fact, rendered inaccessible by the Annex built apparently at a later date. The steep and lofty substructure of the House of the Magician would have made it an inconvenient abode. But as a temple it is exceedingly impressive, looking down as it does upon the Nunnery Quadrangle.

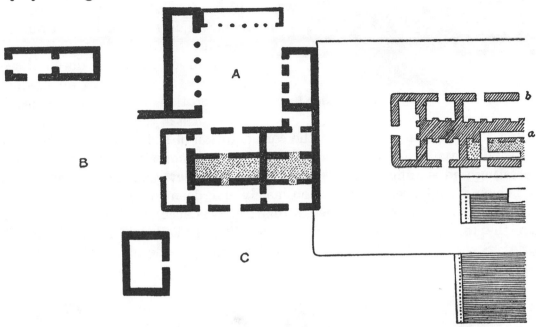

FIG. 139. — Partial ground-plan of the Group of the Monjas: Chichen Itza. Ground-level buildings in black; *b*, second range structures; *a*, third range.

It is difficult, if not impossible, to draw any definite line between the temple and the palace; for it is likely that even in buildings clearly of the latter type there were certain rooms given over to religious rites. A partial plan of the Group of the Monjas at Chichen Itza, after Maudslay, is presented in Fig. 139. This group shows several distinct periods of growth. Moreover, some of the parts seem to show differentiation in use. In particular the small closed court marked A in the plan appears almost necessarily domiciliary. The elaborate frieze decoration of grotesque masks, that characterizes the north and east façade of the eastern ground-level wing, stops abruptly after turning the corner on the south side. The rest is plain. The two buildings which completed the square were of unusually light construction and may even have had wooden roofs. They are in complete ruin and the amount of debris is not great. This secluded

FIG. 140. — Ground-plan: House of Turtles, Uxmal.

court may well have been the abode of the temple attendants. On the other hand, the elaborate decoration of the eastern façade indicates a religious significance for the end chamber. The third story of this building must also have had purely religious uses. A wide stairway leads up to a small single-room structure with an altar-like object in front. The small detached building known as the Iglesia was probably for purely religious uses. The other chambers of this group might have served as a religious college or monastery, or as a chief's palace.

The remarkable symmetry in plan as well as the agglutination of independent

room-units of the larger structures is well brought out in the ground-plans of the House of the Turtles (Fig. 140) and of the Governor at Uxmal [1] and of the Akat'cib at Chichen Itza (Fig. 141). The rooms are either strung out or clustered. The palace structures at Palenque [2] and some of the southern cities often show several groups of rooms adjacent to each other but with disconnected walls.

Elevation Plans. It does not seem necessary to enter into an extended consideration of elevation plans, because most of the important facts concerning them are brought out in the consideration of other subjects. However, the usual Maya method of erecting buildings of more than one story is both interesting and significant and is readily seen from elevation plans. Owing to the cumbersome construction it was ordinarily not deemed safe to put one room directly over another. Nevertheless this feat was accomplished as may be seen from the four-storied tower at Palenque. The so-called Temple of the Five Stories (Structure 10) at Tikal [3] shows three stories, one above the other, and

FIG. 141. — Ground-plan: Akat'cib, Chichen Itza.

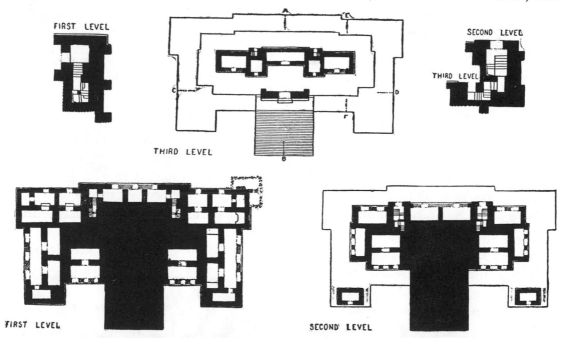

FIG. 142. — Ground-plans: Santa Rosa Xlabpak.

two lower stories at the side of the foundation mound. As a rule, however, the second story was built upon a solid substructure immediately behind the room or rooms of the first story and on a level with its roof. As a development of this method a series of rooms was sometimes constructed entirely around or at either end of a solid mass of masonry. Upon this mass of masonry was built the second story, which might in turn have a smaller core of solid masonry to support the third range of rooms. The principal building of Santa Rosa Xlabpak is a most interesting example of symmetry and fine construction. In Fig. 142 are repro-

[1] Holmes, 1895–1897, pl. VIII. [2] Maudslay, 1889–1902, IV, pl. 3. [3] Tozzer, 1911, pp. 112–113.

duced the careful drawings of Maler giving the floor plans of the three stories of the Palace-temple Tampak, as he calls it, and in Fig. 143 are three typical elevation cross-sections. The masses of solid masonry are shown in black. The first story is on a level with the ground. The rooms open out on all four sides of the buildings and are generally double, one chamber being behind the other. The second story covers a somewhat greater area than the solid core of the first story. The outer walls of the second range of rooms fall in some cases over the interior walls of the first. The third story faces the east and is approached by a broad flight of stairs, at the top of which stands a portal arch. The narrow winding stairway at the back also ascends to the third story (Fig. 142). The rooms at this high level are all single. Stephen [1] calls this building "the grandest structure that now rears its ruined head in the forests of Yucatan."

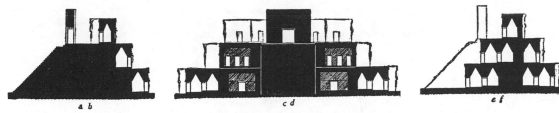

FIG. 143. — Elevations: Santa Rosa Xlabpak.

The Akat'cib at Chichen Itza (Fig. 141) may be compared in certain details to this building. Here the ground-level rooms are finished and the solid mass that was probably intended to support the upper stories is in place, but no second and third story was ever begun. The principal building at Sayil [2] shows all three stories, and is perhaps the most extensive single structure in the Maya area. Other examples of two or three stories built according to the same principle of an interior core might be named.

A peculiar feature of many Maya structures that has frequently been commented upon is the occurrence of rooms that have been filled with earth and stone and sealed up. In almost all cases this seems to have been a preliminary to the construction of second-story rooms immediately above. Examples of such filled rooms are seen in the Monjas at Chichen Itza (ground-plan in Fig. 139). Apparently it was the purpose of the builders to erect a second range of rooms over the East Wing, but this intention was never carried out. The single room of the third story is directly over a filled-up chamber.

Correlation of Buildings. It has been stated that assemblage in northern Yucatan is haphazard as far as the city as a whole is concerned, but that correlation is frequently shown between a number of structures. Of course this is also true in the south, where the cities are generally divided into courts. The grouping of structures around a court likewise occurs in northern Yucatan, but with certain differences. The ground-plan of the Monjas group at Chichen Itza has already been presented. In this group there are several buildings carefully aligned that partially enclose two or more courts. The principal façade is on the north side.

At Uxmal correlation is shown in more unmistakable ways. In the case of the grand Nunnery Quadrangle the group as a whole faces the south. The stair-

[1] 1843, II, p. 162. [2] Stephens, 1843, II, p. 22.

ways are on the south side and in the middle of the South Range of rooms is a portal arch. The North Range is on a higher substructure, and the walls of the building itself are carried higher than usual and are very richly decorated. As

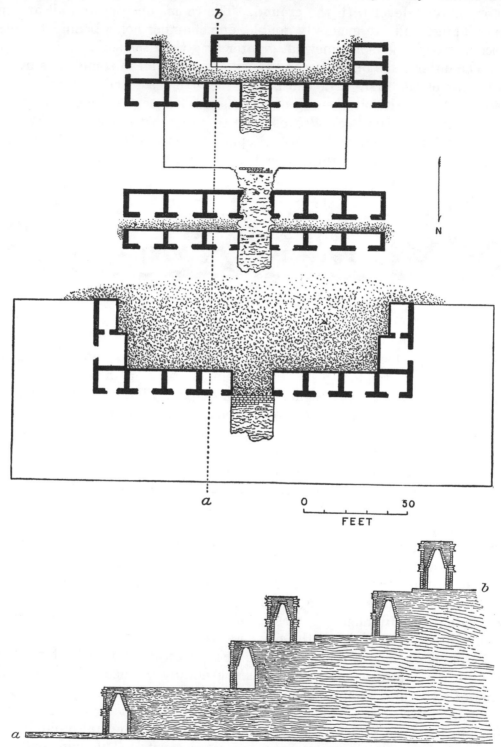

Fig. 144. — Assemblage of Edifice 5, Chacmultun.

a result, this building is visible over the top of the South Range from any point of vantage. The House of the Magician seems to be attached to the southeast corner of the Nunnery Quadrangle, the transition being affected according to

Holmes' plan [1] by two small buildings. It seems likely that the House of the Magician proper is an older building than the Nunnery, since it faces in the opposite direction, but that the Annex to it was built in connection with the latter structure.

The Southwest Group at Uxmal has been clearly presented by Mr. Morley.[2] This group has a four-roomed temple at the southern end, toward which the terraces gradually rise in several levels. Most of the ranges of rooms are built against the side of the next higher terrace. Across the middle of the group extends the House of the Pigeons, with its castellated roof comb and its portal arch (Plate 6, fig. 1). A still more striking development of this idea in a group of much smaller size is seen at Chacmultun (Fig. 144).

The details of Maya construction have been so clearly and admirably described by Mr. Holmes, in his "Archaeological Studies among the Ancient Cities of Mexico," that it is here only necessary to recapitulate the main features. Where, however, a somewhat different interpretation of accepted evidence may have important bearing upon the development of the architectural decoration or upon the connection of the Maya building art with an earlier, more primitive type, then the matter will be discussed more fully.

Substructures. The stone buildings of the Maya, as we have seen, were seldom erected upon ground level, but instead upon artificial mounds. These substructures were apparently not built with an eye to defense (although more or less adaptable to such purposes), but seem to have been purely architectural in function. A large part of the Maya area is without much natural relief, and it might be imagined that the fact led to the use of lofty substructures. But it must be pointed out that these foundation mounds were used as much in hilly country as on the level plain, not only in the Maya area but also in the neighboring Zapotecan and Nahua areas. Often natural elevations were entirely neglected and enormous mounds built up directly from the valley floor, as at Copan. At other sites where the topography was an inevitable factor in the laying out of the city, as at those of the Usumacinta Valley, the natural hills were leveled off or terraced and then artificial substructures reared upon these platforms. Thus it seems clear that the substructure was considered an architecturally valuable feature and one that made directly for grandeur and magnificence quite apart from the question of mere elevated outlook. The pyramid was part of the temple.

The artificial mounds vary much in size, height and shape, but are fairly similar from the point of construction. They usually consist of a solid mass of rubble, mortar and earth faced with cut stone. In many cases it is evident that they were built up by levels. Buried walls and pavements are occasionally found, as in the great acropolis mound at Copan. These may be the remains of the sides and crowns of earlier mounds, which, as the city grew, were found inadequate and so were deeply buried under the new acropolis, or they may be evidences of the method of construction.

It is possible to divide the mounds, as regards size and shape, into two general types, the platform mound and the pyramid. The platform mound includes a great range in contour and elevation, but is marked by the general presence of right-angled corners and irregular terracing. Usually rather low in elevation,

[1] Holmes, 1895–1897, pl. 8. [2] Morley, 1910, a.

they have often several levels, both on the main mounds and on the ells, which are of frequent occurrence. These platform mounds serve as foundations for the larger and more irregular structures. The artificial acropolis that has already been described may perhaps be thrown into this class, although it is a communal rather than an individual substructure.

The pyramids are truncated, usually rectangular, although some have rounded corners, and rise in a series of either vertical steps or slanting terraces. Many

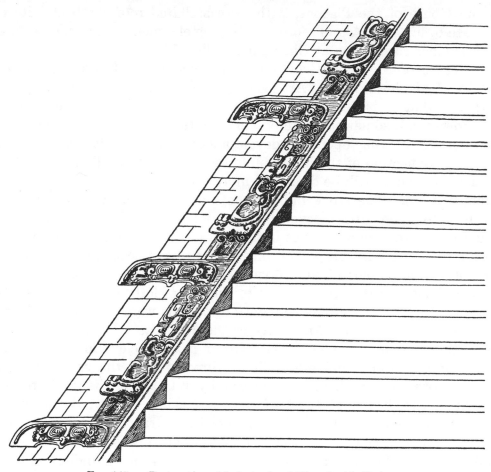

Fig. 145. — Restoration of balustrade of Hieroglyphic Stairway.

variations in form are found. In height the pyramids run from twenty to one hundred feet. The pyramids of Tikal are the highest and the steepest in the Maya area. There are many lofty pyramids in northern Yucatan. The temples of the Usumacinta region are placed, as a rule, on low pyramids.

A very effective decoration was obtained by the use of sunken panels in the stone casings of the various terraces, as may be seen on the pyramid of the Castillo [1] at Chichen Itza and on that Temple I at Tikal.[2] Ornamental stonework of simple but agreeable character may likewise be studied on the very steep pyramid at Rio Beque which has been described by the Comte de Périgny.[3] Sometimes each terrace wall was provided with a simple cornice. The upper part of the substructure of the Monjas at Chichen Itza bears a frieze of mask panels (Plate 28, figs. 3 and 4). Plastic decorations in stucco and painting upon

[1] Maudslay, 1889–1902, III, pl. 56. [2] Maler, 1911, pl. 2. [3] Périgny, 1908.

a plaster base may also have been used to adorn certain substructures. Scanty traces of such decorations are still to be seen.

Stairways were constructed on one or more sides of the pyramids and platform mounds. They were very steep, but usually projected somewhat at the base, and so were not so steep as the mounds themselves. Occasionally, as in the case of the Hierolgyphic Stairway at Copan, the steps were carved with glyphs and monuments were placed at intervals. Low balustrades were rather frequent. Sometimes they received considerable attention. Fig. 145 shows a restoration of the balustrades of the Hieroglyphic Stairway at Copan. A number of so-called serpent balustrades are found at Chichen Itza.[1] The heads of the serpents extend outward at the base of the balustrade, which may be said to represent the simplified serpent body. Serpent stairways seem to be restricted to a definite class of pyramids, namely, those with stairways on all four sides, and to a definite period of Maya art.

Walls. The ordinary wall construction resembles that of the Romans. It is not true masonry, but a rough concrete faced with cut stone. The universal lime rock of the country was the material that was broken up for rubble, burned for mortar and plaster, and cut

FIG. 146. — Cross-section of an interior wall, showing the hearting: Copan.

with flint chisels for surfacing stones or ornamental sculptured details. Walls made entirely of cut stone are rare.

Perhaps the nearest approach to true stone masonry occurs at Copan. Here rectangular blocks of fairly uniform size were laid in a neat and orderly manner. The joints were broken with fair regularity and the corner-stones were laid in a simple locking system. Plate 3 shows some of the best preserved walls at Copan in which these details are readily discerned. A heavy layer of mortar was used for floors and a thin coating for walls, but this material seems to have been seldom used to cement together the building stones.

The most peculiar and significant feature of the wall construction of Copan has yet to be mentioned. The temple walls are not made entirely of stone, but have a core or hearting of pounded earth or clay mixed with broken stone (Fig. 146). This impermanent filling could serve no useful purpose, except to give greater mass and weight to the wall should that be needed. The stonework is thereby converted into retaining walls for an earth embankment. The collapse inward of the stone retaining walls, such as may be seen in Plate 3, fig. 2, is perhaps due to the washing away of the earthen filling, although Professor Saville ascribes the destruction of the walls at Copan to earthquake action.[2] This peculiar method of construction may indicate that the prototype of the Maya temple was a mud-walled structure and that stonework was added as a veneer.

In the wall construction of Tikal, Yaxchilan, Palenque, etc., the use of irregular slabs of limestone set in a plentiful supply of mortar predominates. The

[1] Maudslay, 1889–1902, III, pl. 58. [2] 1892, p. 273.

stones on the outer surfaces are roughly trimmed to shape and minor irregularities covered up under a liberal coating of stucco, which likewise formed the chief medium of ornamentation. The large stucco figures in high relief that served to ornament the roof combs were built up over stone skeletons, as shown by Mr. Holmes.[1]

In northern Yucatan, stucco surfacing is employed to a much less extent than in the south and west. As a rule, the walls are finished off with excellently dressed stones neatly fitted together. But these facing stones are not rectangular blocks such as are found at Copan. The outer face of each block is rectangular, while the inner part is roughly shaped into a tenon and set into the mortar and rubble hearting. The blocks come in contact only along the outer edges. Although having the general appearance of stone masonry, these facing stones have no real structural value. Much fault has been found with the ancient builders for not breaking joints, but with stonework of this character it really makes no difference whether or not the joints are broken.

The mosaic veneer character of the stone surfacing has an important bearing on any criticism of the architectural decoration. For if the stone facing had no structural character, and was frankly considered mere veneer, then the façade decorations were not limited in any way by considerations of mechanical fitness. The ornamental stones could be applied as mosaic without the necessity of maintaining any structural lines. The whole surface of the building became a fair field for unlimited fancy. Such seems to have been the understanding, since even the cornices and string courses of Maya buildings had no real virtue as binding stones, and were apparently intended for adornment alone. The mosaic elements used in façade decoration have roughly hewn tenons that were set into the walls.

Vaults. The Maya vault has usually been described as a corbelled or false arch, built not upon the side-thrust principle of the keystone, but upon the downward thrust of a load upon over-stepping stones. The principle of such a vault was doubtless understood by the Maya builders. Plate 4, fig. 1, reproduces a photograph of a small chamber at Copan that was formerly vaulted. The long neatly cut roof stones may still be clearly made out. Such stones are long enough and broad enough to allow considerable purchase along the contact planes, and the arch of this chamber was doubtless of the corbelled variety. But although the corbelled arch was known and used to a slight extent, the typical Maya vault was monolithic in character through the liberal use of cement, and was intended to be so by the builders. Plate 4, fig. 2, shows an excellent natural cross-section of a typical Maya vault of northern Yucatan. It will be noted that the stones are fairly well cut on the outer surface, but that they have no purchase upon each other, since only the merest edges come in contact. The stones are held in place by the mortar of the filling and the vault is in effect monolithic. The mortar used by the Maya seems to have been rather variable in quality. Sometimes the hearting was made exceedingly tight and resistent, but in other cases the mortar was badly mixed with earth and, after the outer coating of plaster had fallen away, the roots of trees were often able to force their way into the chinks, scale off the veneer and even disrupt the walls. But it is exceedingly doubtful if any kind of construction could have resisted better the

[1] 1895–1897, p. 198.

tropical conditions of heavy rainfall and luxurious vegetation than the mortar construction we have just examined.

Certain other features which increase the stability of Maya vaults deserve mention. The center of gravity for each half of the typical vaults of northern Yucatan often falls within the limits of the supporting walls. As a result, one half of a vault is frequently found standing when the other half is in ruins. The weight over the capstones that bridge the five or six inches between the two halves of the vault is usually very light. When the building is two rooms deep the center wall is very stable, since the overhang is equal on the two sides of the wall. This device of reducing the strain to a minimum has been interpreted by some as an understanding of the principle of the cantilever, but a careful examination will show that such is not the truth. The façades of the buildings of the Usumacinta region have a sloping upper zone, and as a result the front wall has nothing to balance the vault overhang.

The vaults in all Maya cities show one constant feature. Always, or at least in the vast majority of cases, there is a projection of a few inches at the springing of the vault on the inside, that is, the widest part of the vault is perhaps six inches narrower than the width of the room. Now this persistent fact doubtless reflects a universal method of construction. It seems probable that the vault was built over a wooden form, and that the shoulder projection at the spring of the vault was to give a few inches leeway to permit the ready removal of the false work. The walls may also have been made inside a wooden frame which held the veneer in position till the slacked lime mortar had set. Wooden struts were often used. Sometimes these are still found in place.[1]

The application of the monolithic arch to other uses than the roofing of rooms was rare, but a few interesting cases may be noted. It was not used for windows, but windows are an almost unknown feature in Maya buildings except in the roof structures. It was not ordinarily used in doorways. At Palenque, however, there are notable examples of vaults over interior doorways. Similar arched openings also occur in the medial walls above the spring of the vault. Several of these arches have a peculiar trifoil shape.

The half arch built against a façade was used in a number of sites to afford a narrow passage under a stairway. A well-preserved example is found at Chichen Itza under the stairway that ascends to the uppermost range of the Monjas. The arch was also used in aqueducts and small bridges.

But perhaps the most interesting employment is in the independent portal or triumphal arch, examples of which occur at Santa Rosa Xlabpak (Fig. 143), Kabah[2] and Labna. One view of the famous portal arch at the latter city is presented in Plate 15, fig. 2. Somewhat allied to this use of the arch are the vaulted passages in several long buildings at Uxmal, such as the House of the Pigeons, the South Range of the Nunnery and the House of the Governor. The arches in the last-named building (Plate 5, fig. 2) have been blocked up.

It is important to note that the vault as described in the preceding pages is peculiar to the Maya culture and is found in all parts of the area. Although very narrow vaulted chambers occur at Monte Alban and at a few other sites outside of the Maya area, yet the fundamental principles do not seem to have

[1] The interesting study of the Genesis of the Maya Arch by Mr. E. H. Thompson appeared too late to be of service in this discussion.

[2] Stephens, 1843, I, pp. 399–400.

been grasped by any of the neighboring peoples, although other details of construction were readily imitated or developed. Mrs. Nuttall [1] suggests that vaulted rooms of the Maya type may have been in use on the Island of Sacrifices in the harbor of Vera Cruz, but this point cannot be regarded as settled.

The photographs of buildings which are reproduced in Plates 3 to 16 offer an abundance of proof on the principal points that have been made con-

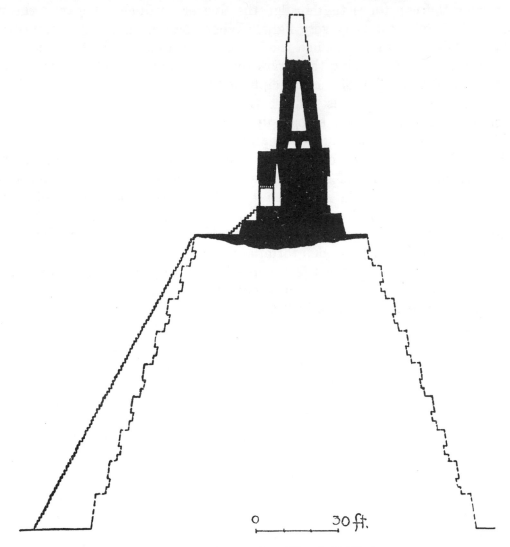

FIG. 147. — Cross-section of Temple V, Tikal.

cerning wall and vault construction. It is obvious that most of the surfacing stones do not support any weight, because other stones beneath them have fallen away. Nearly all of these structures show scaling off of the facing stones, now in the lower zone of the façade, now in the upper zone, and now in the vaults themselves. The inevitable conclusion is that the plain and sculptured blocks were purely and simply a veneer and a mosaic, and that once the mortar had hardened the entire structure was as a single stone.

Roof Structures. Not content with the amount of space for decorations afforded by the façade of the temple, the Maya builders greatly enlarged the area by raising a wall-like superstructure upon the roof. This superstructure is found

[1] 1910, p. 269.

in somewhat different forms in different cities, and from its most common type is often called a roof comb or roof crest. It will be described here in the probable order of the development.

This device for overloading temples with ornament probably was not used at Copan and Quirigua. To be sure, the buildings in these two cities are so completely dilapidated that little beside the floor plan can now be made out. But the amount of debris is not enough to justify the assumption that the buildings were of more than one story. Moreover, the number of sculptured stones, while considerable, does not demand more space than the upper walls of an ordinary façade could give. As a rule, the sculptures on roof structures were of stucco, a material little used in these southern cities.

At Tikal the principal temples, crowning very steep and high pyramids, were themselves topped by a lofty roof structure, which, like the pyramidal base, rose by a succession of narrow terraces. The back wall of the temple appears almost vertical and the greater part of the terrace recession is from the front. In order to support this massive superstructure the temple walls had to be made very thick indeed. The proportion of room space to wall space is much smaller in Tikal than in any other city. From its cumbersome nature we may reasonably conclude that the Tikal roof structures represent the first attempt in this direction by the Maya. The zones of the roof structures appear to have been ornamented with mask panels.

During the recent researches of Dr. Tozzer at Tikal he was fortunate enough to discover two sealed chambers in one of these roof structures. If the plan of the ancient builders was symmetrical, there must be two other similar chambers. A cross-section of this temple is shown in Fig. 147. The four rooms are in two stories and are entirely inclosed by the walls, so that no evidence of them appears on the outside. Their obvious purpose was to lighten the enormous load of the masonry. The temple where this discovery was made has only one very small open chamber and an almost unbelievable large proportion of solid wall. The other temples of the same type have two or three open chambers and a proportionally smaller volume of solid wall. It seems likely that these buildings are of somewhat later date and show an increase of skill in handling the mechanical difficulties.

At Nakum the roof structure on one of the temples appears as three massive towers. In each one of these towers is a small sealed room. At either side of the room, but not connecting with it, are three rectangular perforations, one above the other, that pass completely through from the front to the back of the towers. At La Hondradez roof towers also appear as well as an example of a continuous roof structure. The latter has one feature of peculiar interest. The chamber of the temple is directly under it, and the side walls of this chamber run up to a very great height inside of this lofty roof structure.

The roof structures of the Usumacinta region are typically of a much lighter and more airy construction. The simplest form is a vertical wall, pierced with windows, that rises from the center line of the roof. It seems possible to postulate the course of development of the roof comb at Yaxchilan from a comparison of the structural remains. Naturally the builders gained experience with each new attempt, and so the relative success with which the same problems of construction were met probably indicates time sequence in building. In the first place, there is the roof comb constructed over the single room. To bear

the additional weight of the roof comb, interior buttresses were built which
divided the room into a series of compartments, as may be seen in Fig. 148, *a*
and *c*. In one group of such buildings it was apparently considered unsafe to
put the roof comb directly over the ridgepole; it is therefore set somewhat back.
In a second group the roof comb is over the center line, but the interior but-
tresses are still necessary. A third group shows the temple divided by a longi-
tudinal partition into two rooms. The roof comb then arises with perfect safety
over this central wall. After the discovery of this simple and economical device
the builders must surely have dropped the old clumsy method. But the develop-
ment was not yet complete. Heretofore the roof combs have been narrow, ver-
tical walls pierced by windows.[1] In the fourth group the roof comb is made by

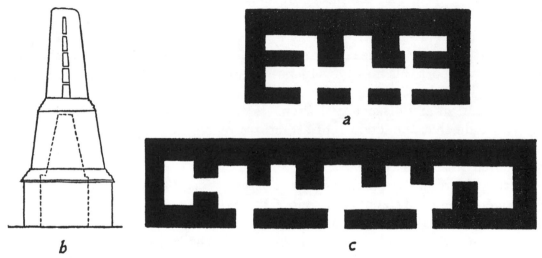

FIG. 148. — Plans of Yaxchilan Temples: *a*, Structure 25; *b* and *c*, Structure 33.

bonding together two walls which incline towards each other. These walls are
pierced by windows, as before. The greater breadth and increased stability
permitted these structures to be raised to a height of at least two stories. The
lower story of the roof comb is like a long corridor. Fig. 148, *b*, reproduces a
cross-section of a Yaxchilan temple of the single-room type crowned by a very
cumbersome two-walled roof structure.

At a ruin on the Tzendales River there is a temple with a roof comb resembling
an open corridor with six windows on each side. This structure and the ones at
Yaxchilan that have just been considered are undoubtedly related to the roof
structures of Tikal. The sealed rooms of the latter city in the course of develop-
ment appear to have opened out into corridors with windows.

The roof combs of Palenque have often been described. Maudslay gives
complete plans of them.[2] They show the highest refinement in the use of the two
walls inclining inward, the mass being reduced to a minimum, so that the whole
structure may be described as stone trellis work. The weight of these roof
combs is borne by the medial longitudinal partition. In every constructural
feature, particularly in economy and efficiency of support, and in artistic refine-
ment, the temples of Palenque are superior to anything else in the Maya area.

[1] It must be admitted that Maler's plans and
descriptions are not very definite in regard to the
single-walled roof comb.

[2] 1889–1902, IV, pls. 65 and 85. See also Holmes,
1895–1897, p. 201.

The roof structure in the cities of northern Yucatan received a sort of differential development. The double-wall type apparently does not occur. The castellated roof comb of the House of the Pigeons at Uxmal (Plate 6, fig. 1) shows a modification of the single-wall type. Roof crests more like those of the south are seen at Sayil[1] and Hochob.[2] A roof comb with rows of windows and cornice-like mouldings is seen upon the Casa Colorado at Chichen Itza (Fig. 149). Indeed, this building is somewhat unusual in that it has both a roof comb and a so-called flying façade.

The flying façade, which is the most common form of roof structure in northern Yucatan, is really a vertical extension of the front wall of the temple, giving a false impression of the height of the building. Although not so beautiful as the roof comb of the Palenque type, yet the flying façade served better to carry the mask panel decoration so common in northern Yucatan. Plate 15, fig. 1, pictures

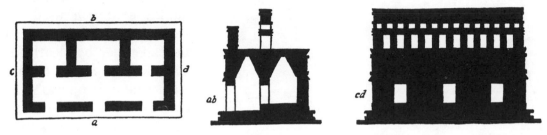

FIG. 149. — Plans of Casa Colorada, Chichen Itza.

the Iglesia of Chichen Itza with its flying façade which is decorated on the front with mask panels and on the rear with a simple lattice design. A graceful flying façade of lattice work surviving upon a badly ruined temple at Sabacche (Plate 6, fig. 2) gives evidence of the excellent construction of this region.[3] In Plate 16, fig. 3, is shown a splendid building at Uxmal with tower-like elevations over the doorways instead of a continuous flying façade.

Columns. The development of the column is closely connected with the handling of doorways to allow for the admission of more light to the inner chambers. The column does not occur at all in the southern part of the Maya area and is none too common in the northern parts. At Palenque its prototype exists in the rectangular piers, all that remains of the front wall of the temple when three doorways are taken out. In northern Yucatan square columns occur, particularly at Chichen Itza, but round ones with a square capital are perhaps more common. The columns are made up of several drums or sections. Good examples of wide doorways with two or three columns occur at Labna,[4] Sayil,[5] Dsehkabtun,[6] Chacmultun (Plate 7, fig. 1) and Tuloom.[7] In many buildings the use of round or square columns really turns the outer chamber into a portico, as has been already explained. Plate 7, fig. 2, shows an intricate interior at Chichen Itza, with rows of drum columns and other unusual features. Columns for interior roof support are rare, but occur at Chichen Itza if not at other cities. The highest development of the column is reached in the serpent columns of the Cas-

[1] Stephens, 1843, II, p. 25.
[2] Maler, 1895, p. 285, central building shown.
[3] For other examples see Stephens, 1843, II, pp. 50–53 (Labna), and Maler, 1895, p. 253 (Chunyáxnic) and p. 254 (Sabacche).

[4] Stephens, 1843, II, frontispiece.
[5] Stephens, 1843, II, p. 17.
[6] Maler, 1902, p. 227.
[7] Stephens, 1843, II, pp. 402–403.

tillo, the Temple of the Jaguars and the Temple of the Tables, all at Chichen Itza. These strongly resemble the serpent columns found by Charnay at Tula.

In the Court of the Columns at Chichen Itza are hundreds of columns, four or more abreast, in long alignments. Their purpose is unknown, but it seems certain that they did not support vaults. It is possible that they supported flat roofs and that the whole group formed a sort of open marketplace. The presence of temples in the group is an argument against this hypothesis. A number of similar groups of smaller size exist in northern Yucatan and will be discussed later in another connection.

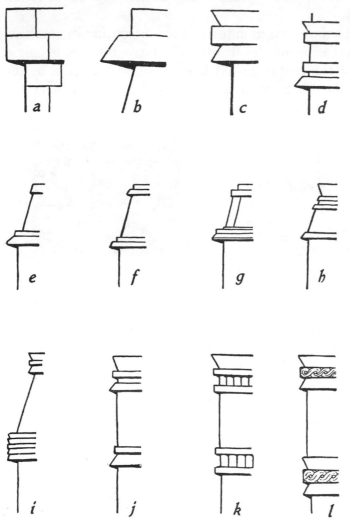

The small plain or banded columns so much used as a façade decoration in northern Yucatan must be clearly distinguished from the columns that serve as supports. The former have no structural character, but are simply mosaic elements used in architectural embellishment.

Cornices. The cornice is one of the most interesting features of the Maya building. The term must be used somewhat widely. Not only are the terraces of the pyramid and the upper portions of platform mounds ornamented by projecting tiers of stone which may be referred to by the term, but the buildings themselves often show cornicelike projections at several levels. The moulding commonly called the medial

FIG. 150.—Cornice forms: *a*, southern area; *b*, Usumacinta area; *c*, northern area; *d, h, i* and *j*, Chichen Itza; *e, f* and *g*, Palenque; *k*, Labna; *l*, Chacmultun.

cornice separates the upper and lower zones of the façade.

The cornice shows a refinement in form and an increase in variety from south to north. A series including the most important varieties of cornice forms is shown in Fig. 150. In the Copan substructures the cornices consist of a simple projection of two courses of stone (Fig. 150, *a*) at the tops of the terrace walls. In the cities of the Usumacinta Valley the type is varied in that the lower part is beveled and projects farther than the upper part, as in *b*. In northern Yucatan the main type is the three-part cornice shown in *c*.

Buildings with the sloping upper range have cornicelike projections at the eaves and also at the top of the sloping portion (Fig. 150, *e* to *i*).

The eaves cornice becomes the medial cornice when the wall becomes vertical (*j* to *l*).

The three-part cornice is much modified by the separation of its members and the introduction of a mosaic moulding of zigzags and other geometric elements (*d*, *k* and *l*). The Monjas and the Iglesia at Chichen Itza furnish examples of these modified cornices (Plate 13, fig. 2, and Plate 15, fig. 1). In the Carocol at Chichen Itza the three-part cornice is developed into a five-part cornice (*i*). It is worth noticing that the three-part cornice is identical in profile with the wrapping of the banded columns so common in the façade decorations of the buildings of northern Yucatan. Wooden poles used as vault struts sometimes have similar bands carved upon them.

Doorways and Wall Openings. The most interesting forms of doorways have already received an oblique presentation under the discussion of the development of the portico and the use of the vault and the column. Fundamentally, Maya doorways are of the simple post and lintel type, but after the concrete walls of the building had hardened there was very little weight upon the lintel. The stones that form the jambs are often of larger size than the usual run of building stones. The lintels are of the very durable zapote wood or of stone. The use of wooden lintels was a decided element of weakness, because after the decay of the lintel the mortar conglomerate over the doorway was often unable to bear up under its own weight. It is probable that no doors were hung in any of the wall openings, although curtains may have been used.

FIG. 151. — Modifications of door jambs; *a*, common form; *b*, Uxmal; *c*, Chichen Itza.

Occasionally the original three faces of each door jamb (Fig. 151, *a*) were increased by a simple modification. At Uxmal there are examples of doorways with the jambs modified as in *b*, while at Chichen Itza a pilaster was sometimes set up to carry a shorter under lintel so that the cross-section of the door jamb is like *c*. This device allowed seven vertical panels for decorative purposes. With the extended use of piers and columns, as we have already seen, doorways are widened until often the whole front of the building resembles an open portico. Typical doorways are shown in many of the photographic plates, and clear drawings of the different types are given by Mr. Holmes.[1] The use of a vault over an interior doorway is found at Palenque.[2]

Wall openings other than doorways are almost negligible when considering the Maya area as a whole. Small rectangular or tau-shaped windows occur. Perforations in the medial walls above the spring of the vaults are characteristic of Palenque, but are not found at most other sites.

Application of Decoration. In all parts of the Maya area the façades of buildings were richly decorated. The upper zone of the façade, whether of the sloping or the vertical type, seems to have been the favorite place for applying decoration. This zone was turned into a wide frieze for designs of many sorts expressed in high-relief stone sculpture, in stucco modeling and in realistic or geometric mosaics. Occasionally the lower zone was also covered with ornament.

[1] 1895–1897, pp. 40–44.　　　　[2] Maudslay, 1889–1902, IV, pl. 5.

The surfaces of the roof combs and flying façades carried decoration of the same diverse character. In many cities these outside designs have been almost completely destroyed by the elements.

Some of the more complicated interior decorations were used to enhance the inner chamber which has been described as the sanctuary. Stone and wooden lintels over the outer and the inner doorways of temples were frequently carved with remarkable pictorial compositions. These sculptures were generally on the under side of the lintel and so directly overhead. They could not be viewed with comfort or accuracy. In a few cases the front of the lintel block was also ornamented. Carved lintels of wood or stone have been found at Tikal, Yaxchilan and other Usumacinta sites and at Kabah and Chichen Itza.

The front wall of the inner chamber was sometimes elaborately ornamented at Copan. The door jambs and the narrow spaces either side of the inner door and the interior columns were also sculptured in some of the more splendid temples, particularly at Chichen Itza. But the most successful and artistic decorations are those which in several instances were applied to the inner walls of sanctuaries. The famous tablets of Palenque belong to this type of architectural enrichment, as do the frescos of the Temple of the Jaguars at Chichen Itza.

Stelae with altars were correlated in many cases with temples and should be considered as a secondary architectural feature. Pyramids and stairways also deserve mention in this connection, although they are treated separately.

Realistic Decoration. Architectural decoration may be divided conveniently into two divisions. 1st, façade decoration; 2nd, interior decoration. The designs employed in the second division by the Maya do not lend themselves to comparative study from an architectural point of view. Those that emphasize the importance of the sanctuary have already been commented upon. Subjectively the range of the interior designs is wide and the manner of presentation realistic. The most striking door jamb, lintel, and sanctuary decorations have been treated already under different headings and do not deserve further discussion.

Façade ornamentation offers a rich field for comparative study. It may be subdivided, according to manner, into realistic, conventional and geometric, as these terms are commonly applied. The markedly conventional will be studied under the captions of "mask panel" and "profile panel," and the minor conventionalizations of the more realistic designs will not be considered.

Few buildings of the Maya area that were decorated in a free manner with realistic designs are now in a well-preserved condition. The method seems to have been more characteristic of the south than of the north. At Copan the façades were apparently decorated in a free manner with human and grotesque figures, the latter sometimes representing divinities, and with feather drapery. The arrangement of these sculptures on the walls is only known in part. The upper zone of the façade apparently carried most of the ornamentation. Temple 22 had a frieze of splendidly carved busts that were possibly arranged in a line with equal intervals of blank wall. At each corner of this building were two great heads, one above the other, made of several stones neatly fitted together. Temple 32, which is situated on a low mound just south of the acropolis, was decorated by more or less realistic carvings representing skulls, heads of the Roman-nosed God, serpent heads in profile, human figures and feather mouldings. The larger sculptures were made in several pieces, each with a long tenon that could be

set in the wall. On this building, as on others, the head and headdress of human figures were sometimes carved on one block, the bust or torso on another and the two legs on a third and fourth. It is worthy of note that true gargoyles, serving as water spouts, occur at Copan. An example is given in Fig. 152.

Judging by the debris, the temple on Mound 26, which is the one approached by the famous Hieroglyphic Stairway, was embellished by feather drapery sculptured in the freest manner imaginable. There were also sculptured human bodies, as well as faces of both the Long-nosed God and the Roman-nosed God.

At Tikal less elaborate decoration limited to bands or friezes is still to be seen on two or more buildings.[1] One frieze that is interesting is seen on the rear of the central temple of a row of seven temples (Structure 55). The design con-

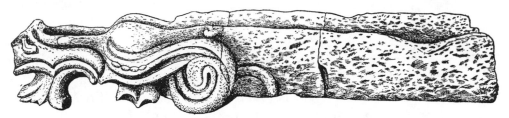

Fig. 152. — Gargoyle in form of serpent head: Copan.

sists of five parts. At each end are two bones modified so as to form an overlocking pattern, next comes an object that probably represents a shield, while in the center is a much destroyed figure that may present some sort of face surrounded by feathers.

At Palenque free decoration executed in stucco is seen on the piers of the Temple of the Inscriptions and of some of the Palace structures. The designs are presented in a most realistic manner in panels that are framed in by bands of astronomical and other symbols. Some of these designs have already been presented and discussed in the General Consideration. Maudslay[2] gives photographs and drawings of all these mural decorations. He also gives a drawing[3] of the much destroyed stucco frieze on the sloping upper zone of the Temple of the Cross. This frieze represents a dragon head in front view with a leg at each side and with fish attached to the headdress. The stucco ornaments on the roof combs of Palenque are too badly destroyed for reproduction. Waldeck[4] gives a drawing of one that shows atlantean figures supporting the cross beams. Mr. Holmes[5] shows in a drawing the stone skeletons that were used for the larger stucco sculptures and the method of attachment to the walls.

In northern Yucatan the surviving use of the sculptures of human figures and other realistic motives on the façades of buildings is seen in a number of instances, although the general method of decoration here is very formal. The Iglesia at Chichen Itza (Plate 15, fig. 1) has on its middle zone two panels each with two seated figures representing anthropomorphic gods. Bodies attached to the wall by tenons occur at Uxmal. On some of the flying façades at various sites in northern Yucatan the same style of sculptures seems to have been used. At intervals, in the geometric and conventionalized ornament that adorns the temples of Uxmal, are details that are strongly realistic. A sculpture of the sort

[1] Maler, 1911, pl. 8.
[2] 1889–1902, IV, pls. 8–11, 27–28, 32–37 and 53–56.
[3] 1889–1902, IV, pl. 68.
[4] 1866, pl. 26.
[5] 1895–1897, p. 198.

may be seen in Plate 8, fig. 2. It represents a personage with a lofty feather headdress seated over the open jaws of a serpent. The carving is executed on several blocks which are fitted together. Plate 9, fig. 1 shows a portion of an

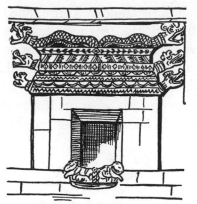

FIG. 153. — Ornamental niche in façade: Uxmal.

interesting façade at Uxmal, where the intertwined bodies of two serpents overlie the geometric and mask panel decoration. Realistic designs which are too indefinite for study are shown in Catherwood's views of Tuloom.

An interesting feature on many façades in northern Yucatan is the niche which was intended to protect or embellish a seated individual represented in stone or stucco. Slight remains of such seated figures can still be made out in some instances. The niches usually take the form of little houses, with two sides and a roof, and are frequently decorated. An example after Catherwood is given in Fig. 153. The finest development of the niche is seen at Labna, Chacmultun and Uxmal (Plates 7, fig. 1, and 16, fig. 3). The niche is often placed over the doorway, and it seems likely that the figure enclosed in it was that of some deity.

Mask Panel. The use of the mask panel is the most noteworthy characteristic of Maya façade decoration. The mask panel is essentially a highly conventionalized face, represented in front view, with its details so modified as to fill an oblong panel. This panel either extends

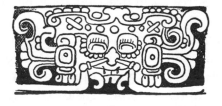
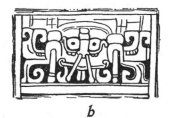

a b

FIG. 154. — Faces limited to rectangular spaces: Chichen Itza.

along the wall surface or folds around a corner. In the case of the corner masks the relief is ordinarily higher than in those on a flat wall.

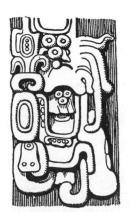

FIG. 155. — Face in profile: Copan.

Before considering the mask panel as it is used in architecture it might be well to examine the general application of faces to rectangular areas. Such areas frequently occur at the bases of stelae, on sculptured door jambs, etc. Fig. 154, *a*, shows a face occurring in a long decorative band. The sides of the face are not framed in, so the design as a result is not strictly rectangular. Another face with many similar features is given in *b*. This face is framed in on all four sides, and the parts extend into all the corners of the area.

The changes which occur when a face in profile is turned into front view is illustrated in Figs. 155 and 156. The profile face is taken from the side of Stela B at Copan. Note the pendent nose, the curled object at the side of the mouth, the oval ear plug with inferior and superior ornaments, the feathered eye and the hair or feathers on the forehead. The front-view face (Fig. 156), occurring on the base of Stela 4 at Yaxchilan, retains most of these

features modified to suit a rectangular area. The featherlike details of the forehead and the feathered eyes are easily seen. The nose hangs down over the mouth. The teeth are replaced by the tips of feathers, a rather unusual substitution. The curled object at each side of the mouth occurs, however, as well as the oval ear plugs with decorative appendages above and below. A somewhat similar panel at La Hondradez is given in Fig. 157. Others of the same type occur in this city, likewise on the bases of stelae.

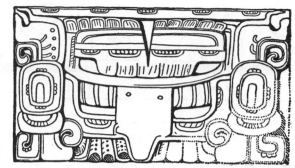

FIG. 156. — Mask panel at base of stela: Yaxchilan.

The rectangular panels on the bases of the stelae of Quirigua are often much more complicated than the examples just given. They present two or three superimposed heads, the upper ones being the headdresses of the lower ones.[1]

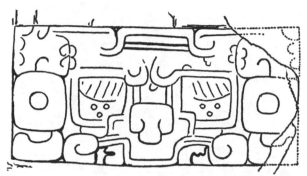

FIG. 157. — Mask panel on base of stela: La Hondradez.

In the southern portion of the Maya area the panel treatment of the façades of temples held a certain vogue, but the details were applied for the most part in stucco and so have since crumbled away. At Copan there were apparently two superimposed mask panels on the corners of Temple 22. These are now very incomplete, and the upper one is represented only by the ear ornaments in the photograph taken by Maudslay.[2] Part of the lower mask on one of the other corners is shown in Plate 3, fig. 2. Aside from this example the architectural decoration at Copan seems to have been in another and freer style than of the mask panel.

Portions of mask panels on the façades and roof structures of Tikal, Nakum, Yaxchilan and Palenque can still be made out. The details of mask panels at Nakum and La Hondradez have been furnished by Dr. Tozzer. Nearly all of these designs are incomplete, but they are decidedly interesting in showing a

FIG. 158. — Mask panel on tower: Nakum.

FIG. 159. — Mask panel partly restored: Nakum.

less trammeled hand than the analogous designs of the north. Three of these panels are given in Figs. 158–160. The most complete one (Fig. 158) is a detail on one of the towers of the roof structure. The face is very simple, the most noticeable feature being the large nose plugs at the base. The second and third examples have the pupil of the eye represented by a spiral groove, while from the upper part of the ear plug ex-

[1] Maudslay, 1889–1902, II, p. 10. [2] 1889–1902, I, pl. 17, c.

tends outward a bunch of feathers. These masks were built out of specially carved stones, but the finer details were expressed in stucco which was applied to the surface of the stones.

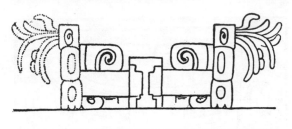

FIG. 160. — Mask panel: Nakum.

The mask panels at Tikal, Yaxchilan and Palenque were largely constructed of stucco. At the latter city, on the frieze of House C, of the Palace, a row of seven faces can still be made out.[1] These are less rectangular than the usual run of mask panels. On an inside wall of the same building are nine other faces in a much better state of preservation. Judging by the examples which Maudslay[2] gives, each one of these faces was different from the others. All were finely modeled in stucco.

Realism is not a marked characteristic of the mask panels, yet it seems likely that a number of conventionalized representations must be included under this general heading. Examples of two designs from Labna illustrate the most realistic panels, following the serpent model, encountered in northern Yucatan. The first of these (Fig. 161) is a corner mask, built up mosaic fashion out of many carved stones. In the open jaws at the front appears a small human head. Above the upper jaw the nose rises in a scroll, and back of this is seen the eye decorated with feathers. The rest of the face is a hodgepodge of sculptured stones that do not seem to represent natural features. The next mask on the same building (Fig. 162) is in front view.

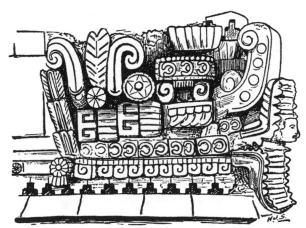

FIG. 161. — Corner mask built up mosaic fashion: Labna.

The jaws are much less prominent, although both protrude slightly. The nose is much enlarged. The ear ornaments at each side of the face are not complete, but the suggested forms are more in keeping with those on the more usual mask panels.

A complicated mask lacking the lower jaw is presented in a somewhat restored condition in Fig. 163. The nose projects hardly more than

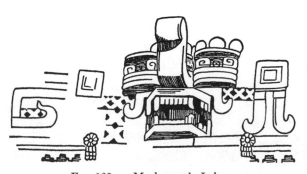

FIG. 162. — Mask panel: Labna.

the teeth. The headdress is ornamented with checker-work. The ornaments at the side of the ear plugs are unusually elaborate for a mask with as much realism as this one shows. The mask is centered over a doorway which is the position first in importance to be filled by such designs.

[1] Maudslay, 1899–1902, IV, pl. 20. [2] 1899–1902, IV, pl. 24.

Masks in which human features predominate are seen in the stucco panels of Izamal preserved in drawings by Catherwood [1] and Holmes.[2] A great human face modeled in stucco appears on the tower at Nocuchich, which has been described and photographed by Maler.[3]

From the examples so far presented the mask panel appears to have had a diverse origin. But, as a rule, it seems pretty clear that the mask represents the feathered serpent. The eyes often show feathered lids. The projecting curl represents the nose of the serpent, which, as has been observed, was commonly elongated. The serpentine head may of course have been intended for that of the Long-nosed God.

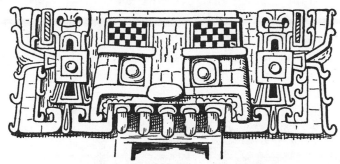

FIG. 163. — Mask panel: Xkichmook.

Fig. 164 gives an ideal mask in its most simplified form but with all the parts. It may be well to run over the main features of the complete mask. The head band usually represents a series of threaded disks or a line of rosettes, the middle and terminal ones being more ornate than the others. This head band extends over the eyes and ends above the ear ornaments. The eye consists normally of three parts, the upper and lower lids and the eyeball. There are two principal forms of the eye, one being round and the other rectangular. In the round eye the upper and lower lids are equal in height and shape, while in the rectangular eye the upper lid is a straight bar and the lower lid is trough-shaped and includes the sides. The eyeball is frequently represented with a forward and backward part, the former representing drooping feathers. The nose is curled in nearly all cases, but presents a considerable variety in profile. The superior nose ornament is usually either a roll-shaped body or a human face. The curious detail is the homologue of the nose scroll on the profile serpent head (Fig. 30, e). Through this object the nose plugs were thrust. Two of the masks on the flying façade of the Iglesia at Chichen Itza still show nose plugs (Plate 15, fig. 1), but they are usually omitted on mask panels. The mouth varies in many details. The lips are much reduced. The teeth are of two kinds; those at the side of the mouth correspond to molars and those on the front to incisors. These teeth have frequently been described as filed, but a comparison with those on the profile head of the serpent proves that the traditional method of representing teeth was followed in these architectural designs. The lateral mouth ornament corresponds to the curled fang at the back of the

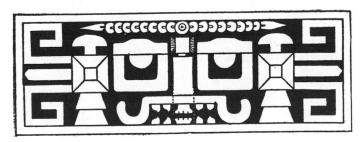

FIG. 164. — Simplified mask panel with all the usual parts.

[1] 1844, pl. 25. [2] 1895–1897, p. 99; Charnay, 1885, p. 262. [3] 1895, p. 289.

mouth on the more realistic representations. The ear plug is usually square and fitted with a peg in the center. The inferior ear ornament represents a pendant, while the superior one varies widely in form. The lateral ear ornament is very important in emphasizing the formal quality of the mask. It usually consists of two frets turned in opposite directions and separated by a horizontal object. These frets possibly symbolize feathers.

The general processes by which designs are modified, namely, simplification, elaboration, elimination and substitution, have already been explained. The general conceptions of the mask panel and its diverse origin have been touched upon, as well as the convergent results attained by the process of simplifying the original forms and throwing them into a geometric order. In the comparative study of the mask panel it is necessary to take strict account of the changes which take place in homologous parts. The ideal simplified mask may be made to serve as a standard for this comparison.

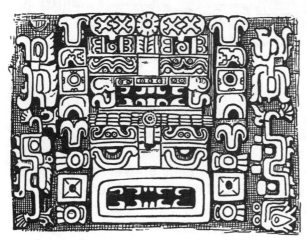

Fig. 165. — Superimposed mask panels: Uxmal.

Some of the mask panels of Chichen Itza are very simple, and others show adornment of the different features. Examples may be examined in Plates 13, fig. 2; 15, fig. 1; 27, fig. 2, and 28, figs. 3–6. Pleasing elaboration is shown in the last illustration. Better examples of highly elaborated masks are seen at Uxmal (Fig. 165 and Plates 8, fig. 2; 9, fig. 1; 14; 16, fig. 3). From the ebb-tide mask of greatest simplicity, the use of subsidiary ornament in elaborating each separate element becomes more and more prominent. The eyelids are ornamented with circles or other figures. Similarly the head band becomes a row of rosettes instead of simple disks. The nose takes on adventitious details, such as crosses and swastikas. The various ear ornaments assume a great variety of shapes, the lateral ones sometimes developing into serpent heads.

The same masks that show elaboration often show elimination as well. Elimination in the case of the mask panels seems to proceed by a pretty definite rule. The outer features are the ones that are cut off, but the process may continue till only the eyes and nose remain. Space considerations have something to do with elimination in many instances. The lateral ear ornaments are the most elastic features of the mask panel. The arms of the frets can be lengthened or shortened according to the space to be filled. If the space is very short, the lateral ornaments are left off entirely. Since the first consideration in placing a mask was to get it centered over the door, this elasticity counted. On the east wing of the Monjas at Chichen Itza (Plate 27, fig. 2) are five masks of varying width, three of which are placed over doors. The spaces not filled by the masks are given over to geometric decoration. On the east front of the same building the lateral ear ornaments are omitted entirely. The masks that cover the façade of Structure 1 at Kabah (Plate 8, fig. 1) evidence further elimination. Not only the lateral ear ornaments but also the head bands are omitted. In fact, except in

the lower tier of masks, each ear plug is held in common by two masks. Examples might be multiplied. About the last stages of elimination are shown in

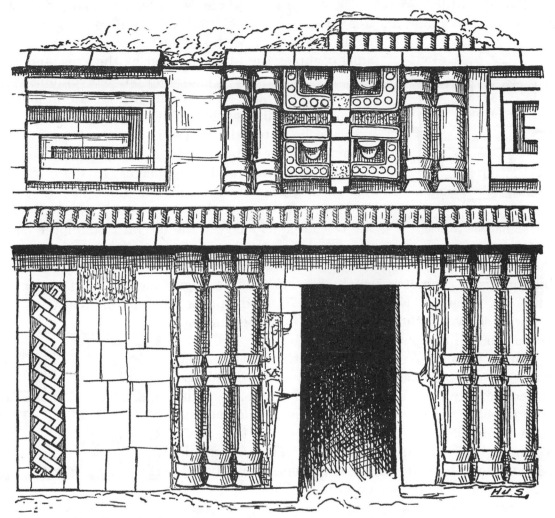

FIG. 166. — Mask panels over doorway, showing extreme elimination: Labna.

Fig. 166 and Plates 9, fig. 2, and 10, fig. 1. In the last photograph referred to the ear plugs and lateral ear ornaments are present but much reduced, and the teeth simplified to a notched line at the bottom of the face. In the other examples only the eyes and nose survive.

The process of substitution overlaps that of elaboration and is even seen in designs where elimination has had full play. An example of the latter is presented in Fig. 167. Here several features are wanting, and a simple geometric design consisting of a line of squares standing on their diagonals replaces the mouth. In Fig. 168 the mouth is replaced by a double fret, turning inward. Both of these figures are taken from the drawings of Catherwood. A more complete

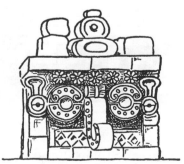

FIG. 167. — Mask panel showing elimination and substitution: Uxmal.

example of substitution is that given in Plate 10, fig. 2. On the lower zone of the façade of the building here depicted are two panels made, mosaic fashion,

out of separately carved stones. The panels are on either side of a door-
way, and while each is slightly asymmetrical the error is reversed from one
panel to the other, so that the design as a whole is perfectly balanced. The
motive that resembles a letter C recalls the shell beads of the more realistic head

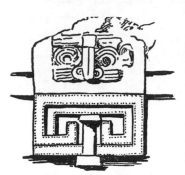

band. The fret at each side of the central part of the
panel occupies the same position as the eyes, and the
tau-shaped grouping of plain and banded columns cor-
responds to the nose. The teeth and the lateral mouth
ornaments are also suggested at the base of the panel.
It should be noted that there is no actual survival of
a single feature, but simply a survival of the old
characteristic order and assemblage. In Plate 28, fig.
2, is given a geometric panel from the upper range of
the Monjas at Chichen Itza. The double frets at each
side of the panel suggest the lateral frets of the com-
plete masks on the lower range of the same structure.

FIG. 168. — Mask panel showing
substitution: Uxmal.

The face, however, is replaced by an arrangement of squares and drum columns.
Characteristic geometric panels that offer only a vague suggestion of the mask
panel are given in Figs. 169 and 170, and appear likewise on many of the
buildings shown in the plates. The purely geometric
decoration will be treated elsewhere.

Profile Panel. We have seen that the mask panel
is merely a front-view face, of any sort, definitely
limited to a rectangular space. Theoretically it is
quite possible to develop artistically a profile face in
much the same way. Examination proves that such
designs actually occur in Maya art. They are much
less common than the front-view panel, probably be-
cause of their necessary asymmetry. This is of course
overcome by the opposition of two similar designs
where such an arrangement is possible.

FIG. 169. — Geometric panel:
Dsibiltun.

The rectangular spaces at the bases of stelae are sometimes decorated with
profile faces. A particularly fine example is reproduced in Fig. 171. It repre-
sents the much elaborated face of the familiar Long-nosed God, looking toward

FIG. 170. — Geometric panel: Dsibiltun.

the left. From the feathered eye issue two
strands which pass to the bottom of the
panel and thence to either side, where each
ends in an attractive vignette containing a
small animal figure. In the circlet at the
left is shown a rat, or some such animal,
and in that at the right a deer. Much
smaller and simpler profile heads may be
seen on Stelae 2 and 3 at Naranjo.[1] On Stela A[2] at Quirigua the lower panel
contains a face, looking upward, which has almost completely broken down into
meaningless scroll-work. Upward-looking heads of a peculiar type are seen on
the bottoms of Stelae 6 and 10 at Yaxha (Fig. 172). The human being above
may be said to stand on the open jaws of the serpent below. The inverted face

[1] Maler, 1908, *b*, pl. 20. [2] Maudslay, 1889–1902, II, pl. 8.

and the hands are hard to explain. While these examples carry us afield, they are evidences of the suggestions for profile heads to be used architecturally.

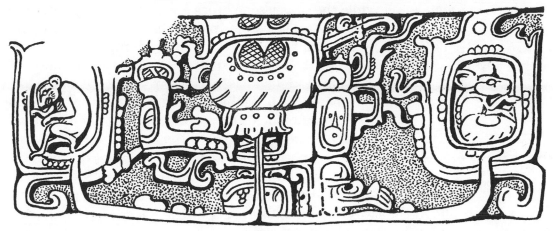

FIG. 171. — Profile panel: Yaxchilan.

In Temple 11 at Copan is represented a conventionalized serpent head, marked with death symbols, arranged vertically at the side of a door. Fig. 173 presents this design as it appears in one of Maudslay's photographs. It is probable that a similar head was placed at the opposite side of the door. Upon the façades of buildings in the Peten region elements taken from profile heads sometimes appear. A frieze on the so-called Palace of the Five Stories at Tikal (Structure 10) consists of a rectangular eye repeated with intervals of blank wall. At Nakum there are scanty remains of what may be regarded as profile heads, although they do not appear to have

FIG. 172. — Panel at base of stela: Yaxha.

been distinctly limited to rectangular spaces. The best preserved of these is given in Fig. 174, taken from photographs and drawings made in the field by Dr. Tozzer. It shows an open serpent mouth which contains a human head and an extended arm. The upper part of the serpent head has fallen away, but the rectangular ear plug with its pendant is still in position. A noteworthy feature of this decoration is that it is modeled in the stucco covering of the wall instead of being built up out of carved blocks in the manner of a mosaic. However, a second fragment at Nakum has carved stones fitted together.

FIG. 173. — Highly conventionalized serpent head in profile: Copan.

Something of the uncertain genesis of the profile mask panel may be gathered from the preceding examples. But the principal occurrences where the geometric mould is unmistakable are in northern Yucatan. Here two profile panels assembled in opposition, one on each side of a doorway, unite with a front-view panel placed above the doorway to form a striking scheme for the decoration of an entire façade.

Plate XI gives views of two portions of the Palace at Hochob which has been explored and described by Maler.[1] The upper picture represents a small façade with the lower zone plain while the upper zone bears a somewhat elaborate mask panel. The central part of the face has fallen away, but can be easily restored in the mind's eye. A row of teeth doubtless projected down over the lintel. The head band is particularly interesting since it consists of a double-headed snake surmounted by rosettes made of separate projecting stones. Locks of hair are apparently intended by the scroll-work between the eyes and the ear plugs. The lower picture shows a very similar face at the top. The principal difference lies in the wavelike figures that represent hair above the two intertwined serpents of the headdress. Below this

Fig. 174. — Remains of wall decoration: Nakum.

face and on either side of the door is an elaborated serpent face in profile, the whole cast into a strikingly rectangular mould. One of these profile heads is given in Fig. 175. It is an interesting example of elaboration, since the top of the eye is formed by a small complete serpent whose tail constitutes the nose plug of the greater head. The noteworthy features in the present connection are the teeth that project inward at the side of the door and the peculiar right-angled turn of the jaw. It should also be stated that the design does not completely fill a four-sided area and that details from other masks intrude into the open spaces.

Fig. 175. — Profile mask panel: Hochob.

A drawing of a broken-down façade at the same city which shows the same elements treated in a simpler manner is given in Fig. 176. Another similar façade, admirably preserved, and from another site, is reproduced in Plate 12, fig. 1. The splendid temple shown in Plate 12, fig. 2, is perhaps the clearest example of any. The doorway has been sealed up, and as a consequence hardly a stone has fallen from its place. The upper face may represent the Sun God with the ornamented tooth. The profile faces are perhaps more complete than any we have yet seen, since the short under-jaw is shown as well as the forked tongue which hangs below it.

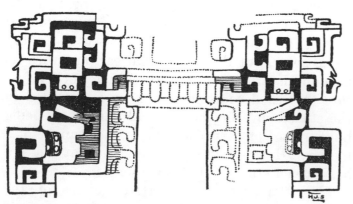

Fig. 176. — Assemblage of profile and front view mask panels: Hochob.

Two other important façades of this type remain for consideration — one at

[1] 1895, pp. 278-279.

Uxmal and the other at Chichen Itza. The façade at Uxmal is that of the Annex to the House of the Magician (Plate 13, fig. 1). No near-by view of the building as a whole is obtainable. Catherwood [1] gives a drawing of the façade, which is accurate as far as it goes, but the upper front-view mask is merely suggested. Seler [2] reproduces this upper mask with all the details that now remain, and Le Plongeon [3] presents detailed photographs of the profile panels with which we are most concerned at this time.

The three principal faces are much complicated by bands of astronomical symbols which overlay the important features and fill in the blank spaces. The one above the doorway is readily made out on account of the eyes. The profile face at either side of the doorway harks back to a type of serpent head that has already been discussed, namely, the more or less modified head with the nose turned back into a fret. The eye is rectangular and is partly concealed by a small human figure attached to the wall by a tenon. This figure is now much destroyed. The teeth of the profile serpent head project inward toward the doorway. The lower jaw that appeared on the simpler examples is lacking. To sum up, the assemblage of three faces shows the effects of all four processes of modification, but especially those of elaboration and elimination.

The last façade to be examined is the justly famous one at the eastern end of the east wing of the Monjas at Chichen Itza (Plate 13, fig. 2), and here elimination and substitution have been carried much further. The only features of the mask panel over the door that survive in their original form are the lateral ear ornaments (see other mask panels on the northern side of the east wing, Plate 27, fig. 2). The face proper has been replaced by a seated human figure, in front view, with a drooping feather headdress. This figure is inclosed in an arch made mosaic fashion. Over the doorway is a row of projecting teeth separated by mouldings from the figure above.

Of the original side-view faces even fewer traces remain. The teeth at either side of the door are of the same character as the ones over it, but are homologous with the teeth of the profile faces in the earlier and more intelligible assemblage. The other features of the two profile heads are replaced by two front-view faces one above the other. The general outlines of the earlier grouping are pretty well maintained in the scheme presented in this façade. The devices that appear on the upper member of the cornice may survive from the earlier scroll work representing hair.

Maudslay [4] has expressed the opinion that the doorway represents an open mouth, but the series just given shows that it represents the surviving elements of an old arrangement of three heads, one in front view and two in profile. There is good reason to believe that the last two examples of architectural decoration in this series are later in point of time than the ones with easily recognizable features.

Geometric Decoration. Many motives which are purely geometric occur on the buildings of northern Yucatan. The geometric panels that show affiliations with the conventionalized faces through the process of substitution have already been considered in some detail. As a rule, geometric figures are not limited to panels, but are applied in string courses or in all-over patterns. Each geometric element is usually carved on a single stone and combined in different

[1] 1844, pl. 11. [2] 1908, p. 162. [3] 1896, pls. 71 and 73. [4] 1889–1902, III, p. 17.

ways to form different designs. Typical design elements are given in Figs. 177 to 180. The element given in Fig. 177, *a*, is used to form zigzags or squares set on

FIG. 177. — Mosaic elements: Labna.

the diagonal (Plates 8, fig. 1; 9, fig. 2; 13, fig. 2; 15, fig. 2; 27, fig. 1, and Fig. 178, *b*). The element with a cross (Figs. 178, *a*, and 180, *b*) is much used in imitation diagonal trellis work which often fills in the spaces between mask panels, but which is sometimes used as the sole motive, as in Plate 6, fig. 2. Squares with figures of different kinds carved on them, rosettes (Fig. 179) and stepped pyramids (Fig. 180, *a*) are of frequent occurrence as independent elements. In other motives, such as the guilloche, two or three repetitions of

the figure may occur on the same stone. The fret is usually of large size and is built up out of many plain stones. As a rule, there is an outer and an inner fret, the latter more or less sunken below the former, but still in relief against the wall. An example of a fret with the planes differentiated by shading has already been given (Fig. 170). The plain and banded column motive (Fig. 181) will be treated in special detail because of its importance and frequent use.

Typical string courses follow the line of the medial cornice. Usually the design shows several motives in rows, one beneath the other. Fig. 182 presents an interesting combination of moulding on either side of a beautiful head that is now in the Museo Nacional at Mexico City. At the top are feathers, next comes a representation of vertebrae. The third row consists of banded columns, the fourth of assorted geometric motives, and the fifth of the stepped pyramid or wall of Troy motive in an inverted position. Frequently the cornice mouldings are

FIG. 178. — Mosaic elements with examples of their development: Chichen Itza.

modified by the introduction of geometric ornament, such as zigzags, guilloches and short columns between the different members.

The rich combination of geometric, conventional and realistic elements that defies description is seen particularly on the buildings of the Nunnery Group at Uxmal and on the House of the Governor at the same city. Photographs of the structures are given in Plates 8, fig. 2; 9, fig. 1; 14, etc. The most striking single feature is the fret which does not form long meanders but is arranged singly or in groups of two or three.

FIG. 179. — The shield as a mosaic element: Labna.

The use of engaged columns, either plain or with simple banded ornament,

is characteristic of a great many buildings in northern Yucatan. These columns are in sections, and each section may be considered a mosaic element. In fact the plain and banded sections of the decorative column are frequently intro-

duced into cornice mould-ings or into mask panels that show substitution. One of the banded sections is shown in Fig. 181. The tenion at the back is not present in all instances.

FIG. 180. — Mosaic elements used in façade decorations: Labna.

Sometimes the entire upper range of a building is ornamented with banded columns placed close together between the medial and the true cornice mould-ings. Examples of such buildings are given in Plates 7, fig. 1, and 16, fig. 1. The columns may appear also in the lower zone, usually in groups and not in a continuous distribution. The detail of a façade decorated with banded columns is given in Fig. 183. In façades of this type the banded sections of the columns may occur at several heights. Three or more banded columns are frequently used to flank or frame in mask panels and doorways, the former in the upper and the latter in the lower zone of the façade. Examples of such uses are shown in Fig. 166 and Plates 9, fig. 2, and 10.

FIG. 181. — Typical banded sec-tion of the banded column.

Stelae. The great monolithic monuments of the Maya commonly called stelae may have served in some cases as grave monuments, but if so this was decidedly a minor pur-pose. Small cruciform chambers have been found under a few of them containing re-mains of what might have been a founda-tion offering. The prime purpose of the monuments is very uncertain. They may have been idols in the same sense that the representations of Buddha are idols. It seems unlikely that they were monuments to individuals, first, because they lack in in-dividuality; second, because most of them bear dates that fall on even, half, or quarter katuns which correspond to intervals of about five years. They may have been connected primarily with the completion of a time period and secondarily with the his-torical events that took place during that time period or the gods that governed it. Whatever their true significance, it seems clear that as objects of art they may be put

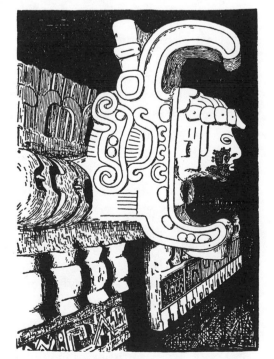

FIG. 182. — Richly ornamented wall with pro-jecting sculpture: Uxmal.

into two groups. The first group includes those that are apparently independent of temple structures, and the second those that serve as auxiliary temple adornment.

The independent stelae prevail at Copan, Quirigua, Tikal and some other sites in the Peten region, where they were set up, as a rule, in a great paved court or plaza. Before each stela there was in most cases an altar. Stelae of the second group also occur at these cities.

The dependent stelae in Copan were likewise mostly set up in the Great Plaza, but were definitely correlated with some mound and generally placed at the foot of stairways leading to the temples. Stelae 3, D, M and N are examples of monuments with a secondary architectural character. Stela 3 is correlated to a mound in the Great Plaza, Stela 4 stands before a minor hieroglyphic stairway, Stela M is directly in front of the famous Hieroglyphic Stairway and Stela N is at the base of the wide stairway leading up to Temple 11.

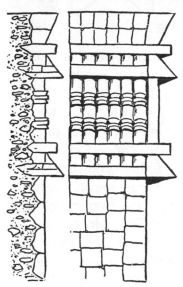

FIG. 183.—Detail of a façade decoration of banded columns: Tantah.

All the stelae at Naranjo, Seibal, Yaxchilan and Piedras Negras seem to have been correlated with temples. The arrangement is more complex than at Copan. The stelae were usually placed upon the terraces in front of the temples in symmetrical order, which, however, is hardly the same in two cases. The question of grouping will be considered again under chronological sequence.

Stelae occur at nearly all the ruins in the southern and western part of the Maya area. Only one has so far been noted at Palenque. In northern Yucatan stelae occur at a few sites, such as Sayil and Tabi, but they are very unusual and are rudely carved. At Sayil the three stelae described by Maler [1] were set up on a low platform. Crude sculptures as well as plain pillars are also found in Chiapas.[2]

The frequent occurrence of perfectly plain stelae in the Peten region has been noted by Dr. Tozzer. It seems possible that these may have been painted with figures instead of carved. It is not improbable that great wooden sculptures, comparable to the stelae, preceded these laborious monuments.

Altars. The most widespread type of altar is drum-shaped, either plain or sculptured. In many cities this is the only kind that occurs. In Copan and Quirigua the altar was especially developed. First came rectangular or drum-shaped altars with wrappings and knots sculptured upon them in addition to human figures and other designs.[3] Apparently this type of altar was intended to represent a bundle. A similar altar painted on a pottery vessel will be shown hereafter. The Altar of Stela 4, at Copan, represents a single knot.

The animal altars have been described. Most of them fall into the series of the Two-headed Dragon, but the Altar of Stela C [4] represents a turtle, and the Altar of Stela F represents two jaguars bound to the sides of two grotesque heads placed back to back (Fig. 99).

There are a number of sculptures at Copan independent of stelae that may be called altars. Some of these are rectangular blocks with beautiful carvings on the sides and tops representing seated figures in rows, grotesque faces of large

[1] 1895, pp. 277–278.
[2] Brinton, 1897.
[3] Gordon, 1902, b.
[4] Gordon, 1896, p. 40.

size and masses of hieroglyphs. Others are thin vertical slabs with sculptures of reptiles.

The animal altars of Quirigua (see Plates 1 and 2) seem for the most part to be independent of the stelae. They mostly belong to the series of the Two-headed Dragon, but one represents a jaguar and another a reptile's head. A drum-shaped altar is also to be seen at Quirigua.

At Tikal most of the altars are plain drum-shaped blocks. Altar 5, however, is finely sculptured on its upper surface. At the Usumacinta sites the altars are also usually drum-shaped and unsculptured, but there are one or two notable exceptions to both of these qualifications. Examples of more or less rectangular altars supported on carved blocks or sculptured heads may be seen at Piedras Negras. In northern Yucatan the table altar is highly developed at Chichen Itza. Here a flat stone is supported by from two to fifteen small stone sculptures. The low platforms or benches that are sometimes built against the wall in sanctuaries or at the heads of stairways may have served as altars. Portable incense-burners of pottery were much used and probably were placed on the altars.

Color. Like the Greeks, the Maya painted their stone sculptures and their stone buildings. There are still many vestiges of color. In some cases an entire monument or building seems to have been painted over by a single tint. In other cases details of ornament were picked out in contrasting tones. The colors were usually applied in a fairly definite way, red for flesh tones, blue and green for ornaments and green for feathers.

In the Peabody Museum are many examples of carved feather-work, grotesque figures, etc., which were used in architectural decoration at Copan. They appear to have been surfaced with smooth plaster and then painted red. Successive coatings seem to have become so thick that they may have seriously impaired the beauty of the original sculptures. Red apparently prevailed at Copan, for Stela 4 likewise shows traces of this pigment.

Maler notes many traces of color on the stelae of Piedras Negras. In this city there was considerable variety in the coloring, with the result that the details of the complex sculptures must have been rendered much more intelligible. Thus the color remains on Stela 1 showed:[1] face, arms and garment, bright red; background, dark red; edge of garment, blue; breast cape, blue; feathers in all cases, green.

Stela 7[2] showed the following color scheme: flesh parts and interior of serpent mouth, bright red; disks of head and breast ornaments, sky blue; feather-work, green; captive's body, red. The feathers were painted green to represent the plumage of the favorite quetzal bird, the sky-blue disks may have been intended for turquoise or jade, while red gave the body a more natural appearance. Maler could find no traces of black, yellow or white.

Maudslay[3] reproduces a painted stucco ornament from one of the rooms of the palace at Palenque, which shows decorative skill of no mean order. Miss Breton has recovered many of the vanishing traces of color on the reliefs of the Lower Temple of the Jaguars at Chichen Itza. They show a large variety of tones, by which the ornaments were clearly contrasted. The whole effect is one of rich tapestry. The bewildering detail which confuses when presented in one tone becomes perfectly intelligible when worked out in color. The remark-

[1] Maler, 1901, p. 46. [2] Maler, 1901, p. 51. [3] 1889–1902, IV, pl. 18.

able stucco reliefs of Acanceh were brilliantly painted when first uncovered. For preserving a record of the form and color of these reliefs thanks are due to Mrs. James, of Merida, and to Miss Breton.

Many instances of fresco paintings upon a flat base are given by Stephens.[1] The fragmentary frescos of Chacmultun have been preserved by Thompson.[2] These are probably purely Maya, while the better known frescos of the Upper Temple of the Jaguars at Chichen Itza may show some influences from Mexico, particularly in the use of speech scrolls. These remarkable paintings have been drawn in fac-simile by Miss Breton. They represent a variety of scenes from the unceremonial side of life. A large number of figures are painted with an astonishing brilliancy of coloring. There is no reproduction of light and shade, but the painting as a whole is in tone. The background is green or blue and thus makes an admirable contrast for the warmer flesh tints. From an examination of the tones, which are numerous but always laid on flat, it seems probable that the artist made color blends, mixing his paint fresh for each piece of color.[3]

In the main range of the Monjas at the same city are a few fragmentary paintings done in the same manner.

Frescos have also been discovered at Santa Rita,[4] near Corosal, in British Honduras. These are executed in a style rather similar to the well-known frescos of Mitla, and seem to show strong foreign influence both in the manner of drawing and in the subjects.

Prototype of the Maya Temple. The question of the probable prototype of the Maya temple deserves brief consideration. Viollet-le-Duc [5] finds evidence in the ornamentation of some of the stone temples of an earlier wooden construction. As is well known, decorative or utilitarian features developed in one material are frequently imitated in other materials, as, for instance, in pottery that sometimes takes over the designs used on baskets or textiles or imitates the natural forms of gourd vessels. It is also in evidence in the higher arts, for the Greek temples constructed of marble retained the shapes of earlier wooden parts as ornaments.

In the case of Maya architecture Viollet-le-Duc finds in the façade given in Plate 14, fig. 2, evidence of log-cribbing and lattice work. The analogy is close enough, but the ornamentation of this particular façade is unique. Lattice work made in stone is very widespread in northern Yucatan, where, however, the buildings are of a much later date than in the southern part of the area. The façades decorated with plain or banded columns (Plates 10 and 16, fig. 1) suggest a wooden construction of upright poles such as is still used in the huts of the natives. The bands might represent in an ideal way the withes which bind these poles together. Here, again, the established chronology interferes with the ready acceptance of this theory.

It seems reasonable to suppose that the original wall construction was of adobe, which was later faced with cut stone. Adobe bricks are widely used in ancient and modern construction from the Pueblo region on the north to Peru on the south. In many instances pyramids and other structures made of them are surfaced with a veneer of cement. This practice was clearly employed in the

[1] See, for instance, 1843, I, pp. 204–205, 409–410; II, pp. 73–75 and 92–93.
[2] 1904, pls. 8 and 9. Other examples recovered by Mr. Thompson are from Tzulá, 1904, pl. 2, and Xkichmook, 1898, pp. 226–227.
[3] Thompson, 1902; Breton, 1906, a.
[4] Gann, 1898–1899, pp. 655–673.
[5] Charnay and Viollet-le-Duc, 1863, pp. 64–68.

case of the great pyramid of Cholula and is seen in many modern houses. The use of adobe is common in the less humid parts of the Maya area. The wide occurrence of this simple form of wall construction points to the likelihood of its being of very early origin. The earthen filling in the walls of Copan may be explained as the surviving indication of an adobe prototype. Copan was one of the earliest Maya cities. The earthen core was a decided element of weakness which was turned into an element of strength in later Maya cities when mortar was substituted for the clay. Yet building stone was plentiful at Copan and could be cut in any required size. Lime of the finest quality was also close at hand, so that even if it were considered necessary to increase the thickness of the wall to give an adequate support to the overstepping roof stones, this need not have been done at the cost of efficient construction. At the same time there is no reason why wooden architecture should not have been developed by the people living in the forested areas where no stone was to be had. There are many mounds in the Usumacinta area from which the superstructures have entirely disappeared.[1]

Minor Arts

Ceramics. In the portions of the New World having the highest culture ceramics often rises to the importance of a major art, and pottery remains frequently constitute the principal results of archaeological research. In the Maya area this art, although finely developed, sinks into comparative insignificance in view of the sculptured monuments.

The art of making pottery had in pre-Columbian times a practically continuous distribution from central Argentina and Chili to southeastern Canada. But the materials and technique varied widely and there were many intensive developments in form and ornament. The art was in some respects most highly developed in the central portion of this vast area, particularly in Peru, Central America, Mexico and the Southwest. But even in these regions there were many fairly distinct ceramic provinces. Of course it is possible, and indeed probable, that there was an infiltration of culture from one province to another.

Certain structural features have a very wide distribution, such as, for instance, the use of ring base and tripod supports for round-bottomed pottery. Three legs furnish the simplest means of stability possible and are employed for a variety of objects the world over. It is but natural that the mechanical economy should be carried a step farther and the legs made hollow rather than solid.

The fundamental similarity in shape and construction, if not in decoration, between the ceramic products of Costa Rica and the Maya area suggests some sort of cultural connection. The art of Nicaragua seems to be more or less intermediate, and shows certain similarities to the Maya vessels in decoration as well as in form.

The ceramic remains found throughout the Maya area include a great variety of vessels for domestic and religious uses as well as figurines, whistles, moulds, stamps, etc. Certain forms are widespread, and possibly show commercial

[1] Mr. E. H. Thompson in a recent article (1912) derives the stone structures of northern Yucatan from the common thatched hut of the present Maya Indian. His explanations do not fit the facts in the earlier Maya cities of the south, however accurately they agree with conditions in the north. The importance of an historical perspective in this discussion will be more apparent after the problem of chronological sequence of style shall have been presented.

distribution from a definite center of manufacture. On the other hand, it is clear that some types of pottery can be referred to definite periods of time, so that the variety is in part explained by chronological sequence.

The pottery was shaped by hand and not by the potter's wheel. To be sure, in some places a block turned by heel and toe was used under the vessel while it was being formed. But this object cannot be called the potter's wheel, because the essential character of the latter comes from the development of centrifugal force. The block in question is still in use in northern Yucatan.[1] A small dish answering the same purpose is used to-day by the Pueblo Indians of the Rio Grande.

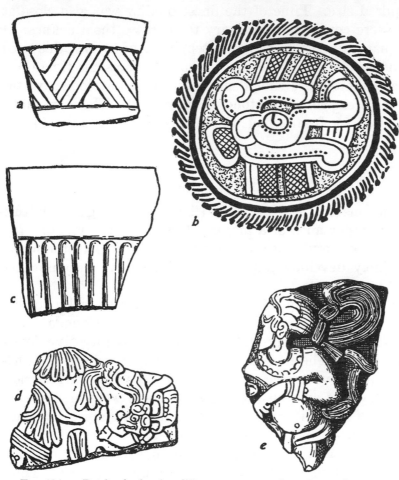

FIG. 184. — Potsherds showing different processes of ornamentation: *a–c*, and *e*, Copan; *d*, Peten region.

An effort will be made to consider briefly the different characteristic styles of Maya pottery, especially as regards ornamentation, illustrating each with a few noteworthy examples. No attempt will be made to distinguish the many variations in paste. Coarse heavy pottery for household purposes has usually no decoration and deserves little consideration here. It is commonly black or red in color, probably depending on whether the burning was done in a smothered fire or an open one. The shapes are various, but flat-bottomed vessels with sides that flare outward seem to predominate.

The more artistic pottery falls naturally into groups according to the method of decoration:

1st. Vessels with incised decorations.
2d. Vessels with moulded or stamped decorations.
3d. Vessels with modeled relief decorations.
4th. Vessels made in the forms of animals, fruits, etc.
5th. Vessels with painted decorations.
6th. Figurines, stamps, moulds, spindle whorls, whistles, etc.

[1] Mercer, 1896, pp. 161–166, describes in detail modern pottery making in Yucatan; Tozzer, 1907, pp. 62–63 and pl. 13, fig. 3. Mr. Thompson has also collected material upon this subject.

Incised pottery made of a fine black or red paste is very widespread. Sometimes the designs are geometric patterns or simplified hieroglyphs, incised in the soft clay with a sharp instrument, and sometimes they are elaborate drawings brought into relief by cutting away the background. Fig. 184, *a*, illustrates the simplest sort of incised black pottery. Such pottery is found throughout the Maya area. Some of the more graceful pieces of red or black pottery that come under this heading have vertical flutings (*c*) made probably by the finger while the clay is soft.

Fig. 185 reproduces a bowl, found near Peto in Yucatan, that is now in the Peabody Museum. The base is a pale yellow and there are traces of a red sizing.

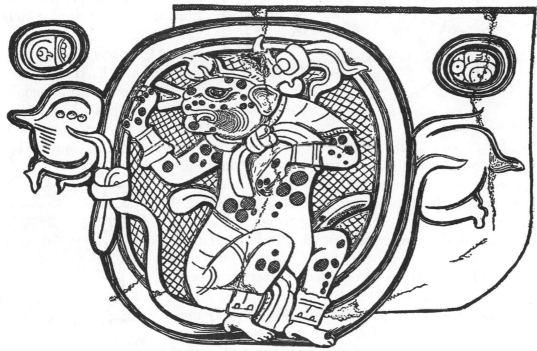

FIG. 185. — Decoration on bowl from near Peto, Yucatan.

The shape of the bowl is indicated diagrammatically in the drawing. The ornamentation consists of a series of painted scrolls on one side and a carving in relief on the other. The carving which is shown in the drawing represents a jaguar seated within a closed ring that is made up of what probably represents a water-lily stem coiled and knotted. The stem has two buds or flowers branching out at opposite sides of the circlet. The jaguar wears a cape tied round the shoulders and a loin cloth or skirt, as well as wrist and ankle bands, nose plugs and a headdress consisting of the well-known head of the Long-nosed God, in front of which is a small flower similar to the flowers at the side of the circlet. Seven oval glyphs are carved around the top of the bowl, two of these being shown in the drawing. The lines which delineate the coiled stem and the flowers are deeply incised.

The jaguar figure is brought into relief through the simple device of cutting away the background. The details of the dress upon the body of the animal are incised in delicate lines and there is little or no modeling. The spots of the jaguar are represented in black paint which has now largely disappeared. The sunken background is marked with incised cross lines which still retain traces

of heavy red pigment. The carving or engraving of this remarkable piece appears to have been done when the clay had become fairly hard and after the surface had been polished, but before burning. It was certainly not modeled in soft clay.

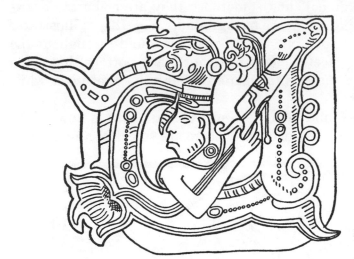

FIG. 186. — Bowl from Calcetok, Yucatan.

A somewhat similar style of decoration is shown in Fig. 186. The bowl represented here is a fine piece of pottery coming from northern Yucatan and now in the private collection of Don Enrique Camara of Merida. The drawing is copied from one made at the expense of Mr. E. H. Thompson. In an elaborate scroll medallion appear the head and left arm of a man who holds diagonally a flexible object. The upper end of this object is a simplified face and the lower end is a flower, possibly a water lily. The composition is very pleasing to the eye. But certain features as, for instance, the headdress, have lost something of their original form, perhaps owing to constant repetition. As in the preceding vessel, the background is here cut away so that the figure stands out in flat relief. Other examples of engraved pottery are seen in Figs. 108, b and 187.

Incised decoration was sometimes effectively modified according to the following method. The outer surface to be decorated was smoothed and covered with a fine white or black sizing. The vessel then appears to have been burned, after which the design, which was usually limited

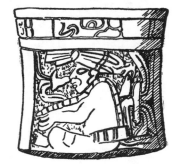

FIG. 187. — Bowl from Island of Jaina.

to a band or a panel, was incised with a sharp tool and the background cut away. The lines of the design and the open spaces of the background thus show in dull red color, while the surface of the raised figures is white or black and more or less polished. In the Peabody Museum there are several interesting pieces of this ware from the environs of Santa Cruz Quiché, Guatemala. An example has been shown in Fig. 48, and another fragment of the same vessel drawn in a manner that more nearly imitates the appearance of the original is given in Fig. 188.

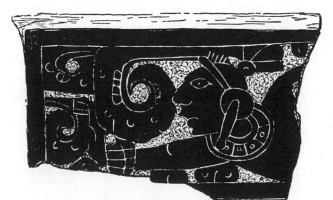

FIG. 188. — Engraved potsherd from Santa Cruz Quiché.

Stamped pottery is somewhat unusual, but a number of interesting forms are encountered. A peculiar flask-shaped type of vessel made of a smooth white paste and bearing on both faces a stamped portrait of the Roman-nosed God and on each of the narrow sides a double column of stamped glyphs has already received comment (Fig. 94). Nearly identical examples of this ware have been found at Coban, Copan and in the Uloa Valley.[1] A rectangular bottle of the same paste and style of decoration is figured by Seler.[2]

a *b*

Fig. 189. — Potsherds showing applied relief decorations.

Other examples of stamped ware of dull red or yellow color are to be seen in the Peabody Museum collections from the Uloa Valley and from Santa Cruz Quiché, Guatemala. From the latter site come two interesting pieces, cylindrical in shape and decorated with stamped designs that are repeated several times around the outside. The stamped designs on these and other bowls are mostly fanciful heads limited to rectangular panels. In some cases tripod legs bear stamped patterns.

In Fig. 184, *d* and *e*, are given two potsherds with realistic designs modeled in relief. It is sometimes difficult to distinguish between this kind of decoration and the finer examples of stamped ware. Of course the arrangement of figures on the outside of a bowl of this sort is unrestrained, while stamped ware shows formal designs. The rounded character of the modeled relief is in marked contrast to the method of engraved or incised relief that has already been described.

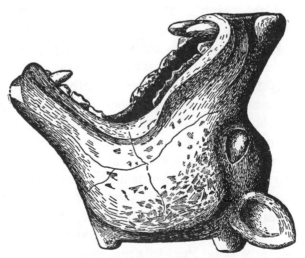

Fig. 190. — Jaguar head vase from Copan.

Reliefs made by appliqué work are much commoner and, as a rule, cruder. The designs and figures that decorate this class of pottery are laid on or built up. Rolls of clay, ribbon-like strips, flat or pointed nodules, and modeled faces are the objects used in making up the decoration. These are arranged on the sides and rims of plain vessels in a variety of ways, while the clay is yet soft, and they remain firmly attached after the firing. This process, although found widely, reached its highest development in the Maya area on the highlands of Guatemala. It seems to be related in a general way to the technique so finely exemplified in the Zapotecan funeral urns. Potsherds showing this method are given in Fig. 189. A beauti-

[1] Gordon, 1898, *a*, pp. 19–20; Seler, 1902–1908, III, pp. 685–686. [2] 1902–1908, III, p. 682.

fully made vessel of this style has already been figured (Fig. 1, *b*). Many others are described by Dr. Seler.[1] Occasionally color was used upon certain details.

Vessels made in various natural forms are fairly common. A remarkable vessel in the form of a jaguar head is given in Fig. 190. A tripod vase with the body modified into a bird and a human face seen in the bird's open mouth was excavated at Copan. Gourd-shaped pots are sometimes found. A splendid example of such a pot, found at Acanceh is in the Museo Yucateco in Merida. The tall-necked bottles found by Dr. Gordon [2] in the caverns of Copan remotely resemble gourds. The bodies are sometimes fluted.

Incense burners present many different forms. Some of the more elaborate ones show a sitting or standing human figure attached to one side of the bowl.

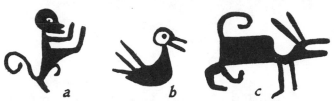

FIG. 191. — Crude painted figures on food bowls: Copan.

Others are modeled into the form of a head or have heads joined to the rim. Incense burners will be discussed more in detail at another time, because they furnish important evidence of the last phases of Maya art from an historical standpoint.

There are many different kinds of painted pottery. Much of the common red or yellow ware evidently intended for domestic uses has painted designs running from crudely drawn monkeys and other animals (Fig. 191) to patterns of purely geometric bands. There is also a red ware of exceeding fineness with designs in black or white.

The finest pottery of all is polychrome ware. The paste is very smooth and of light weight. The background sizing is usually a highly polished yellow-orange or red. The applied colors are very rich and permanent, and include white and black and various shades of red, yellow, orange and brown. Many of the finer pieces have the general appearance of lacquer ware, so glossy is the surface. But this glossy surface is really polished rather than glazed. In fact, glazing does not seem to have been understood by any of the potters of the New World, although in two or more regions they were on the verge of the discovery. A number of pieces from the Maya area show a thin and probably accidental glaze. This is seen on several vases from Finca Pompeya, Guatemala, that are now in the American Museum of Natural History, as well as on figurines from Jonuta, on the Usumacinta River, that are now in the Peabody Museum. The former specimens have a greenish hue, while the latter are jet black.

It is interesting to note that a glazed paint was used by the natives in several parts of the Pueblo area, particularly in the valley of the Rio Grande. The glaze in this case probably came from borax or other salts, which formed a flux upon moderate heating. What may have originated by accident seems to have been developed purposely. The art, however, was short-lived and is unknown to the present-day Indians. It apparently came into general use shortly before the arrival of the Spaniards and may have lasted till the eighteenth century.[3]

[1] 1901, *c*, pp. 139–184.

[2] 1898, *b*, pl. 1.

[3] Pottery with glazed paint is found in New Mexican ruins near Ojo Caliente and in various sites in Pajarito Park, including Puye, Tcherigi and Rito de los Frijoles, all of which are believed to be prehistoric. Potsherds with this kind of paint are found on nearly all the sites near the Rio Grande that are known to have been occupied at the coming of the Spaniards, from Taos and Picuris on the north

An excellent example of polychrome ware is given in Fig. 192. The base is orange color, which is represented by white in the drawing. The background of

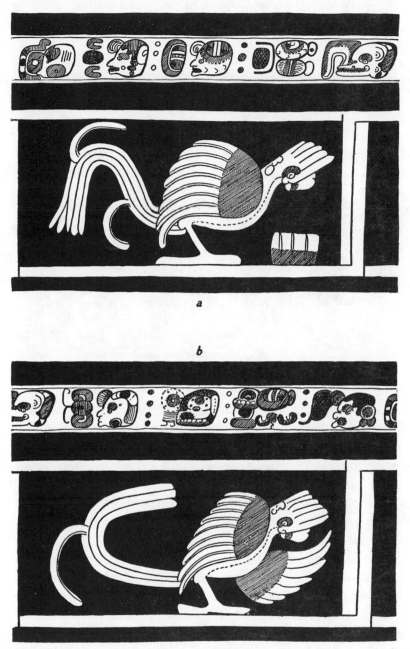

FIG. 192. — Finely painted polychrome bowl with representations of the quetzal: Copan.

the figures is black. The quetzal birds have light red markings on wings and head. In the glyphs there are details in several tones of red and brown. The

to Abo and Tabira on the south. The ware is particularly plentiful in the Galisteo Valley and in the Valley of the Jemez River. Occurrences have been noted as far west as the Little Colorado.

Castaneda, the historian of the Coronado Expedition, refers to the art as follows: " Some very beautiful glazed earthen-ware with many figures and different shapes. Here they also found many bowls full of a carefully selected shining metal with which they glazed the earthen-ware. This shows that

mines of silver would be found in that country." The last statement indicates that he believed the flux to be antimony. In a later passage he says: " In all these provinces they have earthen-ware glazed with antimony and jars of extraordinary labor and workmanship which are well worth seeing."

The glazed paint is usually black but thin applications are more or less translucent and colored by the tone of the background. In some instances the color is brownish with a slight yellowish tinge.

vase in question is cylindrical in shape, with a flat bottom and three short knobs instead of legs. It was excavated by the Peabody Museum Expedition at Copan.

Several other vases of the same shape but with complicated designs representing priests in ceremonial regalia were found by Dr. Gordon [1] in the Uloa Valley. The most interesting designs have been figured by him in his report. Many smaller pieces that may be classed as bowls have designs such as owls, bats and serpents.

A number of remarkable painted vases from the highlands of Guatemala have been described in some detail. The finest specimens were excavated in the environs of Coban. Of these the two most famous were found at Chama by Mr. E. P. Dieseldorff.[2] One of these bears two representations of a bat with outspread wings. On each wing is a crescent-shaped marking. The body of

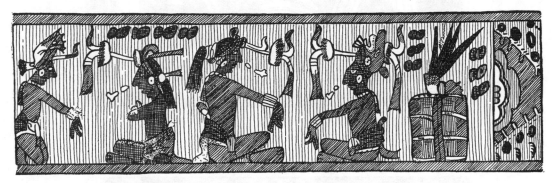

FIG. 193. — Polychrome vessel: El Jecaro, Guatemala.

the bat is grotesquely human. A flame-shaped speech scroll begins in front of the face and twining upward divides into a forward and a backward part. Between the two figures are six excellently drawn glyphs. The background is a rich orange with bands of black, yellow and brown at top and bottom. The delineation is in black, and the interior areas are filled in with white, red and brown. The second vase represents seven human beings drawn in profile and with clear details of dress, upon a light yellow background. The flesh of five of the figures is yellow orange in color but in the case of the remaining two is painted black. The most interesting figure is striding forward with a spear in one hand and a fan in the other. The foreshortening of some of the bodies is rather poor, and the bodies themselves are gross. In connection with each figure are several glyphs that probably give the name of the individual or other information concerning him. Other vessels of the same general character might be mentioned.[3]

But as a rule the variations from black are towards green suggesting the use of borax. In fact, in some cases, the glaze is quite green while in others there are green spots or bubbles. Sometimes there are thin washes of green stain extending beyond the paint. The vessels were turned upside down in firing and in many instances the paint ran badly. Since it is an invariable rule to let the clay and the paint dry thoroughly before firing, it seems likely that the paint fused during the firing. In some cases it seems to have boiled or bubbled considerably. Blisters are seen on many specimens.

Glazed paint does not seem to have been limited to any one kind of ware, but to have been used on all wares that were burned in an open draft kiln (that is, all wares that are not black). It is commonest on a thin hard red ware which shows the use of red and orange sizing. It is also found on terra cotta ware and on ware with a cream coloring sizing.

[1] 1898, a, pls. 4 and 5.

[2] See collection of papers on this subject translated in Bull. 28, Bur. Am. Ethnol., pp. 639–666. For the original color reproductions see Dieseldorff, 1894, a and b, pls. 8 and 13.

[3] See Dieseldorff, 1893, b, pl. 14 (Chama); Seler, 1902–1908, III, pp. 629, 633 (Rio Hondo), 718 (Nebaj).

A small vessel of this type is given in Fig. 193. The persons represented wear flowers in their hair, as do those on the vases just described. They are seated and apparently engaged in conversation rather than in ceremonies. An interesting feature on this vase is the representation of an altar which is apparently a bundle tied by broad bands. The altar recalls the wrapped and knotted stone altars of Copan, as has already been pointed out. Upon the top of the altar shown on the vase is a human head, indicating sacrifice. The glyphs are apparently merely decorative, for all are approximately the same. The colors are orange for background, black for lines, and red, white and brown for masses. This vase was excavated at El Jicaro, near Zacapa, Guatemala, during the construction of the railroad, and was presented to the Peabody Museum by Dr. Lytle.

In the private collection of Don Enrique Camara of Merida, Yucatan, there is a remarkable vase of the same class. This specimen was found at Calcetok, between Merida and Campeche. The paste is very light in both color and weight. The background is a yellow orange sizing with a high polish. Upon this the figures were delineated in black, and certain details filled in in white, red and brown. The shape is cylindrical. The pictures on

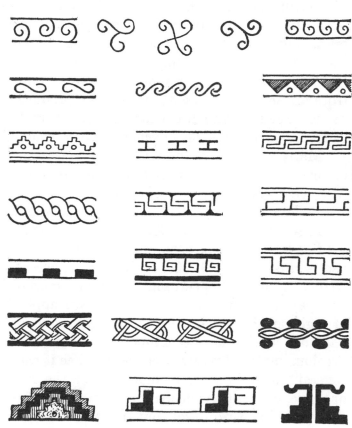

Fig. 194. — Geometric motives used in pottery decorations.

this vase include three standing and two seated men, two deer, a jaguar, a tree, a serpent and a bird.

A description of the remarkable collection of pottery with painted and plastic decoration from eastern Peten, collected by Mr. Merwin for the Peabody Museum, will add much to our knowledge of the ceramic masterpieces of the Maya.

Many vessels that it is impossible to treat in detail show combinations of the different methods of decoration that have been described. A medallion decoration showing the combination of incised and painted design is given in Fig. 184, b.

The geometric units used in ceramic decoration embrace nearly all the more common ones. The fret and the spiral are finely developed, as may be seen from Fig. 194. As a rule, the geometric elements are applied in bands around the neck or rim of the vessel.

Small clay figurines occur very widely in Mexico and Central America, and in the Maya area especially are much diversified. Plate 17 shows human

figurines of markedly different types, which give an excellent idea of the range in form and finish. Many interesting figurines come from the Uloa Valley on the southern frontier (1 to 3). The figurines from Jonuta on the lower Usumacinta (4 and 7) are among the finest from the Maya area. The last four specimens come from the Island of Jaina near Campeche and belong to the private collection of Mrs. W. M. James of Merida, Yucatan, through whose kindness they are here reproduced. The two smaller pieces, 9 and 12, exemplify very common forms, but the two larger ones are exceptional in several ways. One of them is really a tableau and presents three small figures grouped about the legs of a much larger figure. The other is a very unusual piece of modeling. It represents a man, naked except for a loin cloth and breast ornament. The right hand is raised and the left one hangs at the side. The right knee is also raised. The feet are missing. It is possible that this figure is only part of a group. A cast from an ancient terra cotta mould is reproduced in 8. This mould was obtained in the region of the Rio Chixoy in northern Guatemala. The type of face recalls the sculptures of Yaxchilan and Palenque.[1]

Many figurines in human and animal form were used as whistles with three or four notes. Others may have been used as household gods. Pottery stamps with geometric and conventionalized designs and many small objects of clay with ornamentations of various sorts are found in all parts of the Maya area.

Precious Stones. Jadeite and other semi-precious stones were much used for beads, ear plugs, nose plugs, amulets and other small carved objects whose use is unknown. Dr. G. F. Kunz,[2] an accepted authority on precious stones, writes as follows concerning the green stones of Mexico: "Chalchihuitl, a name celebrated in Mexican archaeology, was applied to certain green stones capable of high polish, which were carved in various ornamental forms and very highly valued. There has been much mystery and much discussion as to what this precious material really was, and whence it was obtained. It seems evident that several minerals were included under the name, among them a green quartz or prase, some of the deeper green varieties of techli or Mexican onyx (so called), and probably turquoise; but the precious chalchihuitl has now been proved to be jadeite, a stone which has possessed a singular charm for many aboriginal peoples in widely separated parts of the globe . . ." Nephrite apparently does not occur in Mexico and Central America.

Mrs. Nuttall[3] has been able to show, by the etymology of place names and by the tribute demanded from conquered cities by the Aztecs, that chalchihuitl was a product of definite regions in southern Mexico. Doubtless jadeite occurs in Guatemala and perhaps farther south. Hartmann describes jadeite objects from Costa Rica, which seem for the most part to be of local manufacture, and characteristic of the individualized art of Nicoya. A few specimens were probably acquired from the Maya region to the north. One piece in particular is almost surely Maya.[4] There is considerable similarity between the small human and animal figures crudely carved of green stone and possibly intended to be used as fetiches, that are common in western Guatemala[5] and in Costa

[1] For other examples of figurines see Blackiston, 1910, a and b; Seler, 1895, d; Batres, 1888, pls. 1–3.

[2] 1907, pp. 20–21.

[3] 1901, b.

[4] Hartmann, 1907, pl. 45, fig. 10. Plate 46 shows crude jades from Oaxaca somewhat similar to many from Guatemala and Costa Rica.

[5] The localities represented in the American Museum of Natural History by these crude carvings are Zacualpa, Joyabaj and Sajcabaja.

Rica. This likeness may be due to similarity in technique which is characterized by the use of straight grooves to outline crudely either faces or entire figures. Of course this method is the simplest possible one. In Costa Rica, Guatemala and the State of Guerrero, Mexico, the shape which serves as the basis for most of these figures is that of the celt. Indeed, some of the ornaments must be regarded simply as decorated celts. In other cases celts have been halved or quartered to get material for ornaments. The explanation of this may be that stones of the finest color and texture were hard to obtain, and that the celts which turned out after polishing to be of the desired material were simply transformed into figures with the least possible labor. It must be pointed out that the region in Guatemala from which these stones come is upon the western frontier, where the lapidary's art was not so highly developed as in the great cities of the lowlands.

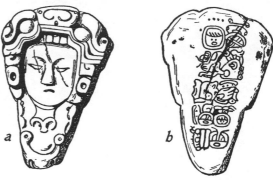

FIG. 195. — Carved jadeite amulet with inscription.

In the working of jadeite and other stones [1] drills and cords were used for boring and cutting. The larger stones were sawn into flat slabs. Sometimes, as has been said, celts were neatly halved or quartered by sand and water grinding in grooves probably through the agency of a cord drawn back and forth. Frequently irregular but somewhat flat pieces of stone were smoothed off or carved upon one side, while the other side was left in the original rough state. Indeed nearly all the carved jadeite objects from Mexico and Central America show portions of the original weathered surface, which is a good indication that the material was found only in small pieces. The cruder specimens have straight incised lines to mark out the details of the figures. Many of the finer objects, however, are freely carved in the graceful curves characteristic of Maya art, often with marked relief and with modeled surfaces.

Perhaps the most famous piece of worked jadeite from the Maya area is the Leiden Plate.[2] This is a thin oblong slab with rounded corners, having upon one side an incised drawing of an elaborately attired human being holding a Ceremonial Bar in his arms. Upon the other side is a column of hieroglyphics. Further discussion of this specimen is reserved for a later section. Another important though less artistic piece is the San Andres Tuxtla Statuette,[3] which will also be treated later.

A well-known jadeite amulet belonging to the famous Bishop collection [4] of jades, now installed at the Metropolitan Museum of Fine Arts, New York, is reproduced in Fig. 195. Upon the front is represented a human face in front view, with a headdress consisting of the upper portion of an animal head. The relief is rather high. Upon the back, which shows the natural weathered surface, are a number of glyphs. Dr. Förstemann attempted a tentative interpretation of the inscription as follows: "From the day 4 Ahau, the 7th of the month Zip,

[1] Sahagun, 1880, pp. 585–587; Seler, 1890, pp. 418–425; Holmes, 1895–1897, pp. 304–309; Saville, 1900, b, pp. 106–107.

[2] Leemans, 1877; Holden, 1879–1880, pp. 229–230; Valentini, 1881, b.

[3] Holmes, 1907.

[4] Bishop Collection, No. 309, p. 100.

when the god K ruled, lived (the person whose face is shown on the other side) until the year which begins with 8 Kan on the 13 of the month Zec." According to this the deceased person lived fifty years, two months and six days. Although it is evident enough that jades were often buried with the dead or used as votive offerings in the temples, it is unsafe to consider them as examples of portraiture.

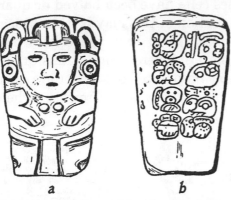

FIG. 196. — Jadeite amulet with red paint on front and inscription on back: Island of Jaina.

A jadeite amulet comparable to this in having an inscription (Fig. 196) on the back was found by Maler on the Island of Jaina near the city of Campeche and is now in the American Museum of Natural History. The grooves on the front show traces of red paint and there are eight incised glyphs on the back.

A number of finely carved ornaments, mostly obtained at Ocosingo, Guatemala, by E. G. Squier, have been described[1] by that early student of Central American archaeology. The larger pieces are pierced for suspension as amulets. A flat slab about four inches long and half as wide shows a human figure seated cross-legged, with the body in front view and the face in profile. Beneath the figure is a conventionalized face. The drawing is rather poor and the relief is flat. More rounded relief is shown in another specimen, roughly triangular in shape, which bears upon the front a human face in front view, with a simple headdress probably representing a conventionalized animal head. The ear plugs at the side of the human face have flaring featherlike appendages, that fill the two upper angles of the triangle. One of the most interesting pieces is reproduced in Fig. 95. This is a thin plate of translucent jadeite representing in stencil-like profile view a typical grotesque face of a Sun God. The carving is the same on both sides of the plate, and the four divisions of the "kin sign" on the forehead and the curve that indicates the pupil of the eye are cut through from one side to the other.

FIG. 197. — Perforations of a jadeite amulet from Chichen Itza.

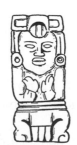

FIG. 198. — Jadeite amulet from Chichen Itza.

Fig. 197 gives three diagrammatic views of a typical jade to show the perforations. One perforation traverses the entire length of the jade and another crosses from side to side. Six dowel holes enter from the side and issue at the back. These were probably used for the attachment of feathers. In Fig. 198 we have the design on the front of the specimen.

In the Squier collection is a globular head with three inscribed glyphs and several kinds of ear plugs, such as are commonly represented in the sculptures. Fig. 199 shows a well-carved square ear plug and Fig. 200 reproduces a clay figurine of a woman found near Coban with ear plugs identical in shape and design. The excavations at Copan by the Peabody Museum revealed a number

[1] 1870. The collection is now in the American Museum of Natural History.

of burials in which were found jadeite beads and other ornaments of stone and shell. The beads were of two kinds, globular and cylindrical. According to the necklaces represented on the stone sculptures these two kinds of beads were frequently strung alternately.

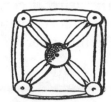

FIG. 199. — Jadeite ear plug: Ocosingo.

Vessels of alabaster and marble are occasionally found. A fine cylindrical jar of marble is figured by Hamy[1] and described as coming from Honduras, on the southern frontier of the Maya area. Two small bowls of very similar appearance were obtained by Dr. Gordon[2] on the Uloa River in northern Honduras and are now in the Peabody Museum. A small and a large

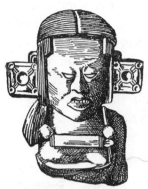

FIG. 200. — Clay figurine showing use of jadeite ear plugs: Coban.

bowl of the same type, the latter with a perforated ring base, belong to the Squier collection in the American Museum of Natural History. All these stone jars have a very characteristic decoration, consisting of short scrolls carved in low but rounded relief, and knob handles carved into animal heads. The large one in the Squier collection has a face on each side (Fig. 201) enclosed in spirals of the same character as those on the smaller pieces. A fine alabaster vase cylindrical in shape and with a simple but pleasing geometric decoration was found by Thompson in the so-called High Priest's Grave at Chichen Itza. This is now in the Field Museum at Chicago.

Metal Working. A large part of the Maya area is very young geologically and does not contain ores of any sort. Upon the southern and western frontiers metals are found, in addition to which small quantities may have been obtained in trade. Owing to this lack of material, within the region of the highest culture, objects of metal are rare. Such as do occur are fully equal to the metal work of the Valley of Mexico or the more distant Costa Rica. Gold and copper and sometimes silver were worked by hollow casting and by hammering. The making of wire filigree is found from Colombia to Central Mexico,[3] and the distribution of this interesting technical process goes farther to show cultural contact than any number of fanciful resemblances in decorative art. The objects to be cast were modeled in wax, pitch, or some such substance. If hollow, an inner form, probably of clay, was used. Decoration was added by rolling out a wire of the wax or pitch and applying

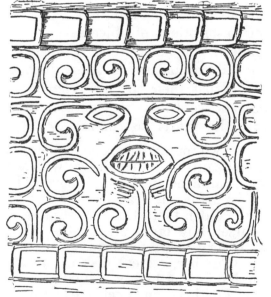

FIG. 201. — Portion of design on marble vase from Honduras.

[1] 1896, pp. 10–11, and pl. 2.

[2] 1908, a, pp. 25–26 and pl. 12, e and f. Dr. Gordon comments on the distribution of this type of object, which seems pretty definitely limited to Honduras.

[3] References on metal working are McCurdy, 1911, pp. 189–226 (Chiriqui); Peñafiel, 1890, pls. 109–113 (Nahua and Zapotecan); Seler, 1890, pp. 401–418 (Nahua); Lumholtz, 1902, II, pp. 296, 413–416 (Tarascan, etc.); Valentini, 1879, a.

this to the surface in whatever design was desired. The whole was then inset in a clay mould and the wax or pitch melted out. In the metal object as cast the wire decoration has the appearance of having been attached by some metallic cement. Sometimes the entire object was built up by coiling and folding over the wire.

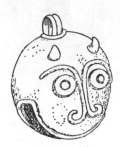

FIG. 202.—Copper bell with appliqué decoration: Honduras.

The most widespread object of metal is the bell, which is similar to the common sleigh bell. Cogolludo [1] states that copper bells were used among the Maya as a medium of exchange. Copper and gold bells similar to those from the Maya area have been found in Zapotecan, Nahua and Tarascan ruins. Fig. 202 is a sketch of a copper bell with coarse wire filigree coming from northern Honduras. It is one out of a very large number found in a cache and subsequently melted down for the small percentage of gold in the metal. Other caches showing similar bells are described by Blackiston.[2] Copper bells, mostly plain, were found in the High Priest's Grave at Chichen Itza. A few gold bells have been found in the Maya territory. Small ornaments of gold and copper are fairly common in Chiapas and Tabasco.

Bernal Dias speaks of the scarcity of gold among the Maya, but mentions a few objects. In the curious narrative called the "Letters of the Companions of Grijalva"[3] some interesting descriptions of objects

a b

FIG. 203. — Baskets represented in sculptures: a, Yaxchilan; b, Chichen Itza.

made of precious stone (probably jadeite) and metals are given. While the general enthusiasm of these discoverers must be discounted, there is no reason to distrust their specific references. There is doubt, however, whether these objects were seen in Yucatan, as stated, or in southern Vera Cruz. In any case the list is instructive.

"Two round disks, one of fine gold, the other of fine silver, handsomely worked with beautiful figures drawn with a free hand. . . . The former measures seven spans and the silver one is smaller by about a little finger.

"Further, a head of a great serpent or dragon: a figure of very fine gold with golden teeth that are easily a span wide and three fingers thick; gather for yourself how large the head is; the eyes are of precious stones and are adorned with very costly feathers.

"Further, a great disk of precious stone completely covered with tiger hide, the hide being highly valued.

"Further, four necklaces with many precious stones set in gold.

"Further, a horn of a seafish, of gold, two spans long and about two palms wide, all of gold.

"Further, a head of gold and many other pieces of gold, silver and precious stone."

Basketry. A basket of simple twilled weaving is held in the arms of a kneeling supplicant shown on one of the lintels of Temple 21 at Yaxchilan.[4] A similar

[1] 1688, p. 181.

[2] 1910, b.

[3] Muller, 1871, pp. 29–30. See also Valentini, 1879, a, p. 97.

[4] Maudslay, 1889–1902, II, pl. 83.

but more elaborate basket is shown in Fig. 203, *a*, which is also represented on a lintel at Yaxchilan. The upper portion of this basket is executed in twilled weaving; the middle portion shows a finer weave, with designs of stepped frets and small rectangles in groups of three. The bottom of the basket seems to be ornamented with feather-work. The shape of these two baskets is somewhat unusual on account of the straight sides and flaring rim. Fig. 203, *b*, apparently represents a basket with colored decoration consisting of ribbons and other adventitious ornament. The drawing is taken from the sculptured wall of the Lower chamber of the Temple of the Jaguars, at Chichen Itza. Basket-work fans are shown in the hands of the figures on the Chama [1] vase.

Braided bands are sometimes represented in headdresses, as in the case of Stela A at Copan and Stela 10 at Seibal. It seems probable that some sort of

FIG. 204. — Imitation of basket weaves on painted pottery: Uloa Valley.

basket foundation may have been used to support the elaborate feather-work. A type of ceremonial staff found at Yaxchilan on Lintels 6 and 43 consists of a woven object similar to an inverted waste-paper basket which is carried on a pole. The Long-nosed God with the serpent appendage is seated on top.

Simple basket weavings appear as painted ornamentation on potsherds from the Uloa Valley (Fig. 204). Complicated braided patterns are common as the rim decoration on pottery from this region, and may have had their origin in the imitation of wicker-work basketry. It is probable that basketry was not of much importance as an art among the Maya, owing to the high development of ceramics.

Textiles. The textile art of the ancient Maya must be studied mostly at second hand from designs sculptured or depicted on the garments of figures represented on stelae and lintels or in mural decorations and codices. There is a strong probability of certain survivals in the modern art of the Indians of Yucatan and Guatemala, but little information is available. The native women of northern Yucatan still embroider their dresses with floral and sometimes geometric patterns which may be pre-Spanish. In 1765 Lieutenant Cook, afterwards the famous captain who explored the Pacific, made an overland trip from Bacalar to Merida. His report contains an excellent description of the appearance of the natives and the country. He comments on the comeliness of the women, who, he said, wore white cotton smocks embroidered with flowers in needlework at the bottom.[2] The present mode is then at least one hundred

[1] Dieseldorff, 1894, *a*, pl. 8; Bulletin 28, pl. 48. [2] Cook, 1769, pp. 29–30.

and fifty years old. The Quiché and other Indians living on the highlands of Guatemala[1] still make their own textiles, but European influence seems to be pretty strong. For instance, silk is widely used for embroidery. The designs are mostly stripes of simple geometric figures, although some pieces show birds and other life forms finely conventionalized. Careful field study among these peoples might result in the determination of many of the ancient designs and their meanings.

The early explorers and historians[2] comment on the beautiful garments worn by the natives of Yucatan. Cogolludo[3] says the cotton cloth of Yucatan made

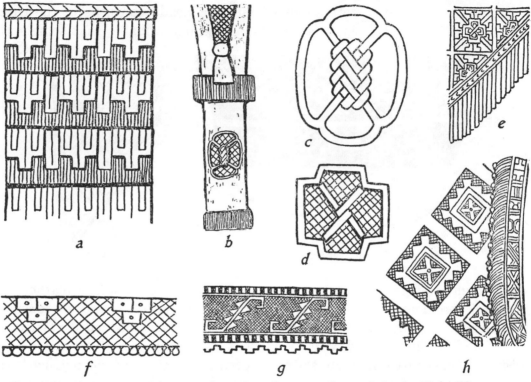

FIG. 205. — Details of textile ornament from the sculptures: *a*, Copan; *b*, *f* and *g*, Piedras Negras; *e* and *h*, Yaxchilan.

in various colors was traded over all of New Spain. Aguilar[4] likewise comments on the extent of the textile industry. Much of the tribute[5] demanded by the Spaniards was in cloth.

The every-day dress of the men was a sort of breech cloth that passed around the hips and had end flaps hanging down in front and behind. In the ancient sculptures these apron-like flaps are often embellished. The apron with a grotesque face between two serpent heads conventionalized in the form of frets (Fig. 15) may have been purely a ceremonial elaboration possible in sculptures but not used in real life. It has, however, a remarkably wide distribution among the southern cities of the Maya area. Often aprons have a sort of openwork

[1] Stoll, 1889, pp. 96–101; Maudslay, A. C. and A. P., 1899, pp. 41–43.

[2] Landa, 1864, pp. 117 and 182–184; Muller, 1871, p. 28; Relaciones de Yucatan, II, pp. 29, 46–47, 104–105, 123, 154, 211–212, etc. For a modern discussion see Schellhas, 1890, pp. 214–228.

[3] 1688, p. 173.

[4] 1639, p. 94.

[5] References to tribute are numerous; see Relaciones de Yucatan, 1900, II, pp. 57, 67–68, 150; Relacion de los Conquistadores, 1870, pp. 193–195, etc. Besides mantas, the tribute matter included wax, cocoa, and, in ancient times, green stones, red shell beads, etc.

design in the center and a fringe at the bottom, as may be seen in Fig. 205, *b*. Aprons of greater width and more elaborate decoration occur, such as the one shown in *a*, drawn from one of the statues on the Hieroglyphic Stairway at Copan. A most beautiful apron is found on Stela 7 at Piedras Negras.[1] The design consists of a symmetrical arrangement of small frets around a Greek cross.

a *b* *c* *d* *e*

FIG. 206. — Garments represented on sculptures and in codices: *a* and *b*, Chichen Itza; *c–e*, Dresden Codex.

A garment in the form of a short skirt reaching half-way down the thigh is sometimes seen upon figures which evidently represent men. Often this skirt has the characteristic markings of a jaguar skin, as may be seen on Stelae P, 2, etc., at Copan. The belt at the top of this short skirt receives the greater part of the decoration, which is usually of a geometric style. Fig. 206, *a*, reproduces the skirt of one of the processional warriors from the Lower chamber of the Temple of the Jaguars at Chichen Itza. This short skirt is marked with crossbones, which may represent painted rather than woven decoration.

The most elaborate textile patterns are found on a sort of blanket which usually envelops the entire body, although in some cases it seems to have been bound around the waist so that the corners hang down on either side. Fig. 207, taken from one of the lintels of Yaxchilan, represents a kneeling supplicant. The entire body of this person is enveloped in a robe having an all-over geometric decoration in squares, a rich border at the bottom and a tasseled fringe along the edge. It is possible that this dress represents the sacklike garment still worn by the Maya women. Similarly gowned figures occur on a number of the lintels of Yaxchilan and upon several stelae from Piedras Negras. As a rule, these figures are of smaller size than those on the same lintels which have the usual masculine dress.

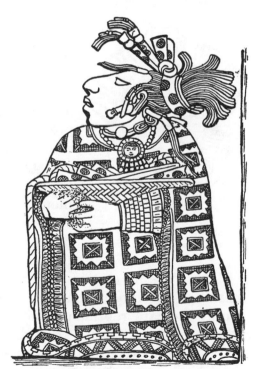

FIG. 207. — Woman richly attired: Yaxchilan.

The geometric designs on these robes are applied in horizontal stripes, in diagonal stripes and in all-over patterns. Very often the border of the bottom is differentiated from the design on the blanket as a whole. Fig. 205, *f* and *g*,

[1] Maler, 1901, pl. 16.

shows two such border decorations, and *h* a fringe border marked with the common planet symbols. Fig. 205, *e*, reproduces the design on a garment which hangs over the shoulder of a male figure. Robes somewhat like these which have just been described are represented in the codices upon figures which are clearly masculine (Fig. 206, *c* to *e*).

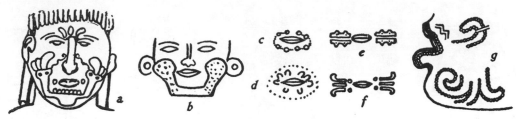

FIG. 208. — Facial tattooing.

What might be called an inset lace medallion often occurs as an evenly distributed design in the body of a garment. The details of two of these inset medallions are given in Fig. 205, *c* and *d*.

Tattooing. Dr. Schellhas[1] has already commented on the evidences of tattooing among the peoples of Central America. These evidences are found upon figurines and in the codices as well as on the sculptures. In Fig. 208, *a* to *f* are taken from the examples that Dr. Schellhas gives. Of these, the first (*a*) is a sketch of the head of a Yucatan figurine representing a man with the cheeks

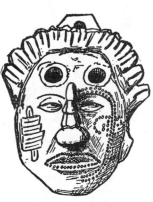

FIG. 209. — Pottery whistle showing tattooing: Tecolpa, Tabasco.

and chin tattooed with a drawing of a jaw bone. There is also a simple design in the center of the forehead. A simpler example of the jaw-bone design is seen in *b*. More often, however, the tattooing consists of simple markings made either around or at the side of the mouth, such as are shown in *c*, *d* and *e*. Fig. 209 presents a terra cotta head with raised designs on each cheek, and on the lips as well, that doubtless represent tattooing.[2] The most elaborate tattooing seems to have consisted of spiral scrolls at each corner of the mouth; examples of this type of facial decoration are seen on the lintels of Yaxchilan (Fig. 208, *b*). The splendid head formerly at Uxmal, and now in Mexico City (Fig. 182), has similar markings upon one side of the face.

There are no certain objective evidences of tattooing upon the body. The markings which occur on the legs of many of the grotesque figures of gods may simply indicate reptilian affinities. The human beings represented in the fresco paintings of Santa Rita,[3] British Honduras, usually have all bare portions of the body covered with minute geometric markings. Circles surrounded with dots, short hooks and short parallel lines are the prevailing motives. It is doubtful whether these markings represent real body ornamentation or merely adventitious elaboration by the artist.

Minor Carvings. A remarkable drawing made on the skull of a peccary is reproduced in Fig. 210. The engraved skull was found in a tomb at Copan,

[1] 1890, pp. 212–213; Landa, 1864, p. 120.
[2] Other examples of tattooing on figurines might be given. See, for instance, Batres, 1888, pls. 1–3.
[3] Gann, 1898–1899, pls. 29–31.

along with a number of pottery and bone objects, during the excavations conducted by the Peabody Museum. The drawing is here shown as if spread out flat and no account taken of the uneven surfaces. In the upper left-hand corner are shown three running peccaries, drawn with a considerable degree of naturalness. The hair is represented by short lines not very close together, which give an excellent idea of the general grizzled appearance of the animals. In the corresponding right-hand corner are represented a jaguar and a monkey in profile,

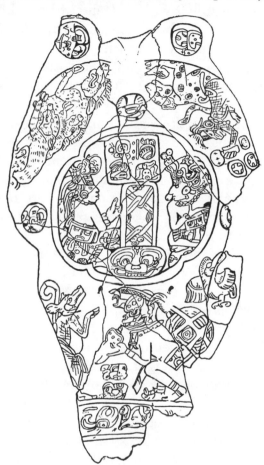

FIG. 210. — Peccary skull with incised drawings: Copan.

back to back. The jaguar is well drawn without any marked divergence from the natural form. The monkey wears a breech cloth, a necklace, ear plugs and a simple headdress. In his right hand he holds a rattle, apparently made from a gourd, marked with three small crosses. The expression on the face of the monkey is very realistic. In the center of the skull within a quadrifoil medallion are two men seated, facing each other, in easy conversational attitudes, one with the face in profile and the body in front view, and the other with both face and body in profile. Both these men wear rather elaborate headdresses. Their breasts are bare and their belts have for decoration a simple face. Between the men and arranged one above the other appear at the bottom a grotesque head, at the top a group of four glyphs and in the middle an oblong object with interlacing bands which may represent an altar. In the lower left-hand corner of the skull is drawn a deer wearing a loin cloth and standing in erect human attitude. In front of this deer is a stooping figure with a death's head. He carries on his back, by means of a tump line, a bundle tied by a number of broad bands. Over this bundle hovers a bird with wings outstretched. Besides the drawings of men and animals which have here been briefly enumerated, there are a number of glyphs scattered about. These glyphs may be name glyphs referring to the nearest figure. This drawing is remarkable for its freedom, its naturalness and its lack of conventionality.

A fragment of a carved animal skull picked up on the river front at Copan is reproduced in Fig. 60. It has already been commented upon at some length.

Shells carved with glyphs have been found at a number of sites. Some interesting examples come from the Island of Jaina. A large shell with a fine inscription has been figured by Thomas,[1] with the statement that it was secured in British Honduras. A beautiful carved shell of Maya manufacture was found during the excavations of Tula. A seated human figure is upon one side and

[1] 1894–1895, pl. 69.

four Maya glyphs upon the other. This specimen has been reproduced by Peñafiel.[1] It is now in the Field Museum at Chicago.

Illuminated Manuscripts. The three Maya codices[2] are of unequal value as objects of art. The Dresden is by far the best. The drawings of some parts are of exceeding delicacy and smoothness, while other pages show much rougher work. This difference in finish may be explained by difference in paper or in authorship. The codex treats of a variety of subjects, and it is possible that each subject was written out by a different hand.

The glyphs of this codex are rich in detail and similar in most features to the glyphs of the sculptures. The cursive style of representation has caused some changes. In the first place, the glyphs are tilted slightly toward the right. Examination makes clear that the stroke for outlining faces and other oval or circular bodies was begun at the lower left-hand corner and carried over and around to the right, ending a slight reverse curve that produces a sort of beak. Details were doubtless put in after the outline had been made. The columns of glyphs were marked out in faint lines to guide the scribe, and the numbers to be set down were marked on lightly. Certain erasures are in evidence. Mistakes of more serious nature were made in some of the calculations, according to Förstemann. It seems possible that there were professional scribes or copiers who did not understand very well what they were transcribing.

The oblong pages of the Dresden Codex are usually divided horizontally into three zones, and each of these zones subdivided vertically into three sections. Frequently a drawing of one or more figures is shown in each of the nine sections, associated with glyphs and numbers. The glyphs often show an intelligible abbreviation of the main figure, and by this means the glyphs of nearly all the gods have been determined. In these uniform spaces all the men and women are of a certain height, no matter whether standing or sitting. The figures are drawn in lively attitudes. Among the poses shown may be mentioned sitting in side view so that of the legs only the bottom of one foot and the foreshortened thigh of the other leg are in view, sitting with legs in front view but with the head turned in profile; sitting with the knees up, squatting and stooping, walking, reclining, and even falling headlong with the body curiously twisted. Objects held in the hand or placed before the figure indicate the attributes and powers.

While most of the more finished drawings are in simple black and white, many others show the use of color for the background, and a few resemble pictures in that several colors are combined to mark out the details of dress and ornament.

The probable connection of some of the gods shown in this and other codices, with those represented by other means, has already been discussed. From the prevalence of glyphs of the southern type, and especially the occurrence of the period glyphs, this codex has been referred to the southern or western part of the Maya area.

Förstemann[3] believes that the codex comes from the region of Palenque. It is significant that neither the Ceremonial Bar nor the Manikin Scepter, the two principal ceremonial objects in the Maya cities of the great period, is seen in this codex. The dates given in the Dresden Codex will be considered in another

[1] 1899, pl. 80, and 1890, pl. 169. See also Charnay, 1885, p. 74.
[2] A revised pagination for these documents is given on page 260. [3] 1897, p. 48.

section. If the last of these dates is historical, the Dresden Codex comes down from the time of the Transition, and may have originated in the region south of Uxmal or perhaps in Tabasco. There are a few remarkable similarities between this codex and others that are ascribed to the Zapotecans. An instance in point is the staff with a hand[1] at the upper end that occurs likewise in the Codex Borgia (Fig. 211).

The Peresianus Codex, now, unfortunately, in a very fragmentary condition,[2] seems also to be an old manuscript that may antedate the coming of the Spaniards by several centuries. The drawing is very fine, and there is reason to believe that in its prime it was equal to the Dresden Codex. The details of the codex show certain rather definite similarities to the sculptures of Naranjo, Quirigua and Piedras Negras, and it seems likely that the manuscript originated in the general region of these cities or was copied from an earlier manuscript having such an origin. A croco-dile-like animal with its head hanging over the edge of a throne and with its feet bound to the body is seen on Plates 3–11 of the de Rosny reproduction. An apparently human figure is seated on this throne, and a god, that varies from page to page, stands be-fore the throne holding a head in his hands, which usually appears to be that of God K, while before his face flutters a bird and before his feet is an offering of maize. The idea of a figure seated on a throne is common on the stelae of the Peten region. Here also the figure is usually human in appearance. One or more other figures, also in human guise, are sometimes arranged before this person, and these frequently hold the Manikin Scepter or some other ceremonial object

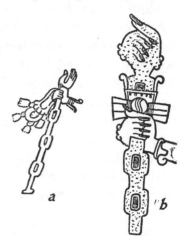

FIG. 211. — Staff ending in hand: a, Dresden Codex; b, Codex Borgia.

in their hands. In other cases the seated figure himself holds the Manikin Scepter or the Ceremonial Bar. The throne or niche in almost all instances has a bound animal placed across it. Sometimes the animal assumes the characteristics of the Two-headed Dragon. Sometimes two animals, one above the other, are rep-resented, the upper one being highly conventionalized. Illustrations of the thrones in the Peresianus Codex and on Stela 32 of Naranjo have been already presented in Fig. 6, d, f and g. For comparative study reference is made to Stelae 5, 6, 11, 14, 25 and 33 at Piedras Negras, and Stelae 22 and 32 at Naranjo. The technique of the sculptures is very different from that of the manuscripts, and this fact should be taken into account. The form of the astronomical band on Plate 22 of the Codex is almost identical with the astronomical band on the back of Stela H at Quirigua (Fig. 6, a and c). The face of the Roman-nosed God attached to the body of a bird appears on Plates 4 and 8 of the manuscript and on the top of Stela 5 at Piedras Negras. Although the resemblances which have just been pointed out are not conclusive, yet they are more so than those shown by either of the other codices for any particular region.

The Tro-Cortesianus Codex is much inferior to the other two in artistic skill, and may be a late work or at least a late copy. The difference in style is

[1] This object also is seen in the Tro-Cortesianus Codex, p. 89.
[2] For the romantic history of this manuscript see Léon de Rosny, 1876, p. 6.

well shown by the drawings given in Figs. 77, 78, etc. The most striking simi-
larity of the Tro-Cortesianus to the sculptures is in the curious representation
of the two birds with interlocked necks (Fig. 102, *i*), which resembles in subject
a rather crude carving at Labna. The glyphs are cruder and simpler than those
of the other two codices, and are inclined to be angular. The glyphs of the Books
of Chilan Balam, which belong to the Spanish epoch, are very much more an-
gular. The Tro-Cortesianus Codex may with some assurance be assigned to
northern Yucatan and to a date not much later than 1200 A.D It contains no
representations of the sun disk and other Nahua and Zapotecan features which
appear in the late sculptures of Chichen Itza. The forms of the gods are similar
in detail to those of the other two codices. All three of the Maya codices are quite
clearly marked off from the ancient books of the neighboring peoples, although
random resemblances occur, as has already been noted.

A word or two may be given to the subject matter embodied in these codices
and the attempts at decipherment. Since the days of Kingsborough [1] attention
has been directed to this field of study. Most of the early attempts at elucida-
tion are practically worthless and even in modern times much has been written
that is of little value. Brasseur de Bourbourg,[2] for instance, began his transla-
tion of the Codex Troano at the wrong end of the manuscript, and used the so-
called alphabet of Landa,[3] which is now known to be no alphabet at all. Charen-
cey and Léon de Rosny worked in a careful and painstaking manner and their
results deserve credit as pioneer efforts. The most important contribution of
Thomas, in his Study of the Manuscript Troano, was his demonstration that
pages 34 to 37 of the Tro-Cortesianus Codex referred to the ceremonies of the
new year as described by Landa, and his comparison with these pages of an analo-
gous passage in the Dresden Codex (pages 25–28). Undoubtedly the greatest
single contribution to the subject in hand is Förstemann's Commentary on the
Dresden Codex. Many valuable papers on definite subjects relating to the
codices have been contributed by Bowditch, Schellhas, Seler, Fewkes, Gates,
etc. Many of these have already been referred to in this text.

The contents of the three manuscripts are largely religious and astronomical,
although the Tro-Cortesianus Codex also casts considerable light on the every-
day life of the Maya. The Tonalamatl [4] or 260-day period is frequently indicated,
usually in a much more abbreviated form than in Nahua and Zapotecan codices.
This time period, with its varying divisions, is employed in connection with
gods, ceremonies, avocations and events. The representation of the new year
ceremonies in the Tro-Cortesianus and Dresden Codices has already been men-
tioned. Possibly the same subject is contained in Plates 19 and 20 of the Codex
Peresianus. Several pages of the Dresden Codex are devoted to intricate astro-
nomical calculations in which the lunar, solar and Venus calendars are correlated
in a wonderful manner. It is possible that some historical references are con-
tained in the Dresden and Peresianus Codices, although this is not very likely. In
the former there are a number of dates that can be expressed in the same system
that was used on the ancient monuments. It is probable, however, that the true
historical records were among those destroyed by Landa and other Spanish priests.

[1] The Dresden Codex was first reproduced by
Kingsborough, 1831–1848, III.
[2] 1869–1870.

[3] 1864, pp. 316–322.
[4] Bowditch, 1910, pp. 266–274; Förstemann,
1895.

III. CHRONOLOGICAL SEQUENCE.

FIRST EPOCH.

Statement of the Problem. In the analysis of any great national art the determination of the chronological sequence of forms is of first importance. How difficult a problem this may become, even in the full light of a civilization continuous to our own times, is seen in the years of labor that were necessary to arrange in such an order the remains of Greek art.

Although the pre-Columbian peoples of Central America had reached what may properly be called the historic stage of civilization, yet their history is unknown to us because we cannot decipher the inscriptions on their monuments. Only in so far as these inscriptions deal with the absolute relationships of numbers have they been satisfactorily explained. It has long been thought that the many glyphs which contain no numbers were used to carry the historical narrative, to give the names and attributes of chiefs and deities, or to make clear the exact nature of the ceremonies connected with each particular monument or temple. The glyphs which do contain numbers are found in series that express one or more dates in the wonderful system of the Maya calendar. But unfortunately these dates were measured in cycles from an imaginary beginning of time in the distant past. Mr. Bowditch,[1] speaking of this beginning date, says:

"If it were possible to connect with certainty the date 4 Ahau 8 Cumhu, from which all these other dates are counted, with our own chronology, we could easily reach a clear knowledge of the dates on which these monuments were erected and these inscriptions were carved, always provided, however, that the dates so given are records of the dates of the erection of the monuments, or at least of the buildings in which the inscriptions are found; and this, I think, is now generally conceded to be the case in almost all instances."

It must be admitted, however, that the attempts which have been made, upon the sole basis of the recorded dates to reconstruct the ancient history of the Maya have not proved over successful. We will now consider the evidence indicating the historical sequence of monuments and cities which a careful study of the art is able to furnish. Such a sequence, even after it has been determined, cannot be put on a basis of actual years until the historical character of at least some of the dates in the inscriptions has been established. The easiest method of presentation is to take up one city after another, beginning with those that show the most archaic forms.

Copan. In western Honduras is situated the ancient city of Copan.[2] The principal monuments of this pre-Columbian capital were first made known to the world through the descriptions of Stephens and the drawings of Catherwood. More recently the splendid plates that illustrate Maudslay's work and the reports

[1] 1903, *b*, p. 3. [2] See Table of Nomenclature, p. 251.

of the detailed explorations of the Peabody Museum, unfortunately prevented from being carried to completion, have furnished additional information. The hundreds of unpublished photographs taken by the Museum expeditions, as well as the fine collection of original sculptures which are now available for study at this institution, were indispensable aids in the present work.

At Copan there are about twenty-five stelae. At least fifteen of these fall into a remarkably homogeneous series presenting the human figure in ceremonial attire. In connection with some of the stelae occur altars also decorated with carvings. There are, in addition, a considerable number of altars that are independent of the stelae. There are abundant remains of temples which had elaborate façade and interior decorations. An attempt will be made to throw this mass of sculpture into its proper chronological sequence.

The stelae of the homogeneous series, already mentioned, will now be considered. Each monolith shows on the front and sometimes on the back also a human figure considerably larger than natural size and richly attired that holds in its arms an object which has already been described as the Ceremonial Bar. This human being stands in a perfectly symmetrical pose, with the heels together and both arms held at the same angle. The figure wears an elaborate headdress, frequently consisting of one animal head over another. At the side of the face are ear plugs with ornaments attached; upon the wrists and ankles are decorative bands, usually carved to represent serpent heads; about the waist is a heavy girdle to which are attached small human or grotesque faces and a fringe of sea shells. From the center of the girdle hangs an apron which is also elaborately ornamented.

In the course of this study the stelae were first arranged in groups according to the proportions of the human figures carved upon them. It was found that this simple method threw them into a definite series in which other progressive variations were easily noted. For instance, the details of dress, of pose, and the degree of relief, all pass through a similar harmonious modification.

A brief description of a number of typical stelae will serve to indicate some of the progressive changes. The drawings in Maudslay's great work may be used to advantage in following this description, because they show the details of dress and ornament so clearly, but it must be stated in advance that the delineation has been more or less standardized. The cruder sculptures are frequently overdrawn in the style of the better ones. The face of Stela P, for instance, is very much overdrawn.

Stela P shows a tall slender figure wearing a jaguar skin skirt and standing with the heels together and the feet turned straight outward. A portion of the torso is distinctly visible above the girdle. In the arms, which are held with the elbows close to the body and the forearms nearly vertical, there is supported the Ceremonial Bar, which in this case has a pendent body (Fig. 46, a). About the neck of the personage represented on this stela is a collar consisting of a grotesque face, and upon the breast is a small face which probably represents a stone or shell pendant. The ear plugs are circular objects to which are connected a number of serpent heads. The purely ornamental details of this monument show very neat and careful work that does not seem at all archaic. But the carving of the legs, arms and face is flat and crude, with sharp edges. The face in particular is very badly done, and the eyes protrude in the same way as on the archaic Greek sculptures.

Stela 2 is another slender stela, although the slenderness is not so marked as in the preceding one. The body maintains the same pose, except that the forearms are not held nearly so vertical. The details of dress are remarkably similar, although in general somewhat more complicated. The torso is broader and the legs shorter and more muscular. The relief is somewhat higher than on Stela P, but is hardly less angular. Both of these stelae show the outlines of the shoulders and waist clearly.

The carvings on Stela I are much more complicated. The figure wears a mask over the face. The Ceremonial Bar is of the pendent type, but represents a dead snake. The girdle is heavier than heretofore, and the outlines of the upper portion of the body are entirely concealed. The figure is decidedly stocky and is sculptured in rather high but angular relief. Certain details of dress and ornament are similar to those of Stelae P and 2, particularly the ear ornaments with attached serpent heads (Fig. 41) and the grotesque face under the chin.

In Stela B a great change is to be noted. Many details of dress and ornament are new or modified. The pose is in general the same, but the feet are turned slightly inward in a more comfortable position and the forearms are held horizontally. The Ceremonial Bar no longer has a pendent body, but consists of a straight panel terminated by much-elongated serpent heads (Fig. 46, *b*). The girdle is exceedingly cumbersome. No part of the torso is visible. The face is visibly larger in proportion to the rest of the body than in the preceding stelae. The legs also have increased in

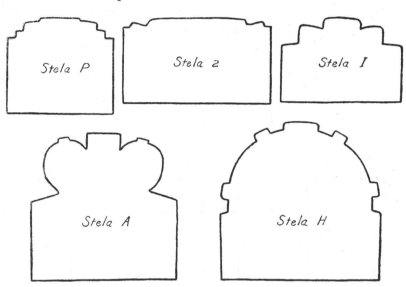

FIG. 212. — Cross-sections of Copan stelae.

length and the middle part of the body has been much reduced. The face is carved with a fair degree of modeling in almost natural relief. The arms and legs are also well rounded and stand out in high relief from the background.

Stela N presents a confused mass of superficial ornament very deeply undercut, but shows much the same pose as Stela B. The face is carved with a fair degree of naturalness, so that the cheeks show delicately rounded contours. The eyes do not protrude, although they are not very deeply sunken. The nose is carved in good relief. The legs and arms are in the full round and are carved almost free from the block. The feet are turned out, but not so much as in the case of Stela B.

The marked increase in relief is illustrated in Fig. 212, which gives the cross-sections of five stelae taken at the height of the thighs. In each case the central projection is that of the apron, while on either side of this is seen the projection of the legs (except in Stela H, which represents a skirted figure). It is readily

seen from the cross-sections of Stelae P and 2 that the relief of these sculptures is low and angular and practically confined to one face of the quarried block. The relief on Stela I is higher, but still angular. On Stela A (which is very similar to Stela B, already described) the legs are not only pretty well rounded, but are carved almost free from the block. The sculpture requires about one-half of the plinth. The personage on Stela H is carved in such high relief that the greater part of a very massive block is required.

In Fig. 213 is given a table of proportions for all the figures on stelae of which reasonably complete measurements could be secured. The headdress is such a variable feature that no account is taken of it. It will be observed that the face is at first about twelve per cent of the length of the body, but later increases

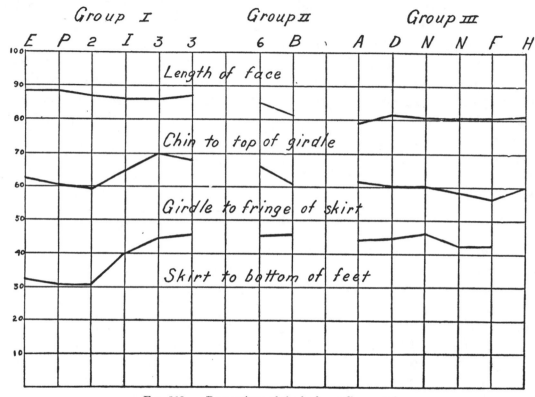

Fig. 213. — Proportions of the body on Copan stelae.

to about twenty per cent. The distance from the chin to the top of the girdle is considerably greater in the case of the first three stelae than in the succeeding ones. The distance from the top of the girdle to the fringe of the skirt decreases considerably. But as a matter of fact the skirt disappears entirely in the later sculptures, and the measurement represents the width of the girdle, which shows decided increase. The distance from the fringe of the skirt or girdle to the bottom of the feet, which represents the visible length of leg, increases nearly one-half over the proportions shown in Stelae E, P and 2.

So, instead of an increase of accuracy in the representation of the natural proportions of the human form, there is a marked falling off. This is due undoubtedly to the heavy ornaments which overlie the body. In the later stelae these are given such high relief that they distract attention from the human form beneath; all the hidden portions of the body are dwarfed. In contrast, the bare portions have an exaggerated importance and are carefully treated. It will be

remembered that the face, arms and legs of the later badly proportioned stelae show much more skillful modeling than do those of the earlier and more properly proportioned ones.

Photographic reproductions are perhaps more convincing than drawings to indicate the range of changes which have been noted. In Plates 18 and 19 are given eight examples of sculptured stelae at Copan. Stela 7 (Plate 18, fig. 1) is probably the earliest stela at this city which bears a sculptured representation of a human figure.[1] The carving is very low, and much of it has disappeared. Stela E (Plate 18, fig. 2) is in higher relief. The forearms are almost vertical. There seems to be no doubt that both monuments antedate Stela P. Next in order is Stela P (Plate 18, fig. 3), which has already been described. Note the flat angular face with the protruding eyes. Stelae 2, 1 and I proceed in order, but are not shown in the series of reproductions. Of these Stela 1 is interesting because it introduces a different type of subject characterized by a turban headdress and a body with little elaboration. This new type is developed in Stela 6 (Plate 18, fig. 4). Two fragments of Stela 5 are given (Plate 19, figs. 1 and 2), one presenting a human face and the other a grotesque. The sculpture is considerably more advanced than in the preceding examples. Stela 3, like Stela 5, has a figure upon both front and back, the best preserved one being shown in the reproduction (Plate 19, fig. 3). This stela probably is the latest one having a Ceremonial Bar of the pendent type. Stela J may be placed with these two sculptures. It has no full-length figure, but instead a grotesque face curiously conventionalized. The new style is ushered in with Stelae A, B and D in the order named. The minor criteria of sequence in the sculptures of the last group are, 1st, the placing of the feet; 2d, the increasing use of feather drapery; 3d, the shape of the eye. The feet of Stela A are turned straight outward, although the relief of the heavy apron would have permitted the more natural pose seen in Stelae B and D. The feather trimming on Stela A is insignificant, but in D and the later monuments it plays a much more important part (Fig. 106, a, d, e and f). The eyes likewise change, although those of these three stelae are almost the same. The most excellently sculptured stelae at Copan are M, N, F, H, C and 4. The feet are in all cases turned in as far as practicable. The use of feather drapery is developed into a splendid decoration. The eyes assume more and more the form with the nearly straight top. The eyes of Stela F have circular markings to indicate the iris. Stelae N and H are reproduced in Plate 19, figs. 4 and 5, and the remaining ones may be examined in Maudslay's photographs and drawings.

Even in the latest stelae the Copan sculptors did not correct the inaccuracies in proportions that have been noted. To the last the original plinth shape of the quarried block makes itself seen in the finished monument. The face projects as far outward as does the chest (except in Stela F). These anatomical errors are not apparent in the small nude busts from the frieze of Temple 22.

Besides the artistic development which has been indicated, there are other reasons for placing these monuments in the order named. Most of the early stelae lie outside of the limits of the great plaza of the city, while the later ones are set up in this plaza. But the strongest proof is furnished by the inscriptions on the sides and back of the monuments. Many of these inscriptions present

[1] Fragments of a stela showing a still earlier style were found by the writer in Copan village in January, 1912. A low relief headdress of a large figure remains on one block.

decipherable dates in the Maya system. The sequence of the dates, when they occur, is the same as the sequence that has already been indicated by the style of sculpture. This was an unexpected confirmation, and permits the time rate of change to be accurately measured. The interval between Stela 7 and Stela N is about one hundred and fifty years. This interval of time is approximately the same as that which has been marked in the course of Greek art, between the crude metopes of the Temple of Selinus and the magnificent frieze of the Parthenon. Further reference to the dates will soon be made.

A study of the glyphs carved upon the backs of the stelae shows that the style of drawing in those glyphs goes through a series of changes parallel to that of the greater sculptures. We are able by a comparison of the glyphs to place a number of stelae which have no large human beings carved upon them. Some of these stelae having only glyphs are undoubtedly earlier than the stelae which have sculptured figures. Stela 9 bears the earliest definitely settled date at Copan, and the style of carving of the glyphs is very similar to that of Stela 7, which is the earliest stelae with a sculptured body. One side of Stela 9 is now plain, but this may once have been decorated with a painting or a very low relief sculpture.[1]

The early glyphs of Copan are flat and rectangular, with many details given in fine incised lines. The drawing is often more vigorous and lifelike than in the later forms. Each glyph is treated as a design and made to fill exactly a rectangular space. The bars that stand for the numeral five are sharp-cornered and often have diagonal markings. There is a marked use of ornamental double outlines on faces. Gradually the glyphs lose their sharpness of outline and richness of detail and become more rounded and simplified. The relief becomes much greater, so that there is often considerable modeling. Perhaps the most advanced carving of glyphs is seen on the Hieroglyphic Stairway, where the forms are very well modeled in high relief. In Plate 20 is given a series of inscriptions from the earliest to the latest. The sequence of the examples is as follows: 1, 5, 6, 2, 7, 8, 3, 4, 9 and 10. The last two examples are from Quirigua.

Probably the earliest stela at Copan is that which has been numbered 15 (Plate 23, fig. 2). This valuable monument has been broken in two pieces in recent years, and now adorns the entrance to a pig-pen in the modern village of Copan. It bears glyphs on all four sides, and on one side is what appears to be a date. Stela 12, the eastern Piedra Pintada, has glyphs which are in very low relief. In fact, they are scarcely more than incised. They have, however, rounded outlines and so may not be so very early. Stela 10, the western Piedra Pintada, has very well-carved glyphs on all four sides. It also has a date which has so far escaped decipherment. Although the relief is rather low, the details of the glyphs are fairly well rounded, and the monument may fall about the time of Stela I or even later. Stela 13 also is more or less indeterminate and probably belongs to the middle period. It has, however, a very primitive drum-shaped altar. Stela 8 appears to be rather late. From this it seems clear that the stelae without full-length sculptures of human beings do not as a group precede the sculptured ones, although most of them are early.

In connection with each stela there was probably an altar, although most of the earlier stelae do not at present show such altars in position. Stela 13 has a

[1] Unfortunately this important monument along with Stela 8 was broken into a thousand pieces in January, 1912, and used in the foundation of an adobe wall around the cemetery of Copan village.

very crude drum-shaped altar with two glyphs carved upon the side. Altar 14 is also a drum-shaped object (Fig. 214). A knotted band encircles it, to which are attached a number of water symbols or "cloud balls," and a crudely drawn bird. From available information it is impossible to tell with what stela this altar was correlated. Stela I has an altar (Fig. 215) still in position. It is drum-shaped and marked with broad knotted bands that pass around each rim of the circumference and over the top and bottom in two directions. The whole is

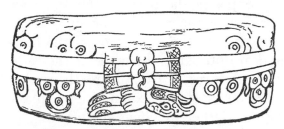

FIG. 214. — Early type of altar: Copan.

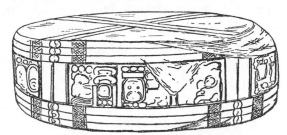

FIG. 215. — Altar of Stela I: Copan.

doubtless intended to represent a bundle. Glyphs are placed around the circumference between the bands. These glyphs are of the same type as those on the stela with which the altar is associated. Broken altars of the same kind but somewhat simpler decoration are found in connection with Stelae E and 1. These are doubtless still earlier than the one just considered. Two drum-shaped altars are connected with Stela 5, one for each sculptured face.

It is probable that the rectangular sculptured blocks X and Y found buried under Stela 5 and Stela 4, respectively, are altars of earlier stelae which were placed under later ones for some ceremonial purpose. The carving upon these rectangular altars (Fig. 216) is very similar to that of the glyphs of the earliest period, and knotted bands are present as in the circular altars. A fragment of a similar rectangular altar (Plate 20, fig. 1) was used as one of the steps in the Hieroglyphic Stairway.[1] The old carving was turned in and so preserved.

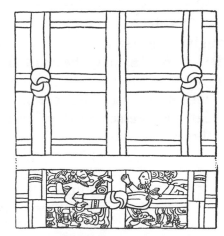

FIG. 216. — Early rectangular altar (Sculpture Y): Copan.

The altars of the later stelae are of diverse form, and most of them have already been described. There are a number of independent altars that are richly sculptured. Most of these can be placed pretty accurately in their proper sequence by the technique of the carving as illustrated by the stelae.

It has already been noted that most of the early stelae are no longer in position. Stela E, placed on the platform west of the Great Plaza, was probably in conjunction with Mound 1. If the monument was originally set up here, the mound must have been one of the first large structures. Stela I was apparently in position before the eastern wall of the Great Plaza was begun, because the wall was continued around and beyond the monument and a niche made for it. The northern end of the Great Plaza was probably only completed when Mound 2 (with the correlated Stela D) was erected. The minor hieroglyphic stairway

[1] Gordon, 1902, a, p. 19.

on the front of this mound may have served as the original suggestion for the great Hieroglyphic Stairway of Mound 26. Most of the monuments and sculptures found in connection with the Great Mound or the Acropolis seem to date from the latest period of the city, following Stela A. An exception is Stela P, which seems to have been reset in the western court without its altar. The altar of this stela may be the one found under Stela 4 in the Great Plaza (Sculpture Y).

Stela M is correlated with the Hieroglyphic Stairway and probably dates from the same time. It is set up directly opposite the base of the stairway. Stela N is correlated with Temple 11 in a similar manner. The carvings on the interior step of this building are of the same style as those on some of the independent altars, notably Altars T and Q, and are probably the work of the same sculptor. The most beautiful and perfect sculptures at Copan are those that served to decorate the façade of Temple 22. A splendid example now in the Peabody Museum is given in Plate 26, fig. 3. Other excellent sculptures, not quite so perfect (Plate 26, fig. 1), occur in connection with Structures 21, 26, 32 and 36, while the rather crude faces (Plate 26, fig. 2) found in the debris of Structure 41 are apparently considerably earlier.

A table that shows in a somewhat graphic manner the sequence and relationships that have just been discussed is herewith presented. Nothing seems to need further explanation except the column that gives the dates in the Maya system. Since frequent reference will be made to the dates on the monuments, it seems best to give a brief description. The subject is complex, and only a few points will be considered. A complete treatment of this difficult subject may be had in a recent work by Mr. C. P. Bowditch entitled "The Numeration, Calendar Systems and Astronomical Knowledge of the Mayas."

The periods in the first column of the table are indicated by position, the digits increasing in value toward the left. Thus the date on Altar K, written 9–12–16–7–8, may be read 9 cycles 12 katuns 16 tuns 7 uinals 8 kins. The system is based on twenty, except in the third position (tun), which is only 18 times the preceding period (uinal), so as to approximate the length of the year. Expressed in days and arranged in ascending values, the periods are as follows:

Kin = 1 day.
Uinal = 20 × 1 = 20 days.
Tun = 18 × 20 × 1 = 360 days.
Katun = 20 × 18 × 20 × 1 = 7200 days.
Cycle = 20 × 20 × 18 × 20 × 1 = 144,000 days.

In the inscriptions the periods are indicated by glyphs, usually grotesque faces, and the numbers that tell how many periods are taken are indicated either by bars and dots, which usually precede the period glyphs, each bar meaning 5 and each dot 1, or by definite face glyphs representing numbers from 1 to 20.

Expressed in days, the date of Altar K, given above, is :

$$9 \times 144000 = 1,296,000$$
$$12 \times 7200 = 86,400$$
$$16 \times 360 = 5,760$$
$$7 \times 20 = 140$$
$$8 \times 1 = 8$$
$$\overline{1,388,308 \text{ days.}}$$

Table 1
Showing the Chronological Sequence
of the Principal Monuments
of Copan, Honduras.

Maya Chronology.	Years from first date.	Stelae.	Altars.	Temples, Mounds, etc.
9-4-10-0-0?	0	Stela 15 — glyphs only — archaic form — low, flat relief — marked use of parallel lines in outlining and in ornamental detail — excellent design — earliest form of glyphs not found at Copan.	Not in situ and altar lost.	The oldest site of Copan may have been near modern Copan village, about a mile west of Great Mound — most of the early stelae found here — may have been ceremonial center while Great Mound was building.
		Stela 16 — fragments of new stela — glyphs of early form — figure on front shows animal headdress — relief very low.	No altar found in connection with Stela 9.	
9-6-10-0-0	40	Stela 9 — glyphs on three sides — sharp edges and angles — use of parallel lines — bars have square corners — excellent design. Fourth side may have had figure — stela destroyed in 1912.	Altar of Stela 12 — plain drum-shaped altar.	
		Stelae 10 and 12 — glyphs only — low relief and rather crude workmanship. These two stelae are correlated in an east and west line passing over Copan. They are set up on hills on opposite sides of the valley. Stela 10 has glyphs of a later form than Stela 12.	Altar of Stela 13 — drum-shaped — plain except for 2 incised glyphs.	The Great Mound shows several levels and remains of vertical walls where the river has cut into its eastern side.
9-11-0-0-0?	129	Stela 13 — glyphs only — relief low but outlines fairly well rounded.	Altar 14 — drum-shaped — knotted bands encircle it — crude bird carvings, also water symbols. Not known to which stela this altar belonged.	
		Stela 8 — glyphs of a late form and small panel of decoration that is likewise late in style. Stela destroyed in 1912.		
		Group I¹ Sculptured stelae — headdress of animal faces — ceremonial bar with pendent body — heels together — toes turned outward forming angle of 180°.		
9-9-0-0-0	99	Stela 7 — crudest form of sculptured figure — relief very low and angular — proportions very slender — forearms are nearly vertical.	Sculptures X and Y probably early altars — one found under base of Stela 4 and other under base of Stela 5 — knotted bands over top and around sides — low relief carvings resemble glyphs of Stelae E, P, etc. Part of a similar altar found as a step in the Hieroglyphic Stairway with old carving turned down.	Under the eastern altar of Stela 5 was found a broken sculpture of simple type. May represent the Two-headed Monster in its earliest form. A similar sculpture associated with Stela 4.
		Stela E — relief higher than on preceding stela.	Altar of Stela E — fragmentary drum-shaped altar with glyphs on the side.	Platform mound east of Great Plaza early — Stela E lies upon it — antedates the Great Mound. Stela P probably reset in the Western Court — no altar in position.
9-9-10-0-0	109	Stela P — relief still low — legs, arms and face angular — eyes protrude — nose very low and flat — details of regalia carefully carved.		
9-10 ? ?		Stela 2 — relief low and angular — details much like Stela P — proportions of figure not so slender.		
9-12-3-14-0	152	Stela I — relief rather high but block-like — proportions of body heavier — length of torso reduced — good ornamental details. Altar-like block underneath.	Altar of Stela I — drum-shaped altar—bands around and over top — glyphs on side.	Stela I probably set up before the eastern stepped wall of Great Plaza was built — instead of moving stela the wall built around it forming a niche.
		Stela 5 — relief rather high — arms and face not so flat and angular — forearms held diagonally — figure on front and back, one grotesque, other natural. Probably dates from 13th katun. Under the base was found Sculpture Y, an early altar.	Altars of Stela 5 — one drum-shaped altar for each face of stela — glyphs around circumference.	
		Stela 3 — relief high — limbs still show angular treatment — distance from chin to girdle much reduced — figure on front and back, both natural. Sculptured "collar" round base.		Structure 41 ornamented with rather crudely carved faces — may date from the time of Stelae 5 and 3. It is a long narrow building south of the Great Mound.
		Group II¹ Sculptured stelae — turban headdress — ceremonial bar with pendent body, except Stela B — grotesque face, full length of stela.		
9-11-15-11-0	144	Stela 1 — new style of stela — rather crude treatment — nose flat — eyes protrude — date about 8 years before Stela I.	Altar of Stela 1 — drum-shaped altar set up on four blocks — knotted bands — glyphs on side.	Mound 9 in the Great Plaza clearly correlated with Stela 1 — which is placed in center of second step of stairway.
9-12-10-0-0	158	Stela 6 — same style as Stela 1, but better — still archaic. "Col-	Altar of Stela 6 — rectangular block with glyphs on sides —	Last stela set up west of the Great Mound in the old part of

		Sculptured stelae	Altar of Stela	
9-13-10-0-0	177	Stela J — no entire figure but grotesque face much conventionalized occupies entire front.	Altar of Stela J — pyramidal base — grotesque head — uniform.	Stela J set up just west of the Great Plaza.
9-15-0-0-0	207	Stela B — In style the principal figure like Stelae A and D of following group — grotesque face occupies entire back of stela. Headdress of principal figure a turban — additional features — feet turned at slightly less than 180°, hence the sculpture later than Stela A.	Altar of Stela B — not found — possibly represented "Two-headed Dragon."	The Great Mound probably erected or enlarged during the 13th and 14th katuns. Buried walls and platforms may indicate the earlier stages. The jaguar sculptures of Structure 19 are of a fairly early style.
Group III.[1]		Sculptured stelae — elaborate headdresses — feather drapery — small human figures, etc. — forearms horizontal — body of ceremonial bar a straight panel — feet gradually assume less awkward position.		
9-14-19-8-0	207	Stela A — sculpture practically in full round and considerable modeling of face and limbs — feet turned straight outward — slight fringe of feather decoration at top of stela.	Altar of Stela A — slight remains of a monolithic altar — undescribed.	Near end of 14th katun a great epoch for sculptures and temples began — perhaps before this attention given to construction of Great Mound or Acropolis. By beginning of 15th katun the Plaza was laid out in final form.
9-15-0-0-0	207	Altar S — bears same date as Stela B — only glyphs — carving of glyphs shows much the same progress as carving of human figure — block-like quality becomes less evident — sharp edges rounded and modeling apparent.	
9-15-5-0-0	212	Stela D — dress similar to Stelae A and B — feet less awkwardly posed — also advance in feather-work on sides — glyphs on back show entire figures carved in well-rounded relief.	Altar of Stela D — represents "Two-headed Dragon" the two heads at opposite corners — body reduced to single bone at each of the two other corners — front head with sun sign on eyes — rear head a death's head.	Mound 2 in clear correlation with Stela D — has a minor hieroglyphic stairway. Structure 32 — temple on south flank of Acropolis with elaborate sculptures showing excellent carving. Belongs to the last period but exact position uncertain.
9-16-5-0-0	232	Stela M — marked advance over Stela D — modeling more perfect — back covered with fine feather drapery — badly broken.	Altar of Stela M — made up of three separate parts — large central part represents body of "Two-headed Dragon" — two heads carved on other stones placed against the body — note the increasing complexity of the altars.	Hieroglyphic Stairway exactly correlated with Stela M — glyphs and larger sculptures of this stairway have no trace of angularity of earlier period — well-rounded relief. Structure 26 — the temple connected with the Hieroglyphic Stairway decorated with busts and heads carved in the finest style.
9-16-10-0-0	237	Stela N — figure on front and back — details of headdress very elaborate and deeply undercut — serpent heads of the ceremonial bar greatly elongated — entire bust of grotesque god in the open mouths. "Collar" round base has glyphs.	Altar of Stela N — monolithic representation of "Two-headed Dragon — a face added to each side as elaboration. Altars U and R — independent altars — nothing very definite by which to place these sculptures.	Temple 11 — exact correlation with Stela N — figures carved on interior step much like those in Altar Q. The stairway to Western Court has date ten years later than Stela N.
		Stela H — most beautiful and perfect stela at Copan — splendid feather drapery — face finely sculptured but too large in proportion to body — chest too flat — these defects never corrected in Copan stelae.	Altar of Stela H — represents simplified "Two-headed Dragon" — sculpture badly damaged — resembles altar of Stela N.	
9-16-15-0-0?	242	Altar G3 — this altar is on thin slab carved on both sides into a two-headed serpent.	Temple 22 dominates Eastern Court — decorated by fringe of beautiful human heads showing remarkable similarity to face of Stela H. Stone imitation of feather drapery used in façade decorations. The interior decoration shows "Two-headed Dragon" over door — splendid carving.
9-17-5-0-0?	251	Stela F — splendid development of feather drapery on the back — on the front the feet are placed at an angle of about 90° — better relief for chest.	Altar of Stela F — five parts — represents two jaguars bound to opposite sides of double-headed grotesque — two jaguar heads and two grotesque snouts form four legs of altar.	Temple 16 — The placing of this temple is rather uncertain. It belongs to the last period, but is probably earlier than Temples 11 and 22.
		Stela C — beautiful stela with figure in front and back — broken in two pieces.	Altar of Stela C represents a turtle — carved on 5 stones.	
			Altar Q — The rectangular altar resembles Altars L, F and T. The small turbaned figures seen on these monuments occur likewise on the steps of Temple 16. The sculpture is correlated with Temple 16.	
		Stela 4 — beautiful but badly broken stela — under the base was found Sculpture X.	Altar of Stela 4 — circular altar with oval cross-section and an encircling rope pattern — probably represents a knot.	
9-18-10-0-0?	276	Stela 11 — Small unimportant stela probably of late date.	Altar G1 and Altar G2 — these altars resemble Altar G3 — the dates are given in the short count and are not very certain — the sculptures are late in style.	Some of the latest sculptures and buildings are covered with several layers of painted plaster. This indicates use for some time after completion.

[1] The groups given here are primarily stylistic and not strictly successive. A new type of stela was well begun before the old type was abandoned.

This vast number of days is added to a constant beginning day which is named 4 Ahau 8 Cumhu and leads to a resulting day which in this case is 3 Lamat 16 Yax. These resulting days are omitted in this table and in most of the other dates which are used in this paper. The quadrinomial system of fixing days which is seen in the names 4 Ahau 8 Cumhu and 3 Lamat 16 Yax is briefly as follows. The Maya year consisted of 18 months of 20 days each plus 5 days that did not fall in any month but which were added to fill out the year. Each of the 20 days was given a number which ran from 1 to 13, and then repeated, so that the same day and number, for instance 4 Ahau, recurred every 260 days. But in addition each numbered day was further specified as occupying a certain place in a certain month. Thus 4 Ahau 8 Cumhu means, in full, the day Ahau with the number 4 falls on the 8th day of the month Cumhu. Of course each named day would occupy a fixed place in each month were it not for the 5 days added to fill out the year. This addition advances the list of days 5 days each year, with the result that each day can occupy on different years 4 places in each month. With the permutation system thus established any day whose number is given and whose place in a month is stated must occur once every 52 years, neither more nor less. This period of 52 years is known as the calendar round. Dates which have only the quadrinomial designation are referred to as being in the short count. They are accurate enough if one can be sure of the particular cycle of 52 years in which they fall.

Most of the dates given in the first column belong to the class known as initial series and are definitely fixed for a very long period of time. Nearly all such dates fall in the ninth cycle, but a few will be considered later that fall in the eighth and tenth cycles. The ninth cycle is approximately 400 years long and is divided into 20 katuns each of about 20 years. The katun will be used more than any other period in comparing dates, because monuments falling about 20 years apart usually show differences that may be ascribed to the advance of culture. The tun period of about one year will be used for more specific datings.

Still other methods than those given were used by the Maya. Sometimes a certain day is declared to fall on the first day of a tun or katun with a certain number and is thus fixed in the long count without a very large element of doubt. The method used in the Books of Chilan Balam and at the time of the Spanish Conquest will be described later.

The second column gives the lapse of years between the first accurately dated monument and the monument before which the date in question appears.

A few notes on doubtful dates are perhaps in order. Stela 15, which from artistic criteria has been placed first in the list of monuments, seems to have an initial series on one side (Plate 23, fig. 2). The inscription, however, is incomplete. Face numerals are used instead of bars and dots, and these occur in the left-hand column, while the period glyphs occupy the right-hand one. The period glyphs are indistinct except the uinal, which represents an entire frog, as on Stela D. The cycle number may be the usual 9. The face for the katun number, which is the significant number, if this is a ninth cycle date, strongly resembles the face for 4 which represents the Roman-nosed God with a kin sign in front of the ear plug. The number before the tun clearly shows a bleached bone and so must be 10 or above. The uinal is preceded by a face with a hand for the lower jaw,

one of the regular signs for zero. The kin glyph and number are wanting. The inscription, then, may be read 9–4–10 (or over)–0–? Since there is a strong tendency to express only even, half and quarter katuns, the most probable date is 9–4–10–0–0. This would be about 40 years earlier than the date of Stela 9 and would agree with the style of the carving.

Stela 13 bears an initial series which, according to a rather poor photograph, seems to be 9–11–0–0–0. Stela 10 also probably has an initial series inscription, but the glyphs are partly defaced and Maudslay's drawing may be slightly inaccurate. The upper part of the first glyph should probably be the face for 9 with the dots around the mouth rather than the face given with the hand for a lower jaw. The katun seems to bear the number 15, the tun the face for 10 (?) the uinal the number 16 or 17 (the 18 is impossible) and the kin 0. But any date in the fifteenth katun is 40 years or more too late for glyphs of the style shown on this monument.

The date on Stela 7 is given in face numerals and was deciphered by Mr. Morley. The early use of face numerals at Copan is worthy of note; it shows that even during the archaic period the calendar and the glyphs were already highly developed. The inscription on Stela 2 is partly defaced, but the top of the katun glyph shows a bleached bone, the usual indication of 10, and in view of the place that this monument occupies in the artistic sequence, it seems pretty certain that the date falls in the tenth katun. There is an undeciphered initial series (owing to the imperfect photographs) on the Altar of Stela 1.

The dates of Stelae 3 and 5 have not yet been deciphered. The initial series on the former is largely destroyed. An important fragment showing the beginning of the initial series of Stela 5 was discovered by the writer on a recent visit to Copan. The glyphs are much worn, but with the aid of the inscriptions on the two circular altars the date of this monument stands in a fair way to be deciphered. In the stylistic sequence these monuments lie between Stelae 1 and 6 on the one hand and A and B on the other. The date of Stela 5 probably falls in the thirteenth katun and that of Stela 3 in the early part of the fourteenth. The inscriptions on the two early rectangular altars, X and Y, seem to be too incomplete to admit of an exact placing in the chronology.

There are, or rather were, a number of initial series on the Hieroglyphic Stairway, perhaps recording the history of the city or the lives of its rulers. The first three that are given by Gordon [1] seem to be trustworthy. They are as follows:

$$9 - 5 - 19 - 12 - 0.$$
$$9 - 8 - 8 - 6 - 5.$$
$$9 - 9 - 14 - 17 - 4.$$

The last definite date at Copan is 9–16–10–0–0. To be sure the beginning of the tenth cycle, 70 years distant from this date, is declared on Altar S and possibly also on Stela 8. The style of the former monument is much more nearly in accord with its own initial series, which marks the beginning of the fifteenth katun. As for Stela 8, the style of sculpture would place this still earlier. These two declarations may have had some prophetic significance. The dates [2] on Altars

[1] 1902, *a*, pp. 21–25. [2] Bowditch, 1910, Table 29.

G1, G2, G3, and Q are rather doubtful. They are given only in the short count, but each date falls in one of its possible positions at the beginning of a quarter katun. The dates of Stela H, F, C and 4 are as yet undeciphered. The last three have long inscriptions with an introducing glyph that resembles that of the regular initial series.[1] Stela H simply states a day in the short count which recurs every 52 years.

The chronology of Copan may be summed up as follows. The earliest monuments are very crude and archaic particularly in regard to the carving of the human face. A steady improvement is noted extending from the ninth to the fifteenth katun. By the beginning of the fifteenth katun almost the last trace of archaic treatment had vanished. The brilliant period lasted until the middle of the sixteenth katun and possibly somewhat longer.

Tikal. The chronological sequence of the sculptures of Copan has been pretty definitely established. That of Tikal, a city at a considerable distance from Copan and in a different environment, will be presented in much the same way. Differences dependent upon the physical nature of available material account for only a small part of the dissimilarity between the monuments of these two cities. Both inherited the same culture, but each developed it along individual lines.

Each Maya city has what may be called its personal equation. In each the same traditional ideas are presented in a somewhat different way and with a different emphasis upon details. New ideas radiated from the points of origin, becoming more or less modified in transit. Undoubtedly some cities were more progressive than others of the same period, or more fortunate in possessing artists of greater originality and builders of greater daring. Some cities were regal and others provincial. Some were great centers of wealth lying in fruitful lands, while others were poor in resources and perhaps held in tribute. Some were creators in fashion, and others mere imitators. Thus, at the same point of time a number of cities might show an unequal advance in technical skill. Some might be found still clinging to old fashions which had passed away in the more progressive centers of art. A personal equation of time must be added to, or subtracted from the apparent time of the styles of sculpture. Besides this inequality of cities really contemporaneous, there is the further perplexing problem of real sequence in cities not contemporaneous; for many settlements were doubtless colonial offshoots of earlier centers of population or were new establishments of older cities, whose people had migrated *en masse*.

Tikal, like Copan, furnishes examples of archaic workmanship in many pieces of sculpture. Here, however, there is no long homogeneous series of monuments, but instead a number of small groups. It is somewhat difficult to argue the line of development from one of these groups to another, because the groups, as such, were probably not strictly successive. When results are cast up, it is found that out of a mass of surmise and conjecture a small number of facts have been definitely established. These seem distinctly worth the trouble.

[1] For attempts at decipherment see for Stela F, Goodman, 1897, p. 131; for Stela C, Goodman, 1897, p. 130; Seler, 1899, p. 708; Thomas, 1897–1898, pp. 776–777; Bowditch, 1910, pp. 134, 195–196; for Stela 4, Bowditch, 1910, p. 135. It is important to note that the late monuments often show calculations much more complicated than the early ones; for instance, Stela N, Bowditch, 1910, pp. 186, 320–321, and Altar U, Bowditch, 1910, pp. 206–207, Altar Q, Bowditch, 1910, pp. 135 and 185.

The stelae [1] may be arranged stylistically in the following groups:

Group 1 — Stelae 3, 7, 8, 9, 13. Group 3 — Stelae 4, 10, 12.
Group 2 — Stelae 1, 2. Group 4 — Stelae 5, 11, 16.

Group 1. In this group the human figure is represented in a style strikingly different from that which has been noted in Copan. The entire figure is shown in profile and in low relief. The proportions of the body are slender, and there is usually no cumbrous mass of dress and ornament. The pose is natural, one foot being placed slightly in advance of the other, so that the rather slender legs are somewhat separated below the short garment. The figure faces either right or left, and one hand grasps a ceremonial staff which rests upon the ground, while the other hand carries a decorated pouch. The blocks of stone upon which the figures are carved do not show careful quarrying, since in all cases the tops are roughly rounded off and the sides more or less irregular. Within this group the stelae may be arranged tentatively in the following chronological sequence: 7, 8, 13, 9, 3. Stela 9 is in the finest state of preservation and is really a very delicate and graceful piece of sculpture. It seems later than the other stelae of the same general style, but the glyphs are certainly less perfect than those of Stela 3. Of this series of stelae numbers 7 and 9 are reproduced in Plate 21, figs. 1 and 2.

Group 2. Stelae 1 and 2 may be put in a class by themselves, although in point of time they probably fall within the limits of Group 1. Both show the same style of carving and both are broken and partly destroyed. The top of Stela 1 is missing and the bottom of Stela 2; between the two, however, the design can be made out very nicely. The two stones stood side by side before a small temple somewhat apart from the main plaza [2] in which were set up most of the other Tikal monoliths. There is one feature that seems to indicate that these sculptures were broken rejects. The lowermost hieroglyphs on the back of Stela 1 were never finished, but were merely blocked out in the rough. The carving of the principal figure on each monument fills the two sides as well as the front, the design being simply bent round the corners of the rectangular block. The pose as far as the head and feet are concerned is the same as in the previous group. But the shoulders and the breast are by necessity shown in front view since, instead of staff and pouch, the Ceremonial Bar is held in the arms after the manner of Copan (Fig. 58). This Ceremonial Bar has a straight central panel, and each serpent head shows the complete manikin god, ventral appendage and all, sitting upon the lower jaw. The sides of the stelae present a confused mass of supernumerary heads attached to a chainlike object that may represent a serpent body. The front of Stela 1 is reproduced in Plate 21, fig. 3.

Group 3. Stela 4 in Group 3 is an irregular stone upon which a figure is rather crudely carved with the face in front view and in very low relief. It is different from any other stela and so cannot be accurately placed, but the style of the glyphs is that of the early period. Stelae 10 and 12 show figures carved in high relief, with the body in front view and the face in profile. In general style these two stelae are comparable to the first group of stelae at Copan, except that the

[1] The stelae referred to are all reproduced by Maler, 1911. For a correlation of nomenclature see page 256.

[2] The location of the stelae in this plaza is shown by Tozzer, 1911, p. 119, and outside of it in pl. 29 of same memoir.

relief is much higher. The legs and other parts of the body have the blocklike character and the dominant angularity already noted in the archaic sculptures of Copan. The feet are turned straight out with the heels together, and the waist is surrounded by a very heavy belt. A new feature that will be frequently met with in other cities not yet considered is the captive who lies on the ground just behind the standing figure.

Group 4. The three stelae in this group are carved upon large blocks of stone with straight sides and rounded tops, which have been carefully trimmed to shape. With a certain degree of assurance, these stelae may be placed in the following order: 16, 11, 5. Stela 16 (Plate 21, fig. 4) represents an elaborately dressed figure standing, with the body in front view and the head in profile and supporting horizontally in the two hands a Ceremonial Bar of unusual type (Fig. 65). The figure stands out clearly against the plain sunken background which is broken only by three short columns of raised glyphs. The carving is very flat, but the space relations of the third dimension are indicated by slightly differentiated planes. This stela is set up in the western part of the city at some distance from the main plaza, and before it lies the beautiful Altar 5. The style of sculpture on the altar is very similar to that on the stela, although the subjects are quite distinct.

Stela 11 presents a pose somewhat similar to that of Stela 16, except that the Ceremonial Bar, which is of the same type, is held by one hand diagonally across the body, while the other hand is outstretched. The relief is low and the detail rich. The headdress shows a fine free use of feathers drawn in sweeping curves. The raised margin of the stela has a simple pattern decoration.

On Stela 5 (Plate 22, fig. 1) the figure stands in pure profile, with the feet close together, one behind the other. The nearer hand hangs at the side and holds a decorated pouch, the farther hand holds up a Manikin Scepter by its usual serpentine appendage. The carving of the figure is in fairly high relief, with a considerable degree of careful modeling. Details of the dress are under-cut. In particular the elaborate feather ornament which hangs down at the back shows a skillful foreshortening of the feathers. There seems no room for doubting that this stela dates from the same period as the splendidly carved wooden lintels of Tikal.[1] The glyphs carved on the sides of this stela are identical, in style and the handling of decorative details, with the glyphs carved on the lintels. There is also a remarkable similarity between this stela and several at Yaxchilan, particularly in matter of dress.

Concerning the decipherable dates of Tikal the following detailed information is contained in a letter from Mr. C. P. Bowditch under date of August 3, 1910.

"Stela 3 is surely 9–2–13–0–0, 4 Ahau 13 Kayab. If this is a historical date, it is one of the earliest known and gives evidence of Tikal having been occupied before the other cities and perhaps being the center of Central American civilization.

"On Stela 10, lower part, we find 9–3–6(or 11)–2–?

9–3–6–2–0 would be 6 Ahau 8 Pax.

9–3–11–2–0 would be 11 Ahau 3 Muan.

The 0–11–19 over this series are not, I think, 'period' glyphs.

"On Stela 17 we read by means of the two dates 9–6–3–9–15, 10 Men 18 Chen.

[1] Maudslay, 1889–1902, III, pls. 71–74, 77 and 78.

"On Stela 16 we have 7 Ahau 13 ? and on A4 we have what looks like the 'end of tun 14,' but no 7 Ahau appears at the end of a tun 14 in cycle 9 except 9–11–14–0–0, 8 Ahau 18 Mol, and the month number in the inscription is.13. If, however, A4 is 'end of uinal 14,' we should have 9–2–4–14–0, 8 Ahau 13 Muan, and the month looks more like Muan than anything else.

"The Altar 5 has no means of determining its place in the long count. The dates run

1 Muluc 2 Muan
 11–11–18
13 Manik 0 Xul
 8–9–19
11 Cimi 19 Mac
 No distance number, — 3 is needed.
1 Muluc 2 Kankin.

From 1 Muluc 2 Muan to 1 Muluc 2 Kankin is 20×364 days = 7280 days =20 years less 20 days = 1–0–4–0 = 4(5–1–0).

"So far the dates are early. But on Stela 5, if the reading of A5 is 'end of tun 13,' as it seems to be, there can be but one date in Cycle 9, namely, 9–15–13–0–0, 4 Ahau 8 Yaxkin, though possibly the month may be something else than Yaxkin."

From this conservative account it is evident that the dates of Tikal are few in number and difficult to place definitely. According to style of carving we have already seen that Stela 3 probably belongs to the end of Group 1 and that there are a number of similar monuments of cruder workmanship and apparently earlier date. If the initial series of Stela 3 is accepted as historical, it must follow that the art of Tikal in its beginnings antedates that of Copan. The date on Stela 3 is about 76 years previous to that on Stela 9 at Copan and about 125 years before that on Stela 7, which is the earliest Copan stela, yet discovered, having a sculptured human figure.

These unexpectedly early dates at Tikal need not militate against the sequence that has been established at Copan. We have seen that on the first monuments of Copan the hieroglyphs were excellently carved and in point of design were even better than on the later ones. They were sharply defined, and each was made to fill exactly a given rectangular space. The line of change was not toward more excellent glyphs but simply toward more rounded lines, higher relief and a greater amount of modeling. We have also seen that the earliest Copan subjects were elaborately attired. No figures showed simple dress except Stelae 1 and 6, and these represented a new departure during the middle period.

Now at Tikal we find what was lacking at Copan; namely, glyphs that seem truly archaic, and figures with simple attire. The method of carving in profile is much easier than carving in front view. It is to be noted, however, that the only stela at Tikal which exhibits a mastery of modeling and foreshortening is Stela 5, that bears the date 9–15–13–0–0 and is contemporaneous with the best period of Copan.

The stylistic development of the hieroglyphs of Tikal should be presented at this time, because so much of the tentative chronological arrangement of the monuments and buildings depends on the evidence they furnish. The crudest form of glyph may be seen on Stelae 8, 13 and 9. The glyphs are placed in a single vertical column, although this fact may have no special significance. They

are not evenly spaced and are not of uniform size. The contours (see Plate 22, figs. 2 and 3, for examples of glyphs from Stelae 13 and 9) show a lack of refinement and artistic quality, and the masses do not neatly fill out a rectangular space. On Stela 3 and on one side of Stela 10 the hieroglyphs are in double columns and exhibit more order in sizing and spacing and are better drawn. Some of the glyphs on Stela 10 have decorative detail expressed in fine, incised lines. This use of decorative etching is still more evident on Stela 12. In fact, many of the glyphs on this stela resemble markedly the earlier glyphs of Copan, but, in general, do not show such angular blocking as is seen at the latter city. The glyphs at the top of Stela 1 are well blocked out and show considerable detail. Those at the bottom were apparently never finished (Plate 22, fig. 4). The inscriptions on Stela 16 and Altar 5 have well-chosen detail and better qualities of design than any examples so far described. They have, however, the same flat surface as all the forms that have preceded. On these latter monuments we see the first use of raised strips of glyphs introduced into the field of the composition itself. Previously the glyphs have occurred only on the sides or the back of the monument. The most skillful use of blocks of glyphs to vary the design and balance the composition will be seen at Yaxchilan and Palenque.

From this consideration it becomes pretty evident that the suggested date of 9–2–4–14–0 is altogether too early for so well-sculptured a monument as Stela 16. The date 9–11–14–0–0 seems much more credible, although still very early, and the simple mistake of leaving out a bar over the month sign glyph is one that might easily occur.

A reading more in agreement with the apparent date of the sculpture is offered by Mr. Morley, namely, that the inscription declares katun 14 rather than tun 14. Katun 14 begins with the day 6 Ahau 13 Muan. Owing to the use of ornamental dots to fill out glyphs, it is very easy to mistake 6 for 8. The lowest dot in A1 appears to be crescent-shaped rather than round, and if this is the case the upper dot must be the same, so that the bar and three dots are cut down to a bar and one dot. This emendation[1] leads to the date 9–14–0–0–0.

The dates on Altar 5 might well fall within the 52 year period that includes the date on the correlated Stela 16. In fact, the final date on this monument would then fall just 31 days short of the date on the stela.

We now come to the final and finest stage of glyph making at Tikal, — the inscriptions on the sides of Stela 5 (Plate 22, fig. 5) and on the beautifully carved temple lintels. Although not carved in high relief, the glyphs are delicately modeled and escape the dead flatness of the earlier forms. The ornamental detail is extremely rich and consists in the skillful use of double-lining, cross-hatching and beading. Under all this, however, there is a strong note of suggestive realism.

It seems probable that the dates in the short count on the wooden lintels fall near the date of Stela 5, which shows the same type of carving. The reading suggested by Mr. Bowditch[2] for two of these lintels is 9–15–10–0–0, which is within three years of the date on the stela.

[1] Mr. Bowditch also seems to concur in this; 1910, p. 184.

[2] 1910, Table 29. Elsewhere (p. 295) he suggests the position to be 10–0–15–8–0. The earlier date seems the better one. The lintel of Temple I (Maudslay, 1889–1902, III, pl. 71) begins with 9 Ahau 13 Pop, which may be 9–13–3–0–0.

.The dates of Tikal seem to agree with the sequence as indicated by the style of carving. The summary of the known dates covers a period of exactly 13 katuns or about 257 years, as follows:

Stela 3	$9 - 2 - 13 - 0 - 0$	Stela 16	$9 - 14 - 0 - 0 - 0$
Stela 10	$9 - 3 - 6$ (or 11) $- 2 - ?$	Lintel, Temple II	$9 - 15 - 10 - 0 - 0$
Stela 17	$9 - 6 - 3 - 9 - 15$	Lintel, Temple IV	$9 - 15 - 10 - 0 - 0$
Altar 5	$9 - 13 - 19 - 16 - 19.$	Stela 5	$9 - 15 - 13 - 0 - 0.$

Mr. Maudslay [1] makes the suggestion that the location of the principal temples of Tikal may indicate their sequence in construction. New temples may have been erected when the fairway of the old ones had become obstructed. A safer method of chronological classification concerns the methods of construction. All the temples of Tikal have a definite type of ground-plan with very little variation in the essential parts. In all cases the room space is a very small proportion of the area covered by the walls. The roof structures are responsible for the heavy construction, but the study of these is incomplete. Dr. Tozzer found inclosed rooms in one of them. A careful plan of every part of all the temples would doubtless give data upon which the structures could be arranged in their proper sequence. Only a suggestion can be made at the present time; namely, that the temples with the largest proportion of room space are the latest in construction. The width of the rooms is especially significant. However, the size and character of the roof structures may explain the differences in floor space in the various temples rather than real advance in the building art.

Upon the basis of comparative floor space the five principal temples fall into the following order of construction: V, IV, III, I and II. The difference in floor space between the two extremes of this list is well marked.[2] The well-known carved lintels which show close technical resemblances to Stela 5 probably were taken from Temples I, II and IV. There are other temple structures besides the five upon the lofty pyramids. Most of these have ground plans very closely resembling those of the principal temples, but executed on a smaller scale. As regards the residential buildings at Tikal it may be noted that the rooms are very narrow, seldom more than six feet in width, and that the walls are thicker than the walls of similar structures at Palenque and in northern Yucatan. The narrowness may be in part due to the frequent use of a second story, which in northern Yucatan was rarely built over the room beneath but over a solid core.

It seems certain that Tikal was one of the first Maya cities to become a center of art and culture. Its monuments illustrate the archaic period as well as the period of greatness. The dates, however, are few and the latest ones so far known do not extend into the sixteenth katun of the ninth cycle. It cannot safely be said that Tikal was abandoned at this time, but it is very significant that such a large city does not show the structures with the superior construction that will presently be described in neighboring cities with later dates.

Earliest dated Objects. The earliest remains of Maya art which bear dates in the long-time count are two small objects of jadeite — the Tuxtla Statuette [3] and the Leiden Plate.[4] The former piece of carving was dug up near

[1] 1889–1902, III, p. 48.

[2] Maler gives a table of heights of these temples, 1911, p. 50.

[3] See Holmes, 1910, for symposium.

[4] Leemans, 1877, p. 299; Holden, 1879–1880, p. 229; Valentini, 1881, b; Bowditch, 1910, p. 121.

San Andrés Tuxtla in the southern part of the State of Vera Cruz, Mexico, and the latter was found during the excavation of a drainage ditch near San Filippo and the Gracioza River on the frontier of British Honduras. Unfortunately this town and river are not shown on any maps that have come to hand. Upon the back of the Tuxtla Statuette is a somewhat imperfect inscription which has been carefully examined by a number of authorities. The date seems to be 8–6–2–4–17, which, if contemporaneous with the carving of the statuette, would make this object of art 403 years earlier than Stela 9 at Copan. The inscription on the Leiden Plate is 8–14–3–1–12 which is 160 years after the date on the Tuxtla Statuette and 243 years before that of Stela 9. As has been seen, the date on Stela 3 at Tikal is 9–2–13–0–0, which is 76 years earlier than the first certain date at Copan.[1] Moreover, there are a number of stelae at Tikal which are apparently earlier than Stela 3, thus reducing considerably the time to be accounted for.

FIG. 217. — Glyphs from San Andrés Tuxtla Statuette.

It must be accepted as self-evident that the Maya calendar could not have sprung suddenly into being, based as it is upon exact astronomical facts and intricate mathematical calculations. There was no earlier civilization in the American field sufficient to furnish even the fundamental concepts of the calendar. No one can tell how long a period of observing, recording and correcting was necessary before the Maya year count was made nearly as accurate as our own, and far superior to the best that the classical culture of Greece and Rome could offer. Furthermore, other features of Maya culture must have passed through a long process of selection and evolution before the beginning of the period of recorded history. The simple pictographs of the American Indian, the only prototype that research has offered, could not in a moment have developed into a complicated hieroglyphic system. Government and religion must also have had time slowly to muster its control over the masses of the people before the great pyramids, some of which probably antedate even the most archaic monuments, could have been attempted.

FIG. 218.—Introducing glyph on Leiden Plate.

On the Tuxtla Statuette the initial glyph is of a very simple form, with a trifoil at the top. There are no period glyphs, the periods being indicated by position as in the Dresden Codex. If this inscription is really an initial series, calculated from the normal 4 Ahau 8 Cumhu, the resulting day and month would be 8 Caban 0 Kankin. There is a glyph at the bottom of the column which has before it the number 8, but this glyph is different from any known form of Caban. The other glyphs on the Tuxtla Statuette are exceptionally angular and lack the usual rich ornamental detail. Examples of these glyphs are shown in Fig. 217. Somewhat similar glyphs were made in northern Yucatan at the time of the Spanish conquest.[2] But it is often difficult to distinguish the crudity of first and last attempts, which in the one case arises from inexperience and in the other from decadence.

[1] Or 36 years earlier than Stela 15 if the suggested date is correct.

[2] See Bowditch, 1910, for plates giving the range of day, month and period glyphs; also Brinton, 1882, *d*. The late demotic forms given by Landa show no angular treatment.

The initial glyph of the Leiden Plate (Fig. 218) is comparable to the usual run of initial glyphs in the inscriptions. It shows the common hassock-shaped figure at the base, which seems to be a spread-out tun sign, as well as a head with a kin sign for the ear plug and the ribbon ornament at the top which corresponds to the trifoil of the Tuxtla Statuette. The comb-shaped figures which commonly occur at the side of initial glyphs are wanting on that of the Leiden Plate. In minor details the initial glyph under discussion seems most to resemble the initial glyph of Stela 9 at Copan.

Period glyphs occur on the Leiden Plate, but they differ from those in the inscriptions. The cycle and katun glyphs seem to be turned about, since the latter rather than the former shows a hand for the lower jaw of the grotesque face. The tun glyph is of unusual form and seems to represent a fish, judging by the tail-like appendage. A very similar tun glyph appears on Stela 3 at Tikal, which is nearest to the Leiden Plate in point of time. The uinal glyph

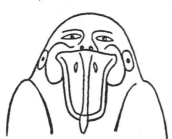

FIG. 219. — Head of the San Andrés Tuxtla Statuette.

shows the characteristic curled fang at the back of the mouth. The differences in the form of glyphs from those on the stelae are such as might naturally be expected in early specimens of a complicated art. After all, the method of indicating periods of numeration by position was entirely sufficient for the needs of the time count. The period glyphs simply gave an extra artistic flourish. The same marked fondness of the Maya for unnecessary complexity led to the use of face numerals instead of bars and dots, and to cryptograms such as occur on Stela J at Copan and Stela H at Quirigua. From this examination it seems justifiable to consider the Tuxtla Statuette and the Leiden Plate as very early examples of Maya art. The dates may tentatively be considered contemporaneous with the making of the objects.

The character of the drawings upon these objects deserves some slight attention. The Tuxtla Statuette is thus described by Holmes:[1]

"The upper part represents a human head with somewhat pointed crown, and with features well defined but primitive in treatment. The lower part of the face is masked with the beak of a bird, suggesting that of a duck or other water-fowl, carved in relief and extending like a beard down over the chest; while covering the cheeks and passing half-way down the sides of the beak are two mustache-like devices in low relief. The idea of the bird suggested by the beak is further carried out by wings covering the sides of the figure, the lower margins of which are engraved with alternating lines and rectangles to represent feathers. Beneath the wings in incised outline are the legs and feet of the bird."

The question might be raised whether the "bird-beak" on the lower part of the face (Fig. 219) may not have been intended to represent the nose of a serpent. There is a narrow tongue-like projection at the end. The statuette would then represent a complex of human, bird and serpent elements quite in keeping with the later developments of Maya art.

The drawing on the Leiden Plate is of the utmost interest, and certain features have already been repeatedly referred to. The drawing represents a richly dressed figure standing with the head and lower part of the body in profile and

[1] 1910, p. 692.

the breast turned nearly in front view. The feet are placed one behind the other. In the arms is held a Ceremonial Bar (Fig. 45), with pendent body such as is seen on the early stelae at Copan (Fig. 46, a). The grotesque heads in the serpent mouth at each end of the bar show the characteristic features of the Sun God. In many details of dress a close connection is shown between the drawing on the Leiden Plate and the monumental sculptures. The headdress has several heads, one above the other; the ear plugs have serpentine ornaments; the belt is adorned by small faces and large shells arranged in threes; a decorated apron hangs down from the waist, and the ankle bands show the common ser-

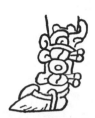

FIG. 220. — Foot of figure on Leiden Plate showing serpent-head ankle ornaments.

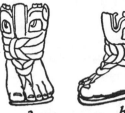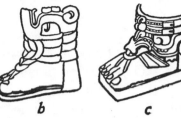

FIG. 221. — Feet of Copan stelae showing serpent-head ankle ornaments.

pent form. Compare, for instance, the ankle ornament in Fig. 220 with those from Copan in Fig. 221. A prostrate figure with the hands tied lies on the ground behind the principal figure.

It seems hardly likely that the heroic figures on the stelae could ever have been attempted without a preliminary development of the designs upon a smaller scale. The Leiden Plate is valuable as showing such an early development.

Quirigua. Quirigua, distant about twenty-five miles from Copan as the crow flies, naturally shows remarkable similarity in assemblage and in monumental remains to the latter city. The agreement at Copan between the dates on the monuments and the stylistic development of the carving encourages the trial use of the dates in arranging and studying the sculptures of Quirigua. Omitting a few dates which are so far removed from the historic period that they probably had merely a traditional or mythological significance, and taking usually the latest date on the monument when there is a choice to be made, the list is as follows:

9–16–0–0–0 Stela H [1]		9–17–10–0–0 Altar B
9–16–5–0–0 Stela J		9–17–15–0–0 Altar G
9–16–10–0–0 Stela F		9–18–0–0–0 Altar O
9–16–15–0–0 Stela D		9–18–5–0–0 Altar P
9–17–0–0–0 Stela E		9–18–10–0–0 Stela I
9–17–5–0–0 Stela A		9–18–15–0–0 Stela K
9–17–5–0–0 Stela C			

The choice of the quarter katun dates as the historical ones is admittedly arbitrary. Fuller details are given below.

Stela J. The initial series is 9–16–5–0–0, 8 Ahau 8 Zotz. From this is made a subtraction of 1–11–13–3 leading back to 9–14–13–4–17, 12 Caban 5 Kayab. The katun coefficient of the subtrahend is apparently zero rather than 1, but if this were really the case the glyph would have been omitted entirely.

[1] The date of Stela H is given on the verbal authority of Mr. S. G. Morley, who recently examined the original monument.

Seemingly independent of this is a second subtraction from the same 9–16–5–0–0, 8 Ahau 8 Zotz, of 18–3–14 leading to 9–15–6–14–6, 6 Cimi 4 Tzec. Both of these resultant dates appear on Stelae E and F and on Altar G.

Stela F. The initial series on the west side is 9–14–13–4–17, 12 Caban 5 Kayab. To this is added 13–9–9 leading to 9–15–6–14–6, 6 Cimi 4 Tzec. The date 3 Ahau 3 Mol, which falls on 9–15–10–0–0 is also stated but apparently is not directly reached by addition or subtraction. 4 Ahau 13 Yax which falls on 9–15–0–0–0 is also declared. Then comes the distance number 1–16–13–3 which when added to 9–14–13–4–17, 12 Caban 5 Kayab, carries us to the concluding date 9–16–10–0–0, 1 Ahau 3 Zip. On the east side this last date is declared in the initial series.

Stela D. The initial series on the west side is 9–16–13–4–17, 8 Caban 5 Yaxkin. Near the bottom is a secondary series of which the last two digits, 13–3, are clear. These are sufficient to raise the date to an even tun whatever the rest may be. The initial series on the east side is 9–16–15–0–0, 7 Ahau 18 Pop.

Stela E. The initial series on the west side is 9–14–13–4–17, 12 Caban 5 Kayab, a date we have seen twice before. To this several additions are made. There are a number of manifest errors which are overcome by the double check of distance numbers and quadrinomial dates as pointed out by Goodman, 1897, pp. 125–127. The first addition is of 6–13–3 and leads to 9–15–0–0–0, 4 Ahau 13 Yax. A second addition of 6–14–6 carries us to the familiar date 6 Cimi 4 Tzec. A third addition of 1–4–16–15 brings us to 9–16–11–13–1, 11 Imix 19 Muan, and a fourth of 8–4–19 to the concluding date 9–17–0–0–0, 13 Ahau 18 Cumhu. On the east side the initial series gives us this last date in full. The date 13 Ahau 13 Uo is also declared, but its position is not stated. This date falls at the end of a quarter katun in 10–0–5–0–0.

Stela A. The initial series is 9–17–5–0–0, 6 Ahau 13 Kayab. In another place is a quadrinomial date, 6 Ahau 13 Zac which may fall at 9–7–10–0–0. No subtraction is in evidence, although the date in this position would hark back nearly 200 years.

Stela C. On the east side the initial series declares 13–0–0–0–0, 4 Ahau 8 Cumhu. This date marks the beginning of the grand cycle and is over 3,000 years earlier than 9–15–0–0–0 around which the really historical dates cluster. On the west side the initial series is 9–1–0–0–0, 6 Ahau 13 Yaxkin. Later an addition of 17–5–0–0 is declared to lead to 6 Ahau 13 Kayab. This date actually occurs at 9–17–5–0–0 rather than at 9–18–5–0–0, showing that the secondary series was either added to 9–0–0–0–0 or that the katun value was intended for 16 rather than 17.

Altar B. The hieroglyphs on this monument are very difficult to read because they represent entire figures. Mr. Bowditch makes the initial series 9–10–0–0–0, 1 Ahau 8 Kayab, but Dr. Seler and Mr. Morley offer the reading given above (9–17–10–0–0, 12 Ahau 8 Pax). The katun glyph seems to show the Roman-nosed God with the twisted nose ornament. This head is characteristically used for 7 and 17. The declaration of the day and month is partly destroyed.

Altar G. The initial series is clearly 9–17–15–0–0, 5 Ahau 3 Muan. The calculations that follow are complicated and the glyphs partly destroyed. It seems indisputable, however, that the date 10–0–0–0–0, 7 Ahau 18 Zip, is declared.

This might be considered to refer to the future rather than to the past. Mr. Bowditch suggests that 10–1–0–0–0, 5 Ahau 3 Kayab, might be intended in another glyph. On the other hand the familiar dates 12 Caban 5 Kayab and 6 Cimi 4 Tzec that on Stelae J, F and E occupied the positions 9–14–13–4–17 and 9–15–6–14–6, respectively, also occur although the long distance numbers given do not seem to lead to them directly.

Altar P. The initial series is clear but the succeeding calculations which may run forward into the future or backward into the past are much destroyed.

The remaining monuments listed, Stelae H, I and K and Altar O, bear initial series dates with little or nothing in the way of addition or subtraction. Altar L may have a partial initial series, but the forms are very unusual. Altar M has a distance number, 3–2–0 running from 4 Ahau 13 Yax to 6 Ahau 18 Zac. The former date falls at 9–15–0–0–0.

From this detailed account it is seen that the choice of an even quarter katun as the date of erection for some of the monuments rests upon a rather slender basis. Calculations run forward and backward. The dates which might have a real historical value may be those which do not fall on an even quarter katun but are reached by calculations. Two of these occur, as we have seen, at least four times. But dates which are important in the city's history may, after all, have no direct bearing upon the erection of the monuments.

From this list it is seen at once that with a few exceptions the dates at Quirigua are later than those at Copan; furthermore, that they occur at quarter katuns or intervals of about five years. Quirigua was apparently founded well along in the historic epoch, possibly by a colony from Copan, and it may have been the place of refuge for the people of Copan if that city was really abandoned, as seems to have been the case. The course of development of the stelae and altars may be said to begin at Quirigua where it leaves off at Copan.

None of the sculptures of Quirigua shows the flat archaic carving of the face that characterizes the early stelae at Copan. Instead the faces of the principal figures are carved in the full round, with eyes well sunken and noses in marked relief. The stone at Quirigua is much harder than at Copan. There is, except for the face, an evident reversion to the less laborious method of low relief. A recession at the shoulders, which frequently extends to the top of the stela, throws the face and the central portion of the headdress into full relief, but the arms, the legs and the details of body ornament follow the plinth-like outlines of the quarried block and have neither the high, rounded relief nor the deep undercutting of the later stelae of Copan. This reversion to flat relief occurs also at other late cities, and may be called archaistic to distinguish it from the truly archaic.

While the stelae are, as a rule, taller than those of Copan, yet the proportions of the human body, as represented by the heroic figure, show the same defects or dwarfing the parts that happen to be covered with clothing or ornament. Indeed, the dwarfing is carried much farther than at Copan. The headdress is much elongated, and a decorated panel is placed beneath the feet so that the design as a whole is lengthened. The poses have greater freedom and variety, frequently departing from the strict observance of bilateral symmetry in the disposition of the limbs. Instead of the Ceremonial Bar the Manikin Scepter is often the principal religious object. This is held in one hand by the appendage

so that it extends diagonally across the body. Feather drapery, skillfully and freely applied, adorns the top of most of the stelae.

It must not be imagined that the artists of Quirigua drew all their ideas from Copan. There are features found there which occur at Tikal, Piedras Negras and other cities, but not at Copan. One of these is a peculiar ornament placed over the ankle (Fig. 222). This occurs widely in the Peten and Usumacinta regions. Another is the Manikin Scepter (Fig. 42, *b*) with the characteristic

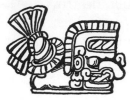

FIG. 222. — Conical ankle ornament: Quirigua.

ventral appendage in the form of a serpent. This was doubtless known to the artists of Copan, but it does not appear on any of the monolithic sculptures. The method of representing a figure sitting in a niche, which characterizes the sculptures of Piedras Negras, is seen on the back of Stela I at Quirigua (Plate 23, fig. 2). The band of planet symbols that arches over the niche is also a feature prevalent at Piedras Negras. The apron-like ornament below the figure in the niche finds its closest analogy on the back of Stela H at Copan.[1]

So much for the general features of the stelae of Quirigua. Chronological sequence at Quirigua is difficult to determine from the art alone. The best evidence is that of increasing complexity, and this is seen in the altars rather than in the stelae. The earliest stela seems to be Stela H, which shows on the front a human figure standing upon a grotesque head and holding a Ceremonial Bar (Fig. 84, *a*) in the same manner as is seen at Copan, and on the back an inscription in a braided cryptogram somewhat like that on the back of Stela J at the latter city. The heads of the bar are represented on the sides of the monument. After its occurrence on this monument the Ceremonial Bar is seen only in decadent forms at Quirigua. No significant difference in style of carving between Stela H and Stela J is noted. The latter appears to be in somewhat higher relief and to have somewhat richer feather drapery.

Stelae F, D and E are the finest monuments of this sort at Quirigua. All three are over twenty-five feet in height and are characterized by extreme elaboration of dress and by splendid use of feather drapery at each side of the headdress. Each stela has a full-length figure on both front and back. The figures on these three stelae as well as those on the fronts of the Stelae A and C wear a small beard. This is likewise seen on some of the later monuments of Copan (Stelae B, C, D, etc.). These three stelae are given in the order of the dates carved on the sides. Except for a slight increase in height there seem to be no features indicating any advance from one monument to the other. The lapse of time represents only ten years, and much change is not to be expected.

Stelae A and C are almost identical in style and subject. Both show a rather simply attired figure on the front and a complicated low-relief design on the back representing a figure with the face turned in profile. They were doubtless carved by a different sculptor than the three stelae just considered.

The quarter katun monuments for the next five periods are monolithic altars. After these come two more stelae, I and K, both being much dwarfed in their proportions. The first of these has already been commented upon. The second is often called the Dwarf. The face is large and the body broad and short. It seems pretty clear that no real dwarf is represented, and that the bad proportions

[1] Maudslay, 1889–1902, I, pl. 61.

are to be explained by the overlying ornamentation of the body which caused a similar distortion at Copan and elsewhere.

The earliest altar is doubtless Altar L, which is of the circular type, with a figure sitting cross-legged in front view but with the face in profile carved upon the top. This altar seems to be the earliest monument so far found at Quirigua. The style of carving might almost be called archaic. There is a curious and apparently incomplete inscription on this monument which, according to Mr. Bowditch, may be 9–14–10–?–?. Another sculpture at Quirigua which may be an altar is described as an alligator's head (Altar M). It appears to be much later than the circular altar, although the date inscribed upon it may be 9–15–0–0–0.

The remaining altars of Quirigua (Plates 1 and 2) are all large and important sculptures that have already been described in some detail. One of them, Altar G, represents a jaguar with a greatly modified body, the other altars present the much elaborated body of the Two-headed Dragon. Animal altars, as these may be called, are known to occur only at Copan and Quirigua, and so offer very strong evidence concerning the connection between these two cities. The last of the altars

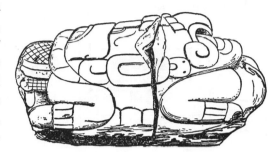

FIG. 223. — Altar N: Quirigua.

and by far the most complex, although all are complex enough, is Altar P. The simplest animal altar at Quirigua and the one nearest to those of Copan in style is Altar N (Fig. 223).

Practically nothing is known concerning the temples of Quirigua, but it is presumed that they were of the same character as those of Copan with much less decoration.

From this survey of the dates and the monuments it becomes evident that Quirigua flourished after the archaic period had passed. The changes which have been recorded witness the struggles of the artists for new effects which they hoped to obtain by complexity of form and ornament.

Naranjo. The important ruins of Naranjo lying east of Tikal and near the boundary of British Honduras only recently have been made known to archaeologists through the descriptions and photographs of Maler.[1] On account of the large number of well-preserved stelae, most of which bear decipherable dates in the native reckoning, the remains of this ancient city are of especial value in the study of the history of Maya art.

The buildings of Naranjo are in such an advanced state of ruin that they furnish little evidence on questions of sequence of construction. The general features of ground-plan and elevation are determined with difficulty, while nothing is known concerning the interior and façade decorations. The sculptured stelae set up before the temples must, however, have been intended to serve a secondary decorative function. It is the distribution and character of these monuments that demand attention. As has been explained, the chief structures of Naranjo are assembled around courts or plazas and orientated according to the four directions. Each court thus constitutes a natural unit, and with its associated temples and stelae might be expected to correspond to a definite period in the

[1] 1908, b, pp. 80–127.

growth of the city. At least three courts inclosed by important secular or religious buildings appear upon Maler's map of Naranjo.[1] In the western court are Stelae 6–11, in the middle court Stelae 12–19 and in the eastern court Stelae 20–32. Stelae 1–5 lie in the western part of the city near the acropolis and are not comprised in a regular court.

As a whole, the sculptures on the stelae of Naranjo bear a greater resemblance to those of Tikal than to those of Copan and Quirigua, but in the character of subject, dress and ceremonial regalia they serve to emphasize the common basis of the culture of all these cities. The figures are carved in very low relief rather than in high relief or full round. As a consequence of the method of low relief the face and headdress are always turned in profile, although the rest of the body is shown in front view. Small faces on girdles are alone represented in full view.

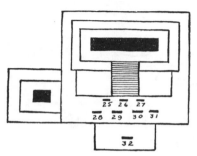

Fig. 224. — Plan of Main Temple, Naranjo, showing placing of the stelae.

The usual subject portrayed is an heroic figure, standing with his feet somewhat apart and turned out, who holds in his arms the Ceremonial Bar. The distortion of the feet and the frequency of the Ceremonial Bar recall the sculptured figures of Copan. But in a number of cases the Manikin Scepter or some sort of ornamented staff or pouch replaces the Ceremonial Bar. The apron with a grotesque face between two serpent heads conventionalized in the form of a fret occurs here, as in most of the cities of the southern Maya area. A number of figures, possibly intended to represent women, wear the long network skirt such as is seen on Stela H at Copan. An important feature at Naranjo, which has been observed at Tikal and on the Leiden Plate but not at Copan or Quirigua, is the presence of a bound captive beneath the principal figure. At Naranjo the principal figure stands on the back of the bound captive, while at Tikal he stands before it. These bound captives have been taken by Maler as conclusive and harrowing evidence of human sacrifice. But they may as well symbolize success in war, even as the foot of the king on the neck of the captive stands for conquest on the ancient monuments of the Far East.

At the eastern end of the city stands the structure that Maler calls the Main Temple. On two terraces before this temple (Fig. 224) are arranged eight stelae. Nearest the temple are Stelae 25, 26 and 27, while in front of these on the same terrace are Stelae 28, 29, 30 and 31. Stela 32 occupies the medial position on a lower terrace, which seems to have been specially constructed to support this monument. It is pretty clear, from an examination of the sculptures, that before this one building is displayed the full chronological range of sculptural art at Naranjo. Of the three stelae in the upper row, namely, 25, 26 and 27, only the first was found in condition to be photographed. This stela (Plate 24, fig. 1) is by all odds the crudest and most archaic in the city. The figure represented upon it holds in an almost vertical position a straight Ceremonial Bar. The figure is carved very simply and there is a noticeable lack of ornamentation. The relief is very low and flat. Stelae 25 and 27 were probably similar in style to this, and the three may well have been taken from some earlier temple

[1] 1908, b, p. 83. See also Morley's map, 1909, p. 544, on which the principal structures are numbered as in this text.

to be set up again in front of this one. Stelae 28, 29, 30 and 31 are much more elaborate. Of these four monuments, Stelae 28 and 29 seem to show the least advance in sculptural art. Stela 30 (Plate 24, fig. 2) is admirably preserved, and many of the incised details of the dress come out clearly in the photograph. This stela, however, presents no real advance in the representation of the human form over the sculptures of Group I at Copan or at Tikal. Stela 32, which stands on the lower terrace, has been so much destroyed by the flaking off of the sculpture that little of the design can be made out. Apparently a figure was represented seated upon an elaborate throne and holding diagonally a Ceremonial Bar. It is still possible to make out the end of this Ceremonial Bar (Fig. 225), which consists of a very complicated scroll-work representing the highest elaboration of the serpent head. This stela is an extreme example of the general process of change leading toward flamboyant curves and complicated detail. It is undoubtedly the latest work of art that has yet come to light at Naranjo.

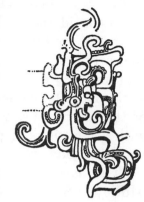

FIG. 225. — One end of Ceremonial Bar of Stela 32: Naranjo.

On the northern side of the same Eastern Court is a temple before which are set up Stelae 21, 22 and 23. Stela 22 shows a style of sculpture apparently much later than the ones that flank it. As on Stela 32, the sculpture represents a figure seated on a throne and holding a Ceremonial Bar. This object does not show the exaggerated scroll-work seen on Stela 32, but the carving of the throne, the lower part of which represents a complicated grotesque profile, is in an advanced style.

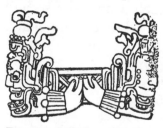

FIG. 226. — Ceremonial Bar, Stela 6: Naranjo.

In the Western Court before a temple facing the south are alligned Stelae 6, 7 and 8. From a stylistic comparison it seems perfectly clear that Stela 6 is earlier than Stela 8 and the latter, in turn, earlier than Stela 7. The increasing use of flamboyant lines in delineation from the date of Stela 6 to that of Stela 32 may be readily seen by comparing the Ceremonial Bar on the earlier stela (Fig. 226) with that on the later (Fig. 225). Intermediate stelae (numbers 7, 12, etc.) present an intermediate elaboration.

The evidence furnished by the monuments attached to these three temples shows that correlated monuments in Naranjo, at least, are of doubtful value in determining the time of construction of the temples themselves. The placing of a number of stelae before a building seems in itself to have been a rather late development. In each of the cases so far considered the middle stela appears to be the latest.

Owing to the lack of homogeneous series, it would be unwise to attempt to arrange all the stelae of Naranjo in their chronological sequence. Many are so badly weathered that the style of sculpture can no longer be determined with assurance.

Stelae 2, 3 and 5 would be early monuments at Tikal, but here they are rather late. Stelae 12 (Plate 24, fig. 3), 13 and 14 before a temple in the Middle Court apparently belong to the later period of the city. Stela 10, located in the same court, has glyphs of late form, but no sculptured figure. This court as a

whole seems to be the latest at Naranjo, although the latest single monument is found in the Eastern Court.

Dominating the Western Court is a structure that Maler terms the Palace of the Tiger Head Stairway. This large building has at its base a hieroglyphic stairway. The glyphs on this stairway are beautifully carved in the most advanced style. One of the blocks is broken and half is missing. In its place is a fragment of a lintel covered with glyphs of a much earlier style.

Although a large and important city, Naranjo does not deserve to be placed in the same class as Copan, Quirigua, Tikal and certain other cities which remain to be considered. The art of this city has a provincial character. The earliest examples are crude, but their crudity lacks the vital quality which distinguished the early art of Copan and Tikal. None of the monuments of Naranjo bear dates that are very early. In nearly all cases the calculations show many additions or step-ups. These step-up dates do not seem to occur on the very early monuments of the Maya. Over a long period the sculptures of Naranjo show a dead level with a few signs of progress. Toward the end there is a rapid development toward flamboyant exaggeration that in itself was a type of degeneration.

The dates of Naranjo have been deciphered by Mr. Bowditch[1] and by Mr. Morley.[2] So far as known there are eight initial series dates and a few additional dates which are fixed in the long count by the declaration of a definite katun. In all other cases the dates are given in the short count and may recur at intervals of 2–12–13–0 (52 years). When such recurring dates are encountered, the choice of the most probable positions in the long count are made according to two methods. First the date is chosen on which the named day marks the beginning of a whole, half or quarter katun. Failing to find such a one, the second method is to accept the date nearest the ascertained date of related monuments.

The dates in the long count are as follows:

Hieroglyphic Stairway	9–10–10–0–0.
Old lintel in the Stairway	Katun 10 declared.
Stela 24	9–12–10–5–12.
Stela 29	9–12–10–5–12.
Stela 22	9–12–15–13–7.
Stela 23	Katun 14 declared.
Stela 30	Katun 14 declared.
Stela 13	9–17–10–0–0.
Stela 14	9–17–14–4–3.
Stela 8	9–18–10–0–0.
Stela 7	Katun 19 declared.

The final or latest dates on each of the stelae of Naranjo, grouped according to the structures before which the monuments are erected, will now be given.

Main Temple (Structure 29).

Stela 28	9–12–19–0–0.
Stela 29	9–14–3–0–0.
Stela 30	9–14–3–0–0.
Stela 31	9–14–10–0–0.
Stela 32	9–19–10–0–0.

The dates of the three crude stelae that form the upper row are unknown. The next four stelae date from what corresponds to the last portion of the archaic

[1] 1910, pp. 102, 118–119, 129, 143, etc. Tables 29 and 31. [2] 1909, pp. 545–550.

period at Copan. They are much later than the stelae of corresponding style at Tikal, but show scarcely any more advance in sculpture. Stela 32 is the latest monument of any city so far considered. The style is the most advanced at Naranjo, but not nearly so remarkable as the sculptures of Quirigua. The date on this stela was decided by Mr. Morley [1] largely upon a consideration of the sequence of style as presented in this paper, but, apart from this line of argument, the fact that a half katun is reached in the calculation is much in its favor.

Structure 27.	
Stela 24	9–13–10–0–0.
Structure 26.	
Stela 21	9–13–9–3–2.
Stela 22	9–13–10–0–0.
Stela 23	9–14–0–0–0.
Structure 23.	
Stela 20	9–13–2–8–16.

The style of Stela 22, as has been already stated, is more advanced than that of Stelae 21 and 23, and its date seems to be altogether too early when the sculptures of this city are taken as a whole. In fact, all the early dated monuments of the Eastern Court are better than might be expected in a city whose later sculpture is so mediocre.

Structure 21.	
Stela 19	9–17–10–0–0.
Structure 17.	
Stela 12	9–18–10–0–0.
Stela 13	9–18–0–3–0.
Stela 14	9–18–0–0–0.

These dated monuments of the Middle Court are seventy years or more later than those of the Eastern Court, but some of them show little if any advance.

Structure 15.	
Stela 10	9–19–0–3–0.
Stela 11	9–17–18–0–0.
Structure 14.	
Stela 6	9–17–1–0–0.
Stela 7	9–19–0–3–0.
Stela 8	9–18–13–0–0.

The monuments of the Western Court bear uniformly late dates. Stela 10 has no sculptures except a double column of glyphs. These are of a well-rounded type and justify the extremely late date. Stela 11, however, is a reversion in style and subject. The style is not very different from that of Stela 30 (Plate 24, fig. 2) and the subject is close to that of Stela 21, which is dated about ninety years earlier. Judging by this evidence, the increase of skill during this period was almost nil. The very late character of the beautiful hieroglyphs of the Tiger Head Stairway is evident at a glance. The early date that appears in the inscription must have a memorial significance. The piece of a lintel which replaces part of one of the sculptured steps is important for several reasons. In the first place, it is valuable as an early fragment, although it may not be so very early after all. In the second place, its presence in the step to com-

[1] 1909, p. 559.

plete a broken sculpture may indicate occupation and use of the building for a long time after it was finished. Why did not the builders carve a new block and put it in place of the broken one? Stela 9 has no decipherable date. It is located on the north side of the Tiger Head Stairway. Subjectively it is one of the most interesting monoliths at this city, since it shows five figures, one larger than the others. The serpent heads of the Ceremonial Bar are decidedly flamboyant, so the stela probably dates from the eighteenth or nineteenth katun. As for the stelae belonging to Structure 14, the marked difference in style, which corresponds to the considerable difference in the dates, has already been pointed out. Stela 6 is very flat and angular. Stela 7 is, next to Stela 32, the most complicated and flamboyant sculpture in the city. Stela 8 has more rounded contours than Stela 6, but is far behind Stela 7.

Structure 9.
 Stela 5 9–17–13–2–8.

This monument in the western part of the city shows the earlier style before flamboyancy came into vogue. Stelae 1, 2, 3, and 4 of Structure 8 have no de-

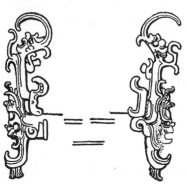

FIG. 227. — Ceremonial Bar, Stela 7: Naranjo.

cipherable dates. Judging by the style of Stelae 2 and 3, the date may be close to that of Stela 5. This ends the list of dated monuments. The most significant fact to be gathered from this rather tedious survey is that while Naranjo started well it remained stagnant during the period from the fifteenth to the eighteenth katun, which was the most brilliant period in Copan and Quirigua. There seems to have been a sudden development during the eighteenth katun that was directed toward complicated curvilinear effects. Taken by and large, the latest dates on the monuments agree very well with the artistic sequence.

There are many other sites in the Peten region where further exploration will vastly increase our store of information. Some of these sites have rather crude provincial sculptures, probably far inferior to the sculptures of the same period in the great cities. Examples of these crude works are seen in several of the stelae of Yaxha.[1] However, one or two monuments at this city are worthy of much praise. The Stela of Benque Viejo[2] is a good piece of work, probably of the later period. A city that might prove to be of first importance is Ixkun.[3] Only one monument from this city is available for study. This is a very interesting one, having a very early initial series date. A portion of the sculpture on this stela representing a bound captive is given in Fig. 228. The relief

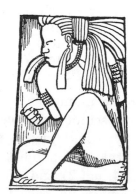

FIG. 228. — Bound captive: Ixkun.

is low, but the carving is spirited and seemingly well along toward the great period. The recently illustrated stela of Motul de San Jose[4] is apparently another late piece of work. In regard to correlating the scattered monuments good

[1] Maler, 1908, b, pls. 15, 16, 17 and 18, fig. 1.
[2] Maler, 1908, b, pl. 19.
[3] Maudslay, 1889–1902, II, pls. 68 and 69.
[4] Maler, 1910, pl. 45.

use can be made of identities in ceremonial regalia such as staffs. Some of the more common staffs are given in Fig. 229.

Seibal. At Seibal there are a number of interesting monuments that have been figured and briefly described by Maler.[1] The forest growth is very heavy over the ruins of this city, and only a meager plan of the principal temple groups was obtained. The stelae are set up in definite relationship to mounds upon which temples formerly stood. An interesting example of correlation is seen in the case of a square mound with a splendid stela opposite the center of each side (Stelae 8–11). Before an oblong mound are arranged Stelae 5 and 7, while the shattered remains of Stela 6 lie between.

All but one of the sculptures represented by photographs are carved in low, delicate relief with the faces in profile. The exception (Stela 2) is a rather clumsy figure in front view. The artistic quality of the Seibal monuments varies widely. Stelae 1, 3, 8, 9, 10 and 11 are among the most beautiful examples of art in the Maya area, while Stelae 2, 5 and 7 are notably crude.

A careful examination of the later two monuments seems to indicate that their crudity must be explained by provincial inefficiency rather than by truly archaic ignorance. The drawing is bad; the eyes, however, are of the late form and the glyphs are rounded. Stelae 6 and 7 (Plate

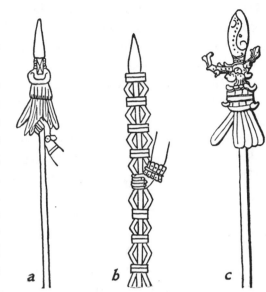

FIG. 229. — Ceremonial spears: *a* and *b*, Chichen Itza; *c*, Palenque.

25, fig. 1) bear, according to Mr. Bowditch,[2] the comparatively late date 9–17–0–0–0. It seems possible that Siebal was a city that came into power long after Tikal and Copan.

Mr. Morley obtained interesting results, as yet unpublished, from an examination of moulded fragments of Seibal monuments, some of which are reproduced by Maler as fragments of Stela 6 and of Stelae 12–15. He was able to piece together several parts of a calculation running from 9–15–15–0–0, 9 Ahau 18 Xul, to well up towards the beginning of the eighteenth katun.

Stela 1, which stands alone at the end of a ruined oblong structure, is a splendidly preserved and exquisitely carved monument. The relief is low with an archaistic flatness, but the details of dress are shown on different planes. The first two glyphs are apparently 3 Ahau 3 Yax, corresponding to the quarter katun at 9–18–15–0–0–0.

The four stelae numbered 8 to 11 are very similar in technical skill. Of these Stela 10 (Plate 25, fig. 2) is in almost perfect state of preservation. The sculptures all exhibit the flamboyancy that was noted in the late carvings of Naranjo and show moreover a number of definite points of resemblance to the latter city in details represented. In two cases a markedly decadent form of the Ceremonial Bar is given. In the second line of glyphs at the top of Stela 11 we see the date 7 Ahau 18 Zip, which ushers in the tenth cycle declared in the following glyph.

[1] 1908, *a*, pp. 10–27 and pls. 3–10. [2] 1910, table 29.

Next comes the sign for 1 katun, and in the column of glyphs in front of the human figure is the date 5 Ahau 3 Kayab followed by the ending sign with 1 katun. This 5 Ahau 3 Kayab is doubtless 10–1–0–0–0. The same date introduces the calculation on the remaining three monuments of this very important group. It may be stated here that these sculptures are the latest accurately dated examples of high art, that have so far come to light. There are two or three other tenth cycle dates that are a few years later than the ones above recorded, but they are not associated with sculptures of great merit.

Yaxchilan. Yaxchilan, situated on the western bank of the Usumacinta River at about 17° north latitude, has been visited and described by a number of explorers. The chief works of art are sculptured stone lintels and stelae.[1] Many of the temples of this city are in a fair state of preservation.

Few of the sculptures of Yaxchilan offer evidence of archaism. Many, on the other hand, show an advance in the representation of the human figure and a knowledge of grouping, perspective, and foreshortening beyond anything seen in the southern cities so far treated. The principal criteria of chronological sequence at Yaxchilan are three: first, development of rounded relief out of flat relief, such as has been already studied at Copan, Quirigua, Tikal, etc.; second, the increase of skill in perspective and foreshortening, briefly noted in the later stelae of Tikal; third, the invention of safer and lighter methods of construction. The first two criteria concern the sculptures, and the last the buildings.

The lintels at Yaxchilan are usually carved on the under side, the space reserved for the carving being approximately square. In this space two or more human figures are represented in low relief. Blocks of glyphs commonly fill the corners and occupy most of the open space between the figures. One of the persons represented is, as a rule, somewhat larger than the other. They commonly face each other, one being drawn in pure profile, while the other has the body in front view and the face in profile. The feet of the person shown in front view are turned directly outward in the awkward pose so frequently noted in other cities, while the figure in profile stands in a soldierly attitude with one leg concealed behind the other.

The attempt to represent the human body in side view, after the front-view method had been established, seems to have led to a fair understanding of the difficult feat of foreshortening, especially in the details of breast ornaments and aprons. It should also be noted that lintel sculptures have the character of a design limited to a given space, and as a natural development of this limitation there results a feeling and an expression of that subtle balance in the grouping of points of interest which is commonly called composition.

The earliest lintels of Yaxchilan seem to be those which show the carvings in low, flat relief, with details of dress and of glyphs simply incised. In the more advanced sculptures the relief is considerably higher and there is more of a feeling for well-rounded-out contours. Also there is a marked increase in artistic quality. As a rule, there are several lintels in each temple, and these commonly show a similar style of carving. The tentative order of some of the principal temples of Yaxchilan on the basis of lintel classification will now be given. There is really little choice among the first five or six positions.

[1] For the notation and nomenclature see p. 259.

Structure 1	Lintels, 5, 6, 7, and 8.	Structure 21	Lintels 15, 16, and 17.
Structure 20	Lintels 12, 13 and 14.	Structure 2	Lintel 9
Structure 33	Lintels 1, 2 and 3	Structure 42	Lintels 41, 42, 43.
Structure 10	Lintels 32 and 33.	Structure 44	Lintels 44, 45 and 46.
Structure 16	Lintels 38, 39 and 40.	Structure 23	Lintels 24, 25 and 26.

In addition to these there are some lintels with only glyphs which are not easily placed. Lintel 10 of Structure 3 seems to show rather archaic carving. Lintels 18, 19, 20, 21, 22 and 23 of Structure 22 are not uniform in style of carving or in appearance. Lintel 18 has incised glyphs; Lintel 21 has glyphs in low relief; Lintel 22 has glyphs in rather high relief, hardly a single one of which is recognizable. The glyphs on this stone resemble somewhat those on Lintels 35 and 37 from Structure 12, but the latter have much more artistic quality. Lintels 27 and 28 of Structure 24 are so badly weathered that it is difficult to judge their style. They resemble the lintel which is now in the Berlin Museum.[1] It is possible that this lintel was taken from the same much destroyed structure.

The stelae of Yaxchilan are arranged before temples much after the manner of those at Naranjo. As a rule, the temples which have carved lintels do not have associated stelae. Stelae 1 and 2 are apparently correlated with Temple 33, which is built upon the greater acropolis while they stand below upon the river bench. This temple also has Lintels 1, 2 and 3 and is one of the largest and best preserved buildings in the city. Stelae 3, 4, 5, 6 and 7 are aligned in front of Temple 20. Stela 3 is at a considerable distance opposite the center of the stairway, while the other four stelae are set up on the lower terrace of the temple. This important temple likewise has three carved lintels. The three Temples 39, 40 and 41 are situated upon the back portion of the greater acropolis. Before Temple 39 is a single stela, No. 10, that is placed directly in front of the doorway. Before Temple 40 are Stelae 11, 12, 13 and 14, arranged symmetrically. Temple 41 has Stelae 15, 16, 17, 18, 19 and 20, three being placed upon the upper terrace and the other three upon the middle terrace of the temple. The two remaining stelae are placed before two of the so-called sepulchral pyramids. As a rule, the stelae of Yaxchilan have sculptures upon both front and back faces, and before each face is a drum-shaped altar. According to Maler,[2] the side which faces the temple has a religious significance and the side away from the temple a secular one.

It will be remembered that when several stelae are arranged before a building at Naranjo they are not all of the same style and period. The same situation exists at Yaxchilan. Stelae 1 and 2 are correlated with the central axis of Structure 33, but are some distance from the structure and on lower levels. Stela 2 is nearer the temple, while Stela 1 occupies the commanding position. The latter monument is splendidly carved in a style far superior to that of the former stela and of the three lintels in the temple itself. Similarly in the case of Structure 20, the monument that occupies the position of honor, namely, Stela 3, is undoubtedly a late work. There are four other stelae before this structure. The two flanking monuments, Stelae 4 and 7, are excellent pieces, and may belong to the same period as Stela 3, but the two middle sculptures are much inferior in design and are carved in lower, flatter relief. Curiously enough, the fragment that according to Maler is the upper part of Stela 5 has

[1] Maudslay, 1889–1902, II, pl. 98. [2] 1903, p. 126.

been published by Maudslay as a part of a lintel from Structure 44 (House M). Probably some confusion in notes occurred, because it is pretty evident that the fragment did not form part of a lintel and the two buildings in question are at opposite sides of the city. The three lintels of Structure 20 seem to be earlier in style than the three fine stelae, but may belong to the same period as the two crude ones.

In front of Temple 39 is a single monument showing careful carvings in intermediate relief. Before Temple 40 were four (or perhaps only three) stelae. Of these Stela 11, which occupies the important position, has splendidly carved and excellently preserved designs upon front and back. The sculptures are in high but somewhat flat relief and show excellent composition. The remaining monuments, judging by Stela 13, are of a much earlier period.

None of the six stelae in front of Structure 41 is stylistically of the latest period. The sculpture in most cases seems to be very low. Stela 16 is something of an exception, but the carving is much inferior to that of Stela 11 before the neighboring temple.

Stelae 8 and 9 remain to be considered. No photographs of the former could be secured. The latter is a carefully executed piece with much grace. The relief is low, but the finish is smooth.

The placing of these monuments in a definite order cannot safely be attempted at this time. Suffice it to say that Stelae 1, 3, 4, 7 and 11 represent the latest and best work, next in order appear to be Stelae 2, 5, 9, 10 and 16, while the remaining known monuments, including Stelae 6, 13, 15, 18, 19 and 20, are in the earliest group.

Under the previous section devoted to architecture many progressive changes in construction were pointed out. As a rule, the crude beginnings were seen in the southern cities of the Maya area and the finished products in the western and northern ones. At the time the statement was made that such structural developments probably indicated chronological sequence. It is almost axiomatic that a sound principle of construction once thoroughly mastered is seldom forgotten. Esthetic art ebbs and flows, but utilitarian art rises steadily and conserves its positive gains. This is particularly true of architecture, as may be seen from the long history of this art in Europe.

The development of roof structures has been explained in some detail (see page 110), from the cumbersome first attempts at Tikal to the airy superstructures at Palenque and in northern Yucatan. At Yaxchilan three or four stages are shown in as many groups of buildings.

The simplest examples show the roof structure, in the form of a narrow wall perforated by windows, placed over the ridge pole of a one-roomed building. The weight is supported for the most part by heavy interior buttresses which divide the long narrow room into a number of compartments and necessitate a number of doorways in the outer walls. Structure 39 is an example with very heavy walls and a heavy roof crest. The room in this temple is very narrow, resembling the rooms in the temples of Tikal. The roof comb is lightened, and the proportion of wall space to room space is reduced in Structures 25, 40 and possibly 41. The attempt to lighten the load by throwing the roof comb off center is seen in Structures 20, 42 and 44. In these buildings the width of the room is increased considerably over the structures of the earlier group. The

buttresses become more prominent. According to Maler's plan, the roof wall in Structure 21 was built directly over the front wall of the building in the form of a flying façade.

In the next group the roof structure rises over the medial partition of a two-roomed building. There are at least two examples of this stage, namely, Structures 23 and 30. In the first of these the interior buttresses are still seen in one of the rooms in spite of the direct support that the roof crest receives. The superstructure is still a single wall with perforations.[1]

The final stage of development shows a roof structure consisting of two walls sloping inward and bonded by cross beams of stone. Each of these walls contains rows of windows. In the case of Structure 33 this double roof wall is placed over a single room and the old interior buttresses are again called into play. It may be remarked, however, that the outer walls of the temple support most of the weight and that this roof crest is much grander and more substantial than any that preceded it. According to Maler's diagram the roof wall of this temple consists of but one wall, but the photographs and Maudslay's sketch prove the opposite to be the case (Fig. 148, b and c). Of course it is uncertain whether this stage came before or after the stage just given showing the mechanical use of a medial wall. It is important to note that the temples of Palenque present a combination of the double-walled roof crest with the medial wall support.

Another example of the double roof structure is seen in Structure 6. Here the two walls rise above the two longitudinal partitions of a three-roomed building. The roof structure may be said to straddle the narrow interior room. There are no interior buttresses. A third example is seen in Structure 19.

The correlation of these different lines of evidence with each other and with the dates given on lintels and stelae is difficult, and the conclusions are far from satisfactory. In many cases the inscriptions are incomplete, and there are no means of knowing whether or not the latest date has been deciphered. Frequently the calculations run from one lintel to another. It has been shown that the different stelae before a single building were probably set up at different times; hence the dates on these stelae are of doubtful value in determining the age of the structure.

Mr. Bowditch[2] has carefully worked over the inscriptions of Yaxchilan, and the following list of dates is compiled from his results. Only the latest date in the inscriptions connected with each building is taken. The arrangement is chronological.

Structure	Names of sculptures	Latest date
24	Lintels 27, 28	9–10–18–16–17.
44	Altar, Lintels 44, 45, 46	9–12–9–8–1.
20	Lintels 12, 13, 14 ⎱ Stelae 3, 4, 5, 6, 7 ⎰	9–15–10–0–1.
21	Lintels 15, 16, 17	9–16–?–?–?.
22	Lintels 18, 19, 20, 21, 22, 23	9–16–1–0–9.
1	Lintels 5, 6, 7, 8	9–16–1–8–6.
16	Lintels 38, 39, 40	9–16–3–3–6.
42	Lintels 41, 42, 43	9–16–4–1–1.

[1] It must be confessed that Maler's plans are hardly convincing on this point. Further field work must be carried on before the art history of the Usumacinta Valley can be made stable and satisfactory. Single wall roof combs are found in Peten.

[2] 1903, a, pp. 27–29.

Structure	Names of sculptures	Latest date
33	Lintels 1, 2, 3. Stelae 1, 2	9–16–6–0–0.
23	Lintels 24, 25, 26	9–17–?–?–?.
10	Lintels 29, 30, 31, 32, 33	9–18–0–0–0.
39	Stela 10	9–18–9–12–1.
40	Stelae 11, 12, 13, 14	9–18–13–13–0.
41	Stelae 15, 16, 17, 18, 19, 20	9–18–17–17–6.

Structure 24, which according to this list has the earliest final date, has two lintels carved on the outer edge but not on the under surface. There are no sculptures on these lintels, except a double row of weathered glyphs. The style, however, seems to be reasonably advanced and the true date of the building may fall in the fifteenth or sixteenth katun. The temple itself is in utter ruin. In the case of Structure 44 the inscriptions on the three splendid lintels, which are of the last type of lintel carving, are undecipherable. The date given is

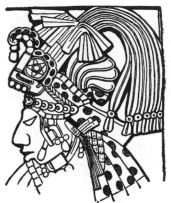

Fig. 230. — Head on fragment of Lintel 41: Yaxchilan.

obtained from a rectangular sculptured block which may have served as a sort of altar. The initial series date is clear enough, but certainly does not give the true date of the monument.

With these two exceptions the dates on the lintels agree in the main with the grouping of these works of art upon a basis of the style of sculpture. It seems that the low-relief style flourished in the first part of the sixteenth katun. In the case of Structure 10 the lintels are accredited with a later date than the style of sculpture warrants. The calculations on these lintels are apparently accurate and specific, and lead to the beginning of the seventeenth katun if not to the eighteenth. Maler considers that the building has an older and a newer part. The first three lintels have only glyphs carved in low relief. The outlines of the glyphs are fairly well rounded, but the style does not seem at all advanced. The other two lintels are carved with figure compositions in low relief. These lintels, which are situated in an L-shaped addition to the building, have glyphs that are apparently of a later type than those of the first three instances.

The dates which are given to Structures 39, 40 and 41 seem to be too late, particularly in the case of the last, where the sculptures are all rather poor and in the earlier style. The interpretation of these dates in the eighteenth katun instead of the sixteenth depends upon the value of a glyph which occurs with unusual frequency at Yaxchilan. This is the katun sign, surmounted by the Ben-Ik sign and preceded by a bar. This sign has been read as meaning 18 katuns, but this reading is admitted to be more or less of a moot point. After the late dates encountered at Quirigua, Naranjo and Seibal the dates of Yaxchilan are fairly early. But probably they all occur after the close of the archaic period. A close resemblance in style is to be noticed between Stela 5 of Tikal and the best group of stelae at Yaxchilan. The method of representing the eye at Yaxchilan (Fig. 230) is the same as seen on the later stelae of Copan.

The dates of Yaxchilan are noteworthy because of the comparative scarcity

of even quarter katuns. The declarations of odd days are obviously more apt to refer to definite events than those which fall at the end of a recurring five-year period. The earliest date at Yaxchilan is an initial series on Lintel 21 that registers 9–0–19–2–4, 2 Kan 2 Yax. This date precedes any known date at Copan or Tikal, and while it may refer to the traditional history of the people of Yaxchilan it is not possible to associate it with any archaic sculptures. A secondary series of 15–1–16–5 brings the final count of this lintel into the sixteenth katun. Stela 1 may read 9–11–12–0–0, 3 Ahau 8 Chen, and may likewise advance into the sixteenth katun. An early initial series is found on an altar near Structure 44. The date reads 9–12–8–14–1, 12 Imix 4 Pop. Although this date does not count forward more than a few months in the secondary series, there is good reason to believe that the true date of the carving is at least fifty years later. Most of the increase in the count on the other monuments covers a comparatively short period and usually falls in or after the sixteenth katun. Maler mentions a hieroglyphic stairway in connection with Structure 5 but gives no photographs of the inscriptions. From this inconclusive survey it is evident that Yaxchilan promises splendid results to the archaeologist of the future.

Piedras Negras. Piedras Negras [1] is situated on the Guatemalan side of the Usumacinta River, about half-way between Yaxchilan and Tenosique. At this city Maler photographed a considerable number of stelae and a few lintels and large table altars. The stelae vary widely in subject and appearance, but arc remarkable for the common use of high-relief sculpture showing the face in front view. In a number of cases a small seated figure is carved in high relief in a sunken niche. The sides of the niche are decorated in delicate low-relief sculpture. Most of the stelae bear figures on both faces, but usually one side is almost destroyed. These monuments are placed in front of buildings, as at Naranjo and Yaxchilan. The buildings, however, are mostly in utter ruin.

The dates which have been deciphered at Piedras Negras are all rather early. The inscriptions in most cases are incomplete, however, and it is possible that there are much later dates than any so far discovered. The latest certain date is that of Stela 3, which registers the beginning of the fourteenth katun. It is possible that 4 Ahau 13 Yax given on Stela 6 may announce the beginning of the fifteenth katun, although Mr. Bowditch prefers the reading 4 Ahau 13 Uo which falls on 9–2–0–0–0. The problem that presents itself at Piedras Negras is the same that we shall find at Palenque. The known dates are much too early to accord with the advanced style of the art. In each case there is urgent need of further exploration.

The earliest and latest dates on the monuments of Piedras Negras that have been deciphered with a degree of assurance are:

Altar 1	13–0–0–0–0,	4 Ahau 8 Cumhu,		
Stela 25	9–8–10–6–16,	10 Cib 9 Mac	to 9–8–15–0–0,	10 Ahau 8 Tzec.
Stela 36	9–10–6–5–9,	8 Muluc 2 Zip	to 9–11–15–0–0,	4 Ahau 13 Mol.
Lintel 2	9–11–6–2–1,	3 Imix 19 Ceh	to 9–11–15–0–0,	4 Ahau 13 Mol.
Stela 1	9–12–2–0–16,	5 Cib 14 Yaxkin	to 9–13–14–13–1,	5 Imix 19 Zac.
Stela 3	9–12–2–0–16,	5 Cib 14 Yaxkin	to 9–14–0–0–0,	6 Ahau 13 Muan.
Stela 6	9–15–0–0–0,	4 Ahau 13 Yax	or 9–2–0–0–0,	4 Ahau 13 Uo.

[1] Maler, 1901, is the only original authority on the monuments of this city.

The following dates appear twice and may have some special significance.

Stela 36 and Lintel 2	9–11–15–0–0, 4 Ahau 13 Mol.
Stela 1 and Stela 3	9–12–2–0–16, 5 Cib 14 Yaxkin.
Stela 1 and Stela 3	9–13–14–13–1, 5 Imix 19 Zac.

It has been suggested that the series of dates on Stelae 1 and 3 might very well refer to the life of some individual.

Before what was probably the principal temple at Piedras Negras are eight splendid stelae (Nos. 1–8), each with one well-preserved face. No two of these are alike. The first one is artistically of less interest than the others, but even here it is seen that the face and headdress are excellently carved in the full round, although the body is given in low relief. This recalls the reversion from the late method of Copan that was noted at Quirigua. The figure is that of a woman wearing a skirt with an all-over decoration of lace insertions in the form of a Greek cross. The glyphs are carved in low, delicate relief, but with well-rounded outlines and many details of enrichment. In the cases of Stelae 2, 4 and 5 the face of the principal figure is turned in profile. Stela 4 is a splendid example of flat, sharp-cornered relief with much fine detail. The headdress is sculptured on several differentiated planes, so that the overlay of one detail by another is clearly indicated. Stela 5 is sculptured in somewhat higher and much more rounded relief. The subject is a man seated on a canopied throne. The canopy is a grotesque head upon the top of which sits a bird, while from the eye issues a grotesque figure that probably represents a god. Other grotesque figures are seen at the back. The personage on the throne holds in one hand a staff bearing the head of the Long-nosed God. A human being in ordinary dress stands facing him. Stelae 3 and 6 present seated figures in fairly high relief. All the features are given in low relief. The latter stela furnishes an excellent example of the figure in a niche. A strip of astronomical symbols combined with the Two-headed Dragon and the Serpent Bird frames in the seated person. A similar design from this city has already received comment (Fig. 57, *d*). Stelae 7 and 8 show standing warriors in front view. The relief is rather high, and certain details are treated in the full round, while certain others are treated in low relief. The enrichment of the dress is remarkable.

Space forbids a complete survey of the wonderful monuments of this little-known city. Careful study of the sculptures available for study fails to disclose any truly archaic specimens unless Stela 29 should be such a one. The glyphs on this broken stone resemble somewhat those on the earlier stelae of Copan.

The artistic evidences indicate that Piedras Negras flourished after the fifteenth katun, which may be taken as marking the end of the archaic period. The mastery of the full round seen here is comparable to that of Copan and Quirigua. The developed form of eye is found here as at Yaxchilan, Quirigua and Copan. The course of development of this feature may be studied on the later monuments of the last-named city and thus pretty accurately dated. Another detail, the development of which may be studied in the light of a known chronology, is the placing of the feet. On Stelae 7 and 8 the feet are turned outward, but the heels are placed as far back as possible, so that the outer angle is less than a straight angle. This is likewise seen on the stelae at Copan erected after 9–15–0–0–0 and on Stela K at Quirigua. Often the relief is so low at Quirigua

and Piedras Negras as not to permit this adaptation, but the sculptors took advantage when given the chance. It was noted at Copan and Quirigua that the elaboration of dress tended to destroy the proportions of the body. At Piedras Negras this malformation is very little in evidence, although the dresses are extremely ornate. The close resemblance between the little seated figure on the back of Stela I of Quirigua and figures in niches at Piedras Negras is another bit of oblique evidence on the lateness of this city. The date of Stela I is 9–18–10–0–0.

It will be remembered that the poses on the larger monuments at Copan are stiffly symmetrical, while at Quirigua this symmetry is more or less broken up. The profile sculptures of Tikal and Naranjo are also formal, although a pose showing bilateral symmetry is naturally impossible. The grouping of two or more human figures is seen on some of the stelae at Yaxchilan as well as on most of the lintels. In the earlier cities a single human figure is represented upon each monument or upon each sculptured side. Now at Piedras Negras not only are the poses greatly relaxed in many cases, but there are also excellent examples of compositions containing several figures. The pose of the figure sculptured on Stelae 13 (Plate 25, fig. 3) is a remarkable exhibition of ease. The turning out of the feet is the only awkward feature. Real action is indicated by seeds or other objects that are thrown downward from the open right hand. The rich details of the dress, illustrating feather-work, beadwork, carved faces, sea-shell fringes and jaguar-hide garments, come out with the utmost sharpness and fidelity. Note, for instance, the plain inside foundation of the feather cloak that hangs down the back. In its triumphs over traditional defects this monument is far beyond anything yet presented in this historical consideration.

Stela 14 shows a human figure, apparently a woman, standing before another figure seated in a niche upon a high throne. To combine a richly attired person in low relief with another in high relief so that the effect is harmonious is no easy problem. The ornate apron of the seated figure lies loosely and naturally across the knees and hangs down in front. Stela 12 is perhaps not so effective, but is an even more ambitious attempt. A chieftain richly attired and holding a decorated spear in one hand sits looking downward in an easy position on a lofty throne. Below him two soldiers, one at either side, keep guard over nine miserable captives bound with ropes. The soldier on the right-hand side is excellently carved, with the torso in three-quarters view. The new desire for realism appears in the graceful disarray of the girdle fringes.

It is interesting to note that Stela 1 at El Cayo,[1] an ancient city situated between Yaxchilan and Piedras Negras, is almost identical in pose with Stela 13, that has just been described and figured. A sculptured lintel from the same building at El Cayo before which this and another stela are placed bears an inscription that clearly runs up into the seventeenth katun.[2] In the same connection it should be stated that the remarkable Stelae 1 and 2 of La Mar,[3] which present the closest analogies in grouping and freedom of action to Stela 12 of Piedras Negras, date from 9–17–15–0–0 and perhaps later.

Other evidence pointing to the same conclusion of a late date for Piedras Negras is seen in the nature of the objects portrayed or omitted. It is significant that the Ceremonial Bar, which appears upon some of the earliest monuments of

[1] Maler, 1903, pp. 83–89 and pls. 34 and 35.
[2] Bowditch, 1903, a, p. 2.
[3] Maler, 1903, pp. 93–96 and pl. 36; Bowditch, 1903, a, pp. 2–3.

the Maya area, is absent from this city. The monuments of Quirigua show that this object fell into disuse during the last quarter of the ninth cycle and that its place was taken by the Manikin Scepter and other objects. It occurs, however, at Naranjo and Yaxchilan. The form of the Manikin Scepter that is found at Piedras Negras is very advanced. The body is absent and the head appears on a staff. On the other hand, the Two-headed Dragon that is of late development elsewhere is very common at Piedras Negras in a phase that is far from realistic.

The architecture of Piedras Negras is too far destroyed to be studied effectively, but the excessive use of stelae as a supplementary architectural feature is a pretty good evidence of late date. The main temple at Naranjo is a very late example of such a development which may serve for comparison.

Palenque. Palenque has long been famous for its temples and sculptured tablets. Early descriptions of its antiquities appear in the works of Antonio del Rio, Dupaix, Waldeck, Stephens, etc. Mr. Maudslay and Mr. Holmes have presented excellent and fully illustrated accounts of the best known buildings. And yet this site has never been fully explored. Certain problems connected with its position in the general chronological sequence cannot be settled until exploration has been carried much farther than it has at the present time. Broken fragments are sometimes more significant than perfect specimens.

The criteria of the age of Palenque are of two kinds — first, artistic; second, architectural. Most of the general remarks devoted to the art of Piedras Negras hold true of Palenque. To be sure, the monuments are of very different sorts. Stelae are unusual at Palenque. A single monument of this sort has been noted. It is apparent that the stone available at Palenque was difficult to work, for very few examples of stone sculpture in the full round have come to light. These few, however, are of excellent workmanship. The stone tablets set up in the sanctuaries are carved in extremely low relief. The finish, however, judging by the Tablet of the Temple of the Sun in the Museo Nacional at Mexico City, is very smooth and the contours well rounded. Lacking easily worked stone, the artists of Palenque fell back on stucco as a material to embody their ideas. The stucco work is in both high and low relief, and shows the finest modeling seen anywhere in the Maya area.

The chronological significance of the growing mastery of foreshortening and composition has already been explained. The handling of the pure profile is seen at its best at Palenque. The anatomy of the human body receives more careful and exact treatment at this city than elsewhere. Likewise there is a distinct appreciation of the contrast value of the open background at Palenque. We have seen that the whole tenor of Maya art in the earlier cities is toward complexity rather than simplicity. A slight subordination of certain details is evident at Yaxchilan and Piedras Negras, but there is little in the way of blank space on the sculptured stones of these cities. The sculptures of Palenque are definitely limited to rectangular spaces. There is considerable elimination in the matter of dress, so that a large part of the body is nude while the headdresses are much less cumbersome than heretofore. The human figures stand out against a plain background, or at least a background relatively plain when the natural exuberance of Maya art is considered.

Certain objective similarities and differences between Palenque and other

cities might be noted. In Fig. 231 we see a short-handled wand bearing the head of the Long-nosed God; *a* is from Palenque and *b* from Yaxchilan. Striking similarities with Piedras Negras in other forms derived from the Manikin Scepter might be noted as well as in the elongated phase of the Two-headed Dragon. The Ceremonial Bar, which was absent from the latter city, is also absent from Palenque. However, in Fig. 66, *b*, is given an object which occurs on the Tablet of the Cross, and which is almost identical with an object that has evidently replaced the Ceremonial Bar on Stela F at Quirigua (Fig. 66, *a*). The Serpent Bird on Stela 5 at Piedras Negras resembles the Serpent Birds on the Tablets of the Cross and the Foliated Cross in all features except the face. This difference is not especially significant. A striking detail in the headdress of Stela 10 at Seibal represents a bird head with a fish in its mouth. In a headdress at Palenque an entire bird with a fish in its mouth is seen. The lateness of Seibal is clearly indicated by the inscriptions.

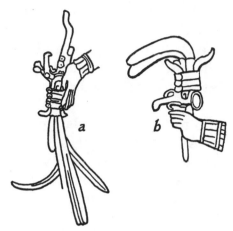

FIG. 231. — Short wands with Long-nosed God: *a*, Palenque; *b*, Yaxchilan.

Perhaps the strongest evidence of the lateness of Palenque is seen in the architecture. In Palenque are found the widest rooms, the thinnest walls, the most refined shapes and the most ideal interior arrangements to be found anywhere in the southern and western part of the Maya area. Certain of these qualifications are equaled in northern Yucatan, but the structures there belong to another and still later epoch. The crowning contributions of Palenque to the development of the roof structure, the sanctuary and the portico have already been briefly explained in the section devoted to architecture. When discussing Yaxchilan a more detailed consideration of the roof structure was attempted as an evidence of chronology.

The roof structures of Palenque show a great improvement over those of Yaxchilan. But the solutions of mechanical problems worked out at the latter city were accepted by the builders of Palenque. The two-walled roof crest is uniformly supported upon a medial longitudinal partition which is more massive than any other wall in the building. The weight is reduced to a minimum by making the roof structures over into a mere trellis work carefully bonded together. The interior walls of the building are also reduced by perforations, the like of which appear at no other city. Since it is perfectly clear that there was extensive intercourse between the various Maya cities, and since the building art would naturally progress toward more safe, economic and beautiful construction, it follows that the structures of Palenque are later in time than those of Tikal and Yaxchilan that furnish analogous but cruder forms.

The development of the sanctuary at Palenque seems to follow the suggestion furnished by Yaxchilan. As a rule, the temples of Yaxchilan have four interior buttresses, two on each side. The two attached to the back wall are near the center, and between these is a deep niche which seems to have been considered the "holy of holies" or the true sanctuary (Fig. 148, *a*). In one temple a carved figure was found in this sanctuary, and in others were found altars. This

niche, no longer the result of necessity in the Palenque temples, seems to have been idealized into a sanctuary of the highest type. This process of development may not all have taken place at Palenque. Mr. Maler [1] describes a temple at Xupa with the same plan and style of decoration as the temples of this city but with heavier walls.

The initial series of Palenque are

Temple of the Cross	12–19–13–4–0,	8 Ahau 18 Tzec.
Temple of the Sun	1–18–5–3–6,	13 Cimi 19 Ceh.
Temple of the Foliated Cross	1–18–5–4–0,	1 Ahau 13 Mac.
Temple of the Inscriptions	9–4–0–0–0,	13 Ahau 18 Yax.
Palace Steps.	9–8–9–13–0,	8 Ahau 13 Pop.

The first three dates are some 3000 years before the beginning of the great period at Copan, and the next two dates are in the first part of the archaic period as established by the sculptures. Long distance numbers are plentiful at Palenque. The latest date reached on the closely connected inscriptions of the first three temples is 9–13–0–0–0, 8 Ahau 8 Uo. The calculations in the Temple of the Inscriptions touch all the even katuns from 9–4–0–0–0 to 9–12–0–0–0 and then skip to the opening date of Cycle 10.

A finely carved slab collected by Dupaix and now believed to be in the Museo Nacional in Mexico City bears the date 9–11–0–0–0, 12 Ahau 18 Ceh. This piece was set in the wall at the head of a stairway leading to a subterranean chamber in the "great temple" at Palenque. Two other similar slabs containing dates are also figured, but the drawings are inaccurate.[2] Another specimen which may have been taken from Palenque is a sculptured disk showing a seated figure surrounded by glyphs. This excellent piece is now in the Museo Nacional at Mexico City and has been figured by Peñafiel.[3] Many writers have credited Palenque with being inhabited at the coming of the Spaniards. Förstemann [4] himself believed that the dates referred to the fifteenth century. Schmidt and Meye [5] thought the chronological order was Quirigua, Copan, Palenque. They note that the finest work of Palenque has "freed itself from all fantastic, unintelligible elements, winning its way to freedom of movement based upon a fuller knowledge of anatomy." Bancroft [6] confesses his own inability and admits a shade of skepticism concerning the ability of others to form a well founded judgment of chronology on the basis of art. Dr. Gordon [7] contents himself with the conclusion that the historical movement was from the south towards the north.

As the matter stands, there seems to be little doubt that Palenque is one of the latest cities of the first great epoch of Maya culture. But perhaps an early occupation might also be revealed by careful observation. No help can be obtained from the dates given in the inscriptions, because these are few in number and altogether too early. Some of them are clearly mythological. The inscriptions of Palenque are extensive and may prove to treat largely of calendarical calculations especially as regards the revolutions of the planet Venus and intercalary days.[8] The suggestion might be made that the knowledge of mathematics increased along with the other phases of culture, and that long

[1] 1901, p. 19.
[2] Antiquités Mexicaines, II, p. 80 and pls. 39–41.
[3] 1910, pl. 118.
[4] 1899, p. 78; Bull. 28, p. 576.
[5] 1883, Last page of Introduction.
[6] 1875–1876, IV, p. 361.
[7] 1904.
[8] Bowditch, 1910, pp. 204–205; 1906, pp. 5–11.

calculations may themselves be an indication of the late date of the monument upon which they occur. It is certain that the very early monuments do not show long secondary series of dates.

It is unnecessary to fix upon an exact date for the period of Palenque. The buildings seem to be pretty clearly of one type, and it seems likely that there was a short, brilliant period that may have fallen either just before or just after the beginning of the tenth cycle. Of course the city need not have been altogether abandoned at the close of this brilliant career.

Other Sites. Two cities which show striking similarities to Palenque in architectural forms and decorative art are Comalcalco and Ocosingo. Both of these cities are on the frontier of the Maya area, the former in the lowlands near the coast and the latter nearly due south of Palenque upon the highlands.

The ruins of Comalcalco have been described by Charnay.[1] While extensive, they hardly deserve the extravagant praise bestowed upon them. The cross-section of one of the buildings shows a type very close to that of Palenque, with comparatively light walls, a simple cornice and a sloping upper zone. Evidence concerning the roof comb is wanting. Square towers occur at this site, another detail suggesting connection with Palenque. Of architectural embellishment only fragments of stucco work remain. These, again, resemble the refined and graceful art of the aforementioned city.

To the west of Comalcalco, along the coast of Tabasco and Vera Cruz, minor objects of Maya art in the form of clay figurines, whistles, etc., have come to light. Batres[2] reproduces a number of these specimens. It was near the western end of this coastal strip that the jadeite statuette of San Andrés Tuxtla, bearing what appears to be a very early Maya date, was found. It must be noted, however, that no remains of sufficient importance have been discovered to justify the belief that this region was an early seat of Maya power. On the contrary, most of the artifacts resemble closely those of Campeche, and it is possible that they were obtained during the later periods of Maya history.

Between Comalcalco and Palenque, near the mouth of the Grijalva River, are the ruins that Brinton[3] identifies as those of Cintla. It was with the natives of Cintla that Cortes fought his first important battle. The artifacts from these sites will be discussed later. At Jonuta, on the banks of Usumacinta, there are earthen temple mounds and pottery remains. Figurines from this site are of a fine and purely Maya type. In the Museo Nacional of Mexico City there is a broken but splendidly carved slab that shows a kneeling human figure carved in low relief with a bird fluttering behind his back. Upon this slab is painted the name Jonuta.[4] If the legend is exact, it proves beyond doubt that Jonuta belonged to the same period as Palenque. The fluttering bird is one of the most remarkable pieces of realistic carving from the Maya area.

The ancient ruins near Ocosingo are sometimes referred to under the name Tonina. They are described by Stephens[5] as of considerable extent.

The ground-plan of one of the temples shows an arrangement of rooms very similar to the highly developed temples of Palenque. In particular, there is an inner shrine on the walls of which Stephens found remains of painted stucco

[1] 1885, pp. 163–177.
[2] 1908, pls. 45–56.
[3] 1896.

[4] Batres, 1888, p. 17, says the slab was found in the State of Campeche.
[5] 1841, II, pp. 258–262.

decoration representing monkeys and human beings, in a style strongly resembling the stucco work of Palenque. Over the doorway of this shrine were remains of a representation of the Serpent Bird which likewise occurs over a doorway at the latter city. Unfortunately Stephens misinterpreted the partly destroyed design as a Winged Globe, thereby furnishing a piece of evidence that has been much used by speculative writers seeking to establish connections between Central America and Egypt.[1] The sketch plan of the elevation of the temple gives the sloping upper zone but shows no roof comb. The walls of the building are light and the chambers wide. Altogether there seems to be little doubt that Ocosingo belonged to the same period as Palenque for at least a part of its existence.

According to Mrs. Seler[2] the painted stucco found by Stephens has since been destroyed by the elements. She figures, however, some stones having excellently carved hieroglyphs and animal heads, and two small stelae representing human figures in the full round with glyphs on the backs. On both pieces the dress, as seen from behind, seems to be a sort of loose cloak with vertical grooves for folds. Dr. Seler[3] reproduces the four sides of a stone with inscriptions containing dates which unfortunately are not placeable in the long count. He also comments on the stelae.

Plate 25, figs. 4 and 5, reproduces the front view of two small headless stelae at Ocosingo that are doubtless of the same type as those just mentioned. These little monuments are very much like the Copan stelae and must have been modeled in miniature after these sculptures. The Ceremonial Bar is held against the breast, the heavy apron with the frets at the sides — a very widespread feature — hangs from the belt, and, most important of all, the feet are placed in a comfortable position with the heels well back of the apron flap. This last detail practically proves that the monuments were carved at a later time than the fifteenth katun because this position of the feet was not thought of at Copan until after the carving of Stela A.

In the Museo Nacional at Mexico City is a small but well-sculptured stela together with fragments of one or two others, all closely resembling the ones just described. The complete stela has been figured by Peñafiel[4] and wrongly called a God of Fire. Upon the back is a cloak like that worn by the figures which Mrs. Seler reproduces. There is a column of weather-worn glyphs down the back. This stela and the fragments of similar ones probably came from Ocosingo. Some of the finest carved jadeite ornaments in the Squier collection were found at Ocosingo and offer further evidence of the high plane of the art of that city.

There are good reasons for believing that most of the ruins on the highlands of Guatemala and the state of Chiapas date from much later than the great period of Maya art. However, there are a few towns that must have flourished near the close of that period. Ruins of the earlier lowland type extend well up the rivers. Dr. Tozzer discovered on the upper Tzendales River a small ruin with remains of several mounds and buildings. One of the buildings had a simple roof comb with windows that has already been described (page 112). A stela

[1] Squier, 1851, p. 248; Le Plongeon, 1896, p. 217.

[2] Seler, C, 1900, p. 147.

[3] 1901, c, pp. 192–195; see also Brine, 1894, pp. 263–265.

[4] 1903, pl. 81.

in fair state of preservation was found. This is reproduced in Fig. 232 from the hurried drawing made in the field corrected by a number of measurements. The Manikin Scepter on this monument furnishes an important link between the original form of the object and the later one consisting of a head on the top of a plain staff. The dress in many details recalls that seen on the figures of Yax-chilan and Palenque. The carving certainly be-longs to the best period, and yet in the inscription we find declared 9–13–0–0–0, 8 Ahau 8 Uo.

Dr. Seler[1] reproduces the upper part of a small stela from Salinas de los Nueve Cerros on the Chixoy River, north of Coban. This shows carv-ing in front view and high relief. Mr. Maler[2] has explored the upper Usumacinta and gives descriptions of several important sites. At the mouth of the Chixoy is the site called Altar de Sacrificios, which has a few interesting sculptures, in particular a stela with an early initial series.[3] Farther up stream at Itsimté-Sácluk are several stelae which resemble strikingly the monuments of Naranjo. At Cankuen, near the head of the river, are still other sculptures. Stela 1 at Can-cuen (Plate 25, fig. 6) is carved in the latest and best style. On one side is sculptured a skirted figure seated cross-legged on a throne or couch and holding a variant form of the Ceremonial Bar. The lower part of this figure is as well pre-served as if it were carved yesterday. The pro-jection of the knees is accurately foreshortened in low relief, and the dress is represented freely and naturally.

Upon the Guatemalan highlands a few stelae have been found. For instance, one resembling the sculptures of the Usumacinta cities may be seen at Chincoltic, near the Lake of Tepan-cuapam.[4] The two fragmentary stelae discovered at Saccana[5] are of the greatest importance be-cause they bear initial series dates in the tenth cycle. Stela 1 is 10–2–5–0–0,. 9 Muan 18 Zac, and Stela 2 is 10–2–10–0–0, 2 Ahau 13 Chen.

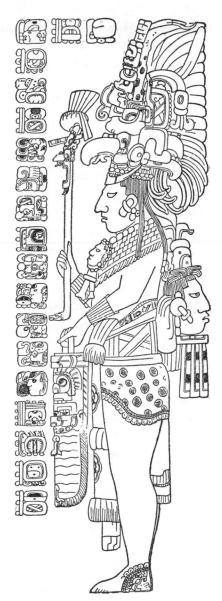

FIG. 232. — Stela at Tzendales.

The stelae have no ornamentation and the glyphs are very rudely carved.

A painted vase from the Quiché region near Huehuetenango that has part of a ninth cycle date is figured by Brinton.[6] The original vase is in the Museum of the University of Pennsylvania. The Chama vase and other pieces of elab-orately decorated pottery from the environs of Coban may also date from the end of the great period. This is indicated, in particular, by a portion of a pottery

[1] 1902–1908, III, p. 576, pl. 1. [2] 1908, a.
[3] Mr. Bowditch makes this date 9–10–3–17–0, 4 Ahau 8 Muan.
[4] Seler, C. 1900, pl. 54. [5] Seler, 1901, c, pp. 17–23. [6] Brinton, 1894, b, p. 140.

box with decoration by a nicely modeled relief that represents a seated figure holding in his lap a Ceremonial Bar (Fig. 63).

The many great ruins in northern Yucatan will be considered in another section. In all that region there is only one initial series date that has been definitely deciphered. This date is in the second katun of the tenth cycle and is found at Chichen Itza. If this region was inhabited during the great period, its culture was of a provincial character.

Summary of First Epoch. We have seen, from this survey of the principal cities of the southern and western portion of the Maya area, that considerable dependence may be placed upon the historical character of some of the dates on the monuments, but that some other dates must be regarded as referring to the past or the future. The historical dates seem to indicate a general movement of culture from the south towards the north and west. The correlation of the period covered by this culture with Christian chronology will be attempted later.

Our examination of the first great age of Maya art is ended. It is now necessary to begin again and establish new criteria for the second great age that reached its height several hundred years later. Perhaps a word of warning is necessary. It must not be thought that Maya culture in its most peculiar features was not continuous through both these ages and even after the close of the second. Learning and religion were maintained as before, doubtless through the aid of books and an organized priesthood. The complicated calendar, as has been demonstrated by Mr. Bowditch and others, remained the same in substance from the founding of Copan until the time of Bishop Landa. Unfortunately for us, however, the use of initial series inscriptions expressing dates in the long count seems to have fallen into disfavor and to have been largely supplanted by the shorter counts of the 52 and the 260 year cycles. The mechanics of architecture and other features of purely utilitarian arts seem hardly to have suffered a set-back. Only esthetic art in its most spiritual and imaginative phases was blotted out by some potent social change.

The explanation of the eclipse of all that was finest in Maya civilization is not far to seek. Any long-continued period of communal brilliancy undermines morals and religion and saps the nerves and muscles of the people as a whole. Extravagance runs before decadence, and civil and foreign war frequently hasten the inevitable end.

THE SECOND EPOCH

The most important cities of the second great age are located in northern Yucatan. In these cities there are admirably preserved temples, as has already been seen, but a general lack of monolithic stone sculptures. The façade ornamentation is a mosaic of small carved stones presenting either geometric or highly conventionalized designs. There are few examples of relief or full round carvings upon which to base any stylistic order. The architectural forms furnish the best evidence of chronological sequence, but these are not figured and described accurately enough to make conclusions certain. Moreover, there is practically nothing to serve as a check upon the theoretical results and to make clear the rate of change except the traditional history embodied, for the most part, in the so-called Books of Chilan Balam. This traditional history makes no

reference to definite buildings and, indeed, only refers by name to the cities of Chichen Itza, Uxmal, Mayapan and Izamal. All the other great cities must be correlated with these four. It may be said, in passing, that the names applied to most of the ruins in northern Yucatan and elsewhere in the Maya area are of modern origin. Many are purely descriptive.

As Copan was the key to the chronology of the south, so Chichen Itza is to that of the north. Not only does this city have many more carvings and excellently preserved structures than any other city, not excepting Uxmal, but its architectural styles are capable of being differentiated, and the traditional accounts refer to it more specifically than to any other center of power. Chichen Itza was probably the last Maya city to fall and one of the earliest to be founded in the northern region. The initial series date which connects this city with the chronology of the earlier cities far to the south and west has already received brief comment and will presently be considered more in detail.

The difficulties of presenting in short space the evidences of chronological sequence after the end of the Great Age are considerable. There is much to be examined, and the facts brought out are only significant when carefully correlated. The results are suggestive rather than definitive. Frequently the occupation of a city extended over two or more periods, and we find materials that were taken from old buildings and used again in new ones. Similarly in minor art pottery vessels, jadeite ornaments, etc. were passed down as heirlooms and finally buried or broken. The different periods will be taken up seriatim instead of the different cities. It seems possible to distinguish the following periods.

 I. Period of the Transition.
 II. Period of the League.
 III. Period of Influence from the Valley of Mexico.
 IV. Period extending from the Fall of Mayapan to the Present Time.

The second and third periods together make up the Second Great Age of Maya art.

The Period of Transition. The period that followed the Great Age may be called the Period of the Transition, because it marks a cultural and a geographical shifting. It is not well defined, but evidence of it exists in a few cities of northern Yucatan which seem to have been founded before all the southern cities were abandoned. The most important connecting links are enumerated below:

1st. Initial Series Inscriptions.
 (a) Chichen Itza, Temple of the Initial Series.
 (b) Xcalumkin, Temple of the Inscriptions.
2d. Manikin Scepter.
 (a) Santa Rose Xlabpak, sculptured panel.
 (b) Sayil, stela.
3d. Wooden lintel with sculptures showing survivals of the old style.
 (a) Kabah.
4th. Stelae.
 (a) Xcalumkin
 (b) Sayil
 (c) Tabi.

In a somewhat detached portion of Chichen Itza, that is commonly known as

Old Chichen Itza, Mr. E. H. Thompson discovered a stone lintel bearing the only date in northern Yucatan that has so far been deciphered. The date is 10–2–9–1–9, 9 Muluc 7 Zac, which falls within a generation of dates in some of the southern cities. The temple in which this lintel was found is briefly described by Seler.[1] It consists of a single room with entrances on the south, the west and the north. The doorway on the west is the principal one, and over it was placed the inscribed lintel. The two door posts are atlantean figures similar in general form to many others in Chichen Itza. At the foot of the temple mound is a half-reclining figure of the Chacmool type. Now, although the lintel itself seems to be old, the two features just mentioned undoubtedly date from the latest building period of the city. It is probably safe to conclude that the lintel was taken from the ruins of an early building and set up in a late one.

A near-by building is the Temple of the Phalli concerning which no definite information is available. The structure takes its name from a series of projecting stones. Although phallic worship was not important in the Maya area, there is some evidence that it existed sporadically. It may have arisen during the decadence that followed the golden age. Brinton[2] has commented on the insufficiency of the evidence of its existence at the time of the Spanish Conquest. Maya art throughout its entire course is remarkably free from anything that might offend the most prudish. The picotes or cylindrical columns in the middle of the courts at Uxmal and elsewhere have been given[3] a phallic significance, but it seems more likely that they are a late modification of stelae. However, an unmistakable phallic column was found at Labna,[4] while Maler[5] records the occurrence of phalli as cornice ornaments at Chacmultun. The building on which these occur is a well-developed example of late Maya construction that can hardly date from as far back as the time of the Transition.

The Temple of the Inscription at Xcalumkin[6] is a two-storied structure, but little now remains of the upper story, or, for that matter, of the northern series of rooms belonging to the lower story. On the southern side there are two small rooms and one fairly large room in good interior preservation. The upper zone of the façade shows remains of lattice work, and it is likely that other ornamentation once existed. On the walls of the principal chamber are traces of paintings, but only scrolls and bands can now be discerned. On the back wall, extending from the apex of the roof to the floor, is the aforementioned initial series inscription with the glyphs arranged in a double column. The doorway of the chamber is a wide one, with two piers or rectangular pillars which have glyphs upon their outer faces. Glyphs also appear upon the capitals, or rather abaci, of the pillars and upon the first course of stones above the lintels.

According to Dr. Seler,[7] the initial series inscription records a ninth cycle date. But a careful examination shows that this conclusion is open to serious doubt. It seems more likely the face numeral of the cycle period is 10 instead of 9. The so-called maggot sign, which resembles the common percentage symbol and is a much used Maya method of indicating death, occurs a number of times in this inscription. It seems to occur on the numeral face that precedes the cycle glyph. The face for 9 is characterized by dots around the month, that for 10

[1] 1908, p. 237. [4] Peabody Museum photographs.
[2] 1882, a, p. 156; also pp. 130–131. [5] 1895, p. 249; 1902, p. 199.
[3] Orozco y Berra, 1880, II, p. 456. [6] Maler, 1902, p. 203. [7] 1908, p. 239.

represents a death's head. The marks on the face are partly destroyed, but one reading is as good as the other. There is one other glyph in the secondary series where the face with the same death sign means 10. The katun glyph is peculiar, but may be 18. The fourth glyph shows the kin signs that characterize the number 4, and the last one is 9 by the bar and dot system. According to Mr. Morley, the most probable reading is 10–18–10–4–9, 7 Muluc 2 Yaxkin. This falls several hundred years later than any other date and is of course open to serious question. Thomas[1] makes a point in regard to this inscription that a shift of one day in the system of counting is shown by the date 8 Caban 4 Zotz. This shift makes the inscription agree with the calendar in vogue in northern Yucatan at the time of the Spanish Conquest.

The life history of the Manikin Scepter has already been given. This object, with a ventral appendage in the form of a serpent, is exceedingly common in the sculptures of the Great Age. It does not occur in the codices or in the obviously late sculptures. It is, however, seen on a stela[2] at Sayil and on a sculptured panel at Santa Rose Xlabpak.[3] The presence of this figure certainly shows a more intimate connection with southern art than is indicated by the generality of northern figures. Its occurrence in one case upon a stela is an added proof of age. Stelae are rarely encountered in northern Yucatan. The sculptured panels of Santa Rose Xlabpak suggest the wall decorations of Palenque. The temple in which they occur is of a developed type and has already been described on page 102. There is evidence that the carved stones forming these panels were taken from an earlier building, because they do not fit together exactly as they are now placed.

The wooden lintel which Stephens[4] found at Kabah is interesting, because it shows a strong survival of the early style of sculpture. The sculptured door jambs[5] from this city probably date from a later time.

The sporadic occurrence of stelae is an evidence of the survival of early ideas. These stelae are not found in correlation with any of the great structures at Chichen Itza, Uxmal, etc., and seem to belong to a different epoch. The sculptures on the stelae are crude, but resemble in certain details the noble monuments of the south. Upon a platform mound at Sayil, Maler[6] found three stelae and a number of small pillars grouped about a circular altar. Two of the former are figured in the account of his explorations. The sculpture is very flat and crude, but the free and easy postures indicate that the crudity comes from decadence rather than inexperience. Careful search might reveal many more examples of these monuments, and enable a reconstruction of the little-known period that followed the great age of Maya art. The stelae of Tabi are very crudely executed. They are known through casts made by Charnay. Maler[7] mentions a monument at Xcalumkin that falls into this category, as do others elsewhere which are referred to by Stephens.[8] The so-called Pillars of Ben[9] in the State of Chiapas may mark a contemporaneous dying out of early forms upon the western frontier.

The historical evidence of the Period of the Transition will be considered in another place. At this time it may be stated that this evidence points to the

[1] 1900–1901, p. 253.
[2] Maler, 1895, p. 278.
[3] Stephens, 1843, II, p. 164; Maler, 1902, p. 223.
[4] 1843, I, pp. 403–407.
[5] 1843, I, pp. 411–413.
[6] 1895, pp. 277–278.
[7] 1902, p. 202.
[8] 1843, I, p. 364.
[9] Brinton, 1897. Le Plongeon, 1881, p. 253, figures a crude stela at Mayapan.

region inland from Campeche as the probable center of the highest culture. Little is known concerning the ruins between Lake Peten and the Gulf of Mexico.

Period of the League of Mayapan. The Period of the Transition was followed by a much greater one, that in accordance with traditional history may be called the Period of the League of Mayapan. Clearly there was a second ascent to high culture caused by organized effort. The seat of this high culture was in northern Yucatan, and the area of its influence was apparently much more restricted than that of the first great age.

Artistically the most noteworthy achievements are in architecture. From a constructional point of view, as has already been stated, the architecture of the second epoch is superior to that of any of the earlier cities with the possible exception of Palenque. Walls are comparatively light, rooms are usually of the maximum width, doorways are frequently enlarged through the use of columns, and both roof combs and flying façades are economically constructed. The façade decoration is marked by the use of the formal mask panel, the geometric panel and the continuous or broken application of plain and banded columns.

The greater number of structures at the important cities of Uxmal, Labna, Kabah, Sayil, Hochob and Chacmultun probably belong to the Period of the League of Mayapan. Many smaller centers in the same region may have risen after the period was well begun and the tide of wealth and power had turned again to the Maya. At Mayapan itself there is a tower of the same type as the Caracol at Chichen Itza, but there are few other remains of consequence and these seem to be late. At Chichen Itza the following buildings probably date from this luxurious age of renaissance:

1st. Akat'cib.
2d. Casa Colorada.
3d. Group of the Monjas.
4th. Caracol.

In the first three cases the buildings show features comparable to the great mass of architecture in northern Yucatan, characterized as it is by the tridentate cornice, the mask panel, lattice work and vertical roof structures. The first three buildings have hieroglyphic inscriptions with details similar to those of the southern sculptures. The last building may belong to the next epoch, since round towers may have been associated with the cult of Quetzalcoatl introduced from Mexico.

Evidence of chronological sequence within the limits of this period are rather hard to discover in the present state of knowledge, and it is impossible from an objective study to fix the rate of change when once the sequence has been established. A theoretical sequence may be worked out in some instances from the apparent evolution in architectural construction and decoration. This, however, is a rather dangerous procedure. More exact data upon this subject may be gleaned from a careful examination of the different parts of the great agglomerate structures, such as the Monjas at Chichen Itza and the so-called palaces at Labna and other important cities.

It has often been noted that the Monjas at Chichen Itza, already briefly described on page 101, represents several periods of growth. Holmes[1] recites the evidence of two or three periods of construction. A breach in the substruc-

[1] 1895–1897, pp. 106–109.

ture exposes a considerable portion of a smaller inclosed substructure. Maudslay[1] goes still farther and finds evidences of foundation enlargements and room additions in the following order. These may be seen on the partial plan given in Fig. 139 and in Fig. 233, which shows the two inclosed substructures of the main building.

1st. The lower half of the third or inmost substructure.

2d. The upper half of the third or inmost substructure.

In connection with these there are no remains of stairways or chambers and no decoration.

3d. The second substructure. This was probably ascended by the present stairway or by a narrower stairway in the same position. The chambers were probably removed, but possibly remain as the two long chambers of the present Main Range. The second substructure has a simple cornice decoration.

4th. The enlargement of the second substructure to form the present foundation and the erection of the present Main Range of rooms (Plate 27, fig. 1). The upper part of the substructure is decorated with mask panels of several kinds (Plate 28, figs. 3 and 4), and the

Fig. 233. — Diagram showing growth of the substructure of the Monjas: Chichen Itza.

main range is decorated with geometric panels, mouldings, etc. (Plate 28, fig. 2). There are remains of frescos that closely resemble those of the Temple of the Jaguars. These may have been painted long after the building was finished.

5th. The filling up of the long northern chamber and the erection of the upper stairway and the single room temple on the roof of the Main Range. The upper stairway is of the same type as the lower one. The walls of the upper temple are made up of miscellaneous sculptured stones that are clearly re-used material (Plate 28, fig. 1).

6th. The erection of the principal portion of the East Wing on the ground-level. This splendid structure is richly ornamented with mask panels of several sorts, and the eastern façade shows the use of a profile mask panel that has already received comment (Plates 13, fig. 2; 27, fig. 2).

7th. The addition to the East Wing fronting on the rear court. The façade of this addition is very simple, its only ornament consisting of the usual tridentate cornices and a frieze of plain columns in groups of three.

8th. The filling up of the central chambers of the East Wing for the support of an upper story that was never built.

Detailed examination of the mask panels which decorate this structure and the adjoining building, commonly called the Iglesia or Church (Plate 15, fig. 1), gives rise to certain interesting questions. The eastern façade of the East Wing (Plate 13, fig. 2) may first be examined. This narrow front is flanked by six corner masks, one half of each appearing on this face while the other half appears on the north or south façade, as the case may be. Four of these masks are symmetrically placed in the lower zone and are rather richly elaborated (Plate 28, fig. 6). The remaining two corner masks are of the same type as the six front-view masks. These front-view panels are distributed, as were the corner masks,

[1] 1889–1902, III, p. 18.

four in the lower zone and two in the upper. Each is framed in by plain strips of stone (Plate 28, fig. 5).

It has been frequently stated that the mask panels of northern Yucatan are mosaics. Now, although the elements in the eight masks on this façade are the same, yet the spaces to be occupied are not of uniform size and the parts are spaced accordingly. The elements of the two upper front-view masks are widely spaced so as to fill areas that are both longer and higher than those in the lower zone.

While the façade as a whole shows careful planning, there is evidence that an attempt was made to re-use old material probably taken from an earlier building. If the carvings had been made to order for this front, they would surely show better joining.

FIG. 234. — Details of re-used mask panels: Chichen Itza.

Other details support this theory of re-used sculptures. In one instance the head band was not put together properly. This head band is made of five carved stones, the center one showing a division of the beaded disks. In one case this center stone was replaced by one of the side stones. Elsewhere on the building the masks are in considerable variety, there usually being two or three of a kind. Many are very loosely fitted together, an example being given in Plate 28, fig. 3.

But the clearest example of the use of heterogeneous material is seen on the flying façade of the Iglesia. This consists of three masks, each of different size and style and each more or less incomplete. These three incomplete masks were not sufficient to fill all the space, so an asymmetrical strip of fretwork had to be introduced at one side to fill out. As an example of the make-shift character of the masks, the two lateral mouth ornaments of the central one are different (Fig. 234, b and c).

That on the observer's right is made of one stone, while that on the left consists of two stones. These two stones belong to a mask of the same type as several on the frieze of the foundation mound of the Monjas (Fig. 234, a), and are undoubtedly a pair of old lateral mouth ornaments made over into one.

It seems reasonable to hold that the later additions to the Monjas Group are made up from the wreckage of several earlier buildings. The design of the eastern façade of the East Wing belongs, as we have seen (page 127), to the most advanced type showing the use of the two profile mask panels at either side of a doorway. It is undoubtedly later in time than the façades that show these features in their purity.

Similarly many other large structures in other cities give evidence of sequence of parts. Mr. Thompson, speaking of the principal edifice of Xkichmook, says:[1]

"The Palace appears to be the result of successive periods of growth. It would seem that the central portion had been completed, and that time left its mark upon the wall before the wings were added, and the eroded surface was hidden beneath a new material. The second story also appears to occupy the site of an older structure. The newer building seems to be identical in style with the old."

It seems unwise to proceed further in the lack of more definite information. It may be stated with assurance, however, that the problems of structural and

[1] 1898, p. 216.

artistic sequence in northern Yucatan are capable of accurate solutions. The buildings with the more simple and graceful decoration, particularly those showing façades with plain and banded columns, will probably be found to date from the end of the Period of the League of Mayapan.

The realistic sculptures of the Period of the League of Mayapan are few and far between. One of the finest has already been presented in Fig. 182. This sculpture certainly does not date from the latest period of Uxmal, because it was found in a wall that had been built over and concealed by another structure. A second interesting but weather-worn example is given in Fig. 235. The human being sculptured in low relief on the cavern wall in the cave of Loltun [1] may be another.

The Period of Influence from the Valley of Mexico. Following the period of pure Maya culture came one in which foreign influence was strongly felt. In particular, the results of influence from the Valley of Mexico are very evident at Chichen Itza, and are, in fact, shown in the greater number of structures of that city.

The well-known identities between the art of Chichen Itza and that of Tula, San Juan Teotihuacan, etc., have given rise to a number of theories of migration. In particular the defenders of the so-called Toltec theory have used these identities as proof of the northwestern origin of Maya culture. Charnay's map of the Toltec migration shows these more or less mythical people passing from the highlands of Mexico to Comalcalco and thence in

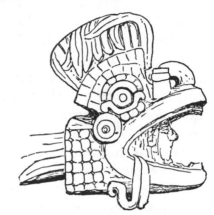

Fig. 235. — Serpent head with human head in its mouth. West Range of Nunnery Quadrangle: Uxmal.

two bands to Tikal and Chichen Itza. But it has been seen that Comalcalco, although on the frontier, is an early Maya city showing no foreign affiliations. Tikal is the earliest and Chichen Itza the latest of all Maya centers. Much evidence besides that furnished by the art can be brought against this theory of the Toltec migration. The true significance of these similarities is not far to seek. An historical explanation will be given in a later section.

The principal structures at Chichen Itza exhibiting Nahua features are

1. Temple of the Initial Series.
2. Castillo.
3. Ball Court Group.
4. Group of the Columns.
5. Structures 9, 10, 12, 13, 14, etc.

The principal features of probable Nahua origin that occur in connection with these structures are as follows:

1st. Architectural features.
 (a) Serpent columns and serpent balustrades.
 (b) Open-work decoration on top of temple walls.
 (c) Sloping or "battered" bases of temple walls.
 (d) Platform mounds with colonnades.
 (e) Flat roofs.
 (f) Ball courts.
 (g) Atlantean supports.

[1] Thompson, 1897, pl. 6.

2d. Artistic and religious features.
 (a) "Chacmool" sculptures.
 (b) Sun disks and the "celestial eye" type of star symbols.
 (c) Speech signs.
 (d) Feathered monsters in front view.
 (e) Processional grouping of warriors accompanied by identifying glyphs.

These many features combining in different ways prove beyond doubt that all the structures named date from the same cultural period. Since Chichen Itza alone shows the complete adaptation of these forms in the Maya area while many cities on the highlands of Mexico present the same details, it follows that the culture is intrusive at Chichen Itza. This conclusion is made more certain by the fact that many other features, clearly of Maya origin, occur at Chichen Itza which are not found at the sites in question on the highlands of Mexico.

The serpent columns of Chichen Itza find their closest parallel in the great columns of Tula, which have been described by Charnay.[1] The columns are either round or square, the serpent head is thrust outward at the base, the body makes the shaft and the tail projects forward and then upward, forming a peculiar capital. The feature of the serpent tail capital seems to be a development peculiar to Chichen Itza. The temples which have serpent columns usually have pyramidal substructures with balustraded stairways on all four sides. The balustrades sometimes end in serpent heads.

This series of temples seems to have been decorated by open fretwork at the tops of the walls, and in no case is the flying façade or the roof comb present. This open-work at the top of the temple walls is represented on the clay models of Nahua temples and in the pictures of them in the codices.

The lower part of the walls of all typical Maya buildings is vertical. The group of buildings under consideration shows a sloping or battered base. This feature is found in early Mexican structures at San Juan Teotihucan, Xochicalco, etc. The use of interior columns for support of the roof is also a Nahua and Zapotecan feature that reappears at Chichen Itza.

Platform mounds with long rows of columns, usually four deep, are plentiful in the curious Group of the Columns at Chichen Itza. Although this feature does not seem to find an exact parallel in Mexico, still the use of columns is much more common there than in Yucatan. All the buildings associated with these peculiar colonnades are of the prescribed type.

Flat roofs are characteristic of Nahua and Zapotecan ruins. They do not seem to have been much used in the Maya area. The colonnades just mentioned may have served to support a flat roof. Some of the buildings attached to the back court of the Monjas probably had timber roofs, either flat or pitched. Stephens found evidence of flat roofs at Tuloom, but elsewhere in Yucatan they are rare.

Atlantean or caryatid supports, architectural and otherwise, have been found at Chichen Itza in the Maya area and at Tula, Tlascala, and Tenochtitlan in the Valley of Mexico. The first site has yielded by far the greatest number of specimens.

In the Temple of the Initial Series at Old Chichen Itza the lintel of the main entrance is supported by two atlantean figures. Each is carved in the round and is made up of five drums of limestone. Fig. 236 reproduces a drawing of one of

[1] 1885, p. 293.

these supports. As may be seen, the figure is stiff, angular and poorly proportioned. Certain details of dress are given in relief, and these details were doubtless originally marked out in color. The two arms are represented in a vertical position, with the elbows unbent, yet the hands are only on a level with the crown of the head. The weight of the superstructure thus rests upon both head and hands, and the figure as a whole has the structural value of a column. Other atlantean figures (Plate 29, fig. 4) at Chichen Itza [1] present the same pose, but the proportions of the body are usually more squat, allowing the whole figure to be carved from a single stone. In at least one other small temple at Chichen Itza atlantean columns serve as lintel supports. More commonly these curious figures are used as legs for table-like altars. As such they occur in the Temple of the Jaguars and in several structures of the Group of the Columns, the most important being the Temple of the Tables.

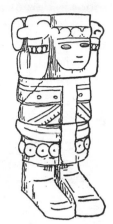

FIG. 236. — Atlantean figure; Temple of Initial Series: Chichen Itza.

Atlantean figures from Tlascala are described by Seler (Fig. 237). These, although lacking much of the ornament in dress found on the Chichen Itza figures, are yet so strikingly similar as to preclude the possibility of independent invention. The excavations in Escalerillas Street [2] in Mexico City have yielded two small figures of the same general type that must be referred to Tenochtitlan. At Tula have been found the bases of large atlantean columns well known through the descriptions of Charnay.[3]

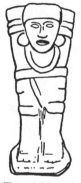

FIG. 237. — Atlantean figure: Tlascala.

Cultural contact is undeniably shown by such striking similarities. Since Chichen Itza alone in the Maya area presents figures of this precise type, it might be assumed that the place of origin for atlantean columns was in the Valley of Mexico. But there is another kind of evidence to be considered before this conclusion is accepted. The idea of human support is capable of being expressed in relief sculptures as well as in the full round. That the later pictographic device was considered as related to the former functional one seems clear from the frequent occurrence at Chichen Itza of atlantean figures in relief (Fig. 11) on door jambs and capitals in buildings of the same type as those which have the table altars. Elsewhere in the Maya area the idea of human support is expressed in a variety of ways. Thus at Naranjo and other cities of the southern region the principal figure represented on the stelae frequently stands upon a prostrate captive. At Palenque, on the famous Tablet of the Sun, the officiating priests stand upon the backs of kneeling grotesque persons, while two other seated men support on their shoulders the altar of the sun. This latter conception is pretty close to that of atlantean columns supporting table-like altars, as at Chichen Itza. As a detail of façade decoration small bodies which appear to hold the cornice upon their raised hands may be seen at Xculoc.[4] These latter are veritable atlantean figures, but are only carved in high relief and not in the full round. Columns with human beings carved on the front occur on Cozumel Island [5] and at Dsecilna.[6] in Yucatan.

[1] See also Maler, 1895, p. 288, and Seler, 1908, pls. 10–17. [2] Batres, 1902, b, p. 19; Peñafiel, 1910, pl. 10. [3] 1885, p. 72. [4] Maler, 1902, p. 208. [5] Holmes, 1895–1897, p. 78. [6] Maler, 1895, pp. 290–291.

From these foregoing examples it seems unnecessary to go outside of the Maya area for the origin of the atlantean conception. It is an open question whether the atlantean column passed from the Valley of Mexico to Chichen Itza or *vice versa*, but that there was a transmission either one way or the other seems clear.

The sculptured stone to which Le Plongeon [1] gave the fanciful name of Chacmool is one of a very widespread type that is more Nahua than Maya. The attitude is peculiar. The sculpture represents a human being, partially reclining upon back and elbows, with the knees raised and the feet drawn in. The head is likewise raised and is turned to one side. In the center of the body is a bowl for the burning of incense, which is held in the two hands of the figure.

The famous Chacmool of Chichen Itza is now in the Museo Nacional at Mexico City. It was excavated in Mound 13, which has been called a mausoleum

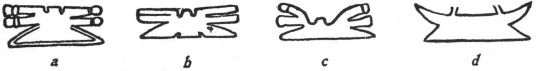

a b c d

FIG. 238. — Breast ornaments representing birds: Chichen Itza.

although its purpose is not clearly established. It is important to note that this figure wears a breast decoration in the form of a conventionalized bird exactly like the breast ornaments seen in the sculptures of the Temple of the Jaguars, the Castillo, the Temple of the Tables, etc. (Fig. 238).

Minor Chacmool sculptures occur at Chichen Itza in connection with Structures 12, 18 and 25, as well as the Temple of the Initial Series that has already been considered. No other sculptures of this type have been reported from the Maya area. But very similar stone carvings have been found at Tlascala [2] and elsewhere in the Valley of Mexico. In the Tarascan area [3] of the State of Michoacan the reclining gods also occur. A drawing in the Museo Nacional at Mexico City by Don José M. Velasco, made in 1892, represents a Chacmool sculpture before a temple at Cempoalam in the State of Vera Cruz. According to a photograph furnished by Mr. E. Mosonyi, a Chacmool sculpture has been discovered in San Salvador and is now placed in the court of the university at the capital of this republic (Plate 29, fig. 5).

Prominent among the remains of the earliest high culture in the Valley of Mexico are evidences of a sun worship apparently differing from the sun worship of the Maya. Among the latter people the sun gods assume human or grotesque forms and are identified by the associated kin or sun sign. This sign may represent primarily the four directions and by extension the sun that gives rise to the conception of the four directions. In the Nahua area the face or disk of the sun is itself represented (Fig. 239, e). This disk in its simplest phase is elaborated with four markings that resemble the principal division points of a compass. In more complicated phases the division points are multiplied and other figures added, as may be seen on the well-known Calendar Stone of Mexico City. This sun disk is called Tonatiuh in the Aztec tongue. It is frequently a constituent part of Mexican place-name hieroglyphs. It is also of common occurrence in

[1] 1886; Salisbury, 1877.
[2] Sanchez, 1877, p. 278; Nuttall, 1901, *a*, pp. 93–96; Seler, 1908, pp. 171–173 and pl. 9.
[3] Lumholtz, 1902, II, p. 451.

Nahua and Zapotecan codices as an object of worship or of astronomical significance. It has a wide distribution as a decorative design upon minor objects of art. The sun disk does not occur in the three Maya codices, nor is it in evidence in any of the Maya cities so far known except Chichen Itza and Santa Rita.

At Chichen Itza the sun disk is distinctly represented both in the sculptures and in the frescos of the Temple of the Jaguars.[1] A human figure is represented

with the sun disk. This feature is also seen in some of the more elaborate sun disks from the Nahua and Zapotecan codices. A sun disk from Mitla is shown in Fig. 239, a.

There is evidence, however, that the sun disk at Chichen Itza was identified with the elaborate astronomical symbol with the serpent heads issuing on the four diagonals. The intermediate stage is given in Fig. 129, where an undeniable sun disk inclosing a human figure shows also four serpent heads attached to the rim.

At Santa Rita, in the northern part of British Honduras, the sun disk likewise occurs. Fig. 239, d and e, gives two sun disks, each with a human head on one side,

FIG. 239. — Sun and star symbols of the Nahua type: a, Mitla; b, Totonacan area; c and d, Santa Rosa; e, Codex Porfirio Dias; f, Codex Fejérváry-Meyer; g, Vienna Codex; h, Chichen Itza; i, Mitla.

the first from Santa Rita and the second from the Codex Porfirio Dias.[2] In the first case the head is inclosed in a conventionalized serpent head, while in the second case the serpent head appears in the center and the head at the top.

Associated with the sun disk at Santa Rita is the type of planet or star symbol which is characteristic of the highlands of Mexico. The astronomical symbols of the Maya have already been described on page 91. A simpler and less diversified method of indicating heavenly bodies was employed in the neighboring areas. Stars were represented as "celestial eyes." Similar examples of these celestial eyes are given in Fig. 239, a, c, f to i, including drawings at Santa Rita, Mitla, etc. What may have been intended for a celestial eye at Chichen Itza appears in h.

[1] Maudslay, 1887–1902, III, pl. 35, and Miss Breton's drawings in the Peabody Museum.
[2] Antigüedades Mexicanas, 1892.

The interesting device known as the speech sign is common throughout the Mexican highlands both on the monuments and in the manuscripts. Its occurrence in the Maya area is rare except at Chichen Itza, where it is elaborately developed. The speech sign is an object of diverse shape, often scroll-like, that is represented as issuing from the mouth to indicate sound or speech. In Fig. 101 is shown a potsherd from Copan with a painted representation of a jaguar

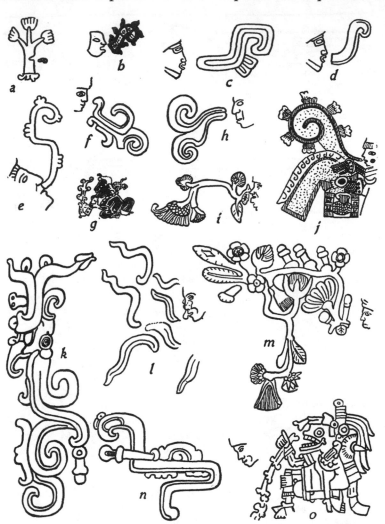

with such a sign attached to his mouth. The hieroglyph of the month Xul and the so-called Burner-period glyph also seem to indicate an animal in the act of howling. In the Maya codices the sounds of animals and of musical instruments are sometimes represented by such symbols, but the speech of human beings is not so shown. In short, the speech sign is an unusual and uncharacteristic feature in Maya art.

A selection of speech signs from different situations is given in Fig. 240. In a is shown the Mexican hieroglyph for Cuauhnahuac (Cuernavaca). In this rebus the "nahuac," which means "near," is represented by its homonym which means "speech." The same is seen in the Mex-

FIG. 240. — Speech scrolls: a and b, Nahua place names; c and d, Xochicalco; e, Santa Lucia Cosumahwalpa; f, h, i, k, l, m and n, Chichen Itza; g, Dresden Codex; j, San Juan Teotihuacan; o, Codex Chavero.

ican place-name hieroglyph, Acolnahuac, where the object endowed with a mouth and speech is an amputated arm instead of a tree. In b is given the place name for Cuicatlan, which means "the place of song." In this instance the speech scroll is elaborated with designs to indicate singing. A drawing in the Codex Borbonicus[1] represents a man beating on a drum and singing, each sort of noise being represented by appropriate symbols. Often the character of the speech sign indicates the nature of the prayer or perhaps the deity to whom it is addressed. Thus in j is probably pictured a prayer for rain and good crops. Flowers adorn the upper scroll, and symbols for running water the lower one. This example is from San Juan Teotihuacan.[2] Similar figures from Chichen

[1] Hamy, 1899, a, p. 4. [2] Peñafiel, 1899, pp. 49–50, pls. 81–87.

Itza are shown in *i* and *m*. At Santa Lucia Cosumahualpa[1] and other sites in Guatemala are still other elaborate examples of flowery speech signs. Returning to Chichen Itza, in *l* is possibly represented a prayer to the fire god and in *n* to the serpent. Examples of serpent heads are fairly common in the speech scrolls of this city. An interesting symbol is that given in *k*, which apparently represents the Long-nosed God. This is shown still better in Fig. 241. In fact, we may see in these drawings the final stage of change that took place in the representation of the Manikin Scepter. The Death God is shown in one of the Mexican codices (Fig. 138, *o*) in the act of delivering a homily on death. From these comparisons we see that the speech signs at Chichen Itza in their high development strongly suggest influence from the Mexican highlands.

FIG. 241. — Speech scroll representing the Long-nosed God: Chichen Itza.

A grotesque monster, that occurs a number of times at Chichen Itza[2] as a decorative motive on structures of the last group, has been identified by Seler[3] as Kukulcan. This figure presents in front view a human face, with a terraced nose ornament, in the more or less rectangular mouth of a monstrous reptile. The inclosing reptile head is characterized by sweeping plumes and by nose plugs at the top and by a long, divided tongue at the bottom. On either side of this grotesque head appears a leg with claws. Examples of this figure occur on the balustrades that flank the front steps of the Temple of the Jaguars as well as upon the end wall of the sculptured chamber below. But the best preserved representations adorn the so-called Temple of the Cones. A portion of a similar sculpture from an unknown source is built into the walls of the house of the hacienda.

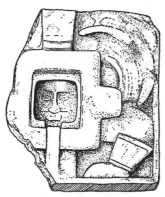

FIG. 242. — Terra cotta tile from Tezcoco.

The nearest approach to this figure in general style of presentation is the front-view reptilian form decorating the upper zone of the Temple of the Cross at Palenque.[4] But an examination shows that the modes of conventionalization do not agree. Both figures, however, probably relate to the Two-headed Dragon with its many divergent forms. The fish and water plant motive is found in intimate relation with both. While the representation of a human head in an animal's mouth is too general in and out of the Maya area to have any specific bearing on the subject at hand, still there is a marked objective similarity between the Chichen Itza sculptures and the headdresses of Stelae 7 and 26 at Piedras Negras, which will be shown later.

But in keeping with other close parallels noted between the art of the last period of Chichen Itza and that of the so-called Toltec cities of the Valley of Mexico we find this conventionalized figure almost exactly reproduced upon a small water-worn terra cotta tile from the ancient Tezcoco. This tile, which is in the American Museum of Natural History, is reproduced in Fig. 242. It practically completes the chain of evidence connecting the last flash of brilliancy

[1] Habel, 1878; Bastian, 1882; Seler, C. 1900, pl. 42. [3] 1908, p. 235.
[2] Maudslay, 1889–1902, III, pl. 52, *d* and *e*. [4] Maudslay, 1889–1902, IV, pl. 68, *a* and *b*.

on Maya soil with the most magnificent epoch in the Valley of Mexico that it-
self ended before the beginning of the fourteenth century. The peculiar terraced
nose plugs that appear on the human heads in the reptile mouth also are seen in
the codices from the highlands of Mexico (Fig. 243, a).

The method of grouping as well as the general style of delineation shown on
the walls of the Lower Temple of the Jaguars and the South Temple of the Ball
Court exhibits similarities to the sculptures on the famous Sacrificial Stone of
Mexico City or Stone of Tizoc. But the most significant similarity concerns the
accompanying hieroglyphs. Above each warrior is a glyph which probably rep-
resents the name of the individual. These
glyphs are drawn in the Mexican manner,
and it is not at all impossible that they are
to be read in the Nahua rather than in the
Maya language. The warriors which appear
with the twining bodies of serpents behind
them find a close parallel in the warrior from
the Codex Borbonicus [1] reproduced in Fig.
243, b, as well as in a sculpture at Tula.[2]

Fig. 243. — Nahua subjects similar to those of
Chichen Itza: a, head with terraced nose
plug and eagle headdress. Codex Vaticanus
3773; b, warrior with attendant serpent:
Codex Borbonicus.

The historical importance of these re-
markable similarities showing intrusive ideas
from the Mexican highlands will be considered presently. It must not be gath-
ered that the art of this period was entirely Nahua, because such a conclusion
would be far from the truth. The inherited features of Maya art still are seen
in many sculptured figures. For instance, there are no drawings from the high-
lands of Mexico that show the knowledge of foreshortening that we see in Fig.
244 from the Temple of the Jaguars. The vault construction, etc., is purely Maya.

The evidence is so complete
and the identities so numerous
that immediate contact between
these two cultures is the only ex-
planation that can be offered. The
traditional evidence of a Nahua
invasion just previous to the down-
fall of the League of Mayapan will
soon be presented. It seems clear
from the sculptures alone that Chi-
chen Itza fell under the influence

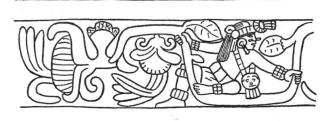

Fig. 244. — Design showing Maya mastery of foreshortening:
Chichen Itza.

of foreigners who infused new spirit into the decadent art and introduced new
ideas of their own. But complications arise from the fact that much of the
early Nahua culture was itself derived at an earlier date from Maya sources,
and still retained traces of its origin at the time of its reversion to Yucatan.

The sculptured columns and pilasters (Plate 29, figs. 1, 3 and 6) of the
temples possessing the features just considered are the most important criteria
of classification of the structures of this period. Many of them have been
reproduced by Dr. Seler. Of especial interest is a small temple with two pil-
asters made of stones wrongly assembled. This structure was apparently made
of waste material, but this material was from the latest period. Perhaps

[1] Hamy, 1899, a, p. 17. [2] Peñafiel, 1890, pl. 154.

the finest single sculpture of this period is that of a jaguar reproduced in Plate 29, fig. 7.

Clear evidences of so-called Toltec or pre-Aztec influences are not wanting elsewhere in the Maya area. In northern Yucatan these evidences apparently relate to the same time as the foreign importations we have just noted at Chichen Itza or to a slightly later time. The ball court at Uxmal [1] may well have been modeled directly after that of Chichen Itza, for in general the structures of this city are purely Maya. The remains that Charnay [2] identifies as those of a ball court at Ake are, indeed, somewhat doubtful. But the possibility of their being such is somewhat increased by the presence of another feature that may be un-Maya. The platform with columns in three rows at Ake resembles the more complicated Group of the Columns at Chichen Itza,[3] which clearly dates from the period of foreign influence. Upon the Island of Cancun off the east coast of Yucatan there are two platform mounds facing each other, which have no walled temples on their summits but only rows of columns.[4] Neither at Ake nor at Cancun is there enough sculptural detail to allow a stylistic comparison. At the latter place, however, was found a broken heroic statue, the head of which [5]

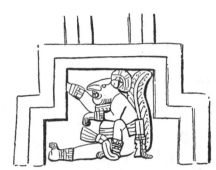

FIG. 245. — A stucco panel at Acanceh.

shows a close resemblance to heads attached to incense burners from British Honduras, Tabasco, etc. that seem to have been in vogue just previous to the Spanish Conquest. Stephens [6] at Mayapan notes the presence of a structure with double rows of columns.

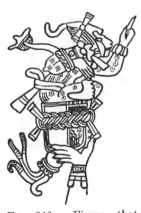

FIG. 246. — Figure that may represent Manikin God: Santa Rita.

The recently discovered wall at Acanceh [7] with its well-preserved stucco reliefs seems to show foreign influence in several details. It is possible that we have here simply a platform with ornate sides like the so-called mausoleums of Chichen Itza. But there are several vaulted chambers near by whose floors are on a lower level than the base of the wall. The ornamentation is unusual in style and subject. The upper projection of the wall presents a series of repeated symbols based upon the eye of the serpent and resembling somewhat the Mexican star signs, while the lower band shows two Maya planet signs in alternation. The middle portion of the wall between these projecting bands is largely given over to more or less humanized animal figures inclosed in panels with terraced outlines (Fig. 245). Prominent among these figures are the squirrel, the bat and the serpent. The speech scroll occurs several times.

The ruins of Santa Rita in the northern part of British Honduras are well known on account of the fresco paintings found and described by Mr. Thomas Gann.[8] The art of this place shows many of the Nahua features that have already

[1] Holmes, 1895–1897, p. 90.
[2] 1885, p. 249.
[3] Maudslay, 1889–1902, III, pp. 36–43, pl. 60.
[4] Arnold and Frost, 1909, pp. 150–151.
[5] Arnold and Frost, 1909, p. 240.
[6] 1843, I, p. 137.
[7] Breton, 1908; Seler, 1911, a.
[8] 1897–1898.

been noted at Chichen Itza. The sun disk and the celestial eyes have already been considered. In general technique the paintings resemble those of Mitla. The Maya admixture is more noticeable in subject than in treatment. It seems possible to identify the faces of both the Manikin God (Fig. 246) and the Roman-nosed God (Fig. 247), although the identification of the former is far from

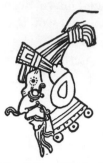

certain. Likewise Maya glyphs occur, particularly numbers combined with the day sign Ahau. The paintings probably record conquests. The style of some of the pottery (Fig. 248) is characteristic of the period just before the coming of the Spaniards.

Brief mention has already been made of the common occurrence upon the highlands of Guatemala and Chiapas of parallel earthworks that Seler[1] has identified as ball courts. If the identification is correct, the presence of these structures may indicate Nahua influence in this region. Such influence must have come in after the fall of Copan and the other great cities of the lowlands, because no such remains are found at these cities.

FIG. 247. — Head of Roman-nosed Sun God: Santa Rita.

The sculptures of Santa Lucia Cozumahualpa are excellent examples of Nahua art, and according to Brinton[2] are to be attributed to the Pipiles, a Nahua tribe. The speech scroll is a prominent feature and is sometimes very elaborate. Other Nahua tribes that carried with them some of the old culture located themselves still farther south near the shores of Lake Nicaragua.

Modern Period. Little is known concerning the styles of architectural decoration in vogue at the arrival of the Spaniards. In regard to the minor arts, however, there is a type of pottery which has been pretty surely authenticated as dating from this last period. This is seen in incense burners made as a rule of a coarse sandy material and showing decoration with faces and entire human figures built up in full relief.[3] The type of face is peculiar and is characterized by a pronounced nose with a beadlike knob at the top. Examples come from Cosumel Island,[4] British Honduras and Tabasco, and are thus of wide distribution. In the last locality they seem to be associated with the so-called ruins of Cintla,[5] with whose inhabitants Cortes fought his first great battle,

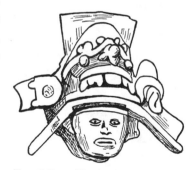

FIG. 248. — Head of figurine with animal headdress: Santa Rita.

and with numerous earthen mounds near Frontera (Fig. 249). A photograph of a stone image of large size on the Island of Cancun showing the same type of face is given in a recent publication.[6]

The modern descendants of these incense burners may be seen among the Lacandone Indians of the Usumacinta Valley (Fig. 250). These vessels are crudely made, but usually have a face on the rim. This face shows the bead above the nose and the old round ear plugs at each side of the head. These features are clearly survivals of the old art. It has already been stated that

[1] 1901, c, pp. 26–32.
[2] 1885, d. See also Lehmann, 1909, p. 16.
[3] Tozzer, 1907, pp. 89–92 and pls. 15–17; Seler, 1901, c, p. 148; Seler, 1895, d, pp. 26–27.
[4] Salisbury, 1878.

[5] Brinton, 1896, p. 268. Some of the specimens collected by Berendt and mentioned herein are now in the Peabody Museum.
[6] Arnold and Frost, 1909, p. 240.

weaving, as practiced in the different parts of the Maya area, may also show certain survivals.

Correlation of Maya and Christian Chronology. Various attempts have been made to bring about a concordance of Maya and Christian chronology principally by means of the sequence of katuns given in the native Books of Chilan Balam. The earliest attempts were based upon Chronicle I, the Book of Chilan Balam of Mani. This document was discovered and first translated from the Maya by Don Juan Pio Perez. The text and a retranslation into English were published by Stephens.[1] The discoverer himself worked out the chronology on the basis of 24 years to a katun and did not correctly determine the number of periods. In these mistakes he was followed by Bishop Carrillo,[2] who drew his results from the manuscript of Perez and from a number of other Maya documents.

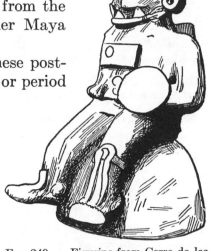

FIG. 249. — Figurine from Cerro de los Idolos: Tabasco.

It is now well established that the katun in these post-Spanish records corresponds in length to the katun or period of the fourth position in the ancient calendar and consists of 20 × 360 days. For ease of calculation this may be lengthened to an even 20 years. The error then accumulates at the rate of about 4 years in 300. In the Books of Chilan Balam each katun is distinguished by the number of day Ahau with which it begins. These fall in the following order: 13, 11, 9, 7, 5, 3, 1, 12, 10, 8, 6, 4, 2, 13, etc. Thus katuns with the same designation can occur only at intervals of 13 × 20, or 260 years. As long as these 260-year cycles are kept in their proper order the count is accurate enough. It was apparently the intention of the native historians to obviate mistakes by repeating all of the katuns in order whether or not there were historical entries opposite them. But in the chronicles as they have survived there are both omissions and repetitions.

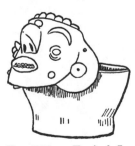

FIG. 250. — Typical Lacandone incense burner.

Abbé Brasseur de Bourbourg[3] and Don Eligio Ancona[4] based their considerations principally upon the work of Perez, the latter using 24 years as the length of the katun. Their chronologies vary somewhat in the number of katuns. What seems to be the proper sequence and number of the katuns was first established by Valentini[5] and later adopted without important change by Brinton.[6] The former worked only with the original chronicle discovered by Perez, while the latter correlated with this document four other more or less similar ones from different towns. The count is carried back 70 katuns, from the end of katun 13, which fell in the year 1541. This places the beginning of the traditional history in the year 160 A.D.

But the Books of Chilan Balam, useful as they are, cannot be regarded as a

[1] 1843, I, Appendix, pp. 434 *et seq.* The original with the commentary of Pio Perez was published by Brasseur de Bourbourg, 1864, pp. 366–429.

[2] 1871, p. 405; 1883, pp. 60–64.

[3] 1857–1859, II, pp. 1–72.

[4] 1878–1880, I, p. 138.

[5] 1879, *b.*

[6] 1882, *b.*

summary of Maya history as a whole. The historical events therein recorded may have referred originally to a single clan, the Itzas, who from a small beginning became more and more powerful till they controlled the destinies of northern Yucatan. This brief history of the most important tribe or ruling family may have later served as a basis and model for the histories of other important tribes or families. Against this supposition is the general lack of purely genealogical data. The tribal or family histories from the highlands of Guatemala furnish detailed genealogical information and give as well accounts of wars and other events.

We have seen that during the Great Period there were many cities with dated monuments and that at the close of this period the use of such dated monuments seems to have been entirely discontinued. Several attempts have been made to bring these dates into some definite relation with our own calendar. One noteworthy attempt, made by Mr. Bowditch, is based upon a date in the Books of Chilan Balam expressed in the quadrinomial system of the Maya and likewise in European chronology. The event recorded is the death of a native chief called Ahpula, which fell on the day 9 Imix 18 Tzec, six years before the completion of katun 13 Ahau, in the year of our Lord 1536. We know that 9 Imix 18 Tzec corresponded to October 21.

The year-bearer, or the 1st day of the month Pop, July 16, 1836, is variously given in these chronicles as 4 Kan[1] and 5 Kan,[2] while in the so-called chronicle of Nakum Pech the year-bearer for July 16, 1841, is given as 13 Kan.[3] No two of these agree with the necessary positions in the 52-year calendar round. The complete year given by Landa begins with 12 Kan and was probably taken down directly from a native informant as the year then passing. Landa's work was completed in 1566. Possibly other dates of this sort will be found in unpublished records. At present the confusion is very great, although the numbering of the katun periods seems to be pretty accurate.

It has already been explained that there is an apparent shift of one day between the ancient and the modern Maya calendar. In fact, the date 9 Imix 18 Tzec is impossible in the long count and must be shifted to 9 Imix 19 Tzec. This change and the discrepancies above noted militate somewhat against the value of the date given for Ahpula's death. If the determination made by Mr. Bowditch[4] is correct, the inscription on Stela 9 at Copan records the year 34 A.D. This determination is certainly much more reasonable than the one made by Dr. Seler upon another date which makes Stela 9 go back to 1255 B.C. If the correlation of Mr. Bowditch is accepted, we must lengthen the Period of the Transition about 260 years to take up the slack time. The chronology at each end of this period is accurate enough.

A second method of correlating the mass of dates in the ancient inscriptions with the European system has been explained by Mr. Morley.[5] It is based upon the general sequence of historical events as outlined in the chronicles and the date in the long count which occurs on the lintel at Chichen Itza. This city is the only one mentioned by name in the chronicles at which a date in the ancient system has been found. The date itself is significant as being one of the latest

[1] Brinton, 1882, b, p. 104 (Chronicle I); p. 162 (Chronicle III).
[2] Brinton, 1882, b, p. 149 (Chronicle II). [3] Brinton, 1882, b, p. 228.
[4] 1901, b. [5] 1910, b.

Table 2
Showing Historical Correlation of the Inscriptions and the Chronicles.

Cultural Periods.	Important recorded Dates in Long Count giving Evidence of Occupation of Cities.
Protohistoric Period **235 B.C. to 160 A.D.**	⊙ Tuxtla Statuette ? ⊙ Leiden Plate
Archaic Period **160 A.D. to 455 A.D.**	Tikal Copan Quirigua ⊙ Stela 3 ⊙ Stela 9
Great Period **455 A.D. to 600 A.D.**	⊙ Stela 5 ⊙ Stela N ⊙ Stela H ⊙ Stela K
Transition Period **600 A.D. to 960 A.D.**	
	⊙ Inscription at Xcalumkin ?
League Period **960 A.D. to 1195 A.D.**	
Nahua Period **1195 A.D. to 1442 A.D.**	
Modern Period **1442 A.D. to ?**	

COMPARATIVE TABLE OF THE TRADITIONA

House of Xahila — Cakchiquel.[1]

1. **Gagavitz,** a great leader who came from Tollan, probably more a culture hero than a historical personage.
2. **Cay Noh** and **Cay Batz,** his two sons who succeeded him while yet boys and were made rulers subject to Tepeuh, ruler of the Quiché.
3. **Citan Qatu,** son of Cay Noh.
4. **Citan Tihax Cablah,** who did not rule because the power was divided among many.
5. **Vukubatz** and **Huntoh,** the former being a son of Citan Tihax Cablah, ruled by grace of Qikab (Quicab) of the Quiché.
 They establish Iximché.
6. **Oxlahuh Tzii,** son of Vukubatz, ruled with **Lahuh Ah,** the son of Huntoh, and later with **Cablahuh Tihax,** the son of Lahuh Ah. His reign lasted till 1509 A. D. At the beginning of his reign he captured Tepepul and Itzayul, the Quiché rulers. In 1496 took place the revolt of the Tukuches and their destruction.
7. **Hun Yg,** the son of Oxlahuh Tzii, ruled jointly with **Lahub Noh,** the son of Cablahuh Tihax. In 1510 messengers sent by Montezuma were received. In 1521 came the pestilence and the chiefs died.
8. **Cahi Imox** and **Belehe Qat** were elected chiefs. In 1524 arrived the Spaniards under Pedro de Alvarado.

[1] Brinton, 1885, *a.*

Important recorded Dates in Long Count giving Evidence of Occupation of Cities.	Archaic Calendar or Long Count.
	⊙ 8-0-0-0-0,　9 Ahau 3 Zip
	⊙ 8-5-0-0-0,　12 Ahau 13 Kankin
	⊙ 8-10-0-0-0,　2 Ahau 18 Yaxkin
	⊙ 8-15-0-0-0,　5 Ahau 3 Pop
Naranjo　　Seibal　　Saccana　　Chichen Itza	⊙ 9-0-0-0-0,　8 Ahau 13 Ceh
	⊙ 9-5-0-0-0,　11 Ahau 18 Tzec
	⊙ 9-10-0-0-0,　1 Ahau 8 Kayab
⊙ Hieroglyphic Stairway	⊙ 9-15-0-0-0,　4 Ahau 13 Yax
⊙ Stela 32　　⊙ Stela 6 / ⊙ Stela 11	⊙ 10-0-0-0-0,　7 Ahau 18 Zip
⊙ Stela 1 / Stela 2　　⊙ Lintel	⊙ 10-5-0-0-0,　10 Ahau 8 Muan
	⊙ 10-10-0-0-0,　13 Ahau 13 Mol
	⊙ 10-15-0-0-0,　3 Ahau 18 Pop
	⊙ 11-0-0-0-0,　6 Ahau 8 Mac
	⊙ 11-5-0-0-0,　9 Ahau 13 Xul
	⊙ 11-10-0-0-0,　12 Ahau 3 Cumhu
	⊙ 11-15-0-0-0,　2 Ahau 8 Zac
	⊙ 12-0-0-0-0,　5 Ahau 13 Zotz
	⊙ 12-5-0-0-0,　8 Ahau 3 Pax
	⊙ 12-10-0-0-0,　11 Ahau 8 Chen

HISTORY OF THE CAKCHIQUEL AND QUICHE.

House of Cavek — Quiché.[2]

1. **Balam-Quitzé,** mythical ancestor of the Quiché.
2. **Qocavib** — possibly the same as Gagavitz, although given little space in the Quiché account.
3. **Balam-Conaché** — probably the first really historical name.
4. **Cotuha** and **Iztayul** appear to have been the first important rulers. The latter is probably Tepeuh of the preceding chronicle.
5. **Gugumatz** and **Cotuha** — Gugumatz was a powerful chief who re-established Utatlan.
6. **Tepepul** and **Iztayul** seem to have been unimportant.
7. **Quicab** and **Cavizimah** — The first named was the greatest of all Quiché rulers, but at the end of a brilliant reign suffered from sedition fomented by his own sons. He established Huntoh and Vukubatz as chiefs of the Cakchiquels.
8. **Tepepul** and **Xtayub,** the sons of Quicab, succeed him.
9. **Tecum** and **Tepepul.**
10. **Vahxaki-Caam** and **Quicab.**
11. **Vukub-Noh** and **Cavatepech.**
12. **Oxib-Quieh** and **Beleheb-Tzi** were rulers when Spaniards arrived and were conquered by Alvarado.
13. **Tecum** and **Tepepul** rendered tribute to the Spaniards.

[2] Brasseur de Bourbourg, 1861.

Short Count.	European Count.	Principal Events of Maya History as Recorded in the Chronicles.	
		Chronicle I. [3]	Chronicle II. [4]
⊙ 9 Ahau 7 5 3 1	⊙ 235 B. C.		
⊙12 Ahau 10 8 6 4	⊙ 136 B. C.		
⊙ 2 Ahau 13 11 9 7	⊙ 38 B. C.		
⊙ 8 Ahau 3 1 12 10	⊙ 61 A. D.		
⊙ 8 Ahau 6 4 2 13	⊙ 160 A. D.	Set out from Nonoual with Holon Chantepeuh (1 and 2). Ahmekat Tutulxiu arrived at Chacnouitan in Katun 2 Ahau (3). Arrived at Chacnouitan after 81 years (2).	Numeration of Katuns begins but no event recorded (1). Mekat Tutulxiu arrived at Chacnabiton (2). Passage of 81 years noted (1).
⊙11 Ahau 9 7 5 3	⊙ 258 A. D.	End of 99 years residence in Chacnouitan (3).	Passage of 99 years noted (2). Residence in Chacnabiton.
⊙ 1 Ahau 12 10 8 6	⊙ 357 A. D.	Hiatus of 120 years. Discovered Ziyan caan or Bakhalal (4).	Chichen Itza learned about. Zian caan discovered (3).
⊙ 4 Ahau 2 13 11 9	⊙ 455 A. D.	End of 60 years' residence in Bakhalal (4) during which Chichen Itza was discovered.	Pop was counted in order (4).
⊙ 7 Ahau 5 3 1 12	⊙ 554 A. D.	Chichen Itza abandoned after 120 years' residence (5).	Chichen Itza destroyed after 200 years' residence (5).
⊙10 Ahau 8 6 4 2	⊙ 653 A. D.	The land of Chanputun seized (6).	The land of Chakanputun seized (6).
⊙13 Ahau 11 9 7 5	⊙ 751 A. D.		
⊙ 3 Ahau 1 12 10 8	⊙ 850 A. D.		
⊙ 6 Ahau 4 2 13 11	⊙ 949 A. D.	Chanputun abandoned after 260 years' residence. Itzas in exile (6). Chichen Itza re-established after loss of Chanputun (7). Uxmal founded by Ahzuitok Tutulxiu: league began between Mayapan, Uxmal and Chichen Itza which lasted 200 years (8).	Chakanputun abandoned after 260 years' residence: Itzas in distress (6). Chichen Itza re-established 40 years later (7). Ahzuitok Tutulxiu founded Uxmal. The rule lasted 200 years (8).
⊙ 9 Ahau 7 5 3 1	⊙ 1047 A. D.		
⊙12 Ahau 10 8 6 4	⊙ 1146 A. D.	Chac Xib Chac, ruler of Chichen Itza, driven out on account of the plot of Hunac Ceel. In 10th year of Katun 8 Ahau depopulated by foreign warriors (9). Ulil of Izamal also involved. War lasted 34 years (10).	The ruler deserted Chichen Itza on account of Hunac Ceel. Seven foreign warriors. Banquet with Ulil of Izamal (9 and 10).
⊙ 2 Ahau 13 11 9 7	⊙ 1245 A. D.	Mayapan invaded by the Itzas under Ulmil on account of the seizing of the stronghold (Chichen Itza) by the joint government. Chichen Itza depopulated by foreigners from the mountains in Katun 11 Ahau, 83 years after the end of the first war (11).	Ruler seized the land on account of Hunac Ceel (11).
⊙ 5 Ahau 3 1 12 10	⊙ 1343 A. D.		
⊙ 8 Ahau 6 4 2 13	⊙ 1442 A. D.	Mayapan finally depopulated (12). Spaniards first passed (12). Death of Ahpula (13).	Fighting at Mayapan on account of seizure of the castle and the joint government (11). Mayapan depopulated by foreigners from the mountains. Passage of 280 years noted (12). Account confused. Foreigners first passed to Yucatan. Passage of 93 years noted (11).
⊙11 Ahau	⊙ 1541 A. D.	Pestilence and small-pox (13). Spaniards arrived from the east (14). Christianity began (14). Bishop Landa died (15). [1579.]	Foreigners arrived from the east (14). The pestilence took place (13). Death of Ahpula (13). Christianity began (14). Bishop Landa died (15).

[3] Brinton, 1882, b; Valentini, 1879, b. The numbers in parentheses refer to the paragraphs of the Chronicles. [4] Brinton, 1882, b; Morley, 1911.

Chronicle III. [5]	Chronicle IV. [6]	Chronicle V. [7]
		The Pauah (year-bearers?) born (1).
		The greater and lesser arrival (3).
hichen Itza discovered (1).		After a residence of 260 years. Chichen Itza discovered in Katun 4 Ahau (5). The tribes go four ways (6 to 13).
op was set in order (1).		When they arrived (no date given) they were accepted as lords of the land (13).
		When they arrived at Chichen Itza (no date given) they called themselves Itzas (14).
Chichen Itza abandoned. They went to Chakanputun for houses (1).		
he land was taken (2).		In Katun 8 Ahau arrived the remains of the Itzas and settled in Chakanputun (19).
Chakanputun deserted by the Itzas. Itzas in exile (2).	Count begins (1). Itzas (?) driven out (1).	
		In Katun 13 Ahau was founded Mayapan and they called themselves Mayas (20).
	The town destroyed by Kinich Kakmo, ruler of Itzmal, and Pop Hol Chan on account of Hunac Ceel (1). The rest of the Itzas driven out. Chichen Itza depopulated in third year of Katun 1 Ahau (2).	
The Itzas driven out on account of the plot of Hunac Ceel (3). The Itzas seize Mayapan and Izamal on account of the plot of Hunac Ceel (4).	Zaclactun Mayapan established by the deposed Itzas (3). Chakanputun burned (3). [This may refer to 260 years previous?]	After 260 years took place the treason of Hunac Ceel (15). They were in exile (16) in Katun 4 Ahau (17).
	Cannibals come. [Caribs.] The middle of Mayapan depopulated in the first year of Katun 1 Ahau. The chiefs lost their power (5).	
Fighting at Mayapan because of the seizure of the fortress by the joint government (5).		Cities abandoned and people scattered (21). People dispersed — cease to call themselves Mayas (21).
The pestilence took place (6). Death of Ahpula (7). Mighty men arrive from the east (8). Christianity began (8). Bishop Landa died (8).	Pestilence took place in fifth year of Katun 4 Ahau (7). Death of Ahpula (8) [date differs from the first three accounts]. Spaniards arrived in seventh year of Katun 11 Ahau (8). Bishop Landa died.	Ceased to call themselves Mayas, became Christians (22).

| [5] Brinton, 1882, b. | [6] Brinton, 1882, b. | [7] Martinez, 1910. |

expressed in this manner. It is 10–2–9–1–9, and thus falls in the ninth year of the second katun of the tenth cycle. Mr. Morley's determination depends upon the accepted fact that the designation of the katun by the day with which it began was common to both the old and the new calendars. Thus the first day of the tenth cycle according to the old system was 7 Ahau 19 Zip and according to the new system was simply katun 7 Ahau. 10–2–0–0–0, 3 Ahau 3 Ceh, equals katun 3 Ahau in the new system. This being known, the problem is to find a katun 3 Ahau that falls during one of the noted occupations of Chichen Itza.

The Chronological Table given in Table 2 covers the entire range of Maya history, and shows the results obtained from the study of the monuments and the native historical records. The periods of the Long Count, the Short Count and the European Count are correlated horizontally in this table. The principal events as related in the different Chronicles are set down in separate columns upon the same principle of arrangement. A synopsis of the recorded history of the Quiché and Cakchiquel is presented in a detached space and in a genealogical manner owing to the lack of definite dating.

It is evident from the table that the period which is richest in monuments is poorest in historical references. But this is hardly to be wondered at when we remember that the chronicles are post-Cortesian, while the dated monuments fall in the first centuries of the Christian era. The Tuxtla Statuette and the Leiden Plate have eighth cycle dates; the Dresden Codex has a few eighth cycle dates, a large number of ninth cycle ones and a few that fall near the end of the tenth cycle. It is very doubtful whether these dates have any historical value.

Chronicles I and II, if the correlation is correct, begin with the round number 9–0–0–0–0 as the time of departure from the mythical land of Tollan. This date is earlier than any date on an erected monument with the exception of a few mythical dates thousands of years previous to the historic period. The first date at Tikal is, however, but 50 years later and thus precedes the stated time of arrival at Chacnouitan (or Chacnabiton) of the party under Holon Chantepeuh, for the migration lasted 81 years. Ahmckat Tutulxiu, however, seems to have arrived a few years earlier. Because, if his residence is placed a cycle later, as Brinton places it, there is little worth in the statement that the residence in Chacnouitan lasted 99 years. Bacalal is being occupied during this time. There is another slight point: the 99 years when added to the 81 years that had preceded makes exactly 9 katuns.

It is clear that there is a hiatus of 120 years at this point. This 120 years falls unfortunately in a most significant epoch, just before the Maya sculptors developed their greatest skill. Perhaps the record of other cities might have filled the gap. Most likely, however, the chroniclers did not attempt to give a résumé of the Maya nation as a whole. Zian caan or Bakhalal seems to have been discovered at the close of the archaic period, as determined by the sculptures. This region or province may be identified with the modern Bacalar. During the 60-year residence at Bacalar the more northern parts of Yucatan were colonized, in particular Chichen Itza. Probably this city and region remained an unimportant province during the brilliant florescence of the Usumacinta centers. Chronicle V indicates in one passage the dispersal of the tribes in the four directions at about this time. This may refer to the spread of Maya culture into central Honduras, western Guatemala, southern Mexico and northern Yucatan.

A detail which may settle the accuracy of the correlation is the statement that Pop (the first month of the Maya year) was counted in order. This counting in order falls about 9–17–0–0–0, and it may sometime be possible to identify the calculations referred to in the chronicle.

The Period of Transition begins with the abandonment of Chichen Itza and the conquest of Chanputun (Chakanputun). This has been commonly taken to mean the region east of Campeche. From the chronicles we may judge that it was already occupied when the Itzas arrived, and that they first founded a city and finally secured complete mastery of the country. Archaeological information concerning this region is very deficient, and it is impossible to state what city or cities may be identified with Chanputun. Iturbide, Santa Rosa Xlabpak and Xcalumkin may be mentioned as likely candidates.

After a sojourn of 260 years the Itzas abandoned Chakanputun. In Chronicle IV there is a statement that Chakanputun was destroyed by fire, which would seem to indicate that it was a city and not a province, but the date of this destruction does not agree very well with the other dates. There is some reason to believe that the Itzas were expelled. It is clear that they suffered misfortune for several decades before they finally established themselves at the old capital, Chichen Itza.

This re-establishment marks the beginning of a new epoch. Mayapan[1] probably existed before this time, and Uxmal was apparently founded a few years after by Ahzuitok Tutulxiu. The three cities combined forces, and the union was known as the League of Mayapan. It apparently existed for about 200 years, the end being marked by civil war. There is no doubt that the greater part of this period of the league was peaceful and prosperous. There are many important cities that were apparently contemporaneous yet concerning which we have no definite historical information. Izamal is involved in the wars at the end of the period.

The references to the so-called plot of Hunac Ceel are voluminous and ambiguous. This person was the ruler of Mayapan and seems to have resorted to treachery to undermine the power of Chichen Itza. The plot is mentioned in all the Chronicles, but the dates given do not agree in all instances.

The coming of warriors from the highlands of Mexico, and in all probability from the cities of Tula, Cholula and San Juan Teotihuacan, as has been shown from a study of the artistic remains, is distinctly stated in a number of historical documents. Chronicles I and II give the names of the seven men of Mayapan, all of whom bear names that are seemingly of Nahua origin. They were the allies of Hunac Ceel, and it seems likely that the vanquished Chichen Itza was turned over to them as the spoils of war. Brinton[2] translates certain pieces of testimony offered in a lawsuit at Valladolid in 1618. According to this testimony the ancestors of the interested parties came from Mexico to found cities in Yucatan. They built the great temples at Chichen Itza, and they settled likewise near Bacalar and upon the northern coast. These other localities correspond to Santa Rita and Cancun, where evidences of Nahua contact were seen in the art and architecture. Landa[3] mentions a settlement of Aztecs west of Merida. Aguilar[4] also states that there were invaders from the highlands who forced the natives

[1] For the traditional account of the foundation of Mayapan by Kukulcan see Landa, 1864, pp. 34–38.
[2] 1882, b, pp. 116–118. [3] 1864, p. 54 [4] 1639, p. 86.

to construct great temples. Alonzo Ponce, in the passage already quoted (see page 7), makes a reference to the lapse of 900 years since the establishment of Uxmal. The Maya often use the number 9 in the generic sense of "many."

We may imagine, from the confusion that follows the plot of Hunac Ceel, that the course of Maya dominion did not flow smoothly. There are references in the chronicles to civil wars and to the final overthrow and destruction of Mayapan. This probably happened after the civilization had sadly declined. Landa,[1] Cogolludo, etc. make reference to the fall of Mayapan. Events subsequent to this have little interest to us because they have no bearing upon the art.

The possibility of the Dresden, Tro-Cortesianus and Peresianus codices furnishing historical data offers an interesting field for speculation. Seler claims that the Tro-Cortesianus Codex shows the calendar system in vogue at the coming of the Spaniards, because the year bearers in connection with the ceremonies of the new year (pages 20–23) are Kan, Muluc, Ix and Cauac,[2] and not Lamat, Ben, Eznab and Akbal. But Mr. Bowditch [3] points out that the only quadrinomial date occurring in the manuscript (13 Ahau 13 Cumhu on page 73) is in accordance with the ancient inscriptions. There are a number of initial series dates in the Dresden Codex counted from the normal date 4 Ahau 8 Cumhu. Most of these are in the ninth cycle, but some are in the eighth and others in the tenth. Mr. Bowditch [4] is inclined to think that present time in this codex is represented by the date 9–9–9–16–0. This hardly seems likely owing to the absence from this manuscript of the ceremonial objects characteristic of that period. This date falls well back in the archaic period about the time Stela P was erected at Copan. According to Mr. Morley there are two eighth cycle dates that fall in the sixth katun and one date that falls in the nineteenth katun of the tenth cycle. Thus a range of over a thousand years is covered almost exactly corresponding to that shown on the monuments if the inscriptions on the San Andrés Tuxtla Statuette and on the Temple of the Inscriptions at Xcalumkin are validated. Unfortunately the codex dates are difficult to read and the dates on the monuments in question are far from established.

CONNECTION WITH OTHER CULTURES

Maya Influence in Nahua and Zapotecan Art. Maya art has now been studied in its crude beginnings, in its greatest brilliancy and in its phases of decadence and renaissance. It has been shown that in a late epoch there was a political and artistic transfer of culture from Mexico. This influence may be ascribed to the cities of Tula, Teotihuacan and Cholula, and others of the pre-Aztec period. Let us now treat in some detail the evidences of artistic influence that the Maya exerted upon their neighbors.

The adequate discussion of the interrelations of culture as a whole would require more space than is available. Suffice it to say that similarities in material arts, social organization and religious institutions bind the various peoples of southern and central Mexico in a firm ethnographic union with the Maya. The principle of divergent evolution is admirably illustrated in nearly all the phases

[1] 1864, pp. 48–52.　　[2] 1902–1908, I, p. 556.　　[3] 1910, pp. 78–79.　　[4] 1909, p. 279.

of culture. The divergence is explained by both geographical and chronological differences. The single item of the elaborate calendar which was used with comparatively little change from the Tarascans and Otomies on the north to the tribes of Nicaragua on the south is itself conclusive evidence of ethnic affiliations throughout the region. It seems reasonably certain that the calendar was invented by the Maya who brought it to its highest stage of perfection. In Mexico it is supposed to have been introduced by Quetzalcoatl. Many names used in the Nahua calendar have the same meaning as those in the Maya calendar. As Gadow [1] points out there are five animals represented as day signs in the Aztec calendar which do not occur on the highlands of Mexico, hence it is reasonable to suppose that the calendar did not originate in that region. All of the animals, on the other hand, do occur in the Maya country. Moreover, the principal divinity of the Aztecs was a war god who had nothing to do with the calendar. Quetzalcoatl, according to most of the accounts of his origin collected by Bandelier,[2] came into Mexico from a foreign land. He it was who introduced fine weaving and the working of jade. It seems quite likely that Quetzalcoatl[3] was a Mexican adaptation of one of the principal Maya deities, probably the Long-nosed God. The fact that Quetzalcoatl was introduced again into the land of his origin by the Mexican invaders does not necessarily militate against this theory. The worship of Tonatiuh, or the sun's disk, seems, on the other hand, to have been a purely Nahua development.

The calendarical system of the Nahua ran in fifty-two-year cycles and there was no method of accurately differentiating the cycles. In this respect it resembled the calendar used by the Quiché who are a Maya tribe. Dependable chronology hardly goes back two hundred years before the conquest. Traditions of earlier times are rather full and many of them probably have a basis of fact. According to these traditions Tula and Teotihuacan were founded in the seventh or eighth century, at about the end of the Maya epoch of greatest brilliancy. But it seems probable that these cities were in their greatest splendor several centuries later, synchronous with the Maya epoch of the League of Mayapan. The early cities in the Valley of Mexico appear to have declined in the twelfth and thirteenth centuries. Other cities rose in their stead; such as Tezcoco, Tlascala, and Tenochtitlan.

From a study of the archaeological remains it is possible to prove at least three epochs in the Valley of Mexico each distinguished from the other by characteristic art, mostly ceramic. The earliest of these periods seems to show no cultural connection with the Maya. This early period will presently be treated in some detail.

The condition of superimposed cultures which characterizes the Valley of Mexico probably holds true in other parts of Mexico. In the Zapotecan area Monte Alban and Tonila certainly represent a different and much earlier period than Mitla. In fact these ruins seem to be more closely connected with the great age of Maya civilization than do the pre-Aztec centers in the north. In the far northwest, the great ruins of La Quemada, Chalchihuites and various sites extending down the Boloños Valley appear to antedate by several centuries the historical Nahua and Tarascan towns of Sayula, Colima and Tzintzuntzan,

[1] Gadow, 1908, pp. 302–303. [2] Bandelier, 1884, pp. 188–198.
[3] For a commentary *variorum* on this subject see Robelo, 1905, pp. 345–437.

while still earlier remains doubtless await the spade of the archaeologist. But there is no reason to ascribe sensational antiquity to any of the famous ruins of Mexico. It seems likely that the effects of the great Maya ascendancy were felt far and wide and it will be interesting to determine some day the exact nature of the original Mexican culture upon which it reacted.

Let us now examine a few examples of art that indicate borrowings. One of the most characteristic and peculiar features of Maya art is the placing

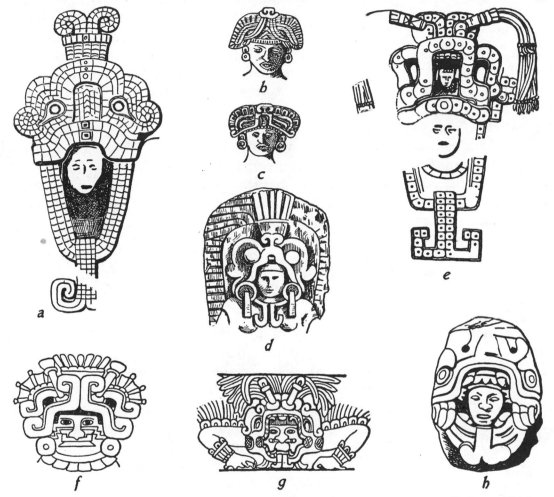

FIG. 251. — The human head in animal jaws: *a* and *e*, Piedras Negras; *b–d*, Oaxaca; *f*, Chalco; *g*, Chichen Itza; *h*, Highlands of Mexico.

of human heads in the mouths of reptiles and other animals. This feature is also seen in a few important sculptures of neighboring areas, where the sporadic cases have a very wide distribution. Highly conventionalized forms in which it is difficult to recognize the original features are much more common. Fig. 251 presents a number of heads for comparison. Of these *a* and *e* are from stelae at Piedras Negras and represent the head of a human being inclosed in a somewhat conventionalized animal's jaws. Note the hook on the outside of each eye, the double curl at the end of the nose and the forked tongue that hangs down over the lower jaw. In the second example nose plugs are seen. On the original sculptures these heads are surrounded by plumes not given in the drawings. Now comparison with *d*, the top of a small stone figure from Oaxaca, will make it

clear that this human head is likewise enclosed in an animal head similar to those described above. The double curl of the nose and the hook at the back of the eye are identical in shape. Many figurines with animal headdresses which may

FIG. 252. — The human head in conventionalized animal jaws: Oaxaca.

or may not have the lower jaw come from the same general locality (b, c and Fig. 252). The head in f is drawn on a slab of onyx from Chalco. The upper jaw of the animal headdress is remarkably complete and the nose plugs are clearly visible. Mr. Holmes [1] has explained this headdress as consisting of two serpent heads meeting in profile, but in this he seems to be mistaken since it is much more likely that a single head in front view was intended. Drawing g repre-

sents a monster already commented upon which appears frequently at Chichen Itza on buildings showing Mexican influence (compare with Fig. 242), while h is a sculptured stone from Mexico that represents a human head in a snake's mouth. But the human head in an animal's jaws is much less common among the Nahua and neighboring tribes than among the Maya. It occurs most clearly on specially elaborated objects such as the Calendar Stone (Fig. 253), and on knives, spear-throwers, and pottery vessels of ceremonial significance, but is rather unusual in minor decorative art. It may be seen in a debased form in many of the small

FIG. 253. — The human head in the jaws of a serpent, Calendar Stone: Mexico City.

FIG. 254.—Serpent head on Cholula pottery.

pottery heads that are found in almost all parts of central and southern Mexico. In the case of the Zapotecan funeral urns and minor figurines it is possible to work out several complete series showing every stage of degenerative evolution. The typical clay figurines of the Totonacan region likewise show vestiges of an original animal's head enclosing the human head. The same is seen in the pottery heads from Cholula and Teotihuacan.

It must be admitted that in Aztec times there was a wide use of eagle and jaguar headdresses of a strikingly realistic character (Fig. 243, a). In some of the codices human figures are represented dressed in the entire skins of animals and birds. In the case of the latter, however, it is at once apparent that the skin of an eagle is not large enough to clothe the body of a man and that the costume must have been merely imitative. This costume may have had its origin in high antiquity and the suggestion drawn from the realm of religious art.

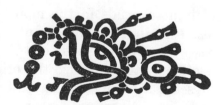

FIG. 255. — Serpent head on engraved bowl from Cholula.

Animal headdresses are very widespread among primitive people in all parts of the world but the lower jaw is usually lacking. In the Maya area, however,

[1] 1895–1897, pp. 304–309.

the ideal character of the human head in the jaws of the serpent, the jaguar, etc., is beyond dispute.

The treatment of the serpent motive in Nahua art and in some other arts of Mexico shows essential similarities to the same object in Maya art. Perhaps the most elaborate examples are the plumed serpents on the Temple of Xochicalco.[1] The supraorbital plate is prominent in the representations of both areas and there are close similarities in the dentition, and in the application of foreign bodies such as nose and ear plugs. But, taken all in all, the serpent outside of the Maya area seems to lose much of its spirituality. Often it is represented as being killed and sacrificed, a condition that never appears in Maya drawings.

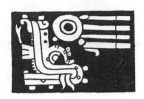

FIG. 256.—Serpent head painted on bowl from Cholula.

It may be worth while first to examine a few serpent

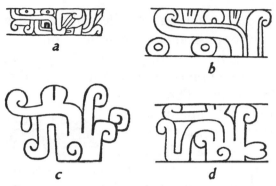

FIG. 257.—Serpent heads on Cholula pottery.

heads having the same features as the heads of the Maya area and secondly to trace the process of degeneration toward the more usual types. The most complete serpent heads are seen in the pottery of Cholula. Fig. 254 reproduces a head painted in different colors. The upper part of the upper jaw is horizontal while the lower jaw is vertical and extends downward. The tongue is attached to the end of the lower jaw and is drawn horizontally. The fang appears near the juncture of the two jaws. The eye is placed in the angle of the upper jaw near the same juncture. On the lower side of the upper jaw we see one molar and one incisor tooth, and on the upper side of the same jaw appears the nose scroll, greatly modified, with two nose plugs sloping backward. In its details of unnatural elaboration this head shows that it was derived from a Maya model (Fig. 30).

In Fig. 255 the circular appendage at the back of the head may represent the ear ornament, the only important detail not appearing on the head first described. Otherwise the second head is much simpler. In Fig. 256 is seen the most characteristic profile of the jaws, with the lower one short and horizontal and the upper one

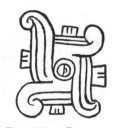

FIG. 258.—Conventionalized serpent heads arranged as a swastika.

long and vertical. In this example the two kinds of teeth are given as well as a fragment that probably represents the tongue. A double fang issues

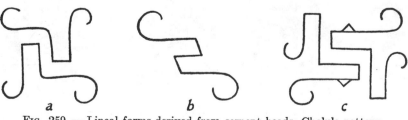

FIG. 259.—Lineal forms derived from serpent heads, Cholula pottery.

from the back of the mouth. The circular body over the eye may represent a displaced ear plug.

[1] Miss Breton, 1906, makes comparisons.

Four highly modified serpent heads are shown in Fig. 257. The teeth survive in almost every case. The first example, *a*, shows the eye, the nose scroll and the ear ornament, in addition to the fully distended jaws. In the second case, *b*, the jaws are in evidence, together with two teeth and three round bodies of uncertain provenance. The two last examples are much more complicated, and some of the features are to be identified only with difficulty.

Another kind of modification is seen in Fig. 258 where the principle of assemblage is the swastika. A circular eye is placed in the center and enclosing this are two heads back to back, one being inverted. The alternating lower and upper jaws, each with its terminal hook, thus form the arms of the swastika. A single molar tooth appears on each side. A variation of this motive is given by Batres.[1]

Fig. 260.—Serpent drawn in curvilinear style: Codex Vaticanus, 3773.

Fig. 259 shows the characteristic serpent profile reduced to a line motive and manipulated by opposition and combination.

In the later drawings of the Aztec period, particularly those of the codices, the serpents show commonplace conventionalisms. Fig. 260 reproduces a rattlesnake with a winding body. The supra-orbital plate is well marked. The opposite development of angularity is seen in Fig. 261. A double-headed serpent, the body making a sort of bowl,[2] is given in the next example (Fig. 262).

Fig. 261. — Serpent head, drawn in angular style: Codex Vaticanus, 3773.

Serpent heads painted on ancient pottery of northern Vera Cruz are reproduced in Fig. 263. These show similarities on the one hand to the Cholula examples already given and on the other to the drawings of the Maya area. The curious scroll designs on stone yokes frequently show more or less similarity to Maya art in the choice of characteristic reptilian lines and curves (Fig. 264). Realistic details also give evidence of affiliations. Note particularly the shape of the supraorbital plate of the head given in Fig. 265.

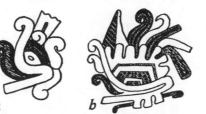

Fig. 262. — Double-headed serpent forming a bowl: Codex Vaticanus, 3773.

Certain interesting sculptures from the State of Guerrero with intrusive serpentine features have recently been described,[3] and these will likewise be found to have points of resemblance to the art of the Maya, more in the processes and the subject matter than in the general appearance of the designs. Serpent forms occur very widely in Mexico, but in many regions are repre-

Fig. 263. — Serpent heads painted on pottery from the State of Vera Cruz.

sented in a manner so simple and direct that the figures offer no proof of cultural contact.

[1] Batres, 1888, pl. 14. [2] Gordon, 1905, pl. 4 and Spinden, 1911, pp. 53–54. [3] Spinden, 1911, pp. 47–55.

As regards other subjects than the serpent there are also evidences of the debt due to the Maya by the other nations of Mexico and Central America. The foreshortening of the human body when shown in a seated position and in low relief is a case in point. Fig. 266 reproduces one of the human figures on the temple at Xochicalco, in which this pose is used. The drawing of the human eye with a straight line at the top might also be cited. This feature may be studied to advantage in the Codex Nuttall and other ancient manuscripts from the southern part of Mexico.[1]

FIG. 264. — Detail of stone yoke from State of Vera Cruz.

In the representations of birds, jaguars, monkeys, etc., there are also many evidences of cultural connections. The same may be said of ceremonial regalia and sacred objects. The peculiar staff ending in a hand (Fig. 211) has already been mentioned as occurring in both the Dresden Codex and the Codex Borgia.

In his various commentaries on Mexican codices Dr. Seler has pointed out many seeming parallels in the religion of the Nahua and the Maya, basing his conclusions largely on evidence furnished by graphic art. For instance, representations of the Shell God and the Bat God occur in both areas and certain complicated passages in the codices of both areas refer to the planet Venus.

FIG. 265. — Reptile head on stone yoke from Vera Cruz.

Without belittling the established work of the eminent scientist mentioned above, it seems necessary to point out that it is very unsafe to assume subjective identities from objective similarities, and it is not too much to say that this practice has played altogether too great a part in the attempted elucidation of the ancient manuscripts. Most of the detailed accounts of religious beliefs and ceremonies that have come down to us refer primarily to the Valley of Mexico, while nearly all the really elaborate codices of a religious nature come from either the Zapotecan-Mixtecan area or from the Maya. So the situation is complicated by chronological, linguistic and environmental conditions when an attempt is made to apply Nahua names to Zapotecan deities and then to make general comparisons with the theology of the Maya. Real cultural connections seldom amount to identities.

Chronological Sequence of Art in Mexico. Having treated thus briefly the general subject of connections in art between the Maya and their western neighbors, there remain one or two points that deserve more specific notice. While it is too early to

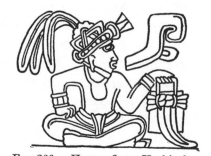

FIG. 266.—Human figure Xochicalco.

attempt more than a tentative classification of artistic remains in Mexico upon a chronological basis, still a few facts which seem significant may be emphasized. The correlation may at least prove suggestive.

It has already been stated that the ruins of Monte Alban, near Oaxaca City, seem to show fairly close affiliation with the Maya, presumably of the earlier

[1] For a classification of the ancient manuscripts belonging to southern Mexico see Lehmann, 1905, a.

period. At this important site there are stelae and other large blocks of stone carved with rather crude figures of men, monkeys, and composite animals. These stones also carry columns of glyphs, which present a striking superficial resemblance to those of the Maya. The numbers are expressed in the bar and dot system. The pottery heads from Monte Alban likewise resemble Maya work. Many of the jadeite amulets found there follow the southern model. Some of these were doubtless obtained in trade.

In architecture the great use of lofty pyramids arrayed around plazas suggests connections as does the occurrence of small vaulted chambers. The small size of the rooms and the absence of columnar support may fairly be taken as good evidence of early date. The apparent absence of the ball court is also worthy of note. This structure, as we have seen, is absent from the early Maya sites, but appears at a later date in northern Yucatan and upon the highlands of Guatemala. In the Zapotecan region it is found at Quie-ngola according to the authority of Dr. Seler.[1] We may make a supposition — subject, of course, to future proof for or against — that Monte Alban was synchronous to the first great Maya cities or slightly subsequent. It was abandoned and in ruins when the Spaniards entered the country.

Mitla, on the other hand, apparently lasted down into the Aztec period. It was, perhaps, captured by the warlike Mexicans in 1495. The well-preserved buildings of this city, with their rich mosaic decoration in many geometric patterns, are too well known to require description. The style is peculiar and is found elsewhere only in a few nearby tombs of the cruciform type. The technique of these mosaic decorations is very close to that used on the buildings of northern Yucatan, although the subject matter is fairly distinct. The rooms are rather wide and in one important instance stone columns were used as a supplementary roof support. The doorways are also wide, this being accomplished by the use of piers. Very little in the way of pottery has been found at Mitla. None of the elaborate Zapotecan funeral urns have been discovered in the tombs although fragments of these vessels may be picked up in the fields. Perhaps the most important criteria of age at Mitla are the remains of fresco paintings.[2] These resemble very closely, both in style and subject matter, the finer Mexican codices. As before remarked, most of these codices were doubtless obtained in southern Mexico. At the advent of the Spaniards nearly all of this region was under the dominion of the Aztecs. The frescos of Santa Rita in British Honduras resemble in many details the frescos of Mitla.

So much for the two chronological extremes of culture. The rich development of Zapotecan ceramic art, as evidenced by the funeral urns of Xoxo and Cuilapa, probably falls after the period of Monte Alban and before that of Mitla. The modeling of the figures, and particularly the faces, is superb and the art of Mitla shows nothing that would have led up to this splendid development. The subject matter is various, but in many instances the human faces are masked in what seems to be a long-nosed grotesque face of serpent origin, not very different from the Long-nosed God of the Maya.

It seems quite likely that careful comparison would result in the arrangement of Zapotecan sculptures in a natural series showing development analogous to that at Copan. There is a marked difference between certain groups of sculp-

[1] Seler, 1902–1908, II, p. 191. [2] Seler, 1895, a.

tured stones at Monte Alban.[1] In the best of these pieces there is used a characteristic assemblage of details that likewise occurs on small sculptured slabs from Etla,[2] Zachila, Tlacolula[3] and Cuilapa. Pottery urns of the elaborate funeral type are rare at Monte Alban, but are found in quantity at the sites just named. A transition from stone art to ceramic art is clearly indicated on many of the clay tablets, urns and figurines. The last decadent stage of hieroglyphic inscriptions may perhaps be seen in the curious lintels of Xoxo and Cuilapa. It seems impossible that these inscriptions could have had meanings. They resemble the purely decorative glyphs on some Maya pottery. One of the pottery pieces in the Sologuren collection[4] represents a temple in clay showing the use of offset paneling so highly developed at Mitla[5] but without geometric enrichment. From this incomplete presentation it is evident that whether the conclusions here set down are true or false, yet the archaeology of southern Mexico contains promise of great results and the life history of Zapotecan art is there for the reading.

Little is known of the art of Tonala,[6] a large ruin west of Tehuantepec and near the Pacific, but the few pieces that have been reproduced suggest the early work of Monte Alban. On the basis of the beautiful pottery with codex-like figures one is tempted to put a late date on the Mixtecan city of Nochistlan.

Farther to the north we come to the famous center whence radiated the culture of the Aztecs and their predecessors, the Toltecs. In the Valley of Mexico the succession is capable of more exact demonstration than in Oaxaca, although there are many important points still undecided and although a chronology expressed in years is a thing for the future.

Mrs. Nuttall has collected a great deal of material upon the earliest known horizon of culture in the Valley of Mexico. Bishop Plancarte has also been industrious in this field. Through collaboration with Mr. Juan E. Reyna the writer was introduced into this new and exciting study.

In 1910 many figurines of a peculiar type appeared on the curio market in Mexico City. They were obtained at Atzcapatzalco, a suburb of the capital, and a place famous in pre-Cortesian annals. At Atzcapatzalco[7] there are remains of several earthen mounds bearing relics of the Aztec and pre-Aztec periods. From these mounds have come some of the most beautiful figurines in Mexico, representing richly attired human beings, birds, monkeys, etc. The level plain also contains relic beds which have been exposed at several points by the pits of adobe and gravel gatherers.

The stratification of the plain is as follows. First comes a layer of alluvial soil some four or five feet in thickness, which towards the bottom seems to be impregnated with a whitish volcanic ash. This layer contains many sharp-edged fragments of pottery, including parts of bowls, figurines, whistles, flageolets, pipes, etc. The ware runs the gamut of the different styles of paste and ornamentation found in the neighboring sites of Teotihuacan, Tezcuco and Tenoch-

[1] Compare Batres, 1902, a, pls. 5 and 6 on the one hand with pls. 2 and 9 on the other, and great improvement will be noted.

[2] Seler, C., 1900, pl. 8.

[3] Seler, E., 1902–1908, II, pp. 359–361.

[4] Batres, 1902, a, pl. 25.

[5] Saville, 1909, p. 189, holds that Mitla was built by the Nahua and later was conquered by the Zapotecans.

[6] Seler, C., 1900, pp. 110–115.

[7] Mr. William Niven of Mexico City has written a number of articles in the Mexican Herald concerning the relic beds of Atzcapatzalco. Dr. Seler, in a paper which has just appeared, 1912, comments on the occurrence of the figurines of the oldest type and presents photographs of them.

titlan. Most of the ware is painted, some is rough and some is highly polished, and many of the vessels have tripod supports.

Underneath the alluvial layer which contains these objects lies a thick stratum of coarse water-bearing gravel mixed with sand. In some places this gravel layer is fifteen or eighteen feet in depth. Throughout this layer are found figurines and potsherds quite different in material and appearance from the relics in the upper bed. The material is a very hard terra cotta containing a large percentage of volcanic ash. The objects are nearly all waterworn and comprise

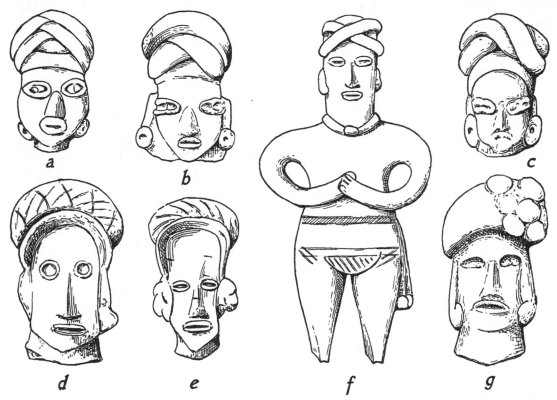

FIG. 267. — Figurines from the earliest culture horizon in Mexico: *a–c*, Atzcapatzalco; *d*, San Juan Teotihuacan; *e*, Tuxpan; *f*, Zapotlan; *g*, Cuernavaca.

figurines, disk-shaped labrets, bulbous resonator whistles, and fragments of bowls with constricted necks and globular bodies. The figurines are usually three or four inches in length. They are naively realistic and often represent nude women in sitting or standing positions with the hands upon the knees or under the breasts. Other figures represent men. The limbs are well rounded, but taper off so much that the hands and feet are much too small. The faces are characteristically long and the heads are of slight depth. The eyes are often tilted, Chinese fashion, and are made by a groove across an applied nodule of clay or by one or more gougings. The headdresses are usually of the fillet type made with little rolls of clay (Fig. 267, *a–c*).

It is probable that the scientific excavation of these beds would show a more exact and detailed stratification of remains than is here given.

It is interesting to note that Mr. Holmes [1] examined in 1884 the stratification of the remains of human handiwork in another part of Mexico City. He describes with great accuracy the superposition of the various ceramic types. Apparently

[1] Holmes, 1885.

none of the early figurines came to his notice, but the round-bodied bowls with constricted necks are mentioned.[1]

Figurines of the same strongly individualized type, referred to above, are found widely in the Valley of Mexico and in the country to the south and west. They are found, for instance, in considerable numbers in an adobe yard on the outskirts of Cuernavaca (Fig. 267, g), associated with the globular pottery. Fragments of the pottery are very plentiful in the extensive lava caves near the same city. A number of these hollow lava flumes were explored in 1910 by Mr. Reyna and the writer, and in addition to the pottery fragments there were found rough beads of green stone and pieces of shell that had evidently served as ornaments. Some of the pottery was ornamented with applied nodules of clay. Hollow tripod supports occur on the early ware.

Perhaps the most interesting point in regard to this early type of art is its obvious relationship to the elaborate funeral pottery coming from Tepic, Colima and western Jalisco. The large hollow figures from this region represent human beings, both men and women, usually engaged in every-day occupations. The expression of the peculiarly long faces with their staring eyes gives a definite character to this ancient art. The reproduction of native ornament is very complete; ear and nose ornaments, facial and body decorations that suggest tattooing, and even textile designs are given by plastic and painted additions to the figures. A very interesting series of specimens, now in the American Museum of Natural History, has been described by Lumholtz.[2] The finest pieces came from Iztlan, and were taken from a burial mound of which Dr. Seler[3] gives a plan.

Small solid figurines, almost identical with those of Atzcapatzalco are found in the same area. Fig. 267, f, reproduces one of four similar pieces from Zapotlan and a head from Tuxpan is shown in e. Dr. Seler[4] presents drawings of three typical specimens.

Figurines of this sort, although they are commonly called Tarascan, occur but rarely in the Tarascan territory. They are not associated with extensive architectural remains. It has been possible to find no detail suggesting cultural connection with the Maya. The headdresses never show, for instance, the natural or conventionalized representation of an animal head inclosing the human head. In this regard the figurines should be distinguished from those of the Totonacan area which resemble them in method of manufacture but which show highly modified animal headdresses.

It is possible that the culture briefly considered above may have continued to flourish in the far northwest after it had been displaced in the Valley of Mexico. The next definite culture in the northwestern frontier had its center somewhat farther to the north, and comprised the important cities of La Quemada,[5] Chalchihuites,[6] Totoate,[7] Estanzuela,[8] etc. At most of these sites are found extensive architectural remains including pyramidal mounds, retaining walls and wide rooms with rows of columns.

[1] Holmes, 1885, p. 73.
[2] Lumholtz, 1902, II, pp. 300–315.
[3] Seler, 1902–1908, III, p. 93.
[4] Seler, 1902–1908, III, p. 94.
[5] Bancroft, 1875–1876, IV, pp. 578–592; Batres, 1903; Seler, 1902–1908, III, pp. 545–559.
[6] A fine collection excavated by Mr. Gamio is in the Museo Nacional in Mexico City.

[7] The collection made by Dr. Hrdlička is in the American Museum of Natural History.
[8] The remarkable pottery from this site has been briefly described by Lumholtz, 1902, II, pp. 460–462 and pls. 13–15. The collection is in the American Museum of Natural History.

The most peculiar art objects are pottery vessels with encaustic or cloisonné decorations. The vessels were apparently fired in the usual manner and then covered with a thick layer of greenish or blackish sizing. This sizing was then cut away with a sharp implement to form a background for complicated geometric and realistic designs, after the fashion of a stencil. The spaces cut away were then filled in flush with paints of various colors so that the whole surface resembled a sort of mosaic. The different inlaid colors were divided off from each other by narrow strips of the original sizing material, so that there resulted a superficial resemblance to cloisonné work. Of course there was no enameling.

The culture of these cities may have been an offshoot of the pre-Aztec or Toltec. The rows of columns suggest this. The encaustic pottery resembles the fine fresco vases of the artists of Tula and Teotihuacan although the technique is really different.[1] At any rate this culture disappeared before the advent of the Spaniards.

Following this there seems to have arisen a new civilization, identified with the Tarascans of Michoacan and various Nahua tribes isolated from those of the Valley of Mexico. The Tarascan mounds are of peculiar shapes [2] and the finest art products are in clay and metal. The stone work, as a rule, is very crude.[3]

The Chacmool type of reclining figure [4] is an interesting detail connecting the art of this area with the thirteenth century products of the Valley of Mexico that were introduced, as we have seen, into Chichen Itza.

Returning to the Valley of Mexico to consider the art that followed the archaic figurines, already described, we find ourselves both helped and hindered by the preserved traditions. The problem here is capable of being solved with the greatest accuracy, but in order to do this much tedious work must be done in comparing and classifying pottery collections. The larger part of the specimens in our museums were not excavated by archaeologists, and in many cases the exact localities are unknown. However, certain peculiar styles of pottery are now pretty well established, as, for instance, the beautiful vases of Teotihuacan [5] and Tula, which after being burned were covered with a heavy white sizing and then painted in delicate colors. Following this comes the polychrome pottery of Cholula and finally the fine Aztec pieces found on the site of the Great Temple in Mexico City. Still other types might be mentioned. The miniature pottery heads should prove important for purposes of classification. The stone sculptures of the early period are few in number but many are still *in situ*, and so are of great value as definite standards of comparison. There is a great need of more archaeological work. Even the important ruins of Teotihuacan are but imperfectly known. The ruins of Xochicalco have been studied in the most superficial way, and not even the ground-plans of the buildings are available for purposes of comparison. The single well-preserved temple forms a very small part of this remarkable site. Excavations might show that this city is even more ancient than Tula and Teotihuacan.

The type of art from the Aztec period is fairly well determined through the

[1] Undoubted examples of this ware have been found in the Valley of Mexico, however. For a remarkable piece see Charnay, 1885, p. 142, and Peñafiel, 1890, pls. 62 and 63. An example in the American Museum of Natural History came from Atzcapotzalco.

[2] Seler, 1902–1908, III, pp. 127–128.

[3] Lumholtz, 1902, II, pp. 331–452, makes many references to the archaeology.

[4] Lumholtz, 1902, II, p. 451.

[5] Peñafiel, 1890, pls. 74–75.

finds that have taken place in Mexico City.[1] Tenochtitlan was founded about 1325, and its period of real greatness did not begin till nearly a hundred years later. Consequently the sculptures that have been recovered are exceedingly valuable as standards of comparison. Sculptures of the same type are found to have followed the Aztec rule into the region toward the south and east. In the south, for instance, we have Aztec sculptures at Tehuacan,[2] and in the east at Teayo.[3]

An examination of the remains in Tamaulipas and Vera Cruz shows a very confusing condition. At the north, in southern Tamaulipas, the Huasteca[4] developed a somewhat peculiar art in stone characterized by crouching and humped-back figures which lack practically every quality found in the sculptures of their kindred to the south. The pottery is more interesting and more peculiar. The finest specimens, of which there are several examples in the Peabody Museum, have narrow necks and flaring sides fluted like melons. Farther to the south, in the Totonacan[5] area, some of the pottery designs suggest Maya influence in minor details. This is particularly true of the ware from the Island of Sacrifices.[6] The use in stone sculptures of reptilian lines and curves recalling Maya handiwork has already been mentioned. It is best seen on the remarkable stone yokes, paddle-shaped stones, etc., and on large sculptured stones at Papantla.[7] The late intrusion of Aztec art is seen in well-preserved sculptures of Teayo.[8] Intrusion of Nahua culture at a somewhat earlier period may perhaps be seen in the Chacmool figure at the Totonacan capital, Cempoalam.[9] Maya influence may be discernible in the more southerly stelae-like sculptures of Tepatlaxco,[10] Quilozintla[11] and Alvarado.[12] The use of bar and dot numerals on the sculptured boulders of Maltrata[13] furnish a suggestive detail. It will be remembered that bars and dots are found likewise at Monte Alban. This method of notation, so much more economical than the one in common use among the Nahua, was only employed in a few of the Mexican codices, particularly in those of the Fejérváry-Mayer group.

From this survey and attempted correlation of ancient Mexican art one thing at least is evident. There is no good reason to ascribe a northern (or western) origin to Maya art because in the north the art in the earliest period is independent of the Maya in all particulars; in the middle period the current set from the Maya towards the people of lower culture on the highlands of Mexico, and only in the last decadent period did influence from the Nahua make itself felt among the Maya.

Problems of Cultural Connection outside of Mexico. In concluding this study of Maya art a brief space may be devoted to certain general problems of cultural contact more or less remotely relating to the civilization developed by the Maya. The writer does not care to dignify by refutation the numerous empty theories[14] of ethnic connections between Central America and the Old

[1] Peñafiel, 1911; Batres, 1902, b; Seler, 1901, b.

[2] Seler, 1902–1908, III, pp. 788–789.

[3] Seler, 1904; another site is Xico, Fewkes, 1903–1904, pp. 245–248.

[4] Seler, 1888, b; Prieto, 1873, pp. 10–57; Fewkes, 1903–1904, pp. 271–284 and pls. 126–129.

[5] Fewkes, 1903–1904, pp. 233–244 and pls. 112–125; Strebel, 1883 and 1885. Batres, 1908, pls. 3–44.

[6] Nuttall, 1910, pls. 7–14.

[7] Seler, 1906, a.

[8] Seler, 1904.

[9] Drawing by Velasco in Museo Nacional referred to above.

[10] Batres, 1905, pl. 1, Seler, 1906, b.

[11] Batres, 1905, pl. 9; Seler, 1906, b; Fewkes, 1906.

[12] Batres, 1905, pp. 17–18.

[13] Batres, 1905, pls. 6 and 7.

[14] For a spirited reply to these theories see Brinton, 1894.

World, but to treat only the questions of cultural ramifications in the New World. Many devotees to this subject have unfortunately confused the ethnological problem of the origin and growth of human cultures with the zoological problem of the origin and dispersion of human kind. The species, man, may have originated in India or where you will. From this unknown center he spread abroad like the fox and the deer till he reached the ends of the earth. We cannot prove that before leaving his first home he had developed a single art. The most suggestive evidence of the antiquity of man in the New World is the vast number of distinct languages spoken by the aborigines, and the marked diversity of physical types. As for any particular kind of culture, it is comparatively short-lived and impermanent. The Maya culture is perhaps the oldest concerning which we have accurate evidence and yet the beginnings of this culture may not antedate the Christian era by more than a few centuries. Every group of human beings has the common inheritance of a tendency and a power to form and reform complex habits partly controlled by environment, and other natural conditions. Very often the phenomenon is presented of two groups of people who speak the same language and yet have different cultures or the obverse of two or more tribes who speak different languages and yet have similar religious, social, utilitarian and esthetic institutions. As for identities or similarities in ideas or artifacts between two or more culture areas, there are several possible explanations among which that of actual transmission is often the least likely.

One group of theories aims to connect Mexico and Central America with Peru and other South American centers. A second group tries to establish a community of interest between the so-called Mound-builders of the Mississippi Valley and the Southeastern States, the ancient and present-day Pueblo Indians of the Southwest and the civilizations of Mexico and Central America. The evidence deserves to be examined in some detail. Perhaps at the end of this examination the subject will be as open to futile speculation as at the beginning. The three principal lines of proof concern:

1st. Pyramids and other features of material culture.

2nd. Religious ideas connected with the serpent.

3rd. Similarities in symbolism and art.

Pyramids. The building of square-base pyramids had a notable distribution among the ancient centers of high culture both in the Old and in the New World. In the Old World, the most famous examples are the pyramids of Egypt. These pyramids were used primarily as tombs and as such seem to have been a development of the mastaba. They were built during the early dynasties and were later supplanted by other forms. The pyramids of Assyria were, however, intended to bear temple structures upon their flat summits. They rose in a succession of vertical steps or sloping terraces and were ascended by zigzag inclined planes or ramps and not directly by stairways. Owing to the lack of stone, Assyrian pyramids were built of sun-dried bricks. Except in the matter of stairways and methods of construction the pyramids of Assyria were not dissimilar from those of Mexico and Central America. Superficial resemblances might also be noted in the assemblage of rooms in the palace structures and in the marked use of inclosed courts.

Pyramidal substructures, or at least solid interior cores in the form of the stepped pyramid, were also used by the temple builders of the Far East. **Dr.**

Leemans has described, in an elaborate publication, the great Brahmin temple of Boro Boedoer, in the Island of Java. This temple is distinctly pyramidal in appearance. Somewhat similar temples occur in the highlands of Cambodia, and elsewhere in the Far East.[1]

Passing to the New World, pyramids are found in three large but detached areas: 1st, western Peru and Ecuador; 2nd, Central America and Mexico; 3rd, the Mississippi Valley and the southeastern portion of the United States.

The pyramids of South America cover a large area, the limits of which have never been exactly determined. Throughout this area there are many important ruins which show no remains of pyramids, and the pyramid may be called a secondary phase of Peruvian culture. The pyramids are of several types. Some are natural hills which have been leveled and terraced, some are artificial mounds of sun-dried bricks or of cut stone. The pyramid of the famous Temple of the Sun at Pachacamac,[2] near Lima, is a natural hill which has been terraced with five low, broad steps faced with well constructed walls. The ruins of the temple occupy the crown of the hill. At Vilcas Huaman,[3] situated about half-way between Lima and Cuzco, are remains of a Temple of the Sun, which is carefully oriented although the walls of the neighboring structures show no such alignment. The pyramid rises in three vertical steps admirably constructed of cut stone, and a stairway ascends it on the eastern side. Proceeding northwards, at Huanuco-viejo[4] are found ruins of an extensive city showing careful orientation throughout. The principal temple is marked by a well made platform mound having a broad stairway. The so-called Fort of Huinchuz,[5] in the region of Pomabamba, is really a temple structure. The substructure is not a rectangular pyramid, but a terraced and truncated cone rising in six steps. The great pyramid of Moche,[6] near Trujillo, resembles in plan many of the substructures of Central America. Attached to the base of the pyramid are extensive platform mounds. But the method of construction discloses differences. The pyramid is built of sun-dried bricks arranged in tiers which incline inwards. The structure upon the summit of the pyramid and upon the subjoined platforms have all disappeared. At Coyor,[7] or Incatambo, near Cajamarca in northwestern Peru, there is an oval dome-shaped outcropping of granite, the natural place of refuge in a valley subject to floods. This elevation shows nine concentric artificial terraces. Upon these terraces houses were constructed, and upon the summit a tower-like temple structure was built. There is a lack of references to pyramids in the Calchaqui area and in the southern provinces of the ancient Peruvian empire. No plans or descriptions of pyramids in Ecuador are at hand, but such remains are said to extend well into this country, and may even cross the southern boundary of Colombia.

In other phases of material culture there are but few striking similarities between Peru and Central America. Architecture is very different in the two areas. Metal working, weaving and pottery making, all of which reached a high

[1] The status of art in the great cultural province of southern Asia is remarkably like that of Central America. The civilizations were on nearly the same plane. The life history of this art has never been fully presented although the historical data available are voluminous. Perhaps it is the stupendous nature of the correlation that has prevented the work from being done.

[2] Uhle, 1903, pls. 16 and 17.
[3] Wiener, 1880, pp. 264–272.
[4] Wiener, 1880, pp. 210–217.
[5] Wiener, 1880, pp. 189–191.
[6] Squier, 1877, pp. 130–132.
[7] Wiener, 1880, pp. 130–134.

plane of development in both localities, are sharply distinguishable as regards the technical processes involved and the appearances of the products. The religious and the social organization of Peru is unlike that of the Maya in most respects, and there is evidence that its development was autochthonous and extended over many centuries.[1] The Peruvians had no system of hieroglyphic writing and no carefully elaborated calendar. Certain features of graphic art will be considered separately, but in general this too was peculiar and characteristic of the region.

Pyramidal substructures apparently do not occur in a long stretch of country from the southern part of Colombia to the central part of Honduras and Salvador. Low burial mounds exist, and well to the north there are low platforms which may have served as foundations for temples. Costa Rica has been said to belong ethnographically with South America. But the ancient metal working of northern Colombia and Chiriqui is characterized by the so-called wire technique that does not occur in Peru or Equador, but is common in Guatemala and Mexico. The marked use of tripod and ring-base pottery in the Isthmus region also suggests a northern affinity. Many of the carved celts and amulets of Costa Rica resemble roughly those of western Guatemala.

At the time of the Spanish conquest certain Nahua-speaking peoples[2] inhabited the shores and islands of Lake Nicaragua. These are said to have been emigrants from Anahuac, who left their home at the disruption of the great civilization preceding the Aztecs. The cultural connection of these southern peoples with their linguistic kinsmen of the north can readily be proved by their carvings and pottery decoration. But of the remains great pyramids and platform mounds seem to be wanting. It might be pointed out that such enormous communal structures demanded a greater organization and control of the masses of the people than would be expected among fugitives in a strange land.

In Salvador,[3] along the course of the Lempa River, platform mounds surrounding courts are known to occur and with these is said to be associated characteristic Maya pottery. Squier[4] described with considerable detail the ruins of Tenampua in Central Honduras. Pyramids and platform mounds are much in evidence. Here and at other sites in the Valley of Comayagua, pottery and other artifacts similar to those of Copan and the Uloa River ruins have been found. A number of pieces of pottery from Tenampua, collected by Squier, are in the American Museum of Natural History. Without doubt this settlement marked the real southern frontier of the Maya pyramid and other characteristic phases of Maya culture.

It might be well next to consider the pyramidal substructures of the United States and attempt to approach the Maya area from the north.

The Mound Area of the United States shows several distinct types of mounds and earthworks. Some of the types have a pretty definite limitation to certain parts of the field. Thus nearly all of the effigy mounds lie within the limits of the

[1] Uhle, 1902; 1903, pp. 19–45. The line of research is continued in 1904 and 1908, in different localities.

[2] Berendt, 1876, pp. 142–144; Pector, 1888, pp. 152–154; Squier, 1852, II, pp. 309, 332.

[3] Squier discusses the Nahua people of San Salvador, 1858, pp. 316–340, and gives notes on the archaeology, 1858, pp. 341–344. Other brief references are Guzman, 1904, Cruz, 1904, and Gonzales, 1906. By far the most important archaeological results are those of Lehmann, 1910. This article unfortunately came to the attention of the writer too late for fuller reference. Dr. Lehmann refers to sculptures of the Chacmool type, describes pottery, etc., and discusses linguistic and cultural questions.

[4] Squier, 1853 and 1858, pp. 133–139.

State of Wisconsin. To be sure, the famous Serpent Mound is situated in Ohio, but this mound falls in a type by itself. The complicated geometric inclosures, perhaps the most remarkable of all mound remains in the entire area, seem limited to the State of Ohio. Burial mounds, of one type or another, occur over the entire area. Pyramidal mounds likewise have a wide distribution and are common in eastern Missouri and Arkansas and in all the Gulf States with the noteworthy exception of Texas.

Of all these types of mounds only the pyramidal type would suggest any cultural connection with Mexico and Central America. These mounds are not, however, constructed of stone and mortar. They are simply built of earth and provided with ramps or inclined roadways instead of stairways. In plan and assemblage, the mound groups at Cahokia [1] in southern Illinois, at Etowah [2] in northwestern Georgia, and Moundville [3] in Alabama show decided superficial resemblances to mound groups in the Maya and Nahua domains. But these resemblances are not more striking than those furnished by the great structure at Moche in Peru already described, or to go still farther afield, by the ruins at Tello in Chaldea, where there were inclosed courts, platform mounds and seven-storied pyramids.

In other phases of material culture the ancient Mound-builders were far behind the natives of Mexico and Peru. Metal working, for instance, probably did not go beyond simple hammering of native copper. Although many of the artifacts, such as ear plugs and breast ornaments, show very careful manipulation they offer no evidences of casting and smelting. Decoration in metal was accomplished by stenciling and by repoussé work. Pottery and textiles, while developed to a noteworthy degree, can hardly be compared with the products of Mexico and Central America.

A stretch of a thousand miles by the nearest land route separates the southwestern outposts of the Mound Area of the United States and the northeastern point of occurrence of pyramids in Mexico. In all this intervening area there is no record of any culture higher than that of the Athapascan Lipan and the mysterious Jumano. The Indians of Texas and of southern Chihuahua are reported to have been completely nomadic and much given to savage warfare.

Indeed, the debatable land is not passed till we reach the territory of the Huasteca in southern Tamaulipas and northern Vera Cruz. These Indians, as we have seen, are linguistically related to the Maya and culturally bound to the civilizations of Mexico. They are lords of the northern marches. Characteristic remains of this region have been described by Prieto, Fewkes and others. Pyramidal foundations mark the sites of the ancient temples.

The most northern ruins on the uplands that clearly lay within the sphere of influence of the Valley of Mexico are those of La Quemada and Chalchihuites in the State of Zacatecas. These ruins, and a number of others in the valley of the Boloños and perhaps extending as far southward as Sayula, give evidence of a fairly distinct and localized culture. The most striking feature of this culture is a peculiar type of pottery decorated with heavily inlaid paints. It has been called encaustic or cloisonné pottery,[4] and it occurs rarely in other parts of

[1] Bushnell, 1904, p. 8.
[2] Thomas, 1890–1891, pp. 292–311.
[3] Moore, 1907, map.
[4] Lumholtz, 1902, II, pp. 460 *et seq.*

Mexico where it may have passed in trade. The architecture shows the use of columns, built up by slabs of stone, which probably supported flat roofs.

North of these outposts stretch several hundred miles of arid desert before the ruined pueblos of the Casas Grandes in the State of Chihuahua are reached. These prehistoric ruins are commonly considered to mark a southern extension of the great Pueblo culture which apparently centered in the States of Arizona and New Mexico, and spread to the north and to the south. There is good reason to believe that all the essential features of the Pueblo culture are indigenous.

It has been pretty definitely established by traditions and by similarities in material culture that the so-called Cliff-dwellers, as well as the builders of the numerous prehistoric structures in the open country, were merely the ancestors of the present-day Pueblo Indians. A careful comparison of pottery fabrics and architectural details throughout the area would probably demonstrate a definite cultural sequence extending over a long period of time. In fact, the researches of Mr. A. V. Kidder along this line have already borne interesting results.

No pyramidal substructures have been reported from any part of the Pueblo area. Bandelier describes [1] some interesting mounds at the Casas Grandes but does not venture the assertion that they served as substructures for temples. However, there were doubtless trade relations between the Pueblo Indians and the tribes in Mexico far to the south. Copper bells have been found at Casas Grandes and at Pueblo Bonito. At the latter site was found a fragment of encaustic or cloisonné pottery which seems to be identical with the typical pottery of La Quemada and Chalchihuites. This object, the significance of which has apparently been overlooked, is now in the American Museum of Natural History. It may serve as an important clue to the comparative chronology of the ruins of Mexico and New Mexico. The atlatl, or spear-thrower, found by Cushing in a pueblo ruin is an additional evidence of trade contact. This implement is not in use by the present-day Pueblo Indians.

Religious Ideas connected with the Serpent. It is well known that the serpent plays an important part in mythology, religion and art, the world over. To the primitive man the serpent naturally represents a great division of animal life. There are quadrupeds and bipeds, including men and birds. Then there are snakes which have no legs at all. Primitive art often lacks in any closer classification of animal life than this, so that the snake is apt to receive an undeserved emphasis in pictographs and designs. The gracefulness and simplicity of the snake's body render it an easy subject for the artist.

The body of the snake combines readily in art with certain characteristic parts of other animals. Wings, horns, feathers and claws are often seen on the grotesque and almost universal " dragons " which result from such combination. Sphinxes and griffins which lack snake features belong to the same category of unnatural beasts made by combination. Snakes and other animals are sometimes given human features according to several processes which have already been briefly discussed. This change is probably due to animistic beliefs — in particular to the application in art of what has been called the pathetic fallacy which endows lower forms of life with the spiritual and mental qualities of human beings.

[1] Bandelier, 1892, p. 550.

But the religious importance of the serpent, while considerable, is very much over emphasized by the devotees of the mystic and occult philosophies. Rarely indeed is serpent worship more than a secondary phase of any religion. When present at all it is often elaborated in art beyond its proper religious significance owing to the artistic possibilities of the subject. In many regions the importance of the serpent in religion has been assumed without good reason from its presence in art and in other regions from incidents given in the mythologies.

The serpent, usually modified by certain unnatural additions, is seen in art over a great portion of North and South America, as well as in the Old World. In mythology it may be found with similar unnatural features among nearly all the Indian tribes of the United States even where no drawings of it are made. Thus Goddard gives myths of the Indians of northern California concerning a horned snake. A similar monster, possessing antlers, and sometimes wings, is also very common in Algonkin and Iroquois legends although rare in art. As a rule among these tribes the horned serpent is a water spirit and an enemy of the thunder bird. It is important to note that the religious importance is not very great — at any rate the magical snake does not rise to the level of a culture hero.[1] In some regions the creature is considered friendly to man and in other regions decidedly unfriendly.

Among the Pueblo Indians the horned snake seems to have considerable prestige in the religious belief.[2] This prestige comes from its connection with water, the great necessity of these people. In this region it is represented on the ceremonial objects but not on the objects of every-day use. Information gathered at the different pueblos concerning the horned and plumed serpent varies in many details. As a rule, it is held that only one such serpent exists and that it is invisible. It lives in the water or in the sky and is connected with rain and lightning. There seems to be more or less of a taboo placed upon the use of the name for this serpent.

Symbolism and Art. Postponing for a moment the subject of the serpent, let us now consider some of the more general questions of cultural affiliation where decorative and pictographic art furnish the evidence. The last group of facts supposedly connecting the cultures of Central America with those in other parts of the New World concerns similarities in symbolism and graphic art.

Similarities in symbolism are always of doubtful value because the symbols are usually simple geometric forms and the authoritative interpretation of them which might furnish convincing proof of ethnic affinity is usually wanting.[3] Variations of the " ring and cross " symbol, for instance, do occur throughout all the ancient cultures of North America as well as among the modern Indians. But, for that matter, they are universal. The circle frequently represents the sun, and the cross the four directions, an idea directly derived from the sun. However, it is quite possible that the symbol may represent in some regions something quite different, — or, for that matter, it may represent nothing at all and have no use other than to embellish. It is clear that some of the so-called " cosmic

[1] Hewitt, 1889.

[2] For general accounts see Fewkes, 1894, a; 1895, a.

[3] The symbolism of skulls and bones can hardly be called esoteric, but such symbols as the hand with the eye in the palm, so common in the ancient art of the Southern States, are distinctly esoteric. The disassociated features, however, might occur anywhere.

symbols " that occur among the Maya represent definite ideas that have little to do with the cosmos as a whole.[1] The normal form of the Sun and Venus glyphs[2] are cases in point. These have already been discussed. An example of similarity in form with difference in meaning is seen in two figures given by Professor Putnam and Mr. Willoughby.[3] One is a design on a shell gorget from Tennessee which has been explained as symbolic of the universe, and the other, from Mexico, is the Nahua hieroglyph for gold.

Little reliance can be placed upon the presence of similar geometric motives to show connection between two regions when the bond is not strongly indicated by other features. The scroll, the fret, the guilloche, the swastika, the stepped pyramid, etc., occur among practically all the high cultures of the world. They form either singly or in combination the universal basis for conventionalization. In many cases they were originally developed through suggestions furnished by the structural limitations of basketry and weaving and were later transferred to other arts.

Realistic art may show relationships between two cultures principally through peculiarities in representation such as mutual deviations from the normal form of the object represented. Similarities in conventionalized art are much more significant than those of purely realistic art, but even here it is not safe to assume that they indicate transmission of ideas from one region to another. Conventionalized art is made by the amalgamation of geometric and realistic motives and since both of these original factors are liable to be the same in two areas, and since the controlling technique, as in textiles, is apt to impose the same restrictions to growth, it follows that similarities may be extended to the two independent products. Since the idealistic modification of natural forms is based upon more or less constant methods of imaginative reconstruction it must be evident that similarities in this phase of art are not necessarily proof of contact.

The examples of representative art which have been most frequently taken to show cultural affiliations in the New World are those which present the modified serpent which has already been discussed. Here again we will cast a quick glance over analogous subjects in Old World art. The reason these foreign analogies are given is to vitiate the apparent importance of the similarities in New World art. If the facts submitted prove anything they prove too much. Everyone is willing to admit the basic physical and psychical unity of man but few will admit the cultural unity.

Many of the ancient temples of India, Burmah, Java, Cambodia, etc., show a high development of the serpent in architectural embellishment. There are great diversity of treatment and a few rather close parallels to Maya art. As a rule the snake body is a simple winding motive completely overlaid by arabesque designs. The idealism does not seem to have led to even partial anthropomorphism although this is clearly shown in the case of the elephant. The hooded cobra is the snake most frequently represented and the single body often ends in a number of heads in accordance with the East Indian method of multiplying arms, legs, and heads upon the bodies of divinities. The Chinese dragon has a composite origin to which the serpent contributes. The closest parallel to Maya art in the ideal

[1] For a discussion of "symbols" in Mexican art see Preuss, 1901. Mrs. Nuttall, 1901, a, has also covered this subject.

[2] The normal or "cosmic" form of the Sun

glyph, probably, has a phonetic value in at least two of the "direction" glyphs. Bowditch, 1910, p. 255.

[3] Putnam and Willoughby, 1895, p. 321, Fig. 31.

development of the serpent is seen in Egypt. Representations of winged serpents occur in connection with a number of the Egyptian deities such as the Goddess Mersokan and the Goddess Ranne. Anthropomorphism of serpents also occurs as may be seen by the examples given by Cooper.[1]

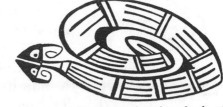

FIG. 268. — Design on interior of a bowl from Calchaqui area.

Winged serpents occur in Greek mythology in connection, for instance, with the chariot of Demeter. A partial humanization of the serpent is seen in some of the monstrous creations. Monsters with human head and torso and with serpent legs are depicted; and various conceptions of Medusa with snakes for locks of hair. Nowhere in the Old World is found the subtle and spiritual conception that existed among the Maya. The human head in the reptile mouth to indicate the innate human intelligence is found only in Mexico and Central America.

The general distribution of the serpent in the mythology and art of the New World has already been given. Let us now consider some of its representations beginning in the Far South. It is well known that the cultural remains of the ancient Calchaqui people of Argentina have many superficial resemblances to the artifacts of the Mound-builders and the Pueblo Indians of the United States. Snakes, with or without horn-like appendages to the head, are common in decoration of the pottery, a fair example being presented in Fig. 268, sketched from a bowl in the Field Museum. Ambrosetti[2] has treated the subject with some detail.

The serpent forms a minor motive in the exuberant decorative art of Peru. The most striking representations of it are found painted on pottery vessels from Chimbote. The serpent of Chimbote has a head that in profile view resembles that of

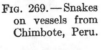

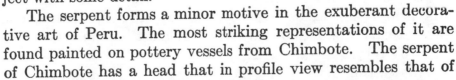

FIG. 269. — Snakes on vessels from Chimbote, Peru.

a dog with ears erect. When the head is represented in top view the likeness to a dog's head largely disappears (Figs. 269, a and b). Composite and grotesque animals with reptilian features also occur in this area.

A splendid piece of textile art from Pachacamac that was unearthed by Uhle[3] has two rectangular panels of design each showing a human figure framed in on either side by snakes that issue from belt and headdress or are held in the hands. A small portion of this fabric is reproduced in Fig. 270 to illustrate how the reaction of textile art upon a natural form has produced a type of conventionalized head similar to some found in Central America: note the turned-back nose.

FIG. 270. — Detail of textile design: Pachacamac, Peru.

[1] Cooper, W. R., 1873. It is difficult to find any except incidental references to the serpent in art in the works of recognized merit dealing with classical archaeology. The writer does not feel justified in going deeply into the subject.

[2] Ambrosetti, 1896 and 1899.

[3] Uhle, 1903, pl. 5.

A unit of design on a polychrome vase from Pachacamac is given in Fig. 271. A fine lot of painted pottery vessels from Nasca in southern Peru is in the Peabody Museum. Many of the complicated designs on these objects seem

to represent some sort of reptile largely overlaid with simplified faces that might well be human.

The decorative art of Ecuador, Colombia and Costa Rica seems to offer little evidence that can be construed to indicate affiliations with Mexico. On the basis of well developed local styles this stretch of country may be divided into many art provinces. There is, however, plenty of evidence of interchange of products and designs within short distances. Serpents of gold with horns or feathers attached to the head have been found in the sacred lakes of the Colombian highlands.

FIG. 271. — Painted design on pottery vessel: Pachacamac.

The purlieus of northern art include, however, parts of Nicaragua. The serpent heads that decorate some of the finer pieces of pottery (Fig. 272) may easily claim a Maya or Nahua ancestry. More convincing proof is furnished

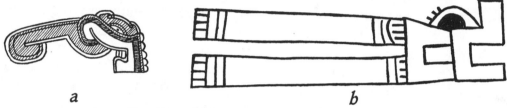

a *b*

FIG. 272. — Serpent heads on pottery: Nicaragua.

by crude stone figures on Zapatero Island and elsewhere.[1] Many of these clearly show the human head in the animal mouth, a feature that originated with the Maya and was taken over by the Zapotecans, Nahua, etc. Fig. 273, *a–c*, present carved stones of this type. It must be remembered that a considerable

part of Nicaragua was, at the time of the Conquest, actually inhabited by tribes that spoke Nahua dialects. Bransford[2] considers the so-called Santa Helena pottery as the product of the intruding Nahua, and thinks the Luna ware ante-

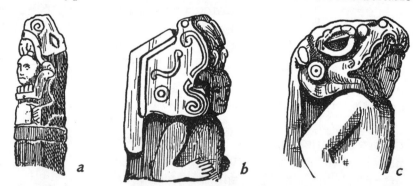

FIG. 273. — Sculptures of Nahua tribes in Nicaragua: *a*, Subiaba; *b*, Zapatero Island; *c*, Pensacola.

dates their coming. Conventionalized forms, probably serpentine, occur on both these kinds of pottery as well as on other fabrics.

A clear example of Maya stone carving that shows the style of Copan has been found near Tegucigalpa on the head waters of the Cholulteca River.[3] This is reproduced in Fig. 274. It may have been an object of trade. The carvings of

[1] Squier, 1850; also 1852, I, pp. 301–328; II, pp. 3–68, 87–98; Bransford, 1881; Bovallius, 1886 and 1887.

[2] 1881, p. 80.

[3] Hamy, 1896, pl. 1.

Santa Lucia Cosumalhuapa [1] have already been referred to as being more Nahua than Maya and as having probably been made by an intrusive Nahua tribe.

Highly conventionalized but recognizable plumed serpents appear on a number of beautiful bowls from the Casas Grandes now in the American Museum of Natural History (Fig. 275). Both Saville [2] and Lumholtz [3] have commented upon this occurrence. The thick-billed parrot is also represented. This bird is a native of Chihuahua but does not extend into New Mexico and Arizona. Nevertheless it is highly prized and semi-sacred among the Indians of the Rio Grande pueblos and in early times a regular trade for its feathers was maintained. It is interesting, if not significant, to find a plumed serpent and a green-feathered parrot of religious and artistic importance in the region of

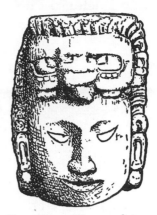

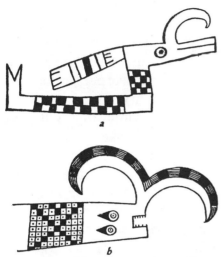

FIG. 275. — Plumed serpents on Casas Grandes pottery.

high culture nearest of all to the high culture of Central America where the quetzal and the serpent were combined.

The most important drawing to suggest connection with the south is that given in Fig. 276. The design in red and black extends around the circumference of a narrow-necked bowl from Casas Grandes. It represents a body, possibly that of a man, stretched out horizontally. Only the legs and head are reproduced in full, the torso being simply a panel of geometric figures. The head is most interesting since it shows a headdress consisting of another head.

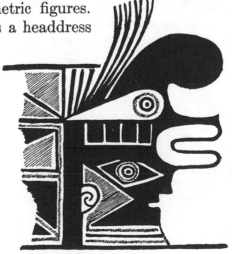

FIG. 276. — Prostrate figure with animal head for headdress: Casas Grandes.

Plumed serpents are seen on ceremonial objects at Zuñi. Fig. 277 gives examples of them. As a rule, however, the miraculous water serpent has a back-

[1] Habel, 1879; Bastian, 1882; Strebel, 1893, etc. The strikingly similar sculptures of Palo Verde and Pantaleon have been described and figured by Mrs. C. Seler, 1900, pp. 232–241.

[2] Saville, 1894.
[3] Lumholtz, 1902, I, p. 96 and pl. 2.

ward curving horn rising from the top of the head and is without feathers. Examples of these horned serpents may be seen on a collection of ceremonial jars from San Ildefonso Pueblo that are now in the American Museum of Natural History.

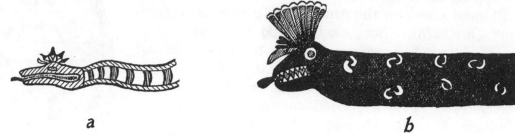

FIG. 277. — Plumed serpents of Zuñi.

That this divine creature is not a modern innovation in the region of the Rio Grande is seen from incised drawings of it in ancient cliff ruins such as those on the Rito de los Frijoles. Fig. 278 reproduces a simple horned serpent on a bowl

FIG. 278. — Prehistoric drawing of horned serpent: Puye.

from the prehistoric ruin of Puye, that is now in the Museum of the Southwest, while Fig. 279 gives the design on one side of a small sacred meal bowl said to have been excavated at Perage, opposite San Ildefonso. Accounts differ as to whether this pueblo was abandoned just before or soon after the coming of the Spaniards. The horned snake in this instance resembles those still found among the Hopi where usually the object is represented in an unrealistic manner.[1] It may be stated that sacred snakes are seldom seen as a decoration on the prehistoric pottery of the western pueblo ruins.

The drawings and carvings which have been most frequently referred to as showing connection between the Mound Area of the United States and Mexico and Central America are more or less realistic in nature. They consist of

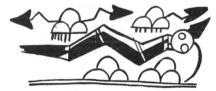

FIG. 279. — Tewa drawing of horned serpent on early historic pottery.

representations of winged and horned serpents, of anthropomorphic birds and of human beings. Many writers, including Holmes, Thomas, Putnam and Moore, have repeatedly suggested Mexican influence in these works in art but without actually coming to any hard and fast conclusions.

The homogeneity of the graphic art of the Mound Area is most remarkable. Certain characteristic details occur in drawings and carvings from one end of this vast area to the

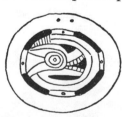

FIG. 280. — Shell gorget with rattlesnake design: Tennessee.

other. Attention is particularly directed towards a method of representing or elaborating the eye that is widespread and peculiar. The eye-ball is represented by a single circle or by two or more concentric circles and to this is added a posterior or inferior appendage usually consisting of two or more acute angles. Examples of this decorated eye are found on drawings of birds, human beings and serpents. The appendage does not seem to represent any natural feature of eyes in

[1] Fewkes, 1894, a, p. 79, shows the serpent reduced to a zigzag line.

general and so is of the utmost importance in showing artistic connection between the objects upon which it does occur.

The representation of the serpent [1] may be considered first. This is frequently seen on shell gorgets and sometimes on pottery. Nearly all the serpents have rattles, and so may safely be considered rattlesnakes although they are not accurately drawn in the matter of body markings. The ornamented eye is an almost constant characteristic. Supernatural features in the nature of wings, backward curving horns, branching antlers and feather crests are often added. A shell gorget of common type is reproduced in Fig. 280. The ornamented eye

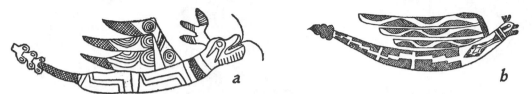

FIG. 281. — Winged and horned snakes of the Mound Area: *a*, Alabama; *b*, Arkansas.

of the snake is in evidence and the markings on the tip of the tail that indicate rattles. Two antlered and winged rattlesnakes are figured in the next illustration (Fig. 281). The second of these shows the " heart-line," a feature common among the present-day Indians from the upper Missouri to the Rio Grande.

In the southern part of the Mound Area there seems to be a close connection between the eagle [2] and the serpent. This may be seen by comparing the typical eagle heads engraved on pottery with the heads of some of the winged serpents.

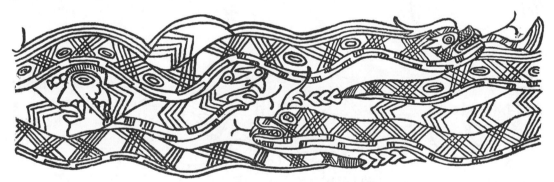

FIG. 282. — Design on a bowl from Georgia.

Slight evidence of the anthropomorphism of the serpent is seen on a small bowl from Georgia (Fig. 282). Upon this vessel are delineated four serpents, three having the elaborated eye that has received comment. Two of these serpents have a branching horn growing out of the head while the others have heads which approximate the human type. One of these human heads has a forehead ornament and the other seems to have an ear plug.

The anthropomorphism of the eagle is much more developed. Representations of the so-called " eagle man " have a wide occurrence. Fig. 283 gives some well known examples of designs done on sheet copper in repoussé. Of these *a*

[1] Moore, 1905, p. 136; 1907, pp. 371–377. Holmes, 1880–1881, pp. 289–293; 1898–1899, p. 91 and pl. 119; Putnam and Willoughby, 1895, etc.
[2] For the eagle see Moore, 1901, pp. 462–463; 1905, pp. 205–206; 1907, pp. 350–351; 388–390.

The other bird, so frequently represented in incised drawings on the pottery of the Southern States, is the ivory-billed woodpecker or the very similar pileated woodpecker.

represents an eagle with little modification except the zigzag lines attached to the eye, while *c* and *e* show the eagle in human form. The beaked nose is obvious and the wings and tail are drawn in the identical manner seen in the first instance with scallop-shaped markings on the former and parallel lines on the

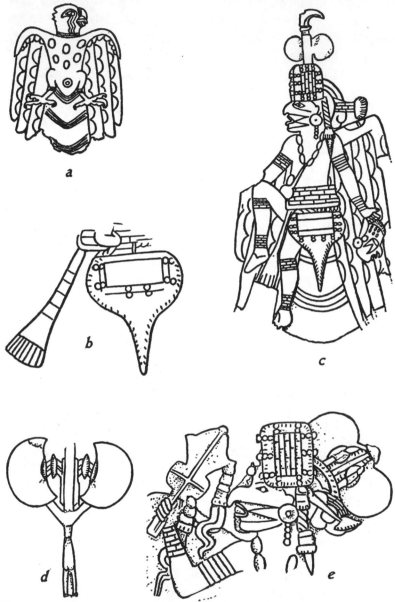

latter. Copper plates with designs comparable to these have been found in a number of sites and shell gorgets with identical details are not uncommon. Sometimes the anthropomorphic eagles lack the wings and tail but possess clawed feet.

In regard to the dress, which is doubtless taken over from that of human beings, note the peculiar rectangular object on the front of the headdress, the hair ornament with crescent-shaped wings that is worn above this, the heart-shaped apron (Fig. 283, *b*) resembling the Scottish apron, and the arm and leg bands. A hair ornament of the same type as those represented on the copper plates (Fig. 283, *d*) was found with them in the Etowah Mound, but Thomas does not seem to have understood its signifi-

FIG. 283. — Copper plates from the Mound Area: *a*, from environs of Peoria, Ill.; *b–e*, from Etowah Mound, Georgia.

cance. The apron and the arm and leg bands appear on a shell gorget from Kentucky (Fig. 284, *a*) that represents a human being with a chunkee stone (?) in one hand. The apron and the rectangular plate of the headdress are seen on a shell gorget from Alabama reproduced in Fig. 284, *b*. This drawing shows an "eagle man" with claws for hands.

A number of writers have directed attention to similarities in shell gorgets from Mexico and from the Mound Area. For instance, Dr. Frederick Starr,[1] after comparing seven examples from the United States with a single piece from

[1] 1896, p. 178.

Mexico, says: "So close and striking are the resemblances that accident cannot account for them, and we are forced to the conclusion that it (the art) must be the offspring of the same beliefs and customs and the same culture as the art of Mexico." Such a conclusion is not forced upon the present writer and possibly a third person may fail to see the compelling resemblances noted by Dr. Starr. A wide range must always be allowed for opinions in matters of art.

References [1] are given below to the seven examples used in this comparison and to a number of other examples including those reproduced in Fig. 284, *a* and *b*. On the Mexican side of the question there are four shell gorgets including the one described by Starr,[2] himself, which came from Morelia. The other three are from Tampico,[3] Tuxpan[4] and an unknown site in Guerrero.[5] All four are brought together by Lehmann.[6] Only the first two resemble in subject or

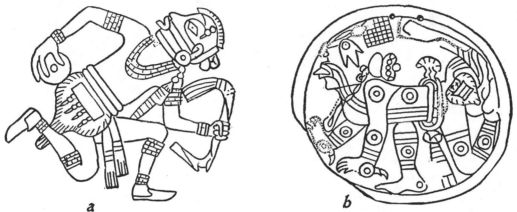

FIG. 284. — Human figures on shell gorgets showing heart-shaped apron, etc.: *a*, Kentucky; *b*, Alabama.

drawing the gorgets of the Mound Area, and even in these cases the similarity is easily explained. A human figure is drawn in a circular space with part of the background cut away stencil fashion. The most prominent features of dress are a belt with apron flaps at front and back, leg wrappings, a circular ear plug and an oblong nose plug. In the specimens from the Mound Area the belt and aprons are usually represented and sometimes bands are shown on the arms and legs and beads around the neck. Circular ear plugs also appear but nose plugs are not represented in a single instance. The ear plugs of Mexico and the Mound Area while they resemble each other in drawings are very different in reality. It must be admitted that the subject of the gorgets is commonplace enough and that the manner of representation might easily arise independently in two areas from the natural limitations and suggestions of the material used.

In the instances from the Mound Area just considered we have recurring features not found in Mexican art, including the ornamented eye and the heart-shaped apron or pouch. These, as we have seen, also occur on copper plates.[7] Moreover, objects of copper and shell, worked in the same manner but repre-

[1] Holmes, 1880–1881, pls. 71–74 and 1903, pl. 29. Thomas, 1890–1891, pp. 306–307, figs. 189–190. Moore, 1899, p. 336, fig. 53; 1905, p. 158; 1907, pp. 397–398, figs. 96–98. Starr, 1896, p. 175; Wilson, 1895, pl. 10.

[2] Starr, 1906, p. 177.

[3] Saville, 1900, p. 100.

[4] Lehmann, 1905, *b*, fig. 1.

[5] Holmes, 1903, pl. 30.

[6] Lehmann, 1905, *b*.

[7] On the technique of these plates see Cushing, 1894, and on copper working in general see Moore and others, 1903.

senting different subjects [1] are very common and widespread in the Mound Area. Certain details even occur in drawings on pottery vessels and fragments of bone.[2] Quite apart from this there are many other objects of art which prove a stage of art sufficiently high to account for the presence of these drawings without invoking foreign influence.[3]

Mr. Fowke [4] in a recent publication comments on a number of copper plates bearing eagle men in repoussé that were found in Missouri to the effect that they

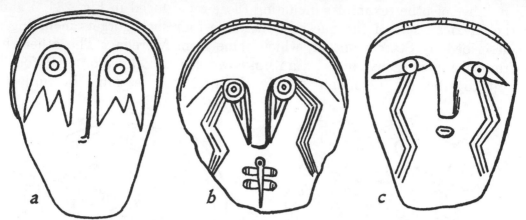

FIG. 285. — Shell marks from the Mound Area: *a*, Tennessee; *b–c*, Virginia.

cannot have been indigenous works of art but were probably brought in from Mexico! Yet there are many examples of this sort of work in the central part of the United States and none in Mexico. Shell masks from Ohio, Kentucky, Tennessee, West Virginia, etc. (Figs. 285, *a–c*) offer further proof of a close-knit unity in Mound Area art since they carry out the features of the elaborated eye. One of these masks was recently excavated from a mound in Manitoba.

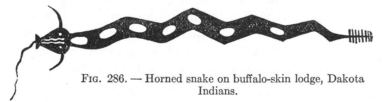

FIG. 286. — Horned snake on buffalo-skin lodge, Dakota Indians.

Indeed, it seems likely that these figures of winged serpents, eagle men, etc., refer to some ancient cosmogenic myth, the episodes of which are here depicted.[5] The supernatural serpents still survive in the mythology of the area and the eagle men may be no other than the miraculous thunder birds. The zigzag lines often connected with the eyes certainly suggest lightning. Other types of Mound culture products need not be considered at this time, since enough has been shown to establish homogeneity.

The horned-serpent motive is not absent from the decorative art of the modern Indians of the Plains. Examples may be seen of its use as a house decora-

[1] Moore figures many specimens of copper, for instance, 1899, pp. 327 and 344; 1895, pp. 160–165, 195–198, 216; 1907, pp. 399–403, etc., etc. For shell carvings of geometric and realistic subjects (crosses, scalloped disks, swastikas, birds, spiders, serpents, etc.) see Holmes, 1880–1881, pp. 267 *et seq.*, and Wilson, 1894, pp. 906–920.

[2] The use of crosshatched areas on the remarkable carved bones and other objects from the Turner Group and elsewhere (see Putnam and Willoughby, 1905; and Gordon, 1907).

[3] For instance the beautiful stone disks, slabs, bowls, pipes, etc., the painted and modeled pottery of the Southern States, the clay figurines from the Turner Group, etc., all reach a high plane of workmanship.

[4] Fowke, 1910, p. 98 and pls. 15–19.

[5] Mr. Moore refers briefly to the probable religious beliefs of the inhabitants of ancient Moundville, 1907, pp. 404–405.

tion among the Blackfoot. Fig. 286 shows a horned serpent painted upon a buffalo-hide lodge of the Dakota Sioux. Among the Menomini, according to Mr. Skinner, the figure is applied to the medicine outfits of conjurors.

The elaboration of the serpent in religion and religious art, leading to certain identities in peculiar and unnatural features, has proved to be one of the most important phenomena of the native culture of the New World — and the Old World too, for that matter. In some of the principal culture areas the development seems to have been entirely independent and indigenous. Elsewhere there may have been an actual connection, often of the most flimsy sort, and entirely unimportant as concerns the larger questions of cultural evolution. For instance, these similar art products may, in some cases, be explained by a recrudescence of ideas transmitted by mythology. Word of mouth travels faster and farther than craft of hand.

Still we may see in these designs the result of a slow exfiltration, with many relays, of ideas originating among the Maya, if you will, but not passing from them directly to the ancient peoples of the Mississippi Valley. There are no trustworthy evidences of trade relations between the Mexicans and Mound-builders, nor is there any sure indication of fundamental unity of culture at any time in the distant past.

Conclusion. This brief presentation of Maya art, which is now brought to a close, leaves many important questions to be decided. In many lines of research the material available has been insufficient to permit a definitive piece of work. The results obtained are, however, suggestive enough to serve as a basis for further study. The principal facts have been blocked out in the rough. We know that the Indians of Mexico and Central America developed an autochthonous culture of a high type. We know that in point of time this culture cannot boast a sensational antiquity or even one which will bear comparison with that in classic lands or in the Far East. We know, in a general way, the course of empire; the epochs of brilliancy and decadence. And we know the end of it all, very much as the priest or Balam sang it in one of the scanty fragments of Maya poetry.[1]

> Eat, eat, while there is bread.
> Drink, drink, while there is water,
> A day comes when dust shall darken the air,
> When a blight shall wither the land,
> When a cloud shall arise,
> When a mountain shall be lifted up,
> When a strong man shall seize the city,
> When ruin shall fall upon all things,
> When the tender leaf shall be destroyed,
> When eyes shall be closed in death;
> When there shall be three signs on a tree,
> Father, son and grandson hanging dead on the same tree;
> When the battle flag shall be raised,
> And the people scattered abroad in the forest.

[1] Brinton, 1890, p. 303.

TABLE OF NOMENCLATURE

RUINS AND MONUMENTS

The following list of ruins and principal monuments is designed as an aid in fixing designations and in cross referencing the descriptions of various modern authors. Only such ruins as are represented by published matter, including photographs of buildings and monuments, ground-plans or descriptions of noteworthy specimens, are included. Even with these restrictions the list is probably far from complete.

ACANCEH
Breton, 1908; Seler, E., 1911, a. Principal mound and Mound with Stucco Façade. Other mounds and buildings not named.

AHUACHAPAN
Lehmann, 1910, p. 735, figures a stela showing Maya influence.

AKE
Stephens, 1843, II, pp. 440–443. Charnay, 1885, pp. 246–256, gives a plan showing the following features: Ball Court, Gallery of Columns, three or more ruined buildings called Palaces, 3 pyramids called Akabna, Xnuc and Succuna.

ALMUCHIL
Maler, 1902, pp. 213–215. Principal Palace, House of Two Chambers.

ALTAR DE SACRIFICIOS
Maler, 1908, a, pp. 3–9. Circular Altar and Stelae 1–6 of which Circular Altar and Stela 4 are reproduced. Mounds unnumbered but plan given.

ANAITÉ II
Maler, 1903, pp. 98–99.

ARROYO HONDO
Seler, 1895, d, pp. 49–50. Painted pottery.

AZUCAR
Tozzer, 1911, p. 93.

BELLOTE
Charnay, 1885, pp. 157–159, gives a short description.

BENQUE VIEJO
Maler, 1908, b, pp. 73–79. The principal building called the Castle of Two Epochs. Stela 1 and a Rectangular Altar.

BOLONCHAC
Sapper, 1895, a, table 5. Mounds A to E. Location of idols shown.

BUDSILHÁ
Maler, 1903, pp. 89–93. Two-roomed building.

CAKIHA
Sapper, 1895, a, table 3.

CALCETOK
Mercer, 1896, pp. 21–31. Cave of the Mice, Actun Spukil. Potsherds, etc. Other caves in vicinity, pp. 32–44.

CANCUN ISLAND
Holmes, 1895–1897, pp. 63–64. Arnold and Frost, 1909, pp. 146–152, give further information.

CANKUEN
Maler, 1908, a, pp. 36–49. Stelae 1–2.

CAVE OF LOLTUN
Thompson, 1897, pp. 6–22. Mercer, 1896, pp. 98–125.

CERRO DE LOS IDOLOS
> Hamy, 1897, pl. 24, figures pottery urns. Charnay, 1885, pp. 356–357, refers to the same pieces.

CHACBOLAI
> Maler, 1902, pp. 197–198, mentions the Castillo.

CHACMULTUN
> A plan of the principal structures is given by Thompson, 1904, pl. 3. Edifices 1–5. Edifice No. 1 is called the Palace.
>
> Maler also describes these ruins, 1895, pp. 249–250, and 1902, p. 199. He refers to Edifice 1 as the Temple Palace of the Phalli, to Edifice 2 as the Chamber of Justice and to Edifice 4 as the Temple-Palace Xetpol.

CHACUJAL
> Sapper, 1895, a, table 4. Mounds 1–8. Maudslay, 1889–1902, II, pp. 28–30.

CHACULÁ
> Seler, 1901, c, pp. 59–77. Ruins mapped.

CHÁNCALA
> Maler, 1901, pp. 13–17. A temple.

CHICHEN ITZA
> The usage in regard to names at Chichen Itza is very complex. Maudslay's notation is taken for the most part in the following classification (Maudslay, III, pl. 2 and pp. 13 et seq.).
>
> No. 1. The Monjas Group consists of the Main Range on the foundation mound, the Upper Chamber on top of the Main Range and the East Wing on the ground level together with the buildings grouped around the Enclosed Court on the south side of the East Wing, the small annex known as the Iglesia or Church and the larger annex known as the Southeast Temple. The L-shaped mound east of the Iglesia has no name nor has the wall and mound attached to the northwest corner of the Monjas Group. Casa de Monjas means Nunnery, but the Spanish term is here retained as a convenient distinction from the Nunnery Quadrangle of Uxmal. The word arose from the traditional use of the buildings for the habitation of sacred virgins (Cogolludo, 1688, p. 176) and not from the use of lattice work in the façade decorations.
>
> Nos. 2 and 3 are small mounds with serpent-head stairways.
>
> No. 4 is the Akat'cib; the name means "the writing in the dark."
>
> No. 5 is the Caracol, Snail or Round Tower. It has a small annex at the southwest corner of the foundation platform.
>
> No. 6. A small temple with a sanctuary, northwest of the Caracol.
>
> No. 7. Casa Colorada, Red House, or Chichanchob. Several unnumbered ruins are near by.
>
> No. 8. Small nameless temple.
>
> No. 9. High Priest's Grave. A deep shaft was found in the center leading down to a burial chamber. This was excavated by Mr. E. H. Thompson and the objects found were placed in the Field Museum at Chicago.
>
> No. 10. Small mound with four serpent-head stairways. This and two small terraces are alligned with the eastern stairway of the High Priest's Grave.
>
> No. 11. The Ball Court also called the Tennis Court and the Gymnasium (Maudslay, III, pl. 26). The Ball Court Group consists of Temple A, commonly referred to as the Temple of the Jaguars but also called Temple of the Tigers and the Shields, Casa del Tigre and Temple of the Ball Court Wall. This structure has a lower ground-level annex at the back called Lower Chamber of the Temple of the Jaguars. Temple B is usually called North Temple of the Ball Court and Temple C the South Temple of the Ball Court.
>
> No. 12. Low terrace east of the Ball Court Group. This is probably the structure called Mausoleum II by Maler, 1895, p. 280, and Seler, 1908, pp. 170 et seq.
>
> No. 13. In this mound was found the Chacmool sculpture, so-called, by Dr. Le Plongeon (see Salisbury, 1877). The mound is called Mausoleum I by Maler and Seler in the places noted. It is badly restored by Le Plongeon, 1896, pl. 57.
>
> No. 14. The Temple of the Cones excavated by Dr. Le Plongeon. This is also called Mausoleum III (Seler, 1908, pp. 235–236).
>
> No. 15. The Castillo or the Castle.
>
> Nos. 16–32, comprise the Group of the Columns, Maudslay, III, pl. 60. This extensive group of closely related structures has never been thoroughly explored. It was first described by Friedericksthal in 1841. The most important structures are:
>
> No. 17. The Temple of the Tables.
>
> No. 21. The Arcade, so called because of an arched passage under the platform with the columns.
>
> No. 22 is probably a ball court and may be called the Small Ball Court.

No. 25. The Temple of the Little Tables was partially excavated by Thompson. It has been described by Maler, 1895, pp. 279–281, and Seler, 1908, pp. 182–183.

No. 26. The Temple of the Stairway was also partially excavated by Thompson. Plates 5, fig. 1, and 7, fig. 2, show this building. Maudslay's plan is considerably at fault. The buildings southeast of this structure are unnumbered.

No. 30. The Sunken Court.

In the northwestern part of the city, Maler excavated two buildings which are not represented in Maudslay's notation. One of these he calls the Building of Two Columns with Changed Stones (Seler, 1908, pl. 26), because the separate stones of the columns bear designs that do not fit together. The stones are apparently re-used material from an earlier structure. The second building he calls the Temple of the Two Serpent Columns, because each column bears a serpent carved in relief upon the front side (Seler, 1908, pl. 25).

Less than half a mile south of the Monjas lie the little-known ruins of Old Chichen Itza. In this site there are many unnamed and unnumbered mounds. Two important buildings in the eastern part of Old Chichen Itza are the House of the Phalli and the Temple of the Initial Series. The latter has been briefly described by Seler, 1908, pp. 237–238. Considerable information concerning Old Chichen Itza and the Group of the Columns was furnished by Mr. S. G. Morley.

The description Stephens, 1843, II, pp. 290–324, gives of Chichen Itza is incomplete but very accurate so far as it goes. The names he uses do not vary from the names used in this classification.

CHINIKIHÁ
Maler, 1901, pp. 10–13. Sculptured table; Stela.

CHINKULTIC, TEPANCUAPAM
Seler, 1901, c, p. 187 and pl. 40. Pyramid and stela.

CHIPOLEM
Dieseldorff, 1895, b.

CHOCOHA
Périgny, 1908, pp. 71–75.

CHÚNHUHUB, CHUNHUHU
Stephens, 1843, II, pp. 130–132, several buildings figured. Maler, 1902, pp. 210–213. Principal Palace or Palace of the Figures, Annex and 1st, 2nd, and 3rd Castillos.

CHUNKATCIN
Thompson, 1888, pp. 164–166, gives a brief description of buildings.

CHUNTICHMOOL
Thompson, 1888, p. 166, mentions a chultun with stucco decoration. This may be the one figured by him in 1898, p. 225.

CHUNYÁXNIC
Described by Maler, 1895, pp. 247–248. Small temple with flying façade figured.

COBA
Stephens, 1843, II, pp. 340–341, quotes a description.

COBAN, CHAMA, ETC.
Dieseldorff, 1893, a; 1893, b; 1894, a; 1894, b; 1895, a. Seler, 1895, d, etc.

COMALCALCO
Charnay, 1885, pp. 161–177. Sketch plan. Structures named are Palace and Towers 1 and 2.

COMITAN
Seler, 1901, c, pp. 189–191.

COMITANCILLO
Sapper, 1895, a, table 9. Mounds A to E, not all mounds numbered on plan.

COPAN
The nomenclature of this city has been pretty well established by Maudslay, 1889–1902, I, pl., and by the Peabody Museum Expeditions, Gordon, 1896, pl. 1. The principal parts and structures are:
Main Structure or the Acropolis.
Great Plaza.
Eastern and Western Courts.
Structures (Mounds, Buildings, Stairways, etc.) numbered 1–56. This numbering is very incomplete, and covers only the ceremonial center of Copan.
Stelae A, B, C, D, E, F, H, I, J, M, N, P. 1, 2, 3, 4, 5, 6, 7, 8, 9, 10, 11, 12, 13 and 15.
Altars and other separate pieces. C, D, E, F, G1, G2, G3, H, I, J, K, L, M, N, O, O1, Q, R, S, T, U, X, Y, Z, 1, 4, 5 (2 altars), 13 and 14.

COPAN — *continued*

Many minor sculptures have not received names or numbers.

Stephens, 1841, I, pp. 130–160, gives a plan and reproduces many of the sculptures but without any system of naming. Some of these drawings are of value in restoring lost parts and giving original locations. A few stelae were reproduced in larger scale by Catherwood, 1844. The drawings of Meye and Schmidt, 1883, have been superseded.

Much work remains to be done at Copan but there seems to be no good reason to renumber or rename the well known sculptures. To do so would be to outlaw and invalidate much classic literature on Maya archaeology.

COZUMEL

Stephens, 1843, II, pp. 372–378. Holmes, 1895–1897, pp. 64–69. Arnold and Frost, 1909, pp. 164–184.

DSECILNA, ZEKILNA

Maler, 1895, pp. 282–284. Palace; Columns with human figures. Stephens, 1843, II, pp. 124–126.

DSEKABTUN

Maler, 1902, pp. 227–230. Principal Palace with Dependent Structures, built round a square, Temple with Roof Comb or House of the Six Chambers.

DSIBILNOCAC, ZIBILNOCAC TZÍBINOCAC

Stephens, 1843, II, pp. 180–190. Maler has also explored it and taken photographs of the structures. Sapper, 1895, c, pl. XXX, fig. 4.

DSIBILTUN

Maler, 1895, p. 251; 1902, p. 230. The Palace, the Temple, the Chamber of Justice.

EL CAYO

Maler, 1903, pp. 83–89. The Palace. Stelae 1–3. Lintel 1.

EL CHICOZAPOTE

Maler, 1903, pp. 100–104. A ruined structure with Lintels 1–4.

EL CHILE

Maler, 1903, pp. 96–98. A double temple.

EL MECO

Holmes, 1895–1897, pp. 69–74. Arnold and Frost, 1909, pp. 143–145.

EL SACRAMENTO

Sapper, 1895, a, table 5. Ball court and three idols.

HACIENDA GRANDE

Sapper, 1895, a, table 2. There seems to be some doubt as to the location of these ruins.

HOCHOB

Maler, 1895, pp. 278–279. Principal Structure and several other temples.

HOLMUL

Tozzer, 1911, p. 93.

HUNTICHMÚL

Maler, 1895, pp. 250–251. Palace of the Half-columns, Building of the Inscription, etc.

ICHPICH

Maler, 1902, pp. 199–202, mentions a number of structures including the Palace.

ITSIMTÉ, YTSIMPTE

Maler, 1902, pp. 215–216. Temple-Palace and Serpent-head Palace. Stephens, 1843, II, pp. 139–141.

ITSIMTÉ-SÁCLUK

Maler, 1908, a, pp. 28–35. Stelae 1–6, of which Stelae 1, 4 and 6 are reproduced. Mounds unnumbered but plan given.

IXIMCHÉ, TECPAN GUATEMALA, PATINAMIT

Stephens, 1841, II, pp. 146–154; Brühl, 1894; Sapper, 1895, a, table 7; Maudslay, 1889–1902, II, pl. 73. Bancroft, 1875–1876, IV, pp. 122–123. Maudslay's map is the best but the mounds are unnumbered.

IXKUN, DOLORES

Maudslay, 1889–1902, II, pp. 21–22, pls. 67–69. Sketch plan. Stela 1 reproduced and others mentioned.

IXTINTA

Sapper, 1895, c, pp. 542 *et seq.*, and pl. 30, figs. 1 and 2; Sapper, 1897, p. 360. Plans.

IZALCO

Seler, 1901, c, pp. 180–181. Maya pottery in western Salvador.

IZAMAL

Stephens, 1843, II, pp. 432–439. Brasseur de Bourbourg, 1866, *a*; Charnay, 1885, pp. 259–265, identifies the pyramids with those mentioned by Lizana, namely 1st, Kinich-Kakmó, 2nd, Ppapp-Hol-Chac, 3rd, Ytzamat-ul. Holmes, 1895–1897, pp. 97–100.

JAINA

Charnay, 1887, *b*; Norman, 1843, pp. 214–218; Hamy, 1897, pl. 26.

KABAH

Stephens, 1843, I, pp. 384–413. Casas 1–3. Structure of the Sculptured Lintels. Structure of the Sculptured Doorjambs. The Broken Arch. Charnay, 1885, pp. 315–320, uses this numbering. Researches of the Peabody Museum at Kabah, as at Labna, are unpublished.

KALAMTÉ

Sapper, 1895, *a*, table 8. Mounds A to H, all not numbered on plan.

KANCABCHEN

Maler, 1895, p. 284. Grotesque sculpture.

KANTUNILE

Grave finds of carved shell, etc., described by Stephens, 1843, II, pp. 341–344.

KEWICK

Stephens, 1843, II, pp. 66–77. Several buildings. Painted slab.

LABNA, LABNAH

An unpublished map of the Peabody Museum Expedition to Labna in charge of Mr. E. H. Thompson classifies the ruins as follows:

Palace Group.
Old Edifice Group.
Portal Group.
Temple Group.

The mounds are associated principally with the last two groups and are numbered 1–20 on the map, although Mound 41 is referred to in Thompson, 1897, p. 19. Many unnumbered terraces are found in connection with the buildings of the first two groups.

The chultunes or reservoirs that were excavated are numbered 1–34 (Thompson, 1897).

Stephens, 1843, II, frontispiece, gives a fine panorama of the Palace Group and describes other structures, pp. 49–59.

LA CUEVA DE SANTA CRUZ

Sapper, 1895, *a*, table 4. Mounds A–G. Seler, 1895, *d*. Bull. 28, p. 103.

LA HONDRADEZ

Tozzer, 1911, p. 93.

LA MAR

Maler, 1903, pp. 93–96, describes the ruins and figures Stelae 1 and 2.

LAS PACAYAS

Sapper, 1895, *a*, table 3. Structures A–K.

LAS QUEBRADAS

Sapper, 1895, *a*, table 3. Plazas I–VI.

LA REFORMA

Maler, 1901, pp. 9–10.

LEMPA VALLEY

Lehmann, 1910, pp. 691–695 and 734–741, discusses Maya influence.

MACOBA

Stephens, 1843, II, pp. 214–219.

MANKEESH

Stephens, 1843, II, p. 223.

MASAPA

Sapper, 1895, *a*, table 6. Mounds A to H.

MATARÁS

Cruz, 1904, gives brief description.

MAYAPAN

Stephens, 1843, I, pp. 131–141; Brasseur de Bourbourg, 1866, *b*; Le Plongeon, 1881, Round Tower, Structure with columns.

Mixco
> Maudslay, 1889–1902, II, pl. 74. Mounds are those of an ancient city between Mixco and Guatemala City. Ancient Mixco is situated north of Guatemala City and is entirely distinct.

Motul de San José
> Maler, 1910, pp. 131–135. Stela 1.

Mujeres Island
> These ruins have been often described: see Stephens, 1843, II, pp. 415–417; Salisbury, 1878; Holmes, 1895–1897, pp. 57–63.

Naco
> Blackiston, 1910, b, describes a cache of copper bells in the vicinity.

Nakum
> Périgny, 1910. Tozzer, 1911, p. 93.

Naranjo
> Maler, 1908, b, pp. 80–127. Stelae 1–32. Morley, 1909, p. 544, also gives the various buildings numbers which run from I to XXIX, and makes the Courts A to E.

Nebaj
> Seler, 1902–1908, III, pp. 718–729. Painted pottery.

Nocuchich
> Maler, 1895, pp. 281–282. Colossal stucco face, Tower.

Nohcacab
> Stephens, 1843, I, pp. 347–348.

Nohcacab, 2nd.
> Périgny, 1908, pp. 81–84.

Nohochna
> Périgny, 1908, pp. 79–80.

Nohpat
> Stephens, 1843, I, pp. 362–368. This ruin may be an older part of Uxmal. The monolithic sculptures have not been numbered or photographed.

Ocosingo, Tonina
> Stephens, 1841, II, pp. 255–262; Sapper, 1895, c, pl. 31; Sapper, 1897, p. 361, fig. 8; Seler, 1901, c, pp. 191–195. The Principal Temple follows the Palenque model. Stelae 1–2 shown in Plate 25, figs. 4 and 5 of this volume after photographs of Dr. Tozzer. Other monuments unnamed and unnumbered.

Oxkintok, Maxcanu
> Stephens, 1843, I, pp. 212–220. Mercer, 1896, pp. 45–63. The Labyrinth, Cave, Mound called Xemtzil.

Oxkutzcab
> Mercer, 1896, pp. 126–145. Caves with potsherds, etc.

Palenque
> The situation in regard to terms is very discouraging and a correlation of the many authorities cannot be attempted. The best thing to do is to accept the nomenclature of Maudslay. His large map, 1889–1902, IV, pl. 1, shows many ruins unnamed and unnumbered.
> The Palace is subdivided into:
> Houses A to I.
> The Square Tower.
> The principal temples are:
> The Temple of the Inscriptions.
> The Temple of the Cross.
> The Temple of the Foliated Cross.
> The Temple of the Sun.
> The House of the Lion. This is perhaps better known as the Temple of the Beau Relief.
> The Southern Temple (Maudslay, IV, p. 34).
> The Northern Temples, 6 in number (Maudslay, IV, p. 35).
> Mr. Maudslay, IV, pp. 7–8, refers to most of the early authorities on Palenque including Antonio del Rio, 1822; Dupaix in Antiquités.Mexicaines, 1834, and Kingsborough, 1831–1848; Waldeck, 1866; Stephens, 1841, II, pp. 291–321; Catherwood, 1844, pls. 6 and 7; and Charnay, 1885, pp. 179–218. Mr. Holmes has also given us a valuable description in 1895–1897, pp. 151–209. Some new frescos were discovered by Dr. Seler, 1911, b.

Pasojon
> Sapper, 1895, a, table 8. Plan.

Peten-Itza, Flores, Tayasal

Maler, 1910, pp. 153–158. One stela in a church but may have come from some other site.

Pethá

Maler, 1901, pp. 30–31. Rock paintings.

Piedras Negras

Maler, 1901, pl. 33, has given descriptive names to the principal structures and has numbered the sculptures as follows:

Stelae 1–37.

Altars I to V.

Lintels 1–4.

The inscription on Stela 3 was drawn and commented on by Maudslay, 1897–1898, and later by Förstemann, 1901, *b.* The inscriptions have been considered in detail by Bowditch, 1901, *c.*

Playa de los Muertos

Gordon, 1898, *a*, pp. 97 *et seq.* Blackiston, 1910 *a.*

Porvenir

Tozzer, 1911, p. 93.

Quen Santo

Seler, 1901, *c*, pp. 97–185. Maps and plans. Structures 1–44. Caves 1–3. Nearby Casa del Sol is not included in above numeration.

Quirigua

The great monuments of Quirigua have already become well known to the world through Maudslay. His system of lettering, II, pl. 2, is adopted in this paper. The only change in the nomenclature is to substitute "altar" for "animal" in the names of the monolithic sculptures carved on residual boulders. The structures are numbered by Mr. Morley, 1912, who has recently conducted archaeological work at this site.

The monuments are:

Stelae A, C, D, E, F, H, I, J and K.

Altars B, G, L, M, N, O and P.

The structures around the Temple Court are numbered 1 to 6.

The monuments illustrated by Stephens, 1841, II, pp. 118–124, and by Meye and Schmidt, 1883, are poorly done and possess only an historic interest.

Rabinal

Maudslay, 1889–1902, II, pp. 25–27 and pl. 70. Groups of buildings, A–G.

Rio Beque

Périgny, 1908, pp. 75–79.

Sabacche, Sabachtché

Stephens, 1843, II, pp. 41–47; Maler, 1895, p. 248. The two buildings figured in Plate 6, fig. 2, and Plate 15, fig. 3, of this volume Maler calls Temple with the Lattice-work and Temple of the Serpent Head.

Sabaka

Mercer, 1896, pp. 146–159. Cave with potsherds.

Sacbey

Stephens, 1843, II, p. 122.

Saccacal

Stephens, 1843, II, pp. 235–237.

Sacchaná

Seler, 1901, *c*, pp. 17–23. Stelae 1–2.

Saculeu, Las Cuyes, Zakuleu

Sapper, 1895, table 6. Mounds A to K. Bancroft, 1875–1876, IV, pp. 128–130.

Sajcabajá

Sapper, 1895, *a*, table 10, Mounds A, B, C, 1 and 2, D, E, F, G, H, I, 1–12, K, 1–4, L. Not all the mounds numbered.

Salinas de los Nueve Cerros

Seler, 1902–1908, III, Art. 3, pl. 1. Stela.

San Andrés Tuxtla

The important statuette from here as described by Holmes, 1907. A map of an ancient city nearby is given by Kerber, 1882. The ruin is probably not Maya.

SAN CLEMENTE
Sapper, 1895, c, pp. 541 et seq., and pl. 32; Sapper, 1897, p. 362. Courts A–D. Structures I–VII, Mounds 1–10.

SAN LORENZO
Maler, 1903, pp. 203–208. Rock Carvings and one or two minor works.

SANNACTÉ
Stephens, 1843, II, pp. 36–38. Two ruined buildings mentioned.

SANTA CRUZ QUICHÉ (see Utatlan).

SANTA ROSA XLABPAK
Stephens, 1843, II, pp. 157–168; Maler, 1902, pp. 220–228. Structures called by Maler, Temple-Palace of Tampak, House of a Room with a Half Arch, Red House, House with Serpent Heads.

SANTANA
Gordon, 1898, a, pp. 8 et seq.

SANTA RITA
Gann, 1897–1898. Mounds 1–23. Frescos on walls of Mound 1.

SANTIAGO DE MARIA
Lehmann, 1910, p. 741. Pottery.

SAYIL, ZAYI
Stephens, 1843, II, pp. 16–27; Maler, 1895, pp. 251–252 and 277–278. Casa Grande or Temple-Palace and many other structures. Maler describes three stelae. This ruin should be carefully explored and mapped.

SEIBAL, SASTANQUIQUI
Maler, 1908, a, pp. 10–28. Stelae 1–15 of which most are figured. Fragments of last four are doubtful; may be altars. Plan given but structures unnumbered.

SILBITÚK
Maler, 1910, pp. 141–142. Sacred Island in the lake.

SIJOH
Stephens, 1843, I, pp. 199–201. Plate stelae mentioned.

TABASQUEÑO
Maler, 1895, pp. 248–249. The Temple-Palace.

TANKUCHÉ
Stephens, 1843, I, pp. 202–206. Building with paintings.

TANTAH
Maler, 1902, p. 218. Two Palaces with banded column decoration.

TEHUACAN
Gonzales, 1906, gives a brief description.

TENAMPUA
Squier, 1853; 1858, pp. 133–139. Bancroft, 1875–1876, IV, pp. 73–77.

TICUL, SAN FRANCISCO
Stephens, 1843, I, pp. 271–283. Slight excavation.

TIKAL
The notation of the Peabody Museum Expedition is employed as shown on the sketch map, Tozzer, 1911, pl. 29. The correlation of this system with that of Maler, 1911, is stated at the beginning of the paper referred to (Tozzer, 1911, p. vi). The monuments are:
Stelae 1–17.
Altars 1–6
Temples I–V.
Structures 1–89.
The correlation with Maudslay, 1889–1902, III, pp. 44–50 and pls. 67–82, is as follows:

Stela A of Maudslay Stela 5
" B " " " 9
" C " " " 10
Temple A of Maudslay Temple I
" B " " " II
" C " " " III
" D " " " V
" E " " " IV

The correlation of the sculptured lintels with the temples in which they were originally placed is difficult and the evidence must be given in some detail.

Temple I.

Lintel 1. Plain and in place (Maler, 1911, p. 27).

Lintel 2. Sculptured, 2 beams removed and 2 in place; doorway 8 feet wide (Maler, 1911, p. 28). The missing pieces may be those shown by Maudslay, III, pls. 71 and 74, left-hand inscription. The height of the sculpture is slightly less than 8 feet, which agrees with the width of the doorway. The fragments seem to be parts of two beams. Two small pieces are in the British Museum and the others in the Museum of Archaeology at Basle, collected by Bernoulli in 1877. The pieces at Basle were splendidly reproduced in heliograph by Léon de Rosny, 1882, pl. 10, *f*, and pl. 12, *i*.

Lintel 3. Out of 5 sculptured beams, 4 removed; 1 on ground in 1895; doorway 6 feet 2½ inches wide (Maler, 1911, p. 28). The sculptured beams shown by Maudslay, III, pls. 72 and 73, could not have come from this temple: 1st, because outer lintel to which they are ascribed is plain and in situ; 2nd, there are 4 beams and hence the fragments could not have come from Lintel 2 which lacks only two beams; 3rd, the width of the third doorway which would determine the height of the sculpture on Lintel 3 is only 6 feet 2½ inches, while the carving is about 7 feet 2 inches.

Temple II.

Lintel 1. Five beams removed; possibly sculptured; width of doorway 7 feet 4½ inches (Maler, 1911, p. 29). Maudslay, III, pl. 69, is probably in error when he labels this lintel "plain." The sculptures last referred to, that Maudslay, III, pls. 72 and 73, ascribes to Temple I, probably came instead from this doorway. The originals are at Basle and the original reproductions were by Léon de Rosny, 1882, pl. 10, *d* (object inverted) and *e*; pl. 11, *g* and *h*.

Lintel 2. Originally 5 sculptured beams; 3 removed entirely; 2 found in 1895 and 1904; doorway 7 feet 1 inch wide. For the fragments see Maler, 1911, pp. 29–30, and pl. 18, fig. 2. These pieces come from the right-hand side of a tablet and so cannot form a part of any of the lintels so far considered.

Lintel 3. Plain and in place (Maler, 1911, p. 31).

Temple III.

Lintel 1. Outer doorway very wide, 12 feet 11½ inches; the 6 beams are missing and may have been sculptured (Maler, 1911, p. 37). On Maudslay's plan, III, pl. 69, this lintel bears the legend "beams fallen." If sculptured the height of this lintel would have been much greater than any lintel sculptures known.

Lintel 2. Sculptured and in place but badly mutilated (Maler, 1911, p. 37).

Temple IV.

Lintel 1. Plain and in place (Maler, 1911, p. 41).

Lintel 2. Six sculptured beams removed; width of doorway 6 feet 11½ inches (Maler, 1911, p. 41). The width of the doorway is slightly less than the height of the sculpture shown by Maudslay, III, pls. 72 and 73, and this fact makes the earlier choice of location, Temple II, Lintel 1, all the more certain.

Lintel 6. Seven or 8 sculptured beams removed; width of doorway 6 feet 4½ inches; thickness of wall 7 feet 9 inches; probable width of sculpture 7 feet 3 inches (Maler, 1911, pp. 42–43).

This lintel is undoubtedly that collected by Bernoulli and now in the Museum of Archaeology at Basle (Maudslay, III, pls. 77 and 78). The dimensions of the sculpture proper are, height, 5 feet 9 inches; width, 6 feet 19 inches. The original condition of the beams is shown in the beautiful heliographic plates of Léon de Rosny, 1882, pls. 8–9.

Thus we have accounted for all the known fragments of Tikal wood carvings except, possibly, a small piece in the British Museum collected by Mr. J. W. Boddam-Whetham in 1875 (Maudslay, III, p. 46 and pl. 71) and another fragment mentioned by Maudslay in his preliminary report, 1883, p. 193, as being in the Christy Collection.

TÓPOXTÉ, LAKE YAXHA

Maler, 1908, *b*, pp. 55–60. Plans of ruins.

TŠOTŠKITAM

Tozzer, 1911, p. 93.

TULOOM

Stephens, 1843, II, pp. 387–407. Plan. Many buildings, largest being the Castillo. Holmes, 1895–1897, pp. 75–78, figures the Castillo from the sea. Dr. Howe, 1911, adds some details. He reproduces a part of a stela or tablet.

TZENDALES

(See pages 111 and 196–197.)

Tzulá
>Thompson, 1904, pp. 8–9. The paintings at the end of one of the rooms are reproduced by Thompson, 1904, pl. 2. There seems to be no doubt but that this ruin and these paintings are described also by Stephens, 1843, II, pp. 92–93.

Uaxac Canal
>Seler, 1901, c, pp. 24–58. Scattered ruins in a valley.

Uloa Valley
>(See Santana and Playa de los Muertos.)
>Gordon, 1898, a. Lehmann, 1910, p. 736. Blackiston, 1910, a and b.

Uoltunich
>Périgny, 1908, pp. 80–81.

Utatlan, Santa Cruz del Quiché
>Stephens, 1841, II, pp. 169–188. Sapper, 1895, c, pl. 33. Maudslay, 1889–1902, II, pl. 72. Mounds unnumbered. Concerning the traditional names, Maudslay, 1889–1902, II, pp. 30–38.

Uxmal
>In naming the buildings at Uxmal the following terms are employed:
>Nunnery Quadrangle with North, East, South and West Ranges.
>House of the Magician with the Annex.
>Ball Court.
>House of the Governor.
>House of the Turtles.
>House of the Birds.
>House of the Old Woman.
>Great Pyramid.
>Southwest Group with the House of the Pigeons and the South Temple.
>There are many descriptions of Uxmal, among which may be mentioned Stephens, 1843, I, pp. 163–186, 226–232, 253–256, 297–325. Stephens in most cases uses the terms given above or their Spanish equivalents. Waldeck, 1834, is so inaccurate that his plates are of little value. He calls the House of the Magician the Temple of Kingsborough. Holmes, 1895–1897, pp. 80–96, gives an interesting description with valuable drawings. His names do not vary greatly from the list given above. Morley, 1910, a, gives a detailed map of the Southwest Group. The very early description of Alonzo Ponce has been quoted in full, pp. 5–8. The description of Lorenzo de Zavala in Antiquités Mexicaines, 1834, I, is of little value.

Valle la Joya
>Lehmann, 1910, pp. 736 and 740. Pottery.

Xampon
>Stephens, 1843, II, p. 124. Two nearby ruins called Hiokowitz and Kuepak.

Xcalumkin
>Maler, 1902, pp. 202–206. Temple of the Initial Series. Other monuments unnumbered and unnamed.

Xcavil de Yaxché
>Maler, 1902, pp. 205–206. The Temple-Palace.

Xcoch
>Stephens, 1843, I, pp. 348–357. A large cave used as well.

Xculoc, Schoolhoke
>Maler, 1902, pp. 208–210. Stephens, 1843, p. 134. The Palace with Figures.

Xkálupococh
>Maler, 1902, pp. 215–216, describes three structures the most important of which he calls the Palace of the Meanders.

Xkanja, Caca Xkanha
>Sapper, 1895, c, pl. 30, fig. 3; Sapper, 1897, p. 360, fig. 3. Plan of two structures.

Xkichmook, Kich-Moo, Xkichmol
>A plan is given by Thompson, 1898, pl. 26, on which are marked: Edifices 1–10. Mounds 1–3.
>Reservoirs or Chultunes 1–19. Edifice No. 1 is known as the Palace.
>A preliminary description of this site was given by Thompson in 1888, pp. 166–170, under the name Kich-Moo. Maler calls it Xkichmol.

Xlabpak of Maler
>Maler, 1902, pp. 204–205. The Principal Temple.

Xlabpak of Santa Rosa
>(See Santa Rosa Xlabpak.)

XUL

 Thompson, 1904, pp. 7–8. Stephens, 1843, pp. 83–84 and 89–90.

XUPÁ

 Maler, 1901, pp. 17–22. A temple of the Palenque type with engraved tablets.

YAABICHNA

 Périgny, 1908, pp. 80–81.

YAKAL-CHUC

 Maler, 1902, p. 219. Structure of the Two Chambers.

YAKATZIB

 Stephens, 1843, II, p. 229. Nearby is an artificial aguada with chultunes in the bottom. Stephens, 1843, II, pp. 224–227.

YAXCHÉ

 Maudslay, 1889–1902, II, pp. 23–25.

YAXCHÉ-XLABPAK

 Maler, 1902, pp. 206–208, mentions Structures I to V, calling III the Castillo.

YAXCHILAN, MENCHÉ TINAMIT, LORRILARD CITY

 The notation of Maler, 1893, pl. 39, is used and is correlated with the less complete surveys of Charnay (1885, pp. 382–399) and Maudslay, 1889–1902, II, pp. 40–47 and pls. 76–98. The site is called Lorillard City by Charnay and Menché Tinamit by Maudslay.

 The numbering of Maler includes: Structures 1–52. Lintels 1–46. Stelae 1–20.

 Besides these there are several unnumbered pieces including an oblong block called an altar in front of Structure 44, and several other altars, two of which are shown by Maler, 1903, pl. 80. A sculptured statue in Structure 33 is also without designation.

 Charnay, 1885.

First Temple, p. 385	Structure 33
Palace, p. 389	Structure 19
Second Temple, p. 390	Probably the roof comb of Structure 6
Lintel, p. 391	Lintel 2
" p. 393	" 24
" p. 399	" 25

 Maudslay, 1883, and 1889–1902, II, pl. 76

House A	Structure 6
" B	" 10
" C	" 11
" D	" 12
" E	" 20
" F	" 21
" G	" 23
" H	" 19
" J	" 25
" K	" 33
" L	" 42
" M	" 44
Lintel, shown in pl. 78, *b*	Lintel 30
" " " pl. 79, *a*, and 80, *a*	" 37
" " " pl. 79, *b*, and 80 *b*	" 35
" " " pl. 81	" 13
" " " pl. 82	" 14
" " " pl. 83	" 15
" " " pl. 84	" 16
" " " pl. 85	" 17
" " " pl. 86	" 24
" " " pls. 87 and 89	" 25
" " " pl. 92	" 1
" " " pl. 93	" 2
" " " pl. 94	" 3
" " " pl. 95 "North Lintel"	" 43
" " " pl. 95 "South Lintel"	" 41
" " " pl. 96	" 42

YAXCHILAN, MENCHÉ TINAMIT, LORRILARD CITY — *continued*

Lintel, shown in pl. 97, left-hand figure Lintel 45
" " " pl. 97, right-hand figure Stela 5
" " " pl. 98 . Lintel 23

Mr. Bowditch, 1903, pp. 20–22, discusses most of the sculptures figured by Maudslay and not by Maler.

YAXHÁ

Maler, 1908, *b*, pp. 61–73. Sketch plan. Stelae 1–10 of which parts of 1, 2, 4, 5, 6 and 10 are figured. Mounds unnumbered.

YARUMELA

Bancroft, 1875–1876, IV, p. 72.

YOKAT

Mercer, 1896, pp. 79–84. Two caves.

CODICES

The following table correlates the page numbers of the three Maya codices with the plate numbers of the reproductions. The numerals in parentheses belong to the reproductions. The two sides of the manuscripts, one labeled "obverse" and the other "reverse," appear in natural order in opposite columns. The top of the pages on the obverse side corresponds to the top of the pages on the reverse side in both the Dresden Codex and the Peresianus Codex (Léon de Rosny, 1887, p. 14) while in the Tro-Cortesianus Codex the top of one side corresponds to the bottom of the other except in pages 77 and 78. Here the scribe apparently had his book top side down as he wrote and consequently these two pages should doubtless be reversed in order when being read. Every student should have his copies of the codices bound in the screen form of the originals.

The Dresden reproduction given here is the second edition of Förstemann, made in 1892. In the first edition of 1880 the numbers of pages 1 and 2 are reversed as well as their opposites, pages 45 and 44 (Förstemann, 1902, p. 2). The two parts of the Dresden Codex really form one manuscript and the pagination should be continuous on each side (Bowditch, 1909, pp. 268–269). The difficulties of the problem are readily seen from Förstemann's original description translated into English by Thomas, 1884–1885, pp. 261–269. Owing to the mass of literature on the Dresden Codex it seems best not to change the references to fit the revised pagination but the latter may be of service in setting up the book from the plates.

The Peresianus reproductions of Léon de Rosny made in 1887 and 1888, the former in color and the latter in black and white, are here correlated with the actual arrangements of the sheets in screen form. The explanations of the editor are not over-lucid in spots. The plates numbered 1 and 12 of the edition of 1887 are reversed in the later one of 1888, possibly for correction, but the text references are identical. Plates 1 and 12 are clearly the outside sheets bearing the stamp of the library and plate 15 is no less certainly the reverse of plate 12 of the edition of 1888.

On the basis of a two-part interlocking series of ahau sequences on the obverse side of the manuscript, which necessitates 13 pages for its complete presentation, Rosny intended to give the numbers 1–13 to the obverse (1887 or 1888, pp. 22–27) at the same time recognizing that the natural pagination of the codex in its present state is 1–11 for the obverse and 12–22 for the reverse (1887 or 1888, p. 15). He thus added two blank pages, 13 and 14, the first to complete the obverse and the second to serve as its opposite on the reverse. But he made a curious error. The pages which he numbers 1 and 12 cannot both be on the same side of the manuscript because both are exposed on the outside of the folded codex. One has to be eliminated from the obverse leaving him still one short of the hypothetical thirteen. To get his full series he also should have added a blank sheet at the beginning which would have been numbered 1 on the obverse and 26 on the reverse.

A careful examination shows that the short page numbered 12 in the edition of 1888 is the one that apparently is devoted to the long involved ahau sequence above noted and hence belongs to the obverse. Its real number should be 11, and all the preceding pages numbered 2–11 should be shifted back one number. The sheet numbered 1 in the 1888 edition is really the last page instead of the first. The mistake probably arose from the fact that this sheet was exposed at the top of the manuscript as folded screen fashion. The ahau symbols that Rosny notes on this sheet (1887 or 1888, p. 18) are very doubtful.

That the above conclusions are correct may be seen from the recent reproductions of the Peresianus Codex by Mr. Gates (1909). The republished photographs originally made in 1864 by Duruy are numbered by Mr. Gates in an approximation of the system of Léon de Rosny in that the interpolated extra pages 13 and 14 are retained. But page 1 is renumbered page 25 and put in its proper place at the end of the codex.

The Cortesianus Codex was published in 1892 by Rady y Degado in the screen form of the original and with the pages unnumbered. The earlier photographic edition of Léon de Rosny, 1883, is very rare. The Troano was brought out as the plates to a dissertation by Brasseur de Bourbourg, 1869–1870. The first plate he gives (page 78) bears no number at all and the others are numbered backwards. The plate numbers of the reverse side are distinguished by an asterisk.

Dresden			Tro-Cortesiansus	
Obverse	Reverse		Obverse	Reverse
First Part			Cortesianus	
1 (1)	78 (45)		1	57
2 (2)	77 (44)		2	58
3 (3)	76 (43)		3	59
4 (4)	75 (42)		4	60
5 (5)	74 (41)		5	61
6 (6)	73 (40)		6	62
7 (7)	72 (39)		7	63
8 (8)	71 (38)		8	64
9 (9)	70 (37)		9	65
10 (10)	69 (36)		10	66
11 (11)	68 (35)		11	67
12 (12)	67 (34)		12	68
13 (13)	66 (33)		13	69
14 (14)	65 (32)		14	70
15 (15)	64 (31)		15	71
16 (16)	63 (30)		16	72
17 (17)	62 (29)		17	73
18 (18)	61 (blank)		18	74
19 (19)	60 (blank)		19	75
20 (20)	59 (blank)		20	76
21 (21)	58 (28)		21	77
22 (22)	57 (27)		Troano	
23 (23)	56 (26)		22 (XXXV)	78 (No number)
24 (24)	55 (25)		23 (XXXIV)	79 (XXXIV*)
			24 (XXXIII)	80 (XXXIII*)
Second Part			25 (XXXII)	81 (XXXII*)
			26 (XXXI)	82 (XXXI*)
25 (46)	54 (74)		27 (XXX)	83 (XXX*)
26 (47)	53 (73)		28 (XXIX)	84 (XXIX*)
27 (48)	52 (72)		29 (XXVIII)	85 (XXVIII*)
28 (49)	51 (71)		30 (XXVII)	86 (XXVII*)
29 (50)	50 (70)		31 (XXVI)	87 (XXVI*)
30 (51)	49 (69)		32 (XXV)	88 (XXV*)
31 (52)	48 (68)		33 (XXIV)	89 (XXIV*)
32 (53)	47 (67)		34 (XXIII)	90 (XXIII*)
33 (54)	46 (66)		35 (XXII)	91 (XXII*)
34 (55)	45 (65)		36 (XXI)	92 (XXI*)
35 (56)	44 (64)		37 (XX)	93 (XX*)
36 (57)	43 (63)		38 (XIX)	94 (XIX*)
37 (58)	42 (62)		39 (XVIII)	95 (XVIII*)
38 (59)	41 (61)		40 (XVII)	96 (XVII*)
39 (60)	40 (blank)		41 (XVI)	97 (XVI*)
			42 (XV)	98 (XV*)
Peresianus			43 (XIV)	99 (XIV*)
			44 (XIII)	100 (XIII*)
Obverse	Reverse		45 (XII)	101 (XII*)
			46 (XI)	102 (XI*)
1 (2)	22 (1)		47 (X)	103 (X*)
2 (3)	21 (24)		48 (IX)	104 (IX*)
3 (4)	20 (23)		49 (VIII)	105 (VIII*)
4 (5)	19 (22)		50 (VII)	106 (VII*)
5 (6)	18 (21)		51 (VI)	107 (VI*)
6 (7)	17 (20)		52 (V)	108 (V*)
7 (8)	16 (19)		53 (IV)	109 (IV*)
8 (9)	15 (18)		54 (III)	110 (III*)
9 (10)	14 (17)		55 (II)	111 (II*)
10 (11)	13 (16)		56 (I)	112 (I*)
11 (12)	12 (15)			

BIBLIOGRAPHY

The following bibliography includes only the works referred to in the text. When two editions are given the pagination of the first is followed in the references. Most of the important contributions of original material bearing on the Maya will be found listed as well as some books which are valuable only for their illustrations or for specific statements of fact.

There is no single work on Mexican bibliography that approaches completeness. Most of the important treatments of this matter are given by Lehmann, 1909, pp. 6–9. In addition to these the bibliographic student will find valuable additions in the "Authorities Quoted" in H. H. Bancroft's Histories of the Pacific States, as follows: The Native Races, San Francisco, 1883, I, pp. xvii–xlix; History of Mexico, San Francisco, 1883, I, pp. xxi–cxii; History of Central America, San Francisco, 1883, pp. xxv–lxxii. In addition Dr. G. P. Winship published in 1894 the Titles of documents relating to America in the "Coleccion de documentos ineditos para la historia de España," in the Bull. Boston Pub. Lib., V (N. S.), pp. 250–263. A classified list of works in the New York Public Library relating to Mexico appeared in 1909, Bull. New York Pub. Lib., XIII, pp. 622–662, 675–737, 748–892. A biographical work entitled Historiadores de Yucatan was published in 1906 by Gustavo Martinez Alomia. Another paper not listed by Dr. Lehmann is from the pen of K. Haebler. The title is Die Maya-Literatur und der Maya-Apparat zu Dresden, in Centralblatt für Bibliothekwesen, XII, 1895, pp. 537–575. Special lists of authorities quoted appear in several of the recent contributions to our knowledge of the Maya.

On the side of cartography the writer makes few references. Nearly all the important descriptive articles on the Maya are provided with maps. A very early map of Yucatan that may date from 1508 is described by Valentini, 1898 and 1902.

AGUILAR, SANCHEZ DE
 1639. Informe contra idolorum cultores del Obispado de Yucatan. Madrid. (Reprint in Anales Mus. Nac. de Mexico, 1900, VI, pp. 13–122.)

ALLEN, H.
 1881. An analysis of the life form in art. (Trans. Am. Philosoph. Soc., XV (N. S.), pp. 279–351.)

ALVARADO, PEDRO DE
 1838. Lettres de Pedro de Alvarado à Fernand Cortès. Première lettre. (H. Ternaux-Compans, Voyages, relations et mémoires originaux pour servir à l'histoire de la découverte de l'Amérique, X, pp. 107–125.)

AMBROSETTI, J. B.
 1896. El símbolo de la serpiente en la alfareria funeraria de la región Calchaqui. (Bol. del Inst. Geog. Argentino, XVII, pp. 219–230.)
 1899. Notas de arqueologia Calchaqui. Buenos Aires.

ANTIGÜEDADES MEXICANAS
 1892. Antigüedades mexicanas. Publicadas por la Junta Colombina de Mexico en el cuarto centenario de descubrimiento de América. Mexico.

ANTIQUITÉS MEXICAINES
 1834. Antiquités mexicaines. Relation des trois expéditions du Capitaine Dupaix ordonnées en 1805, 1806, et 1807 pour la recherche des antiquités du pays, notamment celles de Mitla et de Palenque, etc. 2 vols. Paris.

ANCONA, E.
 1878–1880. Historia de Yucatan desde la època mas remota hasta nuestros dias. 4 vols. Merida.

ARNOLD, C., and FROST, F. J. T.
 1909. The American Egypt: a record of travel in Yucatan. New York.

BATCHELDER, E. A.
 1910. Design in theory and practice. New York.

BANCROFT, H. H.
 1875–1876. The native races of the Pacific States. 5 vols. New York and London.

BANDELIER, A. F.

1884. Report of an archaeological tour in Mexico in 1881. (Papers of Arch. Inst. of America. American Ser., II, Boston, 1884.)

1887. Sources for aboriginal history of Spanish-America. (Proc. A. A. A. S., XXVII, pp. 315–337.)

1892. Final report of investigations among the Indians of the southwestern United States, carried on mainly in the years from 1880 to 1885. Part II. (Papers of the Arch. Inst. of America. American Series, IV, Cambridge.)

BASTIAN, A.

1882. Steinskulpturen aus Guatemala. (Veröffentlichungen der Königlichen Mus. zu Berlin.)

BATRES, L.

1888. Civilización de algunas de las differentes tribus que habitaron el territorio, hoy Mexicano, en la antigüedad. Mexico.

1902, a. Exploraciones de Monte Alban. Mexico.

1902, b. Archaeological explorations in Escalerillas Street, City of Mexico. Year 1900. Mexico.

1903. Visita a los monumentos arqueológicos de "La Quemada," Zacatecas. Mexico.

1905. La lapida arqueológica de Tepatlaxco, Orizaba. Mexico.

1908. Civilización prehistorica de las riberas del Papaloapam y costa de Sotavento, estado de Vera Cruz. Mexico.

BIENVENIDA, L. DE

1877. Carta de Fray Lorenzo de Bienvenida A. S. a El Principe don Felipe dandole cuenta de varios asuntos referentes a la provincia de Yucatan. — 10 de febrero de 1548. (Cartas de Indias, Madrid. pp. 70–82.)

BISHOP, R. H.

1906. Investigations and studies in jade. 2 vols. New York.

BLACKISTON, A. H.

1910, a. Archaeological investigations in Honduras. (Records of the Past, IX, pp. 195–201.)

1910, b. Recent discoveries in Honduras. (Am. Anth. (N. S.), XII, pp. 536–541.)

BOBAN, E.

1891. Documents pour servir a l'histoire du Mexique. Catalogue raisonné de la Collection E. Eugene Goupil. 2 vols. and atlas. Paris.

BOVALLIUS, C.

1886. Nicaraguan antiquities. Stockholm.

1887. Resa i Central-Amerika 1881–1883. 2 vols. Upsala.

BOWDITCH, C. P.

1901, a. Memoranda on the Maya calendars used in the Books of Chilan Balam. (Am. Anth. (N. S.), III, pp. 129–138.)

1901, b. On the age of Maya ruins. (Am. Anth. (N. S.), III, pp. 697–700.)

1901, c. Notes on the report of Teobert Maler, in Memoirs of the Peabody Museum, II, No. 1. Cambridge.

1903, a. Notes on the report of Teobert Maler, in Memoirs of the Peabody Museum, II, No. 2. Cambridge.

1903, b. A suggestive Maya inscription. Cambridge.

1906. The Temples of the Cross, of the Foliated Cross, and of the Sun at Palenque. Cambridge.

1909. Dates and numbers in the Dresden Codex. (Putnam Anniversary Volume, pp. 271–301. New York.)

1910. The numeration, calendar systems and astronomical knowledge of the Mayas. Cambridge.

BRANSFORD, J. F.

1881. Archaeological researches in Nicaragua. (Smithson. Cont. to Knowl., XXV, Art. 2, pp. 1–96.)

BRASSEUR DE BOURBOURG, C. E.

1857–1859. Histoire des nations civilisées du Mexique et de l'Amérique centrale durant les siècles antérieurs à Christophe Colomb. 4 vols. Paris.

1861. Popol Vuh. Le livre sacré et les mythes héroiques et historiques des Quichés, etc. Brussels.

1864. Collection de documents dans les langues indigènes pour servir a l'étude de l'histoire de la philologie de l'Amérique ancienne. III, Paris [contains Landa, 1864, and Pio Perez, 1864].

1866, a. Essai historique sur le Yucatan et description des ruines de Ti-Hoo (Merida) et d'Izamal. (Archives de la Commission Sci. du Mex., II, pp. 18–64.)

1866, b. Rapport sur les ruines de Mayapan et d'Uxmal du Yucatan. (Archives de la Commission Sci. du Mex., II, pp. 234–288.)

1869–1870. Manuscrit Troano. Études sur le système graphique et la langue des Mayas. 2 vols. Paris.

BRETON, A.
 1906, *a.* The wall paintings at Chichen Itza. (Internat. Cong. of Americanists, 15th Sess., Quebec, pp. 165–169.)
 1906, *b.* Some notes on Xochicalco. (Trans. Dept. Arch., Free Mus. Sci. and Art, Univ. of Penn., II, pt. 1, pp. 51–67.)
 1908. Archaeology in Mexico. (Man, VIII, pp. 34–37.)

BRINE, L.
 1894. Travels amongst American Indians, their ancient earthworks and temples, including a journey in Guatemala, Mexico and Yucatan and a visit to the ruins of Utatlan, Palenque and Uxmal. London.

BRINTON, D. G.
 1881. The names of the gods in the Kiche myths, Central America. (Proc. Am. Philosoph. Soc., XIX, pp. 613–647.)
 1882, *a.* American hero myths. A study in the native religions of the western continent. Philadelphia.
 1882, *b.* The Maya chronicles. Philadelphia. (No. 1 of Brinton's Library of Aboriginal American Literature.)
 1882, *c.* The graphic system and ancient records of the Mayas. (U. S. Geog. and Geol. Survey of the Rocky Mountain Region. Cont. to Am. Ethnol., V, No. 3, pp. xvii–xxxvii.)
 1882, *d.* The books of Chilan Balam, the prophetic and historic records of the Mayas of Yucatan. (Penn. Monthly, XIII, pp. 261–275.)
 1885, *a.* The annals of the Cakchiquels. The original text with a translation, notes and introduction. Philadelphia. (No. 6 of Brinton's Library of Aboriginal American Literature.)
 1885, *b.* The lineal measures of the semi-civilized nations of Mexico and Central America. (Proc. Am. Philosoph. Soc., XXII, pp. 194–207.)
 1885, *c.* Did Cortez visit Palenque? (Science, V, p. 248.)
 1885, *d.* The sculptures of Cosumalhualpa. (Science, VI, p. 42.)
 1886, *a.* On the ikonomatic method of phonetic writing, with special reference to American archaeology. (Proc. Am. Philosoph. Soc., XXIII, pp. 503–514.)
 1886 *b.* The phonetic elements in the graphic system of the Mayas and Mexicans. (Am. Antiq., VIII, pp. 347–357.)
 1887. Were the Toltecs an historic nationality? (Proc. Am. Philosoph. Soc., XXIV, pp. 229–241.)
 1887–1889. On the "Stone of the Giants," near Orizaba, Mexico. (Proc. Numis. and Antiq. Soc. of Phila., pp. 78–85.)
 1890. Essays of an Americanist. Philadelphia.
 1894, *a.* On supposed relations between the American and Asian races. (Mem. Internat. Cong. of Anthropology, Chicago, pp. 145–151.)
 1894, *b.* A primer of Mayan hieroglyphics. (Pub. Univ. of Penn., Ser. in Philol., Lit. and Arch. III, No. 2.)
 1896. The battle and ruins of Cintla. (Am. Antiq., XVII, pp. 259–268.)
 1897. The pillars of Ben. (Bull. Free Mus. of Sci. and Art, Univ. of Penn., I, pp. 3–10.)

BRÜHL, G.
 1894. Die Ruinen von Iximche in Guatemala. (Globus, LXVI, pp. 213–217.)

BUSHNELL, D. I.
 1904. The Cahokia and surrounding mound groups. (Papers Peabody Museum, III, No. 1, pp. 1–20.)

BULLETIN 28
 1904. Mexican and Central American antiquities, calendar systems and history. Twenty-four papers by Eduard Seler, E. Förstemann, Paul Schellhas, Carl Sapper and E. P. Dieseldorff. Translated from the German under the supervision of Charles P. Bowditch. (Bull. 28, Bur. Am. Ethnol.)

CARRILLO, C.
 1865. Estudio historico sobre la raza indigena de Yucatan. Vera Cruz.
 1871. Compendio de la historia de Yucatan. Merida.
 1883. Historia antiqua de Yucatan, seguida de la dissertaciones del mismo autor relativos al proprio asunto. Merida.
 1895. El comercio en Yucatan antes del descubrimiento. (Internat. Cong. of Americanists, 11th Sess., Mexico, pp. 203–208.)

CATHERWOOD, F.
 1844. Views of ancient monuments in Central America, Chiapas and Yucatan. Folio. London.

CASARES, D.
 1905. A notice of Yucatan with some remarks on its water supply. (Proc. Am. Antiq. Soc., XVII, pp. 207–230.)

CHARENCY, H. DE
 1871. Le mythe de Votan; étude sur les origines asiatiques de la civilisation américaine. Alençon.

CHARNAY, D.
 1884. Voyage au Yucatan et au pays des Lacandons. (Le Tour du Monde, XLVII, pp. 1–96, and XLVIII, pp. 33–48.)
 1885. Les anciennes villes du nouveau monde. Voyages d'explorations au Mexique et dans l'Amérique Centrale, 1857–1882.
 1887, a. The ancient cities of the New World. Above trans. by J. Gonino and H. S. Conant. London.
 1887, b. Ma dernière expédition au Yucatan. (Le Tour du Monde, LIII, pp. 273–277.)
 1904. Les explorations de Teobert Maler. (Jour. Soc. d'Américanistes de Paris, I (N. S.), pp. 289–308.)
 1906. Les ruines de Tuloom d'après John L. Stephens. (Jour. Soc. d'Américanistes de Paris, III (N. S.), pp. 191–195.)

CHARNAY, D., and VIOLLET-LE-DUC, E.
 1863. Cities et ruines américaines. Paris. One volume and collection of photographs.

CHAVERO, A.
 1884. Mexico a través de los siglos. Tomo I, Historia antiqua y de la Conquista. Barcelona.
 1892. Obras historicas de don Fernando de Alva Ixtlilxochitl. 2 vols. Mexico.
 1900–1901. Pinturas jeroglificas. 2 parts. Mexico.

CODEX BORBONICUS (see Hamy, 1899, a).

CODEX BORGIA (see Loubat, 1898, and Seler, 1904–1909).

CODEX CORTESIANUS (see Rady y Delgado, 1892).

CODEX COLOMBINO (in Antigüedades Mexicanas).

CODEX DRESDEN (see Förstemann, 1880, 1892).

CODEX FEJÉRVÁRY-MAYER (see Loubat, 1901, and Seler, 1901–1902).

CODEX NUTTALL (see Z. Nuttall, 1902).

CODEX PERESIANUS (see Léon de Rosny, 1887 and 1888).

CODEX PORFIRIO DIAS (in Antigüedades Mexicanas).

CODEX TELERIANO-REMENSIS (see Hamy, 1899, b).

CODEX TROANO (see Brasseur de Bourbourg, 1869–1870).

CODEX VATICANUS, No. 3773 (see Loubat, 1896, and Seler, 1902–1903).

CODEX VIENNA (in Kingsborough, 1831–1848).

COGOLLUDO, D. L.
 1688. Historia de Yucathan. Madrid.

COOK, J.
 1769. Remarks on a passage from Balise, in the Bay of Honduras, to Merida, the capital of the province of Yucatan in the Spanish West Indies. . . . in Feb. and March, 1765. London.

COOPER, W. R.
 1873. The serpent myths of ancient Egypt. London.

CORTES, H.
 1868. The fifth letter of Hernan Cortes to the Emperor Charles V, containing an account of his expedition to Honduras. (Trans. by Don Pascual de Gayangos, Hakluyt Soc., London.)
 1908. The five letters of relation from Fernando Cortes to the Emperor Charles V. 2 vols. New York. (Edited by F. A. Mac Nutt.)

CRESSON, H. T.
 1892. The antennae and sting of Yikilcab as components in the Maya day signs. (Science, XX, pp. 77–79.)

CRUZ, F. G.
 1904. Las ruinas de Matarás (antigua Texutla). (Anales del Museo Nacional, San Salvador, I, pp. 436–438.)

CUSHING, F. H.
 1882–1883. A study of pueblo pottery as illustrative of Zuñi culture growth. (4th Rep. Bur. Am. Ethnol., pp. 467–521.)
 1894. Primitive copper working, an experimental study. (Am. Anth., VII, pp. 93–117.)

DIAS DEL CASTILLO, BERNAL
 1803. The true history of the Conquest of Mexico, 1568. (Translated by M. Keating. London.)
 1908. The same, 3 vols. (Translated by A. P. Maudslay. Hakluyt Soc., London.)

DIAS, JUAN.
1838. Itinéraire du voyage de la flotte du Roi Catholique à l'île de Yucatan dans l'Inde. Fait en l'an 1518, sous les ordres du capitaine général Juan de Grijalva. (H. Ternaux-Compans, Voyages, relations et mémoires originaux pour servir à l'histoire de la découverte de l'Amérique. X, pp. 1–47.)

DIESELDORFF, E. P.
1893, a. Ausgrabungen in Coban. (Zeit. für Ethnol., XXV, Verhand., pp. 374–380.)
1893, b. Alte bemalte Thongefässe aus Guatemala. (Zeit. für Ethnol., XXV, Verhand., pp. 547–550.)
1894, a. Ein bemaltes Thongefäss mit figürlichen Darstellungen aus einem Grabe von Chama. (Zeit. für Ethnol., XXVI, Verhand., pp. 372–377. Translated in Bull. 28, Bur. Am. Ethnol., pp. 639–644.)
1894, b. Ein Thongefäss mit Darstellung einer vampyrköpfigen Gottheit. (Zeit. für Ethnol., XXVI, Verhand., pp. 576–577. Translated in Bull. 28, pp. 665–666.)
1895, a. Das Gefäss von Chama. (Zeit. für Ethnol., XXVII, Verhand., pp. 770–776.)
1895, b. Reliefbild aus Chipolem. (Zeit. für Ethnol., XXVII, Verhand., pp. 777–780.)
1895, c. Cuculcan. (Zeit. für Ethnol., XXVII, Verhand., pp. 780–873.)
1905. Jadeite und anderen Schmuck der Mayavölker. (Zeit. für Ethnol., XXXVII, pp. 408–411.)
1909. Klassifizierung seiner archäologischen Funde im nördlichen Guatemala. (Zeit. für Ethnol., XLI, pp. 862–874.)

DITMARS, R. L.
1910. Reptiles of the world. New York.

DURAN, FRAY DIEGO
1880. Historia de las Indias de Nueva España y islas de tierra firma. 2 vols. and atlas. Mexico.

DURUY, V.
1864. Comission scientifique du Mexique. Manuscrit dit Mexicain No. 2, de la Bibliothèque Impériale. Photographié sans reduction par ordre de S. E. M. Duruy, Ministre de l'Instruction publique, etc. Paris. (Reproduced by W. E. Gates, 1909.)

FEWKES, J. W.
1894, a. The snake ceremonials at Walpi. (Jour. Am. Ethnol. and Arch., IV, pp. 7–126.)
1894, b. A study of certain figures in a Maya codex. (Am. Anth., VII, pp. 260–270.)
1895, a. A comparison of Sia and Tusayan snake ceremonials. (Am. Anth., VIII, pp. 118–141.)
1895, b. The god "D" in the Codex Cortesianus. (Am. Anth., VIII, pp. 205–222.)
1903–1904. Certain antiquities of eastern Mexico. (25th Ann. Rep. Bur. Am. Ethnol., pp. 221–284.)
1906. An ancient megalith in Jalapa, Vera Cruz. (Am. Anth., VIII (N. S.), pp. 633–639.)

FÖRSTEMANN, E.
1880. Die Maya-Handschrift der Königlichen Bibliothek zu Dresden. Leipzig. Second edition in 1892.
1887–1898. Zur Entzifferung der Mayahandschriften, I–VII. (The suite of essays is translated into English in Bull. 28, Bur. Am. Ethnol., pp. 393–472.)
1892 (see 1880).
1895. Das mittelamerikanische Tonalamatl. (Globus, LXVII, pp. 283–285. Translated in Bull. 28, pp. 527–533.)
1896. Neue Mayaforschungen. (Globus, LXX, pp. 37–39. Translated in Bull. 28, pp. 537–541.)
1897. Die Kreuzinschrift von Palenque. (Globus, LXXII, pp. 45–49. Translated in Bull. 28, pp. 547–555.)
1899. Aus dem Inschriftentempel von Palenque. (Globus, LXXV, pp. 77–80. Translated in Bull. 28, pp. 575–580.)
1901, a. Commentar zur Mayahandschrift der Königlichen öffentlichen Bibliothek zu Dresden. Dresden. (For translation, see 1906.)
1901, b. Eine historische Maya-Inschrift. (Globus, LXXXI, pp. 150–153.)
1902, a. Commentar zur Madrider Mayahandschrift. Dantzig.
1902, b. Der zehnte Cyclus der Mayas. (Globus, LXXXII, pp. 140–143.)
1903. Commentar zur Pariser Mayahandschrift. Dantzig.
1905. Die Millionenzahlen im Dresdensis. (Globus, LXXXVIII, pp. 126–128.)
1906. Commentary of the Maya manuscript in the Royal Public Library of Dresden. (Pap. Peabody Mus., IV, No. 2, pp. 48–266. Translation of 1901, a.)

FOWKE, G.
1910. Antiquities of central and southeastern Missouri. (Bull. 37, Bur. Am. Ethnol.)

FRIEDERICHSTHAL, E.
1841. Les monuments de l'Yucatan. (Nouvelles Annales des Voyages et des Sciences géographiques. 4th sér., IV, pp. 297–314.)

GANN, T.
1897–1898. Mounds in northern Honduras. (19th Rep. Bur. Am. Ethnol., Pt. 2, pp. 661–692.)

GATES, W. E.
1909. Codex Perez. Maya-Tzendal. Redrawn and slightly restored with the coloring as it originally stood, so far as possible, given on the basis of a new and minute examination of the codex itself. Mounted in the form of the original. Accompanied by a reproduction of the 1864 photographs [see Duruy, 1864]. Point Loma, Cal.
1910. Commentary upon the Maya-Tzental Perez Codex with a concluding note upon the linguistic problem of the Maya glyphs. (Pap. Peabody Mus., VI, No. 1, pp. 5–64.)

GOODMAN, J. T.
1897. The archaic Maya inscriptions. (Part XVIII of Biologia Centrali-Americana, Archaeology, London. See Maudslay, 1889–1902.)
1905. Maya dates. (Am. Anth. (N. s.), VII, pp. 642–647.)

GONZALES, D.
1906. Arqueología Salvadoreña. Ruinas de Tehuacan. (Anales del Museo Nacional, San Salvador, III, pp. 45–49.)

GORDON, G. B.
1896. Prehistoric ruins of Copan, Honduras. A preliminary report of the explorations by the Museum, 1891–1895. (Mem. Peabody Mus., I, No. 1, pp. 1–48.)
1898, a. Researches in the Uloa Valley, Honduras. Report on explorations by the Museum, 1896–1897. (Mem. Peabody Mus., I, No. 4, pp. 1–44.)
1898, b. Caverns of Copan, Honduras. Report on explorations by the Museum, 1896–1897. (Mem. Peabody Mus., I, No. 5, pp. 1–12.)
1902, a. The hieroglyphic stairway ruins of Copan. Report on explorations by the Museum. (Mem. Peabody Mus., I, No. 6, pp. 1–38.)
1902, b. On the interpretation of a certain group of sculptures at Copan. (Am. Anth., IV (N. s.), pp. 130–143.)
1902, c. On the use of zero and twenty in the Maya time system. (Am. Anth. IV. (N. s.), pp. 237–275.)
1904. Chronological sequence in the Maya ruins of Central America. (Trans. Dept. of Arch. Univ. of Penn., I, No. 1, pp. 61–66.)
1905. The serpent motive in the ancient art of Central America and Mexico. (Trans. Dept. of Arch. Univ. of Penn., I, No. 3, pp. 131–163.)
1907. An engraved bone from Ohio. (Trans. Dept. of Arch., Univ. of Penn., II, pp. 103–104.)
1909. Conventionalism and realism in Maya art at Copan. (Putnam Anniversary Volume. New York, pp. 193–197.)

GUZMAN, D. J.
1904. Arqueología Salvadoreña. (Anales del Museo Nacional, San Salvador, I, pp. 381–385.)

HABEL, S.
1878. The sculptures of Santa Lucia Cosumalwhuapa in Guatemala with an account of travels in Central America and on the west coast of South America. (Smithson. Cont. to Knowl., XXII, Art. III, pp. 1–90.)

HAMY, E. T.
1875. Quelques observations ethnologiques au sujet de deux microcéphales américains désignés sous le nom d'Aztèques. (Bull. Soc. d'Anth. de Paris, X, 2e sér., pp. 39–54.)
1878. Les premiers habitants du Mexique. (Rev. d'Anth., I, 2e sér., pp. 56–65.)
1882. Mutilations dentaires des Huaxtèques et des Mayas. (Bull. Soc. d'Anth. de Paris, V, 3e sér., pp. 879–885.)
1896. Étude sur les collections américaines réunies à Gênes à l'occasion du IVe centenaire de la découverte de l'Amérique. (Jour. Soc. Américanistes de Paris, I, pp. 1–31.)
1897. Galerie américaine du Musée d'ethnographie au Trocadéro. Choix de pièces archéologiques et ethnographiques, décrites et figurées. Paris.
1898. Note sur une figurine Yucatèque de la collection Boban-Pinart au Musée d'Ethnographie du Trocadéro. (Jour. Soc. Américanistes de Paris, II, pp. 105–108.)
1899, a. Codex Borbonicus. Manuscrit mexicain de la Bibliothèque du Palais-Bourbon, publié en fac-similé, avec un commentaire explicatif. Paris.
1899, b. Codex Telleriano-Remensis. Manuscrit mexicain du cabinet de Ch. M. Le Tellier, archevêque de Reims, aujourd'hui à la Bibliothèque National (MS. Mexicain, No. 385), reproduit en photochromographie, etc. Paris.

HARTMANN, C. V.
> 1907. Archaeological researches on the Pacific coast of Costa Rica. (Mem. Carnegie Inst., III, pp. 1–95.)

HERRERA, A. DE
> 1726–1730, Historia general de los hechos de los Castellanos en las islas i tierra fierma del Mar oceano. 5 vols. Madrid.

HEWITT, J. N. B.
> 1889. Serpent symbolism. (Am. Anth., II, pp. 179–180.)

HOLMES, W. H.
> 1880–1881. Art in shell of the ancient Americans. (2nd Rep. Bur. Am. Ethnol., pp. 179–305.)
> 1882–1883. Ancient pottery of the Mississippi Valley. (4th Rep. Bur. Am. Ethnol., pp. 361–436.)
> 1884. Antiquity of man on the site of the City of Mexico. (Trans. Anth. Soc. of Washington, III, pp. 68–81.)
> 1887. The use of gold and other metals among the ancient inhabitants of Chiriqui, Panama. (Bull., No. 3, Bur. Am. Ethnol.)
> 1895–1897. Archaeological studies among the ancient cities of Mexico. (Field Columbian Museum, Anth. Ser., I, pts. 1 and 2.)
> 1898–1899. Ancient pottery of the eastern United States. (20th Rep. Bur. Am. Ethnol., pp. 1–201.)
> 1903. Shell ornaments from Kentucky and Mexico. (Smithson. Misc. Coll., XLV, pp. 97–99.)
> 1907. On a nephrite statuette from San Andrés Tuxtla, Vera Cruz, Mexico. (Am. Anth., IX (N. S.), pp. 691–701.)

HOWE, G. P.
> 1911. The ruins of Tuloom. (Am. Anth. (N. S.), XIII, pp. 539–550.)

KERBER, E.
> 1882. Eine alte mexikanische Ruinenstätte bei S. Andrés Tuxtla. (Zeit für Ethnol., XIV, Verhand., pp. 488–489.)

KINGSBOROUGH, LORD
> 1831–1848. Antiquities of Mexico. 9 vols., folio. London.

KUNZ, G. F.
> 1906. New observations on the occurrences of precious stones of archaeological interest in America. (Internat. Cong. of Americanists, 15th Sess., Quebec, pp. 289–305.)
> 1907. Precious stones of Mexico. Mexico.

LANDA, D. DE
> 1864. Relacion de los cosas de Yucatan. This edition by Brasseur de Bourbourg is the one referred to in the text. A later edition appears in Relaciones de Yucatan, II, pp. 264–408.

LEEMANS, C.
> 1877. Description de quelques antiquités américaines conservées dans le Musée Royal Néerlandais d'Antiquités à Leide. (Internat. Cong. of Americanists, 2nd Sess., Luxembourg, II, pp. 283–302.)

LEHMANN, W.
> 1905, a. Les peintures Mixteco-Zapotèques et quelques documents apparentés. (Jour. Soc. de Américanistes de Paris, II (N. S.), pp. 241–280.)
> 1905, b. Altmexikanische Muschelzierate in durchbrochener Arbeit. (Globus, LXXXVIII, pp. 285–288.)
> 1909. Methods and results in Mexican research. Translation into English by Seymour de Ricci. Paris. (Originally published in Archiv. für Anth., VI, pp. 133–168.)
> 1910. Ergebnisse einer Forschungsreise in Mittelamerika und Mexico, 1907–1909. (Zeit. für Ethnol., XLII, pp. 687–749.)

LE PLONGEON, A.
> 1878. Archaeological communication on Yucatan. (Proc. Am. Antiq. Soc., Oct. 21, pp. 65–75.)
> 1881. Mayapan and Maya inscriptions. (Proc. Am. Antiq. Soc., I (N. S.), pp. 246–281.)
> 1886. Sacred mysteries among the Mayas and Quiches, etc. New York.
> 1896. Queen Moo and the Egyptian Sphinx. New York.

LIZANA, B. DE
> 1893. Historia de Yucatán. Devocionario de Ntra Sra de Itzmal y conquista espiritual. Valladolid, 1633. (Reprint by Museo Nacional de Mexico. Mexico.)

LOUBAT, DUC DE
> 1896. Il manoscritto Messicano Vaticano 3773. Rome.

LOUBAT, DUC DE — *continued.*

1898. Il manoscritto Borgeano del Museo Ethnografico della S. Congregazione di Propaganda Fide. Rome.

1901. Codex Fejérváry-Mayer, Manuscrit mexicain precolombien des Free Public Museums de Liverpool. Paris.

LUMHOLTZ, C.

1902. Unknown Mexico. 2 vols. New York.

1909. A remarkable ceremonial vase from Cholula, Mexico. (Am. Anth. (N. S.), XI, pp. 199–201.)

MACCURDY, G. G.

1911. A study of Chiriquian antiquities (Mem. Connecticut Acad. of Arts and Sci., III.)

MALER, T.

1895. Yukatekische Forschungen. (Globus, LXVIII, pp. 247–259 and 277–292.)

1901. Researches in the central portion of the Usumatsintla Valley. (Mem. Peabody Mus., II, No. 1, pp. 9–75.)

1902. Yukatekische Forschungen. (Globus, LXXXII, pp. 197–230.)

1903. Researches in the central portion of the Usumatsintla Valley. Part second. (Mem. Peabody Mus., II, No. 2, pp. 83–208.)

1908, *a.* Explorations of the upper Usumatsintla and adjacent region. (Mem. Peabody Mus., IV, No. 1, pp. 1–51.)

1908, *b.* Explorations in the Department of Peten, Guatemala, and adjacent region. (Mem. Peabody Mus., IV, No. 2, pp. 55–127.)

1910. Explorations in the Department of Peten, Guatemala, and adjacent regions, continued. (Mem. Peabody Mus., IV, No. 3, pp. 131–170.)

1911. Explorations in the Department of Peten, Guatemala. Tikal. (Mem. Peabody Mus., V, No. 1, pp. 3–91.)

MARTINEZ, J.

1910. Los grandes ciclos de la historia maya según el Manuscrito de Chumayel. Merida.

MAUDSLAY, A. P.

1883. Explorations in Guatemala and examination of the newly discovered Indian ruins of Quirigua, Tikal and the Usumacinta. (Proc. Roy. Geog. Soc., V (N. S.), pp. 185–204.)

1886. Explorations of the ruins and site of Copan, Central America. (Proc. Roy. Geog. Soc., VIII (N. S.), pp. 568–595.)

1889–1902. Biologia Centrali-Americana, or contributions to the knowledge of the flora and fauna of Mexico and Central America. Archaeology, 4 vols. of text and plates. London.

1897–1898. A Maya calendar inscription interpreted by Goodman's Tables. (Proc. Roy. Soc. of London, LXII, pp. 67–80.)

1908. (See Dias del Castillo.)

MAUDSLAY, A. C., and A. P.

1899. A glimpse at Guatemala and some notes on the ancient monuments of Central America. London.

MERCER, H. C.

1896. The hill caves of Yucatan. Philadelphia.

1897. The kabal, or potter's wheel of Yucatan. (Bull. Free Mus. Sci. and Art, Univ. of Penn., I, pp. 63–70.)

MEYE, H., and SCHMIDT, J.

1883. The stone sculptures of Copan and Quirigua. (Translation by A. D. Savage.) New York.

MEYER, A. B.

1882. Jadeit- und Nephrit-Objecte aus Amerika und Europa. (Publikationen Königliches Ethnographisches Museum zu Dresden, III. Leipzig.)

MOLINA SOLIS, J. F.

1897. Historia del descubrimiento y conquista de Yucatan con una reseña de la historia antigua de esta peninsula. Merida.

MOORE, C. C.

1899. Certain aboriginal remains of the Alabama River. (Jour. Acad. Nat. Sci. of Philadelphia, XI, pp. 289–347.)

1901. Certain aboriginal remnants of the northwest Florida coast. (Jour. Acad. Nat. Sci. of Philadelphia, XI, pp. 421–497.)

1905. Certain aboriginal remains of the Black Warrior River. (Jour. Acad. Nat. Sci. of Philadelphia, XIII, pp. 125–244.)

1907. Moundeville revisited. (Jour. Acad. Nat. Sci. of Philadelphia, XIII, pp. 337–405.)

MOORE, C. C., and others
1903. Sheet-copper from the mounds is not necessarily of European origin. (Am. Anth. (N. S.), V, pp. 27–54.)

MORELET, A.
1857. Voyage dans l'Amérique Centrale, l'Île de Cuba et le Yucatan. Paris.

MORLEY, S. G.
1909. The inscriptions at Naranjo, northern Guatemala. (Am. Anth. (N. S.), XI, pp. 543–562.)
1910, a. A group of related structures at Uxmal, Mexico. (Am. Jour. Arch., 2nd Ser., XIV, pp. 1–18.)
1910, b. Correlation of Maya and Christian chronology. (Am. Jour. Arch., 2nd Ser., XIV, pp. 193–204.)
1911. The historical value of the Books of Chilan Balam. (Am. Jour. Arch., 2nd Ser., XV, pp. 195–214.)
1912. Quirigua, an American town 1400 years old. (Scientific American, CVII, Aug. 3, pp. 96–97 and 105.)

MULLER, FREDERICK, editor
1871. Trois lettres sur la découverte du Yucatan et les merveilles de ce pays. — Ecrités par des compagnons de l'expédition sous Jean de Grivalja [Grijalva], Mai 1518. Amsterdam.

NORMAN, B. M.
1843. Rambles in Yucatan; or notes of travel through the peninsula, including a visit to the remarkable ruins of Chi-chen, Kabah, Zayi and Uxmal. New York.

NUTTALL, Z.
1886. The terra cotta heads of Teotihuacan. (Am. Jour. Arch., II, pp. 157–178, 318–330.)
1901, a. The fundamental principles of old and new world civilizations. (Papers Peabody Mus., II.)
1901, b. Chalchihuitl in ancient Mexico. (Am. Anth. (N. S.), III, pp. 227–238.)
1902. Codex Nuttall. (Publication of the Peabody Museum.)
1910. The island of Sacrificios. (Am. Anth. (N. S.), XII, pp. 257–295.)

OPPER, A.
1896. Die altmexikanischen Mosaiken. (Globus, LXX, pp. 4–15.)

OROZCO Y BERRA, M.
Historia antigua y de la conquista de México. 4 vols. Mexico.

OVIEDO Y VALDÉS
1851–1854. La historia general de las Indias. 4 vols. Madrid.

PARRY, F.
1893. The sacred Maya stone of Mexico and its symbolism. London.

PECTOR, D.
1888. Indication approximative de vestiges laissés par les populations précolombiennes du Nicaragua. (Archives Soc. Américaine de France, 2nd Ser., VI, pp. 97–125 and 145–178.)

PEÑAFIEL, A.
1885. Nombres geográficos de Mexico. Mexico.
1890. Monumentos del arte Mexicano antiguo. 3 vols. Berlin.
1897. Nomenclatura geografica de Mexico. Mexico.
1899. Teotihuacan. Estudio histórico y arquelógico. Mexico.
1903. Indumentaría antigua. Vestidos guerreros y civiles de los Mexicanos. Mexico.
1910. Destruccion del templo mayor de Mexico antiguo y los monumentos encontrados en la ciudad, en la excavaciones de 1897 y 1902. Mexico.

PEREZ, J. PIO.
1864. Chronologia antigua de Yucatan y examen del metodo con que los Indios contaban el Tiempo; sacada de varios documentos antiguos. (In Brasseur de Bourbourg, 1864, pp. 366–429.)

PÉRIGNY, M. DE
1908. Yucatan inconnu. (Jour. Soc. des Américanistes, V (N. S.), pp. 67–98.)
1910. Les ruines de Nakcun. (Acad. des Insc. et Belles Lettres. Comptes rendus des séances. Bull., pp. 485–489.)

POPUL VUH (see Brasseur de Bourbourg, 1861)

PREUSS, K. TH.
1901. Kosmische Hieroglyphen der Mexikaner. (Zeit. für Ethnol., XXXIII, pp. 1–47.)

PRIETO, A.
1873. Historia, geografia y estadistica del estado de Tamaulipas. Mexico.

PUTNAM, F. W.
 1887. Conventionalism in ancient American art. (Bull. Essex Inst., XVIII, pp. 155–167.)

PUTNAM, F. W. AND WILLOUGHBY, C. C.
 1895. Symbolism in ancient American Art. (Proc. A. A. A. S., XLIV, pp. 302–322.)

RADY Y DELGADO, JUAN DE DIOS DE LA
 1892. Códice Maya denominado Cortesiano que se conserva en el Museo Arqueológico Nacional. Reproducción fotocromolitográfica ordenada en la misina forma que el original. Madrid.

RELACION BREVE
 1872. Relacion breve y verdadera de algunas cosas de las muchas que sucedieron al Padre Fray Alonzo Ponce, Commissario General, en las provincias de Nueva España. (Coleccion de documentos inéditos para la historia de España. LVII and LVIII. Madrid.)

RELACION DE LOS CONQUISTADORES
 1870. Relacion de los conquistadores y pobladores que habia en la provincia de Yucatan, en la ciudad de Mérida. 25 de Julio de 1551. (Coleccion de documentos ineditos relativos al descubrimiento, conquista y organizacion de las antiguas posesiones españolas en América y Oceania, sacados de los Archivos del Reino y muy especialmente del de Indias. Madrid, XIV, pp. 191–201.)

RELACIONES DE YUCATAN
 1900. Relaciones histórico-geográficas de las provincias de Yucatan. 2 vols. Madrid. (Coleccion de documentos ineditos relativos al descubrimiento, conquista y organizacion de las antiguas posesiones españolas de Ultramar. 2nd Ser., XI and XIII.)

RIO, ANTONIO DEL
 1822. Description of the ruins of an ancient city, discovered near Palenque in the kingdom of Guatemala in Central America. London.

ROBELO, C. A.
 1905. Diccionario de mitologia Nahoa. Mexico.

ROSNY, LÉON DE
 1876. Essai sur le déchiffrement de l'écriture hiératique de l'Amérique Centrale. Paris.
 1882. Les documents écrits de l'antiquité américaine. Compte-rendu d'une mission scientifique en Espagne et en Portugal. Paris.
 1883. Codex Cortesianus. Manuscrit hiératique des anciens Indiens d'Amérique Centrale, conservé au Musée Archéologique de Madrid, photographié pour la première fois avec un introduction et un vocabulaire de l'écriture hiératique yucatèque. Paris.
 1887. Codex Peresianus, manuscrit hiératique des anciens Indiens de l'Amérique Centrale conservé à la Bibliothèque Nacional de Paris, avec un introduction. Paris.
 1888. Codex Peresianus (edition in black and white).

ROSS, D. W.
 1901. Design as a science. (Proc. Am. Acad. Arts and Sci., XXXVI, No. 21, pp. 357–374.)
 1907. A Theory of pure design: harmony, balance, rhythm; with illustrations and diagrams. Boston.

ROVIROSA, J. N.
 1897. Ensayo histórico sobre el Rio Grijalva. Mexico.

SAHAGUN, BERNADINO DE
 1880. Histoire générale des choses de la Nouvelle-Espagne. (Edited and translated by D. Jourdanet and Rémi Siméon.)

SALISBURY, S.
 1876. The Mayas, the sources of their history. Dr. Le Plongeon in Yucatan, his account of discoveries. (Proc. Am. Antiq. Soc., April, pp. 16–61.)
 1877. Dr. Le Plongeon in Yucatan. The discovery of the statue called Chac-mol and the communications of Dr. Le Plongeon concerning explorations in the Yucatan Peninsula. (Proc. Am. Antiq. Soc., April, pp. 54–103.)
 1878. Terra cotta figure from Isla Mujeres, northeast coast of Yucatan. (Proc. Am. Antiq. Soc., April, pp. 71–89.)

SANCHEZ, J.
 1877. Estudio acerca de la estatua llamada Chac-Mool ó Rey Tigre. (Anales del Museo Nacional, I, pp. 270–278.)

SAPPER, C.
 1895, a. Altindianische Ansiedlungen in Guatemala und Chiapas. (Veröffentlichungen aus dem Königlichen Museum für Völkerkunde, IV, pp. 13–20 and tables 1–10.)

SAPPER, C. — *continued*

1895, *b*. Die unabhängigen Indianerstaaten von Yucatan. (Globus, LXVII, pp. 197–201. Translated in Bull. 28, Bur. Am. Ethnol., pp. 625–634.)

1895, *c*. Altindianische Siedelungen und Bauten im nördlichen Mittel-amerika. (Globus, LXVIII, pp. 165–169, 183–189. Translated in Smithson. Rep., 1895, pp. 537–555. References are to the translation.)

1896. Sobre la geografía física y la geología de la península de Yucatán. (Bol. Inst. Geol. de Mexico, No. 3.)

1897. Das nördliche Mittel-Amerika nebst einem Ausflug nach dem Hochland von Anahuac. Reisen und Studien aus den Jahren 1888–1895. Braunschweig.

1902. Mittelamerikanische Reisen und Studien aus den Jahren 1888 bis 1900. Braunschweig.

1905. Der gegenwärtige Stand der ethnographischen Kenntnis von Mittelamerika. (Archiv für Anth., III (N. S.), pp. 1–38.)

SAVILLE, M. H.

1892. Explorations on the Main Structure at Copan, Honduras. (Proc. A. A. A. S., XLI, pp. 271–275.)

1894. The plumed serpent in northern Mexico. (The Archaeologist, II, pp. 291–293.)

1897. An ancient figure of terra cotta from the valley of Mexico. (Bull. Am. Mus. Nat. Hist., IX, pp. 221–224.)

1900, *a*. A shell gorget from the Huasteca, Mexico. (Bull. Am. Mus. Nat. Hist., XIII, pp. 99–103.)

1900, *b*. An onyx jar from Mexico, in process of manufacture. (Bull. Am. Mus. Nat. Hist., XIII, pp. 105–107.)

1909. The cruciform structures of Mitla and vicinity. (Putnam Anniversary Volume, pp. 151–191. New York.)

SCHELLHAS, P.

1890. Vergleichende Studien auf dem Felde der Maya Alterthümer. (Internat. Archiv für Ethnog., III, pp. 209–231. Translated in Bull. 28, Bur. Am. Ethnol., pp. 595–622.)

1904. Representation of deities of the Maya manuscripts. 2nd edition revised. (Translated by Miss Selma Wesselhoeft and Miss A. M. Parker, Pap. Peabody Museum, IV, No. 1, pp. 7–47.)

SELER, C.

1900. Auf alten Wegen in Mexiko und Guatemala. Berlin.

1904. Zur Tracht der mexikanischen Indianer. (Internat. Cong. of Americanists, 14th Sess., Stuttgart, pp. 419–426.)

SELER, E.

1886. Maya-Handschriften und Maya-Götter. (Zeit. für Ethnol., XVIII, Verhand., pp. 416–420. Reprinted with additions in 1902–1908, I, pp. 357–366.)

1887. Ueber die Namen der in der Dresdener Handschrift abgebildeten Maya-Götter. (Zeit. für Ethnol., XIX, Verhand., pp. 224–231. Reprinted in 1902–1908, I, pp. 367–389.)

1888, *a*. Die Ruinen von Xochicalco. (Zeit. für Ethnol., XX, Verhand., pp. 94–111. Reprinted in 1902–1908, II, pp. 128–167.)

1888, *b*. Die alten Ansiedelungen im Gebiete der Huaxteca. (Zeit. für Ethnol., XX, Verhand., pp. 451–459. Reprinted in 1902–1908, II, pp. 168–183.)

1888, *c*. Die archäologischen Ergebnisse meiner ersten mexikanischen Reise. (Internat. Cong. of Americanists, 7th Sess., Berlin, pp. 111–145. Reprinted in enlarged form, 1902–1908, II, pp. 289–367.)

1889. Die Chronologie der Cakchiquel-Annalen. (Zeit. für Ethnol., XXI, Verhand., pp. 475–476. Reprinted in 1902–1908, I, pp. 504–505.)

1890. L'orfévrerie des anciens Mexicains et leur art de travailler la pierre et de faire des ornaments en plumes. (Internat. Cong. of Americanists, 8th Sess., Paris, pp. 401–452. Reprinted in 1902–1908, II, pp. 620–663.)

1892, *a*. Some remarks on Prof. Cyrus Thomas' brief study of the Palenque tablet. (Science, XX, pp. 38–39. Reprinted in 1902–1908, I, pp. 555–556.)

1892, *b*. Does there really exist a phonetic key to the Maya hieroglyphic writing? (Science, XX, pp. 121–122. Reprinted in 1902–1908, I, pp. 562–567.)

1893. Is the Maya hieroglyphic writing phonetic? (Science, XXI, pp. 6–10. Reprinted in 1902–1908, I, pp. 568–576.)

1894. Der Fledermausgott der Maya-Stämme. (Zeit. für Ethnol., XXXVI, Verhand., pp. 577–585. Reprinted in 1902–1908, II, pp. 641–652. Translated in Bull. 28, Bur. Am. Ethnol., pp. 233–241.)

1895, *a*. Die wirkliche Länge des Katun's der Maya-Chroniken und der Jahresanfang in der Dresdener Handschrift und auf den Copan-Stelen. (Zeit. für Ethnol., XXVII, Verhand., pp. 441–449. Reprinted in 1902–1908, I, pp. 577–587.)

SELER, E. — *continued*

1895, *b*. Bedeutung des Maya-Kalenders für die historische Chronologie. (Globus, LXVIII, pp. 37–41. Reprinted in 1902–1908, I, pp. 588–599. Translated in Bull. 28, pp. 327–337.)

1895, *c*. Wandmalereien von Mitla. Eine Mexikanische Bilderschrift in Fresko, folio. Berlin. (Translated in Bull. 28, pp. 247–324.)

1895, *d*. Alterthümer aus Guatemala. (Veröffentlichungen aus dem Königlichen Museum für Völkerkunde, Berlin, IV, pp. 21–53. Reprinted with additional plates, 1902–1908, III, pp. 578–640. Translated in Bull. 28, pp. 77–121.)

1895, *e*. Das Gefäss von Chamá. (Zeit. für Ethnol., XXVII, Verhand., pp. 307–320. Reprinted in 1902–1908, III, pp. 653–669. Translated in Bull. 28, pp. 651–664.)

1895, *f*. Alterthümer aus der Vera Paz. (Ethnol. Notizblatt, I, No. 2, pp. 20–26. Reprinted in 1902–1908, III, pp. 670–687.)

1898, *a*. Die Venusperiode in den Bilderschriften der Codex Borgia-Gruppe. (Zeit. für Ethnol., XXX, Verhand., pp. 346–383. Reprinted in 1902–1908, I, pp. 618–667. Translated in Bull. 28, pp. 355–391.)

1898, *b*. Quetzalcouatl-Kukulcan in Yucatan. (Zeit. für Ethnol., XXX, pp. 377–410. Reprinted in 1902–1908, I, pp. 668–705.)

1899. Die Monumente von Copan und Quiriguá und die Altarplatten von Palenque. (Zeit. für Ethnol., XXXI, Verhand., pp. 670–738. Reprinted in 1902–1908, I, pp. 712–791.)

1900. Einiges mehr über die Monumente von Copan und Quiriguá. (Zeit. für Ethnol., XXXII, Verhand., pp. 188–227. Reprinted in 1902–1908, I, pp. 792–836.)

1900–1901. The tonalamatl of the Aubin Collection, an old Mexican picture manuscript in the Paris National Library. Introduction and explanatory text. Berlin and London. English translation by A. H. Keane.

1901, *a*. Die Cedrela-Holzplatten von Tikal im Museum zu Basel. (Zeit. für Ethnol., XXXIII, pp. 101–126. Reprinted in 1902–1908, I, pp. 837–862.)

1901, *b*. Die Ausgrabungen am Orte des Haupttempels in México. (Mittheil. der Anthrop. Gesellschaft in Wien, XXXI, pp. 113–137. Reprinted with additions in 1902–1908, II, pp. 767–904.)

1901, *c*. Die alten Ansiedelungen von Chaculá im Districkte Nenton des Departments Huehuetenango der Republik Guatemala. Berlin.

1901–1902. Codex Fejérváry-Mayer, an old Mexican picture manuscript in the Liverpool Free Public Museums. Berlin and London. English translation by A. H. Keane.

1902–1903. Codex Vaticanus, No. 3773. (Codex Vaticanus B), an old Mexican pictorial manuscript in the Vatican Library. Berlin and London. English translation by A. H. Keane.

1902–1908. Gesammelte Abhandlungen zur amerikanischen Sprach- und Alterthumskunde. 3 vols. Berlin.

1904. Die Alterthümer von Castillo de Teayo. (Internat. Cong. of Americanists, 14th Sess., Stuttgart, pp. 263–304. Reprinted in 1902–1908, III, pp. 410–449.)

1904–1909. Codex Borgia. Eine altmexikanische Bilderschrift der Bibliothek der Congregatio de Propaganda Fide. 3 vols. Berlin.

1906, *a*. Eine Steinfigur aus der Sierra von Zacatlan. (Boas Anniversary Volume, New York, pp. 299–305. Reprinted in 1902–1908. III, pp. 537–542.)

1906, *b*. Die Monumente von Huilocintla im Canton Tuxpan des Staates Vera Cruz. (Internat. Cong. of Americanists, 15th Sess., Quebec, II, pp. 381–389. Reprinted in 1902–1908, III, pp. 514–521.)

1906, *c*. Einige fein bemalte alte Thongefässe der Dr. Sologuren'schen Sammlung aus Nochistlan und Cuicatlan im Staate Oaxaca. (Internat. Cong. of Americanists, 15th Sess., Quebec, II, pp. 391–403. Reprinted in 1902–1908, III, pp. 522–532.)

1906, *d*. Studien in den Ruinen von Yucatan. (Internat. Cong. of Americanists, 15th Sess., Quebec II, pp. 414–422. Reprinted in 1902–1908, III, pp. 710–717.)

1908. Die Ruinen von Chich'en Itzá in Yucatan. (Internat. Cong. of Americanists, 16th Sess., Vienna, pp. 151–239.)

1909–1910. Die Tierbilder der Mexicanischen und der Maya-Handschriften. (Zeit. für Ethnol., XLI, pp. 209–257, 381–457, 784–846; XLII, pp. 31–97, 242–287.)

1911, *a*. Die Stuckfassade von Acanceh in Yucatan. (Sitzungsberichte Königl. Preussischen Akad. d. Wissenschaften, XLVII, pp. 1011–1025.)

1911, *b*. Brief aus Mexico. (Zeit. für Ethnol., XLIII, pp. 310–315.)

1912. Archäologische Reise in Süd- und Mittel-Amerika. (Zeit. für Ethnol., XLIV, pp. 200–242.)

SPENCE, L.

1908. The Popul Vuh. The mythic and heroic sagas of the Kichés of Central America. London. (No. 16 of Popular Studies in Mythology, Romance and Folklore.)

SPINDEN, H. J.

1910. Table showing the chronological sequence of the principal monuments of Copan, Honduras. (Pub. by Am. Mus. Nat. Hist.)

1911. An ancient sepulcher at Placeres del Oro, State of Guerrero, Mexico. (Am. Anth. (N. S.), XIII, pp. 29–55.)

SQUIER, E. G.

1850. Ancient monuments in the islands of Lake Nicaragua. (Supplement to the "Literary World," March 9.)

1851. The serpent symbol, and the worship of the reciprocal principles of nature in America. New York.

1852. Nicaragua: its people, scenery, etc. 2 vols. London.

1853. Ruins of Tenampua, Honduras, Central America. (Proc. Hist. Soc. of New York, Oct. — Letter dated Comayagua, Honduras, June 18, 1853.)

1858. The States of Central America: their geography, topography, climate, population, etc. New York.

1870. Observations on a collection of chalchihuitls from Mexico and Central America. (Ann. Lyceum of Nat. Hist., New York, IX, pp. 246–265.)

1877. Peru. Narrative of travel and exploration in the land of the Incas. New York and London.

STARR, F.

1896. A shell gorget from Mexico. (Proc. Davenport Acad. of Nat. Sci., VI, pp. 173–178.)

1898. A shell inscription from Tula, Mexico. (Proc. Davenport Acad. of Nat. Sci., VII, pp. 108–110.)

1900-1904. Notes upon the ethnography of southern Mexico. (Proc. Davenport Acad. of Nat. Sci., VIII, pp. 102–188 and IX, pp. 63–172.)

STEPHENS, J. L.

1841. Central America, Chiapas and Yucatan. 2 vols. New York.

1843. Incidents of travel in Yucatan. 2 vols. New York.

STOLL, O.

1889. Die Ethnologie der Indianerstämme von Guatemala. (Internat. Archiv für Ethnog., I, Supplement.)

STREBEL, H.

1884. Die Ruinen von Cempoallan im Staate Veracruz und Mitteilungen über die Totonaken der Jetztzeit. (Abhandl. aus dem Gebiete der Naturwissenschaften, Naturwissenschaftl. Verein in Hamburg, VIII, pp. 1–40.)

1885–1889. Alt-Mexico. Archäologische Beiträge zur Kulturgeschichte seiner Bewohner. 2 vols. Hamburg and Leipzig.

1893. Die Stein-Sculpturen von Santa Lucia Cozumalhualpa, Guatemala, in Museum für Völkerkunde. (Jahrbuch der Hamburgischen Wissenschaftlichen Anstalten, XI, pp. 105–120. Translated in Rep. Smithson. Inst. for 1899, pp. 549–562.)

1899. Ueber Tierornamente auf Thongefässen aus Alt-Mexico. (Veröffentlichungen aus dem Königlichen Museum für Völkerkunde, IV, pp. 1–28.)

1904. Ueber Ornamente auf Thongefässen aus Alt-Mexico. Mit Unterstützung des Naturwissenschaftlichen Vereins in Hamburg. Hamburg and Leipzig.

THOMAS, C.

1881–1882. Notes on certain Maya and Mexican Manuscripts. (3rd Ann. Rep. Bur. Am. Ethnol., pp. 1–65.)

1882. A study of the Manuscript Troano. (U. S. Geog. and Geol. Survey of the Rocky Mt. Region. Cont. to Am. Ethnol., V, pp. 1–224.)

1884–1885. Aids to the study of the Maya codices. (6th Am. Rep. Bur. Am. Ethnol., pp. 259–371.)

1885. Palenque visited by Cortez. (Science, V, pp. 171–172.)

1890–1891. Report of the mound explorations of the Bureau of Ethnology. (12th Am. Rep. Bur. Am. Ethnol.)

1892. Key to the Maya hieroglyphs. (Science, XX, pp. 44–46.)

1893. Are the Maya hieroglyphics phonetic? (Am. Anth., VI, pp. 241–270.)

1894–1895. Day symbols of the Maya year. (16th Ann. Rep. Bur. Am. Ethnol., pp. 205–265.)

1897–1898. Mayan calendar systems. (19th Ann. Rep. Bur. Am. Ethnol., pp. 693–819.)

1900–1901. Mayan calendar systems II. (22nd Ann. Rep. Bur. Am. Ethnol., pp. 203–303.)

THOMPSON, E. H.

1887. A ruin at Labna. (Proc. Am. Antiq. Soc., V (N. S.), pp. 9–11.)

1888. Ruins of Kich-Moo and Chun-kat-cin. (Proc. Am. Antiq. Soc., V (N. S.), pp. 161–170.)

THOMPSON, E. H. — *continued*

1892, *a.* The ancient structures of Yucatan not communal dwellings. (Proc. Am. Antiq. Soc., VIII (N. S.), pp. 262–269.)

1892, *b.* Yucatan at the time of the discovery. (Proc. Am. Antiq. Soc., VIII (N. S.), pp. 270–273.)

1897, *a.* Cave of Loltun, Yucatan. Report of explorations by the Museum, 1888–1889 and 1890–1891. (Mem. Peabody Mus., I, No. 2, pp. 1–24.)

1897, *b.* The chultunes of Labna, Yucatan. Report of explorations by the Museum, 1888–1889 and 1890–1891. (Mem. Peabody Mus., I, No. 3, pp. 1–20.)

1898. Ruins of Xkichmook, Yucatan. (Field Columbian Mus. Anth. Ser. II, pp. 211–223.)

1902. Water-colors of the Maya. (Am. Mus. Jour., II, No. 9, p. 91.)

1904. Archaeological researches in Yucatan. Report of explorations for the Museum. (Mem. Peabody Mus., III, No. 1, pp. 3–20.)

1911. The genesis of the Maya arch. (Am. Anth. (N. S.), XIII, pp. 501–516.)

TOZZER, A. M.

1907. A comparative study of the Mayas and Lacandones. New York.

1910. (With G. M. ALLEN.) Animal figures in the Maya Codices. (Papers, Peabody Museum, IV, No. 3.)

1911. Preliminary study of the Ruins of Tikal. (Memoirs, Peabody Museum, V, No. 2.)

UHLE, M.

1889. Ausgewählte Stücke des K. Museums für Völkerkunde zur Archäologie Amerikas (veröffentlichungen aus dem Königlichen Museum für Völkerkunde, I, pp. 1–44.

1902. Types of culture in Peru. (Am. Anth. (N. S.), IV, pp. 753–759.)

1903. Pachacamac. (Univ. of Penn. Dept. of Archaeology.)

1904. Bericht über die Ergebnisse meiner südamerikanischen Reisen. (Internat. Cong. of Americanists, 14th Sess., Stuttgart, pp. 567–579.)

1908. Über die Frühculturen in der Umgebung von Lima. (Internat. Cong. of Americanists, 16th Sess., Vienna, pp. 347–370.)

VALENTINI, P. J. J.

1879, *a.* Mexican copper tools. (Proc. Am. Antiq. Soc., April, pp. 81–112.)

1879, *b.* The katunes of Maya history. (Proc. Am. Antiq. Soc., Oct., pp. 71–117.)

1880. The Landa alphabet; a Spanish fabrication. (Proc. Am. Antiq. Soc., April, pp. 59–91.)

1881, *a.* Mexican paper. (Proc. Am. Antiq. Soc., I (N. S.), pp. 58–81.)

1881, *b.* Two Mexican chalchihuites, the Humboldt Celt and the Leyden Plate. (Proc. Am. Antiq. Soc., I (N. S.), pp. 283–302.)

1882. The Olmecas and the Tultecas. (Proc. Am. Antiq. Soc., II (N. S.), pp. 193–230.)

1898. Pinzon-Solis, 1508. (Gesell. für Erdkunde, Zeitschrift, XXXIII, pp. 254–282.)

1902. The discovery of Yucatan by the Portuguese in 1493. An ancient chart. (Records of the Past, I, pp. 45–59.)

VILLAGUTIERRE, SOTO MAJOR, J.

1701. Historia de la conquista de la provincia de el Itza, reduccion, y progressos de la de el Lacandon, y otras naciones de el reyno de Guatimala, a las provincias de Yucatan, en la America septentrional. Madrid.

WALDECK, J. F. DE

1838. Voyage pittoresque et archeologique dans la province de Yucatan, pendant les années, 1834–1836, folio. Paris.

1866. Monuments anciens du Mexique. Palenque et autres ruins de l'ancienne civilization du Mexique, etc., folio. Paris. (Introduction by Brasseur de Bourbourg.)

WEYGOLD, F.

1903. Das indianische Lederzelt im Königlichen Museum für Völkerkunde zu Berlin. (Globus LXXXIII, pp. 1–7.)

WIENER, C.

1880. Pérou et Bolivie. Paris.

WILSON, T.

1894. The swastika. The earliest known symbol, and its migrations; with observations on the migration of certain industries in prehistoric times. (Rep. U. S. Nat. Mus. for 1894, pp. 757–1011.)

ZORITA, A. DE

1865. Breve y sumaria relacion de los señores y maneras y diferencias que habia de ellos en la Nueva-España. (Coleccion de documentos inéditos relativos al descubrimiento, conquista y colonizacion de las Posesiones Españolas en América y Oceanía, II, pp. 1–126.)

INDEX